1990

# AMERICAN ART
# OF THE 1960s

University of St. Francis

GEN
Sandle
Americ

W9-ADS-644

3 0301 00082270 6

LIBRARY

# AMERICAN ART
# OF THE 1960s

IRVING SANDLER

ICON EDITIONS

*1817*

HARPER & ROW, PUBLISHERS, New York
Cambridge, Philadelphia, San Francisco, Washington
London, Mexico City, São Paulo, Singapore, Sydney

LIBRARY
College of St. Francis
JOLIET, ILLINOIS

AMERICAN ART OF THE 1960s. Copyright © 1988
by Irving Sandler. All rights reserved. Printed in
the United States of America. No part of this book
may be used or reproduced in any manner
whatsoever without written permission except in
the case of brief quotations embodied in critical
articles and reviews. For information address
Harper & Row, Publishers, Inc., 10 East 53rd
Street, New York, N.Y. 10022. Published
simultaneously in Canada by Fitzhenry &
Whiteside Limited, Toronto.

FIRST EDITION

*Designer: Abigail Sturges*

*Copy editor: Marjorie Horvitz*

Library of Congress Cataloging-in-Publication Data

Sandler, Irving, 1925–
    American art of the 1960s.

    (Icon editions)
    Bibliography: p.
    Includes index.
    1. Art, American—Themes, motives.   2. Art, Modern—
20th century—United States—Themes, motives.   I. Title.
N6512.S255   1988        709'.73        87-45662
ISBN 0-06-438507-8          88 89 90 91 92        10 9 8 7 6 5 4 3 2 1
ISBN 0-06-430179-6 (pbk.) 88 89 90 91 92        10 9 8 7 6 5 4 3 2 1

709.73
S216

# CONTENTS

*Color plates follow page 108.*

136,720

# LIST OF ILLUSTRATIONS

Museum of American Art. Acq. #72.41. Photo: Geoffrey Clements.

21. Morris Louis, *Saraband,* 1959. Acrylic resin on canvas, 100⅛″ × 149″. Solomon R. Guggenheim Museum, New York. Photo: Carmelo Guadagno and David Heald.

22. Morris Louis, *Gamma Delta,* 1959–60. Synthetic polymer paint on canvas, 102¾″ × 152½″. Collection of Whitney Museum of American Art, New York. Purchase, with funds from the McCrory Corporation. Acq. #69.57. Photo: Geoffrey Clements.

23. Morris Louis, *Sky Gamut,* 1961. Acrylic on canvas, 90½″ × 56⅜″. Private collection, courtesy Andre Emmerich Gallery, New York. Photo: Geoffrey Clements.

24. Kenneth Noland, *Turnsole,* 1961. Synthetic polymer paint on canvas, 94⅛″ × 94⅛″. Collection the Museum of Modern Art, New York. Blanchette Rockefeller Fund.

25. Kenneth Noland, *New Day,* 1967. Synthetic polymer on canvas, 89⅜″ × 184¾″. Collection of Whitney Museum of American Art, New York. Purchase, with funds from the Friends of the Whitney Museum of American Art. Acq. #68.18.

26. Jules Olitski, *Cleopatra Flesh,* 1962. Synthetic polymer paint on canvas, 104″ × 90″. Collection the Museum of Modern Art, New York. Gift of G. David Thompson (by exchange). Photo: Eric Pollitzer.

27. Jules Olitski, *High A Yellow,* 1967. Synthetic polymer, 89½″ × 150″. Collection of Whitney Museum of American Art, New York. Purchase, with funds from the Friends of the Whitney Museum of American Art. Acq. #68.3. Photo: Geoffrey Clements.

28. Frank Stella, *Empress of India,* 1965. Metallic powder on canvas, 77″ × 224″. Collection the Museum of Modern Art, New York. Gift of S. I. Newhouse, Jr. Photo: Rudolph Burckhardt.

29. Frank Stella, *Sanbornville III,* 1966. Fluorescent alkyd and epoxy paint on canvas. 104″ × 146″. Collection of Whitney Museum of American Art, New York. Gift of Joseph A. Helman, New York. Acq. #83.37. Photo: Geoffrey Clements.

30. Frank Stella, *Agbatana I,* 1968. Synthetic polymer, 120″ × 180″. Collection of Whitney Museum of American Art, New York. Purchase, with funds from Mr. and Mrs. Oscar Kolin. Acq. #68.35. Photo: Geoffrey Clements.

31. Ellsworth Kelly, *Red White,* 1961. Oil on canvas, 62¾″ × 85¼″. Hirshhorn Museum and Sculpture Garden, Smithsonian Institution, Washington, D.C.

32. Ellsworth Kelly, *Red Blue,* 1964. Oil on canvas, 90″ × 66″. Collection Mr. and Mrs. Morton J. Hornick. Photo: Geoffrey Clements, courtesy Leo Castelli Gallery, New York.

33. Ellsworth Kelly, *Spectrum III,* 1967. Oil on canvas, in thirteen parts; overall, 108⅝″ × 33¼″. The Sidney and Harriet Janis Collection, the

Museum of Modern Art, New York.

34. Al Held, left: *Ivan the Terrible,* 1961. Acrylic on canvas, 144″ × 114″. Private collection; right: *Eusopus II,* 1970. Acrylic on canvas, 138″ × 168″. Collection Mara Held. Photo: courtesy the artist.

35. Al Held, *Noah's Focus II,* 1970. Acrylic on canvas, 138″ × 300″. Private collection. Photo: Geoffrey Clements.

36. Alfred Jensen, *The Acrobatic Rectangle per, Eleven,* 1967. Oil, 68″ × 48½″. Collection of Whitney Museum of American Art, New York. Promised gift of Mrs. Oscar Kolin. P.28.77. Photo: Geoffrey Clements.

37. Marcel Duchamp, *In Advance of a Broken Arm,* 1915. Wood and metal "ready-made" snow shovel, 47¾″ high. Yale University Art Gallery, New Haven, Conn. Gift of Katherine S. Dreier for the Collection Société Anonyme. Photo: Joseph Szaszfai.

38. Robert Morris, *Litanies,* 1963. Lead over wood with steel key ring, twenty-seven keys, and brass lock, 12″ × 7⅛″ × 2½″. Collection the Museum of Modern Art, New York. Gift of Philip Johnson.

39. Bruce Nauman, *Self-Portrait as a Fountain,* 1966–67. Color photograph, 19¾″ × 23¾″. Collection Leo Castelli Gallery, New York. Photo: courtesy Leo Castelli Gallery.

40. Andy Warhol, *Brillo,* 1964. Painted wood, 17″ × 17″ × 14″. Collection of Mr. and Mrs. Charles H. Carpenter, Jr. Photo: Rudolph Burckhardt, courtesy Leo Castelli Gallery, New York.

41. Robert Morris, *Untitled,* 1967. Lacquered cold rolled steel, 9 of 16 units, each 36″ × 36″ × 36″. Panza Collection. Photo: courtesy Leo Castelli Gallery, New York.

42. Piet Mondrian, *Composition with Blue and Yellow,* 1935. Oil on canvas, 28¾″ × 27¼″. Hirshhorn Museum and Sculpture Garden, Smithsonian Institution, Washington, D.C. Gift of Joseph H. Hirshhorn Foundation, 1972.

43. Carl Andre, *Lead-Copper Plain,* 1969. Copper and lead, 72″ × 72″. Albright-Knox Art Gallery, Buffalo, N.Y. Charles Clifton Fund.

44. Chuck Close, study for *Self-Portrait,* 1968. Photograph scored in pencil, tape, 14″ × 11″. Collection the Museum of Modern Art, New York. Gift of Mr. Norman Dubrow.

45. Robert Morris, *Untitled,* 1964. Painted plywood, 48″ × 48″ × 48″. Installation photo, Green Gallery, New York, 1964. Photo: Rudolph Burckhardt, courtesy Leo Castelli Gallery, New York.

46. Sol LeWitt, *Serial Project No. 1 (ABCD),* 1966. Baked enamel on aluminum, 20″ × 163″ × 163″. Collection the Museum of Modern Art, New York. Purchase and exchange.

47. Claes Oldenburg, *Two Cheeseburgers with Everything (Dual Hamburgers),* 1962. Burlap soaked in plaster, painted with enamel, 7″ × 14¾″ × 8⅝″. Collection the Museum of

75. Tom Wesselmann, *Still Life Number 36,* 1964. Oil, synthetic polymer and collage on paper, 120″ × 192¼″. Collection of Whitney Museum of American Art, New York. Gift of the artist. Acq. #69.151. Photo: Geoffrey Clements.

76. Tom Wesselmann, *Smoker, 1 (Mouth 12),* 1967. Oil on canvas, in two parts, overall, 108⅞″ × 85″. Collection the Museum of Modern Art, New York. Susan Morse Hilles Fund.

77. Claes Oldenburg, *The White Slip,* 1961. Painted plaster, 41¾″ × 29¼″ × 3½″. Collection of Whitney Museum of American Art, New York. Promised gift of Howard and Jean Lipman. P.55.80. Photo: Geoffrey Clements.

78. Claes Oldenburg, *Soft Toilet,* 1966. Vinyl filled with kapok, painted with liquitex and wood, 52″ × 32″ × 30″. Collection of Whitney Museum of American Art, New York. 50th anniversary gift of Mr. and Mrs. Victor W. Ganz. Acq.#79.83. Photo: Jerry I. Thompson.

79. Claes Oldenburg, *Floor Cone,* 1962. Synthetic polymer paint on canvas filled with foam rubber and cardboard, 53¾″ × 136″ × 56″. Collection the Museum of Modern Art, New York. Gift of Philip Johnson.

80. Claes Oldenburg, *Bedroom Ensemble,* 1963. Wood, vinyl, metal, artificial fur, cloth and paper for a room, 17′ × 21′. Collection National Gallery of Canada, Ottawa.

81. Claes Oldenburg, *Giant Fag Ends,* 1967. Canvas, urethane foam and wood, 96″ × 96″ × 40″. Collection of Whitney Museum of American Art, New York. Purchase, with funds from the Friends of the Whitney Museum of American Art. Acq.#70.44. Photo: Geoffrey Clements.

82. Claes Oldenburg, *Lipstick Ascending on Caterpillar Tracks,* 1969. Painted Cor-Ten steel, 24′ × 13′ × 13′. Original location: Beinecke Plaza, in front of Woodbridge Hall, Yale University, New Haven, Conn. Photo: Shunk-Kender, May 1969.

83. Jim Dine, *Five Feet of Colorful Tools,* 1962. Oil on canvas surmounted by a board on which thirty-two tools hang from hooks, overall, 55⅝″ × 60¼″ × 4⅜″. The Sidney and Harriet Janis Collection, the Museum of Modern Art, New York.

84. Jim Dine, *Double Isometric Self-Portrait (Serape),* 1964. Oil with objects on canvas, 56⅞″ × 84½″. Collection of Whitney Museum of American Art, New York. Gift of Helen W. Benjamin in memory of her husband, Robert M. Benjamin. Acq.#76.35.

85. Red Grooms, *Loft on 26th Street,* 1965–66. Construction of painted plywood, cardboard, paper and wire, 28¼″ × 65¼″ × 28½″. Hirshhorn Museum and Sculpture Garden, Smithsonian Institution, Washington, D.C. Gift of Joseph H. Hirshhorn, 1966.

86. Red Grooms, *Chicago,* 1968. Painted construction, wood and acrylic, 11′ high, 500′ square. Courtesy the Art Institute of Chicago. Gift of Mrs. Maggy-Magerstadt Fisher, 1969.242.

87. George Segal, *The Bus Station,* 1965. Plaster, wood, formica, metal, vinyl, cardboard and leather, 96¼″ × 59⅛″ × 29¾″. Collection of Whitney Museum of American Art, New York. Gift of Howard and Jean Lipman. Acq.#81.22a-f.

88. George Segal, *The Billboard,* 1966. Plaster, wood, metal and rope, 15′9″ × 9′9″ × 1′8″. State of New York, Nelson A. Rockefeller Empire State Plaza Art Collection. Photo: Lee Boltin.

89. Alex Katz, *Ada and Vincent,* 1967. Oil on canvas, 94½″ × 71½″. Collection the artist. Photo: eeva-inkeri, courtesy Robert Miller Gallery, New York.

90. Philip Pearlstein, *Female Model on Oriental Rug with Mirror,* 1968. Oil on canvas, 60″ × 72″. Collection of Whitney Museum of American Art, New York. 50th anniversary gift of Mr. and Mrs. Leonard Lauder. Acq.#84.69.

91. Alex Katz, *Cocktail Party,* 1965. Oil on canvas, 78″ × 96″. Collection, Paul Jacques Schupf, Hamilton, N.Y. Photo: courtesy Marlborough Gallery.

92. Alex Katz, *Vincent in Hood,* 1964. Oil on canvas, 54″ × 66″. Collection the artist. Photo: Rudolph Burckhardt.

93. Alex Katz, *John's Loft,* 1969. Wall piece: cutouts, oil on aluminum, 60″ × 144″. Collection the artist. Photo: Rudolph Burckhardt, courtesy Robert Miller Gallery, New York.

94. Philip Pearlstein, *Two Seated Models,* 1968. Oil on canvas, 60″ × 48″. Collection, Gilbert F. and Editha Carpenter. Photo: Eric Pollitzer.

95. Philip Pearlstein, *Portrait of Linda Nochlin and Richard Pommer,* 1968. Oil on canvas, 72″ × 60″. Collection, Linda Nochlin and Richard Pommer, New York. Photo: Eric Pollitzer.

96. Jack Beal, *The Roof,* 1964–65. Oil on canvas, 96″ × 120″. Robert B. Mayer Family Collection. Photo: Nathan Rabin, courtesy Allan Frumkin Gallery, New York.

97. Alfred Leslie, *Alfred Leslie,* 1966–67. Oil, 108″ × 72″. Collection of Whitney Museum of American Art, New York. Purchase, with funds from the Friends of the Whitney Museum of American Art. Acq.#67.30.

98. Neil Welliver, study for *Pond Pass,* 1969. Oil on canvas, 48″ × 48″. Collection the artist, courtesy Marlborough Gallery, New York.

99. William Bailey, *"N" (Female Nude),* c. 1965. Oil on canvas, 48″ × 72″. Collection of Whitney Museum of American Art, New York. Gift of Mrs. Louis Sosland. Photo: Geoffrey Clements.

100. Malcolm Morley, *Beach Scene,* 1968. Oil on canvas, 110″ × 89⅞″. Hirshhorn Museum and Sculpture Garden, Smithsonian Insitution. Gift of Joseph H. Hirshhorn, 1972.

101. Richard Estes, *The Candy Store,* 1969. Oil and synthetic polymer, 47¾″ × 60¾″. Collection of Whitney Museum of American Art, New

York. Purchase, with funds from the Friends of the Whitney Museum of American Art. Acq.#69.21. Photo: Geoffrey Clements.

102. Chuck Close, *Self-Portrait,* 1968. Acrylic on canvas, 107½″ × 83½″. Collection Walker Art Center, Minneapolis, Minn. Art Center Acquisition Fund, 1969.

103. Chuck Close, *Phil,* 1969. Synthetic polymer, 108″ × 84″. Collection of Whitney Museum of American Art, New York. Purchase, with funds from Mrs. Robert M. Benjamin. Acq.#69.102.

104. Duane Hanson, *Hard Hat Construction Worker,* 1970. Painted polyester, resin, old clothes, fiberglass, talcum, and mixed media, 47½″ × 35″ × 42″. Virginia Museum, Richmond. Gift of Sydney and Frances Lewis.

105. John DeAndrea, *Reclining Woman,* 1970. Polyester and fiberglass, life-size. The David Bermant Collection. Photo: Pollitzer, Strong & Meyer, courtesy of Carlo Lamagna Gallery, New York.

106. Victor Vasarely, *Eridan Jaune* (from the portfolio *Planetarische Folklore*), 1955–64. Serigraph, 24½″ × 25½″. Collection of Neuberger Museum, State University of New York at Purchase. The George and Edith Rickey Collection of Constructivist Art.

107. Michael Kidner, *Yellow, Blue, Green, and White Wave,* 1964. Oil on canvas, 86″ × 58″. Collection the artist. Photo: Hugh Gordon.

108. Josef Albers, *Homage to the Square: Gained,* 1959. Oil on board, 40″ × 40″. Collection of Whitney Museum of American Art, New York. 50th anniversary gift of Fred Mueller. Acq.#79.36. Photo: Geoffrey Clements.

109. Bridget Riley, *Current,* 1964. Synthetic polymer paint on composition board, 58⅜″ × 58⅞″. Collection the Museum of Modern Art, New York. Philip Johnson Fund.

110. Larry Poons, *Night on Cold Mountain,* 1962. Synthetic polymer paint and dye on canvas, 80″ × 80″. Collection the Museum of Modern Art, New York. Larry Aldrich Foundation Fund.

111. Larry Poons, *Untitled,* 1966. Synthetic polymer on canvas, 130″ × 90″. Collection of Whitney Museum of American Art, New York. Purchase. Acq.#66.84.

112. Richard J. Anuszkiewicz, *Radiant Green,* 1965. Synthetic polymer paint on composition board, 16″ × 16″. The Sidney and Harriet Janis Collection, the Museum of Modern Art, New York.

113. Bridget Riley, *Untitled,* 1966. Emulsion on board, 25⅝″ × 20⅜″. Collection of Neuberger Museum, State University of New York at Purchase. The George and Edith Rickey Collection of Constructivist Art.

114. George Rickey, *Omaggio a Bernini,* 1958. Stainless steel, 68½″ × 36″ × 36″. Collection of Whitney Museum of American Art, New York. Gift of Mr. and Mrs. Patrick B. McGinnis. Acq.#64.53.

115. Len Lye, *Grass,* 1965. Stainless steel, wood, motorized and programmed, 36″ × 35⅝″.

Albright-Knox Art Gallery, Buffalo, N.Y. Gift of Howard Wise Gallery.

116. Kenneth Snelson, *Sun River,* 1968. Stainless steel, 126″ × 96″ × 60″. Collection of Whitney Museum of American Art, New York. Purchase, with funds from the Howard and Jean Lipman Foundation, Inc. Acq.#68.46.

117. Stephen Antonakos. Installation photo of 1967 exhibition at the Fischbach Gallery. Left: *Orange Vertical Floor Neon,* 1967. Neon, 108″ × 72″ × 72″. Collection Wadsworth Atheneum, Hartford, Conn. Right: *Red Neon, Wall to Floor,* 1967. Neon, 122″ × 144″ × 168″. Collection the artist. Photo: John A. Ferrari, courtesy Stephen Antonakos.

118. Nam June Paik and Charlotte Moorman, 1964. Publicity photo taken before the Second Annual Avant-Garde Festival, New York. Photo: Peter Moore, copyright © Peter Moore, #8/17/64-C7 (Paik & Moorman, K-456), 1964.

119. Robert Morris, *Untitled (Ramp),* 1965. Grey fiberglass, 24″ × 192″ × 12″. Panza Collection. Photo: Rudolph Burckhardt, courtesy Leo Castelli Gallery, New York.

120. Donald Judd. *Untitled (4 Boxes),* 1965. Galvanized iron and painted aluminum, 33″ × 141″ × 30″. Collection, Philip Johnson. Photo: courtesy Leo Castelli Gallery, New York.

121. Dan Flavin, *Monument for V. Tatlin, No. 61,* 1969. Cool white fluorescent light, 119″ × 23″ × 4″. Collection Leo Castelli. Photo: Rudolph Burckhardt, courtesy Leo Castelli Gallery, New York.

122. Constantin Brancusi, *Endless Column,* 1918. Oakwood, 80″ × 9⅞″ × 9⅝″. Collection the Museum of Modern Art, New York. Gift of Mary Sisler.

123. Robert Morris, *Floor Piece,* 1964. Painted plywood, 17″ × 17″ × 288″. Installation photo, Green Gallery, New York, 1964. Photo: Rudolph Burckhardt, courtesy Leo Castelli Gallery, New York.

124. Anthony Caro, *Georgiana,* 1969–70. Painted steel, 5′ × 15′3″ × 8′. Albright-Knox Art Gallery, Buffalo, N.Y. Gift of Seymour H. Knox.

125. Donald Judd, *Untitled,* 1968. Plexiglas and stainless steel, 33″ × 68″ × 48″. Collection of Whitney Museum of American Art, New York. Purchase, with funds from the Howard and Jean Lipman Foundation, Inc. Acq.#68.36. Photo: Geoffrey Clements.

126. Donald Judd, *Untitled,* 1963. Wood and lead pipe, 19½″ × 45″ × 30½″. Collection, Philip Johnson. Photo: Rudolph Burckhardt, courtesy Leo Castelli Gallery, New York.

127. Donald Judd, *Untitled,* 1968. Steel and Plexiglas, ten units, each 9″ × 40″ × 31″, height 14′3″. State of New York, Nelson A. Rockefeller Empire State Plaza Art Collection. Photo: Lee Boltin.

128. Donald Judd, *Untitled,* 1968. Five open rectangles of painted steel spaced approximately 5⅛″ apart, each 48⅜″ × 120″ × 20¼″;

overall, 48³⁄₈″ × 120″ × 121″. Collection the Museum of Modern Art, New York. Mr. and Mrs. Simon Askin Fund.

129. Robert Morris, *Metered Bulb,* 1963. Mixed media, c. 24″ × 12″. Collection Jasper Johns. Photo: Mark Hedden, courtesy Leo Castelli Gallery, New York.

130. Robert Morris, *Untitled,* 1965. Glass mirrors on wood, four boxes, each 21″ × 21″ × 21″. Installation photo, Green Gallery, New York, 1965. Photo: Rudolph Burckhardt, courtesy Leo Castelli Gallery, New York.

131. Robert Morris, *Untitled,* 1965–66. Fiberglass and fluorescent light, 24″ × 14″ × 97″ in diameter. Dallas Museum of Fine Arts. General Acquisitions Fund and matching grant from the National Endowment for the Arts. Photo: Rudolph Burckhardt, courtesy Leo Castelli Gallery, New York.

132. Robert Morris, *Untitled (L-beams),* 1965. Stainless steel, three beams, each 96″ × 96″ × 24″. Collection of Whitney Museum of American Art, New York. Gift of Howard and Jean Lipman. Acq.#76.29. Photo: Geoffrey Clements.

133. Robert Morris, *Untitled,* 1969. Draped 1″ thick, gray-green felt, 180¹⁄₂″ × 72¹⁄₂″ × 1″. Collection the Museum of Modern Art, New York. The Gilman Foundation Fund.

134. Robert Morris, installation view of *Untitled,* 1970, during the exhibition *Robert Morris,* Whitney Museum of American Art, New York, May 9–31, 1970. Photograph by Peter Moore. © Peter Moore, 1970, New York, N.Y.

135. Dan Flavin, *Pink Out of a Corner—To Jasper Johns,* 1963. Pink fluorescent light in metal fixture, 96″ × 6″ × 5³⁄₈″. Collection, the Museum of Modern Art, New York. Gift of Philip Johnson.

136. Dan Flavin, *The Nominal Three (to William of Ockham),* original 1964, reconstruction 1969. Cool white fluorescent light, 96″ high Collection National Gallery of Canada, Ottawa.

137. Dan Flavin, *Untitled (to the "innovator" of Wheeling Peachblow),* 1968. Fluorescent lights and metal fixtures, 96¹⁄₂″ × 96¹⁄₄″ × 5³⁄₄″. Collection the Museum of Modern Art, New York. Helena Rubinstein Fund.

138. Carl Andre, *Lead Piece (144 Lead Plates 12″ × 12″ × ³⁄₈″),* 1969. 144 lead plates, each approximately ³⁄₈″ × 12″ × 12″; overall ³⁄₈″ × 144⁷⁄₈″ × 145¹⁄₂″. Collection the Museum of Modern Art, New York. Advisory Committee Fund.

139. Carl Andre, *Timber Spindle Exercise,* 1964. Wood, 33″ × 8″ × 8″. Collection the Museum of Modern Art, New York. Gift of Mr. and Mrs. Michael Chapman.

140. Carl Andre, *Cedar Piece,* 1959/1964. Cedarwood, 68³⁄₈″ × 36¹⁄₄″. Öffentliche Kunstsammlung Basel, Museum für Gegenwartskunst.

141. Carl Andre, *Lever,* 137 firebricks, each brick 4¹⁄₂″ × 8⁷⁄₈″ × 2¹⁄₂″; overall, 4¹⁄₂″ × 8⁷⁄₈″

× 348″. Collection, National Gallery of Canada, Ottawa.

142. Tony Smith, *Die,* 1962. Steel, 72″ × 72″ × 72″. Collection Paula Cooper Gallery, New York. Photo: Geoffrey Clements, courtesy Paula Cooper Gallery.

143. Tony Smith, *Cigarette,* 1961. Painted steel, 15′1″ × 25′6″ × 18′7″. Collection the Museum of Modern Art, New York. Mrs. Simon Guggenheim Fund.

144. Ronald Bladen, *Untitled,* 1966–67 (first made in wood, 1965). Painted and burnished aluminum in three identical parts, each 120″ × 48″ × 24″, spaced 9′4″ apart; overall length 28′4″. Collection the Museum of Modern Art, New York. James Thrall Soby Fund.

145. Ronald Bladen, *Black Triangle,* 1966. Wood, 10′ × 9′4″ × 13′. Collection Connie Reyes.

146. Larry Bell, *Untitled,* 1967. Mineral-coated glass and rhodium-plated brass, 20″ × 20″ × 20″. Collection of Whitney Museum of American Art, New York. Gift of Howard and Jean Lipman. Acq.#80.38. Photo: Geoffrey Clements.

147. Richard Tuttle, *Gray Extended Seven,* 1967. Dyed canvas, 48¹⁄₂″ × 59¹⁄₂″. Collection of Whitney Museum of American Art, New York. Purchase, with funds from the Simon Foundation, Inc., and the National Endowment for the Arts. Acq.#75.7.

148. Agnes Martin, *The Tree,* 1964. Oil and pencil on canvas, 72″ × 72″. Collection the Museum of Modern Art, New York. Larry Aldrich Foundation Fund.

149. Robert Ryman, *Untitled,* 1960. Oil on cotton, 43″ × 43″. Collection and courtesy the artist. Photo: Robert E. Matz and Paul Katz.

150. Robert Mangold, *¹⁄₂ Manila Curved Area,* 1967. Oil on composition board, 72″ × 144″. Collection of Whitney Museum of American Art, New York. Purchase, with funds from the Friends of the Whitney Museum of American Art. Acq.#68.14. Photo: Geoffrey Clements.

151. Mark di Suvero, *New York Dawn (for Lorca),* 1965. Wood, steel and iron, 78″ × 74″ × 50″. Collection of Whitney Museum of American Art, New York. Purchase, with funds from the Howard and Jean Lipman Foundation, Inc. Acq.#66.52. Photo: Geoffrey Clements.

152. David Smith, *Hudson River Landscape,* 1951. Welded steel. 49¹⁄₂″ × 75″ × 16³⁄₄″. Collection of Whitney Museum of American Art, New York. Purchase. Acq.#54.14.

153. Mark di Suvero, *Praise for Elohim Adonai,* 1966. Wood and steel, 22′ high × 30′ in diameter. The Saint Louis Art Museum. Gift of Mr. and Mrs. Norman B. Champ, Jr.

154. Mark di Suvero, *Are Years What? (For Marianne Moore),* 1967. Steel, 40′ × 40′ × 30′. Oil and Steel Gallery, New York. Photo: Steven Sloman, courtesy Oil and Steel Gallery.

155. Anthony Caro, *Midday,* 1960. Steel, painted steel, 91³⁄₄″ × 37³⁄₈″ × 145³⁄₄″. Collection the Museum of Modern Art, New York. Mr. and

Jean Lipman Foundation, Inc. Acq.#69.20. Photo: Geoffrey Clements.

182. Richard Serra, *Casting*, 1969. Lead, 4″ × 300″ × 18″. (Destroyed.) Photo: Peter Moore, courtesy Leo Castelli Gallery, New York.

183. Barry Le Va, work of 1967; installation, New Museum, New York, 1979. Aluminum and grey felt. Photo: Bevan Davies, courtesy Sonnabend Gallery, New York.

184. Robert Morris, *Untitled*, 1968. Asphalt, mirror, thread, copper tubing, steel cable, wood, felt, lead; indeterminate dimensions, approximately 26′ × 20′. Photo: Rudolph Burckhardt, courtesy Leo Castelli Gallery, New York.

185. Robert Smithson, *Spiral Jetty*, April 1970. Vesicular black basalt, salt crystals, earth, red water (algae), Great Salt Lake, Utah; coil 1,500′ long, approximately 15′ wide. Photo: Gian-Franco Gorgoni, courtesy of John Weber Gallery, New York.

186. Walter de Maria, *The New York Earth Room*, 1977, New York. Two-hundred-fifty cubic yards of earth and earth mix (peat and bark) weighing 280,000 pounds; covering an area of 3,600 square feet of floor space to a depth of 22″. Installation commissioned and maintained by the Dia Foundation. This sculpture is on permanent view to the public. Dia Art Foundation, New York. Photo: John Cliett. Copyright Dia Art Foundation, 1980.

187. Robert Smithson, *Non-Site (Palisades, Edgewater, N.J.*, 1968. Enamel, painted aluminum and stone, 56″ × 26″ × 36″. Collection of Whitney Museum of American Art, New York. Gift of Howard and Jean Lipman Foundation, Inc. Acq.#69.6. Photo: Geoffrey Clements.

188. Robert Smithson, map and description that accompany *Non-Sire (Palisades, Edgewater, N.J.*, 1968. Ink on paper. Map, 1½″ × 2″; description, 7⅜″ × 9¾″. Collection of Whitney Museum of American Art, New York. Gift of the Howard and Jean Lipman Foundation, Inc. Acq.#69.6. Photo: Geoffrey Clements.

189. Robert Smithson, *Gyrostatis*, 1968. Painted steel, 73″ × 57″ × 40″. Hirshhorn Museum and Sculpture Garden, Smithsonian Institution, Washington, D.C. Gift of Joseph H. Hirshhorn, 1972.

190. Robert Smithson, *1st Mirror Displacement*, 1969. Glass, 1″ thick, 12″ square. Yucatán Travels. Photo: courtesy John Weber Gallery, New York.

191. Michael Heizer, *Double Negative*, 1969–70. Displacement of 240,000 tons of rhyolite and sandstone, 1,500′ × 50′ × 30′. Morman Mesa, Overton, Nevada. Collection the Museum of Contemporary Art, Los Angeles. Gift of Virginia Dwan. Photo: Barbara Heizer.

192. Dennis Oppenheim, *Annual Rings*, 1968. 150′ × 200′. Location: U.S.A./Canada Boundary at Fort Kent, Maine, and Clair, New Brunswick. Schemata of Annual Tree Rings Severed by Political Boundary. Time: U.S.A., 1:30 P.M.; Canada, 2:30 P.M.

193. Christo, *Packed Kunsthalle*, Bern, Switzerland, 1968. Twenty-seven thousand square feet of synthetic fabric and 10,000 feet of rope. Photo: Thomas Cugini. Copyright Christo.

194. Christo, *Wrapped Coast—Little Bay Australia*, 1969. One million square feet. Coordinator John Kaldor. Photo: Harry Shunk. Copyright Christo.

195. Robert Irwin, *No Title*, 1966–67. Painted aluMuseum of American Art, New York. Purchase, with funds from the Howard and Jean Lipman Foundation, Inc. Acq.#68.42.

196. Gilbert and George, *Underneath the Arches*, October 1971. Performed at the Sonnabend Gallery, New York. Photo: Nick Sheidy, courtesy Sonnabend Gallery, New York.

197. Sol LeWitt, *Untitled Cube*, 1968. Painted steel, 15½″ × 15½″ × 15½″. Collection of Whitney Museum of American Art, New York. Gift of the Howard and Jean Lipman Foundation, Inc. Acq.#68.45. Photo: Geoffrey Clements.

198. Robert Morris, *Document*, 1963. Typed and notarized statement on paper and sheet of lead over wood mounted in imitation leather mat, overall 17⅝″ × 23¾″. Collection the Museum of Modern Art, New York. Gift of Philip Johnson.

199. Sol LeWitt, *B 789*, 1966. Baked enamel on steel, 9⅜″ × 8½″ × 30½″. Whereabouts unknown, courtesy John Weber Gallery, New York.

200. Sol LeWitt, *Wall Drawing (III), Part 3*, 1971. Black pencil, five parts overall, 9′4″ × 46′8″. A wall divided vertically into five equal parts with 10,000 lines in each part; part 3: 18″-long lines. Courtesy John Weber Gallery, New York.

201. John Baldessari, *I Will Not Make Any More Boring Art*, 1971. Lithograph, printed in black, composition, 22⅜″ × 29⁹⁄₁₆″. Collection the Museum of Modern Art, New York. John B. Turner Fund.

202. Joseph Kosuth, *One and Three Chairs*, 1965. Wooden folding chair, photograph of chair, and photographic enlargement of dictionary definition of chair; chair, 32⅜″ × 14⅞″ × 20⅞″; photo panel, 36″ × 24⅛″; text panel, 24⅛″ × 24½″. Collection the Museum of Modern Art, New York. Larry Aldrich Foundation Fund.

203. Joseph Kosuth, *Information Room*, installation at the New York Cultural Center, 1970. Books and newspapers. Photo: courtesy Leo Castelli Gallery, New York.

204. Robert Barry, *One Billion Dots*, 1968. Book published by Gianenzo Sperone, Turin, Italy. Photo: courtesy Leo Castelli Gallery, New York.

205. Mel Bochner, *Degrees*, 1969. Installation at Galleria Sperone, Turin, Italy, October 1970. Paint on wall, size determined by height of wall. Photo: courtesy Sonnabend Gallery, New York.

## COLOR PLATES

*(following page 108)*

I. Frank Stella, *Rye Beach*, 1963. Alkyd on canvas, 30⅜″ x 60½″. Private collection, courtesy Blum-Helman Gallery, New York.

II. Kenneth Noland, *Across*, 1964. Acrylic resin on canvas, 97″ x 126″. Courtesy Andre Emmerich Gallery, New York.

III. Al Held, *Mao*, 1967. Acrylic on canvas, 114″ x 114″. Collection Mara Held, New York.

IV. Roy Lichtenstein, *Blang*, 1962. Oil and magna on canvas, 68″ x 80″. Private collection, courtesy Blum-Helman Gallery, New York.

V. Claes Oldenburg, *Giant Loaf of Raisin Bread*, 1967. Liquetex, glue, graphite on canvas, 46″ x 96″ x 40″. Collection Joseph A. Helman, New York.

VI. Alex Katz, *Ives Field # 1*, 1964. Oil on canvas, 78″ x 96″. Collection the artist.

VII. Donald Judd, *Untitled*, 1967. Green lacquer/galvanized iron, each unit 9″ x 40″ x 31″. Collection Joseph A. Helman, New York.

VIII. Dan Flavin, *Puerto Rican Lights (To Jeanie Blake)*, 1965. Fluorescent light, 49″ x 8½″ x 4¾″. Collection Leo Castelli Gallery, New York.

IX. Eva Hesse, *Sans II*, 1968. Fiberglass, 38″ x 170¾″ x 6⅛″. Whitney Museum of American Art, New York.

# PREFACE AND ACKNOWLEDGMENTS

*American Art of the 1960s* is the third volume of my history of American art since 1945, which began with *The Triumph of American Painting: A History of Abstract Expressionism* and continued with *The New York School: Painters and Sculptors of the Fifties.*

In this book I have included artists whose work seemed to me to be new; to contribute to the ongoing tradition of art; and, most important, to partake of the sensibility of that time, that most elusive and perishable awareness that causes art to appear to be peculiarly *of* a period, defining the period, as it were, or, at least, distinguishing it from what came before. Thus, this history treats the sixties as a coherent decade not because of the convenience of rounded numbers but because, in retrospect, it appears that the sensibility that informs its art was first revealed in *Sixteen Americans,* which opened at the Museum of Modern Art, New York, on 16 December 1959, and made its last appearance in *Information,* which opened at the Museum of Modern Art on 2 July 1970.

In my selection of artists I was strongly influenced by a loose and shifting art world consensus in the sixties or, more accurately, by my reading of that consensus. Still, I could not help looking back from the vantage point of the eighties, and I took recent art world estimates of sixties art into consideration. However, my choices were my own, and if my past experience is any sign, I have committed errors of inclusion and especially of omission, mistakes I am sure that time will rectify.

*American Art of the 1960s* differs somewhat from the two preceding books in that more attention is paid to the context of the art, notably the art world. In fact, the art world had become a far larger and more visible, cohesive, dynamic, and commanding force than it had been earlier. I also focus more on attitudes, ideas, and stylistic preferences shared by artists, although I cover the individual oeuvres of some eighty, situating each within a broader stylistic framework while emphasizing its uniqueness. Still, my treatment of individual styles is relatively condensed, the reason being that most have been featured in readily available monographs and catalogues, and what seemed to be needed now in a survey of sixties art was to establish interconnections among artists and their bodies of work and to organize an unprecedented abundance of information.

As in my earlier books, I relied heavily on information and opinions generously provided by artists, above all, but also by critics, historians, museum directors and curators, and dealers and collectors. I would like to thank the artists Vito Acconci, Abe Ajay, Stephen Antonakos, Richard Anuszkiewicz, William Bailey, John Baldessari, Robert Barry, Jack Beal, Robert Berlind, Joseph Beuys, Ronald Bladen, Mel Bochner, Louise Bourgeois, Paul Brach, Christo, Jeanne-Claude Christo, Chuck Close, Russell Connor, Willem de Kooning, Mark di Suvero, Tom Doyle, Rackstraw Downes, Louis Finkelstein, Andrew Forge, Helen Frankenthaler, Nancy

Graves, Stephen Greene, Red Grooms, Philip Guston, Duane Hanson, Grace Hartigan, Al Held, Eva Hesse, Douglas Huebler, Malcolm Hughes, Peter Hutchinson, Robert Indiana, Robert Irwin, Paul Jenkins, Alfred Jensen, Jasper Johns, Donald Judd, Allan Kaprow, Alex Katz, Michael Kidner, Nicholas Krushenick, Ellen Lanyon, Sol LeWitt, Roy Lichtenstein, Robert Mangold, Sylvia Mangold, Brice Marden, Malcolm Morley, Robert Morris, Barnett Newman, Kenneth Noland, Brian O'Doherty, Claes Oldenburg, Philip Pearlstein, Robert Rauschenberg, Ad Reinhardt, George Rickey, Bridget Riley, Walter Robinson, Dorothea Rockburne, Stephanie Rose, Mark Rothko, Robert Ryman, Miriam Schapiro, George Segal, Richard Serra, Harriet Shorr, David Smith, Tony Smith, Robert Smithson, Kenneth Snelson, Jean Spencer, Frank Stella, Sylvia Stone, George Sugarman, Michael Torlen, Jack Tworkov, Andy Warhol, Lawrence Weiner, Tom Wesselmann, and Murray Zimiles.

I also wish to express my appreciation to the art critics and historians Jonathan Alexander, Lawrence Alloway, Dore Ashton, Elizabeth Baker, Jane Bell, Kathleen Weil-Garris Brandt, Michael Brenson, Rosalind Constable, John Coplans, Douglas Davis, Edit DeAk, James Faure-Walker, Michael Fried, Robert Goldwater, E. C. Goossen, Clement Greenberg, Thomas Hess, Max Kozloff, Hilton Kramer, Rosalind Krauss, Philip Leider, Kim Levin, Lucy Lippard, Richard Martin, Joseph Masheck, Amy Newman, Linda Nochlin, Barbara Novak, Robert Pincus-Witten, Richard Pommer, Barbara Rose, Harold Rosenberg, Robert Rosenblum, John Russell, Meyer Schapiro, Gert Schiff, Peter Schjeldahl, Robert Storr, Gene Swenson, Sidney Tillim, Phyllis Tuchman, Kirk Varnedoe, and John Wendler; the museum directors and curators Richard Armstrong, Alfred H. Barr, Jr., John Baur, Robert Buck, Michael Compton, Martin Friedman, Henry Geldzahler, Barbara Haskell, Henry Hopkins, Janet Kardon, Kynaston McShine, Thomas Messer, Dorothy Miller, Frank O'Hara, Richard Oldenburg, William Rubin, William Seitz, Linda Shearer, Alan Solomon, Maurice Tuchman; the dealers Irving Blum, Leo Castelli, Paula Cooper, André Emmerich, Allan Frumkin, Joseph Helman, Carroll Janis, Ivan Karp, Carlo Lamagna, Pierre Levai and Jack Mongaz (of the Marlborough Gallery), Robert Miller, Ileana Sonnabend, and John Weber; and the collectors Vera and Donald Blinken, Marie and Roy Neuberger, Joann and Gifford Phillips, and Ethel and Robert Scull; and the friends of the artists John Cage, Edwin Denby, Morton Feldman, Buckminster Fuller, and Marshall McLuhan.

Among the librarians who have given generously of their time are James Boyles and Thelma Freidus of the State University of New York at Purchase; Paula Baxter, Janis Ekdahl, Daniel Fermon, Daniel Pearl, Clive Phillpot, and Daniel Starr of the Museum of Modern Art, New York; Elisabeth Bell, Krzysztof Cieszkowski, Meg Duff, Beth Houghton, Philip Moriarty, and Jane Savidge of the Tate Gallery, London; Jemison Hammond and William McNaught of the Archives of American Art, New York; Pamela Sharpless Richter of New York University, New York; and Loraine Baratti of the Whitney Museum of American Art, New York.

I am also deeply grateful to all those who helped provide photographs, notably Anita Duquette of the Whitney Museum of American Art; Richard Tooke of the Museum of Modern Art; Julia Ernst of the Saatchi Collection, London; Melissa Feldman of the Leo Castelli Gallery, New York; and John Cheim of the Robert Miller Gallery, New York.

I am especially indebted to Cass Canfield, Jr., of Harper & Row, for his enthusiastic encouragement and useful criticism; the National Endowment for the Humanities for a grant that greatly facilitated my research; Jane Edelson for her aid in edit-

ing the manuscript; Elizabeth Peyton for checking citations; and Michael Davidson, Thomas Kirk, and Caroline Levine for checking the bibliography.

Finally, I would like to acknowledge the support of Judith Richards, Susan Sollins, and Nina Sundell of the Independent Curators Incorporated, New York; Phyllis Bilick and Ileen Sheppard of the Queens Museum; my friends Gilbert Edelson, Sheldon Grebstein, Isabelle and Jerome Hyman, and Nathaniel Siegel; my daughter Catherine for cheering me on; and my wife, Lucy, who closely followed the progress of this book and to whom it is lovingly dedicated.

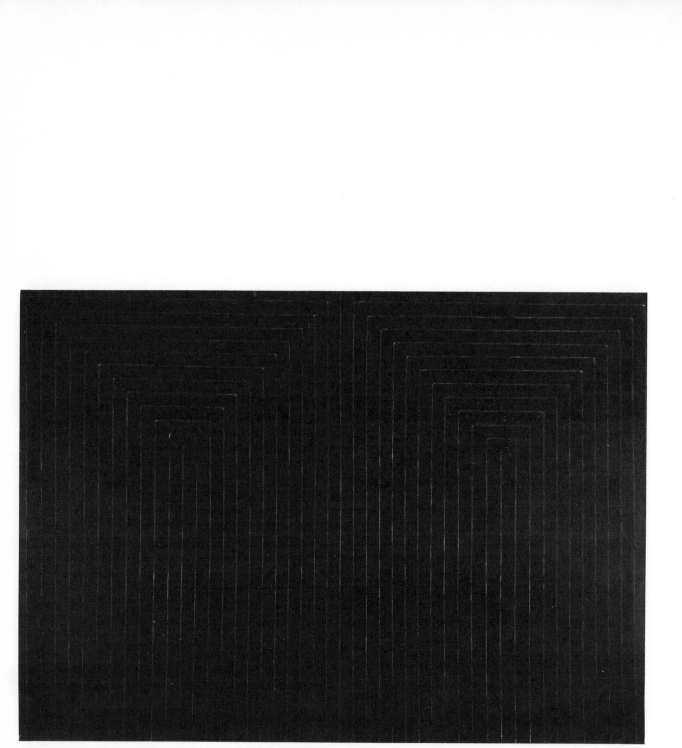

1. Frank Stella, *The Marriage of Reason and Squalor,* 1959. 90¾″ × 132¾″. The Museum of Modern Art, New York.

# INTRODUCTION:
# A PERSONAL MEMOIR, 1958–1962

I entered the sixties eyes closed to emerging new art. Frank Stella's abstractions composed of symmetrical, concentric configurations of black stripes, when first shown in the *Sixteen Americans* show at the Museum of Modern Art in 1959, enraged me. I should have been more open to Stella's painting, if only because it looked *new*, and I was a critic identified with the avant-garde or what was then considered the avant-garde, variously labeled Abstract Expressionism, action painting, the new American painting, and the New York School. I was one of a coterie of some two hundred artists and their friends who lived on or in the vicinity of East Tenth Street in downtown New York City; often visited and partied in one another's studios; frequented the cooperative galleries younger artists organized and managed, the Cedar Street Tavern, and, on Friday nights, a club, simply named the Club, the older artists had founded in 1949; and in general shared a way of life.[1]

We also shared an aesthetic, that of gesture or action or painterly painting, whose creative process is visible in the completed work, as exemplified by the pictures of Willem de Kooning, above all, but also of Franz Kline, Philip Guston, and others. Our involvement with gesture painting was intensified by the downtown art scene. It was stimulating, often inspiring, to be in the company of these artists whom we regarded not only as innovative

and great painters but as brilliant and articulate intellectuals as well. We were sympathetic to artists who had developed styles other than gestural, but only if they were of the older generation, like Mark Rothko (who was removed not only stylistically but geographically, living uptown as he did) and Ad Reinhardt (who was always on the scene but was implacably opposed to Abstract Expressionism of any kind). But we would not accept newcomers with ideas different from our own. More accurately, we attacked them angrily. Thus we joined a long line of modernists who, as Francis Haskell has remarked, partook of "two conflicting (and often unconscious) attitudes toward contemporary art . . . on the one hand, the search . . . for the new, the vital, the inspired, the unconventional; and, on the other, an almost uncontrollable distaste for just those qualities when . . . they do in fact appear."[2]

The primary target of our abuse, at least until the emergence of Pop Art in 1962, was Stella. Stephen Greene, his teacher, recalled that when Stella's work was first shown, Greene was unable "to convince a single artist that it was work of any importance or that it was even 'painting.'"[3] But there were good reasons for our not taking Stella seriously. His work was so reduced—to absurdity, we believed—as to appear nihilistic; at the very least, it seemed boring, and even to cultivate boredom.[4] Moreover, painting that looked

so different from and evidently antithetical to gesture painting, as Stella's did, was something other than expressive, authentic, significant, and contemporary. If gesture painting had value, then Stella's pictures could not. As one eminent art historian summed it up, he was more a juvenile delinquent than an artist.[5]

In retrospect, our response to Stella's work testifies to the importance of its entry into the stream of art. Stella and a few of his contemporaries were the avant-garde and not—as most of us believed—us. Those of us who had begun to have doubts still claimed that gesture painting was the vanguard or, at least, the last worthy one, but we claimed it with lessening confidence. By 1959, gesture painting was avant-garde only in the sense that it was in advance of the taste of the general public: in fact, it had not been extended in any radical manner for some half-dozen years. Moreover, its premises had become so familiar that it had attracted followers in numbers that seemed more like a main army than a vanguard.[6]

Because of this, a growing number of artists and art professionals who had earlier supported gesture painting—among them Alfred H. Barr, Jr., Clement Greenberg, Dorothy Miller, William Seitz, and Leo Castelli—began to think that it was in crisis. By that they meant that the tendency had become too established to yield significant and fresh stylistic developments. They also began to be on the lookout for styles that were in their opinion more viable. Barr believed that he had found an alternative to gesture painting in the flags and targets of Jasper Johns; and Greenberg, in the stained color-field abstractions of Morris Louis and Kenneth Noland.

Members of the coterie to which I belonged were bothered, too, by the mediocrity of most of the recently arrived gesture painters, but their number struck us as a validation of the tendency. I assumed that they (as I) had embraced the art of de Kooning, Kline, and Guston not merely because it was *new* in style but because it was *true* to their (and my) experience. Our search was for what we felt was genuine and real in ourselves, each for his or her own individual identity, as Harold Rosenberg wrote in his article on action painting (an article that strongly affected me).[7] And we believed that the struggle for authentic being was occurring at a time when the efficacy of man's individual actions appeared to count for less and less; when man and his future were increasingly problematic; when man himself was in crisis. The crisis, as we saw it, was existential, social, and political, and not the crisis in style envisaged by Greenberg.[8]

But we could not disregard the glut of gesture painting for long. By 1958, it had become obvious that most gesture painters were making pictures in a known and accepted style. They were the "school" artists—unambitious, derivative, and professional—who fabricated pictures in someone else's manner, with minor deviations to be sure, or who mixed the styles of others, contriving a measure of "originality."[9] Some of us recognized the problem and claimed that its resolution was to be found in distinguishing the genuine and deeply felt from the mannerist and contrived—that is, the good from the bad. After all, inferior art, no matter in what quantities, could not invalidate superior art. But in fact, it did affect what artists created and how viewers attended to art. A glut of banal art in any style rendered that style stale and discouraged lively artists from working in it and viewers from looking at even the best of it.[10] The falling attendance at the artist-run galleries on Tenth Street in the late fifties and their subsequent collapse was proof of that. Gesture painting that was expressive and of quality remained expressive and of quality, certainly, but the style was no longer difficult enough to be challenging; it had become an overworked and thus outmoded manner.

By 1959, the question of whether gesture painting was in crisis or decline was

FACING PAGE:
2. Robert Rauschenberg, *Bed*, 1955. 75¼″ × 31½″ × 6½″. Mr. and Mrs. Leo Castelli.

frequently debated by downtown artists. In response to the growing controversy, I organized at the Club a series of panel discussions entitled "What Is the New Academy?"—asking "What Is?" rather than "Is There?" to imply that in fact there was one.[11] I then compiled a series of seventeen statements by the artist-panelists and several others and published them in *Art News* under the heading "Is There a New Academy?"—the title softened by the editor, Thomas Hess.[12] Opinions differed as to whether gesture painting had become academic. But what disturbed me most was Helen Frankenthaler's blunt comment: "It is no longer a question if the question must be raised."[13]

Almost as troublesome, several of the contributors detailed what a "new academic" picture looked like, as though gesture painting had become predictable. It was, in John Ferren's words, "rough, 'real gutsy' and American . . . a certain speed limit—325 miles per hour. Black and white, of course, with possibly one other color, providing that it is dirty." Ferren went on to say that painterly finesse was taboo since it was European. The picture had to possess a "floundering" look and be "very big."[14] Frankenthaler had a similar image in mind, but she deprecated more than Ferren did, and with less irony, "the slickness of the unslick" and painting that was slightly ugly "in order *not* to look obviously like academy pictures."[15] Friedel Dzubas also denigrated "all the tricks of the current trade, the dragging of the brush, the minor accidents (within reason), the seeming carelessness and violence ever so cautiously worked up to."[16]

Gesture painters rebutted the attacks on the viability of their style, of course, but with a new defensiveness. For example, Nicholas Marsicano even granted that there was a new academy but quickly added that it was "an informal one," because

it has no rules or definitions, fixed leaders or followers, but is in the process of constantly being defined. There are a number of ele-

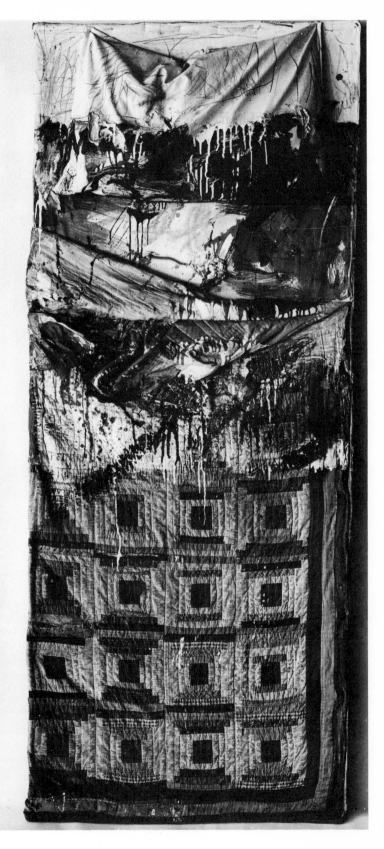

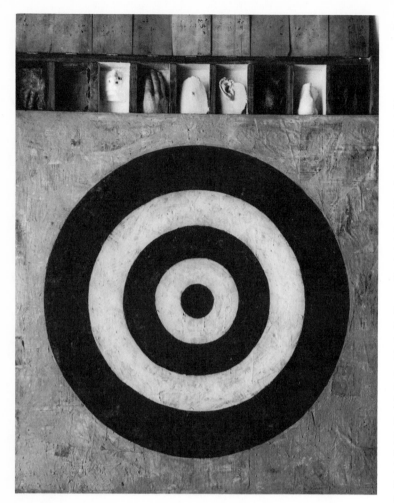

3. Jasper Johns, *Target with Plaster Casts,* 1955. 51″ × 44″ × 3½″. Mr. and Mrs. Leo Castelli.

ments that we possess in common . . . that we search for and need. . . .

We are in a state of exposing and what we do is made available to everyone. There are no secrets. . . . Anyone has a right to take ideas [if one also replaces the inspiration].

If a picture painted today possesses one truth, it remains the absolute truth until you possess one better. . . . The force of certain truths in painting today makes it impossible to paint outside of them.[17]

But Marsicano's "truths" were not those of young artists who were formulating styles different from gesture painting. And the question for the New York art world became: Were they the new avant-garde? During the late fifties, claims were made for Robert Rauschenberg and Jasper Johns, on the one hand, and Morris Louis and Kenneth Noland, on the other. If the measure of their avant-garde status was the negative response to their works by the gesture painters, then the claims were justified—but only somewhat, since their work had its admirers within my coterie, myself included. Still, Rauschenberg's Assemblages, composed of junk materials, and related works by younger sculptors, and Johns's pictures of American flags, targets, etc., were thought by most of us to be Neo-Dada, the new anti-art—in Johns's case, neo-Duchampian—and Louis's and Noland's stained color-field abstractions were regarded as little more than glorified decorations.

But such opinions were beginning to seem vulgar as some of us recognized the quality of the work and understood its rationales. We also made the connections between the recent work and accepted styles. Using Pollock's and Frankenthaler's technique of pouring paint, Louis and Noland had extended Frankenthaler's flooded areas of interacting colors to a purer chromatic abstraction, a field abstraction, reminiscent of that of Barnett Newman and his model, Matisse. And we could no longer consider decorative art necessarily trivial, as we had, even though we were always confronted by the example of Matisse. Rauschenberg and Johns had extended gesture painting by introducing commonplace objects and images, suggestive of Dada Readymades, but their intention was not at all anti-art. Neither was that of young sculptors who made even junkier-looking constructions than Rauschenberg did. Besides, so-called Neo-Dada had begun to achieve art-world recognition, the culmination of which was *the Art of Assemblage* at the Museum of Modern Art in 1961. Rauschenberg would soon be acclaimed internationally as the most important artist of his generation. For a while, it seemed that a development from Assemblage into a form of theater called Happenings was the new avant-garde, but Happenings went into a rapid decline

4. Morris Louis, *Point of Tranquillity*, 1958. 101¾″ × 135¾″. Hirshhorn Museum and Sculpture Garden, Smithsonian Institution, Washington, D.C.

5. Kenneth Noland, *Spread*, 1958. 117″ × 117″. New York University Art Collection.

when most of their originators—for example, Red Grooms, Claes Oldenburg, and Jim Dine—reduced or ceased their performance activities and turned to object-making. By 1961, neither Assemblage nor color-field abstraction struck us as difficult.

Stella's black-stripe abstractions were something else. In retrospect, it is difficult to understand why they should have looked as unprecedented as they did. We were aware that in their preconceptual approach and their preoccupation with picture-making, they were derived from Johns's flags (which were in the line of Duchamp's Readymades) and related to Reinhardt's monochromatic, symmetrical, geometric abstractions (which had their source in Malevich's white-on-white painting). But Johns and Reinhardt were generally denigrated by my circle (although not by me). Geometric abstraction, such as Reinhardt's, and realism, such as Johns's, were considered throwbacks to the thirties, and dead ends. Besides, it seemed to us at the time that Stella had carried the ideas proposed by Reinhardt and Johns to a nihilist extreme. Stella purged whatever human content Johns allowed in his work—the imagery and virtuoso signs of the hand, at least—and although he seemed to share Reinhardt's art-for-art's-sake aesthetic, he made a mockery of it, in our opinion. We had not accepted Reinhardt's purism, and we were not about to accept Stella's seemingly corrupt version—or what we knew of it. Paradoxically, we believed that Stella was mocking Reinhardt in his black-stripe abstractions because they were brushed and their edges were "soft," rendering them impure—like Johns's work. Stella could be viewed as playing off Reinhardt against Johns; purist nonobjectivity against impurist painterly realism. He could also be seen as synthesizing the two, although this was only sensed at the time. Later, when both tendencies were understood to be the major ones in sixties art, Stella's prophetic and ambitious enterprise became clearer.

Yet the "painterliness" of Stella's painting, its directness as well as its large scale and immediacy, could be seen as deriving from gesture painting. But it rarely was; it was simply too systematically reduced, too mechanistic, too indifferently painted. The black-stripe abstractions seemed not only unrelated to gesture painting but to depart radically from it. Stella seemed to refer to gesture painting only to reject it: this apparently was his intention, and that is how it was perceived. Lucy Lippard wrote of Stella that his

> unequivocal rejections of illogic, illusion, and allusion, his advocacy of symmetry, impersonalism and repetition, was unique in its impact on younger artists, most of whom were older than Stella himself. He did not write, but his ideas spread through conversations and through criticism. . . . It seemed as though he had looked at painting as it *was* in 1959, brilliantly diagnosed its symptoms and prescribed the "right" cure.[18]

Certainly Stella's "rational," preconceptual geometry was totally at odds with the "intuitive" improvisation and cultivation of accidental effects found not only in gesture painting but in the pictures of Rauschenberg, Johns, Louis, and Noland as well. In the fifties, chance was taken to be avant-garde, and shocking; in the sixties, preconception was. And yet Stella's pictures did not appear related to such older conceptual styles as geometric abstraction; his were far too direct and immediate. In retrospect, it seems that Stella had found a position between gestural and geometric abstraction that distanced his work from each and thus looked unprecedented and new. But he seems to have had in mind the merging of the two modes of painting, as is suggested by the title of one of his pictures: *The Marriage of Reason and Squalor,* shown in *Sixteen Americans.*

Just as Stella's work shocked the New York School, so did the Pop Art of Andy Warhol, Roy Lichtenstein, James Rosenquist, and Tom Wesselmann when it emerged about two years later. The fact that Pop Art was anticipated by the work

of Rauschenberg and, particularly, Johns did not lessen the shock. And the waves it generated reverberated beyond the confines of the art world, because it partook not only of the formal changes that Stella had introduced but of mass culture—and this disturbed American intellectuals as a whole. To most of us, mass culture, or kitsch, as we called it, was the enemy of both authentic expression and high art. Now we asked: What motive could artists have in introducing kitsch into art? Obviously to debase high art. Pop Art became notorious, the center of controversy from 1962 to 1964, when as a topic of contention it was superseded

briefly by Op Art and then by Minimal construction, spawned by Stella's abstraction.

It was not only Stella's abstraction and Pop Art that infuriated us but the art writing on their behalf. What angered us most were the repeated claims that Abstract Expressionism was dead. "Who killed it?" we asked. Frank Stella? Andy Warhol? The thought was preposterous. Moreover, it was inconceivable to us that Pop artists might in good faith desire to view American urban life and its proliferating communications media anew. And we found perverse, if not absurd, assertions that Stella's painting was painting for its own

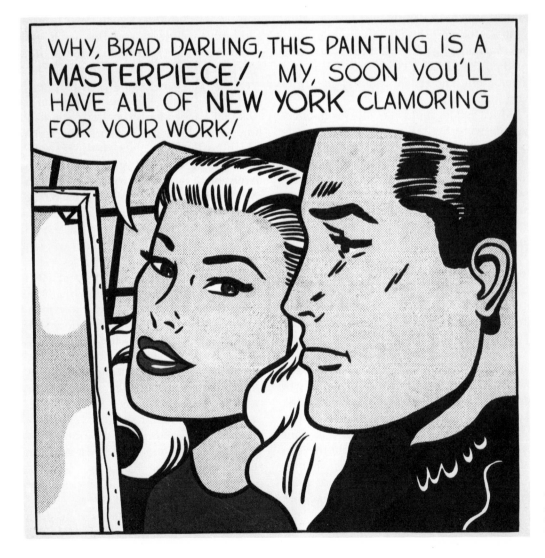

6. Roy Lichtenstein, *Masterpiece*, 1962. 54" × 54". Agnes Gund.

sake *only.* And yet Carl Andre, later an innovator of Minimal sculpture, made just that claim in the first statement about Stella's abstraction, published in the catalogue of *Sixteen Americans.* He wrote:

> Art excludes the unnecessary. Frank Stella has found it necessary to paint stripes. There is nothing else in his painting.
>
> Frank Stella is not interested in expression or sensitivity. He is interested in the necessities of painting. . . .
>
> Frank Stella's painting is not symbolic. His stripes are the paths of brush on canvas. These paths lead only into painting.[19]

Andre was obviously serious, but that was not clear to us. His remarks seemed to parody a claim often made for gesture painting, that it was painting about painting. But we thought this claim was vulgar unless it meant that the painting itself embodied the artist's experience, which was its content, and that was not what Andre (or Stella) had in mind.

Most incongruous of all pronouncements were Stella's own. In 1960, while participating on a panel at New York University, he remarked that he could find few creative ideas in current art; there were not even any good gimmicks. What interested him most was a good idea and not the process of painting it; he could not understand why it was bad for an artist who had a good idea just to execute it, to be an executive artist, as it were. Indeed, Stella claimed to be so indifferent to process that he would welcome mechanical means to paint his ideas. He also said that his conception of a picture was one in which only paint was used and nothing of himself. Stella implied that his major idea was to make a picture that referred only to itself. He seemed to be saying that his idea was both the pretext for making art and its content. Nothing else counted. Stella concluded that he did not know whether he was an artist.[20] He was, of course; what he obviously meant was that he did not want his art to look like what art had looked like or was supposed to look like. But we claimed to take him at his word.

Yet we could not dismiss Stella that easily. We were aware that his ideas were being taken seriously by artists outside our coterie, particularly emerging ones—and that dismayed us. Even had we accepted Andre's assertion that Stella's preoccupation with painting only as painting was valuable or Michael Fried's claim (which he was to make in 1963) that Stella had posed and solved the central formal problem in modern art since Impressionism—to emphasize the thing-nature of painting because that was what painting honestly was—and was therefore the most relevant and ambitious painter of his time, even then we would have considered his enterprise trivial.[21] As we saw it, the idea of posing and solving problems, merely rendering solutions, and the art it gave rise to were impoverished. A view of art as a campaign to advance art toward objecthood and the artist as a brilliant strategist could not compare to the justification for Abstract Expressionism as heroic and sublime, or at least as "serious," the test of which, as Rosenberg asserted, "is the degree to which the act on the canvas is an extension of the artist's total effort to make over his experience."[22] To be valid, such confrontation required that the painter be honest, not to the picture as a thing but to his or her experience of the act of painting.

Claims made for Pop Art struck us as even more trivial than those made for Stella's abstractions, because of its connection to kitsch. The most outrageous statements were Warhol's—for instance, the one echoing Stella: "I think somebody should be able to do all my paintings for me. . . . The reason I'm painting this way [with silk screens] is that I want to be a machine, and I feel that whatever I do and do machine-like is what I want to do." When Warhol was asked whether the commercial art he had once done was more machine-like than his fine art, he replied:

> No, it wasn't. I was getting paid for it, and did anything they told me to do. If they told

me to draw a shoe, I'd do it, and if they told me to correct it, I would. . . . I'd have to invent and now I don't; after all that "correction," those commercial drawings would have feelings, they would have a style.[23]

The notion that an artist would want to—and evidently did—eliminate creativity from art was appalling. So was its publication by Hess in *Art News,* which we considered *our* magazine.

Compared with the comments of Stella, Andre, Fried, or Warhol, those of Rosenberg, Hess, and other art writers and the artists we took our cues from seemed to take up the cause of art and man and generally sounded virtuous. More specifically, Abstract Expressionism was worthy of a strong defense, and we tried. But fewer and fewer young artists seemed to care what we said or even to listen to us, the evidence for which was the decline of the Club after 1960. Worse than that, a number challenged not only our beliefs but their very pertinence to art. What in painting, they demanded to know, represented, symbolized, or signified seriousness or honesty or crisis, existential or any other kind? Point to it, they said. We once could, and could communicate it, or thought we could, but the sensibility, the intellectual climate, had so changed that our kind of art talk was no longer convincing or, at least, intelligible, even to ourselves. I remember thinking around 1958, when the nth artist struck an anguished pose at the Club and announced: "When I paint, I don't know what I am doing," and someone called out: "After twenty years?" and there was laughter, that our rhetoric was no longer believable. But the laughter was edgy, to say the least, because we sensed that values we believed were as necessary in art as they were in life had been lost.

Indeed, our fundamental assumptions concerning Expressionist painting were questioned. For example, Amy Goldin wrote:

As far as I'm concerned, Expressionist esthetics—theories about a special relationship between the artist, his materials and his audience—are pure Hollywood, the stuff of which coffee-table art books are made. The painter as yoyo artist, sending SELF out to the end of the line and then retrieving it, miraculously loaded with transcendence, by a tricky flick of the wrist. The audience, sullen, yearning: "Sock it to me." The artist, eyes glazed with looking into the void, leaps, flinging his all—*will he make it?* If *he* makes it, *we've* made it. Orgasms all around. Happy, happy.

Almost everything that has been written about any Expressionist art uncritically accepts it as an illustration of Expressionist esthetics. It is the unchallenged consensus of opinion that these paintings express the personal feelings of the artist and that they reflect his emotional relationship to the world. As the story goes, Expressionist painting is pure content—formal devices as well as subject matter are read as the "natural" results of direct emotional impulse. The question of individual quality is seldom raised. . . . Expressionist techniques . . . are not treated as components of a style, but as the quasi-involuntary traces of emotion.

As pure argument, this formulation is silly.[24]

What Stella—at age twenty-two—and Pop artists and their friends said was appalling enough, but it was exacerbated by the attention it received and, even more, by the self-possessed, brash manner in which it was said. This made them seem utterly lacking in respect for their Abstract Expressionist elders, not only of the second generation but also of the first. (We did not know it at the time, but this was not so; their contempt was only for the second generation, with the exception of Frankenthaler, Johns, Rauschenberg, Mark di Suvero, John Chamberlain, and a few more.) Their anti-establishment stance was seen by us to be not in the great tradition of modernist iconoclasm but as part of the youth cultism that gripped the sixties, which we found distasteful. One of the popular slogans of the decade was: "Don't trust anyone over thirty." We did know that serious young artists trusted Newman, Reinhardt, and Greenberg,

7. Alex Katz, *The Black Dress*, 1960. 72″ × 84″. Collection the artist.

who, however, were not among the painters or critics esteemed by my coterie. Like other young people—for example, students who demanded participation in revising curriculums, in formulating their own rules of discipline, and in protesting restrictions on their private lives—young artists refused more readily than those who preceded them to accept received aesthetic ideas or even to give them lip service. They dared to be openly critical of what did not feel true to their experience. Moreover, there was a change in dress, music, sexual mores—indeed, a pervasive change in life-style—that made communication between them and us awkward at best. What had occurred was a profound and complex social and cultural upheaval, and that was unnerving.

We were also taken aback by another side of the youth culture and the youth cult—namely, the success of its idols in conventional social terms. We considered ourselves alienated from society and disparaged success, which, at any rate, was rarely forthcoming. Young artists seemed to want to become famous and make money, lots of it. They considered themselves professionals, and most had Master of Fine Arts diplomas to show for it. And a number quickly achieved recognition. For example, by 1961, Stella had been included in *Sixteen Americans*, had received one-person shows at the Castelli Gallery and the Galerie Laurence in Paris, had had a picture reproduced as the cover of *Art International*, and had had his works purchased by the Museum of Modern Art, Nelson Rockefeller, Philip Johnson, and the Burton Tremaines, among

others. Unlicensed freedom and licensed professionalism and careerism struck us as irreconcilable, but young artists, raised on youth and college cultures, embraced both without compunction. And they proved to our disbelief that to achieve worldly success they would have to be avant-garde. And to be written into art history, they would have to seem to break with it. The aesthetic icons they created would have to be iconoclastic.

These young artists and their curator and critic friends and other art-conscious people of their generation, together with a few older and respected figures in the art world, notably Barr, Castelli, Greenberg, Miller, and Seitz, despite differences of taste and opinion, literally constituted a new art world. They created a new climate of opinion in which the new art could be seen sympathetically—indeed, be *perceived as art.* The philosopher Arthur Danto remarked: "To see something as art requires something the eye cannot decry—an atmosphere of artistic theory, a knowledge of the history of art: an art-world."[25]

As for myself, much as I resisted, there was no escaping the power of Stella's abstraction. I was forced to reconsider my definition of "valid" art, to realize that new art demanded an approach different from that of Abstract Expressionist painting, that it could not be judged with criteria that no longer applied. I did not change my mind about the best of gesture painting—and its values—but I stopped treating it as a cause and began to entertain other artistic options and strategies. This enabled me to recognize the chief nongestural developments of the sixties, including formalist investigations of the objecthood of art (Minimal Art) and representations of objects in the world (Pop Art)—both of which drew from sources external to the artist. And I also accepted the impassive, distanced, or cool, seemingly objective, and obviously nonexpressionis-

8. Alex Katz, *The Red Smile*, 1963. 78¾″ × 114¾″. Whitney Museum of American Art, New York.

tic attitude with which the new art enterprises were carried out. However, my resistance to sixties abstraction and Pop Art crumbled slowly; it was not easy to give up old convictions, even if they had ceased to inspire the best new artists.

My change of mind about the new art was influenced by Reinhardt, who was my friend. He professed to hate it all, but I knew that he disliked nongestural styles less than he did gestural ones. I had always admired Reinhardt's self-effacing, polished work, although to his chagrin that did not stop me from loving the Abstract Expressionist painting he hated. I also took Reinhardt's art-for-art's-sake polemic very seriously, considering it the dialectical antithesis of Abstract Expressionist thinking and an antidote to its frequent self-indulgence. It troubled me when Reinhardt asked whether true art was too elevated, too pure to need anyone's ego-tripping self-expression or fantasizing. At the time, I did not connect his purist ideology with Stella's work, which hardly seemed to ennoble art. But I knew that Reinhardt was

interested in the younger artist's work. He objected when I savaged it in a review of 1961 by comparing it to his own black paintings.[26] Had Stella's work been Surrealist or Expressionist, Reinhardt would not have protested. Stella in turn was largely responsible for the rehabilitation of Reinhardt's work—and to a degree, of Newman's. Newman had been patronized at the Club as the little guy with the monocle in the corner until his show at the French and Company Gallery in 1959. But it was only in 1961, when a large picture of his was exhibited at the Guggenheim Museum in the company of major works by his colleagues in the New York School and overshadowed them, that his work was sharply upgraded, even by my coterie.

My change of mind was facilitated by changes in style and attitude by three artists of my generation whom I knew on Tenth Street and whose work I had long admired. These artists—Al Held, Alex Katz, and Philip Pearlstein—unlike most of their contemporaries who matured within the New York School during the fifties, had made successful—indeed, masterly—transitions into nongestural styles. I witnessed all the steps in their developments and was strongly influenced by our conversations at the time.

Katz and Pearlstein suppressed heavy, gestural painting because it had become mannered, or academic, as Katz said as early as 1957. Equally important, rough, overlapping, and scumbled brushwork conflicted with sharp-focus realism, a goal toward which they had begun to aspire, a figurative art more literal, more directly perceptual—that is, based on observed reality—than it had been. The desire for specific representation was announced by Katz in the many portraits of his wife, Ada, that he began to paint in 1957. It would become the essential component of the New Perceptual Realism that would emerge in the early sixties. Moreover, he enlarged his pictures in size and scale so

9. Philip Pearlstein, *Two Models on Studio Floor*, 1962. 44″ × 50″. New York University Art Collection.

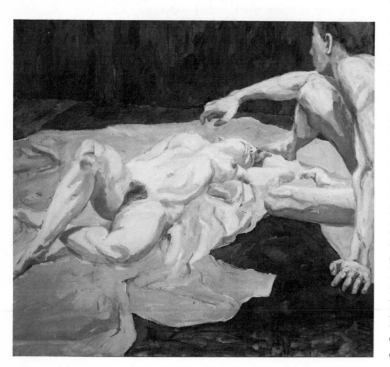

that they would compete in visual impact, muscle, and grandeur with the "big" abstract canvases of the period, looking "major," as it were. At the same time, inspired by Matisse, as were the stained color-field and hard-edge abstract painters, such as Louis, Ellsworth Kelly, and Held, Katz began to make his color more vivid and unexpected, and this expression through color, too, required the suppression of painterly facture. And so did Pearlstein's detailed rendering of his models' mass, which became his primary concern. He formulated a rationale for a new realism in two major articles published in 1962 and 1964. Titled "Figure Paintings Today Are Not Made in Heaven" and "Whose Painting Is It Anyway?" they greatly influenced my thinking.[27]

Pearlstein spoke often of the changes occurring in American art. As he later summed it up, "the sixties were characterized by Pop art, constructions of all kinds, hard-edge abstraction and my own kind of hard realism—it's all 'hard'—sharp, clear, unambiguous. In the fifties everything was ambiguous."[28]

In 1959, Held was confronted with the crisis in gesture painting, which exacerbated his growing dissatisfaction with his own work. This led him to review with a critical eye the abstractions he had painted in the previous four or five years—allover fields of pigment-laden gestures. He became aware that his artistic bent was toward clarity—a kind of classicizing urge. The design in his pictures increasingly engrossed him, and it was buried beneath the thick textures. Held's primary need was to bring his infrastructures up to the surface and articulate them. The ambiguous and unfinished-looking troweled and smeared slabs of paint would have to be cut through and cleaned up.

This Held proceeded to do in the following year, when he brushed freehand quasi-geometric and curvilinear configurations in flat, vivid colors, reminiscent of Matisse. In Held's early quasi-geometric abstrac-

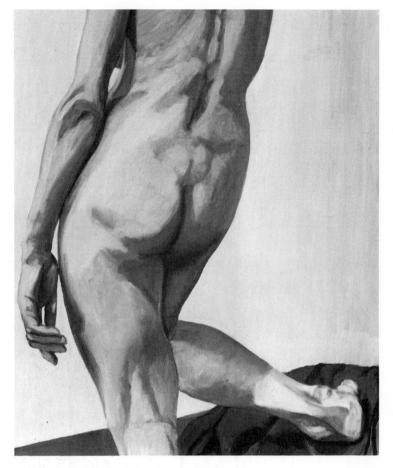

10. Philip Pearlstein, *Back, Female Nude,* 1963. 30″ × 26″. David Hanlin Becker.

tions, the direct process of painting is clearly evident; that is, the forms are composed of visible brushstrokes. But the painterly gestures were soon suppressed, absorbed into the concrete forms of unmodulated colors that they shape. The color-forms and not the gestures came to bear the burden of content. That content remained Expressionist in spirit, since Held aspired to invest each of his color-forms with an individual character and presence, as if each were a real being. But because Held's paintings no longer looked gestural, they were derogated by the leading tastemakers in my coterie. This shocked me into a recognition of how rigid Abstract Expressionist orthodoxy had become. And, as Held said, "there was another way of making art."[29]

11. Al Held, *Untitled*, 1959. 72½″ × 54″. Albright-Knox Art Gallery, Buffalo, N.Y.

12. Al Held, *House of Cards*, 1960. 114¼″ × 253¼″. San Francisco Museum of Modern Art.

# NOTES

1. For a discussion of the New York art world in the fifties, see Irving Sandler, *The New York School: The Painters and Sculptors of the Fifties* (New York: Harper & Row, 1978), chap. 2.

2. Francis Haskell, "Enemies of Modern Art," *New York Review of Books,* 30 June 1983, p. 19.

3. Barbara Rose and Irving Sandler, eds., "The Sensibility of the Sixties," *Art in America,* January–February 1967, p. 46.

4. I should like to stress how boring Stella's work looked to us and how absurd that seemed. I wrote in "New York Letter," *Art International,* 1 December 1960, p. 25: "Stella seems interested in monotony in terms of itself, as an attitude to life and art. His pictures are illustrations of boredom." Defenders of Stella's abstractions claimed that they were not boring but seemed to be to viewers who brought to them expectations generated by Cubist and Abstract Expressionist art.

5. The art historian was Robert Goldwater. He made this remark after a panel titled "Art 60," at New York University, New York, 21 April 1960, which he moderated. The other participants were Jasper Johns, Alfred Leslie, Robert Mallary, Louise Nevelson, Richard Stankiewicz, and Frank Stella.

6. See Sandler, *The New York School,* chap. 13, for a detailed analysis of this development.

7. Harold Rosenberg, "The American Action Painters," *Art News,* December 1952.

8. Clement Greenberg, in *Post-Painterly Abstraction,* exhibition catalogue (Los Angeles: Los Angeles County Museum of Art, 1964), n.p., characterized the crisis as follows:

   Abstract Expressionism was, and is, a certain style of art, and like other styles of art, having had its ups, it had its downs. Having produced art of major importance, it turned into a school, then a manner, and finally into a set of mannerisms. Its leaders attracted imitators, many of them, and then some of these leaders took to imitating themselves.

9. See Sandler, *The New York School,* p. 281.

10. A member of my coterie, Alex Katz, in Irving Sandler, ed., "Is There a New Academy?" part 2, *Art News,* September 1959, p. 39, spoke for artists and other art professionals who had turned against gesture painting or, as he put it, "the more traditional of advanced New York paintings," when he remarked that so many painters were working in this vein that "a reaction against their ideas in general" had set in. "This paradoxical compliment of flattering imitation forces style to change. The general look shifts."

11. From 1956 to 1961, I was responsible for organizing panels at the Club.

12. Irving Sandler, ed., "Is There a New Academy?" *Art News,* part 1, Summer 1959, and part 2, September 1959.

13. Ibid., part 1, p. 34.

14. Ibid., part 2, pp. 39, 58–59.

15. Ibid., part 1, p. 34.

16. Ibid., part 2, pp. 37, 59.

17. Ibid., part 1, p. 36.

18. Lucy R. Lippard, "Constellation in Harsh Daylight: The Whitney Annual," *Hudson Review* 21 (Spring 1968): 177–78. Among the artists influenced by Stella that Lippard had in mind were Carl Andre, Donald Judd, Dan Flavin, Robert Morris, Sol LeWitt, Robert Smithson, Mel Bochner, Eva Hesse, Robert Mangold, and Robert Ryman.

19. Carl Andre, Introduction, *Sixteen Americans,* exhibition catalogue (New York: Museum of Modern Art, 1959), p. 76.

20. Frank Stella, "Art 1960," New York University, 21 April 1960.

21. Michael Fried, "Frank Stella," *Toward a New Abstraction,* exhibition catalogue (New York: Jewish Museum, 1963), p. 28, and Michael Fried, "New York Letter," *Art International,* 25 April 1964, p. 59.

22. Harold Rosenberg, "The American Action Painters," p. 48.

23. G. R. Swenson, interviewer, "What Is Pop Art? Answers from 8 Painters," part 1, *Art News,* November 1963, p. 26.

24. Amy Goldin, "One Cheer for Expressionism," *Art News,* November 1968, pp. 49, 66–67.

25. Arthur Danto, "The Art World," *Journal of Philosophy*, 29 October 1964, p. 571.

26. See Sandler, "New York Letter." When I learned that Stella had not seen Reinhardt's famous slides of art monuments throughout the world and mentioned it to Reinhardt, he offered to give Stella a private viewing, indicating his interest in the younger painter. The slide showing took place in my apartment around 1961. Stella brought Henry Geldzahler. Architectural historian Richard Pommer was also there.

27. Philip Pearlstein, "Figure Paintings Today Are Not Made in Heaven," *Art News,* Summer 1962, and "Whose Painting Is It Anyway?" *Arts Yearbook 7: New York: The Art World* (1964).

28. Rose and Sandler, eds., "Sensibility of the Sixties," p. 53.

29. Maurice Poirier and Jane Necol, eds., "The 60's in Abstract: 13 Statements and an Essay," *Art in America,* October 1983, p. 125.

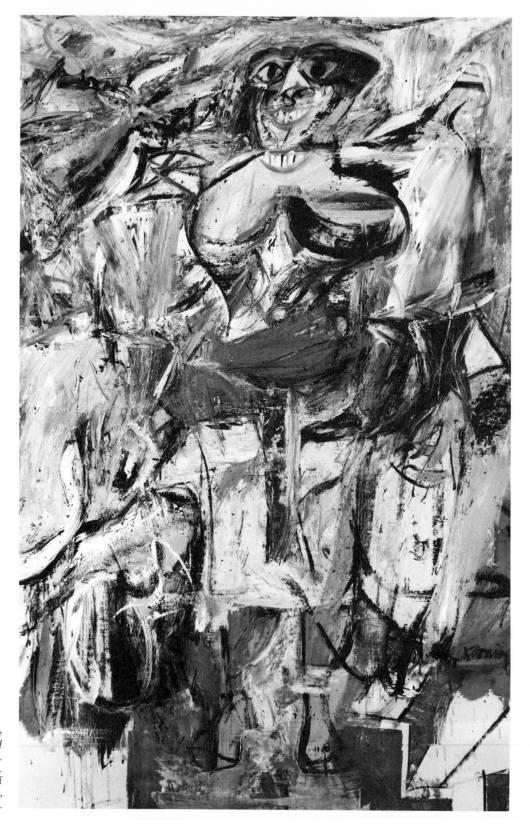

13. Willem de
Kooning, *Woman and
Bicycle*, 1952–53.
76½″ × 49″.
Whitney Museum of
American Art,
New York.

# 1 PAINTERLY PAINTING AND POST-PAINTERLY PAINTING

When Frank Stella graduated from Princeton in 1958, the dominant avant-garde style in America was painterly painting, a term more neutral with regard to content than "Abstract Expressionism," "action painting," or "gesture painting," and thus the one that was preferred in the formalist sixties. The exemplary and most influential painter working in this vein was Willem de Kooning. De Kooning inspired his contemporaries because his painting, which was essentially improvisational drawing with the loaded brush, appeared to embody his own multilayered experience as a modern man and, simultaneously, to continue the great tradition of Western art. He occasionally even quoted Rembrandt and Rubens, as if to make clear his regard for draftsmanship. His pictures retain references not only to past art but to visual phenomena—images of women, anatomical parts, letters of the alphabet, city scenes, and landscapes—and yet they are abstract—that is, modernist. They contain illusionistic space, but de Kooning used the relational design of Cubism to flatten and structure his ambiguous painterly swaths.

What was most impressive about de Kooning's pictures was their complex and multiple meanings. They seem to be both metaphors of the urban environment and of existential being, of phenomena seen and felt. The vehemently brushed open areas of which they are composed appear to be ceaselessly shifting, suggesting a perpetual state of becoming. It seemed as if de Kooning's aim was to avoid the ruts of habit—in a word, stylization—in order to express more nakedly than ever before in art a sense of the artist's creative struggle. For a painting to be honest, it had to be found in that struggle; it had to be direct and uncalculated. Thus de Kooning's improvisational painterly activity was thought to be a metaphor for authentic being; at the same time, it was considered masterly.

Because de Kooning was the "model Abstract-Expressionist," as William Rubin called him in 1958,[1] he was singled out for attack by opponents of painterly painting, because if he could be toppled from his preeminent position, his fellow painterly painters would fall also. Thus, in 1960, Rubin, taking his cues from Clement Greenberg, denigrated contemporary "de Kooning-style" painting as poor in quality and "a losing proposition for de Kooning himself."[2] The tactic used to depose de Kooning was to overstress the painterly, Cubist, and figurative components in his work and reject them as retrograde. His brushwork was condemned because it denied pictorial flatness and suggested illusionistic space. As Greenberg maintained, painterly painting, even at its most abstract, "began fairly to cry out for a more coherent illusion of three-dimensional space, and to the extent that it did this it cried out for representation." But the representation that emerged was "homeless,"

a failed compromise between abstraction and representation. Moreover, to Greenberg, by the middle fifties painterly painting had hardened into mannerism and, therefore, was bad art.[3] Equally damning was de Kooning's reliance on Cubist structure, because it was based on light and dark contrasts, which, like loose brushwork, created illusionistic space. Even in the late sixties, Greenbergian critics engaged in what by then had become a ritual activity of belittling de Kooning, allowing that he was "the 'central' or most typical Abstract Expressionist" with "real but relatively modest talents as a draftsman and sensual colorist," whose work was "*traditional* and *available*," in contrast with the difficulty of a Jackson Pollock or a Barnett Newman.[4] As Greenberg and his followers saw it, the future lay with stained color-field abstraction and/or Stella's Minimalist painting. Barbara Rose, for example, remarked in 1963: "Certainly it is clear today that although de Kooning will probably continue to produce Abstract Expressionist pictures . . . Abstract Expressionism will not produce another de Kooning. Young painters today must begin where Morris Louis left off, as ten years ago they took off from de Kooning or Kline."[5]

If de Kooning can be viewed as the paradigmatic painterly painter, then Stella can be viewed as the paradigmatic post-painterly painter. And he intended to be the seminal artist of the sixties. As he said: "The idea of being a painter is to declare an identity. Not just my identity, an identity for me, but an identity big enough for everyone to share in. Isn't that what it's all about?"[6] Clearly, this identity could not be found in Abstract Expression-

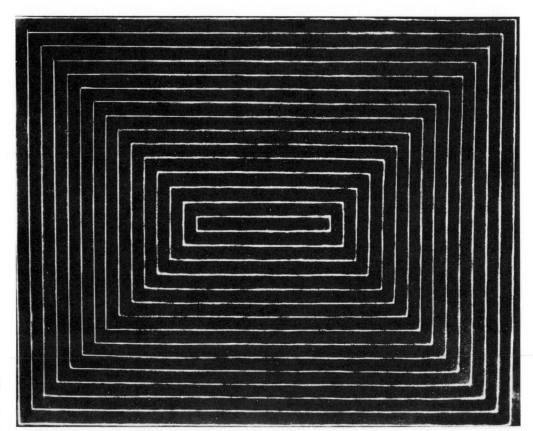

14. Frank Stella, *Tomlinson Court Park*, 1959. 85″ × 109¾″. Robert A. Rowan.

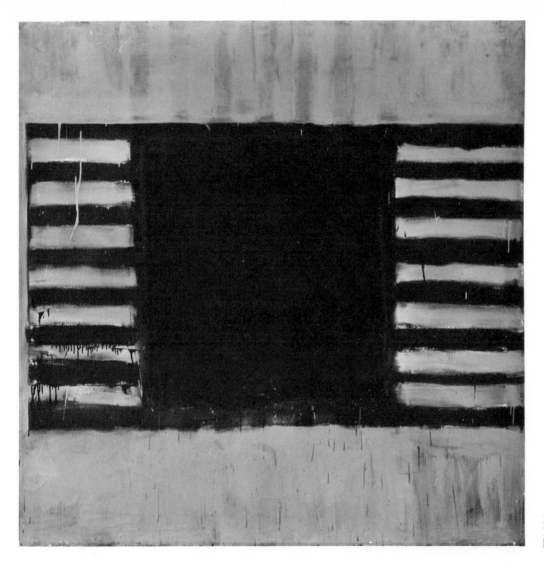

15. Frank Stella, *Zara*,
1958. 80″ × 80″.
Private collection.

ism in 1958. Consequently, Stella assumed
the ambitious task of formulating a new
picture opposed to painterly painting. As
Walter Darby Bannard wrote, with the
work of his friend Stella in mind:

> Abstract Expressionism was repudiated
> point by point: painting within the drawing
> replaced drawing with paint; overt regular-
> ity replaced apparent randomness; symme-
> try replaced asymmetric balancing; flat,
> depersonalized brushing or open, stained
> color replaced the smudge, smear and spat-
> ter.... The entire visible esthetic of Abstract
> Expressionism was brutally revised.[7]

In a footnote accompanying this passage,
Bannard added: "Frank Stella's paintings
of 1959 and 1960 say it better than I can."[8]
Philip Leider wrote even more dramati-
cally than Bannard of their impact. They
looked simple-minded, impersonal, stark-
ly cold, and boring. More than that, they
seemed willfully to challenge, indeed in-
vert, every *angst*-ridden, romanticist jus-
tification of gesture painting "with a cold
smartaleck, humorless methodicalness
that showed up, in the paintings . . . like a
slap in the face."[9]

To achieve his post-painterly painting,
Stella had first "to do something about re-
lational painting, i.e., the balancing of the

various parts of the painting with and against each other. The obvious answer was symmetry—make it the same all over." He then had to deal with the ambiguity of pictorial depth. "The solution I arrived at . . . forces illusionistic space out of the painting at a constant rate by using a regulated pattern. The remaining problem was how to find a method of paint application which followed and complemented the design solution. This was done by using the house painter's technique and tools."[10] It is important to stress that Stella's modular design and allover color were intentionally non-Cubist—that is, not composed by structuring elements of different sizes, shapes, and colors. This kind of "nonrelational design" had rarely been used in modern art and seemed to

offer fresh possibilities, which Cubism no longer did; it would become the "period" design of the sixties.

Stella had started as a painterly painter, and the initial stages in the formulation of his post-painterly paintings had been trial and error. He reduced the signs of process-as-search by confining his brushstrokes to more or less parallel stripes and his palette to black. Once Stella had gotten the idea of his black-stripe picture, he executed it as directly as he could. As he said: "I do think that a good pictorial idea is worth more than a lot of manual dexterity."[11] So much for the "action" valued by the Abstract Expressionists. Stella seemed to use the depth of the canvas stretcher as a kind of module. It dictated the width of the stripes.[12] These were separated by

16. Jasper Johns, *Three Flags*, 1958. 30⅞" × 45½" × 5". Whitney Museum of American Art, New York.

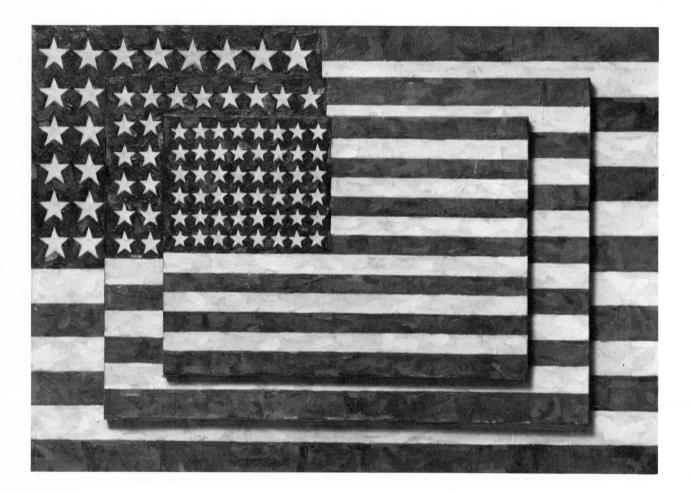

thin strips of bare canvas that called attention to the physical picture surface. The rectangular shape of the stretcher determined the concentric and symmetrical composition of the stripes. The result was a picture whose repetitive configuration appeared to be deduced from or to dictate the shape and thickness of the canvas; that is, a picture that in shape, configuration, and surface referred only to itself as an *object*. It seemed that Stella's idea was to carry to its ultimate solution what formalists considered the central formal problem in modern art: how to articulate the reality of the picture as a *two-dimensional thing*. As Michael Fried saw it, the solution of that problem, a purely formalist aim, was Stella's content.[13] (Later, Stella would offer another, psychological interpretation of his content, but that was not known in the sixties.[14])

Stella's black-stripe paintings were strongly influenced by Jasper Johns's pictures of American flags and targets, which Stella saw at the Castelli Gallery in 1958. What impressed him was that Johns's images were *made* and not *found* in the process of painting, as Expressionists insisted they must be for painting to be genuine. Thus Johns's self-detached exercise of picture-making subverted the rhetoric of gesture painting. It rarely occurred to de Kooning's contemporaries that de Kooning might be *making* a picture in a certain style. After Johns, this thought could not be avoided.

Furthermore, for Stella, the importance of the conceptual component in Johns's work—the idea of painting a flag or a target to look like the real thing, for example—gave him permission to base his own works on predetermined concepts, formalist in nature. Art did not have to be a record of the artist's existential experience; it could be the embodiment of ideas. For Johns, taking his cues from Marcel Duchamp, these were ideas concerning the nature of art-as-object and perception, of the language of art.

Stella was also impressed by the clarity of Johns's flags and targets—a clarity he emulated in the black-stripe paintings—which made them instantly comprehensible. Furthermore, as he said: "The thing that struck me most was the way he [Johns] stuck to the motif . . . the idea of stripes—rhythm and the interval—the idea of repetition. I began to think a lot about repetition."[15] Stella might also have mentioned the concentric arrangement of the stripes in Johns's targets, or the modular and monochromatic character of his pictures of letters and numbers—paintings that anticipated Stella's black-stripe abstractions.

Above all, Stella was struck by the unitary nature of Johns's work—that is, the identification of a single subject, such as a flag, with the painted image of the flag. The whole picture functioned as an object—a flat thing—that was the exact image, shape, and size of a flag. Moreover, as William Rubin remarked: "The thickly textured canvas, enclosing a deep stretcher projecting markedly from the wall, had more solidity, hardness, in short, 'objectness,' than a real flag. Johns thus participates directly in the predominant trend of contemporary painting, which has turned the picture from illusion to object."[16] Johns, in other words, made an *object* of his subject. This approach would lead Stella to his black-stripe paintings and his aluminum- and copper-colored shaped canvases, but because their design was bound to the canvas shape and thickness, they are even more unitary and object-like than Johns's work. Stella's artistic strategy was to bracket out rigorously the formal components in Johns's work—to make an abstraction of them.

The debt that Stella owed Johns was considerable, yet his abstractions were qualitatively different. Stella eliminated subject matter; unlike Johns's pictures, his were nonobjective. Even more than in Johns's flags, attention was directed toward an inflexible, internally consistent idea that generated "frame-locked compositions."[17] And he reduced the painting

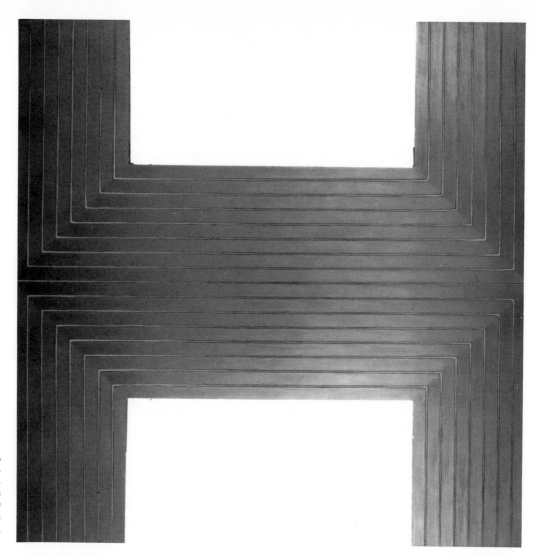

17. Frank Stella,
*Pagosa Springs,* 1960.
99¼" × 99¼".
Hirshhorn Museum
and Sculpture
Garden, Smithsonian
Institution,
Washington, D.C.

or facture, rendering it negligible, in a way that Johns, who cultivated his masterly touch, did not. Moreover, Stella's pictures were large, larger than Johns's, as if to dramatize their formalism. The abstractness, lack of painterly nuance, symmetry, bigness, alloverness or singleness, and clarity of Stella's images caused them to be seen all at once, more immediately than Johns's.

Stella's desire for immediacy attracted him to Newman's pictures at a time when they were not taken seriously by most of his colleagues in the New York School. Stella was inspired by the formal qualities in Newman's works: their large scale, barely inflected surfaces, vertical stripes, and nonrelational or field design. He was indifferent to Newman's claim that his content was the Sublime. Instead, it was Ad Reinhardt's writings—as well as Greenberg's[18]—on which Stella based the formalist aesthetic he developed. Of his generation of artists, it was Reinhardt alone who advocated—vociferously at that—the purification of painting by negating everything that was not of and for painting, particularly extra-aesthetic references that partook of or suggested "life," as he claimed Abstract Expression-

ist pictures did. Reinhardt wanted to purge art of everything but the artness of art. He was ridiculed by his colleagues almost as much as Newman was, but Stella,[19] together with artists influenced by him—Andre, Flavin, Judd, Morris, LeWitt, and Smithson—established Reinhardt as a master, mainstream and not eccentric.[20] When Reinhardt died, Stella said: "He can't play the game anymore, but nobody can get around the paintings anymore either. If you don't know what they're about you don't know what painting is about."[21] Even so, Stella's painting was not directly inspired by Reinhardt's. As Lucy Lippard wrote in 1965: "Reinhardt is now recognized as a rebel and a prophet and is widely admired, but he was a precedent for, rather than an influence on, recent trends."[22] In fact, the square black paintings that look most like Stella's

black-stripe pictures were not begun until 1960 and were not seen widely until 1963, when they were exhibited in the *Americans* show at the Museum of Modern Art.

Each of Reinhardt's black-square paintings is a five-foot square, trisected on the vertical and horizontal to create nine equal squares, all painted smoothly in dark grays, which, though they vary slightly in tone, give the effect of a uniform field, at least on first viewing. Reinhardt considered the black-square abstraction not only the culmination of three decades of his own painting but *the* ultimate picture, and he began to repeat it, and continued to do so (as he claimed he would) until the end of his life. (When Reinhardt's picture owned by the Museum of Modern Art was damaged, a curator was alleged to have asked him to repair it. Reinhardt offered to exchange it instead. The curator de-

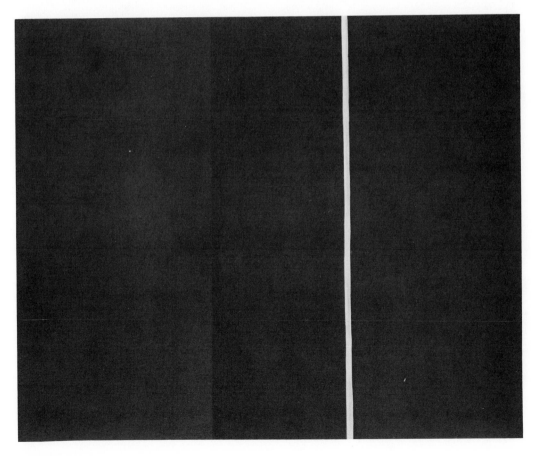

18. Barnett Newman, *Covenant*, 1949. 47¾" × 59⅝". Hirshhorn Museum and Sculpture Garden, Smithsonian Institution, Washington, D.C.

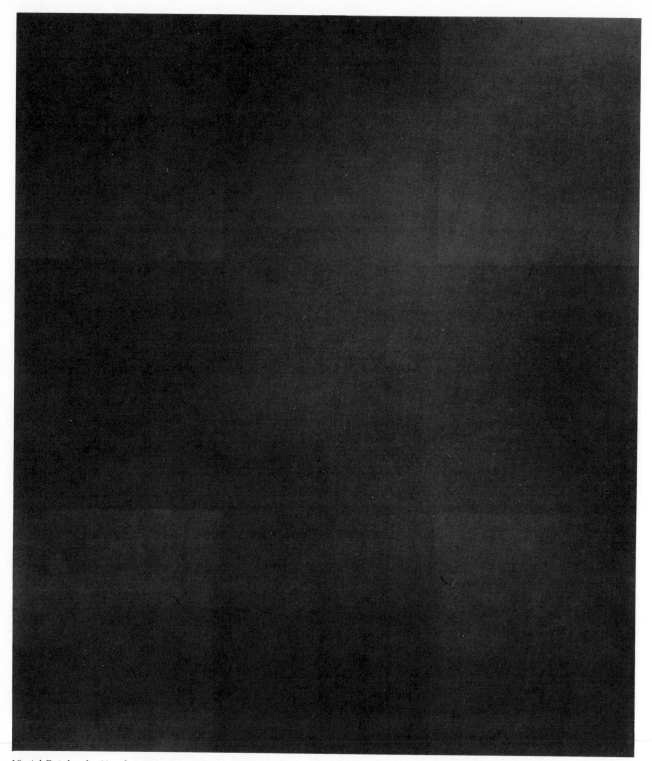

19. Ad Reinhardt, *Number 119, 1958 (Black)*, 1958–62. 84″ × 75″. Hirshhorn Museum and Sculpture Garden, Smithsonian Institution, Washington, D.C.

College of St. Francis Library
Joliet, Illinois

murred, saying that the museum had selected this particular picture and wanted only it. Reinhardt replied that he could not imagine why; there were pictures in his studio that looked more like the Modern's than the Modern's did.) Like Reinhardt's abstractions, Stella's were preconceived; nonreferential in image, color, and space; anonymous-looking, symmetrical, and modular or nonrelational; allover or field in design; and black in "color." But the differences between the works of the two artists are equally pronounced, and these differences were of vital consequence to Stella's peers, prompting them to look to and declare him, not Reinhardt, the seminal artist of the sixties.

Because Reinhardt's abstractions are evenly painted and the edges of the squares within the pictures are sharply drawn, both in painting and in drawing they remain within the tradition of geometric abstraction, even though the viewer does have to peer to make out the geometry, since it is shrouded in dark atmosphere. Like Reinhardt, Stella began a picture by drawing a preconceived geometric design. But then he painted freehand, following his penciled guidelines; his stripes are palpable "paths of the brush,"[23] their edges soft, not hard. Thus Stella, unlike Reinhardt, did not eliminate all signs of the artist's hand, although his painting is too mechanical to be experienced as touch.

Because Stella's stripes are directly painted, his pictures relate to gesture painting—even though gesture is radically reduced—as much as to geometric abstraction. Indeed, it is this quality of directness that accounts in part for his insistence that he was a member of the New York School.[24] He emphasized his affinities to first-generation picture-making by using housepainters' brushes (as de Kooning and Franz Kline did), and aluminum pigment as Pollock did—his color as "impure" as his facture, as it were. Still, if Reinhardt can be thought to have purified

geometric abstraction, Stella created "an impure geometric art," as Donald Judd remarked,[25] although he can also be thought to have purified gesture painting. Both Reinhardt and Stella painted field abstractions: the one extending geometric abstraction to this end; the other, gesture painting. Like gesture paintings and color-field abstractions, Stella's pictures at their most ambitious are large in size, compared with the five-foot-square formats that Reinhardt ended up with.

The most important difference between Reinhardt's and Stella's black paintings is the degree of visibility. Reinhardt began with varied, high-keyed colors and with consummate craft blackened (negated) them to near invisibility. His grays are so close in value as to conceal both the drawing and the color, making it even more difficult to see them, although the ghosts of the geometry and colors are perceptible, if barely. It is as if color and drawing were viewed through a fog, and in this sense, Reinhardt's pictures are illusionistic. Their dark aura also makes them appear ambiguous and mysterious, much as Reinhardt tried to suppress such qualities.

Unlike Reinhardt's images, which are revealed slowly, Stella's patterns are immediately apparent. The stripes are clear and writ large. They are directly painted, seemingly artless—that is, without apparent revision or ostensible craft. In contrast to Reinhardt's atmospheric grays, Stella's color is a blunt black—and later copper and aluminum—which is interspersed with bare canvas, calling attention to it and ironing out pictorial space to an unprecedented flatness, thereby asserting the physicality or objecthood of the canvas. The distinction is subtle but crucial; whereas Reinhardt's picture tried *not* to refer to anything outside itself, Stella's referred only to itself and clearly revealed that it did and how it did it. It zeroed in on what a painted object is rather than on what it is not.

If the literalness, directness, immediacy, and scale of Stella's black-stripe paintings

*136,720*

**College of St. Francis Library**
Joliet, Illinois

separated them from Reinhardt's black-square paintings and related them to Abstract Expressionism, this was only to reject Abstract Expressionism, or so it seemed. But it was precisely the affinity of Stella's works to the preceding dominant style and, at the same time, their dissociation from it that offered new possibilities for development to young artists. Robert Morris wrote that the painting of Pollock, Newman, Rothko, and Still "was an art of immediacy and sometimes overwhelming presence. This wave of energy for, and confidence in, abstract work flowed into the '60's with most of the basic premises intact." However, sixties art was more object-like, "less illusionistic and more obdurately present." It was also "more analytic and less expansive. . . . But the unremitting abstraction and aggressive presence were a continued legacy from the '50's."[26]

Robert Rosenblum wrote that Stella's "art directly intersects almost every important pictorial preoccupation of his time."[27] To painters of his generation who no longer wanted to paint in a painterly manner Stella revealed another approach. As Judd asserted, painterly painting was outworn; Stella's work in its organization and flatness superseded older forms: "It is not only new but better."[28] Stella also influenced major developments in the sculpture of the sixties, which valued literalness. Judd remarked that because the stretchers of Stella's canvases were deeper than usual, they called attention to his pictures as three-dimensional objects, as reliefs. The singleness of their configurations contributed to their objecthood; each seemed to be a unitary thing. This was particularly so when the canvases were shaped in formats other than the conventional rectangle. Stella himself, however, denied any preoccupation with sculpture. He claimed to have notched his canvases and cut out their centers to reduce the sense of perspectival recession, of illusion, created by the concentric patterns in his black-stripe paintings. His aim was to make his works flatter, like pic-

tures.[29] Stella stressed that his work was painting in the following conversation with Bruce Glaser and Judd: "I make the canvas deeper than ordinarily [in order to provide] just enough depth to hold it off the wall . . . to emphasize the surface. In other words, it makes it more like a painting and less like an object, by stressing the surface." Judd demurred: "I thought of Frank's aluminum paintings as slabs, in a way." Stella responded: "I don't paint around the edge."[30] Judd claimed that this was a fault, since it "denies the relief," the irrevocable move into sculpture to which it appeared to point the way.[31] Stella summed up his pictorial intention: "I tried for an evenness, a kind of all-overness where the intensity, saturation, and density remained regular over the entire surface."[32]

There were post-painterly painters other than Stella who can be thought of as formalist, among them stained color-field painters, such as Morris Louis, Kenneth Noland, and somewhat later, Jules Olitski. They made few verbal claims for their abstractions, leaving that to their mentor, Greenberg, and his followers, notably Fried (who was also a former classmate and close friend of Stella's). These critics claimed that the stained color-field painters were concerned exclusively with the formal or pure properties of painting. Indeed, underlying Greenberg's aesthetic was the conviction that "modernist" painting aspires to be pure—that is, occupied exclusively with what is unique and irreducible in the medium, notably the two-dimensional picture plane, but also color. Because color is "optical" or purely visual, it is "pictorial." The antithesis of "optical" is "tactile"—a "sculptural" quality rather than a "pictorial" one. In painting, tactility is produced by thick, unevenly applied paint and the contrast of light and dark values created by textured brushwork and by Cubist design. Value contrast also produces illusionistic space, which further destroys pictorial flatness.

Greenberg's primary butt was painterly

painting. He had been an early supporter but in the late fifties had come to believe that it had ceased to be radical. Its "loose, rapid handling, or the look of it . . . broken color; uneven saturations or densities of paint [produced by smearing, swiping, scrubbing, and scumbling], exhibited brush, knife, or finger marks,"[33] and were not only tactile and illusionistic but had become too much a matter of virtuoso performance. "The look of the accidental has become an academic, conventional look."[34] In Greenberg's opinion, painterly painting had been supplanted as the avant-garde style by the color-field abstraction of Clyfford Still, Mark Rothko, and Newman, embodying a radical vision of painting based primarily on sheer, open color, whose antecedents were the pictures of Matisse and the Impressionists. Because their work "is not broken by sharp differences of value or by more than a few incidents of drawing or design, color breathes from the canvas with an enveloping effect, which is intensified by the largeness itself of the picture."[35] Greenberg established Newman's reputation around 1959. He also began to champion two younger painters, Louis and Noland, arranging one-person shows for them at the French and Company Gallery in New York and, in 1960, publishing a major article on their work.[36] Louis and Noland looked to Newman as well as to Still and Rothko for inspiration and to Greenberg for guidance. They carried the chromatic

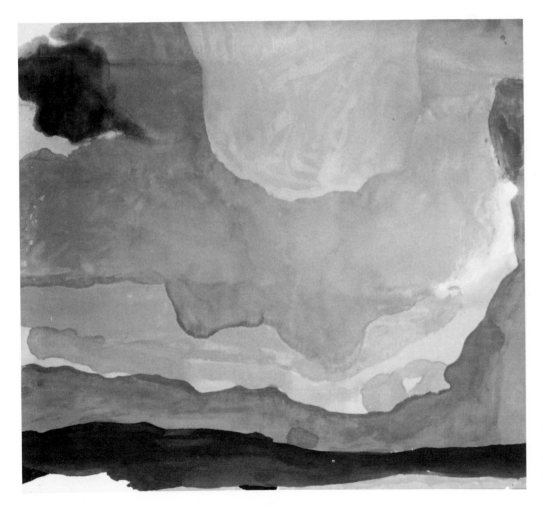

20. Helen Frankenthaler, *Flood*, 1967. 124″ × 140″. Whitney Museum of American Art, New York.

ideas of Newman further, or so Greenberg and like-minded critics believed, by pouring and staining paint, a technique that suppressed tactility entirely. This technique was derived from Pollock and, particularly, Helen Frankenthaler. Hers was the "crucial revelation," as Greenberg remarked. "The more closely colour could be identified with its ground, the freer would it be from the interference of tactile associations; the way to achieve this closer identification was by adapting watercolour technique to oil and using thin paint on an absorbent surface." Frankenthaler retained a degree of touch; Louis eliminated it by spilling "his paint on unsized and unprimed cotton duck canvas, leaving the pigment almost everywhere thin enough . . . for the eye to sense the threadedness and wovenness of the fabric underneath. . . . The fabric, being soaked in paint rather than merely covered by it, becomes paint in itself, like dyed cloth."[37] Thus Louis "began to feel, think and conceive almost exclusively in terms of open colour. The revelation he received became an Impressionist revelation." It led him, like Newman, to reject Cubism, because Cubism was sculptural. Cubism "meant shapes, and shapes meant armatures of light and dark. Color meant areas and zones, and the interpenetration of these, which could be achieved better by variations of hue than by variations of value."[38] Louis's concentration on color and field yielded painting of unprecedented flatness. At the same time, the stained color appears "somehow disembodied," like a translucent veil, even dissolving the picture surface.[39]

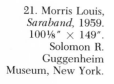

21. Morris Louis, *Saraband,* 1959. 100⅛" × 149". Solomon R. Guggenheim Museum, New York.

The stained color-field abstraction of Louis, Noland, and Olitski appeared far more decorative than the paintings of Newman, Rothko, and Still. Decoration had been denigrated by the older Abstract Expressionists but not by Greenberg, who had long yearned for an elevated form of decoration.[40] Rose remarked that "we can now use 'decorative' in a non-pejorative sense,"[41] implying that decoration was a valid alternative to Expressionism. Indeed, the decorous delectability of color even seemed somewhat iconoclastic. And stained color-field painting achieved intellectual respectability because of the voluminous formalist writing on its behalf. But this heavy cerebral rhetoric could seem at odds with the sheer hedonism of open, buoyant color. As Amy Goldin wrote: "Louis was never a difficult artist. His paintings are not problematic. They are voluptuous and restrained and for making you happy. . . . For these paintings, talk is irrelevant." Yet a great deal had been written about them. The reason: "Nowadays art is art history or it is nothing. The critic plays lyricist to the painter's tune, and his esthetic theories are the words without which no songwriter can possibly survive."[42]

Although the paintings of Frankenthaler, Louis, Noland, and Olitski (from 1959 to 1965) are similar in facture, the differences are pronounced. Frankenthaler flooded linear elements, spreading them into areas of luminous color, but she continued to manipulate the paint, the signs of which remain visible. Louis diluted his pigment more than she did, so that it was absorbed uniformly into the raw canvas, eliminating the textural quality of paint. Staining indicated to Fried that Louis was "at pains to avoid all suggestion of the gestural, manifestly spontaneous 'handwriting' of Abstract Expressionism."[43] Because he eschewed touch, Louis can be considered more a painter of the sixties than Frankenthaler. And yet pouring paint was gestural—certainly compared with Stella's mechanistic drawing—calling attention to the process of creation.

Louis's painting ranged between expansive color-fields in which most of the surface is dyed to almost all-white canvases in which color is compacted. In the expansive vein are the *Veils* (1957–60), in which Louis poured pigment down vertically placed canvases and with the help of gravity produced striated diaphanous, fanned mass images, each of a subtly blended pale color that calls to mind Tiffany glass. Also in the color-field direction are the *Florals* (1959–60), composed of large, billowy films superimposed one on another. Unlike the near monochrome of the *Veils*, the colors in the *Florals* are perceived as more or less discrete planes. They are also varied, bright, particularly at the scalloped edges of the centered images, and gravity defying, most of them floating free within a white margin at the picture edges. Although the *Florals* look expansive, the color areas are poured toward the darker centers of the canvas, palimpsests of spills, countering the emphatic flaring motion.

At the same time, Louis painted his most extreme open-field abstractions, the *Unfurleds* (1960–61),[44] in which rivulets of color—in between line and area—which rarely overlap run downward and inward from below the upper corners of outsized, horizontal canvases, leaving bare the unsized centers. These vast funnel-like expanses of white—at once empty and yet so vibrant as to be perceived as "color"—although partially confined by the free-flowing diagonals of color at the vertical limits of the canvas, seem boundless. From 1961 to 1962 (the year of his death), Louis veered from the expansiveness of the *Unfurleds* to the opposite extreme. In his last series, the *Stripes,* he bundled vertical, multicolored ribbons of slightly varied widths into pulsating shafts that thrust up or down white fields from one edge almost to the other. It is as if he willfully straightened the banked rivulets in the *Unfurleds* and made them the cen-

ter of focus, or abridged and articulated the pendulous skeins that underlie the *Veils.* The *Stripes,* his best-known works during his lifetime, convey a sense of intense color compression without sacrificing a uniform luminosity which animates colored and bare areas alike. In all of Louis's stained canvases, as Rosenblum remarked, it is the "sheer visual assault [that] is so breathtaking in its direct sensuousness [and its] numbing beauty. [The] languid, expansive beauty that newly evokes the exquisite hothouse atmosphere of the most precious Art Nouveau gardens [permits] a luxurious savoring of the most refined sensations."[45]

Noland first became known for his "target" paintings, shown in 1959. Each of these abstractions is composed of concentric bands of color separated by bare can-

vas centered in a square format. In the earlier targets, the edges of the rings are irregular, gestural looking, but they straightened out by 1961. Noland's pictures of harder-edged stripes (in different series: circular, chevron, or horizontal) verge on the geometric in their concern for design rather than color. But his design is symmetrical, thus neutral, unobtrusive, so as to call attention to the interaction of color (as his former teacher Albers did). Fried remarked that Noland's aim was to find a "strictly logical relation between the painted image and the framing edge";[46] hence his paintings of symmetrical chevrons, in which each upper corner of the canvas is cut by the contours of one or two chevrons, the point of one touching the middle of the lower framing edge, or his paintings of horizontal stripes. Noland

22. Morris Louis, *Gamma Delta,* 1959–60. 102¾" × 152½". Whitney Museum of American Art, New York.

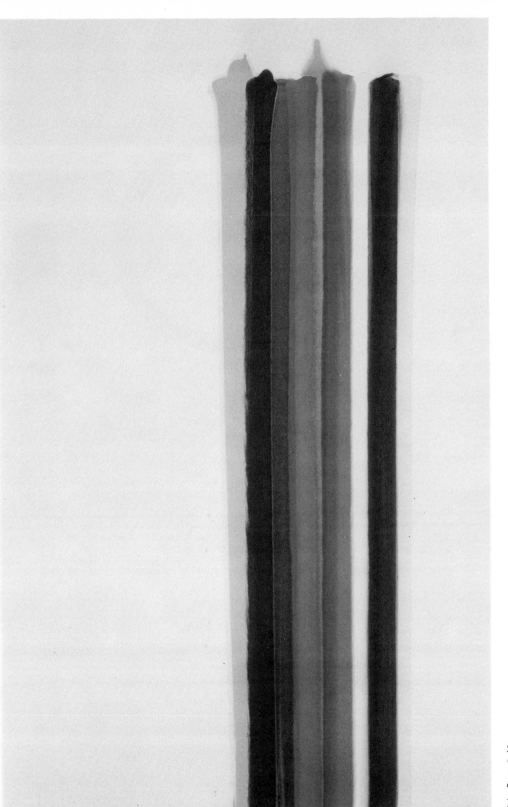

23. Morris Louis, *Sky Gamut*, 1961. 90½″ × 56⅜″. Private collection, courtesy Andre Emmerich Gallery, New York.

24. Kenneth Noland,
*Turnsole*, 1961.
94⅛″ × 94⅛″.
Museum of Modern
Art, New York.

25. Kenneth Noland,
*New Day*, 1967.
89⅜″ × 184¾″.
Whitney Museum of
American Art,
New York.

himself called his composition "self-cancelling" as against "self-declaring." "With structural considerations eliminated, I could concentrate on color."[47] And yet Noland's pictures, like Stella's, can be situated within the tradition of geometric abstraction, but they avoided "its rigidity, brittleness, [and] dryness."[48]

Olitski did not exhibit stain paintings until 1960. His earlier pictures are composed of centered, heavily pigmented images in reticent colors—grays, browns, off-whites. Subsequent paintings are composed of rounded, high-keyed planes set off against black fields. The images are reminiscent of the slabs of pigment in the earlier pictures and of cellular organisms, which formalist critics preferred to disregard. In 1965, taking his cues from the sprayed pictures exhibited by David Smith in 1959,[49] Olitski began to paint primarily with spray guns powered by an electric air compressor. He spattered allover fields of soaked color, which are "as nearly unstructured . . . as anything in painting," as Henry Geldzahler remarked, but this formlessness enabled him to have "given us . . . color itself."

> The paintings are pulled through a trough of paint on the studio floor and are thoroughly impregnated with color. Additional colors are sprayed on, often while the canvas is still wet. In intermediate stages a long rectangle of waste canvas is sometimes used to mask some or most of the painting from the spray, providing the only structural or linear element in the paintings.[50]

In subsequent pictures, Olitski stopped masking, but he continued to draw, now with the brush occasionally along the edges of his canvases so as not to lose the sense of the allover field.

In 1966, Olitski began to spray paint heavily, calling to mind his earlier impasto paintings. But, as Geldzahler wrote, while the "grainy surface . . . offers tactile associations . . . it does new things with color. Together with color, it contrives an illusion of depth . . . yet manage[s] not to violate flatness."[51] Formalist critics were

26. Jules Olitski, *Cleopatra Flesh*, 1962. 104″ × 90″. Museum of Modern Art, New York.

excited by space that could be viewed as simultaneously flat and deep. They discarded their earlier modernist dogmas, no longer calling for opticality and extreme flatness but now embracing illusionism and tactility.

In retrospect, it appears that Louis, Noland, and Olitski covered the range of stained color-field abstraction, filling the paradigm, as it were. Louis focused on *organic* stains; Noland favored formal, *geometric* layouts, softened by staining, to be sure; and Olitski abandoned all shapes, spraying more or less undifferentiated *fields*.

There was one more significant color-field position, that of Stella, which was based on the interaction of stained color-forms. He had begun to use color in 1960, within a year of his execution of the black-

27. Jules Olitski, *High A Yellow*, 1967. 89½″ × 150″. Whitney Museum of American Art, New York.

28. Frank Stella, *Empress of India*, 1965. 77″ × 224″. Museum of Modern Art, New York.

stripe paintings. At first he painted stripes of aluminum and copper—one color in each canvas, the canvases sometimes in the shape of an H, T, or U, or a hexagon, pentagon, or rhomboid with the center cut out. In 1962, he introduced a variety of industrial and commercial colors—Day-Glo, for example—in systematic arrangements, and in the following year, two (and subsequently more) colors, according to "logical" divisions within his shaped canvases. Tying color rigorously to the shapes of the pictures persisted until 1966, when in irregular polygon canvases, he ceased to identify the "literal shape" of the canvas with the "depicted shapes" within it, as Fried remarked.[52] Instead, he focused on the relationships of color-forms, reverting to a design whose source was in Cubism. Stella now risked fussiness, which he had earlier eschewed,[53] but the new move enabled him to be freer in his selection of forms and colors. Still, he did not allow the color to determine the final picture, as did Noland and Olitski, but first established the physical shape of the canvas and chose colors to fit the depicted shapes within it.

These shapes were painted thinly and separated by narrow strips of canvas of slightly irregular edges. Stella commented: "Without them [the soft edges], the Irregular Polygons would have become hard-edge paintings. Leaving them out would have . . . made the pictures snap around a lot. It would have given them a kind of hard, brittle space. [The] necessity of separating the colors, that breathing, that soft line, and that identification of (color with) the ground seemed very important to me in those pictures."[54] The stained forms seemed to recede or advance, introducing fictive space. Though

29. Frank Stella, *Sanbornville III,* 1966. 104″ × 146″. Whitney Museum of American Art, New York.

30. Frank Stella, *Agbatana I*, 1968. 120″ × 180″. Whitney Museum of American Art, New York.

backward-looking in the eyes of sixties avant-gardists,[55] illusionism would open up possibilities for the future of abstract art, whose reductionist flatness was beginning to be seen as a dead end.

Stella began his protractor series in 1967. Composed of interlaced circular and semicircular bands and the inner shapes they form, these pictures were most likely influenced by Hiberno-Saxon illumination, which had interested Stella as a student at Princeton; he had written his junior research paper on it and its relationship to Pollock's poured paintings. Many of the protractor pictures were wall-size, assuming a quasi-architectural dimension, particularly those paintings with rectangular framing edges in whole or in part. They are all openly decorative; as Stella said: "My main interest has been to make what is popularly called decorative painting truly viable in unequivocal abstract

terms [and] so strongly involved with pictorial problems and pictorial concerns that they're not conventionally decorative in any way."[56]

Ellsworth Kelly and Al Held, who were labeled hard-edge painters, were often associated with Stella, Louis, and Noland, particularly after 1963, when all were shown together in *Toward a New Abstraction* at the Jewish Museum.[57] There were similarities in their paintings: simplicity and clarity, lack of surface incident, and generally large scale. Like the stained color-field painters, Held reacted against painterly painting, replacing the heavy and loose facture of his fifties painting with clearly defined planes of clear, flat color. Kelly paid little, if any, attention to painterly painting, since he matured as an artist in Europe, influenced by Matisse, Arp, Miró, and Brancusi.

Like Louis, Noland, and Olitski, Kelly

and Held avoided Cubist composition. Kelly reduced and enlarged his color-forms and Held strung them out to create compositions that did not resemble older geometric abstract styles. But more significant than the similarities between hard-edge and color-field abstraction were the differences—an emphasis on the *tactile shape* of color as against the *optical field* of stained areas of color, that is, of color-form against color-field. Formalist critics tended to stress the stylistic differences between Kelly and Held, on the one hand, and, on the other hand, Louis, Noland, Olitski, and Stella, rather than the affinities. For example, Rosalind Krauss wrote that "Held is stylistically [so] distant from Frank Stella that no amount of polemic will bring them together."[58]

Unlike the imagery of Louis, Noland, Olitski, and Stella, Kelly's painting is based on nature—namely, the silhouettes of visual phenomena. But his subjects—ephemeral shadows or the "negative" space between objects—are often unrecognizable, secreted in order to draw attention to the painting-as-painting. Visualizing objects in silhouette facilitated the translation from the three-dimensionality of nature to the two-dimensionality of the picture surface. Kelly simplified his formats, often to two planes of a different color each or of black and white, abutted in clear juxtapositions rather than interwoven in intricate patterns, as in Cubist design. He was so intent on color-shape as color-*shape* that as early as 1955, he ventured into sculpture, motivated by the idea that "a shape can stand alone."[59] The expressiveness of a picture by Kelly (even when black and white) depends on color. Yet after the vivid hues and black and white make their immediate impact, it is the refinement of the contour drawing and the subtle relation of color to shape that long engage the viewer.

31. Ellsworth Kelly, *Red White*, 1961. 62¾″ × 85¼″. Hirshhorn Museum and Sculpture Garden, Smithsonian Institution, Washington, D.C.

Despite the clarity of the color-shapes, there is considerable ambiguity in many of Kelly's works. The forms are so abutted that the sharp edges unsnap them, creating an optical oscillation that makes it difficult to focus on a form and to determine whether it is figure or ground. As the eye skims over the uninflected surface, all of the shapes are perceived at different moments as positive, or more accurately, in figure-ground reversals. At the other extreme are works comprising sequences of rectangular canvases, each a field of a single color, a color that has been so finely tuned as to most amply fit and articulate its container.

In 1960, Held created a variant of hard-edge abstraction, by making every component in a picture different in form and color. To further dissociate his color-forms, he placed them side by side in extended space—an unprecedented, non-Cubist organizing principle. Held's forms were derived from Matisse's cutouts for *Jazz,* but he converted them, for the most part, into rectangles, triangles, and circles, turning a sensual biomorphism into a strict geometry. Held also made his color stronger than Matisse's—a kind of loud visual noise; his surfaces, more resistant and impenetrable, and less airy; and his forms, more packed and muscular.

Held's painting is distinguished by the specificity of his color-forms. His need was to *transform* rectangles, triangles, and circles, which are by their nature generalized—indeed, are the most generalized of shapes—into particular or concrete forms. His primary aim was to formulate a fresh content whose dimensions are philosophical as well as aesthetic. That is, he aspired willfully to invest each of his color-forms with an individual character. Compared to stained color-field abstraction, Held's clearly drawn color-forms are individualized and obtrusive, weighty, physical, and energy-packed rather than optical and disembodied—and impacted rather than open.

By 1967, Held felt increasingly limited

FACING PAGE:
32. Ellsworth Kelly, *Red Blue,* 1964. 90″ × 66″. Mr. and Mrs. Morton J. Hornick.

33. Ellsworth Kelly, *Spectrum III,* 1967. 108⅝″ × 33¼″. Museum of Modern Art, New York.

34. Al Held, left: *Ivan the Terrible*, 1961. 144″ × 114″; right: *Eusopus II*, 1970. 138″ × 168″. Mara Held.

35. Al Held, *Noah's Focus II*, 1970. 138″ × 300″. Private collection.

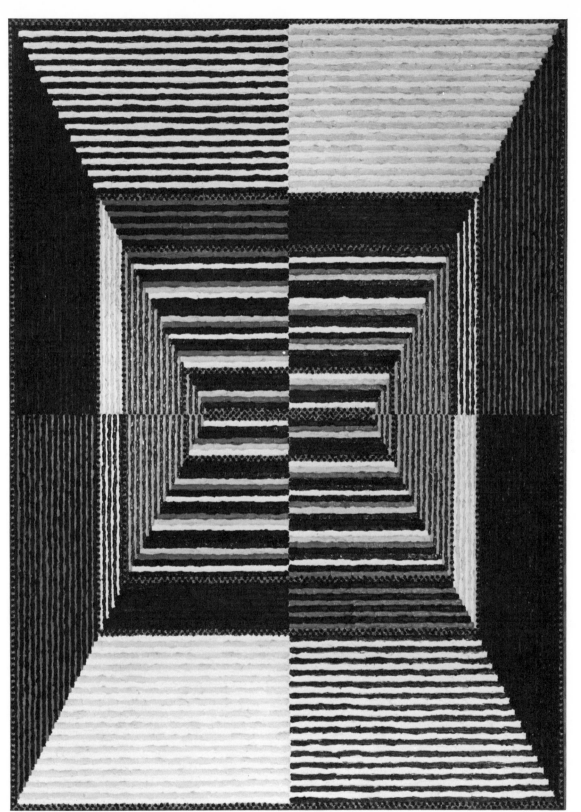

36. Alfred Jensen, *The Acrobatic Rectangle Per, Eleven,* 1967. 68″ × 48½″.
Whitney Museum of American Art, New York.

by the simplicity and flatness of his images. He was also put off by color-field and hard-edge abstraction generally. There seemed to be a glut of this reductive art. His urge was for complexity, and to achieve it, he opened up the picture space, tunneled into it. Using black bands on white grounds, he formed rectangular, cylindrical, and triangular volumes. His structures are pieced together as if they were masonry, and yet they keep coming apart, to be in perpetual flux. In 1969, Held's paintings grew even more complex as he began to interweave the geometric volumes. His aim appeared to be to incorporate multiple events simultaneously in the same space. Thus, his images are perceived in a ramifying variety of often contradictory ways, each of which is "true," exemplifying the constant change, diversity, indeterminacy, and paradox which are inherent in contemporary reality. Held's black and white abstractions anticipated a widespread reaction against reductivism that occurred in art toward the end of the sixties.

Alfred Jensen's paintings were too eccentric to be characterized as hard-edge, but they influenced artists whose works were, and were often shown with them. In 1957, Jensen rejected the Expressionist style he had been working in and began to draw geometric diagrams, generally checkerboard, and to paint them heavily in high-keyed colors derived from light seen through a prism. The pictures were symbolist, based on ancient Chinese and Mayan number systems. From 1964 to 1970, Jensen used the plans of temples and pyramids of Greece and Central America as his subject matter, because they "portray the sun and the planets in their calendrical permutations." Jensen's intention was to translate "truths" first discovered by early civilizations into modern terms. As he saw it: "The view of the ancients was that the universe and nature are essentially arithmetic."[60]

As a visionary, Jensen was a maverick among sixties abstract artists. Kelly and Held were also outsiders, to a degree. Summing up art critical opinion, Brian O'Doherty characterized "the Louis-Noland-Stella group as the center."[61]

## NOTES

1. William Rubin, "The New York School—Then and Now," part 2, *Art International*, May–June 1958, p. 19.
2. William Rubin, "Younger American Painters," *Art International* 1 (1960): 26.
3. Clement Greenberg, "After Abstract Expressionism," *Art International*, 25 October 1962, p. 25.
4. Walter Darby Bannard, "Willem de Kooning's Retrospective at the Museum of Modern Art," *Artforum*, April 1969, pp. 42–44. See also Rosalind Krauss, "The New de Koonings," *Artforum*, January 1968.
5. Barbara Rose, "New York Letter," *Art International*, 5 December 1963, p. 61. Had Rose not been married to Stella, she probably would have added his name to Louis's as a point of departure for younger artists.
6. Philip Leider, "Literalism and Abstraction: Frank Stella's Retrospective at the Modern," *Artforum*, April 1970, p. 44.
7. Walter Darby Bannard, "Present-Day Art and Ready-Made Styles," *Artforum*, December 1966, p. 30.
8. Ibid., p. 35.
9. Philip Leider, "Literalism and Abstraction," p. 45.
10. Frank Stella, a lecture delivered at Pratt Institute, January or February 1960, in Robert Rosenblum, *Frank Stella* (Harmondsworth, Middlesex, England: Penguin Books, 1971), Appendix, p. 57.
11. William S. Rubin, *Frank Stella*, exhibition catalogue (New York: Museum of Modern Art, 1970), p. 32.
12. Each of Stella's stretchers, particularly when deep, *seems* to be the same depth as the width of the stripes, although they are not exactly so.
13. Michael Fried, "Frank Stella," *Toward a New Abstraction*, exhibition catalogue (New York: Jewish Museum, 1963), p. 28.
14. See Brenda Richardson, Introduction, *Frank Stella: The Black Paintings*, exhibition catalogue (Baltimore, Md.: Baltimore Museum of

Art, 1976). Stella's black-stripe paintings, unlike Reinhardt's, have titles. Stella told Brenda Richardson that they derived from a "downbeat" state of mind. Richardson, on pp. 3–4, goes on to say:

> Stella's Black titles are a verbal catalogue of the dictionary definition of the adjective "black," [for example] characterized by the absence of light; thoroughly sinister or evil; very sad, gloomy, or calamitous; marked by the occurrence of disaster; . . . characterized by grim, distorted, or grotesque satire. Death and especially suicide are prevalent references in the titles. The names of three paintings incorporate Nazi references. Four titles derive from major disasters. Several names come from song titles with unusually depressing subject matter. Several others are named for "black and deviate" nightclubs (in Rubin's words) . . . [which Stella said] reminded him of the pre-Nazi, German cabaret scene. . . . References are made to Negro or to blind jazz musicians. When place names are used as titles, they invariably refer to areas of urban blight, tenement housing, minority neighborhoods.

15. Rubin, *Stella*, p. 12.
16. Rubin, in "Younger American Painters," p. 27.
17. Rubin, *Stella*, p. 30.
18. Stella and his classmates Walter Darby Bannard and Michael Fried had read and were impressed by Clement Greenberg's articles while students at Princeton before 1958. They also attended the Gauss Lectures given by Greenberg at Princeton in 1958; the title was "The Logistic of Modernist Painting."
19. Stella so esteemed Reinhardt that in 1960 he purchased one of his black paintings.
20. In October 1966, Reinhardt exhibited in a show entitled *10×10* at the Dwan Gallery with Carl Andre, Jo Baer, Dan Flavin, Donald Judd, Sol LeWitt, Agnes Martin, Robert Morris, Robert Smithson, and Michael Steiner. All of the work was of 1966, except Reinhardt's, which is undated, and Flavin's, of 1964. When Reinhardt was given a retrospective at the Jewish Museum in 1967, he recommended that Lucy Lippard, the art critic most identified with the above young artists, write the introduction to the catalogue.
21. Frank Stella, "A Tribute to Ad Reinhardt," *artscanada*, October 1967, p. 2.
22. Lucy R. Lippard, "New York Letter," *Art International*, May 1965, p. 52. See also Lucy R. Lippard, *Ad Reinhardt* (New York: Harry N. Abrams, 1981), pp. 114, 202. Reinhardt had one-person shows at the Betty Parsons Gallery in 1956, 1959, and 1960. He did not have another show in New York until 1965.
23. Carl Andre, in *Sixteen Americans*, exhibition catalogue (New York: Museum of Modern Art, 1959), p. 76.
24. Frank Stella, interviewed by Irving Sandler on *The Casper Citron Show*, New York, WRFM radio, 29 October 1962.
25. John Coplans, "An Interview with Don Judd," *Artforum*, June 1971, p. 40. Judd found Reinhardt, unlike Stella, too ideal and clean.
26. Robert Morris, "American Quartet," *Art in America*, December 1981, p. 96.
27. Rosenblum, *Stella*, p. 52. It is noteworthy that Stella showed in almost every important show of abstract art in New York during the sixties. Among them were *American Abstract Expressionists and Imagists*, at the Guggenheim Museum, 1961; *Toward a New Abstraction*, at the Jewish Museum, 1963; *The Responsive Eye*, at the Museum of Modern Art, 1965; *Systemic Painting*, at the Guggenheim Museum, 1966; *The Art of the Real*, at the Museum of Modern Art, 1968. He was also included in Clement Greenberg's *Post-Painterly Abstraction*, 1964.
28. Donald Judd, "In the Galleries: Frank Stella," *Arts Magazine*, September 1962, p. 51.
29. Frank Stella, in "Stripe Painting Has Been a Rough Road," *Milwaukee Journal*, 12 June 1960, admitted "that one can get an illusion of depth in . . . black stripe works. 'But I don't want that,' he added. 'In my new paintings, I've even cut out corners of the canvas and varied the directions of the stripes to avoid it.' "
30. Bruce Glaser, interviewer, and Lucy Lippard, ed., "Questions to Stella and Judd," *Art News*, September 1966, p. 60.
31. Judd, "In the Galleries: Frank Stella," p. 51.
32. Rubin, *Stella*, p. 29.
33. Clement Greenberg, "After Abstract Expressionism," p. 24.
34. Ibid.
35. Greenberg, " 'American-Type' Painting," *Partisan Review*, Spring 1955, p. 194.
36. Greenberg, "Louis and Noland," *Art International*, 25 May 1960.
37. Ibid., p. 28.
38. Ibid.
39. Ibid.
40. See Clement Greenberg, "The Present Prospects of American Painting," *Horizon*, October 1947.
41. Barbara Rose, "In Absence of Anguish: New Works by Friedel Dzubas," *Art International*, 25 September 1963, pp. 98–99.
42. Amy Goldin, "Morris Louis: Thinking the Unavoidable," *Art News*, April 1968, p. 49. In response to the heavy theoretical analysis of Louis's paintings, Robert Rosenblum, as early as 1963, in "Morris Louis," *Toward a New Abstraction*, p. 18, remarked that "their optical assault at first stuns the intellect and permits only a tonic exhilaration of the senses. Perhaps it is wisest to accept quite simply these gifts of pure pictorial pleasure, for one has to blink away their undiluted beauty before setting the mind to work." Rosenblum went on to say: "The analytic historian and the garrulous critic, however, will inevitably insist on locating and

describing Louis's achievement."

43. Michael Fried, "Some Notes on Morris Louis," *Arts Magazine,* November 1963, p. 25.

44. Diana Upright Headley, in *Morris Louis: The Mature Paintings 1954–1962* (Ph.D. diss., University of Michigan, 1976), pp. 30, 33, 60, wrote that during his lifetime Louis did not exhibit the *Unfurleds* publicly and showed them privately only to a few friends.

45. Robert Rosenblum, "Morris Louis," *Art International,* 5 December 1963, p. 24.

46. Michael Fried, "New York Letter," *Art International,* 25 May 1963, p. 69.

47. Kenworth Moffett, "Noland," *Art International,* Summer 1973, p. 26.

48. Barbara Rose, quoted in Lucy R. Lippard, "New York Letter," *Art International,* February 1965, p. 35.

49. David Smith's spray pictures were exhibited at the French and Company Gallery in 1959. The gallery was Olitski's. They were reproduced in an eight-page color spread in "David Smith: Stencils for Sculpture," comment by Hilton Kramer, *Art in America* 4 (1962): 32–42.

50. Henry Geldzahler, "Olitski," *Artforum,* June 1966, p. 38.

51. Henry Geldzahler, Introduction, *XXXIII International Biennial Exhibition of Art, Venice, 1966* (Washington, D.C.: Smithsonian Institution, 1966), p. 38.

52. Michael Fried, "Shape as Form: Frank Stella's New Paintings," *Artforum,* November 1966, p. 18.

53. Glaser, "Questions to Stella and Judd," p. 55.

54. Rubin, *Stella,* p. 118.

55. See M. Bochner, " 'Systemic,' " *Arts Magazine,* November 1966, p. 40.

56. Rubin, *Stella,* p. 149.

57. Kelly was shown in New York two years before Louis and Noland were. He had two shows in the Betty Parsons Gallery, in the spring of 1956 and the fall of 1957. The Whitney Museum included his work in *Young America, 1957.* But Kelly did not command widespread art-world attention until the new abstraction emerged in the early sixties.

58. Rosalind Krauss, "Letters," *Artforum,* December 1966, p. 4.

59. William Rubin, "Ellsworth Kelly: The Big Form," *Art News,* November 1963, p. 65.

60. Linda L. Cathcart, *Alfred Jensen: Paintings and Diagrams from the Years 1957–1977,* exhibition catalogue (Buffalo, N.Y.: Albright-Knox Art Gallery, 1978), pp. 8–9.

61. Brian O'Doherty, "Abstract Confusion," *New York Times,* 2 June 1963, sec. 2, p. 11.

# 2 ART-AS-ART VERSUS LIFE-AS-ART: PURIST VERSUS IMPURIST AESTHETICS

As formalist artists banished all that was not intrinsic to the medium, so formalist writers purged extra-formal or extra-stylistic and extra-art historical references—that is, personal, symbolic, and visionary allusions; formalist criticism dealt only with stylistic "facts" and their history. Just as the Expressionist art of the forties and fifties had prompted an increase in subjective criticism, the formalist art of the sixties fostered the growth of objective criticism. And just as the art of the one decade called into question the art of the other, so did their respective critical approaches. The domination of art discourse by formalist critics is made clear simply by listing them, their disagreements notwithstanding, among them Ad Reinhardt; Clement Greenberg and those influenced by him—Walter Darby Bannard, Michael Fried, E. C. Goossen, Rosalind Krauss, William Rubin, and Barbara Rose; the Minimalist sculptor-writers Carl Andre, Robert Morris, Donald Judd, and Robert Smithson; and a critic identified with them, Lucy Lippard. This was indeed a formidable roster.

I have already alluded to the impact of Stella's paintings on artists and critics of his generation. His ideas on art were almost as influential. They were spread mainly by word of mouth, since he did not write them down. What Stella said is exemplified in the following remarks: "I am concerned with the purity of painting."[1]

If the painting were lean enough, accurate enough or right enough, you would just be able to look at it. All I want anyone to get out of my paintings, and all I ever get out of them, is the fact that you can see the whole idea without any confusion. . . . What you see is what you see.[2]

Stella did not deny that painting had content; he simply denied that the content had to be something other than the painting, its literalness or objecthood, as it were. Rather than looking through painting at some extra-aesthetic subjective or objective "reality," Stella focused on the painting itself, its form and quality, claiming that "it's supposed to be entirely visual."[3] Stella's verbal style was appropriate to his painting and aesthetics. In contrast to the Abstract Expressionists, Stella analyzed the formal components of his work "with a flat, disarming matter-of-factness. He thinks and speaks more in terms of plastic 'problem-solving' than of 'expression' and, on the face of it, would seem to be uninterested in the associational aspects of the image."[4]

Stella's aesthetics drew on Greenberg's and Reinhardt's writings. Rose remarked that Reinhardt's "dicta . . . have become nearly canonical for the young artists" of the sixties. His "constant theorizing, dogmatizing and propagandizing actually helped to change the climate."[5] Reinhardt championed an art-for-art's-sake cause as early as 1948, when, with Still, Rothko, and Newman in mind, he ridiculed "transcendental nonsense, the picturing of a

'reality behind reality.'" Instead, he called for "pure painting [in which there] is no degree of illustration, distortion, illusion, allusion or delusion."[6] This led him to proclaim: "The one thing to say about art is that it is one thing. Art is art-as-art and everything else is everything else."[7]

To achieve art-as-art, Reinhardt advocated an aesthetics of negation:

> The one object of fifty years of abstract art is to present art-as-art and as nothing else, to make it into the one thing it is only, separating and defining it more and more, making it purer and emptier, more absolute and more exclusive—nonobjective, non-representational, non-figurative, non-imagist, non-expressionist, nonsubjective. The only and one way to say what abstract art or art-as-art is, is to say what it is not.[8]

Reinhardt urged artists to distill the quintessence of art, first by negating life-as-art—that is, removing all signs of life from art—and, second, by dispensing with elements of past art that art-as-art no longer needed in order to be perceived as art. Such negation would facilitate rendering the artness of art more directly and exclusively than in the past. Deriving art from art is a traditional approach, and it depends on a knowledge of art history. But Reinhardt built into his traditionalism a vanguard principle, for he believed that art undergoes a perpetual revolution, striving always in the direction of purity.

Reinhardt was a formidable polemicist, at once trenchant, provocative, and witty. Proclaiming himself "the Great Demurrer in a time of Great Enthusiasms,"[9] he waged war against any "combining, mixing, adding, adulterating, diluting, exploiting, vulgarizing or popularizing of abstract art [all of which deprived] it of its essence and truth," and corrupted the "artist's artistic conscience."[10] The objects of his merciless ridicule were other artists, particularly his colleagues the Abstract Expressionists. (They reciprocated in kind; for example, Reinhardt was clearly recognizable as the artist named "Pure" in

a spoof by Elaine de Kooning published in *Art News* in 1957.[11]) Like Reinhardt, many sixties artists used aesthetics as a weapon.

Among those against whom Reinhardt waged his art-for-art's-sake crusade was Greenberg,[12] although their attitudes had a great deal in common. Greenberg was the most important formalist art critic—indeed, the most important art critic—in America after World War II. In a review of his book of essays, *Art and Culture*, published in 1961, Hilton Kramer, no aesthetic friend of Greenberg, wrote:

> However one may want to disagree with particular judgments, however one may object at times to the assumptions that lie behind them and the tone in which they are announced, there can be no doubt that *Art and Culture* is art criticism of a very high order—the highest, I should say, in our time. It is the only book in its field that could be seriously compared to the celebrated works of literary criticism produced in this country in the thirties and forties. *Art and Culture* is, moreover, the most important book of its kind since the death of Roger Fry.[13]

Greenberg did not intend for the thirty-seven essays in *Art and Culture* to provide only a record of his past opinions. Indeed, with an eye to the present and seemingly to the future, he freely revised his earlier writings, and reinforcing them with new essays, notably "Modernist Painting" and "After Abstract Expressionism," he honed his essays into a pointed polemic. The earlier, more open Greenberg was succeeded by a more dogmatic Greenberg, and it was this later, post-1960 Greenberg that would significantly influence the art criticism and even the art of the decade.[14]

Greenberg maintained that "visual art should confine itself exclusively to what is given in visual experience, and make no reference to anything given in any other order of experience."[15] Thus he was opposed to the Romanticists' confusion of genres or the Symbolists' syncretism of the arts.[16] Painting ought to refer to nothing beyond itself and be self-contained, like an

object. So should criticism; it should address only aesthetic issues. In fact, Greenberg focused so exclusively on the formal components of art that, as Barbara Rose remarked, in a "discussion of Picasso's *The Charnel House* [he] did not feel called upon to mention, even in passing, that the subject was a death camp, or to consider the specific expressive qualities of the vocabulary of forms employed by Picasso in its representation."[17] Greenberg did call *The Charnel House* "an elegy," and he believed that painting should be expressive. His fear was that unless interpretation was limited to demonstrable formal matters, it would wander so far from its physical object as to lose it. Thus Greenberg aspired to a rigor he believed was lacking in the subjective "expressionist" or "existentialist" criticism prevalent in the fifties, exemplified by Rosenberg's writing, and this rigor appealed strongly to young critics. Greenberg's seemingly empirical prose also was closer in spirit to the post-painterly styles of the sixties. Up-to-date though it appeared, Greenberg's approach had its source in Roger Fry's and Clive Bell's conception of "plastic values" popular in the twenties and in the New Criticism of Blackmur, Ransom, and Tate,[18] which had its heyday in the thirties, when Greenberg was growing up intellectually.[19] The New Criticism sought to analyze literary works as autonomous objects isolated from any personal, social, historical, or other-than-literary context, even if the latter had clearly contributed to their creation. (Ironically, in the sixties, at the very time when formalist discourse was at its zenith in the visual arts, the New Criticism went into eclipse.)

At the core of Greenberg's aesthetics are two ideas—not necessarily connected. The first is that the quality of a work of art is its most important attribute and that it issues from inspiration and taste and does not depend on style. The primary enterprise of art is the production of works of quality and the primary enterprise of criticism is distinguishing good from bad.[20]

The caliber of criticism depended on good taste, taste acute enough to distinguish taste from tastefulness. Indeed, Greenberg believed that good taste challenged tastefulness. Art that initially seemed awkward and crude was more likely to turn out to be in good taste than art that was tasteful.

Greenberg granted that there were no demonstrable or empirical criteria for quality. Quality was not a formal "fact," nor could it be derived from formal "facts." He admitted that the determination of quality was primarily a matter of subjective taste and conviction. It follows that his own taste, no matter what claims were made for it, was only his own. But Greenberg's taste was rarely challenged by young formalist critics; indeed, a number seemed to canonize it. After all, he had been among the first to acclaim the pioneer Abstract Expressionists and David Smith. He was, moreover, the first to recognize Morris Louis, Kenneth Noland, Jules Olitski, and Anthony Caro.

The second of Greenberg's underlying ideas is that in the modern era, each of the arts has been impelled toward what is autonomous and irreducible in or purely of the medium, toward "self-definition," as he put it. Uniquely characteristic of painting, for instance, are "the flat surface, the [rectangular] shape of the support, the properties of pigment." Most important was flatness, for it alone is "unique and exclusive to pictorial art."[21] That a painting is primarily a two-dimensional object has been openly asserted by modernists; in contrast, the old masters acknowledged flatness only implicitly or indirectly.[22] Indeed, to Greenberg, this insistence on the physical medium, on painting that aspires to be *more* painting, made painting modernist. In its urge for purity, painting was required to purge itself "self-critically" of representation and illusion, of every effect that was not of the medium of painting and therefore belonged to the medium of some other art. Painting's progressive purification gave rise to style changes.

Thus Greenberg's thinking was rooted in art history. He conceived of the history of modern art as a mainstream—a succession of avant-garde styles, evolving and dying, each of which advanced art closer to its "self-definition." Once a style is established as modernist, all others are superseded, until, presumably, a purer style emerges.

Greenberg's history of modern art seemed deterministic, as if one modernist style had inexorably, *necessarily,* succeeded another. He denied that he was prescribing history, and insisted, on the contrary, that he had merely *described* the progression of styles. But Greenberg's claims to historical empiricism were often questioned, and with good reason. For one thing, he was dealing with his own time as if it were already historical. For another, he focused so single-mindedly on one style in the sixties as to create the impression that it was historically inevitable. The implication was that there was only one correct style at any one time—and only one way of correctly perceiving it. Whether this style was historically determined or not, Greenberg proceeded as if it were the only one worthy of consideration. Other art was ignored, presumed beneath serious analysis.[23]

The most troublesome aspect of Greenberg's thinking was the relationship between an art criticism based on a *subjective* apprehension of quality and an art criticism based on an allegedly *objective* reading of history. Was it conceivable that a critic would claim a style was historically necessary and deny its quality on grounds of taste? Or vice versa? Greenberg wanted to have it both ways; he tried to resolve the ambiguities and contradictions by claiming that the formalist art of any moment had *turned out* to be the best. He had reached this conclusion, so he claimed, on the basis of impartial observation of the gamut of art of any one time. Yet many people who thought seriously about art questioned Greenberg's professed empiricism: it seemed to them that either he labeled the art he liked "modernist," as in the case of Caro, or he liked some art because it conformed to his ideas of modernism, as in the case of many mediocre followers of Olitski. In either case, he insisted that what he singled out was art of quality. Elizabeth Frank was right when she wrote that Greenberg "identifies form with content, content with quality, quality with his taste, and taste again with the form he prescribes."[24]

After all, Greenberg did claim that "in its 'purity' [each art would] find the guarantee of its standards of quality as well as of its independence."[25] Sidney Tillim seems to have had this remark in mind when he wrote that the formalists'

> linear view of history necessarily interprets art in terms of a mainstream that issues from constantly evolving solutions to a formal problem. As the mainstream is by definition also the best art, i.e., major, all other art *must* pursue other enterprises for which reason it is minor—*if that.* Formalism, then, does not so much interpret history as it interprets *quality,* or rather it sees the history of art as the history of quality.[26]

Other critics, Krauss, for example, believed that Greenberg's idea of history had made taste irrelevant. She thought that this was the power of his polemic. As she wrote, the formalist approach

> was historical in character, which meant that it read only in one direction; it was progressive. [History] was like a series of rooms *en filade.* Within each room the individual artist explored, to the limits of his experience and his formal intelligence, the separate constituents of his medium. The effect of his pictorial act was to open simultaneously the door to the next space and close out access to the one behind him.

Krauss went on to say:

> I never doubted the absoluteness of that history. It was out there, manifest in a whole progression of works of art, an objective fact to be analyzed. It had nothing to do with belief, or privately held fantasies about the past. Insofar as modernism was tied to the

objective datum of history, it had, I thought, nothing to do with "sensibility."[27]

Hilton Kramer agreed with Krauss: "It seems to me that behind Mr. Greenberg's deference to history there lies an unacknowledged belief . . . in a doctrine of historical inevitability . . . which provides him . . . with the governing 'myth' upon which his whole critical position has been constructed."[28] Unlike Krauss, however, Kramer thought that Greenberg's appeal to history was merely an attempt to create an imposing front and validation for his taste. Kramer attributed to Greenberg "the assumption that critical judgments, if they are to carry the authority and force of something more than a merely personal taste, must be made in the name of history." Kramer continued:

> Greenberg's habit of pronouncing all judgments as if they were objective readings of history [is a device] in which taste and personal experience carry very little ontological weight beside the imperious claims of the historical process. . . . The question, of course, is whether this deference to the claims of history is anything more than a rhetorical device; whether it may not be, in fact, as personal and subjective a basis of judgment as any other.[29]

Or, as Tillim remarked: "Formalist art . . . is anything Clement Greenberg likes." Bannard, a follower of Greenberg, added that Tillim "wasn't far wrong."[30] To sum it up, Greenberg's taste was bolstered by his aesthetics, particularly his appeal to art history, and his aesthetics were bolstered by his taste—and both his taste and his aesthetics were esteemed by a generation of critics that emerged in the sixties.

There was another connection between Greenberg's concepts of purity and quality. Both were exemplified by an art based on the minimal gesture, such as Pollock's "drip," Newman's "zip," Louis's stain, and Olitski's spray. There was nothing in the art of painting that called attention to the medium and its support more than such gestures, or focused attention more on

quality. Indeed, Greenberg went so far as to imply that a single risky Intuitive Gesture could yield a Sublime Masterwork. Underlying all his claims to formalist rigor was his adherence to the Romantic myth of the artist as inspired Genius. It was inspiration that imparted quality to art—and what could embody and reveal inspiration as directly as the one-shot gesture?[31] For Greenberg, it was in this minimal gesture that the imperatives of history and the demands of taste were organically joined. History would culminate in an art that was both pure and good. In this sense, the history of modernism is the history of quality.

Of Greenberg's followers, Fried deserves special consideration, because he was of the generation of sixties artists and published extensively after 1962, when Greenberg's writing on individual artists fell off. Fried was also the most single-minded of formalists, and much more than Greenberg, he applied formal analysis to specific works of his contemporaries. Like Greenberg, Fried believed that since Manet, painting had turned away from the concerns of society and had become increasingly occupied with problems intrinsic to painting.[32] Generations of "individual artists [chose] to engage with formal problems thrown up by the art of the recent past."[33]

Fried deviated from Greenberg on one critical point, however. Whereas Greenberg conceived of the "logic" of modernist painting as verging toward purity, toward what was unique and irreducible in each particular art, Fried saw it as a sequence of successive reactions to the new possibilities and problems created by the immediately preceding modernist style, a past style that had presumably solved its problems. As Philip Leider put it, the problem was to determine what was operational in the earlier work and what later painters had to do in order to advance painting. For example, Pollock, in responding to Cubist design, felt the need to loosen it. Therefore, he poured paint.[34] Fried

summed it up: "The chief function of the dialectic of modernism in the visual arts has been to provide a principle by which painting can change, transform and renew itself."[35] Thus, modernist painting became perpetually self-generating, yielding new modernist painting.

It would seem that Fried had broadened formalism, but that was not the case. As he asserted: "Once a painter who accepts the basic premises of modernism becomes aware of a particular problem thrown up by the art of the recent past, his action is no longer gratuitous, but imposed." He was no longer free to create but must confront the situation. He "cannot pass by [but] in some way or other, he must pass through; and the result of this forced passage will be his art."[36] The formalist painter was transformed into a kind of medium of history, and at times Fried wrote as if he or she were. For example, he described "Louis's breakthrough as one in which *painting itself* broke through to its own future."[37] Whether the course of formalist painting was growing purification or a chain of aesthetic reactions, by the late sixties it would strike growing numbers of critics as increasingly narrow, and what was more damning, increasingly boring.

Purist art was one of the two major tendencies in the sixties. The other was its dialectical antithesis, impurist art, although, as I shall indicate, they had at least one key idea in common—namely, a concern with objecthood. The mentors of impure art were John Cage and Duchamp, and the artists most closely identified with them were Rauschenberg and Johns, who were at the height of their careers in the early sixties. The influence of Cage was stronger on Rauschenberg, that of Duchamp, on Johns.[38] Cage was more available than Duchamp to younger artists and thus could shape their thinking more directly. Indeed, it was Cage more than Duchamp himself who popularized the latter's attitudes. Cage's lectures and essays were collected in a book entitled *Si-*

FACING PAGE:
37. Marcel Duchamp, *In Advance of a Broken Arm*, 1915. 47¾" high. Yale University Art Gallery, New Haven, Conn.

*lence,* published in 1961, the same year as Greenberg's *Art and Culture.* Duchamp's own works and ideas received renewed attention after 1959, the year a lavishly illustrated monograph by Robert Lebel was published.[39] Despite Cage's personal accessibility, Duchamp proved to be the greater force in the sixties, because Johns was a seminal figure in the development of Pop and Minimal Art, notwithstanding the greater notoriety of Rauschenberg. In fact, beginning in 1963, there developed what Robert Smithson called "a kind of Duchampitis," a veritable vogue.[40]

The works of Duchamp that most interested sixties artists and critics were the Readymades. These mass-produced, commercial objects—a bicycle wheel, shovel, or urinal—that he began to choose in 1913, named in 1915, and exhibited the following year, were his most original works or, more accurately, nonworks. As Allan Kaprow remarked, Duchamp had the knack of "discovering art where art wasn't."[41] The very commonness of Readymades makes them uninteresting to look at. Moreover, they lack the kind of surface embellishment, signs of the artist's idiosyncratic touch, that appeals to the eye. Thus they are non- or antivisual or, as Duchamp put it, antiretinal. As he said in 1914: "I want something where the eye and hand count for nothing."[42] The elevation of real, everyday objects into art objects fulfilled another of Duchamp's intentions. It struck at every higher claim made for the art product and the art process. If a Readymade was art, then it was art without the work or craft of art. Duchamp's repudiation of the artist's creative process and its self-expressive signs caused his art to look depersonalized—as Cage said, "free of one's likes and dislikes. Duchamp says he wants to make a Readymade to which he is completely indifferent. That's the same idea."[43] Later, Johns said: "I have attempted to develop my thinking in such a way that the work I've done is not me—not to confuse my feelings with what I produced."[44]

Duchamp's antipathy to retinal art issued from his desire for a conceptual art. Even as a painter, he said: "I was interested in ideas, not in visual results. Once again I wanted to put painting in the service of the mind. And of course my painting was immediately considered 'intellectual' and 'literary.' In fact I tried to find a place as far away as possible from 'pleasing' and 'attractive' physical painting."[45] Indeed, as Johns remarked, Duchamp had ventured "through the retinal boundaries which had been established with Impressionism into a field where language, thought and vision act upon one another."[46] Even the Readymade is conceptual; Duchamp declared that it created "a new thought for that object,"[47] and by extension, thoughts, metaphysical in essence, about the nature, definition, and language of art. The Readymade asks of the object what it is. What is the relation of the real, nonaesthetic object to an art object? Can one be the other? Are Readymades works of art or of nonart or of antiart or of pseudo art? Do they, as Johns wrote, "*serve* as works of art and *become* works of art through this service"?[48] Are there conditions whereby they may be *thought* of as art—for example, if that was the intention of the "artist," or because they were placed in a gallery or other art setting: that is, at an aesthetic distance? Is it possible to define art at all? Or is any attempt to do so futile?

Because Duchamp's "creation" issued from a mental choice rather than from artistic making, his contribution to modern art was new ideas, not new forms. Robert Morris asserted that Duchamp's art "resonates in the mind, calling the mind's very processes and judgments into question, invoking laughter and even indifference to escape its habits or to question its values and meanings. Essentially this is a critical art probing into the myths of the culture. It is highly elitist, disguised, indirect." Morris went on to contrast Duchamp with Picasso, whose art was "of exuberance and direct feeling. Startlingly

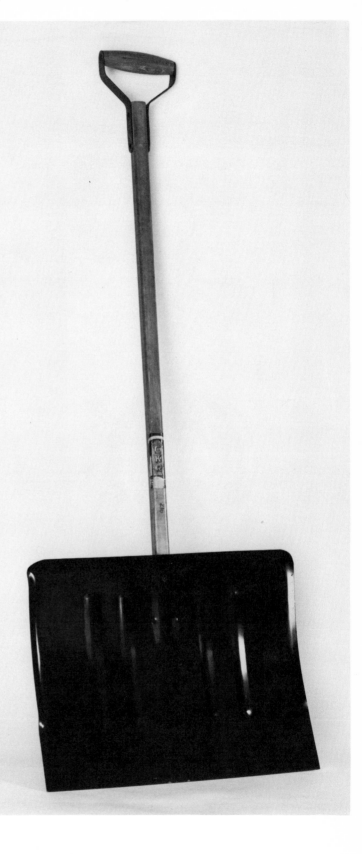

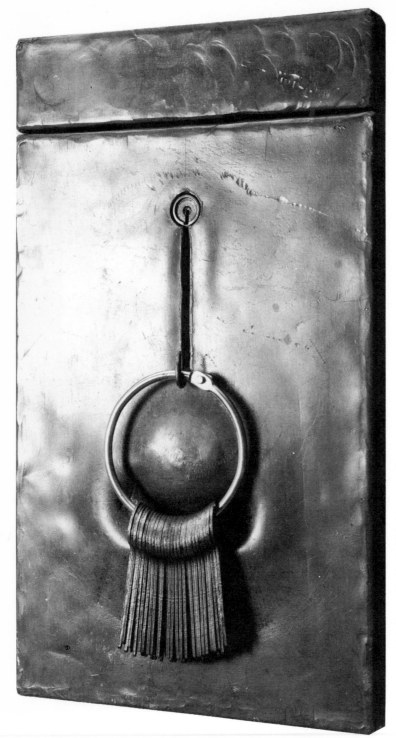

38. Robert Morris, *Litanies*, 1963. 12″ × 7⅛″ × 2½″.
Museum of Modern Art, New York.

immediate, formally amazing and powerfully present, the work runs the gamut of human feeling. [The] ambition here is for heightened emotional response and visual fullness." Duchamp and Picasso did "travel some of the same thematic ground (meditations on the artist and his act of creativity and the force of his sexuality, for example)."[49] But their points of view were profoundly divergent, Duchamp advancing, as William Rubin observed, "speculatively, not by painting but *through cerebration,*" Picasso, through *the act of painting.*"[50]

Cage and Rauschenberg admired Duchamp's Readymades because they blurred the distinction between life and art, this being Cage's primary intention. The idea of everything-in-itself being art was closely related to Cage's idea of every-sound-in-itself being music. But Johns was interested more in the conceptual potential of the Readymades, in investigating the relationship of the real object to the art object in the manner of Duchamp. However, unlike Duchamp, who claimed to detest manual virtuosity, although he had lavished craft on many of his non-Readymades, such as the *Large Glass,* Johns created his readymades with consummate artistry. Whereas Duchamp made the commonplace uncommon through displacing it into an art context, Johns made it unique through artistic making. Even when Johns borrowed directly from Duchamp, as with the measuring stick in *Device,* he rotated it physically in paint.

Duchamp was ambivalent, at least at first, about the use of readymades by young artists. In 1962, he wrote:

This Neo-Dada which now calls itself New Realism, Pop Art, Assemblage etc. is cheap fun living off what Dada did. When I discovered the "ready-mades" I intended to discourage the aesthetic hullabaloo. But in Neo-Dada they are using the ready-mades to discover their "aesthetic value"!! I threw the bottle rack and the urinal in their faces as a challenge and now they admire them as something aesthetically beautiful.[51]

Much as Duchamp prided himself on his iconoclasm, he was nothing but an artist. Indeed, he could not avoid it, as Hal Foster has remarked:

> Artistic conventions are . . . established precisely where they seem rejected—for example, with artists who assume subjects and processes alien to art. . . . Such rejection of the artistic is rhetorical, i.e., it is understood *as* a rejection and so must be timely and tactical. [We] call it "Duchampian."[52]

Following the lead of Duchamp, young artists fabricated readymades: Johns's bronze sculptures of beer cans, for example, or Warhol's wooden boxes silkscreened with Brillo labels so that they looked like replicas of the real things. Still other artists incorporated readymades into their paintings and sculptures, among them Rauschenberg, Dine, Rosenquist, Wesselmann, the English Pop artist Richard Hamilton, and the French *nouveaux réalistes* Arman, Daniel Spoerri, and Jean Tinguely. Even nonobjective artists used readymades: for example, the Minimalists Dan Flavin, who used fluorescent light fixtures, and Carl Andre, who used firebricks and store-bought rectangular metal planes. Indeed, the sixties concern with prefabricated materials and industrial techniques had a source in Duchamp's Readymades. So did the practice of drawing up plans for works that were to be manufactured elsewhere by workers; it reflected Duchamp's antipathy to manual virtuosity.

Johns was influenced not only by Duchamp's Readymades but by ideas and images in other of Duchamp's works, borrowing from and amplifying them freely. For example, Johns's *Thermometer* is anticipated by Duchamp's *Why Not Sneeze?* The shadow cast by an object in Duchamp's *Tu'm* is recapitulated by Johns in *Ne.*[53] Morris also was influenced by Duchamp—and Johns. Taking his cues from Duchamp's *Three Standard Stoppages* and Johns's *Device,* 1961–62, Morris suspended three yardsticks of different lengths from adjacent hooks in *Three Rul-*

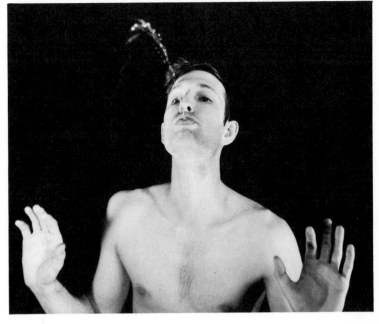

39. Bruce Nauman, *Self-Portrait as a Fountain,* 1966–67. 19¾" × 23¾". Leo Castelli Gallery, New York.

*ers,* 1963, playfully calling into question measuring devices.[54]

Other ideas in Duchamp's works—visual and verbal mixtures, puns, paradoxes, ambiguities, and games—inspired young artists. Like Duchamp, who made incessant notes for the *Large Glass,* Johns kept notes about present and future works, occasionally publishing them, as if to underline the verbal and conceptual side of his enterprise. In *Litanies,* 1963, Morris inscribed each of a bunch of keys with a word from Duchamp's notes for "litanies of the chariot" in the *Green Box.* In *Document,* 1963, Morris attached to his *Litanies* a sworn affidavit withdrawing from it all aesthetic content, reversing Duchamp's gesture of conferring the status of an artwork on a Readymade, as John Tancock remarked.[55] Morris's *Card File,* 1962, is a readymade metal file containing a sequence of cards, in alphabetical order and cross-indexed, that describes the making of a work—at once a record of making and the making of a record. Morris combined Duchamp's note-taking with the self-referentiality of Stella's black-stripe abstractions, reconciling the impurism of the one with the purism of the other, as it

were. With the permission of such works, artists younger than Johns and Morris ventured into a purely conceptual art, dispensing with objects except for the paper on which proposals were written.[56]

Duchamp showed younger artists that documentation of art activities—of any activities, for that matter—could be presented as works of art, as he had done when he placed photographs and facsimiles of his entire body of work in *Box in a Valise*, 1938, 1941–42. Duchamp's documentation often included photographs of himself engaged in some kind of performance, such as playing a game of chess with a naked woman at the Pasadena Art Museum, during his retrospective there in 1963. This and other widely disseminated images of self, pointedly lacking in self-expression, inspired Johns, Morris, and younger artists influenced by them, such as Bruce Nauman. For example, Morris's *I Box*, 1962, calling to mind Duchamp's *Valise*, permits the viewer to open an I-shaped door like an eyelid to reveal a photograph of the artist standing naked, recalling Duchamp's *Belle Haleine*. Nauman's *Portrait of the Artist as a Fountain*, a photograph of himself spitting a stream of water, is a visual-verbal pun that alludes to Duchamp's Readymade urinal, *Fountain*. Morris also staged performances and Nauman made films, works that featured the artists engaged in minimal activities.

Anticipating the performances of Morris and Nauman were the Happenings of Kaprow, Grooms, Oldenburg, Dine, and Robert Whitman. These theatrical activities were inspired primarily by Cage. "Duchamp was certainly very much in sympathy. [He] was an assiduous spectator-participant from the very beginning."[57] A somewhat later manifestation of Performance Art, called Fluxus, was, as George Maciunas, one of the founders, remarked, "a fusion of Spike Jones, gags, games, Vaudeville, Cage and Duchamp."[58] Both Happenings and Fluxus events were specifically object-oriented in that the participants placed as much value

on readymade objects as they did on their acting, which consisted primarily of manipulating the objects. As Oldenburg wrote, the Happening was a "theater of action or of things (people too regarded as things)."[59] Physical manipulation was also central to Performance Art of the late sixties, known as Body Art or Bodywork, exemplified by Vito Acconci's pieces. Body Art was anticipated by Duchamp's having a star shaved on the back of his head, the haircut photographed by Man Ray.[60]

Duchamp's self-documentation was part of a strategy: to make of himself a work of art, without the work, of course, and ostensibly without revealing his psychology. He projected himself in a variety of roles and guises: Marcel Duchamp, Rrose Sélavy, R. Mutt, Belle Haleine, and the Marchand du Sel. Throughout all this, he remained a distanced figure, so much so that he could be viewed as a master of self-detachment, and this role was his primary appeal. Hans Richter wrote that "Duchamp's detachment, the first step of his wisdom, permeates his personality and works like a vacuum on fate, pulling things and people toward it." Richter also remarked that the vacuum Duchamp created replaced "rejected," presumably humanistic, moral and artistic attitudes and constituted his "magical force of attraction."[61] (Later, Warhol, emulating Duchamp, would create a similar vacuum.) What does one do in this vacuum? Play art-life games seriously, in the manner of Johan Huizinga's *homo ludens*. As if to underline this intention, Duchamp abandoned art for chess, or so it was thought. His activity was not lost on younger artists, but he was, he professed, a nonartist, and they were artists. And so they substituted art for chess, treating it as a game in a detached but serious manner, analyzing the art situation they found themselves in, identifying its art problems, making shrewd, elegant, and telling art moves in pursuit of an art checkmate—that is, to inscribe themselves in History.

This    Duchamp-inspired    enterprise

alarmed critics, such as Hess and Green-berg, the more so because questions were being raised as to whether painting remained a viable form of art. A recurring topic for argument in the late sixties was: Is Painting Dead? Hess acknowledged that Duchamp had succeeded in making his life into a masterpiece, but Hess insisted that *only* Duchamp could have done it. Therefore, he was no fit role model. Worse than that, he had been

a corruptor of youth. . . . After abandoning art, he also insisted on remaining an Artist with the prerogative of naming anything he chose to become "his" art. Following this example, hundreds of young and not-so-young artists have involved themselves with exhibitions of numb found-objects, with Happenings that never happen, with feeble protests in the form of subversive bon-mots at gallery openings. All these lost, grey souls, who hope that some day, their life, too, will turn into a masterpiece, creep through a limbo made to the specifications of Marcel Duchamp.

To be sure, "Duchamp is not responsible for the errors of his followers because they should have known that only Duchamp can be his own work of art. . . . That is his lesson. Those who have understood him make the same point: In the Beginning is—Originality."[62] But although Hess did not acknowledge it, the lesson was learned by a significant number of young artists, who did create original bodies of work.[63]

To press their attack on Duchamp in the name of "high art," Hess and Greenberg called into question his abilities as a painter, granting that he had "made two or three of the masterpieces of modern art," notably the *Large Glass* and *Network of Stoppages*.[64] They insisted, however, that it was his mediocrity as a painter that led him to abandon painting for nonpainting enterprises. His attacks on painting were little more than sour grapes. To put it another way, unlike Rubin, who saw Duchamp's cerebration as a process different from painting, Hess and Greenberg saw it as inferior to painting and claimed that Duchamp had embraced it in the first

place because he was, as Hess wrote, "a second-rate painter."[65]

Why, then, was Duchamp's work so compelling and influential? In Greenberg's opinion: "The fascination is more historical, cultural, theoretical than it is esthetic [offering] far more challenge to understanding than to taste." And that fascination was generated by Duchamp's "avant-gardism." He had been the first to embrace newness in art consciously—"the shocking, scandalizing, startling, the mystifying and confounding"—as an end in itself. That was bad, antithetical to "high art." But Greenberg hastened to add that avant-gardism was not to be confused with avant-gardeness. The latter could be fruitful. Greenberg asserted: "Among the many things that highly original art has always done is convert into art what seems to be non-art." Such art often turned out to be good. In contrast, Duchamp showed that everything could be art and therefore art was made by fiat. Art-by-fiat invariably turned out to be inferior in quality. What it won was new areas for *bad* art. Then Greenberg charged: "The issue for art is not merely to extend the limits of what's considered art, but to increase the store of what's experienced as 'good and better' art. This is what extending the 'limits' of art meant for the classic avant-garde. The issue remains quality."

Greenberg went on to say that Duchamp not only had created avant-gardism but, luckily, had exhausted it. "In a few short years after 1912 he laid down the precedents for everything that advanced-advanced art had done in the fifty-odd years since. [It] was Duchamp alone who worked out, as it now looks, every implication of that vision." Therefore, today's "advanced-advanced art . . . amounted to hardly more than elaborations, variations on, and recapitulations of his original ideas." But as Greenberg saw it, many young artists in the sixties did not share his belief that Duchamp had left nothing for his followers to do. They "concluded that the main thing was to look

difficult and that the startlingly difficult was sure to look new, and that by looking newer and newer they were sure to make art history."

But this newness, Greenberg insisted, was really easy to accept and thus was "academic." Indeed, the "new academy" was within the alleged avant-garde. "It is one of avant-gardism's great theoretical services to have demonstrated that the lack, at least, of the unconventional, the adventurous, the advanced, can be standardized enough to be made available to the tritest sensibility." Greenberg attacked Duchamp-inspired art for its appeal to "a new middlebrow consciousness."[66] Hess also took Duchamp to task, for turning Dada's "savage indignation" into "giggles at art in cahoots with the artist's chosen audience," a segment of the bourgeois art world that had learned his "game" and could follow his gambits and stratagems. In Hess's opinion, Duchamp's enterprise was at worst esoteric "camp," because it titillated an in-the-know coterie, and at best aestheticism, for the same reason.

Duchamp had his staunch defenders. They stressed an idea advanced by Hess that Duchamp was an "In-Art-We-Trust-Buster," who fostered the "critical destructive side" of modern art which it needs "in order to remain creative."[67] As Brian O'Doherty wrote:

> Duchamp's genius, and it is genius, was to see the modernist era from the *outside, while in it.* Thus, its myths, energies, and rhetoric lie open to a sympathetic understanding of their absurdity.... The strenuous searches for pure form, the egotisms of "expression," the pseudo-exploration of "advancing," the bourgeois desire for fame, the presumptiveness of initiating social change from a canvas, the smugness of an esthetic moralism—all these could hardly be matters of life and death.... Modernist history won't

let Duchamp in, because he spoiled the fun it had in taking itself seriously.[68]

Duchamp's defenders also stressed the positive effects of Duchamp's iconoclasm—to encourage forays into the new, to deflect the course of art into fresh channels. Furthermore, they disputed Greenberg's claim that there was a contradiction between new art that wins new areas for art and art that was good. That was just his opinion. Art can just as well be both. The new-as-new can be, and sometimes is, new-as-good.

Finally, Duchamp's defenders countered the claim that they were middle class in mentality by accusing their attackers of the same sin. For example, in a catalogue entitled *The Other Tradition,* Gene Swenson castigated formalism, Greenberg's in particular, as a "bourgeois infection, self-satisfied estheticism," which in its boredom had infected "practically every intellectual and artistic community, in the universities, in galleries, in art publications." Swenson pointed out that formalists had succeeded unfairly in relegating not only Duchamp but all of Dada—and Surrealism—to a minor position in the history of modern art.[69] He concluded: "How much longer will we rest content with our defective and infectious critical tools and our academic standards? How many more times can we see the words 'picture plane,' 'modernism,' 'crisis,' 'new,' and 'literary' without flushing?"[70]

Greenberg and Duchamp hated each other's aesthetics. But this mutual antagonism notwithstanding, there was one significant point of agreement: an emphasis on objecthood, the thing or the work of art as a literal thing—and it was this stress on thingness that was central to the art of the sixties.

# NOTES

1. Donald Key, "Stripe Painting Has Been a Rough Road," *Milwaukee Journal,* 12 June 1960. The writer also remarked: "Stella shrugs his shoulders at the idea that his paintings are symbolic. He likes to think of his stripes as . . . pure brush strokes."

2. Bruce Glaser, interviewer, and Lucy Lippard, ed., "Questions to Stella and Judd," *Art News,* September 1966, pp. 58–59.

3. Ibid., p. 59.

4. William S. Rubin, *Frank Stella,* exhibition catalogue (New York: Museum of Modern Art, 1970), p. 41.

5. Barbara Rose, "ABC Art," *Art in America,* October–November 1965, p. 65.

6. Ad Reinhardt, in *Ad Reinhardt,* exhibition catalogue (New York: Betty Parsons Gallery, 1947), n.p.

7. Ad Reinhardt, "Art-as-Art," *Art International,* 20 December 1962, p. 36.

8. Ibid., pp. 37–38.

9. Lucy Lippard, "New York Letter," *Art International,* May 1965, p. 53.

10. Ad Reinhardt, interviewed by Irving Sandler, "In the Art Galleries," *New York Post,* 12 August 1962, p. 14.

11. See Elaine de Kooning, "Pure Paints a Picture," *Art News,* Summer 1957.

12. See Mary Fuller, "An Ad Reinhardt Monologue," *Artforum,* October 1970, p. 38.

13. Hilton Kramer, "A Critic on the Side of History: Notes on Clement Greenberg," *Arts Magazine,* October 1962, p. 61.

14. I dealt at length with the earlier, pre-1960 Greenberg in *The Triumph of American Painting* (New York: Praeger, 1970) and (Harper & Row, 1975) and *The New York School* (New York: Harper & Row, 1978).

15. Clement Greenberg, "Modernist Painting," *Arts Yearbook* 4 (1961): 107.

16. See Renato Poggioli, *The Theory of the Avant-Garde* (Cambridge, Mass.: The Belknap Press of Harvard University Press, 1968), pp. 200–201.

17. Barbara Rose, "Problems of Criticism IV: The Politics of Art, Part 1," *Artforum,* February 1968, p. 32. Rose alluded to Clement Greenberg, "Picasso Since 1945," *Artforum,* October 1966, p. 29.

18. Michael Fried, in "Modernist Painting and Formal Criticism," *The American Scholar,* Autumn 1964, p. 642, called attention to the affinities between the New Criticism and formalist art criticism.

19. Philip Leider, " 'You May Think You Appreciate Morris Louis, But Do You Really?' " *New York Times,* 26 February 1967, sec. 2, p. 27. See also Fried, "Modernist Painting and Formal Criticism," p. 642. Thomas McEvilley, in "Heads It's Form, Tails It's Not Content," *Art-

forum,* November 1982, p. 57, wrote that the formalist position seems in part transposed from the arena of literary debate. The so-called "New Critics" of an earlier generation (especially William Wimsatt, and Monroe Beardsley) did for literature what Greenberg and others both before him and after him have done for the visual arts; they fostered a myth of the autonomy of the literary work, which "should not be judged by reference to criteria or considerations beyond itself." To the New Critics a poem consisted not of referential statements about the world beyond it, but of "the presentation and sophisticated organization of a set of complex experiences in verbal form." . . . Similarly the New Critics, like the Greenbergians, preached . . . that the work of art is a self-contained object accessible in some perceptually fair sense to the objective appreciation of competent agents.

20. See Clement Greenberg, "How Art Writing Earns Its Bad Name," *Encounter,* December 1962, p. 68.

21. Greenberg, "Modernist Painting," pp. 103–4.

22. Ibid.

23. See John Coplans, "Post-Painterly Abstraction," *Artforum,* Summer 1964, and Max Kozloff, "Letter to the Editor," *Art International,* June 1963.

24. Elizabeth Frank, "At Ease in Zion: Clement Greenberg After Forty Years," *Bennington Review,* December 1980, pp. 29–30.

25. Greenberg, "Modernist Painting," p. 103.

26. Sidney Tillim, "Evaluations and Re-evaluations," *Artforum,* Summer 1968, p. 22.

27. Rosalind Krauss, "A View of Modernism," *Artforum,* September 1972, pp. 49–50.

28. Kramer, "A Critic on the Side of History: Notes on Clement Greenberg," p. 61.

29. Ibid.

30. Walter Darby Bannard, "Art Quality and the Formalist Controversy," *Quadrille* (Bennington College), Fall 1974, p. 8.

31. Ad Reinhardt disagreed with Greenberg's conception of the artist as inspired gesturer. In "Art-as-Art," *Art International,* 20 December 1962, p. 37, he called for a preconceived, deliberately crafted art. Intensity, consciousness, and perfection in art "comes only from long and lonely routine preparation and attention and repetition."

32. Formalists who believed that art was primarily about itself and therefore not about "life" failed to see that their stance pertains to "life." Ellen Johnson, in "Jim Dine and Jasper Johns: Art About Art," *Arts and Literature* 6 (November 1965): 140, pointed to the essential psychology of the formalist artist or critic when she wrote that since he "lives in a total reality which

every day becomes more difficult to grasp, is it surprising that he often focuses on that particular segment of reality which he *can* hope to understand: the paraphernalia, properties and problems of painting?"

33. Fried, "Modernist Painting and Formal Criticism," p. 645.

34. Philip Leider, interviewed by Irving Sandler, San Francisco, 27 February 1981.

35. Leider, " 'You May Think You Appreciate Morris Louis,' " sec. 2, p. 27.

36. Fried, "Modernist Painting and Formal Criticism," p. 648.

37. Michael Fried, *Morris Louis 1912–1962*, exhibition catalogue (Boston: Museum of Fine Arts, 1967), p. 11.

38. "John Cage on Marcel Duchamp: An Interview," by Moira Roth and William Roth, *Art in America*, November–December 1973. Cage said on p. 78: "Johns may be closer to Duchamp than Rauschenberg and myself."

39. Robert Lebel, *Marcel Duchamp* (New York: Grove Press, 1959). The Duchamp vogue began in earnest in 1963 with Duchamp's retrospective exhibition at the Pasadena Art Museum, organized by Walter Hopps, followed by *Duchamp Ready-Mades, etc. (1913–1964)*, at the Galleria Schwartz, Milan, in 1964; *Not Seen and/or Less Seen of/by Marcel Duchamp, Rose Sélavy 1904–1964* at the Cordier and Ekstrom Gallery, New York, in 1965; and *The Almost Complete Works of Marcel Duchamp* at the Tate Gallery, London, organized by Pop artist Richard Hamilton, in 1966. There also appeared during the decade two widely disseminated books, one by the editors of Time-Life Books, titled *The World of Marcel Duchamp*, 1966, and the other, Calvin Tomkins's *The Bride and the Bachelors*, 1968, one of whose five chapters was on Duchamp. (The others were on Cage, Cunningham, Rauschenberg, and Tinguely.) These shows, catalogues, and books were augmented by published interviews with Duchamp by William Seitz in 1963, Dore Ashton and Otto Hahn in 1966, and Francis Roberts in 1968, and articles by Cage, Richard Hamilton, and Max Kozloff in 1964; Hess and Donald Judd in 1965; George Heard Hamilton, Richard Hamilton, Robert Lebel, Brian O'Doherty, and Arturo Schwartz in 1966; Johns and Jack Spector in 1968; and Nicolas Calas, William Copley, Anne d'Harnoncourt, Walter Hopps, Johns, and Hans Richter in 1969. These articles are listed in full in Joseph Masheck, *Marcel Duchamp in Perspective* (Englewood Cliffs, N.J.: Prentice-Hall, 1975). Rosalind Constable, in "New York's Avant-Garde and How It Got There," *New York/Herald Tribune*, 19 May 1964, p. 10, singled out Duchamp, then 77 years old, as the greatest influence on contemporary art. She wrote that

it is astonishing that living in the midst of New York is an artist whose creative life span precedes the Armory Show of 1913, precedes even Cubism, and who continues to be an awesomely rich, rewarding and influential source of ideas. . . . It was Duchamp who introduced *le hasard*, or chance, into painting. . . . It was Duchamp, with his philosophy that everything man-made is art, who anticipated Junk Art (and Pop Art) with his "ready-mades."

Constable concluded that today Duchamp serves as an inspiration to the avant-garde. "If the undisputed capital of the art producing world is now New York, its undisputed leader is the calm, handsome, and slightly ironic Marcel Duchamp."

40. "Robert Smithson on Duchamp: An Interview," by Moira Roth, *Artforum*, October 1973, p. 47.

41. Allan Kaprow, in Anne d'Harnoncourt and Kynaston McShine, eds., *Marcel Duchamp*, exhibition catalogue (New York: Museum of Modern Art, 1973), p. 205.

42. Walter Pach, *Queer Thing, Painting: Forty Years in the World of Art* (New York: Harper & Brothers, 1938), p. 162.

43. "John Cage on Marcel Duchamp," p. 74.

44. Vivien Raynor, "Jasper Johns: 'I have attempted to develop my thinking in such a way that the work I've done is not me,' " *Art News*, March 1973, p. 22.

45. Werner Hofmann, "Marcel Duchamp and Emblematic Realism" (1965), quoted in Masheck, *Duchamp*, p. 56.

46. Jasper Johns, "Marcel Duchamp (1887–1968)," *Artforum*, November 1968, p. 6.

47. Ibid.

48. Jasper Johns, "The Green Box," *Scrap*, 23 December 1960, p. 4.

49. Robert Morris, "American Quartet," *Art in America*, December 1981, p. 100.

50. William Rubin, "Reflections on Marcel Duchamp," *Art International*, 1 December 1960, p. 49.

51. Hofmann, "Duchamp," in Masheck, *Duchamp*, pp. 64–65.

52. Hal Foster, "The Problem of Pluralism," *Art in America*, January 1982, p. 11.

53. My discussion is indebted to Max Kozloff, "Johns and Duchamp," *Art International*, March 1964. Johns learned of Duchamp prior to 1959, because of his association with Cage, but it was only after that year, in which Robert Lebel's book appeared, that he learned in detail of the work.

54. John Tancock, "The Influence of Marcel Duchamp," in D'Harnoncourt and McShine, eds., *Marcel Duchamp*, p. 173.

55. Ibid., p. 174.

56. See Joseph Kosuth, "Art After Philosophy," *Studio International*, October 1969, p. 135.

57. Tancock, "The Influence of Marcel Duchamp," p. 171.

58. Adrian Henri, *Total Art: Environments, Hap-

*penings, and Performance* (New York: Praeger Publishers, 1974), p. 159.

59. Claes Oldenburg, *Store Days* (New York: Something Else Press, 1967), p. 80. The concern with objects was also manifest in the performances of the Judson Dance Theater.

60. Ira Licht, "Bodyworks," *Bodyworks*, exhibition catalogue (Chicago: Museum of Contemporary Art, 1975), n.p.

61. Hans Richter, "In Memory of Marcel Duchamp," *Form* (Cambridge, England) 9 (April 1969): 4–5. Quoted in Masheck, *Duchamp*, pp. 149–50.

62. Thomas B. Hess, "J'accuse Marcel Duchamp," *Art News,* February 1965, pp. 53–54.

63. William T. Wiley in "Thoughts on Marcel Duchamp," in Brenda Richardson, *Wizdum: William T. Wiley*, exhibition catalogue (Berkeley, Cal.: University Art Museum, 1971), p. 42, wrote: "What we can learn from Marcel Duchamp is . . . essentially that we do not have to follow his example. Yet should we find in his example a path that interests us we should trust ourselves enough to follow that path as long as it is possible without an overabundance of human misery."

64. Hess, "J'accuse Marcel Duchamp," p. 45. Hess also cited *Tu'm* as one of Duchamp's masterpieces. Clement Greenberg, "Counter-Avant-Garde," *Art International*, 20 May 1971, p. 18.

65. Hess, "J'accuse Marcel Duchamp," p. 45.

66. Greenberg, "Counter-Avant-Garde," pp. 16–18.

67. Hess, "J'accuse Marcel Duchamp," p. 53. Hess also claimed that Duchamp's iconoclasm helped modern art. "Duchamp mocked the pompous metaphysics of geometric abstraction, the decorative pretensions of Synthetic Cubism, the ersatz lyricism of School-of-Paris brushwork. 'Sure, I like Duchamp,' a senior modern painter remarked recently, 'he's been an enemy all my life!' "

68. Brian O'Doherty, *American Masters: The Voice and the Myth* (New York: Ridge Press/Random House, 1973), p. 196.

69. G. R. Swenson, in *The Other Tradition*, exhibition catalogue (Philadelphia, Pa.: Institute of Contemporary Art, University of Pennsylvania, 1966), p. 13, noted: "Even William Rubin, almost the only American historian who has tried to deal seriously with the Surrealist influence on Abstract-Expressionism, in 1963 said that

> It was precisely with Dadaism that real esthetic invention tended to become confused with *illusory originality* . . . the demand for novelty led many lesser painters into 'literature,' that is, beyond the legitimate poetry of imagery organically tied to plastic structures, and into an essentially extra-esthetic iconographic activity."

70. Swenson, *The Other Tradition*, p. 40. Duchamp's *Bride Stripped Bare* was both the frontispiece and the endpiece of Swenson's catalogue. There was only one other illustration, a work by Oldenburg.

# 3 THE SENSIBILITY OF THE SIXTIES

During the period from Johns's first show, in 1958, to the emergence of Pop Art, in 1962, the sensibility of the avant-garde underwent a pervasive change. Young artists embraced artistic attitudes different from those of the preceding Abstract Expressionist avant-garde. Certainly their styles looked radically different. Instead of the hot, dirty, handmade, direct-from-the-self look of fifties art, sixties art looked cool, clean, mechanistic, and distanced-from-the-self. It soon seemed that only work that partook of the changed sensibility commanded attention, and the cooler it looked, the more recognition it received. This new art, this art that looked *of* the sixties—whether stained color-field or hard-edge abstraction, Pop Art, the New Perceptual Realism, Photo-Realism, Op Art, Minimal Art, Process Art, Earth Art, or early Conceptual Art—did not appear to take its inspiration from the artist's psyche, life experiences, or private visions. It spurned those artistic elements that were commonly believed to refer to the artist's being, emotions or moods, and creative process—for example, the brush used as gesture or touch or handwriting or as the throbbing sign of passion or a seismographic indicator of the mind or soul.

That detachment from feeling and distancing from self prompted me in 1963 to label art of the sixties "cool art."[1] To judge from a number of statements by artists on the sensibility of the decade published in 1967, many agreed with my characterization. Allan Kaprow wrote of "cool detachment"; Ernest Briggs, of "not blowing your cool"; and Roy Lichtenstein, of "apparent impersonality." Gene Davis remarked that "coolness, passivity and emotional detachment seem to be in the air. Pop, op, hard-edge, minimal art, and color painting share it in some degree." In Ed Ruda's words: "Stay cool. Burn slow. Live long."[2]

Best exemplifying the new sensibility were Minimal Art and Pop Art, notably the work of Stella and Warhol. It had been Stella's black-stripe abstractions that first dramatized the shift in sensibility in their patent non-Expressionism, even anti-Expressionism. And Warhol's pictures of soup cans and the like seemed even more extreme. What Stella and Warhol substituted for self-revelation was a concern with objects external to the self, objects complete unto themselves—for Stella, the picture as an object; for Warhol, objects in the world. If the sensibility of the sixties can be characterized negatively by a single term, that would be antisubjective or anti-Expressionist, and positively, thing-oriented or object-like. It is this that linked the life-as-art strategies of Duchamp and Cage with the art-as-art strategies of Stella and Greenberg. All recoiled from "the stink of artists' egos," as Johns wrote with Duchamp in mind,[3] and instead looked objectively at objects. In this sense, art of the sixties was a quest for the *real*, for

something tangible to hang on to. Or, as Jack Tworkov, an older Abstract Expressionist in close contact and rapport with younger artists, stated succinctly: "There is a sensibility of the sixties: the emphasis on thingness."[4] Indeed, artists of the sixties did look at things for what they actually were and not as metaphors of human feelings, what Ruskin had termed the "pathetic fallacy." Thus there was a shift— from psychology to physicality, from subjectivity to objectivity,[5] from interpretation to presentation, from symbol to sign—to seeing things as they literally are and "saying it like it is," a catchphrase of the sixties.

In the fifties, subjective images of self were thought to represent humankind generally and to be communicable to others, to be intrasubjective; the self-centered was, by extension, human-centered, humanistic or "anthropomorphic," a more inclusive term than "expressionist" and one commonly used in the sixties. It follows that the object-centered art of the sixties is anti-anthropomorphic or, as I prefer to say, anti-anthropocentric. In broad terms, the change in sensibility from the fifties to the sixties can be viewed as a shift from anthropocentrism to anti-anthropocentrism. In the late fifties and early sixties, there was a slow buildup of anti-anthropocentric opinion within art-world discourse, exemplified by the ideas of Duchamp,[6] Cage, Reinhardt, and Greenberg and supported by the writing—even though little of it was on contemporary art—of Marshall McLuhan, Buckminster Fuller, Alain Robbe-Grillet, and Ludwig Wittgenstein.

The opening statement of the new sensibility in the visual arts, at least the one that first achieved public notice, was Andre's claim that Stella's works consisted of paint matter and of nothing else. "Stella is not interested in expression or sensitivity. [His] painting is not symbolic."[7] Stella himself later elaborated on the implications of Andre's statement. He said:

I always get into arguments with people who want to retain the old values in painting— the humanistic values that they always find on the canvas. If you pin them down, they always end up asserting that there is something there besides the paint on the canvas. My painting is based on the fact that only what can be seen there *is* there. It really is an object.[8]

What you saw was what you saw. Nothing more, nothing deeper, nothing other. Or, as Warhol said later: "If you want to know all about Andy Warhol . . . just look at the surface of my paintings and films and me, and there I am. There's nothing behind it."[9] Donald Judd was as opposed as Stella to reading human sentiments into objects; he called it anthropomorphic. In a conversation with Judd, Lippard suggested that he used the word "anthropomorphism" as a synonym for "humanism." Judd agreed.[10]

When Stella challenged the "humanist" approach by insisting that there is nothing

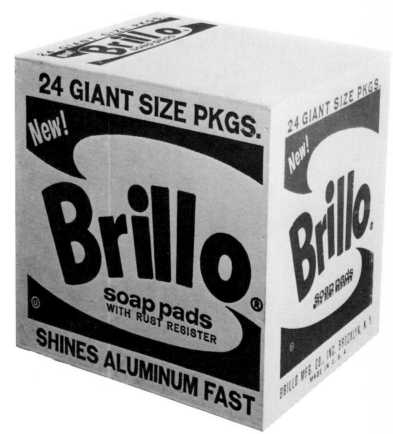

40. Andy Warhol, *Brillo*, 1964. 17″ × 17″ × 14″. Mr. and Mrs. Charles H. Carpenter, Jr.

other than paint on canvas in a picture, he was not assuming a nihilistic stance. He was questioning the reality or veracity of anthropocentric attitudes. If the old values were not relevant, then they were illusionistic and sentimental—extremely negative words in sixties rhetoric. By the same token, viewers with humanistic expectations of art were repelled by Stella's assertions. They assumed that art would comment on "the human condition" in a way that was at once uplifting and clearly aesthetic. They were not prepared for a tough-minded empiricism that was rooted in an "utterly unsentimental world view, devoid of the slogans and utopian dreams of the past," as Kaprow remarked about the sensibility of the sixties.[11]

Reinhardt had been saying much the same thing, though with greater humor:

> I recently pointed out . . . that the word "human" has never been used in relation to art without it implying that there was something wrong with the art. [The] word "humanist" always seems to justify something that is wrong. Just like if you say an artist is a "nice human being," you're almost saying there's something wrong with him as an artist. You say, "That artist is a bastard," and that already sounds like . . . at least he's a good artist. . . . But the word "human" is not only disreputable but it's fake. . . . I mean, after all, all art is human. You know, animals and vegetables don't make it. The social protest painter used to think that if you made a face in a painting, it made it human but it didn't.[12]

Anthropocentrists were even more incensed by Pop Art than by Stella's abstractions. They accused Pop Art of trivializing high culture in a cold and calculated manner by introducing into it subjects and techniques of low or kitsch or mass culture, thus making the art itself kitsch. By manipulating the signs of consumer culture, Pop artists were supposed to have glorified it. My comments about Warhol and Lichtenstein in 1965 exemplified the anthropocentric attitude to Pop Art:

> More than any earlier artists, they focus on subject-matter, not on execution, which is mechanistic, or on the artists' interpretation, which is minimal. But the subjects to which they force attention so insistently are totally banal and interchangeable. Furthermore, as copyists, they signify that they cannot realize any but the most elementary imitative ends in art—that it is impossible for them to communicate anything of import. . . . There is no room for the spirit of man or for the exercise of his imagination in [their] world of resistant things. And when the image of man does appear, it is as an impersonal thing— the offspring of ads and comic-strips.[13]

I also believed that Pop Art lacked the high purpose, depth, and richness—in a word, the humanism—of Abstract Expressionism. To be sure, Abstract Expressionist paintings were often ambivalent and ironic about the human condition, but at least they exhibited human vestiges, such as angst-ridden gestures, exemplifying existential being, or expansive color fields, which suggested a yearning for transcendence (in an age when God was supposed to be dead). Kirk Varnedoe has coined the label "survivor humanism"[14] for this alienated, post-Buchenwald, post-Hiroshima humanism, which because it was humanism remained morally, spiritually, and socially committed. But young artists of the sixties poked fun at any idea of the artist-as-hero or the artist-as-shaman. It had become unbelievable to them, and they purged even the minimal anthropomorphic content of Abstract Expressionism from their works.

For human sentiments, Stella substituted aesthetic quality. He would aspire to make high art. He believed that artistic values stood apart from other human values and could be experienced as such. So did Greenberg, who, citing Immanuel Kant, wrote that the kind of experience provided by art could "not be obtained from any other kind of activity."[15] The implication was that there was a special human faculty for the appreciation of aesthetic quality, and presumably it involved the viewers' emotions or, at least, the feeling for aesthetic quality. More than that,

Stella and Greenberg implied that the sole purpose of art was to appeal to this faculty. Their views were based on the questionable conception of the human personality as compartmentalized into separate faculties, each responsible for a particular kind of awareness.[16] But it is noteworthy that the idea was taken as seriously as it was. Most likely, the reason was that the "myths" of human depth, soul, fate, passion, grandeur, morality, transcendence, and the like having been jettisoned, aesthetic quality seemed all that remained of high human values.

It took time for the sensibility of the sixties to reveal itself fully. Stella's work, for example, at first was generally considered in terms of style, not content—as a reaction against Abstract Expressionism. His detractors claimed that Stella, bored with gesture painting (which remained the "valid" avant-garde style), jadedly and perversely and antihumanly fashioned an antithetical style.[17] His advocates believed that the overworked and outworn and thus no longer avant-garde work of the myriad followers of de Kooning, Kline, Philip Guston, and Hans Hofmann had become so boring that Stella was indeed justified in rejecting it and in formulating a new, non-Expressionist picture. Novelty was vital to sixties artists. "Make it new" had long been an expectation of modernism; it now became an obsession. Artists were quick to react against stale and tired ideas and strove to make "the next move in art." They aimed to connect with the most advanced or difficult ideas at any moment, the cutting edge of art. It was their ambition to formulate an artistic strategy that would enable them to cross over this boundary from established styles into the new. Any individual point of view or sense of identity that they sought to develop was conditioned by their prediction of the next move; this became their bet with art history, as it were. But the urge to novelty was combined with other intentions.

In the view of his friends, Stella, in creating a picture that referred only to itself, had posed a critical artistic issue and had solved it objectively and impassively. Thinking in stylistic terms led naturally to thinking in art historical terms, and Stella was often thought to have repudiated the entire Romantic-Symbolist-Expressionist-Surrealist tradition in modern art. Instead, he was supposed to have situated himself within and made the latest move in another tradition, a formalist tradition in which, according to Fried, "the thing-nature of the paintings came to be emphasized."[18] (By 1967, Fried would turn against "objecthood" as a goal of painting, but with a passion that reveals how central it was in his thinking, as it was in that of the sixties as a whole.[19])

It was natural initially to consider the new art in stylistic contrast with the old, because the differences were readily visible and that was how members of the art world were inclined to think. But it soon became clear that it was superficial to deal with style change in terms of formal distinctions only and to consider boredom with existing art and an urge for novelty as the primary motivations for the change. If the new art was significant, then it had to have occurred for more profound reasons and it had to parallel broader changes in culture and life. The world had to have changed and art with it.

Just that was professed by Leonard B. Meyer in an article published in 1963, "The End of the Renaissance? Notes on the Radical Empiricism of the Avant-Garde," which was widely discussed by artists.[20] Meyer proposed a new aesthetic whose "conception of man and the universe . . . is almost the opposite of the view that has dominated Western thought since its beginnings." It "represents a radical break with our common cultural convictions [and our] fundamental assumptions about the nature of men, the universe and man's place in it, which are so much a part of our habitual modes of thought and perception that we unconsciously take them for granted." He summed up the new attitude as follows: "Man is no longer to be the

measure of things, the center of the universe. . . . His goals and purposes; his egocentric notions of past, present, and future; his faith in his power to predict and, through prediction to control his destiny—all these are called into question, considered irrelevant, or deemed trivial." Meyer concluded that "*the Renaissance is over.*"[21]

Against a human-centered aesthetic Meyer posited an aesthetic of "radical empiricism" or of "uncompromising positivism."[22] At its core was the idea that cause-and-effect was no longer believable. Individual things and events could be established as real, but there was no accounting for the connections between them. It follows that no sequence of events should or could be perceived as having a goal or purpose toward which it might be developing or progressing. "In a novel by Robbe-Grillet [or] a composition by Cage [one does not] feel that one event follows *from* (is the result of) what went before. It simply 'comes after.' And since no event or action refers to or leads us to expect any other event or action, the sequence of events is, in any ordinary sense of the term, meaningless." Meyer went on to say: "The denial of causality and the correlative denial of predictability have important consequences. In the first place, rational choice, which depends upon the possibility of envisaging the results of alternative courses of action, becomes a senseless fiction. (This being so, it makes no difference whether an art work is produced by the consistent use of chance, by a purely gratuitous act, or by the rigid application of a predetermined formula.)"[23] In the second place, the less one perceives of relationships among things, the more one tends to be aware of their existence as things-in-themselves. "For the radical empiricist, the isolated object freshly experienced is the chief source of value."[24]

But could such a singular thing, unrelated to any other thing, be evaluated? Could one be better or worse than another? Meyer's answer was no. Therefore,

we ought not to try to choose. "We ought to remain detached: seeing, hearing, and observing the objective series of empirical events."[25] Art criticism was obsolete. Cage had earlier called for a suspension of aesthetic judgments. His conception of art appreciation was popularized in 1964 by Susan Sontag in an article, "Against Interpretation," which she later used as the title of a book of her essays.[26] But it did not necessarily follow that a thing, even though produced by chance or an arbitrary formula, could not possess quality or be perceived as possessing quality. Both the accidental and the arbitrary could be inspired. Even a chance procedure involved choice, if only because it had to be chosen. And how much did this decision, among others, count for?

The theories of Cage, Meyer, and Sontag notwithstanding, artists of the sixties and their friends, particularly those influenced by Stella, Reinhardt, and Greenberg, and even most of those inspired by Cage and Duchamp—for example, Rauschenberg and Johns—aspired to quality. The judgments that they held in abeyance had to do with matters other than aesthetic quality. In the words of Paul Richard, a Harvard classmate of Henry Geldzahler:

> You never got hung up on any one subject, and there were no fixed positions or ideologies; it was a *field* situation, in which everything interacted with everything else—a whole new area of awareness that was wide open for discovery. . . . There was a constant, shifting movement of thought, without connectives, and you had to move with the flow and not hang on to things. We didn't talk politics—that would have been uncool.

But Richard stressed:

> The basic preoccupation was with aesthetics, but aesthetics without any sort of hierarchy except quality. Baez and Bob Dylan were interesting, and so was Bach. It was a new language. . . . The Beatles [spoke it] in their music, and John Lennon got a lot of it into those books he did: puns, put-ons, W. C.

Fields one-liners, McLuhan-type perceptions—the whole cool style.[27]

Alan Solomon saw the life- and intellectual-style of the sixties in much the same way as Richard: "Much of the spirit of the new art scene [seems] pervasively 'cool.' . . . It is a mode of acceptance, of openness, of suspended judgement, of masked intensity. [The artist] is suspicious of passionate commitment to any values, suspicious of belief in the absolute meaning of anything, and particularly suspicious of kinds of display which hint at these."[28] Such openness led to a widespread receptivity to the new, which could be genuinely avant-garde or, when aesthetic quality was lost sight of, could be mere neophilia.

Not all sixties artists and art writers were as open in their thinking as the ones Richard and Solomon had in mind. A number believed that there was only one valid attitude for the time. Judd, for example, prized a tough-minded empiricism—going by the facts, by concrete sensations, whose source was in William James's Pragmatism. Taking her cues from Judd, Barbara Rose wrote that his "rejection of illusionism is deeply rooted in the pragmatic tenet that truth to facts is an ethical value. For Judd, illusionism is close to immorality, because it falsifies reality. [Things] must be as they appear to be. [Pragmatism] equates truth with the physical facts as experienced."[29] Judd himself remarked: "A shape, a volume, a color, a surface is something itself. It shouldn't be concealed as part of a fairly different whole. The shapes and materials shouldn't be altered by their context."[30]

As Judd saw it, the opposite of Pragmatism was a tender-minded rationalism—going by universal, idealistic principles. In his opinion, rationalistic idealism was European, and pragmatic empiricism was American.[31] Or, if memory holds, as Henry Ward said, Americans go deeply into the surface of things. Literalism had emerged as a central feature in current American art.[32]

Robert Morris also focused on the immediate thingness of sculpture, "the physical nature of sculpture [as] an obdurate, literal mass."[33] Mel Bochner summed up by quoting three philosophers: Husserl, "Go to the things themselves"; Hume, "No object implies the existence of any other"; and A. J. Ayer, "There is nothing more to things than what can be discovered by listing the totality of the descriptions which they satisfy."[34]

That a new sensibility in art had emerged could not be determined by the art-conscious public until connections among the various styles of the sixties had been made. The art world had recognized, certainly by the end of 1962, that the attitudes and styles of a Stella or a Warhol, artists who were commanding attention whether they were liked or not, were significantly different from those of their Abstract Expressionist elders. But the connections between the new abstraction and Pop Art tended to be overlooked. As late as 1963, the first major show of stained color-field and hard-edge painting—*Toward a New Abstraction* at the Jewish Museum—was conceived as an antidote to Pop Art. Until links among diverse new styles were made and what they shared in common was specified, the pervasiveness of the new outlook and its uniqueness— that which made it of its time—could not be understood. Yet critics and curators were reluctant to make such connections, at least until well into the sixties.

I was probably the first to comment in print that certain styles, such as Pop Art and Minimalism, seemed to be uniquely of their time and thus related. In a series of articles published in 1963–64, I tried to specify what these styles shared, and called it "cool."[35] Connecting Stella, Warhol, and Roy Lichtenstein, the Op artist Larry Poons, and Judd, I characterized them as the most extreme of "a growing number of young artists who have rejected the premises of abstract expressionism," its "ardent romanticism," and the "urgency [of its adherents] to give form to their deepest passions and thoughts." "Be-

cause the group they are a part of is the most vociferous and perhaps the most populous in the New York art world today, I have come to believe that its point of view may turn out to mark the 1960s as abstract expressionism did the 1940s and 1950s."

I then remarked on the attributes shared by the cool artists, notably their reliance on preconceived ideas and their preference for impersonal, mechanistic techniques to execute their ideas. The product of this approach was a deadpan art "devoid of signs of emotion." I identified Reinhardt and Johns as the most influential forerunners of cool art because the pictures of both were predetermined and dispassionately crafted, although aesthetically antithetical in other respects.

What struck me most strongly about cool art was what I took to be its nihilistic attitude. As I saw it, Stella had reduced his "aspiration—almost to zero." Poons's "works are like optical machines which produce visual tensions and nothing else." Related to Poons were kinetic artists "who either assault the eye with movements of such velocity as to prevent thinking or feeling, or who are intrigued with motion in art as a meaningless activity." Partaking of the same sensibility were Warhol and Lichtenstein, who confined themselves to copying ads and comic strips without transforming them appreciably. An art so limited in ambition could communicate only a "sense of absolute frustration and despair . . . boredom and indifference." Other cool artists were intent only on solving formal problems. For example, Minimal sculptors "make sculptures that are solely objects—the 'logical' culmination of the idea that a work of art is a thing-in-itself. . . . This last seems to be the intent of Don Judd, whose abstract constructions are sculptural counterparts of Stella's canvases." In comparison with the humanistic strivings of the Abstract Expressionists, cool art seemed to me to deny "that meaningful action, self-realization and transcendence are possible."[36]

I came to this conclusion because, as I recall, I was swayed by Samuel Beckett's prose, which I knew was admired by the cool artists.[37] The master of minimal language and the novelist of entropy, Beckett not only denied that man was at the center of the universe, in control; he claimed that man was nothing and nowhere. "There is nothing to express, nothing with which to express, together with the obligation to express."[38] In *The Unnameable*, he wrote:

> I invented it all, in the hope it would console me, help me to go on, allow me to think of myself as somewhere on a road, moving, between a beginning and an end, gaining ground, losing ground, getting lost, but somehow in the long run making headway. All lies. I have nothing to do, that is to say nothing in particular. I have to speak, whatever that means. Having nothing to say. . . . No one compels me to, there is no one, it's an accident, a fact. Nothing can ever exempt me from it.

The concluding words of the book: "you must go on, I can't go on, I'll go on."[39]

Brian O'Doherty wrote of cool art as "The New Nihilism" in an article that appeared in the *New York Times*. He emphasized even more strongly than I had the anti–Abstract Expressionist aspect of the new art, and went on to say: "The new nihilism is first of all a total abnegation of the self. Brushstroke, the signature of self, is eliminated in favor of a smooth, anonymous finish. It is antispontaneous, its motifs logical, measurable, reproducible." Machine-like anonymity replaces "personality, paramount since the Renaissance. . . . The new nihilism marks the arrival of a new generation, a cool, hip generation that has gone beyond *angst* to indifference," an indifference caused by the threat of the Bomb and "the atrocities of the social machine grinding down individuality and feeling." Whereas the Abstract Expressionists had reacted with anxiety and outrage, the new generation was disengaged and uncommitted—neutral. O'Doherty concluded that in sup-

pressing emotion and annihilating self, the new nihilist became a "mass-produced object producing objects in turn." This loss of identity was welcome and not, as in the past, feared, because the "removal of the self makes possible the remarriage of artist and society in a modern context."[40]

Barbara Rose viewed the new sensibility much as O'Doherty and I did. In an important article of 1965, "ABC Art," she characterized Minimal sculptures and also Warhol's Pop objects as "big, blank, empty things," "vacant or vacuous," impersonal and anonymous, akin "to the world of things." Rose remarked on their chilly "lack of feeling or content," though their "hollow barrenness" nonetheless possessed "a certain poignant, if strangled expressiveness." The "subjective, the tragic," was rejected in favor of the "factual, [the] matter-of-fact." Thus, "part of what the new art is about is a subversion of the existing value structure." Rose also introduced artists in the other arts who partook of the cool sensibility, notably the dancer Yvonne Rainer, who manipulated objects—for example, moved a pile of mattresses, one by one, from one place to another; employed nondance movements and repetition, as in *The Bells,* in which she repeated the same seven movements for eight minutes.[41]

Rose, O'Doherty, and I sensed that a thing-oriented art was related to the culture at large and had its source in the history of Western civilization, but we could not articulate its broader ramifications. Czeslaw Milosz later did. He wrote that man takes "refuge in the world of objects," because "Human affairs are uncertain and unspeakably painful."

> European culture entered a phase where the neat criteria of good and evil, of truth and falsity, disappeared; at the same time, man became a plaything of powerful collective movements expert at reversing values, so that from one day to the next black would become white, a crime a praiseworthy deed, and an obvious lie an obligatory dogma. Moreover, language was appropriated by the people in power who monopolized the mass media and were able to change the meaning of words to suit themselves. [Every] pronouncement on human affairs [is] uncertain. . . . As opposed to the human domain with its shaky foundations . . . objects have the virtue of simply existing—they can be seen, touched, described.

Thus, "a chair or a table [can be] precious simply because it is free of human qualities and, for that reason, deserves envy."[42]

The consummate anti-anthropocentric statement was made by Robert Smithson in a series of articles beginning with "Entropy and the New Monuments," 1966. Indeed, more than any other of his contemporaries, he formulated a full-blown cosmology, fanciful and satiric, playful and unsystematic, though it was. In Smithson's view, human destiny depended on the second law of thermodynamics, which revealed that energy is more easily lost than obtained. Therefore, the universe will eventually be turned into an all-encompassing sameness, a state of entropy.[43] The future would not be the Golden Age that the humanists dreamed of but the Ice Age. Progress was taking place *in reverse.*[44] Like it or not, that was the dismal reality, and Smithson accepted it matter-of-factly—with irony and black humor, to be sure.[45] If entropy was our fate, then that art which provided its "visual analog" and "celebrated" it would be the most valid. In his opinion, such "monuments" to "energy drain" had been made by Malevich and were being made by Judd, Morris, LeWitt, Flavin, and Stella.

As Smithson saw it, entropy was not only the universe's future condition. It was also at hand—in our present environment. For example, the "cold glass boxes" that have come to dominate our cities, though much denigrated, "have helped to foster the entropic mood."

> This kind of architecture without "values or qualities," is, if anything, a fact. From [it] we gain a clear perception of physical reality free from the general claims of "purity and idealism." . . . As the cloying effect of such

[worthless] "values" wears off, one perceives the "facts" of the outer edge, the flat surface, the banal, the empty, the cool, blank after blank; in other words, that infinitesimal condition known as entropy.

The slurbs, urban sprawl, and the infinite number of housing developments of the post-war boom have contributed to the architecture of entropy. Judd, in a review of a show by Roy Lichtenstein, speaks of "a lot of visible things" that are "bland and empty," such as "most modern commercial buildings, new Colonial stores, lobbies, most houses, most clothing, sheet aluminum, and plastic with leather texture, the formica like wood, the cute and modern patterns inside jets and drugstores." [These have] brought to art a new consciousness of the vapid and the dull. But this very vapidity and dullness is what inspires many of the more gifted artists.[46]

Smithson's friend Peter Hutchinson also offered a bleak vision of the world and art. He wrote:

Donald Judd's faceless boxes are frozen in numbing seriality. Sol LeWitt's modular mazes are as immovable as crystals frozen at absolute zero. . . . The works reject emotion and display none. There is nothing human about them or the abstract geometry, topology, algebra and crystal symmetry on which they are constructed. The works are about as inorganic and alien to life as can be imagined.

What is going on here? Why are these artists taking this position? Why have they chosen this time to flout age-long beliefs and question the very importance of life itself? . . .

It is high time, it seems, that some reorganization of thinking take place. The fear of the inorganic is a primitive fear.[47]

The opposite of the entropic was the organic, and Smithson seemed to have a congenital distaste for it, unless it was so profuse as to seem the counterpart of the entropic, hyper-opulent as opposed to hyper-prosaic, as exemplified in the sculpture of Paul Thek. Smithson wrote: "Thek achieves a putrid finesse, not unlike that disclosed in William S. Burroughs' 'Nova Express': '—Flesh juice in festering spines of terminal sewage—Run down of Spain and 42nd St. to the fish city of marble flesh grafts—'. . . . The slippery bubbling ooze from the movie 'The Blob' creeps into one's mind."[48]

The language of art discourse also became anti-anthropocentric. As Smithson said: "The myth of the Renaissance still conditions and infects much criticism with a mushy humanistic content. . . . The 'meanings' derived from the word Renaissance, such as 'truth,' 'beauty' and 'classic' are diseased words and outmoded criteria."[49] Bochner added other debased terms to Smithson's, among them " 'tradition' . . . 'romantic,' 'expressive' . . . 'psychology,' 'analogy,' 'depth' . . . 'feeling' . . . 'lyric,' 'individual' . . . 'sexuality,' 'biomorphic,' 'biographic.' " Bochner concluded that "the entire language of botany in art—can now be regarded as suspect."[50]

This antibotanical or antibiological and, underneath it all, anti-anthropocentric stance was bolstered by the art historian George Kubler's *The Shape of Time: Remarks on the History of Things,* first published in 1962 and issued as a paperback in 1966. Kubler characterized the traditional approach to art history as follows:

We speak without hesitation of the "birth of an art," of the "life of a style," and the "death of a school," of "flowering," "maturity," and "fading" when we describe the powers of an artist. The customary mode of arranging the evidence is biographical, as if the single biographical unit were the true unit of study. The assembled biographies then are grouped regionally (e.g. "Umbrian School") or by style and place ("Roman Baroque"), in a manner vaguely patterned upon biological classifications by typology, morphology, and distribution.

However, as Kubler viewed it:

The biological model was not the most appropriate one for a history of things. Perhaps a system of metaphors drawn from physical science would have clothed the situation of art more adequately than the prevailing biological metaphors: especially if we are dealing in art with the transmission of some kind of energy; with impulses, generating cen-

ters, and relay points; with increments and losses in transit; with resistances and transformers in the circuit. In short, the language of electrodynamics might have suited us better than the language of botany . . . for the study of material culture.[51]

Reinhardt,[52] Morris,[53] and Smithson hailed *The Shape of Time.* Smithson wrote: "Biological science has since the nineteenth century infused in most people's minds an unconscious faith in 'creative evolution.' An intelligible dissatisfaction with this faith is very much in evidence in the work of certain artists."[54]

In keeping with the anti-anthropocentrism of the art of the sixties, art critics turned from interpretation to description. Rather than treating art as the expression of the artist specifically and of humankind generally, they were factual, delineating an art object in detail, recording what they saw and could verify by pointing at it. For example, Bochner remarked: "When Robert Smithson writes about his piece *The Cryosphere* for [a] catalogue, he lists the number of elements, their modular sequence and the chemical composition of his spray-can paint. He strips away the romance about making a work of art. 'Artmystics' find this particularly offensive."[55]

Many sixties artists and art writers believed that instead of expressing the artist's *experience* (ontology), the new art was intent on revealing and renewing its visual *language* (epistemology), and this meant equating the language of art with its objecthood.[56] It follows that Expressionism was a dead language. Terms such as "ontological" and "epistemological" were used frequently by college-bred artists in the art discourse of the sixties, and they were fortified with quotes from Wittgenstein and Maurice Merleau-Ponty. Roland Barthes, another intellectual much admired in the sixties, called attention away from the creator to the "language." In "The Death of the Author," he attacked "the image of literature to be found in contemporary culture [because it] is tyrannically centered on the author, his

person, his history, his tastes, his passions. [The] *explanation* of the work is always sought in the man who has produced it, as if, through the more or less transparent allegory of fiction, it was always finally the voice of one and the same person, the *author,* which delivered his 'confidence.'" Barthes claimed that it is language alone that speaks, not the author. Thus criticism's function was no longer to *decipher* "the Author (or his hypostases: society, history, the psyche, freedom) beneath the work" but to *distinguish.* Since there is no underlying *ground,* "the space of writing is to be traversed, not penetrated."[57] The focus was on the surface of literature, not any alleged deeper meanings.

If claims for the expression of the artists' psyche, sentiments, emotions, moods, etc., were denied, what *was* required of an art work? As Judd saw it, only to be "interesting."[58] In fact, "interesting" replaced "expressive" as a criterion for value. "Interesting" was not just a neutral term. Warhol, in his inimitable way, epitomized what it signified to him and presumably to many of his contemporaries. "During the 60s, I think, people forgot what emotions were supposed to be. . . . I never thought in terms of 'love' again. However, I became what you might call *fascinated* by certain people."[59] To be "interesting," art had to be novel, above all, and/or, in the words of a sixties catchphrase, "where it's at."

Perhaps the best summation of the sensibility of the sixties was a series of statements by artists that Barbara Rose and I compiled and published in *Art in America* in 1967.[60] In the same year, Brian O'Doherty tried to put all the culture he then considered relevant in a box, much as Duchamp had with his lifework. Published as *Aspen 5+6,* the box included essays, fiction, recorded music and statements, interviews, documents, poetry; works of art by Tony Smith, Sol LeWitt, Mel Bochner, and O'Doherty himself; and films by Hans Richter (1921), László Moholy-Nagy

(1932), Robert Morris and Stan Van Der Beek (1964), and Robert Rauschenberg (1967). O'Doherty's focus was on Dadaism and Constructivism. Among the more significant entries were essays by Barthes ("The Death of the Author"), Kubler ("Style and Representation of Historical Time"), and Douglas MacAgy ("The Russian Desert: A Note on Our State of Knowledge"). There were also recordings of Marcel Duchamp reading his "The Creative Act"; Samuel Beckett's "Text for Nothing #8," read by Jack McGowan; excerpts from *Nova Express* by William Burroughs, read by the author; and an excerpt from *Jealousy* by Alain Robbe-Grillet, read by the author. Also included were recordings of "The Realistic Manifesto" (1920) by Naum Gabo and Antoine Pevsner, read by Gabo; and the scores of "Fontana Mix-Feed, Nov. 6, 1967" by John Cage, and "The King of Denmark" by Morton Feldman, both realized by Max Neuhaus; an interview with Merce Cunningham and his recording of "Space, Time and Dance" (1952); and poetry by Michel Butor and Dan Graham. O'Doherty dedicated *Aspen 5+6* to Stéphane Mallarmé. His intention, as he wrote (under the pseudonym Sigmund Bode), was "to construe a situation in which persons, things, abstractions, become simply nouns and are thus potentially objectified."[61]

Because it was never fully formulated and clearly articulated, anti-anthropocentrism was not perceived as an ideology in the sixties. Rather, it was an attitude, assumed by the public for the new art without too much theorizing. Its suppositions tended to be hidden. They were revealed now and then in remarks that indicated a powerful predilection for literalness and thingness—such as Stella's "My painting really is an object" and "What you see is what you see"—and assimilated and quoted (and requoted) in art conversation and writing. But such remarks were rarely considered in a broader cultural or social context. Anti-anthropocentric ideas seemed to speak to the sensibility rather than to the intellect. It was the widespread preference of sixties artists for particular materials, notably of industrial origin; machine-shop fabrication; and formal elements, such as single cubic forms and modular or serial grids, that pointed to an underlying attitude. Before being perceived as anti-anthropocentric, these materials, techniques, and forms were perceived as *new*—they had been employed infrequently prior to the sixties—and they were valued because they were new.

Sixties sculptors (unlike junk sculptors of the fifties) were attracted to brand-new industrial materials, such as neon, Plexiglas, polyester, and other synthetics, because they avoided the conventional look of existing art. Certainly Judd's galvanized iron and aluminum, and his palette of Harley Davidson Hi-Fi Red and 1958 Chevrolet Regal Turquoise, looked untraditional.[62] Equally unorthodox was the practice of Judd and likeminded artists of having their work manufactured in factories. Sixties sculptors preferred depersonalized machine work to personalized handwork. So did Pop and Minimal painters, such as Stella, who had said in 1960 that he would welcome mechanical means to translate his ideas into painting.[63] Warhol, who employed a mechanical silk-screen technique to reproduce photographs, which in themselves were produced by mechanical means, said that he wanted to be a machine.[64]

Andre and Flavin eliminated artistic making entirely by arranging storebought artifacts. Mel Bochner reported: "Andre's *Lever* is a 360-inch row of firebricks laid side to side on the floor. He ordered them and placed them. He demythologizes the artist's function."[65] Barbara Rose concluded that a "mechanical, reproducible, not hand-made look," whether in Pop or the new abstract art, is "more objectionable than the unpleasant imagery. . . . And, if art can be mass-pro-

duced or made by anyone . . . then the artist as an individual no longer counts. . . . This finally is too much for the humanists to swallow."[66]

With regard to Minimal sculpture, Lucy Lippard liked machine-turned appearances. They revealed "an admirable disassociation from sentimentality, from the pretty, the petty, the decadent 'sensitivity' and 'good taste' of much American and European academic abstraction. Rather than the fine art past, [Minimal sculptors] have chosen the industrial future as their point of reference."[67] Robert Morris agreed; he went so far as to relate the new factory-made art "to manufactured objects [from mud bricks to materials that get segmented, stacked, and shipped] and not to previous [studio] art. . . . The [basic] ideas of industrial production . . . are repetition and division of labor: standardization and specialization."[68] It was widely believed that the "adaption of industrial-commercial techniques and materials" exemplified the sensibility of the sixties, as Robert Mangold observed. Roy Lichtenstein called attention to the "apparent impersonality [of] factory surfaces." Allan Kaprow also commented on the exclusion of "hand-work and individualized personality." Jack Tworkov spoke of the prevalence of "polish, smoothness, brightness." Leon Golub summed it up: "Art today is clean, sometimes diamond perfect. [It] is made not so much by aberrant individuals as by remarkable artist-technicians."[69]

Sixties artists favored the rectangular plane or volume and the "right angle grid as [the most logical] method of distribution and placement."[70] Thus they continued a tradition of geometric art, but

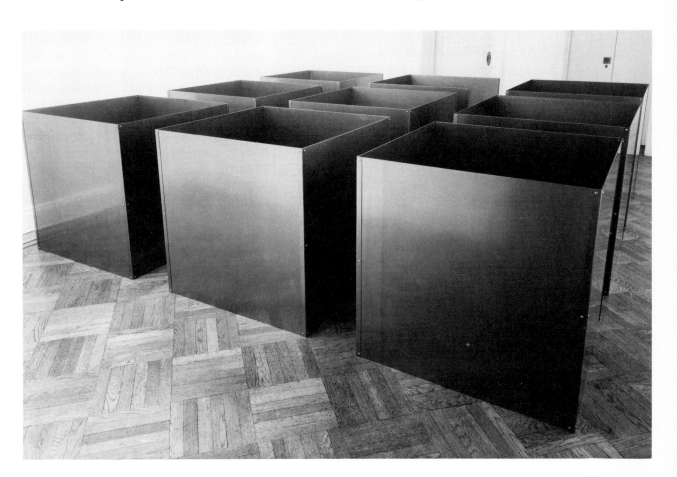

41. Robert Morris, *Untitled*, 1967. Each unit 36″ × 36″ × 36″. Panza Collection.

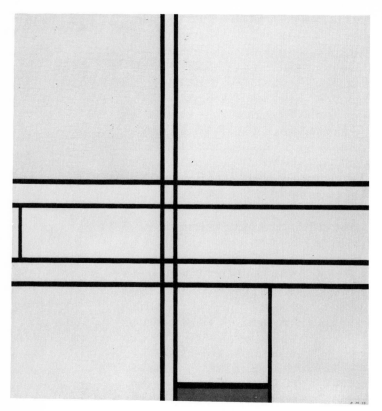

42. Piet Mondrian, *Composition with Blue and Yellow*, 1935. 28¾" × 27¼". Hirshhorn Museum and Sculpture Garden, Smithsonian Institution, Washington, D.C.

they differed from most of their predecessors who composed with separable, disparate elements in the Synthetic Cubist manner of a Picasso or a Mondrian. In contrast, sixties artists used modular grids (and also somewhat more complex serial grids, which strongly call to mind modularity), which cause a work to cohere into a single entity. Sixties artists called this formal paradigm *nonrelational arrangement,* as opposed to Cubist-inspired *relational structure,* and the distinction was crucial, since the latter was dismissed as outworn and retrograde. No wonder that the modular grid should be central in sculpture by Carl Andre and Sol LeWitt, and in painting, both abstract—e.g., by Larry Poons—and figurative—e.g., by Andy Warhol (soup can patterns), and by Malcolm Morley and Chuck Close (checkerboard renderings of photographs). Single minimal objects, such as Robert Morris's sculptures, were also nonrela-

tional—in contrast to welded construction, whose origin was in Cubist collage—and were perceived as radical.

Painters, especially, preferred grids, because they delineate surfaces, asserting the physical flatness of the picture plane. In fact, of all possible configurations, modular grids are the flattest and most strongly emphasize the picture as an object. They are also looked *at* rather than *through* to some subject or illusionistic space beyond them. Thus they deny the deep or psychic meanings that anthropocentrists attached to illusionistic depth. Grids, moreover, whether in painting or in sculpture, seem unrelated to living organisms.[71] As Morris observed, the rectangular unit and, by extension, the grid it constitutes are "the most inert and least organic" of artistic elements.[72] In contrast, orthogonal, relational structures can suggest human figures and gestures, as Judd asserted; for example, two lines crossed to make a T, as in a structure by Mondrian, call to mind a torso with extended arms and what that might signify.[73] There is more tension in a T-formation than in a homogeneous checkerboard. Morris considered surfaces under tension as anthropomorphic because "they are under the stresses of work much as the body is in standing." Minimal objects, which possess no extended or moving parts, are also lacking in tension. "Objects which do not project tensions state most clearly their separateness from the human. They are more clearly objects,"[74] inanimate and static.

Minimal objects and grids look impersonal. They do not usually depend on human touch (although a number, such as Agnes Martin's abstractions, do) but appear to be reduplicable, as if by mechanical means. Moreover, their form is monotonous. LeWitt remarked: "The best that can be said for either the square or the cube is that they are relatively uninteresting in themselves. [They] lack the expressive force of other more interesting forms. [It] is immediately evident that a square is a square and a cube, a cube."[75]

Thus Minimal objects and grids can be thought to exemplify the aesthetics of boredom and as such to deny humanist expectations in art. More than that, the static, repetitive, undifferentiated, uniform, and infinitely extendible modular arrangements can evoke a state of entropy, of which Smithson spoke.

Amy Goldin remarked: "Grids generate . . . a sense of the presence of objective, pervasive laws" or a "grammar."[76] They seem concerned not with human experience expressed *through* the language of art (an ontological concern) but instead *with* the language of art (an epistemological concern). It is noteworthy that LeWitt used the word "grammar" to mean system[77] and that Morris spoke of the cube and right-angle grid as "a kind of 'morpheme' and syntax."[78] The modular grid in particular calls attention to its grammar. Because it looks like a graph, it seems to want to be the container of and vehicle for information, presumably about "life" or reality; yet such expected information is absent, and the grid in sixties art provides information only about its own order and its function in a work of art. Bochner

was interested in this distinction; he quoted James J. Gilson's *The Senses Considered as Perceptual Systems*: "A wholly invented structure need not specify anything. This would be the case of structure as such. It contains information, but not information about, and it affords perception, but not perception of."[79]

Systemic modular and serial grids do not have the potential for growth or development, as anything living does. They do not *evolve* from some past situation to some future goal. Instead, they *unfold* in a predictable and repetitive manner. Systemic art avoids the intuitive trial-and-error *process* of relating elements whose final form is not known (the process of Mondrian). It focuses attention on the predetermined, conceptual *program* or system that generates it. To be sure, the *choice* of an idea or system was subjective or intuitive, as LeWitt said.[80] But once the choice was made, it was dealt with objectively. It dictated the execution of the work and its end product. Systemic art "precludes breaking the system"; it permitted only the combination of elements belonging to that system.[81] Thus it offered a strategy for

43. Carl Andre, *Lead-Copper Plain*, 1969. 72″ × 72″. Albright-Knox Art Gallery, Buffalo, N.Y.

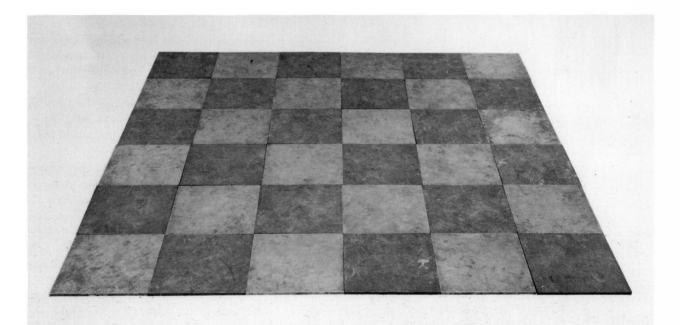

44. Chuck Close, study for *Self-Portrait*, 1968. 14″ × 11″. Museum of Modern Art, New York.

subjected himself to 'objective' rule-governed methods, he could not in principle be prey to subjective memory, to the temptation to reproduce the familiar [presumably anthropocentric] patterns of earlier music."[84]

LeWitt summed up systemic art:

The aim of the artist would be to give [viewers] information. . . . He would follow his predetermined premise to its conclusion avoiding subjectivity. Chance, taste, or unconsciously remembered forms would play no part in the outcome. The serial artist does not attempt to produce a beautiful or mysterious object but functions merely as a clerk cataloging the results of his premise.[85]

The result would be a new kind of art.

American systemic artists on the whole, namely the Minimalists, were not interested in the mathematical, scientific, or philosophical implications of the formulas they used. In this sense, their use of serialism or set theory was "purposeless," as LeWitt wrote,[86] except as a pretext for making art-as-art. The Americans differed from systemic artists generally known as "Constructivist," who with a few exceptions were European. The latter continued the Russian Constructivist and Suprematist and De Stijl and Bauhaus tradition of geometric abstraction, which was idealistic, visionary, utopian, or spiritual. The Constructivists believed that mathematics and science were repositories of universal truths, and that their work was *about* such truths, disclosing the underlying laws, rational structures, and operations of nature, including human nature.

At the least, Constructivism was thought to glorify reason as the highest state of human consciousness and aspiration. American Minimalists rejected the rationalism and scientism of European Constructivism. They invented systems that were arbitrary, often perverse, ruining the logic of a piece, as LeWitt remarked.[87]

Given the focus of sixties artists on modular and serial grids, it is not surprising that the sixties was "the great graph paper

creating design without the process of composing, releasing the artist from the burden of artistic making, from—as Stella said—the kind of personal, generally anxious decision-making favored by the Abstract Expressionists.[82]

The same applies to serial music based on arithmetic, much admired by LeWitt and Bochner. In an article titled "The Serial Attitude," Bochner remarked: "The composer is freed from individual note-to-note decisions which are self-generating within the system he devises."[83] Programs that minimized the process of personal choice abolished the artist's knowledge of the past. Christopher Butler wrote of the systemic composer that "in so far as he

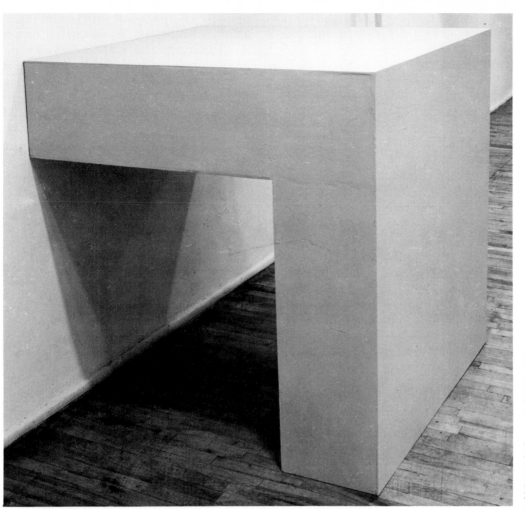

45. Robert Morris, *Untitled*, 1964. 48″ × 48″ × 48″. Installation photo, Green Gallery, New York, 1964.

46. Sol LeWitt, *Serial Project No. 1 (ABCD)*, 1966. 20″ × 163″ × 163″. Museum of Modern Art, New York.

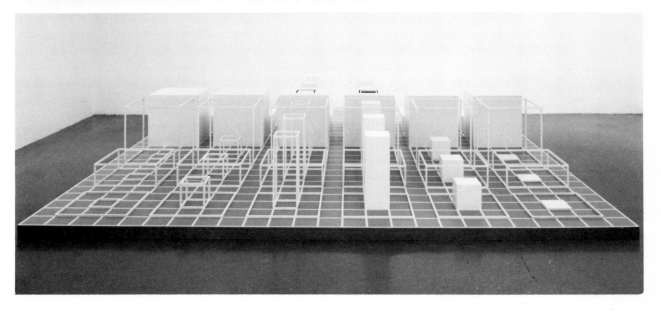

period," as John Elderfield quipped.[88] The grid was indeed the stylistic emblem of the decade.

The sensibility of the sixties can be defined further by reviewing the writings of those figures in intellectual and cultural fields that most interested young artists— Alain Robbe-Grillet, Ludwig Wittgenstein, Marshall McLuhan, and Buckminster Fuller. Robbe-Grillet was the most persuasive spokesman for the new sensibility. Indeed, his "new novel" was characterized as "literature of the object" and "literal literature." In 1964, I drew parallels between him and American Pop and Minimal artists, although he quite likely had little if any direct influence on them:[89] "Convinced that all emotional and intellectual comments that novelists might make about human experience have been exhausted, Robbe-Grillet describes only the surface of the world around him, impervious to any system of meaning."[90]

Robbe-Grillet rejected the notion that all things in the world are signifiers of man. In actuality, he remarked, nothing is, but to say so is considered by humanists a crime against humanity. In the past, novelists had always interpreted the phenomena they observed, using adjectives, metaphors, analogies, and the like to humanize and personalize things, to suffuse them in an anthropocentric mist of deeper meanings and associations. Objects denoted human emotions, moods, states of soul. Mountains were "majestic"; the sun was "pitiless," etc. Robbe-Grillet claimed that such signifiers were "reiterated too insistently, too coherently, not to be regarded as clues to a whole metaphysical system." This system was no longer interesting; it was never true.[91]

Objects, in Robbe-Grillet's view, evoke nothing but themselves; therefore, they have no frame of reference, significant or absurd, no history or future. They have nothing to say to man, and yet they are there, requiring the attention of artists. Accordingly, the mission of art is to restore reality by "measuring, locating, limiting, defining" it. Indeed, Robbe-Grillet urged artists to coolly and dispassionately represent the appearance of the world with immediacy so as to avoid habitual frames of reference that prevented it from being seen as itself only. Thus art would "free us of our blindness." Such realism would seem "slightly 'unaccustomed' [and would reveal] the unaccustomed character of the world that surrounds us," unaccustomed because "it refuses to conform to our habits of apprehension and to our demands."[92] When Robbe-Grillet did see Lichtenstein's Pop Art, he remarked in 1968 that he felt "very close" to it. He reported:

> In an interview that Lichtenstein gave a French weekly [he was asked]: how were you led to inscribe comic book images in your paintings? He replied: well, struck by the lie that existed in the search for a depth of sentiment in lyric abstraction [Abstract Expressionism], I thought it necessary to restore a certain flatness. . . . He said: I have the feeling that these flat images conform far more . . . to what really goes on in our heads, than those false depths they are still trying to introduce into painting.[93]

Robbe-Grillet understood that everyone had his or her version of reality and personal way of expressing it. Interpretation was unavoidable. Even so, he concluded: "Let it be first of all by their *presence* that objects and gestures impose themselves," and let this presence continue to prevail over what else an artist may convey.[94] But what of the work of art as a *thing* in the world? What of writing itself and paintings and sculptures? Were they merely to be looked through at other things in the world? Robbe-Grillet dealt with this by claiming that the novel creates reality. "Fiction writing, unlike reportage, eye-witness accounts or scientific descriptions, isn't trying to give information—it constitutes reality."[95] This led him to claim a marked concern for the form of the writing.

Still, the relationship between a real art object and the real object it represents,

each of which is presumably self-sufficient, possessing no signification external to itself, raises difficult questions, much debated in the sixties. Are art objects like any other objects? What is the relation of objects represented in an art object to the art object? Are they different, and how? If the art object creates reality, is its reality more "meaningful" than the reality it represents? Are the art objects themselves more "meaningful" than that which they depict? Are art objects less alienated from the artist than other objects because they are created by the artist? Does the artist, and by extension man, have a special relationship to them? If an art object is an object in itself, what are its qualities, its formal requirements, etc., and how are they determined? How do they conform with the aim of representing things in the world? Is the representational in conflict with the formal? Sixties artists did not come to any consensus about such theoretical issues. They tended to treat the art object as a real object, literally, and as nothing else—as in Minimal Art—or as a real object that depicted another real object, having it, or trying to have it, both ways—as in Pop Art, the New Perceptual Realism, and Photo-Realism.

Donald Judd summed up Robbe-Grillet's central thesis without intending to. About Robert Morris's sculptures, he wrote that they "exist after all, as meager as they are. Things that exist exist, and everything is on their side. They're here, which is pretty puzzling. . . . Everything is equal, just existing, and the values and interests they have are only adventitious." Judd went on to say: "Morris' objects seem to express this flat, unevaluating view. Western art has always asserted very hierarchical values. Morris' work [seems] to deny this kind of assertion. [It] implies that everything exists in the same way through existing in the most minimal way."[96]

Judd's own art criticism relied on description more than that of any of his contemporaries. This approach was advocated by Susan Sontag in "Against Inter-

pretation" in 1964. Mixing ideas culled from Robbe-Grillet and John Cage, Sontag maintained that interpretation of content in contemporary art was inimical to art because it destroyed its immediate sensual appeal. To look for deeper meanings in art, particularly moral ones, was disreputable, and the proper function of criticism was to analyze form and to describe the appearance of works of art.[97]

Because of the artists' growing concern with factuality in the middle and late sixties, references to Wittgenstein became common in art criticism.[98] Wittgenstein was of no interest to the Abstract Expressionists; Sartre and Camus were. Their existentialism was based on individual experience, on what philosophy could reveal about life as it is lived. It was, in a word, ontological. Existentialism was predicated on the idea that human existence is absurd because it ends in death. Its adherents focused on "alienation and estrangement; a sense of the basic fragility and contingency of human life; the impotence of reason confronted with the depths of existence; the threat of Nothingness, and the solitary and unsheltered condition of the individual before this threat."[99] This approach seems antihumanist, except that the existentialists also believed that in the face of death, life has an absolute value. Moreover, man was free to make himself; he was responsible for his own choices, morally responsible. Indeed, he determined his own existence and was thus something of a hero, though in the end an absurd one. It followed that existentially minded artists in art as well as in life avoided subjecting themselves to fixed and habitual patterns, standards, or ideas. To partake authentically in the human adventure, they said, one should live in a mood of expectancy, remain open to change, grow. To do otherwise would be to turn oneself—and by extension one's art—into a finite *thing*. And making a thing-like thing was anathema to the Abstract Expressionists. For the artists of the sixties, it was the goal of art.

In contrast to existentialism, Wittgenstein's thinking was positivist, focused on linguistic analysis, on what could be said about anything, on epistemological issues distanced from the analysis of life. For Sartre, metaphysics was "a living effort to embrace from the inside the whole of the human condition," as Anthony Manser remarked. "Though Wittgenstein regarded these issues as vitally important, he . . . also believed that they could not be discussed."[100] As positivists saw it, to be meaningful a concept had to be verifiable. They refused to speculate about unverifiable propositions that dealt with spiritual and moral issues. Wittgenstein summed it up in the last sentence of *Tractatus Logico-philosophicus:* "Whereof one cannot speak, thereof one must be silent." F. P. Ramsay added: "What we can't say we can't say, and we can't whistle it either." And A. J. Ayer added to that: "A great deal of bad philosophy comes from people thinking that they can whistle what they cannot say."[101]

In short, Wittgenstein, like Robbe-Grillet, rejected explanations. " 'People who are constantly asking "why" are like tourists who stand in front of a building reading Baedeker and are so busy reading the history of its construction that they are prevented from seeing the building.' 'The tendency to explain instead of merely describing' gives only bad philosophy."[102] Wittgenstein concluded that description ought to replace explanation.

Just as Wittgenstein focused his attention on language, so painters and sculptors focused on the form or structure of a work of art—what one looks *at*—as the sole vehicle of meaning. It was not clear that linguistics had a visual counterpart, but artists tried to approach art as if it did. Perhaps the primary appeal of Wittgenstein to sixties artists was his desire to avoid confusion. Like him, they were disposed to clarify. This accounts for their empiricism, their description of things, representing them as signs of themselves, and their use of simple unitary objects and modular grids. The urge was for specificity. Barbara Rose even suggested that the Minimal constructions of Judd and Morris often look like illustrations of Wittgenstein's philosophical propositions. They employed simple, geometric forms to evoke a sense

of presence or concrete thereness, which in turn often seems no more than a literal and emphatic assertion of their existence. There is no wish to transcend the physical for either the metaphysical or the metaphoric. The thing, thus, is presumably not supposed to "mean" other than what it is; that is . . . to be suggestive of anything other than itself.[103]

Formalist criticism drew philosophic sustenance from Wittgenstein's positivism. Michael Fried claimed Wittgenstein as well as Clement Greenberg as his mentor. Both Fried and Greenberg believed that extra-aesthetic issues could not be discussed fruitfully. Only the work of art as a self-contained object could be the proper subject of criticism. Greenberg also made claims for the empiricism of his art criticism, insisting that he was describing only what was.

There was a close relationship between positivism and structuralism, which also interested sixties artists and art professionals. Peter Brook wrote of "the cool sensibility of structuralism," which he contrasted with the "committed writing" of existentialism. "The conception of man as a creature of his language, as the user of sign-systems that define his place in the world—which characterizes the work of Claude Lévi-Strauss, Michel Foucault and Roland Barthes—rejects humanism."[104] Barthes's *Critical Essays,* 1964, in particular, seem to deny meaning; literature (as well as life) was to be studied as a pure formal system, not for its content but for its linguistic structure.[105]

Marshall McLuhan was the most talked about intellectual in the art world of the sixties. He even became a cult figure, particularly to Pop artists and to those in the circle of his friend John Cage who were

attempting to introduce new technologies into art. McLuhan took the limelight soon after his book *Understanding Media* was published in 1964.[106] The following year, Tom Wolfe reported: "He is a word-of-mouth celebrity. . . . The paperback edition of his book . . . has been an 'underground bestseller'—that is, a bestseller without benefit of publicity—for six months."[107]

McLuhan proclaimed that a revolution in communications was in progress. This was being brought about by the decline of old technologies and the emergence of new ones. The old technologies that had prevailed for the five centuries since Gutenberg's invention of movable type were typographical—linear. All linearism, said McLuhan, was obsolete. (Cage also believed this.) Tom Wolfe summarized (and popularized) McLuhan's theories in 1965:

> The new technologies of the electronic age, notably television, radio, the telephone and computers, make up a new environment. A new environment; they are not merely *added* to some basic human environment. . . . They radically alter the entire way people use their five senses, the way they react to things, and therefore, their entire lives and the entire society. It doesn't matter what the content of a medium like T.V. is. . . . The most profound effect of television—its real "message" in McLuhan's terms—is the way it alters man's sensory patterns. *The medium is the message*—that is the best-known McLuhanism. . . . A whole generation in America has grown up in a T.V. environment . . . millions of people, 25 and under.[108]

McLuhan's theories were used to justify the *new* art of the *new* generation, which had focused its attention on the properties of the various media.

McLuhan believed that television was a "cool" as opposed to "hot" medium. A "hot" medium provides a great deal of information to viewers, so that they need not participate; they remain passive observers. In a "cool" medium, such as television, imagery is poorly defined, low in information (compared to film, for exam-

ple); it has to be filled in by the viewers; their response must be active, or "hot." Like television, sixties art was "cool"; there was talk, as I recall, that this was because the generation of artists who created it had been reared on television. Thus McLuhan was thought to account, at least in part, for the change of sensibility that occurred in the sixties.

The notion of "hot" and "cool" media is problematic. So is McLuhan's basic idea that the medium is the message, or so it seems today, but in the sixties, both conceptions were plausible. Even Harold Rosenberg, the crusty champion of Abstract Expressionism, was impressed with McLuhan's central thesis.

> What takes place at any moment in the rectangle of the comic strip or on the screen of the TV set may not be worth serious reflection. But as you look, or look and listen, in the particular way demanded by the comic strip or the television image, something is slowly happening to one or more of your senses, and through that to your whole pattern of perception—never mind what gets into your mind.[109]

The seriousness with which McLuhan took the mass media and the claims he made for them were very attractive to Pop artists. He made their enterprise respectable. For example, he told a *Newsweek* reporter: "The whole culture of North America has gone . . . iconic. . . . The words in the balloons [of comics] aren't just words; they're icons. Comics come at you all at once—wham!" *Newsweek* also reported that McLuhan was to appear on a panel at the University of Pennsylvania's Annenberg School of Communications to discuss the topic "From Gutenberg to Batman."[110] Certainly McLuhan contributed to the new receptivity to the mass media, to the willingness to accept both "high" and "low" culture and even to see them as a kind of continuum or in mutual feedback rather than as a conflict of "high art" versus "kitsch." McLuhan also made the success of Pop artists respectable. He was, after all, an academic who was lionized

not only by the art world but also by the business and media worlds, called upon by the executives of corporations such as General Electric, IBM, and Bell Telephone to lecture and to advise. And McLuhan cultivated his celebrity image, cleverly using the media—appearing on television whenever he was given the opportunity and giving interviews to the mass magazines—and lecturing frequently on the college circuit.

McLuhan regarded Buckminster Fuller, his friend and Cage's, as "the brightest man alive,"[111] "a modern Leonardo, a high priest-philosopher of the machine-age."[112] Fuller achieved public recognition with the publication in 1963 of *Ideas and Integrities: A Spontaneous Autobiographical Disclosure,* his first book in twenty-five years, and a book of poems, *No More Secondhand God.* In 1960 there had already appeared the first survey of Fuller's career—the development of his houses, geodesic domes, car, mathematics—by Robert W. Marks.[113] Fuller became a cult figure in the art world of the sixties, artists by the hundreds turning out to hear his four-to-eight-hour lectures. So popular had he become that in the single year of 1967 (at the age of seventy-two), he had some ninety speaking engagements.[114]

As early as 1927, Fuller had "elected . . . to change the whole world. He decided to synthesize all the marvelous discoveries of technology in all fields and apply them to human needs."[115] He believed that there was plenty of everything for everybody on earth, but that it was not being properly distributed. To illustrate and remedy this, Fuller devised a World Game that "was to be man's next hope: the computerized interplay of world resources, world strategies."[116] Computers would show the way. The world would follow.

Like McLuhan and Fuller, Cage believed that a total revolution was occurring. The true function of art would now be to teach people to pay attention to their lives, and to reveal to them the immensi-

ties of the technological changes affecting their lives so that they could be "free to enter into the miraculous new field of human awareness that is opening up."[117] Technology was to Cage and Fuller and the new media were to McLuhan inexorable and impersonal forces that determine man's being and future. Man's irrationality, appetites, prejudices, psychic hang-ups, and the like were of no account in the face of evolution, of historical necessity. Indeed, Fuller insisted on " 'leaving out the human equation.' To him psychology is a guessing game . . . just not worth attending to." His aim "is to *reform the environment and not the man.*"[118] The brave *new* world—a utopia that was qualitatively different from any former world—was imminent and nothing could stop it.

Critics of Fuller and McLuhan pointed out that their optimistic visions of human and social developments were too sweeping to be acted upon. For example, Fuller believed that a single power grid shared by Alaska and Siberia made good economic sense and therefore was destined to come into being. But were there not serious moral as well as political reservations? And would the leaders of America and Russia permit it? Fuller's response was to proclaim that politicians were the enemy. They divide people, getting in the way of uniting and sharing technology. His slogan was: "Evolution, technology—not politics."[119] Cage summed it up in the title of the essay he contributed to the Marshall McLuhan issue of *Aspen* in 1967: "Diary: How to Improve the World (You Will Only Make Matters Worse)."[120] Marcel Duchamp agreed; politics was "a stupid activity, which leads to nothing."[121]

Moralistic assessments, too, were futile. When McLuhan was attacked for refusing to deal with the ethical implications of the mass media—that is, with their debasement of high culture—he brushed aside such criticism as irrelevant. As he saw it, his role was to provide the facts dispassionately and impersonally, not to evaluate or judge. And he attacked the moralizers:

"The mere moralistic expression of approval or disapproval, preference or detestation, is currently being used in our world as a substitute for observation and a substitute for study. People hope that if they scream loudly enough about 'values' then others will mistake them for serious, sensitive souls who have higher and nobler perceptions than ordinary people."[122]

Tom Wolfe thought that antimoralism was central to the sensibility of the sixties.[123] He identified the moralizers as the literary intellectuals, or "literati." They were the enemies of empiricism.[124] Wolfe had a point. Morris Dickstein, in his cultural, primarily literary, history of the decade, asserted that "the most striking quality of the cultural life of the sixties was the combination of political militancy and cultural bohemianism."[125] In the art world, however, cultural bohemianism was prevalent in the fifties and political militancy only in the late sixties. It is noteworthy that there was no American literary counterpart to the French "new novel." Dickstein singled out "[Herbert] Marcuse, [Paul] Goodman and [Norman O.] Brown as the theorists whose work had the greatest impact on the new culture of the sixties,"[126] and they were read by artists. He mentioned McLuhan only in passing, and Greenberg, Fuller, Wittgenstein, and Cage not at all.

Sixties visual artists were temperamentally on the side of Cage, McLuhan, and Fuller. Like them, they embraced an impersonal, cool empiricism, free from values, whether political or moralistic. Thus it would seem that the art world had a perception of the sensibility of the sixties different from that of the American literary world. In fact, for most of the decade, the art world and the literary world were out of phase, at least until the war in Vietnam heated up, and then politics became as important to artists as to writers.

The question arises: Did the change in aesthetic sensibility reflect or perhaps anticipate social transformations? Certainly the motivations of sixties artists were primarily aesthetic; painters and sculptors responded first to art and its recent history. But the general change in style can be related to social, political, and economic changes as well. It is intellectually perilous to draw correlations between art and society. There is no necessary connection, except of course for styles that aim to make direct social statements. And when correlations between art and society are made, they are frequently vulgar and philistine, particularly those which focus so exclusively on the context of art that they lose track of the art. Nevertheless, generalizations about the relations between art and society must be risked. To limit the analysis of a change in sensibility as profound as that which occurred in the late fifties and early sixties to aesthetic issues is to trivialize its meaning.

What had changed in American life during the dozen years after World War II? Above all, there had occurred a revolution in the nature of production and communications.[127] In the decade after 1947, the number of television sets in American homes jumped from ten thousand to forty million.[128] Americans as never before were bombarded with events throughout the world, as they happened, with unprecedented vividness and immediacy. At the touch of a button, viewers were witness to wars, natural catastrophes, assassinations and other political happenings, the intimate details of life in a Bronx ghetto or at a go-go party. And there were soap operas, sitcoms, crime series, giveaway programs, movies, etc. It became difficult to avoid, even if one wanted to, mass culture and the perpetual commercials—all in one media package. Television and through it mass culture exerted novel pressures on the American consciousness. It is no wonder that Pop Art should have emerged in 1962.

Like the mass media, computer technology transformed American life. The new technology was feared by many, particularly anthropocentrists, since it emulated many human functions—even thinking—

so as to seem to expropriate and thus call into question the very humanity of humankind. Moreover, science appeared to be hostile to the existence of art. As Elizabeth Hardwick wrote: "Technology threatens to dry up the sources of feeling." But she also granted that the fruits of technology have "an austere, beckoning beauty. The humanist is dead." But "a technological society might have a technological art . . . even if some of us might regret the losses adaptation would bring." Perhaps this was unavoidable, since "What we can no longer do with confidence we discard; it becomes out of date, academic or commercial."[129] Other commentators welcomed the new technological society as the inspiration for art: the new art could convey the feeling of what it was to be alive in the new age.

The changed society provided new role models for artists. Prior to World War II, the central figures in the American economy were blue-collar laborers directly engaged in machine production (hardware) and the executives who managed them. After the war, the economy, increasingly based on computer programming (software), was managed by white-collar technicians in large bureaucracies. Their primary activity was mental—distanced from actual production, which was increasingly automated. As Robert Morris remarked: "An advanced, technological, urban environment is a totally manufactured one. Interaction with the environment tends more and more toward information processing in one form or another and away from interactions involving transformations of matter."[130]

Sixties artists resembled the new workers in that they conceived of creation more as a conceptual enterprise than as a physical exercise of artistic making. There was a change from an art-making that was as manual as it was mental—that is, which involved manipulating tools with mind, eye, and hand—to an art-making that was primarily mental, based on ideas. Alan Solomon claimed that the change reflected "the artist's altered view of himself [from a self-image] as a heroic figure whose manual skill and whose performance are unique and unparalleled, to an idea of himself as a man with a special vision . . . for whom the execution of the object is less important."[131]

There were both gains and losses in this shift: for example, the loss of a particular intelligence exercised in the physical process of forming—a kind of visual thinking that transmuted ideas by involving more of the artist than the mind alone—a loss compensated for, perhaps, by the freedom of the mind to range where it will. It is no wonder that toward the end of the decade there should have emerged an exclusively conceptual art. It is also not surprising that in its form much of sixties art was based on modular and serial systems that resembled computer printout.

After World War II, there had occurred an enormous expansion of the economy. The gross national product doubled from 1955 to 1965. And the potential for future growth seemed limitless. Americans in large numbers became affluent, not only in the upper and middle classes but also in the lower classes and minorities. The new prosperity—and government subsidies—enabled unprecedented numbers of young people to attend universities and colleges, where in most cases they were required or encouraged to take courses in art appreciation, art history, or studio disciplines. After graduation, many continued to be interested in art, a considerable number in avant-garde art. By the late fifties and notably in the early sixties, they swelled the number of artists, dealers, collectors, art editors and critics, and museum professionals—all of whom constituted an art support network or art world—and the general public for art. The increased interest in art also generated an enormous expansion nationally in the number and size of museums, community art centers, and other art institutions. By 1974, there were six hundred such institutions, more than 85 percent of which had

come into being after 1960.[132] It is important to stress that it was not only prosperity but the confidence generated by prosperity that encouraged the newly affluent to buy and in other ways subsidize art. Moreover, the art world became increasingly fashionable, particularly after the emergence of Pop Art in 1962.

The symbol of the new progressiveness and expansiveness, in American life and culture generally, was John F. Kennedy. His election to the presidency in 1960 closed the seemingly stifling Eisenhower era and opened what appeared to be an unlimited "New Frontier." Everything seemed possible. It was during Kennedy's administration that the National Endowment for the Arts was conceived. As important to the nation's cultural climate as the charismatic, literate, rich yet politically liberal, youthful President was his beautiful young wife, Jacqueline, who was at one and the same time culture- and fashion-minded, who indeed united culture and fashion with little loss of either "seriousness" or glamour.[133]

The art world was also beguiled by Kennedy's "cool." His style emerged in sharp relief against Nixon's "hot" during their television debates, and it contributed greatly to his election victory. Gore Vidal was struck by "the spectacle of a President who seemed always to be standing at a certain remove from himself, watching with amusement his own performance. He was an ironist in a profession where the prize usually goes to the apparent cornball. With such a man as chief of state, all things were possible."[134] Kennedy's irony was exemplified by his quip at a White House dinner honoring Nobel Prize winners: "I think this is the most extraordinary collection of talent, of human knowledge, that has ever been gathered at the White House—with the possible exception of when Thomas Jefferson dined alone."

The sense of buoyancy and optimism that permeated American life, including life in the art world, began to sour after the Vietnam War turned into a debacle in 1967 and Robert Kennedy and Martin Luther King were assassinated the following year. Artists seem to have become pessimistic earlier. Why at a time when the conditions of life for almost everyone seemed to be improving, when humanitarianism seemed to be on the rise, was avant-garde art, which commanded the most art-world attention, anti-anthropocentric? It seems to have embodied an underlying, darker vision. Or, it may be that art that eschewed political statements was nonetheless an early warning of the malaise that would grip American society toward the end of the decade.

# NOTES

1. Irving Sandler, "The New Cool-Art," *Art in America* 1 (1965). This article was a compilation of material that first appeared in a series of reviews in the *New York Post* in 1963–64.
2. Barbara Rose and Irving Sandler, eds., "Sensibility of the Sixties," *Art in America*, January–February 1967, pp. 45, 48, 50.
3. Jasper Johns, "Marcel Duchamp (1887–1968)," *Artforum*, November 1968, p. 6.
4. Rose and Sandler, "Sensibility of the Sixties," p. 49.
5. "Subjective" and "objective" are often misconstrued as opposites. Their relationship is more complex. For example, the choice of one "objective" problem for investigation rather than another is "subjective," and may well depend on which one an artist finds interesting or moving. At its core, "objective" art at its best is inspired. Moreover, the decisions an artist makes concerning medium, size, scale, surfacing, cannot help being intuitive or "subjective," even if the primary process of investigation is "objective." These decisions are like inflections of an artist's voice; they contribute to his or her images the force of an individual artistic personality, its intensity and vitality. They enable viewers to experience the work with more than just the intellect. Decisions of sensibility also imbue a work with its quality. And quality may be perceived in work based on an objective approach just as in work that is more "subjective." By the same token, signs of "subjectiv-

ity," or what is commonly taken for "subjectivity," are only in part "subjective." A work of art, unless it is completely left to chance, is organized to some degree, and that requires conscious and deliberate choice and craft.

6. Francis Roberts, "I Propose to Strain the Laws of Physics," interview with Marcel Duchamp, *Art News,* December 1968, p. 47. (The interview was held in 1963.) Duchamp considered anthropocentrism "a little idea to be mocked." He added that the Readymade was an "iconoclastic gesture" aimed at the "de-deifying of the artist."

It was also Duchamp who had penciled the mustache on the *Mona Lisa,* or rather a reproduction of it, deliberately defacing the most popular monument of Humanism.

7. Carl Andre, "Frank Stella," *Sixteen Americans,* exhibition catalogue (New York: Museum of Modern Art, 1959), p. 76.

8. Bruce Glaser, interviewer, and Lucy R. Lippard, ed., "Questions to Stella and Judd," *Art News,* September 1966, pp. 58–59.

9. Robert Hughes, "The Rise of Andy Warhol," *New York Review of Books,* 18 February 1982, p. 7.

10. See Donald Judd, interviewed by Lucy Lippard, New York, 10 April 1960. Transcript in Archives of American Art, New York.

11. Rose and Sandler, "Sensibility of the Sixties," p. 45.

12. Mary Fuller, "An Ad Reinhardt Monologue," *Artforum,* October 1970, p. 40.

13. Sandler, "The New Cool-Art," p. 100.

14. J. Kirk T. Varnedoe, "Henry Moore," lecture at Columbia University, New York, 26 April 1985.

15. Clement Greenberg, "Modernist Painting," *Arts Yearbook 4* (1960): 103.

16. See Jonathan Miller, *McLuhan* (London: Fontana/Collins, 1971), p. 34.

17. See Irving Sandler, "New York Letter," *Art International,* 1 December 1960.

18. Michael Fried, "Frank Stella," *Toward a New Abstraction,* exhibition catalogue (New York: Jewish Museum, 1963), p. 28.

19. See Michael Fried, "Art and Objecthood," *Artforum,* Summer 1967.

20. Leonard B. Meyer, "The End of the Renaissance? Notes on the Radical Empiricism of the Avant-Garde," *Hudson Review,* Summer 1963. Andy Warhol, interviewed by G. R. Swenson, in "What Is Pop Art?" part 1, *Art News,* November 1963, p. 61, said: "Did you see that article in the *Hudson Review* ('The End of the Renaissance?' Summer 1963)? It was about Cage and that whole crowd, but with a lot of big words like radical empiricism and teleology."

21. Meyer, "The End of the Renaissance?" pp. 172, 174, 182, 186. Similar statements were made by artists of the sixties. Mel Bochner, in "Primary Structures," *Arts Magazine,* June 1966, p. 34, wrote that Minimal Art was "subversive in that it points to the probable end of all Renaissance values [and] humanistic stammering." Later in the sixties, Joseph Kosuth in "Art After Philosophy," *Studio International,* October 1969, p. 134, also attacked humanist reasoning, for its "unreality." Twentieth-century thinking had progressed far beyond it. Sir James Jeans had shown that humanist conjectures were no longer applicable or believable. They

were good enough for the man-sized world, but not, as we now know, for those ultimate processes of nature which control the happenings of the man-sized world, and bring us nearest the true nature of reality. . . . One consequence of this is that the standard philosophical discussions of many problems, such as those of causality and free-will or of materialism or mentalism, are based on an interpretation of the pattern of events which is no longer tenable. The scientific basis of these older discussions has been washed away, and with their disappearance have gone all the arguments.

22. Meyer, "The End of the Renaissance?" p. 178.

23. Ibid., pp. 180–81. Meyer's focus on a thing-in-itself was influenced primarily by Cage's Zen-inspired thinking. But his claim that because an isolated thing or event could be perceived as real, "radical empiricism" was "a position of uncompromising positivism" also derived from Wittgenstein. Thus Meyer effected a curious combination of Cagean Zen and Wittgenstein's positivist literalness, both of which entered significantly into sixties art discourse. Meyer's aesthetic applies best to Cage-inspired art, which was very visible in 1963 and was obviously on Meyer's mind. But he did allow for art based on preconceived formulas, but such art, with the exception of Stella's, was not yet prominent.

24. Ibid., p. 180.

25. Ibid., p. 181.

26. Susan Sontag, "Against Interpretation," *Evergreen Review,* December 1964, reprinted in *Against Interpretation* (New York: Delta/Dell, 1967). Sontag was influenced by Robbe-Grillet as well as by Cage. This is clear in her assertion on p. 7 that "interpretation is the revenge of the intellect upon art. Even more. It is the revenge of the intellect upon the world. To interpret is to impoverish, to deplete the world—in order to set up a shadow world of 'meanings.'"

27. Calvin Tomkins, *The Scene: Reports on Post-Modern Art* (New York: Viking Press, 1976), pp. 11–12.

28. Alan Solomon, *New York: The New Art Scene* (New York: Holt, Rinehart & Winston, 1967), pp. 41–42. Photographs by Ugo Mulas.

29. Barbara Rose, "Problems of Criticism V: The Politics of Art, Part 2," *Artforum,* January 1969, pp. 47–48.

30. The Editors, "Portfolio: 4 Sculptors: Don Judd,"

*Perspecta 11* (1967), p. 44. Judd said:

> I wanted work that didn't involve incredible assumptions about everything. I couldn't begin to think about the order of the universe or the nature of American society. I didn't want work that was general or universal in the usual sense. I didn't want to claim too much.

31. See Donald Judd, interviewed by Lucy Lippard. Judd's empiricism was rooted in American philosophy. But European philosophers had also dealt with it. For example, Edmund Husserl and Maurice Merleau-Ponty were also read by sixties artists. See Marcia Hafif, "Getting on with Painting," *Art in America*, April 1981, p. 134.

32. Barbara Rose, "Problems of Criticism V: The Politics of Art, Part 4," p. 48. Rose, on p. 44, remarked that in their taste, Americans were disposed to the "natural, the uncontrived, the immediate, the direct, the 'honest' . . . the physical, and the literal." She went on to say that "indigenous American forms" were characterized by "their cleanness, integrity, efficiency, and simplicity." Amy Goldin, in "The Antihierarchical American," *Art News*, September 1967, pp. 48–49, set forth a number of Judd's beliefs:

> Somehow art should be true to the fundamental assumptions of the society in which it is produced. . . . It is . . . a question of using contemporary principles, modern forms of organisation. I had often heard him say that the hierarchic principle, for example, was outmoded, false and basically irrelevant to American art.

Judd remarked on pp. 49–50: "Primary and secondary forms, some things being *naturally* subordinate to others . . . A very played-out European idea. I think Americans have always tended to escape from it." Judd added that in paintings like Newman's and Stella's, "the rectangle of the canvas itself is the dominant form." It is not a container for something else.

33. Robert Morris, "Notes on Sculpture: Part 1," *Artforum*, February 1966, p. 43.

34. Mel Bochner, "Serial Art (Systems: Solipsism)," *Arts Magazine*, Summer 1967, p. 39.

35. Sandler, "The New Cool-Art," p. 96.

36. Ibid., pp. 96–97, 99, 100–101.

37. See Samuel Beckett, "Text for Nothing, Number 8," read by Jack MacGowran, record in Brian O'Doherty, ed., *Aspen 5+6*, Fall–Winter 1967, sec. 4; Lucy Lippard, "Rejective Art," *Art International*, 20 October 1966; and Barbara Rose, "ABC Art," *Art in America*, October–November 1965. In 1969, Sol LeWitt executed a pen-and-ink drawing for Samuel Beckett's *Come and Go*, which was published in *Harper's Bazaar*, April 1969.

38. Samuel Beckett, "Three Dialogues with George Duthuit," *Transition*, December 1949;

quoted in Christopher Butler, *After the Wake; An Essay on the Contemporary Avant-Garde* (Oxford, England: Clarendon Press, 1980), pp. 79–80.

39. Samuel Beckett, *The Unnameable* (New York: Grove Press, 1958), pp. 36, 179. Reflecting Beckett's outlook, William Wiley, in Joe Raffaele, and Elizabeth Baker, "The Way-Out West: Interviews with 4 San Francisco Artists," *Art News*, Summer 1967, p. 73, said: "I identify with Fellini's character in *8 1/2* who says, 'I don't have anything to say, but I want to say that.' What could be more relevant? It expresses a real understanding of where he is, which is that he isn't anywhere."

40. Brian O'Doherty, "The New Nihilism: Art Versus Feeling," *New York Times*, 16 February 1964, sec. 2, p. 15.

41. Barbara Rose, "ABC Art," p. 65. Composer friends of sixties artists, LaMonte Young, Terry Riley, Philip Glass, and Steven Reich, created what came to be labeled Minimal music. See Wiley Hitchcock, "Minimalist Music and Minimalist Art," in *Symposium: Music and the Visual Arts*, College Art Association Annual Meeting, New York, 13 February 1986.

42. Czeslaw Milosz, "Ruins and Poetry," *New York Review of Books*, 17 March 1983, pp. 22–23.

43. Robert Smithson, "Entropy and the New Monuments," *Artforum*, June 1966, p. 26.

44. Smithson's refusal to believe in progress and utopia was in the tradition of Yevgeny Zamatin's *We* and Aldous Huxley's *Brave New World*, both published between World Wars I and II, and George Orwell's *1984* and *Animal Farm*, all of which were inspired by Dostoevsky's novels.

45. A state of entropy had its attraction. Mel Bochner and Robert Smithson, in "The Domain of the Great Bear," *Art Voices*, Fall 1966, p. 51, wrote of

> forbidden zones . . . dazzling realms . . . dimensions beyond the walls of time . . . The problem of the "human figure" vanishes from these . . . infinities and . . . cataclysms. Time is deranged. . . . Disasters of all kinds flood the mind at the speed of light. Anthropomorphic concerns are extinct in the vortex of disposable universes. . . . History no longer exists.

46. Smithson, "Entropy and the New Monuments," p. 27. Like Smithson, LeWitt wrote an article ("Ziggurats," *Arts Magazine*, November 1966) extolling New York City's ziggurat architecture, commonly denigrated for its banality.

47. Peter Hutchinson, "Is There Life on Earth?" *Art in America*, November–December 1966, pp. 68–69.

48. Smithson, "Entropy and the New Monuments," p. 29. Smithson and his friends claimed that horror and science fiction movies were sources of inspiration, providing for both their "organic

needs" and their "inorganic needs." Some landmarks of Sci-Fic are *Creation of the Humanoids* (Andy Warhol's favorite movie) and *The Planet of the Vampires* (movie about entropy).

49. Robert Smithson, "Toward the Development of an Air Terminal Site," *Artforum*, Summer 1967, p. 40.

50. Bochner, "Primary Structures," *Arts Magazine*, June 1966, p. 33. Bochner also included as irrelevant the words "experiment," "purity," "space," and "avant-garde." "Experiment" was rejected because it implied that there was something of deeper significance to discover. "Avant-garde" also implied a venturing into the unknown to find new meaning. "Purity" was much too idealistic. "Space" was repudiated because it was the primary concern of painting.

51. George Kubler, *The Shape of Time* (New Haven: Yale University Press, 1962), pp. 5, 9.

52. Ad Reinhardt, in "Art vs. History," *Art News*, January 1966, p. 61, quoted Kubler: " 'Biographic, iconologic and stylistic art histories do not fit the facts.' 'The definition of art as a system of formal relations matters more than meaning.' "

53. Robert Morris began "Notes on Sculpture, Part 1," p. 43, with a sympathetic discussion of Kubler's thesis.

54. Robert Smithson, "Quasi-Infinities and the Waning of Space," *Arts Magazine*, November 1966, pp. 29–30.

55. Mel Bochner, "Primary Structures," p. 33.

56. See Robert Pincus-Witten, *Postminimalism* (New York: Out of London Press, 1977).

57. Roland Barthes, "The Death of the Author," in O'Doherty, ed., *Aspen 5+6*, sec. 3, n.p.

58. Donald Judd, "Specific Objects," *Arts Yearbook* 8(1965), p. 78. Judd remarked that specific objects "need only to be interesting." This is commonly interpreted to mean that art need not be expressive. However, Judd did not write that. What he had in mind was that Specific Objects did not "have a lot of things to look at, to compare, to analyze one by one, to contemplate. The thing as a whole, its quality as a whole, is what is interesting."

59. Andy Warhol, *The Philosophy of Andy Warhol (From A to B and Back Again)* (New York: Harcourt Brace Jovanovich, 1975), p. 32.

60. Rose and Sandler, "Sensibility of the Sixties."

61. O'Doherty, ed., *Aspen 5+6*, sec. 2, n.p.

62. Douglas Davis, *Art and the Future: A History/Prophecy of the Collaboration Between Science, Technology and Art* (New York: Praeger Publishers, 1973), p. 41.

63. Panel, "Art 1960," New York University, New York, 21 April 1960.

64. See Swenson, "What Is Pop Art?"

65. Mel Bochner, "Primary Structures," p. 33.

66. Barbara Rose, "Pop in Perspective," *Encounter*, August 1965, p. 60.

67. Lucy R. Lippard, "The Third Stream: Constructed Paintings and Painted Structures," *Art Voices*, Spring 1965, p. 49.

68. Robert Morris, "Notes on Sculpture, Part 3," *Artforum*, Summer 1967, p. 26.

69. Rose and Sandler, "Sensibility of the Sixties," pp. 45, 49, 54–55.

70. Morris, "Notes on Sculpture, Part 3," p. 26.

71. Modular grids can be seen as referring to observable reality—for example, cities built on a checkerboard plan and certain International Style buildings.

72. Morris, "Notes on Sculpture, Part 3," p. 29.

73. Donald Judd, conversation with the author, New York.

74. Morris, "Notes on Sculpture, Part 3," p. 29.

75. Lucy R. Lippard, "Homage to the Square," *Art in America*, July–August 1967, p. 54.

76. Amy Goldin, "Patterns, Grids and Painting," *Artforum*, September 1975, p. 51.

77. Sol LeWitt, in Lucy Lippard, "Homage to the Square," p. 54.

78. Morris, "Notes on Sculpture, Part 3," p. 26.

79. Bochner, "The Serial Attitude," *Artforum*, December 1967, p. 31.

80. Sol LeWitt, "Paragraphs on Conceptual Art," *Artforum*, Summer 1967, p. 80.

81. See Lawrence Alloway, *Systemic Painting*, exhibition catalogue (New York: Solomon R. Guggenheim Museum, 1966), p. 19.

82. William Rubin, *Frank Stella*, exhibition catalogue (New York: Museum of Modern Art, 1970), p. 13.

83. Mel Bochner, "The Serial Attitude," p. 30. It is noteworthy that Warhol and Lichtenstein partook of this attitude in their predetermination of subjects and their rejection of the creative interpretation or "transformation" of their subjects; their images seemed to duplicate the originals.

84. Butler, *After the Wake*, p. 11.

85. Sol LeWitt, "Serial Project #1, 1966," in O'Doherty, ed., *Aspen 5+6*, sec. 17, n.p.

86. LeWitt, "Paragraphs on Conceptual Art," p. 80.

87. Ibid.

88. John Elderfield, "Grids," *Artforum*, May 1972, p. 53.

89. Alain Robbe-Grillet's views did not become fully known in the New York art world until 1965, when his book of essays, *For a New Novel: Essays on Fiction* (New York: Grove Press, 1965), was published in English. However, his "manifesto," "A Fresh Start for Fiction," had appeared in *Evergreen Review* 3 in 1957, and in the following year his novel *Le Voyeur* was published in translation. It is noteworthy that a segment of Robbe-Grillet's *Jealousy* was included in the issue of *Aspen 5+6*, sec. 5, edited by Brian O'Doherty in 1967, a sign of its relevance to sixties artists. Robbe-Grillet began to be noticed in America as early as 1956. André Maurois, in "Literary Letter from France," *New York Times Book Review*, 2 December 1956, p. 60, singled out Robbe-Grillet as a

young critic who had been predicting the death of the traditional novel. In Time Inc. Archives, New York, Rosalind Constable Reports, Constable noted the emergence of an entirely new kind of writing, the *nouveau roman*, exemplified by Robbe-Grillet's *Les Gommes*, 1953, and *Le Voyeur*, 1955. She remarked that Roland Barthes had written the first serious analysis of the new tendency in *Critique*, 1954. Constable also wrote that Robbe-Grillet's essay "Nature, Humanism, Tragedy" was published in the *Nouvelle Revue Française*, October 1958; it appeared in English in the *London Magazine*, February 1959, and *Evergreen Review*, Summer 1959. By 1960 or 1961, the *nouveau roman* had become fashionable in Paris.

90. Sandler, "The New Cool-Art," p. 100.

91. Alain Robbe-Grillet, "Old 'Values' and the New Novel (Nature, Humanism, Tragedy)," *Evergreen Review* 9 (Summer 1959): 101.

92. Robbe-Grillet, "A Fresh Start for Fiction," p. 101.

93. Alain Robbe-Grillet, interviewed by Paul Schwartz, in "Anti-humanism in Art," *Studio International*, April 1968, p. 169.

94. Robbe-Grillet, "A Fresh Start for Fiction," p. 102.

95. Alain Robbe-Grillet, "From Realism to Reality," *London Magazine*, May 1965, p. 33.

96. Donald Judd, "Nationwide Reports: Hartford: Black, White and Gray," *Arts Magazine*, March 1964, pp. 37–38.

97. See Sontag, *Against Interpretation.*

98. Michael Fried gave a book by Wittgenstein to Frank Stella and Barbara Rose as a wedding gift. Andre once remarked: "There was a point in the early sixties when everyone had the Blue and Brown Book in the john."

99. William Barrett, *Irrational Man: A Study in Existential Philosophy* (New York: Doubleday Anchor Books, 1958), p. 31.

100. Anthony Manser, "On some differences between English and Continental philosophy," *20th Century Studies* 1 (March 1969): 74.

A number of artists and critics—for example, Robert Morris and Michael Fried—read Maurice Merleau-Ponty with great interest and sympathy. Among existentialist thinkers, he was the most phenomenological. Taking his cues from Husserl, he centered his philosophy on the perception of things. However, Merleau-Ponty's name did not appear in art-world discourse or writing with the frequency that Wittgenstein's did.

101. See Time Inc. Archives, New York, Rosalind Constable Reports.

102. Ian Hackling, "Wittgenstein the Psychologist," *New York Review of Books*, 1 April 1982, p. 43.

103. Rose, "ABC Art," p. 66.

104. Peter Brook, in Peter Brook and Edmund White, "From Albert Camus to Roland Barthes," *New York Times Book Review*, 12 September 1982, pp. 1, 20.

105. Edmund White, ibid., p. 34.

106. The McLuhan cult began with the publication of his *The Gutenberg Galaxy* (Toronto: University of Toronto Press, 1962).

107. Tom Wolfe, "What If He Is Right?" *New York/ Herald Tribune*, 21 November 1965, p. 6.

108. Ibid., pp. 7–8. As McLuhan saw it, the new technologies were involving "us totally in one another's lives." Thus the world was evolving into a "global village." See Marshall McLuhan, "Culture and Technology," *Times Literary Supplement*, 6 August 1964, p. 700. Not only did the "global village" seem to be emerging in "hippie" communities, such as Haight-Ashbury in San Francisco, but artists were setting up communes. Grace Glueck, in "New Mix for New Mex," *New York Times*, 26 March 1967, sec. 2, p. 24, reported that "a 'spiritual retreat . . .' is planned by USCO, a tribe of McLuhan-oriented poets, artists, engineers and filmmakers. . . . USCO earns its bread by way of 'media mixes'—eye-popping, mind-blowing electronic environments that make use of films, tapes, slides." Glueck's article was reprinted in *Aspen 4* (Marshall McLuhan issue), Spring 1967.

109. Harold Rosenberg, "Books: Philosophy in a Pop Key," *New Yorker*, 27 February 1965, p. 131.

110. "The Story of Pop," *Newsweek*, 25 April 1966, p. 57.

111. See Time Inc. Archives, New York, Rosalind Constable Reports.

112. See David Jacob, "An Expo Named Buckminster Fuller," *New York Times Magazine*, 23 April 1967, p. 140. *Time* did a cover story on Fuller, "The Dymaxion American," on 10 January 1964. In 1967, *Aspen* published a McLuhan issue (no. 4) in twelve parts. Cage was responsible for one part, headed by an excerpt: "When information rubs against information." Richard Kostelanetz, ed., *John Cage* (New York: Praeger Publishers, 1970), was dedicated to Fuller.

113. Robert W. Marks, *The Dymaxion World of Buckminster Fuller* (New York: Reinhold, 1960).

114. Hugh Kenner, *Bucky: A Guided Tour of Buckminster Fuller* (New York: William Morrow & Company, 1973), p. 14.

115. Jacob, "An Expo Named Buckminster Fuller," p. 135.

116. Kenner, *Bucky*, p. 284.

117. Tomkins, *The Bride and the Bachelors* (New York: Viking Press, 1968), p. 75.

118. John Donat, "Buckminster Fuller," *Studio International*, June 1970, p. 243.

119. Jacob, "An Expo Named Buckminster Fuller," p. 139. See also Kenner, *Bucky*, p. 26.

120. John Cage, "Diary: How to Improve the World (You Will Only Make Matters Worse)," *Aspen 4* (Marshall McLuhan issue), Spring 1967, sec. 4, n.p.

121. Pierre Cabanne, *Dialogues with Marcel Duchamp* (New York: Viking Press, 1971), p. 103.

122. Gerald Emanuel Stearn, *McLuhan, Hot and*

*Cool* (Harmondsworth, England: Penguin, 1968), p. 320.

123. See Tom Wolfe, *The New Journalism* (New York: Harper & Row, 1973), part 1. What fascinated Wolfe was the change in life-styles brought about by postwar affluence, styles that abandoned "proprieties, pieties, decorums," as he wrote on p. 29, exemplified in the art world by Andy Warhol's milieu. Wolfe believed that these would be the legacy of the decade:

> A hundred years from now when historians write about the 1960's in America . . . they won't write about it as a decade of the war in Vietnam or of space exploration or of political assassination . . . but as the decade when manners and morals, styles of living, attitudes towards the world changed the country more critically than any political events.

Wolfe's own writing, an example of what he called the New Journalism, also seemed of the sixties because it captured *the surface of things* and avoided underlying moral analysis.

124. Cage, McLuhan, and Fuller accepted one moralizer, Harold Rosenberg, the art critic for *The New Yorker*, who was a brilliant, witty, and amusing raconteur, and who happened to admire McLuhan. For example, in 1966, The Foundation for Contemporary Performance Arts, Inc., in which Cage was the leading spirit, presented a series of six lectures at the Poetry Center of the 92nd Street YM-YWHA in New York. Rosenberg was one of the speakers; the others were Fuller, McLuhan, Merce Cunningham, Norman O. Brown, and Peter Yates.

In a key essay titled "On the De-definition of Art," *Art News,* December 1971, p. 23, Rosenberg called for an art that "provides a means for the active self-development of individuals— perhaps the only means." This was the moral aspiration of Abstract Expressionism in the forties and early fifties, as Rosenberg saw it, and because it was decreasingly forthcoming, new art not only did not equal Abstract Expressionism but was in crisis. The primary reason was that the artist was no longer the product of the art he or she created—that is, in the "action" of creation—but had become the creator of art, an artist by self-declaration. Anything an "artist" produced was "art." Because such claims by fiat were unconvincing, art had entered a state of "de-definition."

"De-definition" was accompanied by "de-aestheticization"—that is, when art was re-duced, as Minimal Art was; when it was produced out of materials intended for purposes other than art, including living people in performance, and earth, as in Earthworks; when it was random and without form, as in Process Art; and when it was conceptual. Thus Rosenberg stood on moral grounds against most art that was new in the sixties, and his writing became progressively beside the point and sour.

125. Morris Dickstein, *Gates of Eden: American Culture in the Sixties* (New York: Basic Books, 1977), pp. 68, 142.

126. Ibid., pp. 69–70.

127. See Davis, *Art and the Future,* p. 72.

128. William L. O'Neill, *Coming Apart: An Informal History of America in the 1960's* (New York: Quadrangle Books, 1977), p. 3.

129. Elizabeth Hardwick, "Notes on Leonardo and the Future of the Past," *Art in America,* March–April 1966, pp. 36–38.

130. Robert Morris, "Notes on Sculpture, Part IV: Beyond Objects," *Artforum,* April 1969, p. 54, n. 1. Barbara Rose, in "ABC Art," p. 58, called attention to Richard Wollheim's remark that a decision can represent work. Rose also noted John Ashbery's statement that what matters in art is the artist's "will to discover, rather than the manual skills he may share with hundreds of other artists." She related "a downgrading of talent, facility, virtuosity, and technique with [the] elevation of conceptual power."

131. Alan Solomon, *New York: The New Art Scene,* p. 43.

132. Karl E. Meyer, *The Art Museum: Power, Money, Ethics* (New York: William Morrow & Company, 1979), p. 74.

133. Mary Holland was quoted in Georgina Howell, *In Vogue: Six Decades of Fashion* (London: Penguin Books, 1975), p. 254, as saying that Jacqueline Kennedy had won

> *Vogue*'s talent contest in 1951 when, in answer to a question about People I Wish I Had Known, she had chosen Baudelaire, Oscar Wilde and Diaghilev. The good-looking and clothes-conscious Mrs. Kennedy has resolutely "eschewed the bun-fight and the honky-tonk of the American political scene and is inclined, instead, to the gentler practice of painting, conversation, literature and fashion."

134. Gore Vidal, *Reflections Upon a Sinking Ship* (Boston: Little, Brown, 1969), p. 161.

# 4 THE ARTIST AS A MAN OF THE WORLD

During the sixties, the economic and social lot of a significant number of avant-garde artists improved considerably. Largely responsible was the patronage of a growing number of new-rich collectors with a taste for radical art.[1] Spawned by the burgeoning world economy, they generated a boom in the art market.[2] And artists, as beneficiaries, began to feel less alienated from society than their predecessors had, and to consider themselves "men of the world," to use Allan Kaprow's label.

Sales and prices of contemporary American avant-garde art began to rise toward the end of the fifties. This was heralded, as it was fueled, by the sale of Jackson Pollock's *Autumn Rhythm* to the Metropolitan Museum in 1957, soon after the artist's death. The price was for then an astonishing $30,000, doubly astonishing because not a single painting had sold from Pollock's show just six years earlier. It was surprising at the time that any avant-garde artist should have achieved monetary success on this scale, even Pollock, who had been the "ice-breaker" Abstract Expressionist, as de Kooning called him, and the most notorious artist of his generation, becoming something of a pop hero: Jack the Dripper, as *Time* called him in 1956.[3] But the surprise soon abated as his less famous colleagues also received their share of acclaim and riches.[4]

American collectors were encouraged to buy Abstract Expressionist painting because of its recognition abroad.[5] That began in a big way in 1958, when the Museum of Modern Art circulated a major survey, *The New American Painting*, throughout Europe.[6] The show convinced many leading European artists and art professionals that the center of world art had moved from Paris to New York. Even in Paris, as one critic reported, "The fact that this exhibition remains, after five months, the one really lively topic of discussion in any gathering of artists, critics or dealers speaks for itself. It constituted one of the most apparently significant events of the postwar period in Paris [perhaps] the Armory show of postwar Paris."[7] Young artists in particular were enthralled. For example, in England, some two dozen of them, including William Turnbull, Anthony Caro, Harold and Bernard Cohen, Robyn Denny, John Plumb, and John Hoyland, began to look for inspiration to the New York School and, with the cooperation of the critic Lawrence Alloway, joined to present their works and ideas to the public in shows they organized and called *Situation*.

Upon its return to America, in 1959, *The New American Painting* was presented at the Museum of Modern Art. It was followed in the same year by *Sixteen Americans*, which featured alternatives to Abstract Expressionism by a younger generation who would command art-world attention in the sixties. These two prestigious shows of advanced art, back to

back, as it were, in the establishment citadel of modern art, were crucial catalysts for the explosion of the art market. In 1959 too, de Kooning's show at the Sidney Janis Gallery was sold out on its first day for a total of $150,000,[8] establishing a new high in prices for living American painters. Even more surprising was Johns's instant recognition and the success of his first one-person show, held at the Leo Castelli Gallery shortly before the de Kooning show. All but two of Johns's pictures were sold; three were purchased by Alfred Barr for the Museum of Modern Art. The acquisition of Stella's *Marriage of Reason and Squalor* by the museum in 1960 also made a big impression, particularly because he was only twenty-three at the time and had not yet had a one-person show.[9]

*The New American Painting* and *Sixteen Americans* were followed in 1961 by large and impressive surveys of *the Art of Assemblage,* at the Museum of Modern Art, and of *American Abstract Expressionists and Imagists,* at the Solomon R. Guggenheim Museum. The four shows established the New York School as never before. In 1962, Pop Art emerged suddenly, and its instant fame and quick success were unprecedented. It was the first avant-garde art to appeal simultaneously to art professionals—for example, museum directors and curators, who quickly organized exhibitions throughout America—the mass media, and a large general public. And it boosted the art market as no new art ever had, particularly after the Sidney Janis Gallery mounted a large international show, *The New Realists,* in the fall of 1962, some ten months after the inception of Pop Art. Sidney Tillim remarked: "With the same business acumen and perfect timing that made him the Duveen of Abstract Expressionism . . . Janis has moved in on the 'pop' craze at harvest time. Let us not underestimate the association of his gallery with 'pop' art at the present time."[10] Thomas Hess agreed: "The point of the Janis show . . . was an implicit proclamation that the New had

arrived and it was time for all the old fogies to pack. What *Life* (the magazine) calls the 'Red-Hot Take-Over Generation' was in."[11]

The notoriety of Assemblage and Pop Art served to enhance the reputations of the precursors of the two tendencies, Rauschenberg and Johns, both of them represented by the Castelli Gallery. Rauschenberg, in particular, won growing acclaim at home and abroad. From 1961 to 1964, he was given a number of highly regarded shows in Europe, which contributed considerably to his winning the International Grand Prize for Painting at the thirty-first Venice Biennale in 1964. The most prestigious of international surveys of contemporary art, the Venice Biennales were so well attended and closely watched by art dealers and collectors that they virtually assumed the function of trade fairs.

As was to be expected, Rauschenberg's triumph elicited growls about American cultural imperialism. But in the end, as Alloway concluded: "Rauschenberg [at age thirty-nine] seemed like a young prize winner, the way John F. Kennedy seemed like a young President."[12] Venice established Rauschenberg as the legitimate heir and thus potentially the equal in stature of the first-generation Abstract Expressionists. In turn, Johns and then Stella, the Pop artists, and others who followed would be considered on a par with Rauschenberg.

On the whole, the new-rich collectors bought avant-garde art because they liked it. But they were also attracted to *novelty* and sought *quality.* They recognized that art was different from fashion, claims to the contrary made by elitist critics notwithstanding.[13] Clothes were perishable; art was not. Styles did go in and out of fashion, but the avant-garde collectors observed that a few of the artists in each style survived to be recognized as masters, their work metamorphosed from tokens of fashion to lasting icons of art. This was the work collectors aspired to be the first to collect, and they were shrewd enough to

learn what they could about art and seek guidance from art professionals, who gave the best advice they could, since their reputations as tastemakers were at stake.

In their desire to be first to acquire art, avant-garde collectors tracked it into the studios, befriending the artists and both participating in their social activities and inviting them to join the collectors' own, helping to shape an art world very different from the poor, art-talk-dominated, hermetic art world of the forties and fifties. The life of art in the sixties grew increasingly modish, particularly after the arrival of Pop Art. As Robert Scull recalled: "It came with an entire Pop scene in which everything was Pop. [It] was truly an expression of its moment: the clothes, vinyl, movies, fads. [It] was so new it took our breath away. The high luster of it was the way we were living; the parties we were giving; the good times; . . . breaking the old mores, traditions; and living was swinging."[14]

The media loved both the art and the scene. They embraced Pop "with an outraged, scandalized, priapic delight," as Tom Wolfe reported.[15] *Newsweek* commented: "Naturally enough, pop has turned up most insistently in those places where what's new is what sells—the world of art, television, fashion and advertising."[16] It is no wonder, then, that Pop Art was recognized with unprecedented speed.

Museums in pursuit of gifts of money and art and media attention made their openings occasions of extravagant entertainment. A few museum directors and curators even became art celebrities, roles they cultivated in part because it helped in dealing with the fashion-minded rich. The best-known was Henry Geldzahler, Associate Curator of American Painting and Sculpture at the Metropolitan Museum of Art. One *Herald Tribune* columnist called him

the Telstar of the art world and all its subsidiary planets—a man so tuned in to all its wave lengths that he registers events almost before they happen. . . . When the great Klieg lights of the mass media turned in upon [the Pop artists] he was discovered in their midst. . . . To the schools of reporters and *avant-garde* hunters he was someone they would have had to invent had he not already existed—an art historian in touch, in the know, a hip Metropolitan curator, a young critic unhampered by a body of criticism who liked the new thing, and yet, if necessary, could talk about it in the old language. . . . Geldzahler knows just about everybody there is to know. Quite apart from his personal charm, he is an information center— and in the electronic world, information is the most important commodity.[17]

Geldzahler was "hip," but his commitment to art was serious; he was a brilliant curator of unquestioned integrity. Indeed, when Thomas Hoving, then the Metropolitan's director, in an attempt to "get with it," dealt directly with Robert (Bob) and Ethel (Spike) Scull at a dinner party and arranged for the exhibition at the Museum of Rosenquist's notorious *F-111* (notorious in part because it was bought by the Sculls for an alleged $60,000), Geldzahler immediately resigned. He returned only after Hoving promised not to meddle in his curatorial realm.[18]

Museum and gallery openings, art-world parties, auctions at which each new record bid was applauded, benefit dinners and dances became major social and fashion events. At them, the "with it" paraded themselves in the latest and most outrageous clothes. In their wake, the media created an aura of glamour about art and those involved in it. Wolfe reported: "Art openings began to take over from theater openings as the place where the chic, the ambitious, and the beautiful congregated. . . . Art museum committees replaced charity committees as the place where ambitious newcomers could start scoring socially."[19] The art world became *the* fun place to be "in," where "what's happening" was "at."

As early as 1963, art-world parties emu-

lating those in New York were being enacted in the "provinces." For example, in Washington, D.C., at the Gallery of Modern Art, there took place "The Pop Art Festival." *Time,* in its "Show Business" section, reported that "the climactic event" was a Happening called *Stars* by Claes Oldenburg. (In the same issue of the magazine, there appeared a four-page cover story titled "Pop Art—Cult of the Commonplace.")

> Washington society prepared [for the Oldenburg event] by getting itself puffed, powdered and sloshed. Little dinners were eaten intimately in Georgetown. The jolly crowd then collected at the gallery to see what was going to happen. Nearly everyone sat on campstools. . . .
>
> A member of the gallery staff announced that she had successfully achieved blue ice cream. She had mixed blue dye and vanilla ice cream with a monkey wrench. The New Frontier moved an inch forward on its stools. This was obviously going to be some happening.

*Time* commented that the proceedings made "the point that Washington is a hell of a party town." The article ended with the exit of "official Washington, gurgling hip-hip for happenings."[20]

The neophiliac collectors were exemplified by the Sculls. They were passionately committed to the new art. As Warhol wrote, Bob, who was in the taxicab business, "pulled off what everyone who collects dreams of—he built the best collection by recognizing quality before anybody else was on to it, while it could still be bought cheap."[21] The Sculls became notorious for their voracious acquisition of the far out. Tom Wolfe wrote an article about them in the fashionable *New York* supplement of the *Herald Tribune.* Bob and Spike "are one of *the* great success stories of New York since World War II." They frequent "that whole world of opening nights and the parties they write about in the papers." "She has already graduated to the big time in fashion." They made it big and fast and they had fun. "Spike,

you know what my philosophy is? My philosophy is, *Enjoy.*"[22] Warhol remarked that "the Sculls were models and heroes" for a "lot of . . . swinging mod couples."[23]

The art world as a fashionable playpen was exemplified at its most extreme by Andy Warhol's Factory, as his studio was named. In this silver-coated loft, the subcultures of the avant-garde, representing rich chic, fashion, youth and drug cultures, sex of every imaginable kind, rock music, and the media, met. And at the core of his "underground" scene was Andy—pallid, passive, self-absorbed, and distant, implacably cool—indeed, the living exemplar of sixties cool. He was the omnipresent starmaker with the unerring and inexplicable knack of attracting the attention of the media and thus the world outside. A succession of style-setting superstars of Warhol's creation became momentary household names, among them Baby Jane Holzer (the wife of a wealthy broker) and Edie Sedgwick (a member of one of America's most distinguished families).[24]

Andy Warhol recalled:

> Famous people had started to come to the studio, to peek at the on-going party. . . .
>
> The counterculture, the subculture, pop, superstars, drugs, lights, discotheques—whatever we think of as "young-and-with-it"—probably started then. There was always a party somewhere. . . . "All Tomorrow's Parties" was the name of a song the Velvets [Warhol's rock band] used to do. In those days everything was extravagant.[25]

By 1965, Warhol had achieved such notoriety in society that his group was rated by Eugenia Sheppard just below Jacqueline Kennedy's coterie in the ranking of the fashionable.[26]

It was not all perpetual partying in Andy's world—not for Warhol himself or for the art professionals in his circle. He was an artist, after all,[27] and he did have serious associates—Castelli, Ivan Karp, Geldzahler,[28] Alan Solomon—who admired him most for his art, although their connection with him drew attention to themselves. This, of course, was by no

means always welcome and certainly not their only claim to fame. But with regard to the cultural *life* (as distinct from the *art*) of the sixties, Warhol's loft was its decadent fun house. The original Factory moved into high gear in 1963, remaining primarily within the art world through 1964. Around 1965, it began to attract ever greater numbers of other-than-art-world types, declining in art-world attention by the following year, and coming to an abrupt halt with the near-fatal shooting of Warhol in 1968. After Warhol's recovery, the Factory's role changed; it became increasingly commercial, engaged in the production of art that would make money, what Warhol called Business Art.

In 1966, Max's Kansas City, a two-story restaurant and bar owned by Mickey Ruskin, replaced the Factory as the "in" night spot where the worlds of art and fashion interacted. Bruce Kurtz reported:

> The first regulars from the art world came from the Park Place Gallery and the Green Gallery. . . . Ruskin was extremely supportive of his artist clientele, most of whom were living on very small incomes. . . . Ruskin traded art for credit with Chamberlain, di Suvero, Myers, Ruda, some of the Green Gallery artists, Frank Stella, Kenneth Noland, Malcolm Morley, Dan Christensen, Sol LeWitt and Michael Heizer, among others, assuring a nucleus of art clientele.[29]

They were joined by people in the other arts, celebrities of all kinds, fashion designers, photographers, models, gossip columnists, and, of course, Warhol's entourage. However, even with the din of the perpetual rock music, coteries of artists continued to meet for serious conversation, notably the coterie that included Robert Smithson, Carl Andre, Sol LeWitt, Eva Hesse, Dorothea Rockburne, and Mel Bochner.

Why did the world of fashion embrace the world of artists, particularly in Warhol's Factory and Max's Kansas City? The most convincing answer was given by Tom Wolfe. In his view, the new rich were motivated by *la nostalgie de la boue*—nostalgia for muck. Such nostalgia tends to come into vogue "whenever a great many new faces and a lot of new money enter Society."[30] Wolfe elaborated:

> "Society"—the minority that establishes manners—is today a "talent" or "success" aristocracy. Fewer and fewer people are in society today because of their ancestry or any other kind of inherited or immutable status. They are all in society today because of their success. They have triumphed in their careers. Their careers are diverse, although more and more of them are in newer fields of information and communication—television, show business, publishing, the arts, advertising. They have no common meeting ground or tradition out of which a style of life could grow.[31]

Therefore, "in New York today, the 'success' aristocracy achieve status first, then look around for styles with which to celebrate it." And these styles above all had to set the new "society" apart from the conventional, boring bourgeoisie. Wolfe went on to say:

> New arrivals have always had two ways of certifying their superiority over the hated "middle class." They can take on the trappings of aristocracy . . . and they can indulge in the gauche thrill of taking on certain styles of the lower orders. The two are by no means mutually exclusive; in fact, they are always used in combination.[32]

Pop Art was *the* consummate art of *boue;* on the one hand, it was high culture and thus aristocratic, and on the other hand, it was rooted in popular or mass culture and could be taken as kitsch and camp—debased high culture. Warhol's own work was rattier than other Pop Art, as David Antin noted: "Everything Warhol touches becomes intricately seedy. . . . He has moved from painting to film, to the taped novel, soap opera, the discotheque, all sharing the same precisely pinpointed defectiveness."[33] Warhol himself remarked on the Factory's "seedy glamour."[34]

But the new "society" could not maintain its exclusiveness for long. The conventional middle class quickly embraced Pop

Art. Indeed, Pop became a mass phenomenon in 1965, thereby losing its fashionableness in the New York art world, but, as *Newsweek* reported, "infiltrating the hinterlands."[35] The middle class also invaded art-world haunts, such as Max's Kansas City. As Ronald Sukenick recalled:

> [By] the time Allen Ginsberg in an Uncle Sam top hat appeared in a subway ad for *Evergreen Review* with a caption saying "Join the Underground," a whole generation of Americans in the 60's were doing so. . . . Soon there were long lines of middle-class citizens at the door [of Max's Kansas City] waiting for admission to . . . a safe milieu where "these weird kinds of people," in the words of one of them, were "not going to bite your lips and eyelids off." . . . Max's was a symbol of the culture explosion known as "The Sixties" at the moment it reached critical mass and detonated, radically influencing mainstream culture at the same time it blew itself apart and left in its wake a half-bred "Hipoisie."[36]

A final question remains. Of what significance was the profuse coverage of art in the media: newspapers and mass-circulation magazines that devote considerable space to fashion, widely read specialized fashion periodicals, and television? The answer is simple: It generated an unprecedented culture boom. The media's motives were hardly altruistic. They responded initially to a popular demand for information about art and those who made it, sold and bought it, and validated it. But once involved in art, the media, as was their practice, established readily identifiable "names" or "personalities"— not only Bob and Spike and Warhol, who avidly cultivated notoriety; some, like Stella, who avoided it; and still others, like Castelli and Geldzahler, who coped the best they could. Because the media needed celebrities, they manufactured them through publicity; in turn, the manufactured celebrities manufactured news, more accurately pseudo news, and more publicity.[37] Media coverage was generated by and validated their celebrity.

Because art celebrities made publicity, the Seventh Avenue garment industry began to enlist a number of them to promote new fashions. And because the "rag trade" was a primary source of advertising profits for newspapers and fashion magazines, they began to feature art celebrities and their friends and associates. Indeed, gossip columns, such as Eugenia Sheppard's in the *New York Herald Tribune*, became a source of art news, or, closer to the truth, art gossip. So did articles in the mass media, such as those by Tom Wolfe, the sixties' sharpest eye for fashion, which also appeared in the *Trib*. Lavishly featured by the media, art celebrities became the prototypes or models, tastemakers or trendsetters, for larger groups. They created new audiences for art, many of whose members wanted to become art celebrities in their own right. In particular, members of the art-conscious new rich living outside New York hoped to be the Bobs and Spikes of their own communities. Hundreds began to collect art and to help organize, sponsor, fund, and build new museums and community art centers, on whose boards they sat.

These art celebrities attracted another, much larger audience for art, a new fashion-conscious mass public. Fashion had ceased to be the exclusive province of the very rich or the upper classes. Mass production enabled the only moderately affluent to follow the lead of the trendsetters. They received the word from *Life, Look, Time, Newsweek, The New Yorker, Esquire,* as well as from *Vogue, Harper's Bazaar,* and other glossy, "hair dryer" magazines. From "what people are talking about" columns they learned very quickly what was stylish not only in clothes and house furnishings but in the arts and everything else. Growing numbers of the general population now lived in expectation of the new. Most could not afford to buy the more publicized paintings and sculptures, but they did buy inex-

pensive prints and works by little-known artists, and memberships in museums and art centers, whose openings and special events they attended. They took courses on art, became museum docents, and subscribed to art magazines. They got interested and remained interested in art and information about art.

Responding to their new notoriety and with the new opportunities to achieve wealth, celebrity, and tastemaking power, avant-garde artists of the sixties began to act more like successful "professionals" than "bohemians," more like doctors and lawyers.[38] The image artists had of themselves was radically different from that of the fifties. Then, vanguard artists figuratively took vows of poverty. They could achieve recognition from other artists and a few art professionals, and this sustained them, but such acceptance could not be considered success in conventional American terms. No one got rich. The larger world ignored avant-garde artists, and they tended to be or act alienated. They were bolstered in their alienation by the belief that only damned and neglected, anxious and private outsiders had made significant contributions to modern culture. Their esteem for these pure and heroic geniuses in cold-water lofts was matched by their contempt for the middle class, which by refusing them its recognition and rewards only proved its own debased values. Nonsuccess was nothing to be ashamed of, and they even embraced antisuccess, or professed to, heatedly and proudly, aware that alienation and poverty were only too often responsible for tragic lives.

As the fifties progressed, the mystique of alienation came to accord less and less with the condition of artists. Hubert Crehan noted in 1958 that a "kind of success has fallen to the American abstract art movement." The work had begun to sell. "There has been a change in the situation. . . . No one would call it the millennium, but things are not so precarious as they were once."[39] Secretly, most of the artists

wished for conventional success, the sign of which was the ease with which they accepted fame and fortune when it was conferred upon them. "Winning" did make them feel guilty, as Larry Rivers observed,[40] but not enough for them to spurn it. This prompted John Ferren as early as 1959 to chide his fellow Abstract Expressionists: "You don't have to worry about those commitments you made in the old days; somehow, your revolutionary status is preserved intact and is, in fact, fortified by every award, prize or sale."[41] However, Ferren's moralistic attitude (Geldzahler characterized it in 1962 as "a nostalgia for the good old days when the artist was alienated, misunderstood, unpatronized") had little impact on young artists at a time when the "American artist has an audience, and there exists a machinery—dealers, critics, museums, collectors—to keep things moving."[42] Barbara Rose agreed that the image of the "scorned and starved" artist was no longer convincing, not when the artist is "the darling of the White House and the fashion magazines."[43]

Instead of cultivating antisuccess, sixties artists seemed intent on "making it," according to prevailing social standards. That meant becoming rich, famous, and fashionable. Artists took on the ways of the world, getting "with it" by attending the right parties, gallery and museum openings, auctions, benefit dinners, even retaining public-relations firms, and vying for attention from the media. Most artists on the make continued to profess their hatred for careerism, and they were duly applauded for their alleged purity (although it seemed occasionally that the more an artist or art professional hustled, the more piously he or she condemned careerism). But it was not all that crass. Making it was also viewed as a validation of art and, ironically, of the society that formerly spurned it; artists believed with justification that they achieved fame and money because their work was good, and it was the work that really counted. After all, artists had to

make it in the art world, as they had in the past; but in the sixties when they made it, it often counted in the "real" world—and that was the difference.

But could a successful artist, accepted by the middle class, be considered avant-garde? Before the sixties, radical art, art adversary to established culture, was recognized first by the artists who created it and by a small circle of enthusiasts, generally avant-gardists in the other arts, who also felt alienated from society. But their discovery was passed on in time to a circle of art professionals sympathetic toward innovation, and finally to a larger public for art. Thus revolutionary art was sucked down into the middle class—and when it was, it ceased to be avant-garde.[44]

In the sixties, the process had so speeded up that radical art was assimilated and purchased by a sizable middle-class audience almost instantly. Indeed, this audience expected and even encouraged artists to subvert conventional culture by venturing to extremes. And yet artists who could no longer profess alienation continued to claim for themselves avant-garde status. As they viewed it, they could be avant-garde without being alienated if their art was at the cutting edge (however one defined it). It did not matter who bought it or why. But this reasoning did not go unquestioned. Avant-garde claims seemed less and less creditable. As Rivers scoffed: "Is there an avant garde? Is there anything else? . . . What is more glamorous or *Glamour* magazine more in search of? Name an artist below thirty who hopes for anything else than some place in this esthetic Vatican."[45] James Wines added:

Today's art-public is one of instant acceptance. New York scene's mettlesome firebrand is fortunate if his work is controversial for more than a winter season. . . . Instant success, wealth and wide audience affections have been embraced with enthusiasm by the artist of the new scene.

This acclaim has not been achieved without considerable debt to the mass media and all the commercial machinery traditionally frowned upon in art circles. . . .

In the past the challenge of the avant garde was to work against the establishment. . . . Today the establishment, art public and avant garde are one congenial alliance. Innovation, the more outrageous the better, is welcomed with the same vigor once reserved for the conventional salon product.

Wines concluded: "Instant avant garde and instant establishment become blended."[46] Leon Golub agreed; concerning the avant-garde's historic enemy, the academy, he wrote: "Since everyone is in the avant garde, the ranks of the academy are empty!"[47]

Kaprow fleshed out the new image of the vanguard artist in a widely debated article, "Should the Artist Be a Man of the World?" that appeared in *Art News* in 1964. As he saw it, the artist (and his art-professional friends and patrons) had changed radically. In brief, "if the artist was in hell in 1946, now he is in business." More than that: "The best of the vanguard artists today are famous, usually prolific, financially comfortable. Those who are not yet, can be; and those few who will not be, must agree that they have rejected the opportunity out of preference for the tradition of artistic martyrdom or out of fear of temptation." As for sixties artists:

The men and women of today's generation matured during and directly after World War II, rather than during the Depression. They are almost all college-educated, and are frequently married, with children. Many of them teach or have taught. On the street they are indistinguishable from the middle-class from which they come and towards whose mores—practicality, security and self-advancement—they tend to gravitate.[48]

Alan Solomon's image of the new artist resembled Kaprow's. He added: "For some of them, the span from barest beginnings to public acceptance and financial success took only a few years, or even less, a kind of experience almost without precedent in American art. [Thus] they do not

feel the same tension with society that affected their predecessors."[49]

Not only were artists on the whole products of a middle-class upbringing; so were their patrons and the art professionals of their generation. And this created a bond among them all. Kaprow reported: "Among those who have helped the vanguard to become well-known and successful are fellow schoolmates from the '40s, the new curators, gallery dealers and critics, risen to prominence since [World War II]. Mutual interest between these segments of the profession is quite natural."[50] Kaprow might also have mentioned new-rich collectors who not only purchased art but sat on the boards of museums and foundations. Harold Rosenberg, the champion of the alienated Abstract Expressionists, wrote of the new patrons:

> The rise of the Vanguard Audience has altered the situation of art in America, probably for the good. [It] has provided the American artist with a public that is for the main part professionally trained, intellectually alert, culturally sophisticated, international in orientation and, above all, enthusiastic about novelty and change. . . . The evolution of the Vanguard Audience, its values, its psychology, the depth and tempo of its enthusiasms, is the major phenomenon that art will have to deal with in the decades before us.[51]

(Only four years earlier, it would have been inconceivable for Rosenberg to have treated the *nouveau-riche* collector sympathetically or even seriously.)

Kaprow reported that the social life of artists was "with clients, fellow-artists and agents, an increasingly expedient social life for the sake of career rather than just for pleasure. And in this, they resemble the personnel in other specialized disciplines and industries in America."[52] Rather than spurning the new rich as their alienated avant-garde predecessors had, sixties artists felt at ease with them, indeed cultivated them; the artists redirected their behavior from introvert to extrovert, as Ernest Briggs wrote.[53] In response, as

Kaprow remarked, society "nowadays—at least a rapidly-growing part of it—pursues the artist instead of exiling him."[54] Or, as Thomas Hess wrote ironically, the new collector "wants a picture on the wall and the artist sitting underneath it, eating a canapé."[55] In fact, the very mode of socializing changed. In the fifties, artists met primarily to talk about art, in their studios, at the Cedar Street Tavern, and at the Club, all of which were in the same neighborhood. There was drinking at the Cedar and drinking and dancing at the Club, but only very late at night, after everyone had talked himself or herself out. Alan Solomon observed that the new scene was much more diffused geographically than the earlier one:

> The new artists never talk [as the Abstract Expressionists did]. Loft dancing parties and discotheques have become the new social loci. Indeed, Rock and Roll has become the background music for the new generation, as jazz was for the old. . . . The new dancing . . . the frug and the monkey hardly lead to elaborate social intercourse.[56]

Solomon overstated the case somewhat. There was still a good deal of serious conversation, in the studios and even at Max's Kansas City, but not as much as in the fifties.

Much of sixties art talk was about who was selling what for what to whom and had attended what chic party. But it was generally assumed that genuine artists did not need fashion-minded collectors and were—or ought to be—impervious to their influence. Kaprow claimed otherwise, and this gave rise to the most heated controversy. He insisted that the middle-class artists should supply art that the middle class could feel most comfortable with. And: "Middle-class money, both public and private, should be spent on middle-class art, not on fantasies of good taste and noble sentiments."[57] (As if to illustrate Kaprow's point, Gerald Laing and Peter Phillips applied "a kind of market research" to art-making. They conducted interviews with 137 consumers about the kind of art

they would like, collated the information, and constructed a work accordingly, titling it *Hybrid*—the "optimum art object of the mid-'60's," Alloway called it.[58] As Kaprow viewed it, the choice of what role the artist was to play in society was up to the artist. He or she could assume the role of "archetypal victim who is 'suicided by society' (Artaud)" or try to be a successful "man of the world."[59] And if artists could not make it in a reasonable time, they ought to think of quitting.[60] After all, as Jack Tworkov put it with more than a tinge of bitterness, "To be fashionable is good, to be unfashionable is bad esthetics."[61]

Kaprow was at his most vulnerable when he implied that avant-garde artists should keep their middle-class audience in mind while making their aesthetic decisions.[62] It was on this issue that Thomas Hess attacked him. Would not artists become alienated from their true beings or visions? And what about, in Hess's words, "such nineteenth century Romantic bric-à-brac as Inspiration, Passion, Redemption, Mystery"?[63] What was worse, were "not serious artists . . . being pushed off the stage . . . in favor of chic art-gimmicks," and being distracted from their work?[64] Hess had in mind an image of a "true" artist, the artist as Romantic hero or shaman, who, in order to develop as an artist, went into an interior exile "aggressively indifferent [to] middle-brow, middle-class society."[65]

Kaprow denied the validity of Hess's image, claiming that it was absurd to continue to conceive of artists as "a kind of self-conscious aristocracy which [they] assumed after the titled aristocracy lost its power in Europe [and] a priesthood of exclusive truth finders."[66] How could artists be alienated from their true being if that being was bourgeois? But in hindsight, Hess seems to have been closer to the truth of artists' practice than Kaprow was. The most innovative and the best of sixties artists did not switch styles in response to their vanguard audience's changing tastes or any other external pressure. Nor did these artists exploit signature or "brand-name" styles. Indeed, judging from their work, change appears to have occurred organically, a natural growth, rather than in swift shifts, and even when the change was sharp, as in Stella's case, it anticipated fashion rather than responded to it. The artist remained in command: even Warhol, who at times took his subject matter—but not his style—from the suggestions of others.

Nor did artists, even when they had a waiting line for their work, produce for a market. Lichtenstein remarked in conversation that if he did he would lose the collectors waiting to buy his work. They wanted it because they and art professionals they looked to for guidance were convinced that he painted what he did because he needed to, and they were sophisticated and sharp-eyed enough to recognize if he did not. So in the privacy of his studio his intention remained creation, not fabrication. In sum, innovative artists who were men of the world pursued their own visions and were not subject to changing fashions, or even to the demand for change; and their work bears this out. The new rich may have embraced their work, but they did not influence its creation. Actually, Kaprow's characterization of the artist as a man of the world applied not to innovators but to their derivative followers, on the whole mediocre. Kaprow did not distinguish between the two.

Kaprow's assertion that by 1965 the artist was in business was exemplified by Warhol's career. As Calvin Tomkins remarked:

From the moment he came to New York, from Pittsburgh, in 1949, Warhol pursued fame with the singlemindedness of a spawning salmon. He made himself one of the highest-paid commercial artists in New York through hard work as much as through native talent. And then, realizing that a commercial artist's fame was necessarily limited, he pushed on into the less anonymous fields of "fine art," movies, rock music, multimedia

spectacles—getting as much exposure as he could get out of each, measuring his success by the publicity he generated.[67]

Thus Warhol became a man of the world with a vengeance, even proclaiming himself a "business artist." In 1966, he went so far as to place an ad in the *Village Voice* offering to endorse " 'clothing Ac-Dc . . . helium . . . whips . . . anything . . . MONEY!' "[68] Warhol once claimed that he asked a woman friend of his what to paint, and she answered: " 'Well, what do you love most?' That's how I started painting money."[69] Many art professionals would not believe that Warhol's remarks were serious. There must be something more to his intentions; as Robert Hughes stated: "If he declared that he was only interested in getting rich and famous, like everybody else, he could not be telling the truth; instead, he was parodying America's obsession with celebrity, the better to deflate it."[70] Hughes himself took Warhol at his word; Warhol was interested only in celebrity and money.

After the attempt on his life in 1968, Warhol changed his life-style, partly out of fear, partly because of careerism, and he abandoned the Factory and set up a regular business office. What motivated him was the recognition that underground culture could be made salable.[71] He would try to "hit the right mixture of counterculture and slick commercialism to cash in big on the new youth market [for magazines, movies, and music]," just as the hippie musical *Hair* and the film *Midnight Cowboy* had.[72] His ambition, as he put it, was "to have a movie playing at Radio City, a show on at the Winter Garden, the cover of *Life,* a book on the best-seller list, a record on the charts."[73] And if his success was not quite that spectacular, it was nonetheless remarkable.

Perhaps the best gauge of the self-image of the artist in the sixties was the aspiration of art students. On the whole, they aimed to be successful professionals; unlike students of the fifties, who attended art schools such as Hans Hofmann's, they went to colleges and universities, earning BFAs and MFAs, tangible signs of their professionalism. There they also acquired social skills that would be useful in their careers. As Rosenberg saw it: "Instead of resigning himself to a life of bohemian disorder and frustration," the urbane art student "may now look forward to a career in which possibilities are unlimited. In short, painting is no longer a haven for self-defeating contemplatives, but a glamorous arena in which performers of talent may rival the celebrity of senators or TV stars."[74]

This change was exemplified at Yale, America's most prestigious art school, from the fifties into the sixties, and prototypical of our leading graduate art schools generally. During the fifties, under the leadership of Josef Albers, Yale turned in on itself. The curriculum was based on foundation courses in color and drawing devised by Albers and his assistants, courses aimed to develop perceptual faculties. Students were indoctrinated with the belief that the New York art world was corrupt, focused only on fashionable styles. As an antidote, artists should develop as artists independently, isolated from the temptations of current bandwagons, and show in New York only when they had achieved independent styles.

This attitude changed in the sixties, particularly after Jack Tworkov was appointed chairman of painting in 1963. Tworkov oriented Yale toward the New York art world, which had already begun to command the attention of the student body. This became the policy of most major graduate art schools in America. They made available Abstract Expressionism and the diverse tendencies that followed, turning their institutions into arenas of competing ideas, aesthetics, and attitudes—somewhat like New York. The goal was to prepare students for careers in art by offering a rich variety of artistic options to encourage students to develop

points of view that might change the course of art or contribute radically to it. Adding to the intellectual ferment was the growing number of visiting artists from New York—working pros one read about in art magazines—who were invited to lecture or to teach for varying periods. They not only criticized the work of students but made them aware of what was happening in the art world and provided role models. Students developed a familiarity with the New York art world—its structures and strategies. This gave them the confidence to think of coming to New York, experience the ferment of ideas, and exhibit their work while young.[75]

In an article titled "The College Intellectual, 1965 Model," David Boroff was impressed by the "coolness" and careerism of current students. "Bohemianism as a cult has virtually disappeared from the campus, yet it is everywhere. It has been assimilated into the mainstream." "If there is one theme that unites college intellectuals . . . it is their recognition of the intellectual abundance and of the multiplicity of their options." Moreover, they expected to inherit an affluent world. The college intellectual "learns quickly how the machinery of society works. [He or she is] inclined therefore, to think in terms of working through the power structure."[76]

# NOTES

1. Sam Hunter, in *The Harry N. Abrams Family Collection,* exhibition catalogue (New York: Jewish Museum, 1966), n.p., wrote:

   in a short span of time, serious avant-garde collecting changed from a private and depreciated "act" of commitment to untested ideas into a conspicuous public activity that drew more and more eager recruits from the new age of affluence. Advocacy and support of experimental art has now gained such a hold on the American imagination that the normal lag between artistic invention and its public acceptance is disappearing.

   This applied not only to the new-rich collectors but to a sizable audience for art, of which they were a small part.

   Henry Geldzahler, in "Introduction," *XXXIII International Biennial Exhibition of Art, Venice 1966* (Washington, D.C.: Smithsonian Institution, 1966), p. 20, observed:

   Whatever gap there once existed between advanced painting, painting ahead of its audience, and generally acknowledged classic contemporary painting, has narrowed to the point where the two are identical. [The] audience in large part understands the process of art history and is willing to accept pictures which are still somewhat impenetrable and verbally elusive. The Museum of Modern Art and its publications, the art magazines, the university art history courses, and still other forces . . . have prepared many thousands of interested viewers to look for the new and to evaluate it intelligently.

   Geldzahler wrote that in 1966. In 1961, McClandish Phillips in "Museum Attendance Is Soaring as Curators Revitalize Displays," *New York Times,* 27 November 1961, pp. 1, 32, had already remarked on soaring museum attendance and listed the reasons:

   Increased money and leisure to devote to an interest in the arts. A public cultivated to a new consciousness of styles, periods and modes, again a product of leisure time. The coming of age of a generation that became attached to museums when young because of the museum's intensive programs of child education. Space given to museums' attractions by newspapers, magazines and television, but notably by Life, whose full-color spreads have conveyed excitement to many. The attractiveness, timeliness and genius of museum displays, some of which are tied to headlines.

   The purchase in 1961 of Rembrandt's *Aristotle Contemplating the Bust of Homer* by the Metropolitan Museum of Art for a then record $2.3 million and its extensive media coverage generated widespread public interest in the visual arts.

2. The boom in the art market was, as J. B. Plumb, in "A Nose for Treasure and a Taste for Profit," *New York Times Book Review,* 15 February 1981, pp. 10–11, remarked, "an extraordinary economic development of the postwar Western world . . . one of the most remarkable social phenomena of our time." And what made the boom even more remarkable was that it was new-rich collectors who were responsible for it and that the taste of a significant number of them was for avant-garde art. It was as if the widespread belief in infinite possibilities in the sixties gave rise to an appetite for novelty and change in art.

The growing interest in the art market was reflected in the publication in 1961 of Richard H. Rush, *Art as an Investment* (New York: Prentice-Hall), and a pamphlet *Taxes and Art*, issued by the French & Co. Gallery, New York. See also Philip Leider, "Books," *Artforum*, June 1962.

Even department stores tried to cash in. Grace Glueck, in "Dime-Store Dali," *New York Times*, 17 January 1966, p. 92, reported:

Woolworth opened an art gallery in one of its Fifth Avenue stores last May. . . .

Thanks to Woolworth and other venders, 1965 may go down in history as the year that—for better or for worse—chain store merchandising really moved in on art.

One major factor is the booming art market. The other is the success of the Sears, Roebuck art-selling plan, begun in 1962 under direction of the actor and collector Vincent Price.

Both have helped to spur the scramble among discount, department and dime store chains to sell "originals" to what they believe is a vast hungry public that more conventional art galleries can't hope to reach.

Woolworth's began its Fifth Avenue venture after a two-week trial art sale at its Menlo Park, N.J. store had drawn 45,000 viewers.

E. J. Korvette, the discount chain, opened an art gallery last October at its store in Douglaston, Queens.

3. See "The Wild Ones," *Time*, 20 February 1956. Earlier, *Life* had triggered Pollock's notoriety by publishing an article titled "Jackson Pollock: Is He the Greatest Living Painter in the United States?" *Life*, 8 August 1949.

4. Les Levine, in "A Portrait of Sidney Janis," *Arts Magazine*, November 1973, p. 53, quoted Janis that after Pollock's *Autumn Rhythm* was sold for $30,000, "we had a little less trouble selling a De Kooning for ten, then [*sic*] we had a month earlier trying to sell one for five."

5. See Clement Greenberg, "How Art Writing Earns Its Bad Name," *Encounter*, December 1962, p. 67. Rosalind Constable reported in 1958 that for the first time, Europeans were acquiring quantities of American art, and avant-garde art at that. See Time Inc. Archives, New York.

6. In 1956, the Museum of Modern Art organized an exhibition of works by Americans from its own collection that toured Europe. The show made a strong impression abroad. For example, Lawrence Alloway, in "Background to Action: 4. The Shifted Centre," *Art News and Review*, 7 December 1957, p. 1, wrote: "The recent and, as far as Europe is concerned, sudden dominance of American artists in world art is a fact." He concluded on p. 2: "New York is to mid-century what Paris was to the early 20th century: it is the centre of Western art." *The*

*New American Painting* reinforced that opinion.

7. Annette Michelson, "Paris," *Arts Magazine*, June 1959, pp. 17–18.

8. See Marvin Elkoff, "The American Painter as a Blue Chip," *Esquire*, January 1965, p. 38. The success of de Kooning's show was later considered historic—but only in terms of the market, for de Kooning's career spanned more than a quarter of a century, and he was widely admired as the foremost painter of his generation, within the New York School, at least. His reputation helped, but also of considerable importance was the promotion by the Janis Gallery, which, in establishing reputations for contemporary artists, was second in importance only to the Museum of Modern Art. Janis's taste was validated by his dealing in such modern masters as Picasso, Matisse, Miró, and Mondrian. Consequently, when he took on Abstract Expressionists, his clients paid attention. But more than that, he mounted group shows mixing Europeans and Americans, at first using the one to provide cachet for the other, and then implying a parity between the two (a practice begun by the Kootz Gallery in the late forties).

9. Sophy Burnham, in *The Art Crowd* (New York: David McKay, 1973), p. 361, reported that the price of a large black picture by Stella in 1959 was $1,200; it brought $6,000 in 1964, and $25,000 in 1969. A Lichtenstein Pop painting sold for $1,200 in 1962 and $40,000 in 1967.

10. S.T. [Sidney Tillim], "In the Galleries: The New Realists," *Arts Magazine*, December 1962, p. 43. Despite Janis's success in promoting the Abstract Expressionists, most left him for the Marlborough-Gerson Gallery (later the Marlbrugh Gallery), an international giant which opened its New York operation with great fanfare in the fall of 1963. See "Art: Marlborough Country," *Newsweek*, 25 November 1963, p. 73. The Abstract Expressionists left Janis paradoxically because Marlborough-Gerson offered them a vast exhibition space, a big business organization, and a chain of European outlets, and because Janis had exhibited Pop Art, which they despised as too commercial, in *The New Realists*.

11. T.B.H. [Thomas B. Hess], "Reviews and Previews: 'New Realists,'" *Art News*, December 1962, p. 12.

12. Lawrence Alloway, *The Venice Biennale, 1895–1968: From Salon to Goldfish Bowl* (Greenwich, Conn.: New York Graphic Society, 1968), p. 151.

13. Hilton Kramer, in *The Age of the Avant-Garde: An Art Chronicle of 1956–1972* (New York: Farrar, Straus and Giroux, 1973), p. 4, implied that the new art is perishable: " 'What's new?' is no longer the exclusive possession of a tiny 'informed' public. It is now the daily concern of vast bureaucratic enterprises whose prosperity depends on keeping the question supplied with

a steady flow of compelling but perishable answers." Art, even new art, involves too much money and ego to be expendable.

14. Robert Scull, interviewed by Paul Cummings, New York, 15–28 June 1972, p. 19. Transcript in Archives of American Art, New York.

15. Tom Wolfe, "Bob and Spike," in *The Pump House Gang* (New York: Farrar, Straus and Giroux, 1968), p. 182. The popularity of Pop Art gave rise to Pop criticism, whose primary concern was with what was fashionable. This was parodied by Brian O'Doherty in "Vanity Fair: The New York Art Scene," *Newsweek*, 4 January 1965, p. 54.

What's the word? Pop is chic, thus going out. Op is in. Hard edge? Doubtful. Abstract Expressionism? Big names in, the rest—out. And a nifty little revolution for sideshow purposes: "Object" art. Coming attractions: Kinetic art (bone up on the Poetry of Technology). The Word on the words? Commitment is out. So are Accident, Chance, Happening, and other deities. Alienation is still in, but badly shopworn. The big word is Cool, which won out over Deadpan.

Even serious art magazines succumbed to Pop criticism. James S. Ackerman, "Rx for Art Criticism," *Art in America*, March–April 1966, p. 29, wrote: "In its recent advertising campaign, Art in America suggested that its subscribers could expect answers to 'Is Op the End?'; 'Will the Figure Return?'; 'After Abstract Expressionism, What?'"

16. "The Story of Pop," *Newsweek*, 25 April 1966, p. 56.

17. Frances FitzGerald, "What's New, Henry Geldzahler, What's New?" *New York/Herald Tribune*, 21 November 1965, p. 15.

18. See Andy Warhol and Pat Hackett, *Popism: The Warhol 60's* (New York: Harcourt Brace Jovanovich, 1980), pp. 283–84.

19. Tom Wolfe, "Upward with the Arts—The Success Story of Robert & Ethel Scull," *New York/World Journal Tribune*, 30 October 1966, p. 23.

20. "Show Business: Happenings: Pop Culture," *Time*, 3 May 1963, p. 73.

21. Warhol and Hackett, *Popism*, p. 86.

22. Wolfe, "Bob and Spike," pp. 177, 179–80.

23. Warhol and Hackett, *Popism*, p. 86.

24. See "The Story of Pop," *Newsweek*, 25 April 1966, p. 31.

25. Andy Warhol, *The Philosophy of Andy Warhol (From A to B and Back Again)* (New York: Harcourt Brace Jovanovich, 1975), p. 31.

26. Eugenia Sheppard, "Inside Fashion with Eugenia Sheppard," *New York/Herald Tribune*, 17 October 1965, sec. 2, p. 2. Sheppard went on to say: "Just at the moment the *Andy Warhol* Group consists mostly of Eddie [sic] Sedgwick with a touch of Ethel and Robert Scull and Baby Jane Holzer."

"Modern Living: Society," *Time*, 27 August 1965, p. 65, reported that "the newest darlings on the social circuit are artists and artisans who ten years ago were talked about but seldom talked to. . . . At the moment, the magic names are Andy and Edie."

27. Diana Rice and Ruth Labo, "The Art World According to Karp," *Images and Issues*, Spring 1982, p. 47. Ivan Karp said that Warhol was "a man who works *immensely* hard at his art, who *always* made his own pictures."

28. Warhol and Hackett, in *Popism*, p. 193, wrote that in 1966, his friendship with Geldzahler had cooled. Geldzahler was interested primarily in art, Warhol, in "Pop—Pop anything." See Roger Vaughan, "Superpop or A Night at the Factory," *New York/Herald Tribune*, 3 August 1965, pp. 7–9.

29. Bruce Kurtz, "Last Call at Max's," *Artforum*, April 1981, p. 27.

30. Tom Wolfe, *Radical Chic and Mau-Mauing the Flak Catchers* (New York: Farrar, Straus and Giroux, 1970), p. 32.

31. Tom Wolfe, "New Manners for New York: Part II: The Confidence Game," *New York/Herald Tribune*, 7 February 1965, p. 6.

32. Wolfe, *Radical Chic*, pp. 32–33.

33. David Antin, "Warhol," *Art News*, Summer 1966, p. 59. The shabby quality in Warhol's work resulted from his repeated use of unclean silk screens and similarly careless technical practices, though he obviously chose which of his works to exhibit in public and sell.

34. Warhol and Hackett, *Popism*, p. 219.

35. "The Story of Pop," p. 56.

36. Ronald Sukenick, "Up from the Garret: Success Then and Now," *New York Times Book Review*, 27 January 1985, p. 30.

37. See Anthony Haden-Guest, "The Celebrity Syndrome," *New York/World Journal Tribune*, 26 March 1967, p. 8.

38. See Allan Kaprow, "Should the Artist Be a Man of the World?" *Art News*, October 1964. Dorothy Seckler, in "The Artist in America: Victim of the Culture Boom?" *Art in America* 6 (1963): 28, quoted Larry Rivers: "Today . . . You can go into art as a career the same as law, medicine or government."

39. Hubert Crehan, "Recent Attacks on Abstract Art," *It Is 1*, Spring 1958, p. 63.

40. Seckler, "The Artist in America," p. 28.

41. John Ferren, in "Is There a New Academy?" part 2, *Art News*, September 1959, p. 39.

42. Henry Geldzahler, in "A Symposium on Pop Art," *Arts Magazine*, April 1963, p. 37.

43. Barbara Rose, "Dada Then and Now," *Art International*, 25 January 1963, p. 27.

44. See Arthur Holitscher, *First Exhibition of Russian Art*, exhibition catalogue (Berlin: Van Dremen Gallery, 1922); in Stephen Bann, ed., *The Tradition of Constructivism* (New York: Viking, 1974), pp. 72–73.

45. Barbara Rose and Irving Sandler, eds., "Sensibility of the Sixties," *Art in America*, January–February 1967, p. 46.

46. Ibid., p. 47.

47. Ibid., p. 55.

48. Kaprow, "Should the Artist Be a Man of the World?" pp. 34–36. Hubert Crehan made many of the same points that Kaprow did earlier, in "Recent Attacks on Abstract Art," p. 63.

Philip Pearlstein, in Rose and Sandler, eds., "Sensibility of the Sixties," p. 53, agreed with Kaprow: "The artist's condition has changed. One now owns a brownstone in the West 80s, or on Park Slope, or one buys into a cooperative loft building or a dairy farm somewhere. . . . What is more important, though, is the change in attitude . . . that lets serious, dedicated, totally committed artists buy, own property and have children . . . and not feel themselves destroyed. The romantic self-image is gone."

49. Alan R. Solomon, *New York: The New Art Scene* (New York: Holt, Rinehart & Winston, 1967), pp. 16–23.

50. Kaprow, "Should the Artist Be a Man of the World?" p. 36.

51. Harold Rosenberg, "After Next—What?" *Art in America* 2 (1964): 71–72. Rosenberg, in "A Guide for the Unperplexed," *Art News*, September 1966, p. 46, added:

The entire social basis of art is being transformed—to all appearances for the better. Instead of being, as it used to be, an activity of rebellion, despair or self-indulgence on the fringe of society, art is being normalized as a professional activity within society. For the first time, the art formerly called vanguard has been accepted *en masse* and its ideals of innovation, experiment, dissent, have been institutionalized and made official.

52. Kaprow, "Should the Artist Be a Man of the World?" p. 35.

53. Rose and Sandler, eds., "Sensibility of the Sixties," p. 50.

54. Kaprow, "Should the Artist Be a Man of the World?" p. 35.

55. Thomas B. Hess, Editorial, *Art News*, October 1964, p. 19.

56. Solomon, *New York: The New Art Scene*, pp. 12–15.

57. Kaprow, "Should the Artist Be a Man of the World?" p. 58.

58. Lawrence Alloway, "Hybrid," *Arts Magazine*, May 1966, p. 39.

59. Kaprow, "Should the Artist Be a Man of the World?" p. 35.

Gene Davis, in Rose and Sandler, eds., "Sensibility of the Sixties," p. 48, remarked: "The condition of the artist, economically at the least, seems to be on the upswing. There are few starving Gauguins around today unless they are dedicated masochists. There are fellowships and grants as well as teaching jobs at colleges and universities. And affluent society is buying art wholeheartedly. . . . Federal funds are being earmarked for art."

60. Kaprow, "Should the Artist Be a Man of the World?" p. 35. It was possible for an artist to know how he or she stood with the middle-class audience. As Pearlstein wrote in Rose and Sandler, eds., "Sensibility of the Sixties," p. 53, "an artist of the 'avant garde' of any stylistic persuasion . . . can expect to have almost immediate and public, even institutional, reaction and evaluation of his work. He has made it, or he just becomes one of the pack. His place is determined awfully fast."

61. Rose and Sandler, eds., "Sensibility of the Sixties," p. 49.

Hilton Kramer, in "The Season Surveyed," *Art in America* 3 (1964): 108, was also repelled by the new social status of the avant-garde artist:

The thing that impresses one more and more about the New York gallery scene . . . is the degree to which its values reflect so cheerfully and accurately the values of American society as a whole. Gone are the days when artists stood aloof from the mainstream of American life, votaries of sensibility defending precious and exalted principles against the boorish complacencies and bad taste of the majority. . . .

In politics and education and show business, it is the scandals that have long been the headline-makers—scandals, as distinct from achievements—and our artists are now showing us that they, too, are marvelously adept at this venerable American pastime. . . . It is now . . . the loudest voices and most extravagant of showmen who become the most talked about, and therefore—by means of that curious cultural alchemy that turns publicity into respectibility—the quickest to be accepted into the world where reputations are made and styles are accepted, praised, and given instant historical significance.

Among both our artists and the art audience, dullness is feared like a plague.

62. In this sense, the artist as a man of the world at his crassest was, as Mario Amaya, in *Pop as Art . . . and After* (New York: Studio/Viking, 1965), p. 16, imagined him, one "who works in almost direct relationship to the commercial art world, who produces for exhibitions rather than for himself, who tries to anticipate the expectations of powerful critics and dealers, and who must create attention at all costs or perish in a sea of thousands of other artists, all fighting to reach the raft of success."

63. Thomas B. Hess, Editorial, *Art News*, October 1964, p. 19.

64. Thomas B. Hess, "Artists and the Rat Race," *Art News*, January 1965, p. 23.

Like Hess, Gene Davis, in Rose and Sandler, eds., "Sensibility of the Sixties," p. 48, had serious reservations about the current success of artists. "In giving up his cold-water flat . . . the artist of the sixties has lost a precious commodity—his privacy and the freedom to work out

his own artistic hang-ups undisturbed by the solicitation of the critics, dealers, art magazines and mass-media."

65. Hess, "Artists and the Rat-Race," p. 23.

66. Allan Kaprow, "La Sfida del Sistema," *Metro* 14 (1968): 37.

67. Calvin Tomkins, "The Art World: The Art Incarnate," *New Yorker,* 5 May 1980, p. 114.

68. "The Story of Pop," p. 57.

69. Warhol and Hackett, *Popism,* p. 18. Warhol, on p. 114, remarked: "Picasso was the artist I admired most in all of history, because he was so prolific," implying that he was a "business artist," like Warhol himself.

70. Robert Hughes, "The Rise of Andy Warhol," *New York Review of Books,* 18 February 1982, p. 8.

71. Warhol and Hackett, *Popism,* p. 280.

72. Ibid., p. 249. Warhol, on p. 250, wrote that in the counterculture, there were two kinds of people, those who aspired to commercial success and those who wanted to remain underground. As he viewed it:

The way to be counterculture and have mass commercial success was to say and do radical things in a conservative format. Like have a well-choreographed, well-scored, anti-Establishment "hippie be-in" in a well-ventilated, well-located theater. Or like McLuhan had done—write a book saying books were obsolete.

73. Ibid., p. 204.

74. Harold Rosenberg, "A Guide for the Unperplexed," p. 46.

75. See Irving Sandler, "The School of Art at Yale, 1950–1970: The Collective Reminiscences of Twenty Distinguished Alumni," *20 Artists: Yale School of Art 1950–1970,* exhibition catalogue (New Haven: Yale University Art Gallery, 1981).

76. David Boroff, "The College Intellectual, 1965 Model," *New York Times Magazine,* 6 December 1964, pp. 134–37.

# 5 THE AVANT-GARDE ART WORLD

What was the art world of the sixties? A group of what might be called art professionals committed to new art—museum directors, curators, and trustees; art editors, critics, and historians; art dealers and collectors; and, most important, the artists to whom they listened—were *the* tastemakers. Prominent among these were Robert Rauschenberg, Jasper Johns, Frank Stella, and Andy Warhol; Alfred Barr, Dorothy Miller, Henry Geldzahler, and Alan Solomon; Clement Greenberg and John Cage; Leo Castelli, Sidney Janis, Richard Bellamy, and Ivan Karp; and Philip Johnson, Robert and Ethel Scull, and Burton and Emily Tremaine.[1] Although a number of these art professionals had been active in the Abstract Expressionist art world, many had not. On the whole, the new art of the sixties gave rise to a new art world, which included many young newcomers. These artists and art professionals were only a part of a larger art world, but as the avant-garde, they commanded greater attention than their numbers would seem to warrant. Being New Yorkers enhanced their status, because artists and art professionals throughout America believed that art had to be shown and recognized in New York before claims could be made for it as nonprovincial and significant, not to say major.

The members of this art world appointed themselves—that is, they designated *the* artists, *the* dealers, *the* critics, *the* curators, etc., who "belonged." How

this came about is not clear; perhaps it is unknowable, but it did take place. Robert Irwin once described a computerized study that attempted to define the community of artists in Los Angeles. The researchers, of whom he was one, using the so-called small-world hypothesis, began by asking a few artists to provide the names of other artists without defining what was meant by the term "artist," and then asked the artists named to do the same, on and on. As Irwin recalled, when the list numbered about six hundred, it suddenly stopped growing. This was the community "that everyone recognized—didn't necessarily identify with—but recognized." Moreover, the names of some twenty artists appeared on the list of almost every other artist; they constituted the recognized core group—what I would consider the artist *members* of the art world. Irwin was surprised by this display of unanimity by a group of artists who could agree on little else, a unanimity he could not account for. There was another unexpected result. Individuals "who made nothing that could in any way be thought of as art" were named, indicating that the "system of identification was sensitive enough to recognize something which had not yet objectified itself" as art.[2] A similar study of the New York art world would have yielded comparable results.

The New York art world functioned in two major ways in the sixties. One, it formed a "scene" that was necessary for

the well-being of art. Art thrived in New York, which attracted not only ambitious artists, who established dialogues with other ambitious artists and with art professionals, but also art professionals: art editors and critics who worked for art magazines published in New York; bright directors and curators who were drawn by the great museums there; private dealers who were committed to discovering, exhibiting, and selling the best, liveliest, and most provocative art; and knowledgeable collectors who lived there. The scene emanated an aura that inspired artists to engage difficult ideas, drove them to work to the utmost of their abilities, and provoked them constantly to question and extend their styles—with one eye to the art-for-the-ages in the museums nearby and with the other eye to the hot-off-the-griddle work of the most recent art-school graduates to enter the scene.

The art world also functioned to *validate* art—that is, to discover and show it, explicate and transmit information about it, and establish its stature in relation to other art. This was particularly so for new art, because it was the most problematic. The task was to establish the innovative as good. The validation of difficult art was achieved primarily through a loose *consensus* of the members of the art world. As Hans Haacke put it, they came "to an informal, unorganized agreement that something that was done by somebody who is participating in this fluid, funny thing that is called the art world is now considered art, and not something else."[3] It was assumed that only a consensus could determine whether art was art or not and whether it was good or bad, because there were no demonstrable, objective criteria.

It follows that the ultimate validator of art was a consensus of consensuses—or the verdict of "history." The art world in the sixties was extremely conscious of art history, in part because so many of its members were schooled in that discipline. They assumed that history established the stature of new art, turning it into art-for-

the-ages, and they hoped that history would ultimately validate the new art they supported (art that they often thought had to break with history to make history) and, in the process, write into history their own activities on its behalf—although they frequently behaved as though the art they promoted were already inscribed in the history texts.[4] It was recognized that the judgments of history are temporal and transient, thus not very reliable. But art of extraordinary quality did appear to get to be accepted by so many consensuses that its validity appeared eternal—beyond history. Indeed, it is likely that the appeal to history issued from an urge for immortality. Quality could be seen as timeless, absolute, universal; and art that possessed it could achieve a mythic or quasi-religious status.

An art-world consensus was revealed quantitatively by the number of shows given an artist in museums and private galleries; by the number of works acquired by museums and important collectors and included in museum exhibitions and on permanent or frequent display; by the number of articles and serious reviews written about the work by critics, and so forth. "How many" counted for much, but so did "which," "where," and "who." Certain artists, galleries, critics, publications, curators, museums, etc., had more prestige than others. To be a significant tastemaker, an artist had to create a body of work that not only appeared to have quality, make an important *new* contribution to art, seeming to change its course, and thus to be of potential historic interest, but also attracted the attention of other artists and professionals so that a coterie was formed about him or her. To be important, an art professional had to be ahead of his or her colleagues in recognizing major new art, and had to write about it, show it, or sell it, just as Greenberg had that of Pollock, Newman, Louis, and Noland; and Castelli that of Rauschenberg, Johns, Stella, and Lichtenstein. Alfred Barr of the Museum of Modern Art ranked above all

other museum professionals. The prestige conferred on an artist by Barr's exhibition of a work in the permanent collection—the greatest in the world—was inestimable; there was no greater honor than a retrospective show. Indeed, the prestige of the museum was so great that it was often accused of creating the history it was supposed to be documenting.[5] Belonging to the Castelli Gallery was worth more than belonging to any other gallery. An essay about an artist or even a favorable mention by Greenberg counted for immeasurably more than did any other critic's writing. An article in or a reproduction on the cover of *Artforum* contributed more to an artist's status than did similar treatment in any other art magazine. Being in an important private collection—for example, that of a trustee of the Museum of Modern Art, such as Philip Johnson; of the Sculls, because of their media coverage; or of William Rubin, a respected art historian and critic, who in 1967 was appointed curator of painting and sculpture at MoMA[6]—meant more than being in presumably lesser collections.

What made an artist's or an art professional's opinion count or carry weight was the seriousness with which it was taken within the art world, the attention paid to it, its persuasiveness, in a word, at any moment. This was what was meant by *power*—that is, the effectiveness of an individual's role in shaping the consensus and thus in validating art. Independence of opinion was valued, particularly if it contributed substantially to defining the area of art discourse. But to merit consideration, any opinion had to relate to the discourse, deal with issues and styles deemed relevant by the art world, and fit within the context of its thinking. This last was not monolithic. It tended to be split into at least two main camps—one espousing a formalist or purist art-for-art's-sake position, the other advocating an impurist mingling of life and art—and there were any number of positions that could be taken between these extremes. They could even be bridged, as Solomon and Geldzahler did. But the art world understood the dialectic between purity and impurity: its particular frames of reference, terminologies, and hierarchies of artists. Certain assumptions about art, artists, and the art world became so ingrained that they did *not* require articulation. For example, Max Kozloff vehemently attacked the aesthetics of formalist critics, and yet accepted the abstract artists they championed. In 1965, he wrote: "Of late, the career of abstract art, once uneasy and open-ended, is gelling in the work of a handful of American painters who have pressed a series of interlocking, but unique visions into existence. Three such painters are Kenneth Noland, Jules Olitski, and Frank Stella. Another, still in his twenties, is Larry Poons."[7]

In general, the consensus favored art that "advanced" formally or was thought to "advance" from a known aesthetic position. Stella's black-stripe paintings, for example, were seen as a "next move" from Johns's paintings, or Louis's stained abstraction as a novel development of Pollock's and Frankenthaler's "pour" technique and Newman's color-fields. What mattered to art professionals was the sense that an established stream of art seemed to have been deflected in a new direction—a phenomenon that was demonstrable, that could be pointed to—although they claimed to be attracted more by the high quality of the new work. Actually, it was easier to recognize quality in new art that bore some relation to past art whose quality was accepted than in new art that was unprecedented. It is difficult to know whether it was the novelty of the new art or its quality that exerted the initial appeal. In all likelihood, novelty took precedence over quality. The new was proclaimed as good—by consensus, as it were.

Art professionals looked to the artists they admired and to one another for confirmation of their taste, ideas, and activi-

ties. In most cases, the esteem of their colleagues was the primary reward for their work—the gratification of being "right," of feeling "in" where it counted—and, if not that, the means whereby other goals were achieved. Recognition by the art world often led to tangible rewards—commissions for dealers, promotions for museum personnel, etc.—and the rewards were taken as proof of the esteem.

Art professionals interacted easily because most were conditioned by a common culture: they came from the same social class, received a similar education, lived in Manhattan, saw the same shows in galleries and museums, read the same art books and magazines, were inclined to new art, and so forth. To put it simply, they spoke the same language. Thus it was natural for them to get to know one another personally, and because they did, the art world was a loose association. In fact, it was difficult for its members in New York *not* to interact, unless they avoided innumerable gallery and museum openings, lectures and panels, art-world parties, dinners, weekends in the country, and other social events.

Personal contacts facilitated the flow of information. Art professionals looked to what their colleagues recommended and, if they esteemed someone's taste, they were disposed to the art he or she spoke highly of. For example, Stella had been a student of William Seitz, Robert Rosenblum, and Stephen Greene at Princeton. They spoke to Castelli, John Myers, and Dorothy Miller of their admiration for his painting. Myers included Stella in a new talent show he organized at the Tibor de Nagy Gallery. Miller saw the work there. Soon after, she received a phone call from Castelli, who invited her to go with him to visit Stella in his studio. She was so impressed by what she saw there that she returned with Alfred Barr and included Stella in her *Sixteen Americans* show at the Museum of Modern Art.[8] Barr then was instrumental in purchasing *The Marriage of Reason and Squalor* for the Mod-

ern. Soon after, Castelli gave Stella his first gallery exhibition. For a time after he began to work at the Metropolitan Museum in 1960, Geldzahler accompanied Richard Bellamy and Ivan Karp, often both together, on visits to studios, on the lookout for new artists for the Green and Castelli galleries. Geldzahler felt that there "was a real reason for them to go and there was a real reason for me to go, too, because . . . I had a lot to learn from them."[9]

The art professionals' common awareness of contemporary art and culture—what was stale, what was fresh—although it shaped and was shaped by their individual appetites and perceptions of quality, caused them to favor the same art or to consider it seriously or, at least, to understand why it was admired. This led Michael Compton of the Tate Gallery, London, to remark on the "astounding degree of unanimity . . . on what is good, bad, and indifferent" found in the international circle concerned with contemporary art. Addressing a group of leading directors of American and European museums, he said:

> If we were to go into a room individually and were asked to make our selections out of two hundred paintings, I bet you that the correlations between our answers would be incredibly close. But this isn't conspiracy; it arises out of the fact that we belong to the same club, and that the field of contemporary art is, so to speak, a subculture, which validates itself rather in the way, I think, that a religious group validates itself. Also, like a religious group, what we're setting out to do is proselytize something that we personally feel excited about.[10]

And, as with religious groups, there were schisms. Curiously, the most divisive splits occurred among art professionals whose aesthetic attitudes were close, the most abrasive of which was within the narrow area of purist abstraction, between so-called formalists and Minimalists.[11] The emotion with which intricate polemical battles were carried on was peculiarly in-

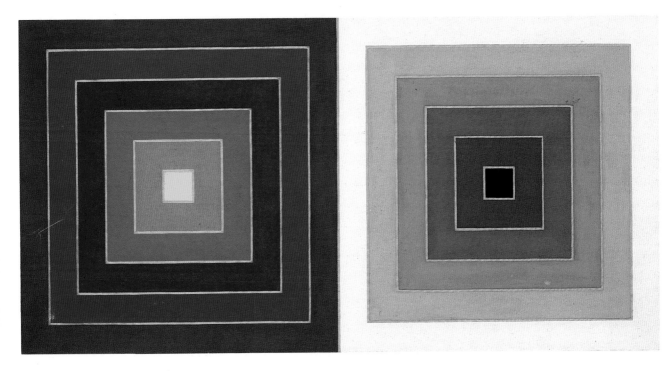

**I.** Frank Stella, *Rye Beach,* 1963. Alkyd on canvas, 30⅜″ x 60½″.
Private collection, courtesy Blum-Helman Gallery, New York.

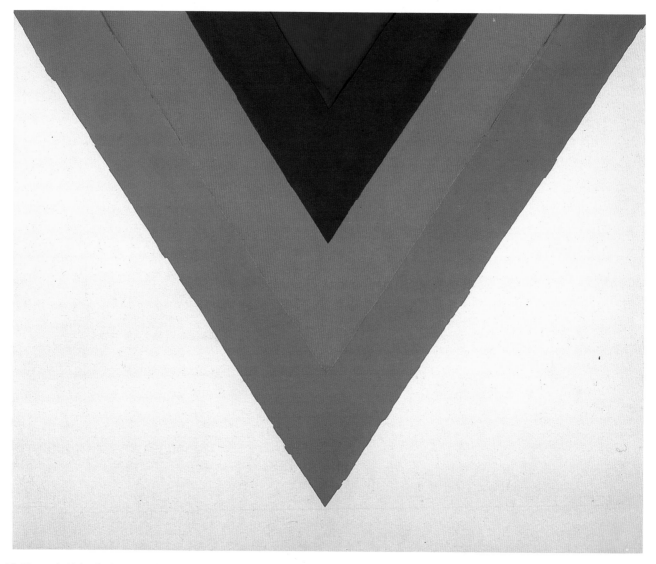

**II.** Kenneth Noland, *Across,* 1964. Acrylic resin on canvas,
97″ x 126″. Courtesy, Andre Emmerich Gallery, New York.

**III.** Al Held, *Mao*, 1967. Acrylic on canvas, 114″ x 114″.
Collection, Mara Held, New York.

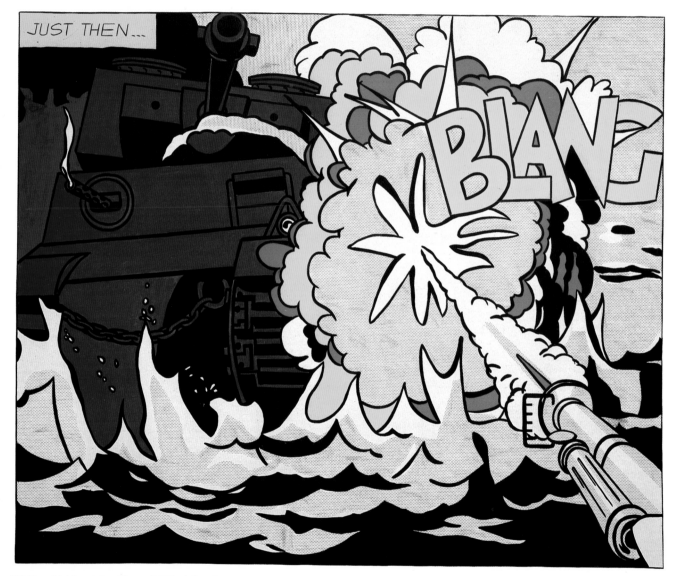

**IV.** Roy Lichtenstein, *Blang,* 1962. Oil and magna on canvas, 68″ x 80″.
Private collection, courtesy Blum-Helman Gallery, New York.

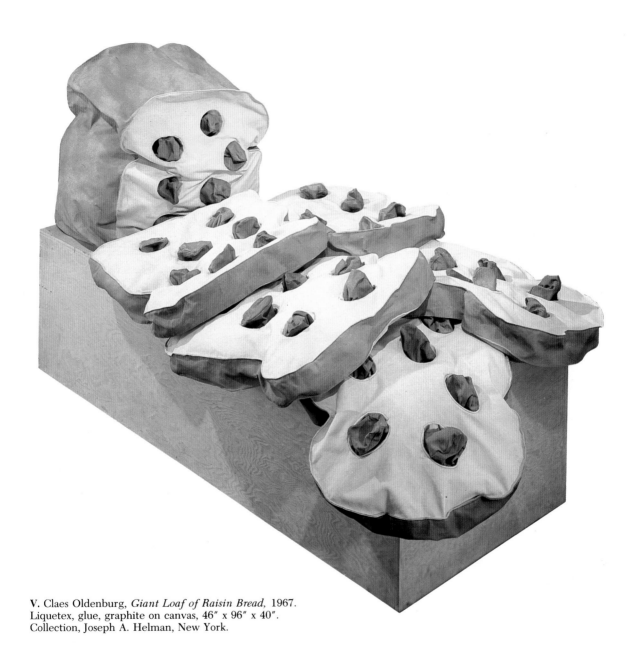

**V.** Claes Oldenburg, *Giant Loaf of Raisin Bread*, 1967.
Liquetex, glue, graphite on canvas, 46″ x 96″ x 40″.
Collection, Joseph A. Helman, New York.

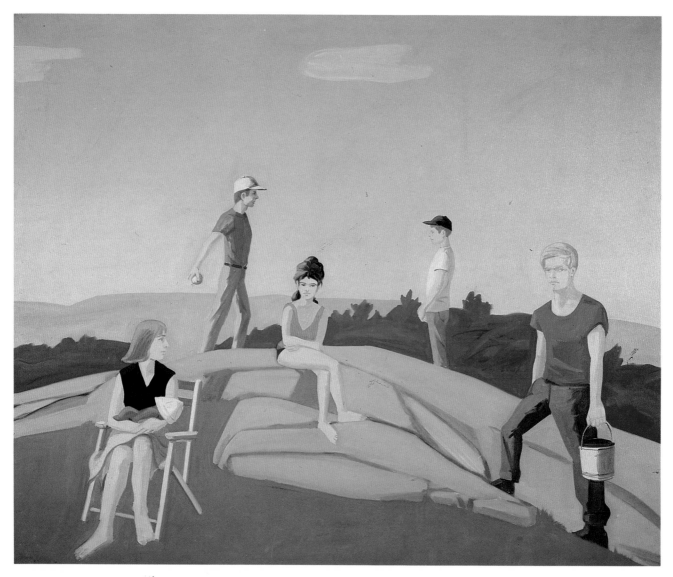

**VI.** Alex Katz, *Ives Field #1,* 1964. Oil on canvas,
78″ x 96″. Collection, the artist.

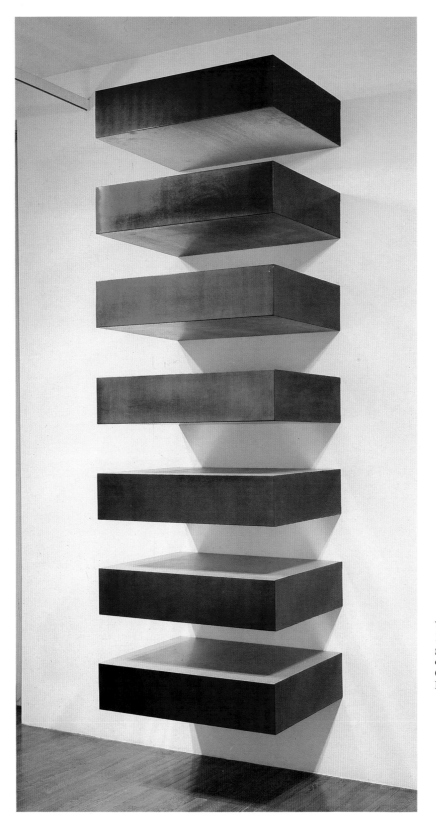

**VII.** Donald Judd, *Untitled,*
1967. Green lacquer/
galvanized iron,
each unit 9″ x 40″ x 31″.
Collection, Joseph A.
Helman, New York.

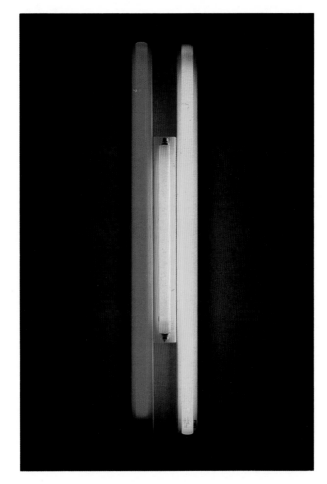

**VIII.** Dan Flavin, *Puerto Rican Lights (To Jeanie Blake),* 1965. Fluorescent light, 49″ x 8½″ x 4¾″. Collection, Leo Castelli Gallery, New York. Photo: courtesy Leo Castelli Gallery.

*Below:*
**IX.** Eva Hesse, *Sans II,* 1968. Fiberglass, 38″ x 170¾″ x 6⅛″. Collection of Whitney Museum of American Art, New York. Purchase with funds from Dr. and Mrs. Lester J. Honig and the Albert A. List Family. Acq.#69.105.

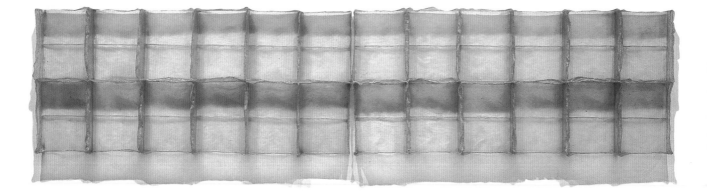

tense, exacerbated because the coteries involved made cultist demands for art-canonical purity, and because art discourse and art were closely related, the one often influencing the other. The mixture of finely honed intellectuality and quasi-religious passion made sixties art talk dramatic and compelling, if only for the initiated.

A "core" group of artists, as Robert Irwin observed, constituted the prime movers of the art world. Through a "dialogue of colleagueship," they defined what art was and determined whether it was significant and had quality.[12] This fact was often overlooked; the assumption was that artists looked to the art world for validation, and they did to some degree. For the most part, however, dealers, editors, critics, museum directors, curators, and collectors relied on the artists they admired for information, ideas, and, equally important, opinions.[13] When art professionals were strongly impressed by an artist's work, particularly if it was problematic, they generally searched out the artist to learn at first hand about his or her intentions and conceptions. Who else knew better what they were? Art professionals also listened closely to what an artist had to say about other artists. It was a natural process.

In deciding whether to represent artists, dealers responded not only to their art but to their personalities in the attempt to gauge potential for development as well as current achievement. After all, a dealer who undertook to promote an artist naturally thought of what the future might hold. Dealers and the artists they represented often became close friends, as in the case of Castelli and Rauschenberg and Johns, leading the one to be swayed by the opinions of the others. Castelli remarked that his gallery was a kind of club and that belonging was what made being a dealer most attractive.[14]

With a few exceptions, critics also moved in artists' circles in search of ideas and information, and collectors visited studios, intent on discovering artists before dealers did. Museum directors and curators cultivated artists too. When seven of the Western world's leading museum professionals were asked what they felt was the single most important influence on their decision-making, every one answered that it was artists. As Compton stated: "If we want to know what is good . . . we go and ask the artists. Secondly, we determine what is good art by the fact that other artists imitate it."[15] In fact, artists acquired tastemaking power only after their work began to interest other artists and then art professionals, leading to the formation of coteries. A coterie provided an artist with a group of peers who strongly believed in what he or she believed in, a group that was, moreover, the artist's most knowledgeable, stimulating, and critical, and therefore ideal, audience. Coteries took the art of their members out of the realm of doing-one's-own-thing and placed it in the realm of culture, turning art-making into culture-making, as Al Held noted.[16] A coterie identified its leaders, but it also occurred to its members that a group was more influential than an individual in promoting art. Thus, although they were competitors, they tended to foster one another's careers, if only for a short time. Not all coteries succeeded: only the few that could generate sufficient energies to activate significant sectors of the art world on their behalf.

Jeffrey Deitch summed it up:

New directions in art begin with an early consensus among small groups of artists that certain individuals are doing important work. A mutual admiration society between John Q. Artist and his friends would not necessarily lead anywhere. But when a young critic joins the circle and starts talking them up, and when an adventurous collector buys some pieces and starts inviting the artists over for dinner, you have the beginnings of a little clique.

If the members of the group are lively enough then perhaps the clique will begin taking over a corner table at one of the art-

ists' bars several nights a week. Perhaps a young dealer will put several members of the clique into a group show [giving them] a public identity for the first time. . . . With a strong core group of artists who admire each other and think along similar lines, a critic or two to deliver the rap, and with dealers and collectors expressing a tentative interest, the clique is already something to be reckoned with. It already has power.

These informal cliques that are continually forming, merging, splitting, growing, and disappearing are the real key to power in the art world.

In conclusion, Deitch reiterated: "It is likely that the newest trends in art would already have strong constituencies in the artist community before they came to the attention of the art elite." Furthermore: "The power to change the direction of both short and long term art history is in the hands of the emerging artists and their art world contemporaries."[17]

Among the leading coteries, one was centered on Rauschenberg and Johns and involved their mentors and friends Cage and Merce Cunningham and their dealer, Castelli, whose gallery was a focal point. Younger artists in the gallery—Stella, Lichtenstein, and when the Green Gallery closed in 1965, Rosenquist, and also Oldenburg, Warhol, and Morris—became members of the Rauschenberg-Johns coterie.[18] So did Cage's and Rauschenberg's friends in Experiments in Art and Technology (EAT), such as Billy Klüver and Robert Whitman. The circle also included Castelli's associate, Ivan Karp, dealers Richard Bellamy and David Whitney, museum curator Alan Solomon, art critic Barbara Rose (Stella), and collectors Robert and Ethel Scull.

Stella attracted his own coterie, including his former Princeton classmates: painter Walter Darby Bannard and critic Michael Fried; his professors: critic-historians Robert Rosenblum and William Seitz, and painter Stephen Greene. Other members were Rose, curator Henry Geldzahler, photographer Hollis Frampton, sculptors Carl Andre and John Chamberlain, painters Will Insley, Neil Williams, Larry Poons, and Larry Zox, later joined by Minimal sculptors Donald Judd and Robert Morris.

Another coterie was centered on Clement Greenberg and embraced his formalist aesthetic. Solomon called the group the Green Mountain Boys, an allusion to Greenberg's name and the mountains of Vermont, the location of Bennington College, at which many of the "Boys" taught.[19] The artists were Frankenthaler, Paul Feeley, Morris Louis (who died in 1962), Kenneth Noland, Jules Olitski, and Anthony Caro, most of whom exhibited in the André Emmerich Gallery. Elder statesmen were David Smith and Barnett Newman (for a time). Younger artists were Bannard, Zox, and Poons, who were also in Stella's coterie, and for a short period, Stella himself and Rose. Friedel Dzubas and Michael Steiner later joined this circle. Among the critics were Rosalind Krauss and Kermit Champa; among the curators, Jane Harrison Cone, Kenworth Moffett, Geldzahler, and E. A. Carmean. The dealers in the Greenberg group were Emmerich, Kasmin in London, and in Paris, Laurence Rubin, brother of William Rubin, who was also sympathetic to Greenberg's aesthetic.

Still another coterie of younger artists came to be called the Bowery Boys, because most lived close to one another on the Bowery. They were inclined toward Minimalism and the tendencies it gave rise to. The circle began to form in 1960 at the Museum of Modern Art, where its charter members worked: LeWitt manned the information and book-sales desk; Lippard and Robert Mangold worked in the library, and Dan Flavin and Robert Ryman were guards. In that year, LeWitt met Eva Hesse and her husband, Tom Doyle; Lippard became friendly with them in 1963, the year before she began to write art criticism.[20] She remarked:

In 1965, Smithson and Nancy Holt met Bochner, Hesse, Vollmer (and me). Bochner

met Hesse and LeWitt. . . . In the same period, Tom Doyle brought his dealer, Virginia Dwan, to LeWitt's studio; LeWitt introduced her to Smithson; both ended up with Doyle in the stable of the Dwan Gallery, and Smithson helped Ad Reinhardt [a father figure of the coterie] with the "Ten" show there in fall, 1966, which made Dwan the hot bed of "cool art."[21]

Dealers in contemporary art constituted a special breed.[22] They were generally the first to introduce new art to the public. They often took the advice of artists and art professionals they admired,[23] but it was they who risked their reputations and money (gallery and warehouse rents, salaries paid to assistants, secretaries, and bookkeepers; outlay for publicity, shipping, insurance, photography, etc.). Shows in commercial galleries preceded coverage by art magazines. The latter might review a first show of an unknown but waited for art-world opinion to build up prior to publishing an article on an artist. And museums marked time until the artist's reputation was established by repeated shows in private galleries and articles in art magazines. When a Castelli, a Bellamy, or an Emmerich exhibited a little-known artist, it was "more an act of faith than a business proposition."[24] Such dealers dealt not as brokers in art of proven market worth but as aesthetic adventurers with a streak of the impresario, not afraid to gamble on their taste. The financial burden of dealers was made heavier in the sixties because of stipends many began to pay artists and because of the growing need they felt to promote their artists. Dealers not only took ever larger advertisements in the growing number of art magazines but began to produce ever more lavish exhibition announcements, catalogues, and posters. (Museums, fueled by new money, followed suit, their publications often approaching coffee-table proportions. In fact, the sheer mass of printed material on new art was one phenomenon that set the sixties apart from the preceding decades.)

More often than not, new art did not sell. (In the relatively few cases where prices subsequently jumped—and there was no predicting that they would—dealers were often condemned as rapacious, their initial risk-taking forgotten.) All in all, there was not much profit to be made, even by the best-selling galleries in new art, until late in the sixties.[25]

What, then, were the motives of dealers, other than making money? Above all, love of art and an urge to do something about it. Then, as Castelli said, hero worship of artists and a desire to be with them, to live their lives.[26] Castelli also seemed more intent on making history than on getting rich. He dreamed of being a contemporary Paul Durand-Ruel, Ambroise Vollard, or Henry Kahnweiler. Of course, if Castelli succeeded in his ambition, he could not help making money, given the expanding art market; still, his eye was not on what might readily sell but on what was of quality and significance, even if there was no immediate market for it. Sidney Janis, who rivaled Castelli as the preeminent dealer in contemporary American art, was much like his friend. Sculptor Sidney Geist wrote of Janis: "Beyond his entrepreneurial skills, Janis has breadth of knowledge, a fervent and unflagging love of art and an intuition of grandeur."[27] And the same could be said of André Emmerich and younger dealers, such as Richard Bellamy and Ivan Karp, indeed of the majority of leading dealers, but not all. Their opposite number was Frank Lloyd of the Marlborough Gallery. When asked what art he collected, he was reported to have replied: "I only collect money, I don't collect pictures."[28]

In large part, a dealer's tastemaking power was measured by his or her success in selecting new artists whose work would command consensus support. It was vital to achieve the reputation of being a discoverer, of showing art before it became established (and expensive). A successful dealer's taste would be validated in time by growing sales at ever higher prices to

ever more prestigious private and public collectors, by articles and museum shows—all of this augmenting his or her status. A dealer's success was also gauged by the ability to keep the successful artists he or she discovered and to attract others. As Stella remarked, the reputation of the Castelli Gallery was based on "the cumulative impact of . . . artists who seem to have the ability to make an impression." "Leo has a nice sense of what is going on, where the main line of energy and activity is. If you go to see Leo, you're not going to be out in left field, you're going to be somewhere near where the action is."[29]

Because of the number of consensus-supported artists he represented, Castelli was the leading dealer in new art. He had been an early friend and supporter of the Abstract Expressionists and was instrumental in organizing the legendary Ninth Street show in 1951. By the time he opened his own gallery, in 1957, however, most of the older Abstract Expressionists were taken by the Janis Gallery, and Castelli looked to the next generation. The followers of established styles did not engage him for long; he soon recognized that Johns and Rauschenberg were different, and he grew increasingly enthusiastic about them and about Pop and Minimal artists who extended their ideas. Castelli was intensely conscious of art history and its contemporary developments. His view was not recorded in published articles or books, but it was understood by the art world—and recognized as an aesthetic counter to that of Greenberg. Castelli's position was manifest in his choice of artists. It provided a sense of a logical and necessary evolution from one generation to the next or, more important, a sense of history being made. There was implicit in his selection a genealogy: Johns begat Stella, Lichtenstein, Warhol, and Morris; Rauschenberg begat Rosenquist; Stella begat Judd and Morris; Johns and Morris begat Nauman; and so forth.

Castelli was among the first of American dealers to recognize that there was a market in Europe for American art. He was convinced that the prestige generated by sales and recognition abroad would help him achieve validation for his artists and build a market for them in the United States. As he said: "I always believed a world reputation was necessary for my artists. . . . For years and years I made sacrifices in sending paintings over to Europe."[30] It was expensive, but Castelli did not stint. So openhanded was he that he achieved a justified reputation for being prodigal and altruistic and an obviously unjustified reputation for being a poor businessman. It needed a Castelli, fluent in six languages, to internationalize the American art that followed Abstract Expressionism. His gallery became a haven for foreign art professionals; he also possessed the cosmopolitanism, refinement, and poise that allowed him to be at home in their countries. He understood the importance of cultivating the press and the other media and went out of his way to be hospitable to critics and journalists, and generous in providing them with information and photographs. Understandably, this material kept cropping up in periodicals.

Castelli developed the European market by advertising lavishly and arranging shows for his artists in a loose network of what he called "friendly" galleries throughout Europe (and America), which entered into split-commission arrangements with his own gallery and represented his artists in their "territories."[31] This enabled him to prepare the groundwork for Rauschenberg's capture of the International Grand Prize for Painting at the Venice Biennale in 1964. The acclaim for Rauschenberg and, soon after, Johns paved the way for the speedy recognition of Pop Art, which in turn augmented Rauschenberg's and Johns's reputations, all redounding to the prestige of Castelli and his gallery and facilitating ever greater success.

Because of Castelli's success, he was often singled out for calumny, as the vil-

lain who "did in" Abstract Expressionism and "put over" Pop Art, as the "Svengali of Pop Art," according to the *New York Times* in 1966.[32] Yet in the following year, Philip Leider, editor of *Artforum,* who was both worldly and incorruptible, volunteered the following statement in (of all places) a homage to Castelli published by the gallery:

> As everyone knows, Leo Castelli bribes all the critics, and that's how come.
>
> As everyone knows, Leo Castelli exerts unwholesome pressures on art magazines with his unscrupulously vast advertising budget, and that's how come.
>
> As everyone knows, Leo Castelli is all the time maneuvering so cunning in ten languages at all the international art annuals and biennials and triennials, and that's how come.
>
> As everyone knows, Leo Castelli all the time flatters and fawns the rich collectors and that's how come.
>
> Leo Castelli has been showing and selling the best art in the world for ten years but that has nothing to do with it, as everybody knows.[33]

Most of the other contributors to that Castelli catalogue were, like Leider, leading sixties art professionals of unquestioned integrity: critics or critic-historians—Lawrence Alloway, Thomas B. Hess, Max Kozloff, Annette Michelson, Barbara Rose, Robert Rosenblum, William S. Rubin, Leo Steinberg, and Calvin Tomkins; museum directors or curators—William C. Agee, Ellen H. Johnson, William Seitz, and Alan Solomon; as well as composer John Cage. Leider and the assortment of other art notables had an image of Castelli as an individual devoted to living art and not some money-grubbing abstraction.

Although Castelli was unquestionably *the* dealer of the sixties, even he could not achieve success for all the artists he represented. Castelli's "failures" point up the fact that the art world was not monolithic. There was no single center, and no one person or group controlled its varied and far-flung activities, and this even though

the art world was small enough for most leading critics, dealers, curators, and even collectors to know each other. No single agency, not even a Castelli, could guarantee an artist's success. Nor could the esteem of fellow professionals assure success for a gallery, the proof of which was the demise of the Green Gallery in 1965 after five seasons. Indeed, as Amy Goldin wrote in her obituary for the gallery: "The financial failure of Green would be meaningless if it were not accompanied by massive evidence of its artistic success."[34] The gallery was run by Richard Bellamy, who was truly the "eye" of the sixties. He had exhibited, often the first to do so, Rosenquist, Oldenburg, Segal, Samaras, Bladen, di Suvero, Morris, Wesselmann, Flavin, Poons, and Judd, and he introduced many of the liveliest unknown artists to Castelli and other dealers. The gallery was subsidized by Robert Scull, who promised to purchase a specified amount of art. Yet despite Bellamy's recognized taste in new art, a taste validated by the art world, and the financial backing of Scull, the Green Gallery did not survive. The cause was a gap between the cost of rising stipends to artists and the proceeds from sales.

Just as dealers validated new art and contributed to the art-world consensus, so did large-scale collectors, whose numbers jumped in the affluent sixties.[35] Why did they collect? Above all, for aesthetic gratification. But art could also be a means of self-definition. And it could satisfy an acquisitive urge. Displayed conspicuously, it could testify to the elevated or, at least, lively taste and culture of its owners. Their acquisitions could make them fashionable, both offering them entry into the art world and enhancing their social position. Above all, art could confer the distinction associated with aristocratic behavior on collectors, the majority of whom were new rich.[36] A number intended to donate their holdings to a museum, receiving in return a permanent room or wing, or even an entire museum named after them, as was the case with Joseph Hirshhorn and

Roy Neuberger, the names going down through the ages. In addition, avant-garde collectors hoped to be written into history, because, as Scull put it, they got "involved with people who create [and were] of some help in buying their work early in their lives."[37] At the least, they desired to build collections that would impress the art world that they really grasped what was happening in the newest art and could make fine discriminations. Thus they solicited advice from artists and art professionals, if only to confirm their own taste.

It would be naive to underestimate the lure of potential monetary profit. Art was an investment, and it was expected that prices would go up for art of quality, particularly in an expanding market—and in most cases, consensus-supported art did. Art was also a hedge against inflation. Moreover, there were generous tax benefits. Jerome S. Rubin remarked:

> A gift of tangible property, such as a work of art [to a public museum], is deductible in the amount of the fair market value of the property at the time of the gift, irrespective of how much the donor may have paid for the property. Moreover, the donor is not taxed for any increase in value. The postwar bull market in the art world, itself feeding on the tax laws, has thus opened up extraordinary opportunities for the high-bracket taxpayer.[38]

But committed collectors did not acquire art for purposes of tax deductions, although they took full advantage of them. Nor did they care about investing for profit, although they were pleased when prices went up, since this confirmed their taste. They bought art before it reached safe levels of acceptance and a concomitant price level, when it was avant-garde, indeed because it was avant-garde; a number of neophiliacs would accept nothing less. This led them to vie for particular paintings and sculptures, or try to acquire an artist's work before any other collector or even dealer had, going so far as to track it right into the studio. So avid were collec-tors for certain works that they feuded bitterly with one another and with dealers; the notorious rivalry of the Sculls and the Tremaines was a case in point.

Artists and art professionals engaged in a continual discourse about art. All felt compelled to deal with their experience of art verbally. What distinguished art critics was their desire to record their opinions for publication and their ability to write— and the quality of the prose was vital. For criticism to be more than a private matter, it had to relate to art-world discourse. Critics tried to direct the discourse and influence the consensus it yielded, but they looked to the art world for confirmation of their opinions. Like artists and fellow professionals, they yearned to be written into history, as Baudelaire and Apollinaire had been or as Greenberg was likely to be. Rose remarked on "the critic's new sense of his historical role, his wish to be affiliated with whatever history will judge to have been the *avant-garde* work of a particular moment (whether he likes it or not)."[39] In her opinion, being on the side of history counted for even more than an individual's experience of art.

Like other members of the art world, most critics listened closely to the artists they admired—and read their writing because artists often wrote criticism or polemics on behalf of the art they and like-minded artists were making. This prompted Lippard to remark: "In the mid-'60s the lines between 'artist' and 'writer' and 'theoretician' were blurred."[40] Certainly it was far more acceptable in the sixties than in the fifties for artists to be verbal about art history, criticism, and theory. And it was openly acknowledged that every work itself constituted, among other things, a gloss on all other art, a visual gloss that could be translated into words. Criticism was not something alien, foisted on art, but was intrinsic to the creative act. This attitude enhanced the role of art critics, and they grew increasingly influential in shaping the art-world consensus. They also benefited from the demand on the

part of a new and growing international public for up-to-the-moment information, opinion, and advice about advanced and difficult styles, which were turning over with bewildering rapidity.

Notwithstanding the newly elevated image of art critics, their economic condition remained low. A few were well paid and had full-time jobs, notably those employed by the *New York Times, Newsweek,* or *Time.* But most were free-lance, writing for monthly art journals; they were the most poorly paid of art professionals. With the exception of a handful who could turn out reams of writing, they had to support their criticism by teaching, lecturing, curating guest shows in museums, jurying, etc., often risking conflicts of interest. Consequently art writing was done primarily for its own sake. Because there were relatively few critics, they could generally publish what they themselves chose to write, but in most cases only if there was sufficient corroborative opinion in the art world. There were other limitations, such as the taste of art editors, who, though they might publish articles on artists they did not esteem, might stint on illustrations, particularly in color, which many artists prized more than writing, more even than exhibitions.[41]

Greenberg was "the dean of post-war critics," as William Rubin called him in 1960.[42] Because his formalist ideology dominated art discourse, he rivaled Castelli in power. Greenberg, in his role of "kingmaker,"[43] was instrumental in establishing stained color-field painting as equal in stature to Pop Art and Minimal Art. His tastemaking power was augmented by that of critics influenced by him—notably Bannard, Fried, Krauss, Rose, and Rubin—and the prestige of *Artforum,* in which most of them published. They esteemed Greenberg because of his taste and his seemingly rigorous formalist practice.

In the name of empiricism, Greenberg insisted on dealing exclusively with the formal components of art, the analysis of which he claimed was objective, implying scientific—that is, visually demonstrable. He condemned as disreputable inquiry into issues "external" to art, exemplified by the subjective, existentialist, and poetic art writing prevalent in the fifties, writing based on such unverifiable notions as creative agony, self-discovery and self-transformation, and visions of the sublime.[44] Greenberg rooted his formalist analysis in art history, claiming to *describe* styles in modernist art, and their progression. He appealed to history and science, the two most powerful myths of the twentieth century, as Jacques Ellul had called them. Ellul also wrote of "the transmutation of history into a value, which leads to the view that history is the judge of good and evil"[45] or—in art—good and bad, and that is the view of art history to which Greenberg subscribed.[46] His "eye" did seem to be on the side of history, and that was a large part of his charisma. He had been early in recognizing the Abstract Expressionists, notably Pollock in the forties, and Still, Newman, and Rothko in the early fifties, when they were relatively neglected. And he had been the first to champion Louis and Noland in the late fifties and Caro and Olitski in the early sixties. Thus Greenberg's taste contributed considerably to his influence; it was as important as his reasoned justifications for the art he admired. Together, Greenberg's taste and his ideas lent his criticism an unequaled authority.

Greenberg's seemingly objective and history-minded approach felt just right to young critics of the sixties, because many were or had been graduate students of art history in our most elite universities: Harvard, Columbia, and Princeton.[47] The method they had learned was genealogical: style A begat style B begat style C. Like their professors, such as Sydney Freedberg at Harvard, Greenberg stressed the formal continuity of art, indeed the inevitability of its development right down to the present moment (and even into the future, so it seemed). As he

viewed it, Abstract Expressionism had run its course and had begat—or progressed into—post-painterly stained color-field abstraction. Because it was based on the technique of soaking thinned pigment into raw canvas, stained color-field painting approached more closely than ever before the goal of modernist painting—that is, the intrinsic expressiveness of the painting medium without any other reference. In sculpture, Greenberg believed that the modern tradition stemmed from the welded construction of Picasso, Julio Gonzales, and David Smith, and claimed that it had been most successfully extended by Caro.

Young scholars, struck by the affinity between formalist art history and formalist criticism, were excited by both Greenberg's approach and his interpretation of modernist history. Greenberg conveyed the impression of owning the history of modern art, including its latest phase. Conceiving of certain current styles as the legitimate continuation of a historic mainstream of high modernist art—and formalists tended to use the terms "modernist," "avant-garde," "mainstream," and "high" interchangeably—young historian-critics could be proper academics and on the cutting edge of art.[48] They put their extensive academic training in the service of the formalist art of their own generation. In the process, they academicized art criticism, analyzing formal minutiae at great length, bolstering their analyses and opinions with elaborate footnotes (first introduced by Fried), and favoring a dense prose—all of which were believed to be signs of seriousness.

Formalist artists themselves accepted Greenberg as their mentor. After all, as Rose put it: "Greenberg had the ability to see and to verbalize, before many, if any, artists saw it themselves that a post-Cubist style of abstraction had to come from a synthesis of Pollock's all-over structure combined with Matisse's [and Newman's] saturated color. In lectures, informal talks and social contacts, he articulated his pro-

phetic views."[49] The formalist conception of modernist movements as links in a stylistic chain led Greenberg and his followers to imagine the next link. It was assumed that the same close relationship between a current modernist style and its predecessor would obtain for its successor—and why could not they have a say in what the "next move" might be? As Fried saw it:

> modernist painting is at least a criticism of itself. And because this is so, criticism that shares the basic premises of modernist painting can play a role in its development only somewhat less important than that of new paintings themselves. [The] formal critic . . . in discussing the work of painters he admires . . . can point out flaws in putative solutions to particular formal problems; he is even justified in calling the attention of modernist painters to formal issues that, in his opinion, demand to be grappled with.[50]

Critics found it gratifying to advise artists; in this way they could influence the course of art and determine the future of art history. And to history-minded critics, to choose on the side of history was crucial. But how was the painting of the future to be selected? Fried remarked that "at any moment—including the present one—one particular kind of painting is more advanced, more radical . . . and will prove more fecund in its results than any other kind."[51] History would tell.

Formalist painting and criticism were appealing for other reasons. By its nature, avant-garde art was difficult, and this guaranteed its high-art and anti-kitsch quality. Greenberg had implied this in his very first article on art, written in 1939.[52] He continued to reaffirm the connection between difficulty and high seriousness,[53] and claimed that genuine modernist art could be truly appreciated only by a cultivated elite, or perhaps by an elite cultivated enough to accept Greenberg's conception of what is modernist art. Contributing to the snob appeal of such elitist rhetoric was the conviction that there was one and only one right way of viewing an

artist's work; any other way was beneath contempt. Leider ironically summed up this unyielding posture: "You may *think* you appreciate Morris Louis, but do you *really* appreciate Morris Louis?"[54] Leider had Fried's criticism in mind. As Fried saw it, if a viewer admired nonformalist art, that made him or her incapable of *properly*—that is, correctly—appreciating formalist art.

> I feel tempted to say, if someone likes *that* stuff . . . I simply can't believe his claim that he is *also* moved or convinced or flattened by the work of Noland, say, or Olitski or Caro. . . . The most I can do is assume that whoever makes this claim admires Noland's or Olitski's paintings or Caro's sculptures, not for the wrong *reasons* exactly, but, as it were, in the grip of the wrong experience—an experience of mistaken identity.[55]

There is a sense of urgent mission in Fried's remark which is found in formalist criticism generally—a sense that the critics were engaged in a crusade in the cause of high art versus *"that* stuff"—and this, too, was part of its appeal. They were convinced that what really counted in American art was the work of Louis, Noland, Olitski, Caro, and their followers, and that it was formalist art criticism's mission to gain recognition for them. After all, these artists, although few, were the inheritors of modernism and were the contemporary innovators in that tradition, the true heirs of Manet, Monet, and their successors. The course of painting and its continuing vitality, indeed its fate, depended on them. This was a grandiose claim, far more monumental than claims made for originality or authentic self-expression; indeed, it made the latter seem trivial. What formalist artists were supposed to be doing was so momentous that it deserved the finest critical receptivity and performance, and formalist critics believed that they were equipped to deliver. As a correlative to their positive partisan stance, formalist critics condemned or, as was more common, ignored nonformalist styles. It was as if they were not worthy of serious consideration, and when they were referred to, it was as amusing novelties, at best marginal and minor, at worst kitsch.

As attractive to sixties critics as Greenberg's objective and history-minded approach was his demand for judgments of aesthetic quality, even though they could only be based on idiosyncratic taste and, thus, could not be empirical. He insisted that the primary function of art criticism was to determine quality, to tell the good from the bad. Like Greenberg, his followers believed that criticism depended on connoisseurship, and as academic art historians, they prided themselves on their trained eyes as well as on their trained minds. Greenberg had taken Rosenberg to task because he could not "explain why any one by-product of 'action painting' should not be valued more than any other."[56] Greenberg could not *explain* why one color-field painting was better than another, but he and his followers thought they could; at the least, they believed they were more likely to be right. For example, Fried claimed that the formalist critic had the edge in determining quality since his "special burden [is] to objectify his intuitions with all the intellectual rigor at his command," although "the objectivity he aspires toward can be no more than relative."[57]

Thus formalist criticism with its mixture of objective analysis and subjective taste—its aura of science and connoisseurship; its sense of history and mission, of history-making; its devotion to scholarship and pursuit of quality—was attractive to historian-critics. It set them apart from all who were not similarly cultivated and it was directed to an avant-garde art presumed to be so difficult that it could be fathomed only by an initiated elite, or more accurately, elect, whose aim was to elevate public taste. The combination was hard to resist.

Formidable though Greenberg's criticism was, it was subject to frequent challenges, which curbed its power over the

art-world consensus. His most vociferous opponents were a group of other formalists—Minimal sculptors Judd, Morris, and Smithson; and critics Lippard and, former followers of Greenberg, Rose and later Krauss—who denied his specific interpretation of formalism and, with a few exceptions, the roster of artists he promoted. If, as Greenberg maintained, each of the arts was turning in on its own medium, why had he opted for welded construction, which he claimed aspired toward the "pictorial," rather than sculpture that approached the object, which was the nature of sculpture?

Greenberg's aesthetic was also repudiated by antiformalist critics, who commanded art-world attention, such as Lawrence Alloway, John Ashbery, Dore Ashton, Douglas Davis, Thomas Hess, Max Kozloff, Hilton Kramer, Brian O'Doherty, Fairfield Porter, Harold Rosenberg, Robert Rosenblum, William Seitz, Leo Steinberg, and G. R. Swenson.[58] They rejected the implication that the progression of styles in modern art (and presumably Western art) was historically inevitable and that this progression was funneling inexorably through Noland, Olitski, and Caro. The authority of history—even a sense of historical inevitability—was conferred on art that had not had sufficient time to earn it, and on writing about art too new to lend itself to factual analysis and evaluation. The formalist appeal to history and empiricism struck antiformalists as a kind of specious special pleading. Antiformalists were also repelled by the suggestion that formalists could foresee aesthetic developments and accused them of being art touts. Certainly critics who professed to value intellectual rigor were not practicing it when they "described" the future. And what was also troubling, they often tried to influence its course, by self-fulfilling prophecy, as it were, their criticism shaping art, which in turn corroborated criticism.

Antiformalists also attacked Greenberg for refusing to entertain as serious or high any art that did not fit the formalist canon established by him, thus impoverishing the discourse of contemporary art. He was denigrated as an ideologue whose criticism had "rigidified into dogma."[59] Indeed, while formalist critics promoted the sculpture of a dozen mediocre followers of Caro, they dismissed out of hand the sculpture of an Oldenburg.[60] Toward the end of the sixties, the continual repetition in formalist criticism of the same few names of formalist artists came to be seen as narrow, esoteric, tedious—and increasingly irrelevant. When every true-believing formalist proclaimed passionately that the foreseeable future of painting was in the touch of Olitski (and his look-alikes), that Western art depended for its continuing vitality on what he (and they) would paint next, particularly when the painting itself got to look progressively more boring, then claims for quality or anything else were discredited.[61] When in the name of taste Andrew Wyeth was proclaimed a better artist than Johns (in what seemed to be a crass attempt to destroy a central figure of the opposition), then formalist criticism had become utterly unbelievable.

Editors of art magazines constituted a special category of art critics; most had begun as critics and continued to write while editing. The best—Thomas Hess of *Art News*, Hilton Kramer of *Arts Magazine*, James Fitzsimmons of *Art International*, and Philip Leider of *Artforum*—were independent in their taste in art and art writing, and commissioned and vetoed articles accordingly. But they were sensitive to art-world opinion and accommodated to it. After all, art magazines were essentially trade journals, and catered to the art-conscious public, which wanted to know what was happening in the art world.[62] Articles were often timed to appear with gallery and museum shows, because the opportunity to see the work, at least in New York or other major art centers, generated reader interest. In this way, museum personnel and dealers inad-

vertently had a say in what got published and when, but that was more or less the extent of their influence, unless they were among the select art professionals an editor chose to listen to. It was commonly supposed that advertising, which, more than subscriptions and newsstand sales, made magazines profitable, had a great influence on their policies, but in practice the power of a dealer through withholding or increasing advertising in leading magazines was negligible. Still it was the increase in advertising and the growth of an affluent, international, avant-garde readership that generated new, lavishly illustrated art magazines, of which the most influential were *Art International* and *Artforum.*

In the early sixties, *Art International* replaced *Art News* as the journal of the avant-garde, primarily because it published established critics—Greenberg, Rubin, Goossen, and Alloway—and newcomers, such as Fried, Rose, and Kozloff. Its editor, Fitzsimmons, recognized that the European art world wanted information about new American art, and he provided it, accompanied by good reproductions, many in color, in a handsome format.[63] *Art International* remained the most timely magazine until about 1964 or 1965, when *Artforum* (which was modeled on it) supplanted it, partly because Fried, Rose, and Kozloff moved from the one to the other, and new critics, such as Sidney Tillim and others who had been writing for *Arts Magazine,* joined its contributors. (*Art International* continued to command attention because it was the most internationally minded of art publications and because Lucy Lippard wrote its "New York Letter.")

*Artforum* started on the West Coast in 1962, and until 1965 its policy was to feature young Californians. Early on, the magazine introduced New York artists in order to keep the California art world abreast of recent developments in the East, to juxtapose California and New York artists of the same generation, and to

attract a national audience. To further this policy, *Artforum* commissioned New York critics to write for it.[64] Its commitment to a West-East axis was epitomized in its June 1965 issue, which featured American entries to the São Paulo Bienal, among them Barnett Newman, Frank Stella, Larry Poons, and Donald Judd from the East Coast, and from the West Coast, Larry Bell and Robert Irwin, who of all the Californians had achieved the greatest recognition in New York, and Billy Al Bengston. It is noteworthy that the American participants were selected by Walter Hopps of the Pasadena Museum, a close friend of Leider and John Coplans, the mainstays of *Artforum.* The magazine moved from Los Angeles to New York in 1967.

Leider and his colleagues were intensely conscious of the avant-garde artists of their own generation. Although there were sharp differences of opinion about which were the best and most significant, the conflicting views were given space, since Leider wanted to make the magazine an open forum of new art. But *Artforum* critics generally agreed on who were the important artists of the sixties, whether they liked them or not, and the image the magazine projected was of endorsement of those artists. Indeed, *Artforum*'s relevance and power resulted from its urgent commitment to a relatively small number of young artists, presented as the originators of major new styles.[65] Not surprisingly, the magazine came under frequent attack because of its presumed clannishness and its relation to the art market. Even Coplans began to wonder whether *everything* in art of any significance was really being made in America and shown in a half-dozen New York galleries, and coincidentally being featured by *Artforum.*[66]

Leider was fiercely independent and proud, caring much about art, little about business. He, like the magazine's leading contributing editors, believed that it was necessary for art critics to put themselves on the line for new art, to makes choices

and stand up for them. One won out or was relegated to the dustbin of history. Yet he was responsive to the views of his friends, the closest of whom were Stella and Fried, during his early years in New York, and Smithson and Serra, toward the end of the decade.

While in California, Leider had supported the Duchamp-Cage aesthetic. He remarked with approval that Warhol eliminated " 'the artist' with his baggage of 'esthetics as we know it' [and] the critic with his baggage of lunatic distinctions, judgments, significant and insignificant forms, 'second guesses,' killing doubts, museum mentality." Warhol had released "a truly subversive energy."[67] Later, Leider embraced formalism:

> The basic issue in painting and sculpture since 1900 has been the attempt to keep the medium alive in the face of the encroachments of photography, theater, the movies and architecture. . . . It is this search for what no other form can give that has guided, as Clement Greenberg says, the best painting of our century.
>
> By the 1960's . . . only two roads remained passable for the most ambitious artists of our time, the road of high art or the road of low art, relentless formal orthodoxy or equally relentless blasphemy.

Leider went on to say: "High art in the sixties, as exemplified, say, in the work of Morris Louis or Jules Olitski or Kenneth Noland or Frank Stella, is impersonal, formal, humorless, abstract, cerebral, instantaneous. It is intensely conscious of the need to match or surpass the quality of the best art of the recent past." In contrast, low art "seeks a breakthrough by turning its back on the formal dialogue entirely and disguising its concern with art behind a facade of a mock concern with 'life.' It is informal, capricious, humorous . . . and works in utter indifference to the notion of quality."[68] Leider chose to be on the side of high art, his position close to Fried's.

*Artforum* featured Minimal as well as stained color-field abstraction, and soon after, late-Minimal developments. All were represented in a "Special Issue on American Sculpture," Summer 1967, a number that was *Artforum*'s high point. Included were Morris's "Notes on Sculpture, Part 3," on Minimalism; Fried's "Art and Objecthood," a polemic on behalf of formalism against Minimalism; Smithson's "Toward the Development of an Air Terminal Site," a seminal proposal for an Earthwork; and LeWitt's equally seminal "Paragraphs on Conceptual Art."

Leider's positive response to the Process Art of Serra, the Earth Art of Smithson and Michael Heizer, and Conceptual Art opened up an unbridgeable gulf between himself and Fried. Leider grew increasingly friendly with Serra[69] and Smithson, who became Fried's major antagonist. Unlike Fried, who wanted to separate art from anything else, treating it as distinct and privileged, Smithson wanted to carry the issues of art into life, setting up a dialectic between works of art and their environment. Leider ended up championing late-Minimal artists. In his opinion, they constituted the new avant-garde by rejecting received ideas and advancing art. Theirs was the authentic next move in mainstream art, and their work was admirable. Leider would not tolerate second-generation Pop Art and color-field abstraction. But he was also responding to the Vietnam War, just as the artists he admired were—an issue dealt with later.

Museums were the most important agencies in the validation of art, because they were (or were commonly thought to be) shrines elevated above commercial interests and concerned solely with quality or standards of taste, art for the ages, the values of tradition, historical continuity, and the scholarship required to achieve these goals. More than that, as André Malraux once remarked, America's museums were its cathedrals.[70] In the sixties, their numbers grew enormously; there was a veritable building boom. And more museums than ever before began to acquire and exhibit new art, this constituting a significant change in their purpose.

For the art of the past, the museum served as the guardian of quality—acquiring, maintaining, and exhibiting works of lasting aesthetic worth—but with new art, its traditional role was problematic. The staying power of new, radical, and often subversive art could not be predicted. There was a difference between being a caretaker of old art and being a talent scout for new, between the conservator and the adventurer, as it were.

As Werner Hoffman wrote:

> [The] museum—call it a secularized church or an ivory tower or an aesthetic cemetery— has basically been conceived as a stabilizing institution . . . that preserves and advocates values, standards of taste, and so forth. [However,] this stabilizing function of the museum really doesn't fit into many artistic currents or ideas of today . . . which in fact try to *de*-stabilize values, standards of taste, preconceived ideas of art, and so on. [A] work of art is . . . not an answer, but a challenge.[71]

To put it another way, the reputation of the museum as a shrine derived from its permanent collection of time-proven masterworks. But when the museum entered the realm of living art, when it acquired new and often problematic avant-garde art, it entered a realm where values and standards were not clear, certainly not time-tested. And yet the proven art of the past could not but validate the current art that museums acquired and exhibited. Even iconoclastic works of art that tried to purge themselves of the authority of museums were transformed into icons, by their proximity to the established masterworks owned by the museum; the new works received their cachet from the old.[72] The problem was exacerbated when museums organized temporary exhibitions of new art, a function often opposed to that of accumulating masterworks.

Nevertheless, museums managed to reconcile the iconoclasm of the avant-garde and the pull of tradition, the idea of art for the ages. Pointing the way was Alfred H. Barr, Jr., the guiding force of the Museum of Modern Art. He achieved this through an inspired combination of connoisseurship, scholarship, and showmanship. As a connoisseur, he assembled the greatest permanent collection of modern art in the world, recognized not only by the art-conscious audience but by a general public as well. As a scholar, he subjected modern art to scrupulous art historical inquiry, stressing its connections to other styles, past and present, and thereby conferring on it a dignity that only earlier art had been thought worthy of previously. As a showman, he displayed works with exquisite taste and panache and published lucidly written and stunningly designed catalogues. Barr aimed to counteract the popular notion of modern art as a lunatic aberration; instead, he projected it as the art of its time—and therefore as an art historical phenomenon. It was simply the Art with a capital *A* of the latest period of art history, some of it equal in significance and quality to that of any past period. By stressing the links between old and new styles instead of the breaks, Barr paved the way for modern art to enter art history, and by establishing earlier avant-garde styles, he paved the way for the acceptance of the latest avant-garde, making iconoclasm a matter of tradition. He himself became a leading arbiter of quality of the most radical art as well as of the traditional modern art against which it had rebelled.

In assimilating art that aimed to break the flow of history into that flow, in turning revolutionary art into a part of an ongoing tradition—more than that, in placing it in the context of a historical continuum—Barr made the art itself seem history-conscious. The history-minded sixties embraced this dialectical feat without a qualm. Barr's enterprise was buttressed by Greenberg's theory that modernist art advanced through the pursuit of quality. Standards of excellence could be revealed only by established masterworks. Consequently, to advance art, modernist artists had to assimilate past art and its standards,

and by doing this they were the true heirs of tradition. More than Greenberg or any other art professional, however, it was Barr who made modern and avant-garde art respectable and, equally important, had since 1929 educated a mass public about its values and merits; his texts on modern art sold in the hundreds of thousands of copies. By 1960, a sizable public was prepared to accept American avant-garde art, as is clear in the favorable reception of *The New American Painting*, and this was but a prelude. In the sixties, in Manhattan alone, four museums besides the Modern—the Jewish, the Whitney, the Guggenheim, and the Metropolitan—featured new art. Their commitment was exemplified by the decision in 1969 that the Metropolitan Museum of Art celebrate its centennial with a major show of New York painting and sculpture from 1940 to 1970, mounted by Henry Geldzahler. Composed of 410 works in 50,000 square feet of gallery space, it was one of the biggest shows ever put on by the Metropolitan and attracted a quarter of a million viewers (the third-largest attendance in its history).

Museums expanded their activities in contemporary art for a variety of reasons, not the least of which was that the work was available and relatively inexpensive. Rapidly changing "sexy" shows of new art attracted the media; media coverage boosted museum attendance, and museums needed large audiences to assure their existence and growth. Spinning turnstiles pleased the trustees and enabled museums that depended on public funding to request ever larger grants. When art was so difficult that it discouraged attendance, museum professionals justified their box-office failures by claiming that they were essentially educators whose purpose it was to uplift public taste in a democratic society. Indeed, this educational function in the first place enabled museums, like schools and libraries, to justify their claims to public funds. (This was also the reason that contributions of private money and works of art to museums could be deducted from taxable income.) But what counted most in justifying public subsidies were attendance figures, and if it took showmanship to bring up the body count, museums went with the flow. They did not put it that way. Rather they insisted, with justification, that to remain alive, they were obliged to treat culture as a living organism. To do otherwise meant turning their museums into mausoleums. The climate of opinion was conducive to this kind of thinking in the sixties. In a decade when "relevance" was a catchword, museums could shed their sepulchral stigma by embracing timely art. There was a risk in collecting unproven art too quickly: the potential sacrifice of quality. But the desire for relevance overcame the reservations of museum professionals. And taking their cue from Barr, they claimed that if they turned out to be right in only one of ten or even twenty acquisitions, the risk was worth it.

Many museum directors and curators not only entered the field of contemporary art but, like dealers, collectors, and critics, vied to be first in recognizing significant new art and being acknowledged as pacemakers by other art professionals. This led them to participate actively in the art world, assuming its values—and its momentary opinions—rather than distancing themselves in order to *evaluate* and *revise* them, which traditionalists believed was their proper function. They acquired and exhibited the works of living artists about which there was an art-world consensus. Equally important, they organized, or borrowed from institutions that did retrospectives of consensus-supported artists and surveys of current movements.[73] In fact, it was in what these museums collected, and in what they chose to show, and in the temporary shows they mounted, that the art-world consensus or collective taste was most clearly seen.

Only Barr among museum professionals identified with the new art rivaled Castelli or Greenberg in stature, but Solomon and

Geldzahler deserve to be singled out.[74] Solomon, the "go-go" director in the first half of the sixties, was a professor of art history at Cornell University, and his academic credentials gave him cachet. He met Castelli in 1958, while visiting the Rauschenberg show, and became a close friend. Soon after, he organized his own Rauschenberg exhibition at the Andrew Dixon White Museum at Cornell, and in 1963 at the Jewish Museum, of which he had become director. With this retrospective and one devoted to Johns the following year, as well as a large display of color-field and hard-edge painting, including Stella, Noland, Kelly, and Held, in *Toward a New Abstraction*, Solomon established the Jewish Museum as *the* museum of the sixties avant-garde. As the American commissioner at the Venice Biennale in 1964, he selected Rauschenberg, who was awarded the first prize, adding to Solomon's prestige. He early acclaimed Pop Art, but he also supported the new abstraction, embracing the two dominant tendencies in the early and middle sixties.

Toward the end of the sixties, Geld-zahler replaced Solomon as the "with-it" curator. He had performed in Happenings; he was a close friend of Warhol, whom he saw or telephoned every day for a half-dozen years, and of Stella, with whom he took trips to Persia, Brazil, Czechoslovakia, and France. Like Solomon, Geldzahler was an early impresario of Pop Art, defending it publicly, *and* of hard-edge and color-field abstraction, all of which he featured at the 1968 Venice Biennale, of which he was American commissioner. By the time he organized *New York Painting and Sculpture: 1940–1970*, he had cooled toward Pop Art and relegated it to "an episode, an interesting one that has left its mark on the decade, and will continue to affect the future, but not as a major modern movement which continues to spawn new artists," although he continued to admire the innovators of Pop. Geldzahler now committed himself to Greenbergian dogma and leading formalist artists.[75] However, in his selection for the Metropolitan Museum survey, with the art-world consensus in mind, he covered Pop Art, the new abstraction, Minimal Art, and welded construction.

## NOTES

1. The names cited appeared on a list of art-world celebrities in *New York/Herald Tribune*, the mass-media organ of the avant-garde, on 17 May 1964, pp. 12–13. Others mentioned were Alexander Liberman, Martha Jackson, Eleanor Ward (of the Stable Gallery), Lee Bontecou, Jim Dine, Roy Lichtenstein, Robert Morris, Barnett Newman, Claes Oldenburg, James Rosenquist, and George Segal. Other prominent members of the avant-garde art world were André Emmerich, Virginia Dwan, William Rubin, Michael Fried, Barbara Rose, Max Kozloff, Philip Leider, Robert Rosenblum, William Seitz, and Donald Judd.
2. Robert Irwin, in Minutes of the National Endowment for the Arts Seminar, Los Angeles, 1–2 October 1982, pp. 151–56.
3. "Hans Haacke," interviewed by Robin Winter, in *View* (Oakland, Cal.: Crown Point Press, 1978), p. 20.
4. A number of art professionals were so historicizing that they assumed that contemporary artists who were the most history-minded would best meet the test of time. For example, Michael Fried, in "New York Letter," *Art International*, 25 April 1964, p. 59, wrote:

   Stella's paintings . . . are historically self-aware. They both arise out of and demonstrate a personal interpretation of the particular historical situation in which "advanced" painting first found itself in the late fifties. And they look to present and future developments in painting to provide what will either be their justification or . . . their irrelevance. This historically self-aware attitude towards one's work, together with the acceptance of history as that which in the long run determines validity, are the hallmarks of *modernism*, a notion which seems to me . . . relevant to the understanding of much of the finest painting of the past decades.
5. Maurice Tuchman, ed., *Validating Modern Art: The Impact of Museums upon Modern Art*

*History,* report of a symposium (Los Angeles: Los Angeles County Museum of Art, 1975), p. 14.

6. In 1969, William Rubin was promoted to chief curator and in 1970 to director of the Department of Painting and Sculpture.

7. Max Kozloff, "Larry Poons," *Artforum,* April 1965, p. 27.

8. Dorothy Canning Miller, interviewed by Paul Cummings, New York, 26 May 1970–16 June 1971, pp. 238–39. Transcript in the Archives of American Art, New York. Miller described these events. There are varying interpretations of who alerted whom, since all would like to be credited with discovering Stella. Lil Picard, in "Making the Scene," *Arts Magazine,* February 1967, p. 17, wrote that because Castelli took Miller to Stella's studio, as he saw it: "Stella got his first 'Castelli show' at the Museum of Modern Art."

9. Henry Geldzahler, interviewed by Paul Cummings, New York, 16 February 1970, pp. 29, 54. Transcript in Archives of American Art, New York.

10. Tuchman, *Validating Modern Art,* pp. 9–10.

11. Despite the affinities in Greenberg's and Reinhardt's thinking, Greenberg had no regard for Reinhardt's painting. In "Recentness of Sculpture," *American Sculpture of the Sixties,* exhibition catalogue (Los Angeles: Los Angeles County Museum of Art, 1967), p. 25, he called him "a trite artist" and rejected his painting as the product of a "very timid sensibility." In turn, Ad Reinhardt, interviewed in Mary Fuller, "An Ad Reinhardt Monologue," *Artforum,* October 1970, p. 38, accused Greenberg of being an "agent and dealer," implying he was corrupt as a critic. Moreover, Reinhardt insisted that all color in painting, whether by Newman or by Noland, was impure and thus meretricious. Followers of Greenberg who admired Stella rarely mentioned the affinities of his painting to Reinhardt's, probably in deference to Greenberg. Yet Stella had purchased a painting by Reinhardt, which he displayed prominently in his home. Artists and writers in the Minimalist camp enthusiastically acclaimed Reinhardt as painter and polemicist, even regarding him as a kind of mentor.

Greenberg championed Noland and Olitski but ignored Stella, whose pictures he disliked because they seemed to him too idea-bound and mechanically rendered. Followers of Greenberg, notably Fried, Rose, Krauss, and the painter-writer Bannard, added Stella to the duo of formalist painters. Stella was also admired as the seminal influence on Minimal Art by its supporters, Lippard and the artist-writers Judd, Morris, Andre, LeWitt, Smithson, and Bochner. They were sympathetic to Noland's work, but not to that of Olitski and his followers, whose decorativeness they disdained, and they were hostile to Greenberg, who supported it. Greenberg countered by condemning Minimal Art. Fried and Bannard agreed with Greenberg's negative appraisal of Minimal sculpture, but Krauss and Rose broke with them on this issue. Stella himself liked the work of both formalist and Minimal painters and sculptors.

12. Irwin, National Endowment for the Arts Seminar, p. 156.

13. Clement Greenberg was something of an exception. Artists in his circle who emerged in the late fifties and sixties may have looked to him for advice more than he looked to them. However, during the forties and early fifties, he listened to artists, such as Lee Krasner (Pollock) and Barnett Newman.

14. Leo Castelli, interviewed by Paul Cummings, New York, 14 May 1969–8 June, 1973, pp. 101–2. Transcript in Archives of American Art, New York. For example, Johns and Stella persuaded Castelli to represent Morris.

15. Tuchman, *Validating Modern Art,* p. 9.

16. See Al Held, interviewed by Paul Cummings, New York, 19 November 1975–8 January 1976. Transcript in Archives of American Art, New York.

17. Jeffrey Deitch, "Art and Money: Who Has the Power," *Flash Art,* October–November 1981, p. 47.

18. Castelli, interviewed by Cummings, p. 86, called his gallery "a type of coterie . . . that extends from Rauschenberg, Johns, Stella through the Pop Art group and now to Morris, Judd, to Serra, Sonnier. [It's] a very cohesive group."

19. See Alan Solomon, "The Green Mountain Boys," *Vogue,* 1 August 1966. *Berg* is German for "mountain." Bennington College was a center of Greenbergian activities. In 1966, Feeley, Noland, Olitski, and Caro owned homes and studios near the college. Greenberg was an occasional lecturer and adviser to the art program. He recommended that Caro and Olitski be appointed to the faculty.

20. In 1964, Dan Flavin "borrowed" the Kaymer Gallery on West Broadway to exhibit his work. After this show, he organized a group exhibition for many of his friends and acquaintances—one of the earliest featuring Minimal artists. Besides Flavin, it included Sol LeWitt, Donald Judd, Robert Ryman, Frank Stella, Jo Baer, Darby Bannard, Larry Poons, and Leo Valledor. The selection indicates a crossover of the Stella coterie and the Bowery Boys; for example, Carl Andre, who was close to Stella, became a good friend of LeWitt's.

Leo Valledor was a member of a coterie that showed at the Park Place Gallery, which opened in the fall of 1962. Besides Valledor, the founding artists were Mark di Suvero, who was the leading figure in the group, Dean Fleming, Peter Forakis, Robert Grosvenor, Anthony Magar, Tamara Melcher, Forrest Myers, and

Ed Ruda. David Bourdon, in "E=MC² à Go-Go," *Art News,* January 1966, p. 59, wrote that the group was hostile to reductive Minimal Art.

> Its painters sympathize with Al Held, Frank Stella and, to a greater degree, Neil Williams and Larry Poons. The sculptors, perhaps greater in strength because they are part of a larger tendency, feel affinities with Ronald Bladen, David Weinrib, David von Schlegell, Tom Doyle, Chuck Ginnever, George Sugarman, and they revere such older masters as José de Rivera, Alexander Calder and David Smith.

The Bowery Boys also esteemed Barnett Newman and Tony Smith.

21. Lucy Lippard, "Intersections," *Flyktpunkter/Vanishing Points,* exhibition catalogue (Stockholm: Moderna Museet, 1984), p. 12. Lippard commented that many of these artists wrote articles about one another's work and the ideas they shared, promoting both, as it were.

In 1965, the John Daniels Gallery, run by Dan Graham and David Herbert, exhibited LeWitt, Baer, and Will Insley. After 1967, the coterie became friendly with European artists, among them Gilbert and George, Richard Long, Daniel Buren, Mario Merz, and Marcel Broodthaers. A number of Bowery Boys were habitués of Mickey Ruskin's Max's Kansas City bar. Other members of the circle included Dorothea Rockburne, Peter Hutchinson, Sylvia Mangold, Brian O'Doherty, art historian Barbara Novak (O'Doherty), dealer John Weber, and composers Philip Glass and Steve Reich.

22. Leading galleries of contemporary art in the sixties were Sidney Janis, Leo Castelli, Green, André Emmerich, Stable, Dwan, Richard Feigen, Laurence Rubin, Robert Elkon, Fischbach, Knoedler, Howard Wise, Pace, Allan Frumkin, Bykert, Allan Stone, Betty Parsons, Tibor de Nagy, and Jill Kornblee. Artists on the whole believed that dealers were necessary to them. They recognized, as Frank Stella remarked in "Frank Stella," *Art & Auction,* February 1983, p. 60, that

> business and art really don't mix. Someone once asked Philip Guston: "Why can't you do it, what's so great about Sidney Janis?" Philip Guston answered, "Nothing is so great about Sidney Janis, but when he gets up in the morning, the first thing he thinks about is selling the paintings. When I get up in the morning, the first thing I think about is making a painting.

Guston might also have mentioned that the Janis Gallery was not a private studio but a public exhibition space.

23. Calvin Tomkins, in "Profiles: A Good Eye and a Good Ear," *New Yorker,* 26 May 1980, p. 62, reported that Castelli said: "It's true that Bob [Rauschenberg] and Jasper [Johns], and very sensitive people like David Whitney and Richard Bellamy, who seem to function as barometers, do influence my judgment. You have to have a good eye but also a good ear." Castelli and Karp decided jointly on selecting new artists for the gallery.

24. Carter Ratcliff, "The Art Establishment: Rising Stars vs. the Machine," *New York,* 27 November 1978, p. 53.

25. Richard Feigen, in "Art 'Boom,' " *Arts Magazine,* November 1966, p. 23, wrote:

> Castelli is the most successful dealer of the new generation. In a recent newspaper article, his annual sales were estimated below $500,000. I would guess that the sales of the four galleries doing the largest volume in younger artists' work—Castelli, Janis, Feigen and Pace—do not exceed $1,300,000 annually. Wildenstein probably does this in a month. Of this, their gross margin, after paying the artists, is perhaps $500,000. . . . There is little, if any, profit.

26. Castelli, interviewed by Cummings, p. 30.

27. Sidney Geist, "Brancusi-Mondrian: A Sum, A Summa," *Artforum,* February 1983, p. 71. The quote by Geist has a special significance because he was singularly uncommercial.

28. "Artfinger: Turns Pictures into Gold," *Time,* 25 June 1973, p. 71.

29. Stella, "Frank Stella," p. 61. Artists wanted to belong to galleries that represented artists they respected because they wanted their work to be exhibited in the context of work they valued. It was their primary reason for joining a gallery.

30. Josh Greenfield, "Sort of the Svengali of Pop," *New York Times Magazine,* 8 May 1966, p. 38.

31. Castelli acquired the work of his artists so that he could transport it at will. He did this by outright purchase and by providing artists with generous monthly stipends. Castelli's practice of advancing money to artists was rare in the United States. American dealers had generally worked on a consignment basis, taking a one-third commission on the works they sold. Castelli considered this system obsolete. See Castelli, interviewed by Cummings, p. 87.

The first and most important of Castelli's "friendly" galleries was that of his former wife, Ileana Sonnabend, in Paris, which opened in 1962. She and Castelli arranged for their shows to travel to galleries in Cologne, Hamburg, Munich, Milan, Rome, Turin, and Zurich.

Castelli's establishment of "friendly" galleries pointed the way to other dealers, such as André Emmerich and John Weber.

32. Greenfield, "Sort of the Svengali of Pop," p. 34.

33. David Whitney, ed., *Leo Castelli, Ten Years,* exhibition catalogue (New York: Leo Castelli Gallery, 1967), n.p.

34. Amy Goldin, "Requiem for a Gallery," *Arts Magazine,* January 1966, p. 27.

35. In Sophy Burnham, *The Art Crowd* (New York: David McKay Company, 1973), pp. 24–25. Ivan Karp estimated that there were 250 avant-garde collectors in America. Among the better-

known collectors were Ethel and Robert Scull, Emily and Burton Tremaine, Ben Heller, Philip Johnson, Vera and Albert List, Harry N. Abrams, William Rubin, Richard Brown Baker, Larry Aldrich, Joseph Hirshhorn, Roy Neuberger, and Howard and Jean Lipman. But even the most acquisitive of these Americans did not collect on the scale of Peter Ludwig in Cologne and Giuseppe Panza di Biumo in Milan.

36. John Kenneth Galbraith, in "Books: Art Depravity and the Rich," *New York*, 12 May 1975, p. 86, commented rather uncharitably about the latest entrants into his social class:

> There are far too many of them, and especially in New York. So wealth is no longer a source of any distinction. Moreover, many of the traditional enjoyments—alcohol, food, big houses, elaborate entertaining, heavy jewelry—are now regarded as unhealthy, fattening, vulgar, administratively a burden, or a dangerous invitation to burglars and holdup men. So distinction must be sought elsewhere, and the principal possibilities are art, philanthropy, and foreign policy.

37. Robert Scull, interviewed by Paul Cummings, New York, 15–28 June 1972, p. 27. Transcript in Archives of American Art, New York.

38. Jerome S. Rubin, "Art and Taxes," *Horizon* 8 (Winter 1966): 12. Quoted in Karl E. Meyer, *The Art Museum: Power, Money, Ethics* (New York: William Morrow & Company, 1979), p. 35. Rubin reported on the benevolence of the American tax laws.

> A gift to a museum of a Degas drawing bought before World War II for $1,000 and worth $20,000 in 1963, would have netted an 80 percent taxpayer a deduction of $20,000, and therefore a tax saving of $16,000, whereas the sale of the same drawing to another collector at a price of $20,000 would have resulted in a capital gains tax of $4,750 and cash in hand of only $15,250. (These figures reflect federal taxes only; state income taxes would also have taken their toll, thus making the charitable gift still more attractive.)
>
> Clearly under these circumstances, it is more rewarding to give than to sell; in responding to his sense of altruism and high purpose, the astute collector had been able to benefit not only his soul but his bank account.

Thus the Internal Revenue Code has been the primary support of museum acquisitions and the burgeoning art market. Because of their donations, the taste of wealthy trustees could shape the permanent collections of museums.

39. Barbara Rose, "The Primacy of Color," *Art International*, May 1964, p. 26.

40. Lucy R. Lippard, "Intersections," p. 14.

41. Iain Baxter, in *Conceptual Art and Conceptual Aspects*, exhibition catalogue (New York: New York Cultural Center, 1970), p. 41, wrote: "A reproduction in a top art magazine is worth two one-man shows."

42. William Rubin, "Younger American Painters," *Art International* 1 (1960): 26–28.

43. Gene Davis, in Barbara Rose, "A Conversation with Gene Davis," *Artforum*, March 1971, p. 54, said, "We knew that [Greenberg] was a kingmaker; we knew that he had immense power, as evidenced by his piece in *Art International* in 1960 about Noland and Louis. The effect it had was very impressive."

44. See Clement Greenberg, "How Art Writing Earns Its Bad Name," *Encounter*, December 1962. Greenberg attacked Rosenberg and poet friends of the artists who generally published in *Art News*.

Michael Fried, in "The Confounding of Confusion," *Arts Yearbook 7: New York: The Art World* (1964): 37, also deplored the "slovenliness" of American criticism: "The most distressing single aspect of the contemporary New York art scene is . . . its inability to handle ideas and issues generated by the art itself with even a bare minimum of intellectual rigor." He singled out Harold Rosenberg, Ben Heller, and Thomas B. Hess. The difference between existentialist-inspired criticism of the fifties and formalist criticism of the sixties is clear in Fried's attack on Rosenberg and Hess on pp. 43–44:

> Most important of all is the fact that no one—and this includes Mr. Hess and Mr. Rosenberg—has ever demonstrated the so-called crisis-content of a single Abstract Expressionist painting. This would entail pointing to elements in it and trying to elucidate their significance: a procedure which could not possibly be more alien to their critical styles.
> . . . Along with this goes an inability to make judgments of quality except on generic grounds. Their implicit contention is that all paintings which manifest crisis-content are good, and the rest are more or less worthless.
> . . . But since there are no visual criteria by which one can determine whether a particular painting manifests crisis-content or not, the grounds for judgments of value must remain at least equally obscure.

Fried made this statement as if he had criteria for the judgment of quality and judged pictures by them. Of course, he did not. Existentialist critics and formalist critics had different conceptions of the artist. The differences were between the artist-as-existential-hero and the artist-as-professional, between the artist-as-social-outcast and the artist-as-man-of-the-world, between the artist-intent-on-exploring-being and the artist-intent-on-investigating-aesthetic-problems, between the artist-in-crisis and the artist-as-art-maker.

45. Jacques Ellul, "Modern Myths," *Diogenes*, Fall 1958, p. 28.

46. See Clement Greenberg, "Can Taste Be Objec-

tive?" *Art News,* February 1973.

47. Fried, Krauss, and Cone were trained at Harvard, where formalist art history held sway. They looked to Wölfflin, who conceived of an art history "in which styles are described as succeeding one another in accord with an internal dynamic or dialectic, rather than in response to social, economic and political developments in society at large." (Michael Fried, "Modernist Painting and Formal Criticism," *The American Scholar,* Autumn 1964, p. 646.)

48. Walter Darby Bannard, in Rose and Sandler, eds., "Sensibility of the Sixties," p. 54, remarked: "Avant garde . . . presumes a 'mainstream,' a directional flow of a series of stylistic changes. [There] is always an avant garde within any vital art environment. . . . I believe the avant garde in painting today consists of painters who are dealing with color problems."

49. Barbara Rose, "Retrospective Notes on the Washington School," *The Vincent Melzac Collection,* exhibition catalogue (Washington, D.C.: Corcoran Gallery of Art, 1971), p. 22. William Rubin, in "Younger American Painters," p. 26, also claimed that Greenberg had "extraordinary prophetic insight." See also Barbara Rose, "New York Letter," *Art International,* 25 April 1963, p. 57. Even Lawrence Alloway, in *Art International,* Christmas 1961, p. 30, acclaimed Greenberg for his "extra-ordinary prescience."

50. Michael Fried, "Modernist Painting and Formal Criticism," p. 648.

51. Ibid., pp. 646–47.

52. See Clement Greenberg, "Avant-Garde and Kitsch," *Partisan Review,* Fall 1939.

53. Clement Greenberg, in "Where Is the Avant-Garde?" *Vogue,* June 1967, p. 112, wrote that the avant-garde

> arose in response to a threat and a challenge. The threat lay in the fact that the highest standards of art were being increasingly exposed to the attrition of a market no longer governed by the tastes of a cultivated elite. The challenge lay in the even more definite fact that high art was no longer able to maintain itself without innovation (or renovation) of a kind more constant and more radical-seeming than had been necessary in the four hundred years before.

54. Philip Leider, "You May Think You Appreciate Morris Louis, but Do You Really?" *New York Times,* 26 February 1967, sec. D, p. 27.

55. *Art Criticism of the Sixties,* symposium at the Poses Institute of Fine Arts, Brandeis University (New York: October House, Inc., 1967), n.p. Emotions were exacerbated when the contestants made similar claims for their art. It was assumed that there was a right interpretation, *the* right interpretation, and one's very salvation depended on getting it right. Controversy took on the embattled character of a medieval dispute over a biblical commentary. Remark-ing on "the tone of polemical virulence that has characterized recent American art criticism," Barbara Rose, in "The Politics of Art," *Artforum,* February 1968, pp. 31–32, singled out Fried "for the exclusivity of his position and the passion and urgency of his tone."

Fried writes of a new type of disagreement among critics, "the disagreement that occurs when two or more critics agree, or say, that the work of a particular artist or group of artists is good or valuable or important, but when the terms in which they try to characterize the work and its significance are fundamentally different."

Describing himself as angered and stunned when he reads what seems to him "bad or merely meretricious criticism" praising work he admires, he states: "Indeed I am surprised to find that I feel more desperate about what seems to me bad or meretricious criticism written in praise and ostensibly, in elucidation of art I admire than I do about bad or meretricious art."

56. Greenberg, "Art: How Art Writing Earns Its Bad Name," pp. 67–68.

57. Michael Fried, "Modernist Painting and Formal Criticism," p. 664. Leider, in " 'You May Think You Appreciate Morris Louis,' " sec. D, p. 27, went even further than Fried, claiming that whether one liked a style or not, its formal components in relation to the art that precedes and follows it remain "endurable, palpable and verifiable," enabling one to arrive at "a rational standard for distinctions of quality within the body of [an artist's] work, a task almost never attempted, much less achieved, in the pablum that fills most catalogue essays" and presumably other writing on art.

58. Among notable attacks on Greenberg were Max Kozloff, "A Letter to the Editor," *Art International,* June 1963; and Leo Steinberg, *Other Criteria: Confrontations with Twentieth-Century Art* (New York: Oxford University Press, 1972).

59. Barbara Reise, "Greenberg and the Group: A Retrospective View, part 1," *Studio International,* May 1968, p. 255.

60. In 1974, when Kenworth Moffett was giving Michael Steiner a retrospective at the Museum of Fine Arts, Boston, he wrote in "Pop Art: Two Views," *Art News,* May 1974, p. 31, that Oldenburg was a "feeble" artist. "The lack of the slightest formal integrity prevents his droopy painterly objects from being more than archly cute."

61. See Lawrence Alloway, "The Dealer–Art Critic Cycle," *Artworkers News,* January 1981. Around 1967, there occurred a sharp rift in the thinking of Greenberg and Fried, but both continued to favor Noland, Olitski, and Caro. Fried, in "Art and Objecthood," *Artforum,* Summer 1967, n. 4, p. 23, questioned Greenberg's idea that "the irreducible essence of pic-

torial art consists in . . . flatness and the delimitation of flatness" and therefore "a stretched or tacked-up canvas already exists as a picture—though not necessarily as a *successful* one."

Fried maintained that Greenberg's view now had to be rejected, because the urgent need was for painting to declare its conventional, pictorial essence. Thus, a bare canvas could not conceivably exist as a picture, unless "the enterprise of painting [changes] so drastically that nothing more than the name would remain." Moreover, to be a painting, it is necessary for it to "stand comparison with the painting of the past whose quality is not in doubt." The "crucial question" in painting is not what its minimal conditions are but whether it is "capable of compelling conviction, [that is,] of succeeding as painting."

Thus Fried rejected Greenberg's conception of the history of modern painting as its progression toward the goal of objecthood, even though, like the target toward which Zeno's arrow was approaching, it would never be reached. Instead, he formulated a different "logic" of its development. He asserted on p. 23, n. 4, that art "which inspires conviction . . . is largely determined by, and therefore changes continually in response to, the vital work of the recent past." That is, it deals with new problems thrown up by modernist art in the process of solving old ones, and thus renews it, and, in the process, aspires to the quality of past masterpieces. Thus the evolution of modernist painting consisted of a series of moves, each of which depended on an internal dialogue with painting that immediately preceded it (and these moves might even be retrogressive). Fried's notion of style change was based on such unverifiable subjective notions as "conviction" (a word close to "sincerity" and "honesty," which the Abstract Expressionists loved to use and Fried despised because they could not be pointed to in a work of art). Fried's idea that modernist artists faced multiple and open-ended options, whose validation only the future would determine, might seem more open than Greenberg's narrow conception. But Fried would allow only one *correct* formalist art at any moment. And he did not make clear why any one option should be more modernist than any other. If modernist art could move backward, as he claimed it could, then it could move anywhere. As if to narrow options, it appears, Fried chose to single out a few artists, notably Noland, Olitski, Stella, and Caro, and accept whatever they made as truly modernist, only because they made it. Formalism ended up by serving these few artists doubly.

62. In a review of twenty-two art periodicals, Jasia Reichardt, in "Potted Art," *Studio International,* June 1966, pp. 226–27, wrote: "What is striking about these publications is not the dif-

ferences between them, but their similarities in content, scope, and layout."

63. *Art International* was started, owned, edited, and published by an American art critic, James Fitzsimmons, who was based in Zurich. It was first called *European Art This Month* and was primarily that, a guide to art exhibitions. Expanded in 1959, it began to include a "London Letter" by Lawrence Alloway and a "Los Angeles Letter" by Jules Langsner, and articles by Goossen, Rubin, and Sandler. Fitzsimmons admired Greenberg and looked to him for guidance. Although he published critics who were not identified with Greenberg and were opposed to his aesthetic, his attitude was revealed by his waffling when Max Kozloff attacked Greenberg directly. Kozloff's polemic was published not as an article but as a "Letter to the Editor," June 1963, to which Fitzsimmons added disparaging remarks.

64. Largely because of *Artforum,* New York critics began to follow California art and make regular visits to the West Coast.

65. *Artforum*'s editorial policy was focused and positive in its stance on new art at a moment when other art magazines were vacillating. As Leider saw it, *Artforum*'s major competitor in America, *Art News,* had declined because the romantic and poetic style of its writing had ceased to be relevant, and because its editor, Thomas Hess, remained devoted to second-rate Abstract Expressionists and hostile to new art generally.

66. See John Coplans, interviewed by Paul Cummings, New York, 4 April 1975–4 August 1977. Transcript in Archives of American Art, New York.

67. Philip Leider, "Saint Andy: Some Notes on an Artist Who, for a Large Section of a Younger Generation, Can Do No Wrong," *Artforum,* February 1965, p. 28.

68. Philip Leider, "Gallery '68: High Art and Low Art," *Look,* 9 January 1968, p. 14. As Leider saw it, there was a dialogue between Stella and Noland: "the primacy of color [and] irresistible structural logic." Nothing in the other arts could "compare with the sustained intensity of this encounter." Leider also wrote of "a number of excellent artists" who work in between high art and low art. "Two important artists actually seem to take their strength from an area quite outside of painting and sculpture—architecture." They were Tony Smith and Larry Bell.

Leider had an enormous regard for Fried, particularly during 1966 and 1967, when they were closest. Leider went so far as to publish Fried's doctoral dissertation, "Manet's Sources: Aspects of His Art, 1859–1865," as an entire issue of *Artforum,* March 1969. In "You May Think You Appreciate Morris Louis," an article on a major retrospective of Louis's work at the

Los Angeles County Museum of Art in 1967, Leider wrote more about Fried than Louis, even though he acknowledged that Louis had painted "half a hundred of the most beautiful paintings ever made in America." "Fried, based at Harvard University, is one of the most challenging of that group of younger critics, commonly known as 'formalists.'" His critical essays were "characteristically dense, exhaustive and—there is no other word for it—brilliant."

69. Philip Leider, in "How I Spent My Summer Vacation, or Art and Politics in Nevada, Berkeley, San Francisco and Utah," *Artforum,* September 1970, p. 40, wrote: "I had been talking to Serra on and off for about two years. He has a gargantuan appetite for art and its problems. Ideas explode in his head with the regularity of Dexedrine spansules popping. He has a fine sense of art world theatrics and times his art world (life) actions with . . . precision."

70. Meyer, *The American Museum,* p. 12.

71. Tuchman, *Validating Modern Art,* p. 9.

72. Jack Burnham, "Problems of Criticism IX," *Artforum,* January 1971, p. 41.

73. Museums validated art through costly shows, which at times made national and international news. They further propagated the work through traveling exhibitions, both in the U.S. and—if the artist had a reputation, as many of the artists associated with Castelli and Greenberg did—abroad, generally in Holland, England, and Germany.

74. Although he was not as well known in New York as were Solomon and Geldzahler, because he was based outside the city, Walter Hopps deserves to be mentioned with them as a leading museum professional of the sixties. According to John Coplans, in "Pasadena's Collapse and the Simon Takeover, Diary of a Disaster," *Artforum,* February 1975, pp. 32–33: "His earliest activities centered as much around San Francisco as Los Angeles. Between 1953–56, he began to organize exhibitions in Los Angeles wherever he could find the space. In 1957–58 he started the Ferus Gallery in Los Angeles with Edward Kienholz, which, in fact, was more an artists' cooperative than a commercial gallery. When Irving Blum became a partner in the gallery in 1959, Hopps began to work more at Pasadena as a free-lance curator, rising to acting director. He was close to the founding editors of *Artforum,* and like them aspired to advance the West Coast as an originator of artistic culture. Indeed, he "had virtually single-handedly lifted the little museum into national prominence." In 1968, Hopps was appointed director of the Washington Gallery of Modern Art. By then he had already been acclaimed in Philip Leider, "Cornell: Extravagant Liberties within Circumscribed Aims," *New York Times,* 15 January 1967, sec. D, p. 29, as "the most gifted museum man on the West Coast (and, in the field of contemporary art, possibly in the Nation)."

75. Henry Geldzahler, *New York Painting and Sculpture: 1940–1970,* exhibition catalogue (New York: E. P. Dutton, 1969), pp. 26–29.

# 6 THE ART-WORLD CONSENSUS

As I wrote in the preceding chapter, at every moment in the sixties there was a loose consensus among art professionals about what was the best and most significant in current art. At times, that consensus seemed so unanimous that to many outsiders the art world appeared to operate as a cabal or a conspiracy. But in actuality it did not;[1] the consensus issued primarily from the independent judgments of individuals, shaped by a common culture though they were. To be sure, participants in the art world tried to influence the consensus through persuasion; sometimes they could and did apply pressures—artists on dealers and vice versa; art editors on critics; museum trustee-collectors on museum directors and curators—but such pressures were more often than not resisted and in any case did not amount to much.

If there were few if any secret arrangements—none has ever been proven—there was cooperation; since art professionals moved in the same circles, this was only natural. A curator who wanted to organize a show of an artist's work might, to help gain museum approval, enlist the aid of a trustee who might also be a collector of that artist's work; or the trustee-collector might enlist a curator. The artist's gallery might help the curator mount the show and prepare the catalogue. The curator might ask critics to write about the work. The dealer might schedule a gallery show at the same time as the museum show, commission a critic to write an introduction to the gallery catalogue, and buy advertisements in art magazines. Because of the museum show and its topicality, art editors might assign critics to write articles or agree to accept articles submitted by critics. Both dealer and curator would provide information and photographs to critics for such articles. The show might encourage the museum director and trustees to arrange for the purchase of the work—and so forth.[2]

Cooperation often looked like collusion, particularly when influential tastemakers focused on a single artist, as they often did. It was not uncommon for leading galleries (e.g., Castelli or Emmerich) to be showing a few artists at the same time that leading art magazines (e.g., *Artforum*) were featuring them in major articles by leading critics (e.g., Fried)—at the same time that major museums (e.g., the Jewish Museum or the Whitney) were exhibiting and acquiring the work, and collectors (e.g., the Sculls) were buying it. The narrowness of focus was exacerbated by the mass media. They monitored a few celebrated artists and tastemakers. Because of the rapidity with which information was transmitted to ever growing segments of the population in the sixties, the work of those few deemed newsworthy became so well known that it seemed already to have entered history. The sheer weight of mass-media (augmented by art-magazine)

coverage turned avant-garde art even in its early stages into instant art history.

Most art professionals had a genuine passion for art, and sensitivity to it, but they were also engaged in money-making, careerism, self-aggrandizement, social climbing, and much else that was beside the point of art. It would be naive to deny this. But an "eye," at least, was a prerequisite for worldly success. To put it directly, the members of the art world were motivated by a profound urge for quality. They supported good art or what they considered good. It would have been perverse not to and harmful to their reputations.

Nevertheless, those who entered into shaping the consensus, for whatever reasons, merit close scrutiny, since it was the consensus that determined for its time what had aesthetic value. The sixties call for such scrutiny more than the forties and fifties, because the art world had changed drastically from one period to the next, having grown considerably in size, resources, and influence.[3] In the earlier period, rewards, such as sales or recognition outside the avant-garde artists' immediate milieu—for example, by art magazines or museums—were rare. Such manifestations of success were negligible in the formation of a consensus. That was based primarily on the opinions of the artists involved, very few of whom had achieved worldly success or even expected to and had little reason to be motivated by other than aesthetic considerations. Artists could not help being purer then. In the sixties, the number of art professionals grew—as did the opportunities for private gain—and they asserted themselves more strongly than their counterparts had a decade earlier, although they continued to look to artists for guidance. Their fundamental concern was still quality, of course, but given the jump in their numbers and the worldly temptations they faced, nonaesthetic considerations *may* have intruded more into their decision-making process.

If the art world arrived at a consensus for reasons other than quality, the consensus could be considered "corrupt." This could happen when consensus-supported artists made art that would fulfill the expectations of art professionals—dealers who demanded what they believed would sell; critics who wanted art to illustrate a particular dogma—but only if the artists subverted their own creative will. Or the consensus could be perverted through unscrupulous and venal manipulation or perhaps by undue pressure by members of the art world. It would seem that information in these matters would be difficult to come by, and there is indeed not much on record. But the art world was a relatively small community and it thrived on gossip. Very little, if any, dirt remained hidden.

On the evidence of their art, consensus-supported artists created new art according to their needs, dreams, ideas, and/or intuitions; the consensus followed their lead, and less inspired artists followed the consensus. Derivative, bandwagon art was quickly recognized as second-rate, and if it achieved any art-world recognition because of its relationship to new art, it was only in the short run.

No leading dealer was known to have advised consensus-supported artists on what to create. One major critic, Greenberg, did—and a few of his followers tried. Greenberg was the mentor of Louis, Noland, Olitski, Caro, and their followers, not only in the sense that he formulated an ideology for their painting and sculpture but because he was a critical audience for their work. Indeed, for several, he constituted the only significant audience, *an audience of one,* and therefore he was listened to and depended on. As for his influence in an artist's studio, Greenberg resembled a kind of editor whose advice is valued by creative writers.[4]

Enemies of Greenberg claimed that any critic who presumed to advise an artist on how to make art had exceeded the legitimate bounds of criticism. Moreover, any artist who would listen to such advice was deemed to be lacking in independent vi-

sion and artistic personality. But this need not be the case. Artists have always been influenced: most often by art but also by ideas of every conceivable kind—Rauschenberg and Johns, for example, by those of Cage. There is no convincing reason why Greenberg's art criticism could not constitute a valid source of inspiration, and there is the testimony of David Smith, Louis, Noland, Olitski, and Caro that it did.[5]

Greenberg was also faulted for having unduly influenced the consensus through promotional activities other than his art criticism. He was accused of having marshaled a coterie of artists, critics, curators, dealers, and collectors, some of whom served as museum trustees, in support of formalist art. Formalist dogma led naturally to the formation of a coterie. If, as Fried wrote, the historical fate of a style depended on its "fecundity, whether in fact it proves to have been the road to the future,"[6] then the fecundity of a current style could be measured by the number of artists and art professionals it engaged. Consequently, a sizable coterie might influence the climate of opinion and convince the current consensus (and those to come) that formalist art, or, at least, the best of it, was the most flourishing and consequential of its moment. Judd had noted this in 1964: "There is . . . the funny practice of using the fact of numerous followers to prove the importance of the leaders."[7] Moreover, Greenberg entered the art market, as adviser for the French and Company Gallery. But the art world was well aware of Greenberg's taste in art and of his activities on behalf of painting and sculpture that he admired, and these were taken into account when the consensus was formulated.

Castelli was also accused of corrupting the art-world consensus in one critical instance. He was supposed to have "arranged" Rauschenberg's winning of the first prize at the Venice Biennale in 1964. But he did not. To understand what happened, it is necessary to think back to the defeat of Franz Kline by the French painter Fautrier in the Biennale of 1960. Fautrier had been shown frequently throughout Europe, promoted in advertisements, and written about by André Malraux, among others. Kline was comparatively unknown, and little material about him was available in Europe. Even had the jury considered him the better artist, his lack of visibility would have made it too risky to give him the prize.[8] Castelli had learned a lesson. From 1961 to 1964, he arranged for Rauschenberg to be given well-advertised shows in Paris, London, and other important European art centers.[9] Rauschenberg's show in Paris in 1961 coincided with the exhibition of the New Realists, who embraced the young American as one of their own. His retrospective in London in 1964 generated the same kind of excitement as his show in Paris. Rosalind Constable reported:

> English critics raved and crowds stood in line to get in. The London *Sunday Telegraph* called Rauschenberg . . . "the most important American painter since Jackson Pollock," and the august London *Times* conceded that he is "already a major inspiration to the young painters here, there, and almost everywhere."[10]

Thus, by the time of the Biennale, Rauschenberg had come to exemplify a generation of young artists, was the best-known of the Americans included, and, therefore, had the best chance to win. The American commissioner, Alan Solomon, lobbied vigorously on Rauschenberg's behalf in Venice—and so did Castelli.[11] Solomon reported that Castelli got "hoarse in the Piazza talking in . . . six languages. [He distributed] stacks of publications about his artists when the jury came through the pavillion; none of the other dealers had all this material about their artists."[12] There were rumors of bribery and the like. But Solomon protested angrily in a letter to the *New York Times* that the suggestion of corruption, never substantiated,

impugns not only my honor, my professional qualifications and standards and my basic intelligence, but also those of the officials of the USIA who invited me to arrange the exhibition, the officials of the State Department who appointed me Commissioner, the officials of the Biennale who invited me to nominate jurors, the seven jurors chosen . . . and the Italian Council of Ministers which put up the prize money, let alone the artists and dealers Castelli is supposed to tell what to do.[13]

What the rumormongers in Venice had overlooked was the slow buildup of Rauschenberg's reputation in Europe during the preceding four years. In 1961, for example, the magazine *Connaissance des Arts* asked each of some 140 critics, collectors, dealers, museum directors and curators, historians of modern art, writers, professors, and artists to choose his or her ten favorite painters. Of the eighty who responded, only one included Rauschenberg. In contrast, in 1965, 100 French intellectuals voted Rauschenberg the most important artist to have emerged since World War II.[14]

All in all, there seems to have been little corruption or undue tampering with the consensus in the sixties, and except for the alleged manipulations of Greenberg and Castelli, none of it was significant.[15] I have put the question to many art professionals, and only William Seitz complained of excessive manipulation. Even art-world figures of the political left, their hostility to bourgeois art marketing notwithstanding, could recount only minor instances of corrupt practices, and all agreed that on the whole the consensus was honestly arrived at. It should be noted, however, that art professionals, even Marxist, did not begin to examine the art world until the last year or two of the sixties. This probably confirms that there was little of interest to be said, although it may also indicate fear or insensitivity to the issue.[16]

But what if the entire art world and by implication its consensus were corrupt—and this accusation was also made. Seitz, for instance, remarked that when avant-

garde art "came into existence some one hundred years ago, [it] was precisely *alienated* art: an art of committed innovators and seers, cut off from acceptance by the philistinism of officials and the public." With the instant success of Pop Art in mind, Seitz went on to say: "To have the demand for avant-garde art greater than the supply—the situation we have arrived at today—is laughable."[17] Seitz's view of the sixties art world was conditioned by a myth of a past age when artists were purer and their art more profound, because they were isolated from corrupting pressures and intent only on fulfilling their own individual visions. However, there is no evidence that art created by successful masters of modern art who entered a public arena of dealers, collectors, critics, and curators was per se inferior. Did affluence and worldliness harm the painting of Picasso or Matisse? Did its quality suffer?[18]

Seitz implied that the values of the larger world had become those of the art world and had corrupted art. The booming art market had introduced a market mentality—bolstered by tangible financial and other rewards—that willy-nilly perverted purely aesthetic considerations. It certainly became more common, in many cases unavoidable because of jumps in prices and publicity in the media, to think of dollar value when calculating aesthetic value—and perhaps even to equate the two. Did art sell because it was thought good or was it thought good because it sold? Did it become expensive because it was valued or was it valued because it was expensive? And if novelty was a value foisted on art by the art world, was the new valued more than the good?

It is conceivable that new-rich collectors, many of whom were also museum trustees, and the dealers they patronized—and perhaps the art professionals they befriended—were, to put it directly, vulgar. A remark by Leon Kraushar published in *Life* would make it seem so:

All that other [than Pop] stuff—it's old, it's old, it's antique. Renoir? I hate him. Cé-

zanne? Bedroom pictures. It's all the same. It's the same with the cubists, the abstract expressionists, all of them Decoration. There's no satire, there's no today, there's no *fun*. That other art is for the old ladies, all those people who go to auctions—it's nothing, it's dead. Pop is the art of today, and tomorrow, and all the future. These pictures are like IBM stock, don't forget that, and this is the time to buy, because pop is never going to die. I'm not planning to sell my IBM stock either.[19]

By association, the art new-rich collectors and their art-world associates liked may have been vulgar; they may even have admired it *because* it was vulgar. The question was often posed with regard to Pop Art, which the new rich were alleged to have promoted. Did the introduction of low-art subject matter into high art revitalize high art and expand its realm, or did it debase and trivialize high art? Or, as David Rosand put it: "Are [Pop works] transformed at least by context—off the supermarket shelf and into the gallery? Or do they not rather transform the aesthetic context itself, reducing the gallery pedestal to the supermarket shelf?"[20] Op Art raised similar questions: it was often viewed as mass entertainment and not as serious art.

It was also conceivable that rich collectors did not favor art that conveyed social messages. Certainly artists of the sixties whose work was frequently and strongly social did not rate high in the consensus, although a few, such as Leon Golub, Edward Kienholz, Peter Saul, and H. C. Westermann, received some recognition. Did they and others less known deserve more? Social neutrality was exemplified in a major show titled *The Art of the Real,* organized by E. C. Goossen at the Museum of Modern Art, which traveled to the Tate Gallery in London. On the cover of the Tate catalogue there appeared in bold print: "THE ART OF TODAY'S REAL MAKES NO DIRECT APPEAL TO THE EMOTIONS, NOR IS IT INVOLVED IN UPLIFT, BUT INSTEAD OFFERS ITSELF IN THE FORM OF

THE SIMPLE IRREDUCIBLE IRREFUTABLE OBJECT."[21] Implicit in this statement was the belief that art that aimed to be aesthetically radical had to purge itself of outworn, socially uplifting subject matter. Did the appeal of the art, presumably to the new rich collectors and their art-world "lackeys," lie in its neutrality? To put the question another way: Did the new rich choose *their* kind of art? Did money assert its own taste and enshrine that taste in museums? If it did, then the art it chose may have revealed more about the appetites of the new rich than about their receptivity to quality. But this is only conjecture.

In my opinion, art professionals generally tried to select the most vital and best art they could, and they succeeded in the short as well as in the long run—with some exceptions, to be sure. In the final analysis, if the consensus was not all it should have been, no better way of determining quality had developed. Hilton Kramer, an art-world curmudgeon, if ever there was one, summed it up:

I have enough acquaintance with the cultural life of countries where there are no unofficial dealers, where everything is handled through government agencies and an artist exists entirely at the mercy of bureaucrats who make decisions upon what level of accomplishment the work now meets. To know that, compared to the obvious alternatives at least, the art market represents a realm of freedom for the artist, and I don't underestimate any of the difficulties of it, the corruptions involved, the self-serving that goes on, or the suffering that it causes people who are its casualties. But there is no *perfect* system, and from my own observation, it's the least imperfect that I can imagine at the present time.[22]

It seems to me that the art-world consensus about artists of the sixties is most accurately revealed by influential museum shows. In that decade, museum directors and curators, unlike their predecessors, had descended into the art world and reflected its opinion, but they

tended to wait longer than most art professionals before committing themselves to new art. They also tended to be less subject to the art world's "corrupting" influences—market values, fashion, neophilia—but the influences were certainly exerted on them as never before.[23] Most art-world museum directors and curators were sophisticated enough to function in the world. They understood what advantages their institutions had to offer the art world and how to resist its blandishments and pressures.

Museum professionals were most vulnerable in their dealings with the trustee-collectors who were their bosses, most of whom were selected because of their wealth and the art they owned, both of which museums coveted. After all, they provided most of the money for buildings, acquisitions, and exhibitions, as well as for operating expenses. A major function of a museum director was to cultivate his or her trustees.[24]

Boards of trustees generally gave the museum staffs free rein to do their jobs; when they chose to interfere they were difficult to resist, because they had the final decision-making power, notably because of their right to hire and fire directors. Trustees served on committees to review acquisitions and to help formulate exhibition policy. On the whole, they were interested in art and supported museums—as cultural and educational assets in their communities—out of altruism. There were rewards, of course, harmless ones such as the prestige that public service confers or the admittance into higher social circles. And trustees as collectors and potential donors could call on museum professionals for advice. But trustees did have their own opinions and tastes, and it was natural that they would expect the museums they served to accept what they bought, good or bad, whether in consultation with museum directors and curators or not. There was a potentially unsavory side to this, having to do with tax deductions for gifts of art works—and they

could be considerable. In many cases, it was actually more profitable to give away art as tax write-offs than to sell it. A museum show of an artist's work could cause a rise in prices of the work. Trustee-collectors were aware of this and occasionally used their positions for what might be construed as mercenary ends.[25] But these abuses affected the consensus only marginally if at all, and museum shows remain the best indicators of the art-world consensus.

The art of the sixties was ushered in by *Sixteen Americans,* organized in 1959 by Dorothy C. Miller at the Museum of Modern Art. Two tendencies were featured: so-called Neo-Dada—the label would soon be supplanted by Assemblage—whose leaders were Robert Rauschenberg and Jasper Johns; and post-painterly abstraction, including Frank Stella and Ellsworth Kelly. In 1961, the museum conferred its official stamp of approval on *the Art of Assemblage,* mounted by William Seitz. Ranging from Cubist collage to the latest junk construction, the show was a historic, international survey, but it served to reinforce the establishment of Rauschenberg and Johns.[26] In 1963, Alan Solomon curated a retrospective of Rauschenberg's work, and in the following year, one of Johns's work, both at the Jewish Museum.

Museums began to present shows of Pop Art in 1962, within a year of its emergence. The first, titled *New Paintings of Common Objects,* was arranged by Walter Hopps at the Pasadena Museum of Modern Art, with a catalogue text by John Coplans (reprinted in *Artforum*). The following spring, there were four additional museum shows: Alloway's *Six Painters and the Object* at the Guggenheim Museum; *Popular Art* at the Nelson Gallery–Atkins Museum, Kansas City, with a catalogue text by Ralph Coe; Douglas MacAgy's *Pop Goes the Easel* at the Contemporary Art Museum, Houston; and Alice Denny's *The Popular Image* at the Washington Gallery of Modern Art, with a catalogue introduction by Solomon. In the

summer of 1963, Alloway's *Six More* was exhibited at the Los Angeles County Museum, followed in the fall by Coplans's *Pop Art USA* at the Oakland Art Museum and Gordon Smith's *Mixed Media and Pop Art* at the Albright-Knox Art Gallery, Buffalo, New York. In that year, too, Dorothy Miller included Robert Indiana, Claes Oldenburg, and James Rosenquist in her *Americans 1963* at the Museum of Modern Art, signaling the museum's acceptance of Pop Art. On the basis of these shows, as early as the end of 1963 there had developed a consensus as to who the major Pop artists in New York were. Most art professionals were agreed on Roy Lichtenstein, Rosenquist, Andy Warhol, and Tom Wesselmann. They were frequently shown with Rauschenberg, Johns, Oldenburg, and Jim Dine; although the latter denied that they were Pop artists, their inclusion in major shows contributed both to their stature and to that of Pop Art. There was less unanimity about Robert Indiana and George Segal, but they, too, were often exhibited as Pop artists.[27]

Stella and Kelly were included not only in Miller's *Sixteen Americans* in 1959–60 but in *American Abstract Expressionists and Imagists,* organized by H. H. Arnason at the Guggenheim Museum in 1961. Consisting of a picture each by sixty-four artists, it was a survey, but Arnason, like Miller, was partial to post-painterly painters, or, as he called them, "imagists," who were striving "towards the end of greater simplicity, clarity, and power of expressive means," and he predicted that their importance would grow.[28] Along with Stella and Kelly, other young "imagists" exhibited were Al Held, Alfred Jensen, Morris Louis, and Kenneth Noland. Held, Jensen, Kelly, Noland, and Stella, as well as Richard Anuszkiewicz and Agnes Martin, were also included in *Geometric Abstraction in America,* organized by John Gordon at the Whitney Museum in 1962. A historical survey, it consisted of seventy-one artists, most of whom worked in older Cubist-inspired geometric styles, but a number of new abstractionists were tacked on. A related show, titled *Formalists,* was curated by Adelyn D. Breeskin at the Washington Gallery of Modern Art in 1963. Among the forty-four artists she selected were Kelly, Martin, Jules Olitski, Larry Poons, Stella, and Pop artist Indiana.

Hard-edge and stained color-field abstraction came into its own right in *Toward a New Abstraction,* mounted by Ben Heller at the Jewish Museum in 1963. Among the nine artists included were Held (with an essay by myself), Kelly (Geldzahler), Louis (Rosenblum), Noland (Solomon), and Stella (Fried). In 1964, Greenberg further established stained color-field and hard-edge abstraction in his *Post-Painterly Abstraction* at the Los Angeles County Museum. Among the thirty-one artists included were Held, Jensen, Kelly, Louis, Noland, Olitski, and Stella.

In 1965, Fried curated *Three American Painters*—Noland, Olitski, and Stella—at the Fogg Art Museum, Harvard University. Fried's catalogue introduction was widely read and debated in the art world. Louis and Noland were also included among five participants in *The Washington Color Painters,* assembled by Gerald Nordland at the Washington Gallery of Modern Art. Held, along with Ronald Bladen and George Sugarman, was exhibited in *Concrete Expressionism* at the Loeb Student Center, New York University; the exhibition was organized by me, and my catalogue introduction was reprinted in *Art News.* In 1966, Lawrence Alloway mounted *Systemic Abstraction* at the Guggenheim Museum; it included Held, Kelly, Robert Mangold, Martin, Noland, Poons, Robert Ryman, and Stella.

In 1965, William Seitz presented *The Responsive Eye* at the Museum of Modern Art, which, despite the museum's sponsorship, was not well received by the New York art world.[29] Comprising more than

one hundred artists from fifteen countries, the show featured Op Art but included a number of new abstract painters: Kelly, Louis, Martin, Noland, and Stella. Among the artists more clearly identified with Op Art who emerged were Anuszkiewicz, Poons, and Bridget Riley. Kinetic sculpture received even less art-world recognition than Op Art. Shows such as *Directions in Kinetic Sculpture* at the University of California Art Museum at Berkeley in 1966 and *Kinetic Sculpture* at the San Francisco Museum of Modern Art in 1967 were neglected or panned. Kinetic art did better when it was exhibited with Op Art, as in *Kinetic and Optic Art Today* at the Albright-Knox Art Gallery in 1965. Along with Anuszkiewicz, Poons, and Riley were Len Lye (featured with seven pieces) and George Rickey, who commanded the most art-world attention. Light Art achieved recognition in 1966–67, in a series of shows, the most important of which was *Light–Motion–Space* at the Walker Art Center, Minneapolis. In 1968, Robert Doty organized *Light: Object and Image* at the Whitney Museum: among those exhibited were Stephen Antonakos and Dan Flavin.[30]

Minimal sculpture was established with the *Primary Structures* show, organized by Kynaston McShine at the Jewish Museum in 1966. The exhibition included both construction-sculpture, notably that of Anthony Caro and his former students, and all of the major Minimal sculptors, but the latter's work made the stronger impression. Among the Minimalists were Carl Andre, Larry Bell, Ronald Bladen, Dan Flavin, Donald Judd, Robert Morris, Tony Smith, and artists associated with them, Richard Artschwager and Sol Le-Witt.[31] *A New Aesthetic* at the Washington Gallery of Modern Art, 1967, included Judd, Flavin, and Bell; the catalogue essay was by Rose. *Sculpture of the Sixties*, organized in 1967 by Maurice Tuchman at the Los Angeles County Museum of Art and accompanied by a catalogue-book, most accurately reflected the art-world consensus about American sculpture as a whole. It included construction-sculptors Caro, John Chamberlain, and Mark di Suvero; Minimalists Andre, Bell, Bladen, Flavin, Judd, Morris, Tony Smith, and Robert Smithson; kinetic sculptors Lye and Rickey, as well as Kelly, Edward Kienholz, Bruce Nauman, Oldenburg, Lucas Samaras, Segal, Kenneth Snelson, Sugarman, William Wiley, and Westermann. *Plus By Minus: Today's Half Century*, presented by Douglas MacAgy at Albright-Knox in 1968, was the summary show of Constructivist and Minimal tendencies in the sixties. It surveyed Suprematism, the Bauhaus, Concrete Art, Zero, the New Tendency, as well as many unaffiliated artists, notably Americans. Among the ninety-two participants were the younger artists Anuszkiewicz, di Suvero, Flavin, Jensen, Judd, Kelly, Morris, Poons, Rickey, Riley, Tony Smith, Smithson, and Snelson.

Process Art received major museum validation in *Anti-Illusion: Procedures/Materials*, organized by Marcia Tucker and James Monte at the Whitney Museum in 1969. Among the artists represented were Andre, Eva Hesse, Barry Le Va, Morris, Nauman, Ryman, Richard Serra, and Richard Tuttle. (Composers Philip Glass and Steve Reich were also included.) The first museum show of Earth Art was curated by Willoughby Sharp at (and around) the Andrew Dickson White Museum at Cornell University; the catalogue of the show was widely disseminated. Among the participating artists were Jan Dibbets, Richard Long, Morris, Dennis Oppenheim, and Smithson.

Conceptual Art was frequently mixed with Process Art and Earth Art. It was recognized in Europe before it was in America; the first major exhibitions were *When Attitudes Become Form: Works–Concepts–Processes–Situations*, organized by Harald Szeemann at the Kunsthalle in Bern, Switzerland, and *Square Pegs in Round Holes*, organized by Edy de Wilde at the Stedelijk Museum in Amsterdam,

both of them in 1969. In 1970, Kynaston McShine curated *Information* at the Museum of Modern Art, placing the museum's imprimatur on Conceptual Art. Among the artists in McShine's show who were in both of the European shows were Andre, Joseph Beuys, Dibbets, Michael Heizer, Douglas Huebler, Long, Morris, Nauman, Oppenheim, Smithson, and Lawrence Weiner; in one of the shows, Artschwager, Robert Barry, Bochner, Hanne Darboven, Joseph Kosuth, LeWitt, Ryman, and Serra. His eye on America, McShine also included Vito Acconci, John Baldessari, Le Va, and Edward Ruscha. In the same year as *Information,* Donald Karshan organized at the New York Cultural Center *Conceptual Art and Conceptual Aspects,* representing the more extreme of the Conceptual artists, among them Barry, Bochner, Dibbets, and Huebler.

The New Perceptual Realism and Photo-Realism began to receive museum recognition in 1968 when Linda Nochlin and some of her students mounted a large exhibition titled *Realism Now* at the Vassar College Art Museum. In the following year, the Milwaukee Art Center organized *Aspects of a New Realism,* accompanied by a catalogue with essays by Sidney Tillim and William S. Wilson. Major recognition, however, was not forthcoming until 1970, when the Whitney Museum exhibited *22 Realists.* The New Perceptual Realists who emerged were Alex Katz, Philip Pearlstein, Jack Beal, Alfred Leslie, and William Bailey; the Photo-Realists, Richard Estes, Malcolm Morley, and Chuck Close.

In 1969, Henry Geldzahler organized a major exhibition titled *New York Painting and Sculpture: 1940–1970* at the Metropolitan Museum of Art to commemorate the museum's centennial. Because it was at America's greatest museum, organized by the art world's most fashionable curator, and spanned the three decades during which New York art was the most vital in the world, the forty-three artists included

were taken to constitute a pantheon of American art. Indeed, Geldzahler intended something of the sort; he claimed to have chosen painters and sculptors because their work "significantly deflected the course of recent art." However, he also had the art-world consensus in mind, particularly in his selection of twenty-one newer artists; he limited his selection to those who had emerged before 1965. They were John Chamberlain, Mark di Suvero, Dan Flavin, Helen Frankenthaler, Jasper Johns, Donald Judd, Ellsworth Kelly, Gabriel Kohn, Roy Lichtenstein, Morris Louis, Robert Morris, Kenneth Noland, Claes Oldenburg, Jules Olitski, Larry Poons, Robert Rauschenberg, James Rosenquist, George Segal, Tony Smith, Frank Stella, and Andy Warhol. In his catalogue introduction, Geldzahler listed other "artists of quality," among them Al Held, Alex Katz, Tom Wesselmann, Jim Dine, and Robert Indiana.

Three distinguished museum directors —elder statesmen, so to speak—tended to choose the same artists Geldzahler did in shows they organized at the end of the sixties. They were James Johnson Sweeney, who curated *Signals of the Sixties* at the Honolulu Academy of the Arts, 1968; H. H. Arnason, *American Artists of the Nineteen Sixties* at the Boston University School of Fine and Applied Arts, 1970; and Alan Solomon, *Painting in New York: 1944 to 1969* at the Pasadena Art Museum, 1969–70. All three curators selected painters Johns, Kelly, Lichtenstein, Louis, Noland, Olitski, Poons, Rauschenberg, Stella, and Warhol. These artists were also on Geldzahler's list, along with Frankenthaler and Rosenquist. Rosenquist was selected by Sweeney and Arnason. The latter also chose Anuszkiewicz. Sweeney added Dine, Held, and Indiana; and Arnason added Frankenthaler and Wesselmann. Only Sweeney and Arnason chose sculpture, and they agreed on Morris. Arnason also included di Suvero, Oldenburg, Segal, Tony Smith, and Snelson.

There was no clearer sign of consensus support than a one-person show in a major museum with art-world cachet, particularly in Manhattan.[32] The Museum of Modern Art granted this honor to Oldenburg in 1969 and Stella and Tony Smith in 1970; the Whitney Museum, Judd in 1968, Frankenthaler in 1969, and Dine and Morris in 1970; the Guggenheim Museum, Jensen in 1960, Louis in 1963, Lichtenstein in 1969, and Andre in 1970; the Jewish Museum, Frankenthaler in 1960, Rauschenberg in 1963, Johns in 1964, Noland in 1965, and Flavin in 1970; and the Metropolitan Museum, Rosenquist in 1968 and Olitski in 1969. In 1968, Christo wrapped the Museum of Modern Art.

Artists who were given shows in important American museums outside New York were: In 1962, Oldenburg at the Museum of Contemporary Art, Dallas. In 1963, Kelly at the Washington Gallery of Modern Art. In 1964, Kelly at the Institute of Contemporary Art, Boston. In 1965, Warhol at the Institute of Contemporary Art, Philadelphia; Caro at the Washington Gallery of Modern Art. In 1966, Warhol at the Institute of Contemporary Art, Boston, and the Contemporary Art Center, Cincinnati; Tony Smith at the Wadsworth Atheneum, Hartford, Conn., and the Institute of Contemporary Art, Philadelphia; Lichtenstein at the Cleveland Museum of Art; H. C. Westermann at the Nelson-Atkins Museum of Art, Kansas City. In 1967, Louis at the Los Angeles County Museum of Art; Olitski at the Corcoran Gallery, Washington; Lichtenstein at the Pasadena Art Museum, the Walker Art Center, Minneapolis, and the Contemporary Art Center, Cincinnati; Oldenburg at the Museum of Contemporary Art, Chicago; Flavin at the Museum of Contemporary Art, Chicago; Tony Smith at the Walker Art Center. In 1968, Olitski at the Institute of Contemporary Art, Philadelphia; Held at the San Francisco Museum of Modern Art, the Corcoran Gallery, and the Institute of Contemporary Art, Philadelphia; Westermann at the Los Angeles County Museum; Pearlstein at the Carnegie-Mellon Institute, Pittsburgh; Estes at the Hudson River Museum, Yonkers, N.Y.; Nicholas Krushenick at the Walker Art Center; Indiana at the Institute of Contemporary Art, Philadelphia. In 1969, Westermann at the Museum of Contemporary Art, Chicago; Morris at the Corcoran Art Gallery. In 1970, Warhol at the Museum of Contemporary Art, Chicago, and the Pasadena Museum; Lichtenstein at the Nelson-Atkins Museum of Art, the Museum of Contemporary Art, Chicago, the Seattle Art Museum, and the Columbus (Ohio) Gallery of Fine Art; Wesselmann at the Newport Harbor Art Museum; Pearlstein at the Georgia Museum of Art, Athens; Morris at the Detroit Institute of Art; Flavin at the Los Angeles County Museum of Art; LeWitt at the Museum of Art, La Jolla, Cal.; and Tony Smith at the Newark Museum.

## NOTES

1. Irwin Fleminger, in "The New Art Selection Process," *Art News,* January 1967, p. 56, claimed that to believe the art world was a conspiracy was "a paranoid delusion."
2. Art-world roles were often complicated because art professionals played multiple roles: curators wrote criticism or collected art; collectors served on museum boards or dealt in art; critics curated shows or advised collectors; and so forth.
3. Although the growth of the art world in New York was dramatic, its numbers were comparatively small, consisting at the end of the decade of, for example, at most—not counting artists— some three dozen gallery dealers, four dozen major collectors, six dozen art editors and critics, and five dozen museum directors and curators. Even if these numbers are enlarged to include out-of-town art professionals who were recognized by the art world in New York, the number would not be more than double or triple.
4. Interview with André Emmerich, New York, 9 October 1980. I cannot be specific about how

Greenberg "edited" art. In the case of Louis, it seems to have meant suggesting which direction to take and advising on which works to show. Perhaps the interaction or collaboration was of the nature suggested by John Elderfield in his introduction to *Morris Louis,* exhibition catalogue (London: Arts Council of Great Britain, 1974), p. 74, n. 5:

> Greenberg's influence on Louis should not be underestimated; neither should it be misunderstood. Louis's final decisions were his alone. At times, Greenberg's eye was in advance of Louis's; it was in part due to Greenberg's criticism of Louis's Martha Jackson Gallery exhibition of November 1957 that he returned to painting veils. On the other hand, Greenberg now feels that Louis's views about the hanging of the veils (with the bottom edge anchored) and about the cropping of the stripe paintings (so that the stripes are cut off by the framing edge at top and bottom) were in advance of his own.

Diane Upright Headley, in *Morris Louis: The Mature Paintings 1954–1962* (Ph.D. diss., University of Michigan, 1976), p. 59, footnote 78, remarked: "The degree to which Louis trusted Clement Greenberg is revealed in a notation made by the artist on an unstretched canvas . . . *Dalet Tet.* At the upper right in front of the canvas appears the following: '1″ of white on each side as per Clem.' "

If Elderfield's and Headley's remarks are accurate, then no other major critic I know of entered as actively into the creative process of major artists as did Greenberg. And it may be that Greenberg's influence on artists was far stronger than Elderfield indicated. Frank Bowling reported in "Formalism: A Selective View," *Cover* 6 (Winter 1981–82): 40:

> Greenberg does not tell artists what to do; he nearly always *surmises* as to how best an artist might, even should proceed. . . .
>
> And here is the rub: you don't have to follow his advice; only the best do. . . . What is undeniable is that during Greenberg's long career he has shown that what appeals, immediately and instinctively to him, are the right things. . . .
>
> The formalist artists, known to Greenberg, score every time because even the "bad" work they make has a core of grit.

5. Like Greenberg's criticism, writing by Minimal artists also seemed to give rise to and influence art in the sixties. Critical suppositions about the nature of art, the next move, or what was required to fill out or extend a Minimalist paradigm generated art—and, because they were published in art magazines, advertised it. The triple thrust of polemic, artistic practice, and promotion certainly did help influence the consensus, but not unduly, since it was understood that it was the artists who were their own critics.

6. Michael Fried, "Frank Stella," *Toward a New Abstraction,* exhibition catalogue (New York: Jewish Museum, 1963), p. 28.

7. Donald Judd, "Local History," *Arts Yearbook 7: New York: The Art World* (1964): 26.

8. Lawrence Alloway, *The Venice Biennale: 1895–1968* (London: Faber and Faber, 1969), pp. 144–45.

9. In 1961, Rauschenberg's combine-paintings were shown at the Galerie Daniel Cordier in Paris and the Galleria dell'Ariete in Milan; in 1963, in the Galleria del'Obelisco in Rome and the Galerie Ileana Sonnabend in Paris; and in 1964, again at the Galerie Ileana Sonnabend and at the Galleria Civica de'Arte Moderna in Turin and the Whitechapel Art Gallery in London.

10. Rosalind Constable, "New York's Avant-Garde . . . ," *New York/Herald Tribune,* 17 May 1964, p. 7.

11. Castelli, in Josh Greenfield, "Sort of the Svengali of Pop," *New York Times Magazine,* 8 May 1966, p. 40, later conceded: "I was somewhat responsible for the Rauschenberg victory because I did a lot from the beginning, not just a month or two before the Biennale. Rauschenberg had much exposure. He had had great shows in England, Sweden, Denmark, Germany—everywhere. I was never unconscious of Europe. And to the Europeans Rauschenberg was obviously interesting." Constable, in "New York's Avant-Garde . . . ," p. 7, corroborated Castelli's remark.

12. Alan Solomon, in *Leo Castelli: Ten Years,* exhibition catalogue (New York: Leo Castelli Gallery, 1967), n.p.

13. Alan Solomon, "Letters," *New York Times Magazine,* 5 June 1966, p. 120. See also Sophy Burnham, *The Art Crowd* (New York: David McKay, 1973); Alloway, *The Venice Biennale;* Hilton Kramer, "Art: Venice Machinations," *New York Times,* 16 June 1966; Annette Michelson, "The 1964 Venice Biennale," *Art International,* 25 September 1964; Calvin Tomkins, "The Big Show in Venice," *Harper's Magazine,* April 1965.

It is noteworthy that Roy Lichtenstein did not win a prize at the Venice Biennale in 1966, even though Castelli worked as indefatigably for him as he had for Rauschenberg two years earlier. Kramer, in "Art: Venice Machinations," p. 54, reported:

> Certainly the campaign for Mr. Lichtenstein seems well organized. The bookshops here [in Venice] are prominently displaying a bright and hastily produced illustrated multilingual paperback anthology of critical writings on Mr. Lichtenstein's work. . . . Three international art journals featuring Mr. Lichtenstein on their covers . . . are very much in evidence, as is a fourth, *Art International,* published in Switzerland by an American. The last contains an article on Mr. Lichten-

stein by Otto Hahn, the French critic, and has nothing about the other Americans showing here.

14. Dorothy Seckler, "The Artist Speaks: Robert Rauschenberg," *Art in America,* May–June 1966, p. 73.

15. Sophy Burnham, in *The Art Crowd,* pp. 130, 134, 146, tried very hard to document corruption in the art world, but it did not add up to anything significant.

16. It surprises me as I look back on the sixties how little analysis and questioning there was of the art-support network. We believed in art and the art world. We did not believe that anyone in our world would do anything grossly corrupt—that is, they would not compromise their aesthetic principles for money or for any other reward—but there were small improprieties, lapses in morality, and conflicts of interest, such as favoring a friend or someone who could be of help, on the part of even the most respected art professionals. A critic or curator might accept a work by an artist friend as a gift and, if the need arose, sell it. It seemed natural and innocent and not morally wrong. No one thought much about it. Perhaps we should have.

17. William Seitz, "Problems of 'New Directions' Exhibitions," *Artforum,* September 1963, p. 25.

18. Steven W. Naifeh, *Culture Making: Money, Success, and the New York Art World* (Princeton, N.J.: Princeton University Press, 1966), pp. 34, 43, 46.

19. "You Bought It, Now Live with It: The Country's Leading Collectors of Pop Art Enthusiastically Fill Their Homes with It," *Life,* 16 July 1965, p. 59. The new collectors could be seen merely as arrivistes, as John Myers saw them in "Junkdump Fair Surveyed," *Art and Literature,* Autumn–Winter, 1964, pp. 129–30. He wrote that the acquisition of art, bought for so little, provided a host of blessings. The new collector

> is no longer regarded as just a sharpie installing Laundermats in Teaneck or Peapack. He can with his freshly acquired works of art become a Contributor to the Museum and, with his snappy little wife, get invited to pre-opening dinner parties and shake hands with a Rockefeller. . . . Before you know it he's elected to a committee or becomes a Friend Of. He can then sit in judgment as to which work will have the honor of being a New Acquisition. [With] his new *persona* he gets invited to art parties. . . . Aglow with his "self-knowledge" the new collector begins to feel he's more than just another collector. He is an Eye. . . . He makes his way to artists' studios where, as an arbiter of taste, he will buy what he wants—cheaper. [The] new collector begins to receive public acclaim: his collections, his apartment, his snappy little wife

appear in full color in *Time, Vogue,* the *Ladies' Home Journal. . . .* The older collectors start worrying about how to keep him out of their clover. . . . But how can they squeeze him off a committee when he owns 22 Rauschenbergs, 4 Klines and 7 Gorkys—along with the stuff he's *really* crazy about?

20. David Rosand, "Critique: Style and the Puritan Aesthetic," *Art Voices,* Fall 1966, p. 15.

21. E. C. Goossen, *The Art of the Real,* exhibition catalogue (London: Tate Gallery, 1968).

22. Hilton Kramer, in Elayne H. Varian, introduction, *Twenty Galleries/Twenty Years,* exhibition catalogue (New York: Grace Borgenicht Gallery and Terry Dintenfass Gallery, 1982), p. 12.

23. As early as 1963, William Seitz, one of the most high-minded and respected of curators, critics, and historians, bitterly condemned art-world pressure on curators who were organizing museum shows of new art. There was, as he wrote in "Problems of 'New Directions' Exhibitions," pp. 24–25,

> a Pandora's box of problems that have arisen over the last few years as a result of the sweeping success of avant-garde art. Any curator preparing an exhibition that reflects, or can affect, a current trend will be subject to various pressures, especially if his museum has a wide influence, that can range from salesmanship and persuasion to coercion. . . . It is easy to say that he should choose works on the basis of quality, and only quality, but we know from experience that the newer the direction the harder quality is to define. . . . Once I had a partial answer to the changing direction of art: always follow the artist; never try to manipulate the future. But now the artist's leadership has become so intertwined with speculation, salesmanship, promotion schemes, Mondo Cane sensationalism and the insatiable appetite of the masscult and midcult press for Sunday-supplement copy, that true vision is difficult to extricate.

Seitz went on to ask whether "the life of art is to become 'art biz.'" For Seitz himself, it had not. His example testifies that art professionals were able to resist pressures and temptations, if with some difficulty.

24. John Walker, in *Self-Portrait with Donors* (Boston: Atlantic-Little, Brown, 1974), p. xi, wrote: "The greater part of my adult life has been spent collecting collectors who would, I hoped, become donors. This was my principal job as a museum curator and later as a museum director, positions I held for over thirty years."

25. See John Coplans, in "Pasadena's Collapse and the Simon Takeover, Diary of a Disaster," *Artforum,* February 1975, pp. 37, 39.

26. Assemblage was also featured in the first major museum show of younger New York artists held abroad. Titled *4 Americans,* it was organized by

Pontus Hultén at the Moderna Museet in Stockholm in 1962. It included Robert Rauschenberg, with nineteen works, Jasper Johns, with twenty-four, Richard Stankiewicz with twenty-five, and Alfred Leslie with forty-seven.

27. The American consensus was quickly reflected in shows abroad. Among the more important were *The Popular Image* at the Institute of Contemporary Art, London, in 1963; *Amerikanste Pop-Kunst* at the Moderna Museet, Stockholm, in 1964, which traveled to the Stedelijk Museum, Amsterdam, with texts by Alan Solomon and Billy Klüver; *Nieuwe Realisten* at the Gemeentemuseum, The Hague, in 1964, and *Neue Realisten Pop Art* at the Akademie der Kunst, Berlin, in 1964, with a text by Werner Hoffman, and *Pop, etc.*, at the Museum des 20. Jahrhundertes, Vienna, in 1964. In 1967, Pop Art was featured by William C. Seitz in *USA Environment USA: 1957–1967*, which was the American contribution to the São Paulo Bienal, Brazil.

28. H. H. Arnason, *American Abstract Expressionists and Imagists* (New York: Solomon R. Guggenheim Museum, 1961), p. 24.

29. *The Responsive Eye* was considered so negligible that Henry Geldzahler omitted it from his bibliography of important catalogues of sixties shows in *New York Painting and Sculpture: 1940–1970*, exhibition catalogue (New York: E. P. Dutton, 1969), pp. 482–83. It is noteworthy that before *The Responsive Eye* opened, on 25 February 1965, Richard Bellamy's Green Gallery showed *Impact* (December 22–January 9), the Martha Jackson Gallery, *Vibrations II* (December 29–January 30), and the Sidney Janis Gallery, *Abstract Trompe l'Oeil: Five Painters Who Lead and Mislead the Eye* (Albers, Anuszkiewicz, Herbin, Poons, and Vasarely) (January 26–February 27).

30. *Kunst Licht Kunst* at the Stedelijk van Abbemuseum, Eindhoven, Holland, in 1968, organized by Frank Popper, was the high point of Light Art in the sixties.

31. There were two earlier museum shows that featured Minimal artists. The first, titled *Black, White and Gray*, was organized by Sam Wagstaff, Jr., at the Wadsworth Atheneum, Hartford, Conn., January–February 1964. Donald Judd, in "Nationwide Reports: Hartford: Black, White and Gray," *Arts Magazine*, March 1964, p. 36, wrote that the show "was chosen, though not entirely, to display an attitude common to a number of artists. The attitude is new and has never been the subject of a museum show before." The artists included were Newman, Reinhardt, Johns, Dine, Indiana, Lichtenstein, Warhol, Flavin, Morris, Tony Smith, and Stella. It is noteworthy that Pop and Minimal artists were mixed. The second show, *8 Young Artists*, was organized by E. C. Goossen in October 1964 at the Hudson River Museum. In 1968, Minimal Art received recognition in Europe in a show titled *Minimal Art* at the Gemeentemuseum in The Hague and in the selection at *Documenta 4*, Kassel.

32. Geldzahler, *New York Painting and Sculpture*, p. 23. As an aside, it is instructive to list the artists of the sixties featured on the covers of *Artforum:* 1964, George Segal and Andy Warhol; 1965, Larry Poons, Jules Olitski, and Roy Lichtenstein; 1966, Frank Stella and Dan Flavin; 1967, Morris Louis, H. C. Westermann, Kenneth Noland, and Frank Stella; 1968, Claes Oldenburg, Anthony Caro, Robert Irwin, Larry Poons, and Carl Andre; 1969, Richard Serra, Helen Frankenthaler, Ellsworth Kelly, Robert Smithson, Keith Sonnier, Claes Oldenburg, and Michael Heizer; and 1970, Frank Stella, Eva Hesse, and Donald Judd.

# 7 POP ART

The object-obsessed, cool sensibility of the sixties was initially announced in Stella's black-stripe abstractions, which attracted art-world attention in 1959, but in 1962 it was Pop Art, so called because its subject matter and techniques were borrowed from commercial art—billboards, comic strips, packaging, television programs and commercials, movies, glossy magazines, and advertising—that commanded the interest not only of the art-conscious audience but also of the fashion-minded and even the general public. In fact, for a movement proclaimed by art professionals as radically new, public acceptance was uncommonly swift. Within two years after the emergence of Pop Art, its premises had been dealt with extensively in major museum shows and their catalogues, and in serious essays in art magazines,[1] as well as in innumerable popular articles in the mass media. *Time, Newsweek,* and *Life,* and big-circulation newspapers, reported excitedly on the new sensation, at first treating it as a freakish fad but covering it extensively, if only because journalists found it as easy to write about as abstract art was difficult. There was so much commentary that Pop Art acquired its own instant art history, a good deal of which might be labeled Pop Art History, since celebrities and media-featured art openings, parties, and related events were given prominent coverage.[2]

Pop Art was ushered in by the one-person shows of Claes Oldenburg and Jim Dine, in December 1961 and January 1962 respectively. Although neither was a Pop artist in the narrow sense of that term, their work created a sensation because it represented the artifacts of daily life. In an environment titled *The Store,* Oldenburg filled a shop that he rented on East Second Street in Manhattan with a fantastic mélange of garishly painted plaster "replicas" of the cheap commodities sold in the "real" stores on the Lower East Side. The pictures in Dine's show at the Martha Jackson Gallery (the first given to a "Pop" artist by an uptown dealer) consisted of vigorously painted visual and verbal images of suspenders, beads, hats, neckties, and palettes. Up to that time, Oldenburg and Dine had made Assemblages but had been better known as Happening-makers. Their Assemblages were not included in *the Art of Assemblage,* which had just closed at the Museum of Modern Art, although their Happenings had been dealt with in the catalogue. But their new work could not be viewed in the context of Assemblage; it was something new. At the end of January 1962, following Dine's show, James Rosenquist opened, at the Green Gallery, an exhibition of paintings based on billboards, and at the beginning of February, Roy Lichtenstein showed paintings of comic strips and advertisements at the Castelli Gallery. The next fall, the Stable Gallery exhibited Andy Warhol's pictures of Campbell's soup cans and Coke bottles, Marilyn Monroe and Elvis

Presley, and do-it-yourself, by-the-number paintings.[3]

Only ten months after its first appearance, Pop Art was made respectable by a large international show, *The New Realists,* at the Janis Gallery in the fall of 1962. Brian O'Doherty observed in the *New York Times:* "With this show, 'pop' art is officially here."[4] The status conferred on Pop Art by the Janis show was augmented by a series of major museum shows in Pasadena, New York, Kansas City, Houston, Washington, and Los Angeles, mounted from September 1962 to July 1963. By the end of the following year, Pop Art's shock had worn off, and art-world interest began to slacken, although a half-dozen or so of its innovators continued to command attention.

Pop Art can be considered broadly as that art of the sixties which represents or interprets mass-produced common objects and subjects culled from commercial art—that is, the signs of things and people. On the basis of this inclusive approach, the Pop artists can be thought of as the latest—and the most extreme—in a long line of modern artists who looked to ordinary artifacts and/or popular culture for inspiration. Among the antecedents of Pop Art were Picasso's and Braque's collages of 1912–13; Duchamp's Readymades, presented as is (e.g., *Bottle Rack*) or "assisted" (e.g., *Apolinère Enameled*); Schwitters's collages made of trash; Léger's New Realism; Stuart Davis's and Gerald Murphy's canvases that included "pop" motifs. Later, in the fifties, de Kooning made the "smile" of *Woman I* from a cigarette advertisement; Larry Rivers based his notorious *Washington Crossing the Delaware* on Emanuel Leutze's calendar-art-like "machine" of the same title; Rauschenberg made combine-paintings and Johns,

47. Claes Oldenburg, *Two Cheeseburgers with Everything (Dual Hamburgers),* 1962. 7″ × 14¾″ × 8⅝″. Museum of Modern Art, New York.

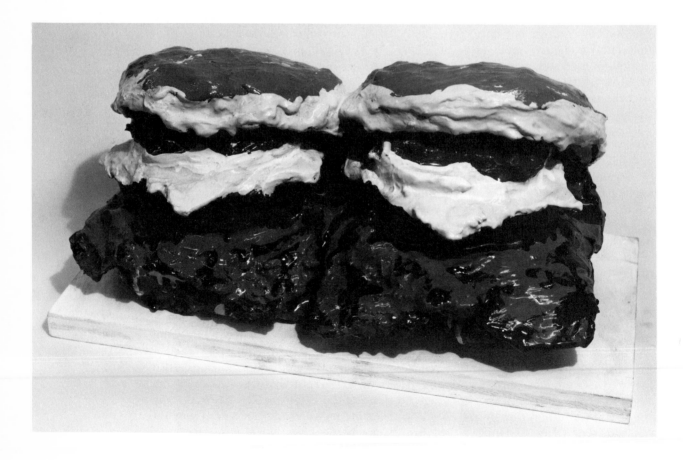

pictures of American flags, letters, numbers, etc.; Richard Stankiewicz, John Chamberlain, and Mark di Suvero constructed sculptures incorporating junk; and Allan Kaprow, Red Grooms, Robert Whitman, Oldenburg, and Dine created Happenings.[5]

Pop Art can also be considered narrowly, as art that represents images selected from commercial art—signs of objects and signs of signs—and, equally important and more radical, art that utilizes the mechanical, and thus impersonal, techniques of commercial art (techniques new in easel painting), such as Warhol's silk screens of photographs,[6] Lichtenstein's stenciling of Ben Day dots, and Rosenquist's billboard technique and airbrush spraying. I use the label Pop Art in this narrow sense, as Robert Rosenblum did:

> Pop Art . . . must have something to do not only with *what* is painted but also with the *way* it is painted; otherwise Manet's ale bottles, Van Gogh's flags and Balla's automobiles would qualify as Pop Art. The authentic Pop artist offers a coincidence of style and subject, that is, he represents mass-produced images and objects by using a style which is also based upon the visual vocabulary of mass production.[7]

In fact, one of the most important innovations of Warhol was to make commercial photography and print-making central to his art, ushering in the use of media that became central to art in the sixties. (This led to the elevation of fine photography, long considered a minor art, to the "high art" status of painting and sculpture.) Given the narrow definition, *the* Pop artists were Warhol, Lichtenstein, Rosenquist, and Wesselmann. Rauschenberg, Johns, Oldenburg, and Segal did not fit, because their work retained a painterly or gestural look which did not call to mind commercial images or techniques.

The Pop artists depicted subjects that were brand-new in the sense of being unused and thus devoid of the often picturesque, sentimental, and nostalgic flavor

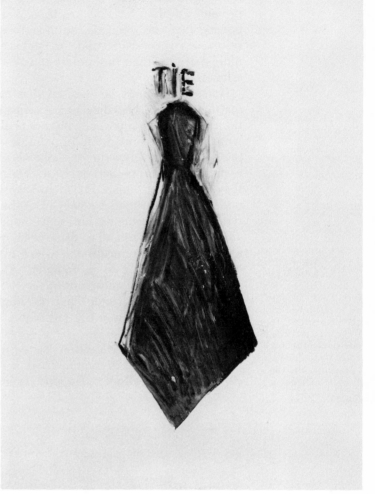

48. Jim Dine, *Tie*, 1962. 25¾" × 19½". Ileana and Michael Sonnabend.

of Assemblages, which were composed of found junk and other old materials. Pop subjects were represented factually with a cool objectivity; they were signs and not symbols of things, and it was this that made Pop Art characteristic of the sixties. On the whole, the images were untransformed except for changes in size and medium. These, of course, were critical, as changes in context generally are. However, deadpan literalness was valued, and anything that got in the way was suppressed, particularly painterly handling, because it generated an ambiguous, "poetic" space and because it denied the specificity or "thing-like" quality of the image. If the literal representation of ex-

isting objects and images is considered the primary criterion for Pop Art, then Warhol and Lichtenstein could be thought to be more rigorously factual, or, at least, more extreme, than Rosenquist and Wesselmann were.

However, it must be stressed that no matter how novel or radical or iconoclastic the Pop artists seemed, they did not challenge the basic conventions of painting— that is, the two-dimensional and rectangular canvas—although at times they did stretch them. As Lichtenstein said, he was "anti-getting-away-from-the-tyranny-of-the-rectangle, anti-movement-and-light . . . and anti all of those brilliant ideas of preceding movements which everyone understands so thoroughly." He admitted to being "anti-paint-quality" in the sense of "anti-nuance" but not anti-painting,[8] and certainly not anti–"good" composition.

American Pop Art was often related to English Pop Art and French *nouveau réalisme,* or New Realism, by art profession-als. Actually, the English and American artists knew little, more likely nothing, about one another's art. The misunderstanding arose because the label Pop Art was given both varieties by the English art critic Lawrence Alloway. But when he first coined it in 1954, he did not mean for it to be applied to fine art. Rather, he and a group of artists and their friends who met at the Institute of Contemporary Art in London to discuss popular culture used the label to mean the products of the mass media. The focus was on phenomena of American origin and inspiration: Madison Avenue advertising; Detroit automobile design; Hollywood movies; science fiction; pop music; and the like.[9] After 1956, beginning with Richard Hamilton, artists such as Peter Blake, Richard Smith, R. B. Kitij, Peter Phillips, Derek Boshier, Allen Jones, and David Hockney began to use motifs from popular culture in their images. But they relied on Cubist design and collage, and on painterly handling. Thus their works related more to Rauschen-

49. Installation of *New Realists* exhibition, Sidney Janis Gallery, New York, 1962. From left to right, works by Peter Agostini, Tom Wesselmann, Mimmo Rotella, George Segal, Andy Warhol, Robert Indiana, and Claes Oldenburg.

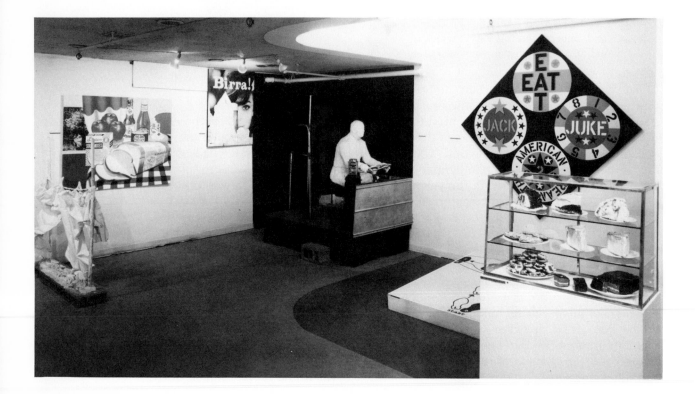

berg's combine-paintings and Larry Rivers's pictures than to the canvases of Warhol and Lichtenstein.[10]

American Pop Art was also different from French *nouveau réalisme,* with which it was often confused since both came to public attention at roughly the same time and were shown together in *The New Realists* show at the Janis Gallery. The *nouveaux réalistes,* as the art critic Pierre Restany named them, formed a group in 1960 and were given a show in Paris the following year. Its original members were Yves Klein, Tinguely, and Arman; they were joined by others, among them Raysse, Spoerri, de Saint-Phalle, and Christo. Those in the Janis show did not impress the New York art world, as Lippard remarked: "The European contributions looked pale, overworked, and strongly Surrealizing compared with the new pop art. For the *Nouveaux Réalistes* are primarily Assemblagists, and there are already a plethora of Assemblages being shown in New York." Lippard went on to say:

> [The] Americans take their daily reality straight, whereas the Europeans are likely to call their sources "daily mythologies." Stylistically and formally, the European artist is not as aggressive as the American, but he is given to manifestoes and demonstrations that are ferocious, emotional and *engagé* in contrast to the "cool" Anglo-American viewpoint, which spurns group identification. The Parisian attitude . . . is far more literary [and] sociological.[11]

The French artists looked upon mass culture as alien and bizarre rather than as an accepted part of everyday experience. In contrast, as Tillim remarked, the Americans "give you the thing itself—pow."[12]

The years 1961 and 1962 were obviously prime for the emergence of Pop Art. It is noteworthy that the Pop artists in New York arrived at their styles independently; they did not know each other.[13] Thus no single artist can claim convincingly to have been the first who inspired the others. However, all shared a common

culture and responded to the same aesthetic and social stimuli. There was clearly something in the air. Only in the sixties could artists have mustered the confidence to use objects borrowed from popular or low culture, particularly commercial art, with the serious intention of creating high art. It would have been unthinkable in the Depression thirties or wartime forties, when for the great mass of Americans, consumer goods were not affordable or available. In intellectual circles during that period, kitsch was considered the enemy of high art, beneath serious consideration. This attitude changed in the fifties, the change brought about by an economic boom accompanied by an unprecedented growth of the mass media, notably television, whose primary function it was to advertise the plethora of mass-produced goods. Naturally, there developed a widespread interest in the field of communication. Moreover, the information industry became the topic of fashionable sociological research (and discourse)—for example, that of Marshall McLuhan. It was only when a significant number of artists was prepared to believe that the mass media had so evolved that they had drastically and irrevocably altered ways of seeing the world and had to be dealt with seriously in art that Pop Art could emerge as a serious style and be taken seriously.

As Henry Geldzahler viewed it in 1963, "pop art was inevitable."

> The popular press, especially and most typically *Life* Magazine, the movie close-up, black and white, technicolor and wide screen, the billboard extravaganzas, and finally the introduction, through television, of this blatant appeal to our eye into the home—all this has made available to our society, and thus to the artist, an imagery so pervasive, persistent and compulsive that it had to be noticed. . . .
>
> The artist is looking around again and painting what he sees. . . . We live in an urban society, ceaselessly exposed to mass media. . . .

Pop art is immediately contemporary. . . . It is an expression of contemporary sensibility aware of contemporary environment.[14]

Even before the advent of Pop Art, Alloway had written that it was through the bombardment of our senses by the mass media that we know the world. "Because the media is a fund of known allusion, shared names and attitudes, shapes and colours, it has a claim to be common ground between artist and audience."[15] When this view became accepted, fine artists could use popular culture as a store of iconography. Rosenquist remarked:

I'm amazed and excited and fascinated about the way things are thrust at us. [We are] attacked by radio and television and visual communications . . . at such a speed and with such a force that painting . . . now seem[s] very old-fashioned. . . . Painting is probably more exciting than advertising—so why shouldn't it be done with that power and gusto, with that impact.[16]

(The kind of immediacy Rosenquist found in the mass media was an attribute of the abstractions of Pollock, Newman, and other Abstract Expressionists, an attribute the Pop artists emulated even though they rejected much else.)

The Pop attitude obtained not only in Pop Art but in new architecture, literature, and film, a sign of its growing influence. In his seminal book, *Complexity and Contradiction in Architecture,* published in 1966, Robert Venturi "asked for the recognition of the diverse components of the real environment . . . as a valid cultural manifestation."[17] In the introduction, Vincent Scully wrote that Venturi "is one of the very few architects whose thought parallels that of the Pop painters—and probably the first architect to perceive the usefulness and meaning of their forms. He has clearly learned a good deal from them during the past few years. [His] 'Main Street is almost all right' is just like their viewpoint."[18] In his catalogue introduction to *The New Realists* show, John Ashbery remarked on the "importance of objects, especially artifacts," not only in current visual art but also in the " 'objective' novels of Robbe-Grillet and Sarraute, or . . . in the recent films of Resnais and Antonioni."[19] The New Journalism, exemplified by Tom Wolfe's writing, which came into vogue in the middle sixties, broke down the barriers between "low" journalism and "high" fiction, somewhat as Pop Art did.

Like Robbe-Grillet, the Pop artists insisted that their subjects be allowed to *be* and not be exploited for purposes other than what they were—that is, for poetic, symbolic, or metaphorical effect. The Pop artists intensified the reality of their subjects by isolating and magnifying them, but not by changing their appearance appreciably. They were, as Billy Klüver wrote in 1962, preoccupied with *"fact,"* and thus in "the American Tradition. Establishing the fact avoids sentimentality, theorizing, arrogance, academies, arguments, critics, manifestos. The single most important word for the current movement. One might call the artists 'The Factualists.' "[20] Indeed, Factualism was an early label for Pop Art but was quickly superseded.

Concern with realism led the Pop artists to reject the abstractness of Abstract Expressionism, overlooking the fact that the greater part of it was figurative, though not representational. For example, Indiana wrote: "Pop is everything art hasn't been for the last two decades. It is basically a U-turn back to representational visual communication."[21] In order to record the facts, the Pop artists decided in advance what to paint, unlike the painterly painters. They also spurned the Expressionism in Abstract Expressionism, the improvisational signs of the seemingly inward-looking, emotionally involved process of painting—the unpremeditated brushmarks themselves. Warhol said that he "wanted to take away the commentary of the gestures."[22] Wesselmann remarked: "I don't attach any kind of value to brushstrokes."[23] Indiana was even more ada-

mant in his rejection of the "self-conscious brush stroke and the even more self-conscious drip. . . . Impasto is visual indigestion."[24] And Rosenquist said: "I want to avoid the romantic quality of paint."[25]

The consummate Pop Art comment on gesture painting was not a statement but an image—of brushstrokes in pictures by Lichtenstein. He took an existing subject that was supposed to be spontaneous and drew and painted it meticulously—tediously—applying commercial-art techniques. Lichtenstein acknowledged that he intended to poke fun at Abstract Expressionism. His "brushstrokes" were executed in a spirit contrary to gesture painting, deliberately painstaking rather than free, hard-edge rather than painterly. The result was a misconstrued picture of a picture,[26] a Pop parody of an Abstract Expressionist emblem. More ambiguous and equally subversive was Warhol's earlier *Do It Yourself,* 1962 (exhibited in *The New Realists* show), which consisted of a partly painted diagram of a painting-by-the-numbers. This kind of mechanistic painting had become a kitsch fad, and by using it as the subject of high art, Warhol called into question elevated ideas of picture-making, the very nature of creativity. Warhol also parodied Abstract Expressionism through sloppy silk screening that created "painterly" effects;[27] these could mistakenly be taken for subjective.

It was the denial of painterly touch that separated the Pop artists from Johns, whose choice of a commonplace, man-made, flat, single image in a picture, such as *Flag,* had influenced Warhol and Lichtenstein, as it had Stella before them. Johns himself had depersonalized gesture, pointing the way to a nongestural aesthetic and becoming the main bridge between introspective gesture painting and objective Pop Art. But in the end, the brushiness of Johns's "things" caused them to look something other than what they were, this distinguishing them from Pop Art.[28] The Pop artists acknowledged their

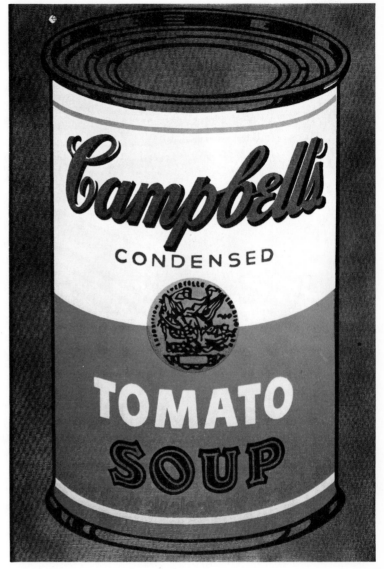

50. Andy Warhol, *Campbell's Soup,* 1965. 36⅛″ × 24⅛″. Museum of Modern Art, New York.

debt to Johns, but in their desire for straightforward representation, they eliminated all signs of hand in favor of a slick mechanical look.

Bellamy commented favorably on the "depersonalized, anonymous, objective" character of Pop Art.[29] Lichtenstein also wanted his work "to look programmed or impersonal," even industrial, but he added: "I don't really believe I am being impersonal when I do it."[30] Warhol took an even stronger impersonalist stance. He

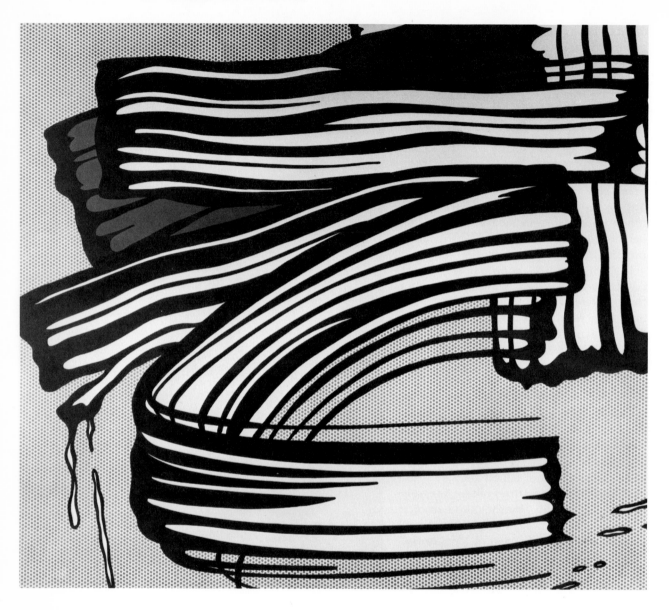

51. Roy Lichtenstein, *Little Big Picture*, 1965. 68″ × 80″. Whitney Museum of American Art, New York.

said that the reason he was using silk screens "is that I want to be a machine, and I feel that whatever I do and do machine-like is what I want to do."[31]

Because they valued depersonalization, the Pop artists were often thought to be closer to Johns's mentor, Marcel Duchamp, than to Johns. Janis, in his introduction to *The New Realists,* called Duchamp the "most prophetic of the Dada painters [and the] most influential and encouraging to Factual artists every-

where. Duchamp's *Readymades* . . . remain today art works of vision and of particular significance and inspiration to the New Realist."[32] Duchamp himself viewed Pop Art as a move away from a "retinal" art toward a conceptual art. He said: "If you take a Campbell's soup can and repeat it 50 times you are not interested in the retinal image. What interests you is the concept that wants to put 50 Campbell soup cans on a canvas."[33] But the Pop artists were concerned with the

appearance of what they painted. More-over, much as they rejected painterly painting, they valued painting as a fine art, although their use of commercial tech-niques was often mistaken as antipainting. Thus their acceptance of Duchamp's ideas was limited. Pop works, after all, are not Readymades, like Duchamp's, but "re-mades," like Johns's.

On the whole, Pop artists thought of their pictures as benign or, at least, neu-tral. For instance, Lichtenstein said: "Pop Art looks out at the world," adding that "it appears to accept its environment, which is . . . different—another state of mind."[34] Warhol remarked that Pop Art is "liking things."[35] "I just paint things [portraits of things] I always thought were beautiful, things you use everyday and never think about. I'm working on soups, and I've been doing some paintings of money. I just do it because I like it."[36] Indiana shared Warhol's outlook: "Pop is a re-enlistment in the world. It is shuck the Bomb. It is the American Dream, optimistic, generous and naive. . . . Pop is love in that it accepts . . . all the meaner aspects of life. . . . It is the American Myth. For this is the best of all possible worlds."[37]

As a celebration of consumer society, Pop Art was a kind of "capitalist realism," America's answer to "socialist realism." From this point of view, Pop Art was con-sidered an up-to-date variant of American scene painting. G. R. Swenson had this in mind in the first article published on Pop Art, titled "The New American 'Sign Painters' "—Pop Art as a label had not yet come into use and the term was not men-tioned. He wrote: "There is something im-pudent in these works, something so simple-minded as to be unexpected." The new sign painters focus "on exhausted symbols" and bring "them to life with an exploded scale." They "revitalize our sense of the contemporary world. They point quite coolly to things close at hand with surprising and usually delightful re-sults."[38] Geldzahler also considered Pop Art "a new American regionalism,"

but this time, because of the mass media, the regionalism is nation-wide and even export-able to Europe. . . .

There is an Ogden Nash quatrain that I feel is apposite:
"I think that I shall never see
A billboard lovely as a tree.
Perhaps unless the billboards fall,
I'll never see a tree at all."
Well, the billboards haven't fallen, and we can no longer paint trees with great contem-porary relevance. So we paint billboards.[39]

Ivan Karp agreed, but he saw the American "landscape with its accoutre-ments [as a] monstrous spectacle," which the Pop artist, or "Common Image" artist, as Karp called him, observed with "a con-summately generous view," even though "it grates on the nerves" and does "not invite contemplation." "His philosophy is that all things are beautiful," and this ena-bles him to record, and only to record, the despicable without sentimentality, sensi-tivity, or refinement. What the Pop artist accepted calmly and without criticism but with "humorous wonderment" was, to list some of Karp's descriptive words (trans-lating them all into adjectives): hostile, horrible, vacuous, conceited, vicious, simple-minded, hateful, vile, stupid, ag-gressive, hard, vomity, cruel, stale, brutal, vulgar, nauseating, trembling, ghastly, fearful, and numb.[40] Alan Solomon also considered Pop Art "disgusting," be-cause

the new artists have brought their own sen-sibilities and their deepest feelings to bear on a range of distasteful, stupid, vulgar, as-sertive and ugly manifestations of the worst side of our society. Instead of rejecting the deplorable and grotesque products of the modern commercial industrial world [and] the incredible proliferation of *kitsch* . . . these new artists have turned with relish and excitement to what those of us who know better regard as the wasteland of television commercials, comic strips, hot dog stands, used car lots, juke boxes, slot machines and super markets. They have done so not in a spirit of contempt or social criticism or self-conscious snobbery, but out of an affirmative

and unqualified commitment to the present circumstances. . . . For them this means a kind of total acceptance.[41]

Solomon's interpretation was corroborated by Lichtenstein, who remarked on his "involvement with what I think to be the most brazen and threatening characteristics of our culture . . . but which are also powerful in their impingement on us."[42] Rosenquist's attitude was similar: "A painter searches for a brutality that hasn't been assimilated by nature . . . a new vision . . . geared right to the present time."[43]

The brutality read into Pop Art was often viewed as an up-to-date manifestation of the primitivism of a Picasso or a Brancusi, which had figured so significantly in modern art.[44] To characterize its spirit, Swenson quoted Meyer Schapiro's remark that Henri Rousseau "saw marvels which 'spelled modernity for the popular mind . . . with the same wonder as the man in the street and painted them with the devoted literalness of a modern primitive.' " Like Rousseau's canvases, Warhol's are "full of that spirit, full of good will and a large natural talent."[45] Jules Langsner summoned forth another Rousseau: "The celebration of common objects particular to our mechanized civilization represents a Jean-Jacques Rousseau primitivism in reverse. The impulse is the same." Like "the happy carefree Noble Savage in a state of nature, the artist turns to despised objects in his everyday surroundings."[46] Because these things looked not like the subjects of high art but like low or commercial art, they appeared to be primitive, which implied insensitive, according to Lichtenstein. He tried to cultivate the appearance of insensitivity in order to add vitality to his painting, which, however, could not really be insensitive, since then it would not have been art.[47] As primitives of a sort, Pop artists also avoided "arty" or precious, tasteful or slick advertisements, as Lippard observed, "based on exactly what Pop Art is getting away from: expert art-school design, striking but tasteful colour,

asymmetrical composition, and Bauhaus to Abstract Expressionist iconography."[48] Because the primitivism of Pop Art implied a deliberate descent from high culture, Pop Art could be regarded as *nostalgie de la boue,* or, as Tillim called it, "the downward mobility of the avant-garde in search of the new."[49]

The Pop artists' "state of nature" was America, because, as Lichtenstein remarked, industrialization had permeated its everyday life more than in Europe and there were fewer remains of any earlier life.[50] Coplans also characterized Pop Art as peculiarly American. Its subject matter struck him as native not only in sociological but in aesthetic terms; he declared that the Pop Art movement was the latest, probably the final, episode in the struggle of American art to free itself from European influences.[51] Or as Indiana proclaimed: "I propose to be an American painter."[52]

However, Coplans saw Pop Art as a deliberate, outrageous, and daring social commentary, critical of American society. He broached this interpretation in a review of the first museum show of Pop Art, titled *New Paintings of Common Objects.* Coplans singled out Warhol and Lichtenstein and claimed that their art had developed in reaction to commercialism and consumption. "Lichtenstein's hairspray carries a moral judgment. . . . The vulgarity of the image itself is shocking in the way the howl of the Beat poets is." And Warhol's

> now famous Campbell soup images . . . can be read as a pun on people, how much alike they are, how all that changes is the name. His S & H Green Stamp painting reminds us of a hive of grey flannel clerks, all identically clothed, all working for a pay check, to be spent on identical goods in identical supermarkets to get identical stamps to redeem them for identical goods to be put in identical homes and be shared with stereotyped wives.[53]

Edward Kienholz, himself a trenchant interpreter of American life, remarked:

FACING PAGE:
52. Andy Warhol, *100 Cans,* 1962. 72″ × 52″. Albright-Knox Art Gallery, Buffalo, N.Y.

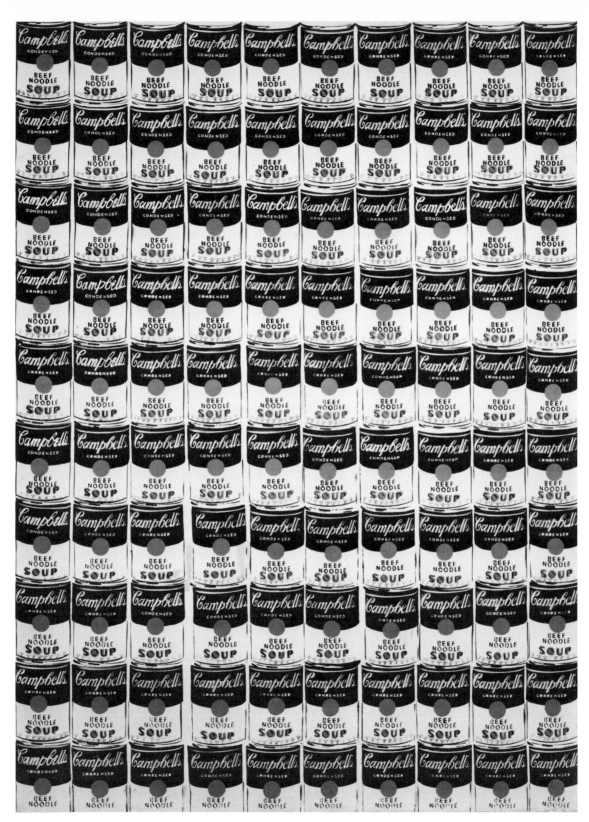

"Warhol's show is social protest, the Campbell's Soup show. It has to do with the extreme commercialism around and of everybody being fed up with it."[54] But Kienholz did not indicate what it was in the work that gave rise to his judgment. Neither did Tillim when he wrote that Pop Art was the art of the Kennedy years, the exemplification of the American Dream.[55]

The Pop artists did attempt explicit social statements, but only occasionally. For example, Rosenquist's *F-111,* 1965, was a pointed critique on the industrial-military complex and the consumer society. But on the whole, Pop Art's messages, especially Lichtenstein's and Warhol's, are cool and ambiguous, as, for example, Lichtenstein's battle scenes, which are boyhood fantasies of war, not protests against it, and his utterly banal romances, in one of which a young woman says: "It's . . . It's not an *engagement ring.* Is it?" In Warhol's race riots, the repetition of a single newspaper photograph seems to distance, make anonymous, and cancel the outrage rather than dramatize and condemn it. As Warhol said, "when you see a gruesome picture over and over again, it doesn't really have any effect."[56] Oldenburg once said to Warhol:

> When I see you repeat a race riot . . . I don't see it as a political statement but rather as an expression of indifference to your subject.
> Warhol: It is indifference.
> Glaser [interviewer]: Isn't it significant that you chose that particular photograph rather than a thousand others?
> Warhol: It just caught my eye.
> Oldenburg: You didn't deliberately choose it because it was a "hot" photograph?
> Warhol: No.
> Oldenburg: The choice of these "hot" subjects and the way they are used actually brings the cold attitude more into relief.[57]

Because Warhol and Lichtenstein did not interpret their subjects, their work appeared to deny social commentary—indeed, any commentary. Still, claims were made that its social message was precisely in its lack of message. Detached, disengaged, neutral, it became a kind of mirror reflecting American life for good or bad, depending on the point of view of the observer, without him or her having to specify why. As David Antin remarked: "It is funny or vicious depending on your taste."[58] Michael Compton agreed with Antin, but took a somewhat different tack. Pop Art "is not straightforwardly funny, nor is it unequivocally satirical. It is more an awareness of what is going on than a deliberate adoption of attitudes and opinions. It does not tell you what to think; it assumes you know what you need to know."[59] Or, as Warhol put it: "Everybody was part of the same culture now. Pop references let people know that *they* were what was happening, that they didn't have to *read* a book to be part of culture—all they had to do was to *buy* it (or a record or a TV set or a movie ticket)."[60] Pop Art assumed certain attitudes and values—a way of life.

But what if Pop Art's deadpan was satiric or ironic? If it was, then its stance was equivocal. Philip Leider found this subversive. He was struck by the "supersophisticated" manner in which Warhol manipulated ambiguities in his art.

> It is an art that may be a mockery or may not be a mockery, that seems most a mockery when most fashionably accepted, most subversive when most a fad. It is an art that seems capable of feeding the most disruptive energies of a sardonic generation only when it is the very toast of the bourgeois world, and Warhol's younger admirers enjoy his fashionable prominence as much as they enjoy the disdain with which he is treated by so many critics.

Leider concluded that it was from Warhol's art, if from any art, that "a truly subversive energy has been released."[61] In what way subversive? Warhol's nontransformation of his subjects meant copying, and copying meant faking. Warhol could be viewed as having forged Brillo boxes and the like. If his works were meant to be fakes, they could be viewed as emblems of

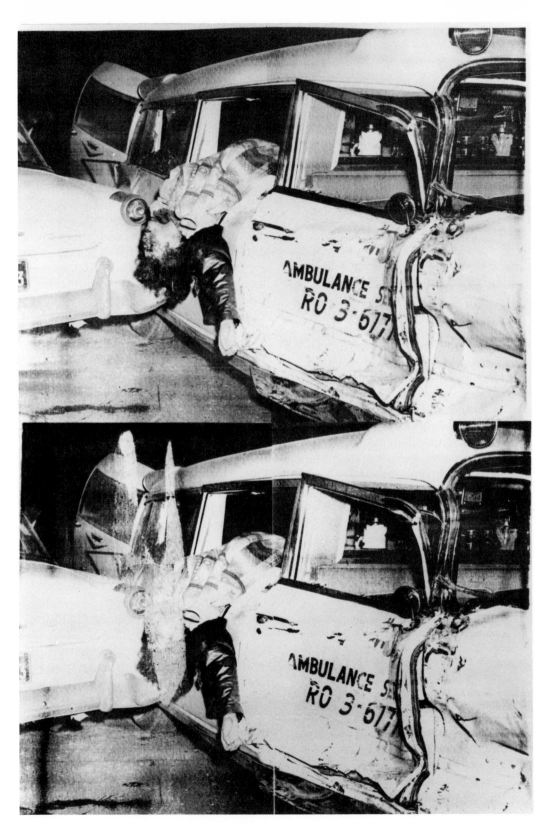

53. Andy Warhol,
*Ambulance Disaster*,
1963. 119″ × 80⅛″.
Dia Art Foundation,
New York.

inauthentic art and, by extension, inauthentic being, which was taken to be the fate of the individual in a consumer society. The irony was compounded because Warhol's works were forgeries not of high art but of commodities elevated to the status of high art. From this point of view, Warhol could be considered a subversive artist—and he made it pay, which many believed was doubly subversive.

When Pop Art emerged in 1962, its advocates, such as G. R. Swenson, John Coplans, Henry Geldzahler, and Lawrence Alloway, had the first say. Those who disliked it tended to withhold their commentary. I recall being urged by friends to refrain from writing about Pop Art at all, since any publicity, even negative criticism, was presumed to help the cause of the enemy.[62] Critics favorably disposed to Pop Art claimed that it was the first realist style since the inception of abstract art, or, at least, since de Kooning's *Women,* that looked radical rather than reactionary with reference to both imagery and form. Swenson first broached this idea: "Like all artists who are unwilling to imitate [existing art, Pop artists] force a re-examination of the nature of painting and its changing relation to the world." Swenson called their enterprise "the newest phase of the continuing revolution that characterizes painting in the twentieth century."[63]

In its form, Pop Art was closely related to hard-edge and stained color-field abstraction. As Geldzahler wrote:

> The best and most developed post-Abstract Expressionist painting is the big single-image painting. . . . I am thinking of Ellsworth Kelly, Kenneth Noland, Ray Parker and Frank Stella, among others—and surely this painting is reflected in the work of Lichtenstein, Warhol and Rosenquist. . . . The aesthetic permission to project their immense pop images derives in part from a keen awareness of the most advanced contemporary art. And thus pop art can be seen to make sense and have a place in the wider movement in recent art.[64]

Like the new abstract painters, the Pop artists valued immediacy and flatness, the sign of which was their frequent choice of two-dimensional subjects, such as comic strips. Judd went so far as to claim that Warhol was essentially an abstract artist, "since it is easy to imagine Warhol's paintings without . . . subject matter, simply as 'over-all' painting of repeated elements."[65] If other critics would not go so far as Judd, many believed that Pop Art had more in common with the new abstraction than with any contemporary realist style. Indeed, it was the radical abstract components of Pop Art as much as its kitsch subjects that made it an issue of obsessive controversy in the art world at the time.[66]

But Pop artists had another use for the new abstraction: to aestheticize their commercial imagery. This drew artists identified with Pop—e.g., Robert Indiana—close to the new abstraction, on the one hand. On the other hand, artists identified with the latter—e.g., Nicholas Krushenick—verged close to Pop Art. Indiana stenciled words—DIE, EAT—in a hard-edge style that called to mind that of Kelly. Krushenick's abstract forms were outlined in black, much like comic strips and Lichtenstein's imagery, but without their literary references. In a related manner, Richard Artschwager fused Pop Art and Minimal Art; his furniture-like Formica objects come close to being simple, geometric, abstract volumes.

Many supporters of the new abstraction, however, had little or no sympathy for Pop Art. Younger formalist critics of the same generation as the Pop artists initially responded favorably to their painting but soon turned against it. Even Fried was "moved by Warhol's beautiful, vulgar, heart-breaking icons of Marilyn Monroe," as he wrote in 1962. "At his strongest . . . Warhol has a painterly competence, a sure instinct for vulgarity (as in his choice of colours) and a feeling for what is truly human and pathetic in one of the exem-

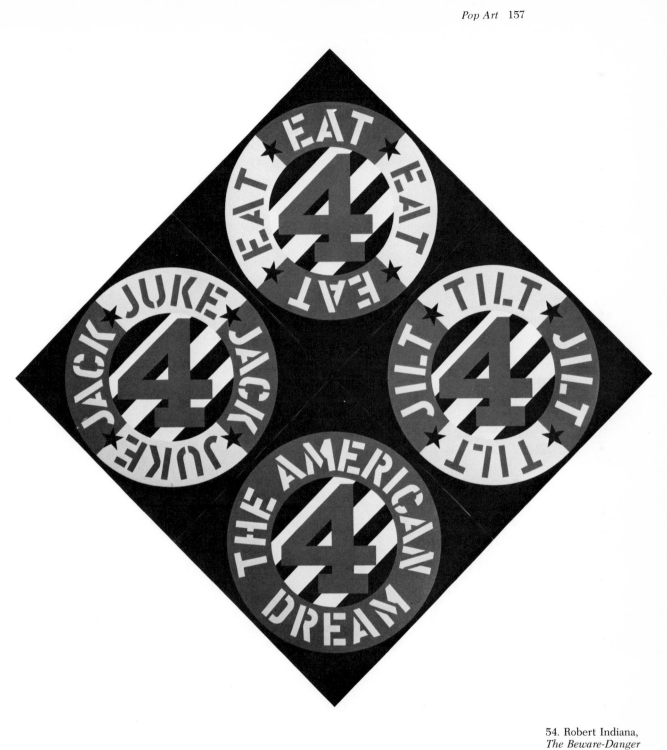

54. Robert Indiana,
*The Beware-Danger
American Dream #4,*
1963. 102″ × 102″.
Hirshhorn Museum
and Sculpture
Garden, Smithsonian
Institution,
Washington, D.C.

plary myths of our time that I for one find moving." But Fried was ambivalent, and he concluded: "I am not at all sure that even the best of Warhol's work can much outlast the journalism on which it is forced to depend."[67] Within a year, Fried's attitude had hardened. In a review of Lichtenstein's show, he wrote:

The kind of criticism I would level against Lichtenstein is not that his paintings are ugly or that their content is vulgar; it is, rather, that they are trivial. . . . Inasmuch as his paintings are also abstract patterns, they are interesting but irrelevant to the issues raised by the finest abstract painting of our time. [Lichtenstein] is one of the most amusing artists working today; but I remain unconvinced that he is something more.[68]

Greenberg's view was similar to Fried's. He wrote: "But as diverting as Pop art is, [it does not] really challenge taste on more than a superficial level."[69] He concluded that Pop Art was so "tamely artistic" and "obviously tasteful" that it was "more essentially, and visably, academic than Ab-

55. Nicholas Krushenick, *Red, Yellow, Blue, and Orange,* 1965. 84″ × 71¼″. Whitney Museum of American Art, New York.

56. Richard Artschwager, *Description of a Table*, 1964. 26¼″ × 32″ × 32″. Whitney Museum of American Art, New York.

stract Expressionism had ever been, even in its last and worst days."[70]

Ben Heller, who organized the *Toward a New Abstraction* show at the Jewish Museum in 1963, saw Pop Art as a *threat* to nonobjective art, because it monopolized art-world attention. Viewing it as low art, he even considered titling his show "High Art."[71] Even more than Heller, Barbara Rose claimed that Pop Art was the enemy of the new abstraction. She wrote that Pop Art's "pictorial conventions and roots are the same as those of abstract art . . . two-dimensional shapes having legible contours." Moreover, both Pop Art and the new abstraction are characterized by "bland impersonality, aloofness, disavowal of emotion or 'message' . . . vulgarity, un-

pleasantness, and bad taste." But there was a difference—a crucial difference: "the abstract aspect remains as remote and unassimilable as ever . . . whereas the imagistic aspect, providing a relief from the difficulties of abstraction while still carrying the *cachet* of vanguardism, has found a large public and elicited a response totally out of proportion to its importance."[72]

By the end of 1962, artists and critics who assumed the role of self-appointed custodians of high modernist art launched an attack on Pop Art. A number of older Abstract Expressionists in the Janis Gallery left in protest shortly after *The New Realists* was exhibited there. Critics who were identified with painterly painting,

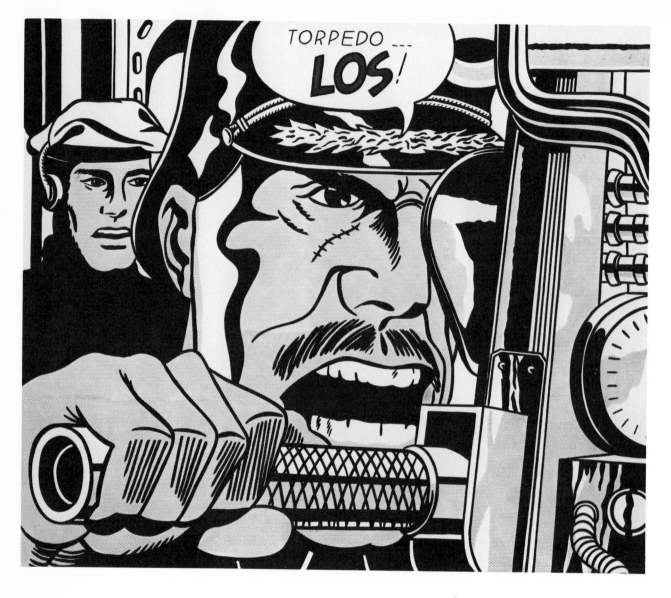

57. Roy Lichtenstein, *Torpedo . . . LOS!* 1963. 68″ × 80″. Robert B. Mayer Family Collection.

such as Harold Rosenberg, Thomas Hess, Dore Ashton, and myself, and critics who were not, such as Greenberg, Hilton Kramer, and Max Kozloff, condemned Pop Art for its lack of authentic creativity, authentic ways of experiencing art and life, and uniqueness of style.

Because Pop Art was based on kitsch, we castigated it as kitsch or worse in what became a veritable crusade against the "Kitsch-niks."[73] Hess wrote that "in falling for the banal [the Pop artists] have fallen into it."[74] At "A Symposium on Pop Art"

at the Museum of Modern Art in 1962, Kramer asserted that Pop Art's "social effect is simply to reconcile us to a world of commodities, banalities and vulgarities. . . . This is a reconciliation that must—now more than ever—be refused, if art—and life itself—is to be defended against the dishonesties of contrived public symbols and pretentious commerce."[75] Kramer concluded that Pop Art was an art of capitulation to the world of alienating things. High modernist criticism of Pop Art often degenerated into little more than self-

righteous vituperation. In an article titled "Pop Goes the Artist" in *Partisan Review,* "serious" culture's in-house journal, Peter Selz, a curator at the Museum of Modern Art, wrote: "Far from protesting the banal and chauvinistic manifestations of our popular culture, the Pop painters positively wallow in them. 'Great, man!'" They "rejoice in the Great American Dream . . . cater to infantile personalities capable only of ingesting, not of digesting nor of interpreting [and willfully regress] to parochial sources just when American painting had at last entered the mainstream of world art." Furthermore:

> What is so objectionable about Pop Art is this extraordinary relaxation of effort, which implies further a profound cowardice. [The artists are] slick, effete, and chic. They share with all academic art—including, by the way, Nazi and Soviet art—the refusal to question their complacent acquiescence to the values of the culture. And most ironic of all is the fact that this art of abject conformity, this extension of Madison Avenue, is presented as *avant garde.*

In Selz's opinion, Pop Art merely exploited the discoveries of the genuine avant-garde. And because it did, it was "a more dangerous opponent to High Culture" than other forms of "kitsch" or academicism. Finally, and most despicable of all, Pop Art was commercial. Indeed, the proof of its worthlessness was its success, which was attributed to the vulgarity of the new-rich avant-garde audience. As Selz fulminated: "Eager collectors, shrewd dealers, clever publicists, and jazzy museum curators" were promoting it. But there was one consolation. Pop Art would "soon be old-fashioned because 'styling' has been substituted for style, and promotion has taken the place of conviction. [When] its market collapses it will collapse for good."[76]

But the word "kitsch" had become so much of a cliché that it was an outmoded weapon in the battle against Pop Art. A fresh word was needed to better serve the cause, and that was to be "camp," borrowed from homosexual argot. Camp was popularized by Susan Sontag, in an article in *Partisan Review,* 1964. She characterized camp as art that consciously or unconsciously "was serious about the frivolous, frivolous about the serious," art that favored style over content. Camp was marked by a "love of the unnatural: of artifice and exaggeration" and was used by cliques as esoteric private codes.[77] Sontag exempted Pop Art from that category, remarking that "a number of these new artists . . . are indeed worth taking seriously."[78] As she saw it, Pop Art was anti-camp because of its concern with perceptual and formal issues.[79] "In fact, the merit of these paintings is not as an anthology or inventory of Americana, but as a visual experience, a research . . . into ways of seeing more rigorously and precisely. (The banal subject-matter is simply an interesting 'given' in that experience.)"[80] But Sontag's colleagues in the intellectual establishment pounced on her label and used it to derogate Pop Art. For example, Hess spoke of Warhol's films, such as the twenty-four-hour movie of the Statue of Liberty, as camp gestures because of their perverse exaggeration of reality and because the artist conspired coyly with his audience. The film was boring, "but his friends are delighted to understand that Warhol meant it to be a bore."[81] In part because of her article on camp, Sontag became a celebrity, something of a Pop avant-gardist—"the dazzling intellect of the year," as Warhol later called her[82]—to her dismay. But although she tried to make the frivolous serious, her article was turned into trivia, used as the basis of a campy party game of classifying culture into camp and noncamp categories. Sontag had done this in her article;[83] her aim, of course, was to sharpen issues, but that could also be seen as camp—yet, as one wit quipped, not campy enough.

But why would artists want to bother with the "crassness, the vulgarity, the depressing tawdriness of modern advertising

art"?[84] Art was supposed to transcend the banal, was it not? Did not its refusal to do so reveal a lamentable lack of artistic ambition, depth, and seriousness, particularly when compared to Abstract Expressionist paintings, which were "monuments to the human spirit, to the search for a new artistic reality"?[85] Perhaps Pop Art was satirical, as Lippard suggested: what else could its subjection of the viewer to such indignities be? Surely there was no other reason to paint vulgar images from which all sensitive souls recoiled in horror.[86] But Kozloff would have none of this. The Pop artists were "New Vulgarians," rubbing the spectators' noses "into the whole pointless cajolery of our hardsell, sign-dominated culture. . . . The truth is, the art galleries are being invaded by the pin-headed and contemptible style of gum chewers, bobby soxers, and worse, delinquents."[87]

Lichtenstein countered Kozloff's remarks simply: "There are certain things that are usable, forceful and vital about commercial art. We are using these things—but we're not really advocating stupidity, international teenagerism and terrorism." However, Lichtenstein allowed that he was kicking up his heels at established culture. He had aimed for "a painting that was despicable enough so that no one would hang it." "The one thing everyone hated was commercial art," so that was where to begin. But he added ironically, "apparently they didn't hate that enough either."[88]

Pop Art's indifference to humanity seemed most shocking when it dealt with the human figure. It was perverse enough when it focused on objects; worse, on commodities, the most debased of objects that anyone supposed to value culture could imagine; but unforgivable when it equated man with a soup can or a character in a comic strip.[89] Because Pop Art was hailed by influential art professionals as *the* figurative art of its time, it angered artists and critics hostile to Abstract Expressionism who for years had prosely-

tized for and prophesied "a return to the figure," either a "humanist" figure[90] or a "new image of man," the survivor of Buchenwald and Hiroshima.[91] More in line with the artists of the sixties were the New Perceptual Realists, such as Alex Katz and Philip Pearlstein, who advocated the literal representation of live models, not unlike Pop Art in attitude but totally unlike it in appearance. Sidney Tillim, a spokesman for the New Perceptual Realism, wrote that Pop Art "opens a path beyond the seemingly exhausted alternatives of *abstraction—without returning to the 'figure.'*" Pop Art was realism of a sort, but it was actually closer to the new abstraction, which is why, compared to other figurative styles, it "has received the lion's share of attention."[92]

What, then, did the Pop artists themselves think about the figure? Rosenquist wanted the recognizable images and fragments of images that he culled from commercial art and juxtaposed in collage fashion to evoke the mélange of images that might be seen on a city street or on TV commercials. As he remarked: "I'm interested in contemporary vision—the flicker of chrome, reflections, rapid associations, quick flashes of light. Bing-bang! Bing-bang! I don't do anecdotes; I accumulate experiences."[93] Wesselmann was equally concerned with present reality, but his focus was on the erotic dimension in popular culture. Warhol was occupied with depersonalization in contemporary society, treating Pop celebrities like soup cans and neutralizing hot news photographs of disasters through repetition. Lichtenstein was drawn to comic book characters because they were engaged in love, war, and other human dramas traditional in the history of art—in a mode peculiarly of our time.

But Lichtenstein's aim was aesthetic—to create a formally unified composition. He aspired to formalism and realism at the same time. So, more explicitly, did Rosenquist and Wesselmann. Even Warhol, whose silk-screen paintings were "care-

lessly" executed, giving them a "paint-erly" look,[94] shrewdly judged the results. However, the possibility that Pop Art might possess aesthetic quality—or even be art—was often denied. Leo Steinberg, who admired Pop paintings, remarked nonetheless: "I am not prepared to tell whether they are art or not [because] I cannot yet see the art for the subject [which] exists for me so intensely." He went on to say: "The objection to an art like Caravaggio, like Courbet, any sort of real, raw, tough, realistic breakthrough in the history of art—the objection to it is always that it ceases to be art." Steinberg concluded: "One thing I am sure of: critics who attack pop art for discarding all aesthetic considerations talk too fast."[95]

Most critics reared in Abstract Expressionism saw Pop pictures as poorly or indifferently painted, naturally, because the "painterliness of painting"[96] was not evident; the technique seemed as banal as the subjects. As Jules Langsner wrote, once the initial shock of seeing mundane objects in high art wears off, the viewer becomes "as bored with the painting as with the object it presents."[97] The Pop artists shrugged off such attacks by claiming that they did not want painterliness in the first place, but they did want quality. Lichtenstein said that the Abstract Expressionists did not understand this, because "neatness and patness [are] insensitive" to them.[98] Pop Art was also widely denigrated for its "poverty of visual invention." But the hard-core Pop artists, Warhol and Lichtenstein, did not want to be formally inventive; what they did—or rather did not do—to their subject matter was innovative, unprecedented in the history of art: that is, their refusal to interpret or transform it in any readily apparent manner. Nontransformation and the anonymity it gave rise to were the most unnerving aspects of their work. When Lichtenstein made a painting of a well-known diagram that Erle Loran made of a painting by Cézanne in his book on the Post-Impressionist master, Loran was so

incensed that, it was rumored, he threatened to sue, but he wrote an article instead, claiming that he could not "accept soup can painting as art [because] it contains no transformation. . . . Copies are not transformations."[99]

Lichtenstein did, of course, transform his subjects—in medium and blown-up scale and, also, in context. He removed a comic strip frame from its original commercial-art context and placed (or more accurately, displaced) it in two fine-art contexts: the first, painting, and the second, the art gallery or museum. And he did alter his subjects with formal considerations in mind. He said:

> Transformation is a strange word to use. It implies that art transforms. It doesn't, it just plain forms. . . . I think my work is different from comic strips—but I wouldn't call it transformation. . . . What I do is form. . . . [The comic strip] intends to depict and I intend to unify. And my work is actually different from comic strips in that every mark is really in a different place, however slight the difference seems to some. The difference is often not great, but it is crucial.[100]

Indeed, it was. Pop Art was not commercial art. As Lichtenstein implied, it created a space between "high" art and "low" art in which its expressiveness was found.

In the early sixties, it was common to treat Pop Art as a kind of collective enterprise, its practitioners more or less interchangeable as Rosenhols and Oldenquists, but it soon became apparent, at least to those who followed developments in current art closely, that the common denominator of Pop styles—the use of commercial-art subjects and techniques—was of lesser interest than the individual styles of the Pop artists. Certainly, by 1963, as Judd wrote, Pop artists were "too diverse to be given one label."[101] Indeed, the comments made about the movement as a whole—for example, that it exemplified vulgarity—increasingly appeared vulgar. With time it became clear that whatever other observations might be made about Pop Art as a collective style—

sociological, iconographic, and the like—each of the major Pop artists had developed a unique, individual style.[102]

Lichtenstein's subjects—comic strips, primarily—and his basic technique—dot screen stenciling—were taken from commercial art. Unlike comic book illustrations, his pictures were composed, every pictorial element rearranged, reshaped, and refined until they knit together in a strong structure, making him a formalist in comparison to Warhol. In all his statements about his painting, Lichtenstein stressed his formal or abstract concerns, his *recomposition* of comic strips and his use of them in art to avoid academic composition. He insisted: "My intention is to make a work of art, but I don't want to show that intention."[103] And the subject matter did hide his intention, leading *Life* magazine to ask whether Lichtenstein was "The Worst Artist in the U.S."[104] But he believed that the "immediate and of-the-moment meanings [of his subjects] will vanish,"[105] and that the formal qualities would come to the fore. As Ellen Johnson saw it:

It's not just that he enlarges the comic and puts it in a new context, but he gives it scale; he makes a monumental painting from a

58. Roy Lichtenstein, *Kiss with Cloud*, 1964. 80″ × 68″. Irving Blum, New York.

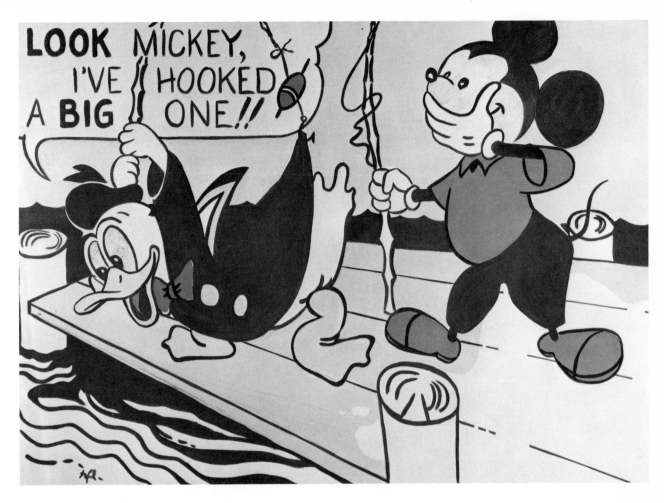

trifle. Comparing Lichtenstein's *I know how you must feel, Brad* with its comics source, one sees how he proceeds. Eliminating inessentials, he dispenses with finger-nails and forearm muscle indications, cuts the number of lines throughout and more tellingly states and varies their curved or angular character. He changes the colours and gives them more force (from a dull red to a bright blue in the dress, from dirty yellow to brilliant gold in the hair), thus further idealising the ideal girl of the comics; he intensifies the range and contrast of values; makes the flabby landscape background into a jagged, expressive pattern; transforms the vague rocket-like shape on the left into a neat vertical column.[106]

Paradoxically, while being formal, Lichtenstein was also literary, the most literary of the Pop artists. Certainly, the pictures for which he is best known tell "emotion"-loaded stories. Such narratives had been anticipated in his pre-Pop canvases; before 1957, as he said, he painted

reinterpretations of those artists concerned with the opening of the West, such as Remington, with a subject matter of cowboys, Indians, treaty signings, a sort of Western official art in a style broadly influenced by modern European painting. From 1957 onwards my works became non-figurative and abstract expressionist. In the latter part of this body of work I used loosely handled cartoon images. In the summer of 1961 I made a complete break into my current work. . . .

The early ones were of animated cartoons, Donald Duck, Mickey Mouse and Popeye,

59. Roy Lichtenstein, *Look Mickey,* 1961. 48″ × 69″. Collection the artist.

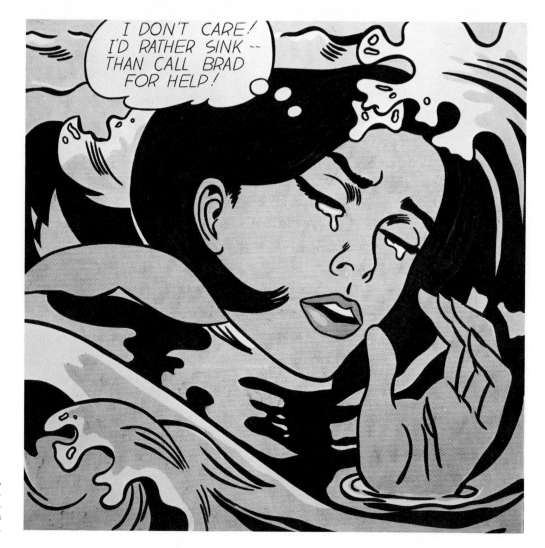

60. Roy Lichtenstein, *Drowning Girl*, 1963. 67⅝″ × 66¾″. Museum of Modern Art, New York.

but then I shifted into the style of cartoon books with a more serious content such as "Armed Forces at War" and "Teen Romance."

Lichtenstein elaborated: "Using a cartoon subject matter . . . some of which I was getting from bubble gum wrappers, eventually led to simulating the same techniques as the originals."[107]

Lichtenstein chose his subjects for personal reasons, because they were reminiscent of his boyhood reading. He also liked the emotional directness of the comics and, at the same time, the way they distanced the romance and violence they portrayed, introducing a note of irony. As Lichtenstein remarked: "One of the things a cartoon does is to express violent emotion . . . in a completely mechanical and removed style."[108] Cartoon subjects enabled him to put human drama into modernist art without lapsing into sentimentality. Lichtenstein also chose to paint comic strips because they had not yet been aestheticized or academicized by other artists, at least not "fine" artists.

But much as he looked to the comics, Lichtenstein kept a variety of modern masters in mind—Léger, for example. Judd noted: "The schematic modeling, the

black lines and the half-tones of Ben Day dots resemble Léger's localized modeling and black lines around flat colors."[109] Lichtenstein also looked to modern masters for subjects. He made pictures of mass-produced reproductions of pictures by Picasso, Mondrian—whose primary colors were also the colors of commercial printing and the ones Lichtenstein favored—and Monet, the Ben Day dot substituted for the brush dab. Using cartoon techniques to render masterworks—or their machine-made reproductions—is at once homage and parody; the satire seems aimed more at "fine" than at "commercial" art. It was as if Lichtenstein had inverted Pop Art's assimilation of low art into high art, by executing high art using the techniques of low art—playing with different codes, as it were.

This kind of play is clearest in Lichtenstein's notorious painting of Erle Loran's Cézanne diagram. Loran's diagram was a commentary on Cézanne's picture, and Lichtenstein's painting was a commentary on Loran's diagram—that is, on Loran's way of seeing the Cézanne. Lichtenstein said:

> The Cézanne is such a complex painting. Taking an outline and calling it Madame Cézanne is in itself humorous, particularly the idea of diagramming a Cézanne when Cézanne said, ". . . the outline escaped me." There is nothing wrong with making outlines of paintings. I wasn't trying to berate Erle Loran because when you talk about paintings you have to do something, but it is such an oversimplification trying to explain a painting by A, B, C and arrows and so forth. I am equally guilty of this.[110]

Loran's diagram also appealed to Lichtenstein because Cézanne's hand, his sensibility or sensitivity, was removed from it; the effect was mechanical and anonymous.[111] In a letter to *Artforum,* Pjete Lindstrom speculated that Lichtenstein may have chosen Loran's diagram as his subject because the arrows, broken lines, etc., "automated" the paintings, making "funny pitchers" of the Cézannes.[112]

Lichtenstein copied Picasso's *Woman with a Flowered Hat,* 1940, in the Morton Neuman collection, much as Picasso based a series of pictures on Delacroix's *Femme d'Algiers,* indicating a kindred humor and love-hate relationship to past art. Actually, Lichtenstein copied a cheap reproduction of the Picasso, not the original, because, as he said, "a Picasso has become a kind of popular object—one has the feeling there should be [one] in every home. . . . But there is a kind of emphasis on outline, and a diagrammatic or schematic rendering which related to my own work."[113] Lichtenstein's version is clearly unlike its model. For example, the colors of the face and hair are different, and Picasso's mannerisms are missing. But if one did not know the Picasso well, the Lichtenstein

61. Roy Lichtenstein, *Portrait of Madame Cézanne,* 1962. 68″ × 56″. Private collection.

62. Roy Lichtenstein, *Modern Painting with Clef*, 1967. 100⅛″ × 180⅜″. Hirshhorn Museum and Sculpture Garden, Smithsonian Institution, Washington, D.C.

could well look like a copy. And yet there is no mistaking the one for the other. In fact, the more he copied Picasso, the less it looked as if he did, such was the irony of the work.

Lichtenstein's decision to copy Picasso and Mondrian, the innovating masters of Cubism and Abstract Cubism respectively, was not inadvertent. Cubist composition had interested him for a long time. In his early Pop pictures, it had been something to avoid, as in his paintings of a golf ball or a frankfurter, in which he centered a single image of the object on a blank ground. Lichtenstein's seeming nontransformation of his subjects was another way of avoiding Cubist designing. But in 1966, he began to compose his pictures in a Cubist manner, improvising with motifs taken from Cubist-inspired Art Deco architecture and decoration of the twenties and thirties—the decade of his boyhood and adolescence. Lichtenstein was probably motivated not only by nostalgia but by the proto-Pop nature of Art Deco, which could be thought of as

Pop Cubism. He also projected these ideas into sculptures, which resembled moderne interior design found in pre–World War II movie emporiums. By *inventing* his compositions, Lichtenstein reacted against his earlier minimal treatment of Pop subjects. His desire for complexity paralleled that of Stella and Held at the time, heralding a general turn away from reductiveness—a shift in sensibility.

Warhol's style was based on the reproduction of newspaper and magazine imagery through photomechanical silk-screening on canvas. About his motives, Warhol said in 1962: "I adore America and these are some comments on it. My image is a statement of the symbols of harsh, impersonal products and brash materialistic objects on which America is built today. It is a projection of everything that can be bought and sold, the practical but impermanent symbols that sustain us."[114]

After abandoning a successful career in commercial art in 1960, Warhol began to paint comic strips and the labels of cans in an Abstract Expressionist manner. By

1962, he suppressed painterly handling but continued to execute advertising images by hand in imitation of impersonal mass production. He soon turned to silk screening photographs, which made his work even more impersonal.

In his first New York show, Warhol exhibited his celebrated Campbell soup cans and Coke bottles, and images of Marilyn Monroe and Elvis Presley, among other pictures. For his next show, he filled the gallery with minimal wood boxes silk screened with Brillo labels and the like. In 1964, he exhibited flowers, and in 1966, helium-filled silver balloons and pictures of a cow's head pasted directly to the wall like wallpaper. These images were suggested by his friends. As he said, asking someone what to paint did not embarrass him, "because Pop comes from the outside."

Henry [Geldzahler] gave me the idea to start the Death and Disaster series. . . . Ivan [Karp] said, "You know, people want to see

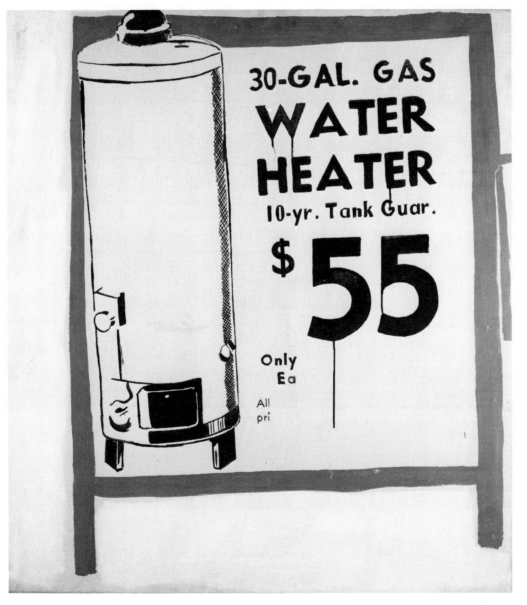

63. Andy Warhol, *Water Heater*, 1960. 44¾" × 40". Museum of Modern Art, New York.

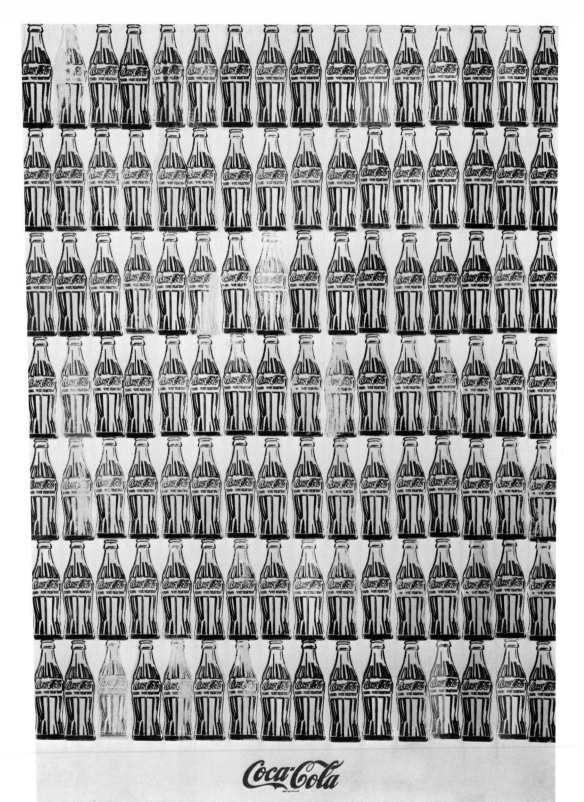

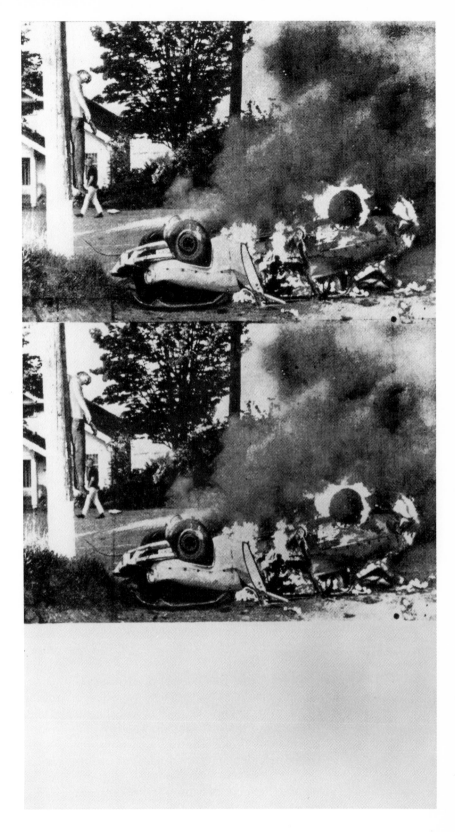

FACING PAGE:
64. Andy Warhol,
*Green Coca-Cola
Bottles*, 1962. 82¼″
× 57″. Whitney
Museum of American
Art, New York.

65. Andy Warhol,
*White Burning Car
Twice*, 1963. 79″ ×
42½″. Ileana and
Michael Sonnabend.

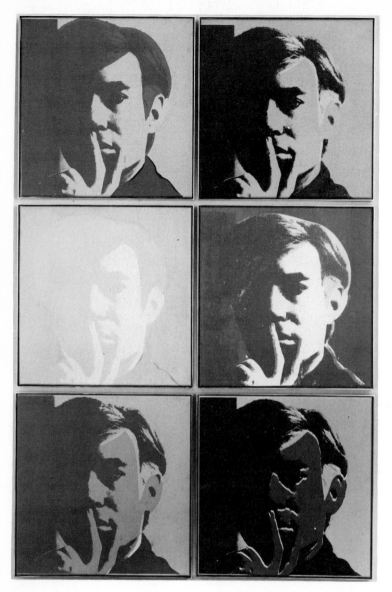

66. Andy Warhol, *Self-Portrait*, 1966. Six canvases, each 22⅝" × 22⅝". Sidney and Harriet Janis.

so resembled the real thing, their status as art was problematic. Indeed, it was only when Warhol's neutral, commercial images were placed in the context of an art gallery or a museum that they took on the aura of fine art. It was left to the viewers to interpret them, depending on their attitudes to high and popular culture. In this sense, Warhol's work was a mirror that reflected back what the viewer brought to it.

Warhol did not limit his art to making pictures and objects. His repetition of images—*100 Soup Cans,* for example—and his use of the human image in his self-portraits and subsequent portraits of celebrities led him late in 1963 to produce movies: uncut and unedited film portraits as repetitive as his paintings. These early films were monotonous, to say the least—*Sleep* is six hours long—but because, not in spite, of their utter boredom, they won the Independent Film Award, the top prize of the underground cinema. In 1965, Warhol organized the Exploding Plastic Inevitable, featuring the rock band the Velvet Underground, a multimedia light environment—it later became the Electric Circus—at a time when the music and the light shows were in vogue.[116] He would also write a novel by tape-recording whatever came to mind. In 1969, he and John Wilcock began to publish a jet-set gossip magazine, titled *Interview.*

Warhol fashioned not only art but a world of his own: the silver-foil-lined Factory, populated by celebrities, the fashionable rich, and misfits—some of whom he designated as superstars—but a decreasing number of his art-world colleagues.[117] As a celebrity, Warhol turned himself into a household name, like a Campbell soup can, Elvis Presley, Tuesday Weld, and other subjects of his pictures. As early as 1962, he characterized the celebrities he painted as "products";[118] later, he would call them "plastic idols."[119] Warhol had a keen awareness of brand name, and he used the worlds of art, avant-garde film, fashion, and the media to establish his own

*you. . . . "* That's how I came to do the first Self-Portraits. Another time he said, "Why don't you paint some cows . . .?"[115]

So accepting was Warhol of existing reality that none of his subjects was altered or transformed for the sake of interpretation, except that occasionally shoddy silkscreening by Warhol and his assistants produced accidental "handmade" or painterly effects—more accurately, pseudopainterly effects. Because Warhol's images

trademark. As Mary Josephson characterized Warhol's "image":

> [His] mature physiognomy is directly appropriated from the stars of the forties—Dietrich, Crawford, Hayworth. There is the slightly open mouth, the lidded gaze, the blankness that encourages projection. . . . This blankness is much more than a device; it is an iconographic signature with a high symbolic content. Its suggestiveness depends on its *superficiality;* any hint of expression, of inner life, immediately withdraws from the image its iconic status and returns it to the banality of everyday living. . . . Warhol's genius in composing his own face is that there is nothing *behind* it . . . no motivations, no psychology, no beliefs, no hint of an effect that contains a traceable cause.[120]

What is ultimately "expressed" in a Warhol work is his detachment from his subject, from himself—or *detachment itself.*

After 1968, Warhol's major creation was "Andy Warhol, Business Artist." His ambition had always been to be famous and make money, to be the companion and peer of the wealthy and fashionable, and now he succeeded.[121] He made of his life, or more accurately, of its surface, a Pop Art masterpiece, and in living the life of a celebrity and projecting a glamorous self-image, he became a performance artist of sorts in the "real" world, but of mythic proportions, somewhat as Duchamp had before him and Joseph Beuys would after him.[122] The "aesthetics of celebrity" had a widespread attraction in the cultural worlds of the sixties, and Warhol personified it in the visual arts, much as Mailer did in literature.[123] Indeed, as Geldzahler remarked: "What always impressed me about him was the way he seemed plugged into the *Zeitgeist.* He was really the unconscious conscience of the sixties";[124] he mirrored what his generation aspired to.

Rosenquist's subjects, scale, wide-angle vision, and technique were derived from outdoor billboards he had once painted.

But he was also inspired by the painterly qualities of Johns's and Kelly's pictures:

> Johns would start with a flag . . . and then he'd just paint and paint and paint and he'd end up with a flag, but those pictures were about all that paint and all that travelling. . . . Kelly would refine a shape from life, from a pair of overalls or a plant, in the most sensual way.[125]

Billboard images were realistic, but from the vantage point of the painter, they were abstract. As Rosenquist said, on a scaffold he could see only huge details— for example, a yard-long nose at a distance of two feet. " 'I'd start an ad . . . and in it, I'd see a lot of things I would never see in a studio.' "[126] "The face became a strange geography, the nose like a map of Yugoslavia."[127] This experience led Rosenquist

> to make pictures of fragments, images that would spill off the canvas instead of recede into it. . . . I thought . . . that I would paint them as realistically as possible. Then I thought about the kind of imagery I'd use. I didn't want to use anything brand-new [or] anything antique either, like ancient guitars. I wanted to find images that were in a "nether-nether-land," things that were a little out of style, but hadn't reached the point of nostalgia.[128]

Rosenquist's mélanges of literal images can be viewed as metaphors of urban reality, recalling Rauschenberg's combine-paintings. In his review of Rosenquist's first show, in 1962, Swenson wrote that he "forces the viewer to recognize the discordant and anonymous elements of an environment which faces him daily."[129]

Because Rosenquist's billboard fragments are unrelated, they look strange, incongruous, and surprising, doubly so because the images are gargantuan, conveyed with immediacy. Rosenquist claimed that he was searching for a "mysterious quality."[130] In this sense, Rosenquist was a Pop Surrealist—as much as a Pop urban realist. He was also a Pop Cubist, because his work shares a collage aesthetic—unlike Warhol's and Lichten-

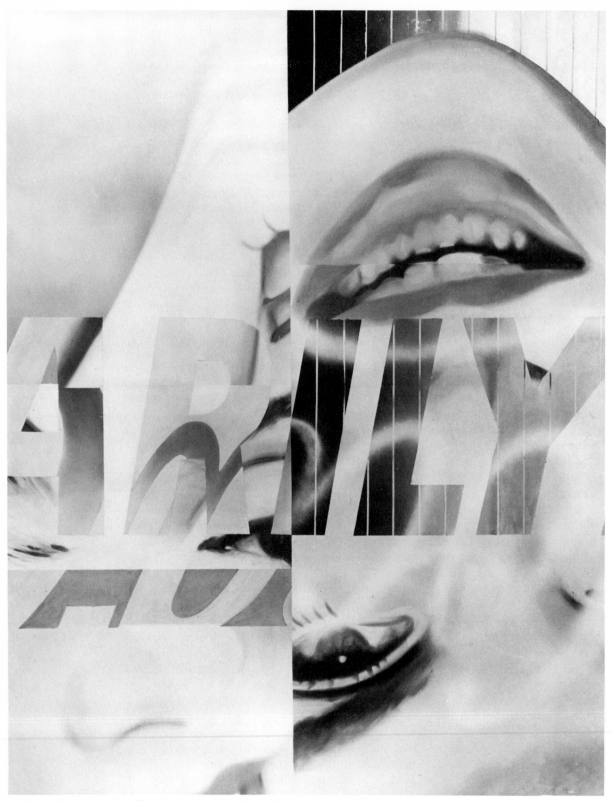

67. James Rosenquist, *Marilyn Monroe, I*, 1962. 93″ × 72¼″. Sidney and Harriet Janis.

stein's single images. Above all, Rosenquist's concerns were formal. He went so far as to remark: "The objects in the painting are used to sustain a color and space idea, so that I am able to finish the painting instead of being guided by a passion at a particular moment."[131] Of *One, Two, Three,* G. R. Swenson wrote: "The blue and pink sections, although recognizable as a car fender and satin dress, could almost stand by themselves as an abstract painting. The third section, formed by the two extensions of the frame and a wire

between them, adds another and presumably white 'abstract' element of the wall."[132]

Rosenquist rarely tackled political themes; however, his most notorious work, *F-111,* named after a warplane, is a social commentary on the Vietnam War. It was notorious, partly because of its political references; partly because of its mural size—made to cover all four walls of a room in the Castelli Gallery, it measured eighty-six feet; partly because it was sold for an alleged $60,000—a huge price

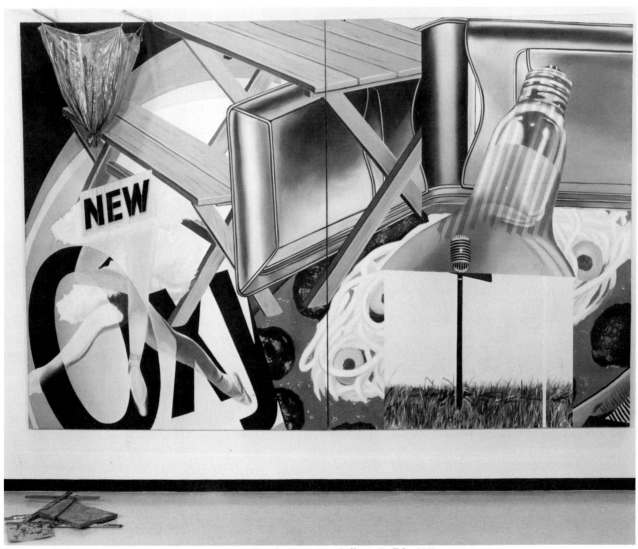

68. James Rosenquist, *Nomad,* 1963. 84″ × 210″. Albright-Knox Art Gallery, Buffalo, N.Y.

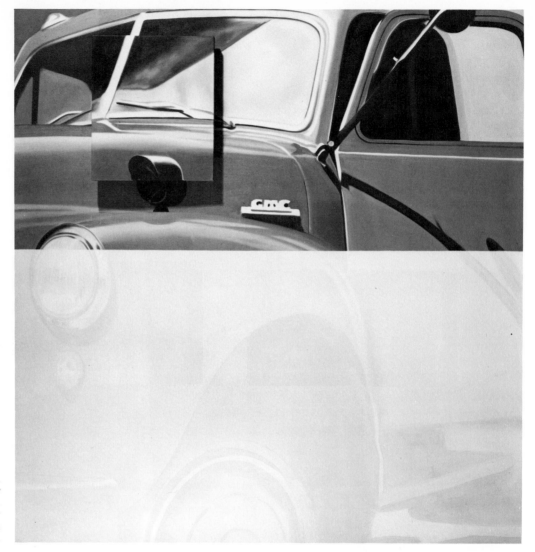

69. James Rosenquist, *Untitled (Broome Street Truck)*, 1963. 72″ × 72″. Whitney Museum of American Art, New York.

then—which was announced on the front page of the *New York Times;* partly because the price and publicity constituted a social commentary of sorts on the status an avant-garde artist could achieve in the middle sixties. *F-111* was shown again at the Jewish Museum, and from 1965 to 1968, it traveled to museums in Stockholm, Amsterdam, Switzerland, Denmark, and Germany; to the São Paulo Bienal in Brazil; and then returned to New York. There, it was displayed at the Metropolitan Museum in an exhibition arranged by the museum's director, Thomas Hoving, without consulting his curator, Geldzahler, who resigned. Titled *History Painting—Various Aspects,* the exhibition included three other pictures: Nicolas Poussin's *The Rape of the Sabine Women,* Jacques-Louis David's *The Death of Socrates,* and Emanuel Leutze's *Washington Crossing the Delaware.* The catalogue included among other entries one by Robert Scull, the owner of *F-111.* The exhibition of *F-111* in the company of Poussin and David, as well as the introduction of an essay by a collector in a Metropolitan Museum catalogue, and the resignation (and

70. James Rosenquist, *F-111*, 1965. 10′ × 86′. Private collection, U.S.A.

71. Detail of James Rosenquist, *F-111*.

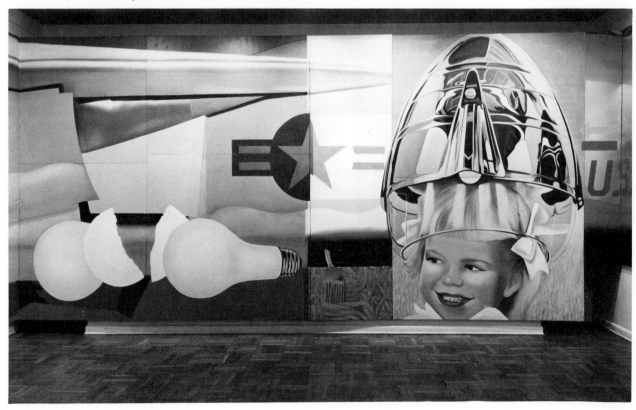

subsequent rehiring) of Geldzahler, generated intense controversies, which redounded to the fame of the picture.

In *F-111*, Rosenquist juxtaposed the Day-Glo image of the warplane, somewhat larger than its actual size; orange canned spaghetti, like entrails; an atomic mushroom cloud under an umbrella; a cute child's head under a hair dryer; an angel food cake; a Firestone tire—among other garish life-size fragments. This mixture of military and consumer products pointed to the close relationship between the two. Rosenquist himself said: "A man has a contract from the company making the bomber . . . and he plans his third automobile and his fifth child because he is a technician and has work for the next couple of years." John Russell commented: "Some little girls could live high off the hog because some other little girls were going to be burned alive—that was what had to be faced in the mid-sixties, and Rosenquist was one of the Americans who didn't run away from it."[133] In 1960, five years before *F-111* was painted, Alloway had already written:

The media . . . whether dealing with war or the home, Mars or the suburbs, are an inventory of pop technology. The missile and the

72. James Rosenquist, *Tumbleweed*, 1963–66. Approximately 54″ × 60″ × 60″. Mr. and Mrs. Bagley Wright.

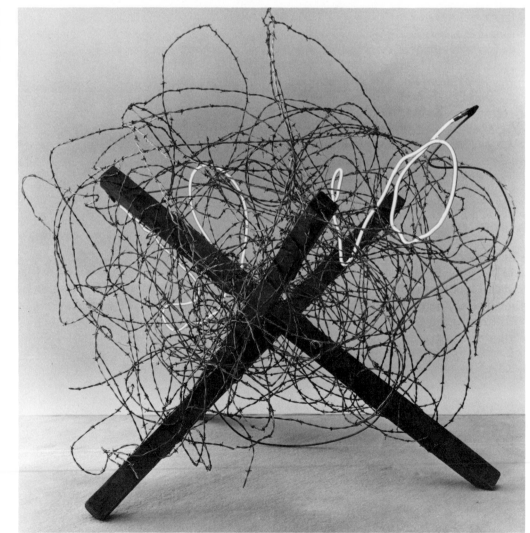

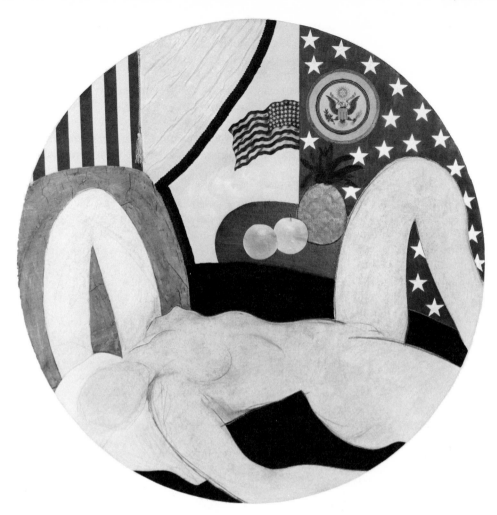

73. Tom Wesselmann,
*Great American
Nude,* 1961. 47½″ in
diameter. Mr. and
Mrs. Burton
Tremaine, Meriden,
Conn.

toaster, the push-button and the repeating revolver, military and kitchen technologies, are the natural possession of the media—a treasury of orientation, a manual of one's occupancy of the twentieth century.[134]

After *F-111,* Rosenquist continued to create environmental pictures and to experiment with a variety of media. In 1968, he introduced Mylar sheets into his work; cut into vertical ribbons, they produced reflective effects. In *Horizon, Home Sweet Home,* 1969, he used a dry-ice machine to fill the exhibition space "with a thick, silvery haze that rose from the ground like a morning fog. Through the clouds, one saw colors fusing, reflecting, and bending like rainbows."[135]

Rosenquist's most radical works were

his constructions in space. In *Capillary Action II,* he incorporated a real tree, which he painted and wired with neon, and into which he inserted a slatted, paint-dripped stretcher. His intention was to show how, in his words,

> nature becomes increasingly modified by man until the natural and artificial blend into each other. This awareness prompted the creation of an art work that could somehow project these two opposite feelings— naturalness and artificiality. . . . After thinking about the problem . . . I decided that I could achieve my ends best by using an actual tree—a small sapling, perhaps—in a free-standing sculpture.[136]

*Tumbleweed,* 1963–66, composed of neon and sticks of wood, around which chro-

mium barbed wire is coiled, "is about seeing a huge tumbleweed [in Texas] which was as big as a house coming towards me as I was driving in a car. [Later on,] I thought of chrome-plated barbwire as a barricade and a piece of neon light going through like a rabbit going through a barricade."[137] About his work generally, Rosenquist said: "I still think about a space that's put on me by radio commercials, television commercials, because I'm a child of that age. Things, billboard signs, everything thrust at me. [In] the numbness that occurred, I thought something could be done."[138]

In his paintings of the middle fifties, Tom Wesselmann had been strongly influenced by de Kooning, but in 1959, he reacted against the older Abstract Expressionist by using found materials to make a series of small (under twelve-inch) collages. In 1960, Wesselmann began to portray female nudes, drawn from life with an eye to Matisse. Paste-up silhouettes, overdrawn with paint, pencil, pastel, and charcoal, they became the central images of his collages. One figure of 1961, sprawling across the surface, was titled *Great American Nude;* it was the first in a series that numbered ninety-nine by the end of the decade.

The early *Nudes* were composed of roughly outlined, flat pink shapes, faceless but with accentuated lips, nipples, and

74. Tom Wesselmann, *Great American Nude #57*, 1964. 48″ × 65″. Whitney Museum of American Art, New York.

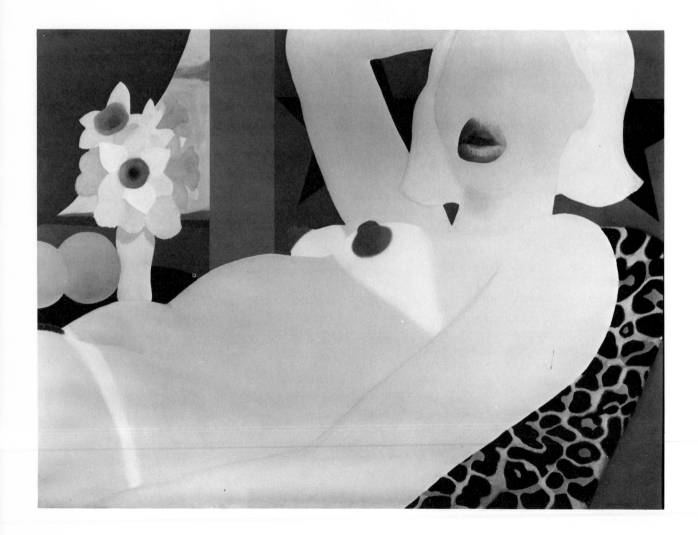

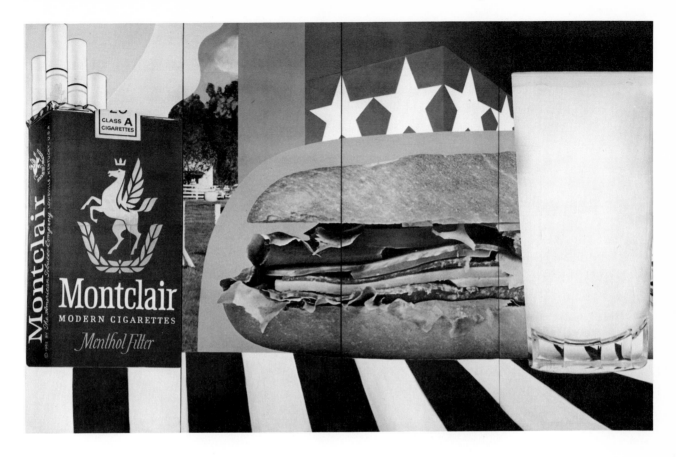

genitalia. About their composition, Wesselmann wrote, referring specifically to *Great American Nude #2*, 1961: "The nude, the door, walls, and table are painted; the floor is real linoleum; the bed and the curtain are fabric; the still life is from a subway poster; the window is a travel poster; and the picture on the wall is a reproduction from an art magazine." In 1962, Wesselmann's style changed; as he said: "Colors became cleaner, edges got sharper, collage materials got newer. . . . In general, all the visual elements were hardened. . . . All traces of the act of painting disappeared."[139] As in the earlier work, the composition remained Cubist—like Rosenquist's. Wesselmann soon used fragments from larger advertisements, enabling him to enlarge the size of his work. He also introduced three-dimensional objects and, eventually, sound, light, and television. In 1963, he turned a

number of his pictures into environments by introducing real furniture—tables, radiators, carpets—and in one notorious work, the breast of a live woman that protruded in from the ceiling.

From 1962 to 1964, Wesselmann added to his *Great American Nudes* a series of *Still Lifes,* composed primarily of images of foodstuffs and kitchen items cut from subway posters and other advertisements. But his more urgent concern was with the female nude in a bedroom or bathroom setting, and he soon focused on it. He treated the nude as a symbol of contemporary American woman, depersonalized yet seductive, surrounded by cosmetics, toiletries, cigarettes, cigarette packages, the telephone, and other consumer goods, as well as fruits and flowers—oranges, roses, daffodils—which quote her sexual parts. Indeed, as the sixties progressed, Wesselmann's treatment of his subject be-

75. Tom Wesselmann, *Still Life Number 36,* 1964. 120″ × 192¼″. Whitney Museum of American Art, New York.

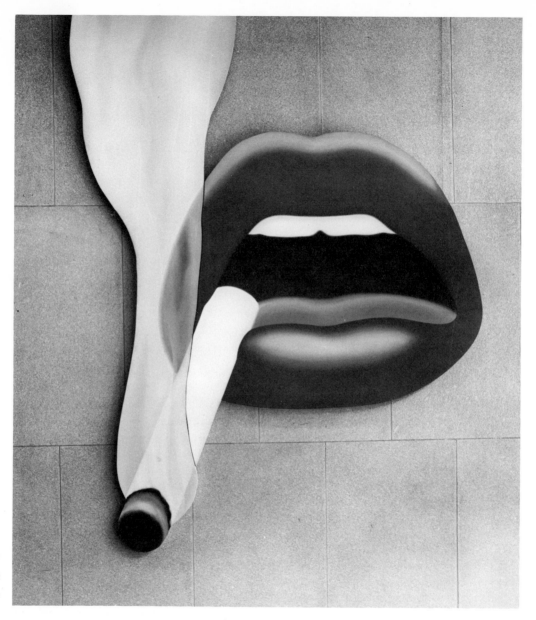

76. Tom Wesselmann, *Smoker, 1 (Mouth 12)*, 1967. In two parts, overall 108⅞" × 85". Museum of Modern Art, New York.

came increasingly sexual. To further heighten the erotic dimension of the female anatomy, he began to make shaped pictures, many of molded plastic, of isolated breasts, legs, feet, and genitalia. The most provocative of these fetish- or icon-like works are cut-out, painted, heavily lipsticked lips, often puffing on a smoking cigarette, as a sign of consummated sex. More than any other Pop artist, Wessel-mann focused on the sexual component both in advertising, in which it is central, and in modern art, eroticizing Matisse's nudes, for example. But he also seemed motivated by psychic pressures and sexual fantasies.

Claes Oldenburg was not a Pop artist in the narrow sense of the term, as Lichten-stein, Warhol, Rosenquist, and Wessel-mann were. He did make sculptures of

common objects, but they were imaginative re-creations, not representations. And he did not simulate the techniques of commercial art. In fact, until 1965, his work possessed a rough painterly look which both related to and parodied Abstract Expressionist facture. Because his objects were shown at the end of 1961, shortly before the emergence of Pop Art, Oldenburg became identified with the movement. In the context of Pop Art shows, in which he was invariably included, his work looked like a kind of Pop Expressionism or, as he put it, "objective expressionism."[140] He said as early as 1962:

> All that I do is the result of a relationship between myself and some object, event, or place in my immediate experience. My pieces tend to be conceived as fragments—torn from a certain context, and that context is my life in a particular place. What I do results from my desire to reconstruct my experience. . . .
>
> I am fond of materials which take the quick, direct impress of life, such as paper and plaster. . . . I like to let the materials play a large part in determining the form. With material, as with the object, what I seek is a personal exchange. My art is autobiographical.[141]

About the specific objects Oldenburg favored, he wrote: "Without snobbism as to what material—it is frequently simple (like a pie), frequently discredited (like filth), frequently impossible (like human beings), furthermore I am sentimentally attached to the absurdities and naivisms of popular art."[142]

Oldenburg's original contribution was not to the iconography of art—Johns had shown the way—but to the history of sculptural *form,* specifically his innovation of soft sculpture, and this was his ambition: "If I didn't think that what I was doing had something to do with enlarging the boundaries of art I wouldn't go on doing it. I think, for example, the reason I have done a soft object is primarily to introduce a new way of pushing space around in a sculpture or painting."[143] Indeed, sculp-

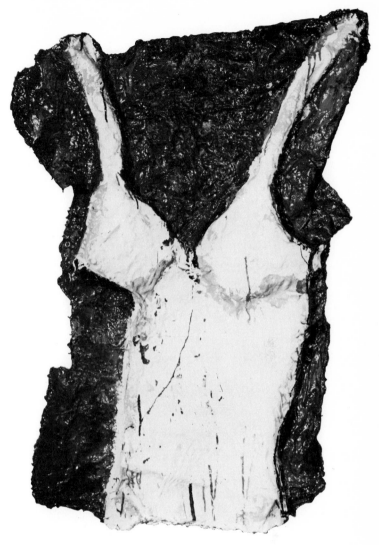

77. Claes Oldenburg, *The White Slip*, 1961. 41¾" × 29¼" × 3½". Whitney Museum of American Art, New York.

ture had traditionally been hard and rigid. Softness introduced a vast new range of experiences: vulnerability, passivity, yielding—above all, sensual experiences associated with the human body and its functions. Oldenburg was also occupied with formal issues, although this was not always clear because of the humor and irony of "combining [his] notions of sculpture with [his] notions of a simple 'vulgar' object: hamburger or bedroom."[144]

Oldenburg remarked in 1962 that his work took three forms: the object, the in-

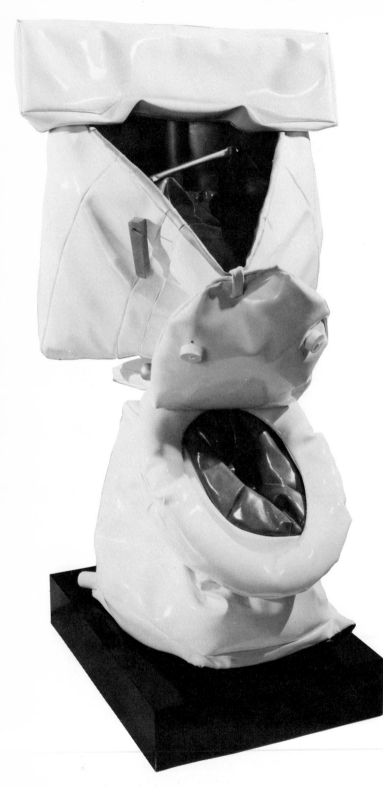

78. Claes Oldenburg, *Soft Toilet*, 1966. 52″ × 32″ × 30″.
Whitney Museum of American Art, New York.

terior place, and the exterior space. In retrospect, his work appears to have evolved more or less from one form to the next. In 1959, Oldenburg pieced together objects from corrugated cardboard, burlap, and other materials picked up in the gutter and drawn on crudely with heavy black lines. From these Assemblages, he evolved an Environment, which in 1960 he turned into a Happening titled *The Street*. His interest in street life led him, from 1961 to 1963, to work on *The Store*, in a rented store on East Second Street. He filled this interior space with roughly worked plaster sculptures of the kinds of commodities found in stores—pieces of pie, shirts, hats, pants, flags, and the like (in the midst of which he staged Happenings). The objects were garishly enameled, and Oldenburg's formal concern was with color, unlike the monochromatic *The Street*, in which the emphasis was on drawing. At this time too, Oldenburg began to enlarge his pieces to colossal size—for example, the eleven-foot long ice cream cone, 1962, anticipating his later public monuments. These gargantuan pieces were also his first soft sculptures.

In 1963, Oldenburg moved to Los Angeles, where he began to work on *The Home*, building bedroom, bathroom, and kitchen furniture and accessories, concentrating on their mass and volume, rather than on line or color. The major and most notorious work, *Bedroom*, 1963, "might have been called composition for (rhomboids) columns and discs." Oldenburg hoped that in time, it would be appreciated for its abstract qualities. Meanwhile, "my little gray geometric home in the West, is two-stepping with Edward Hopper." *Bedroom* was "real," "based on a famous motel along the shore road to Malibu, 'Las Tunas Isles,' in which (when I visited it in 1947) each suite was decorated in the skin of a particular animal, i.e., tiger, leopard, zebra. My imagination exaggerates but I like remembering it that way: each object in the room consistently

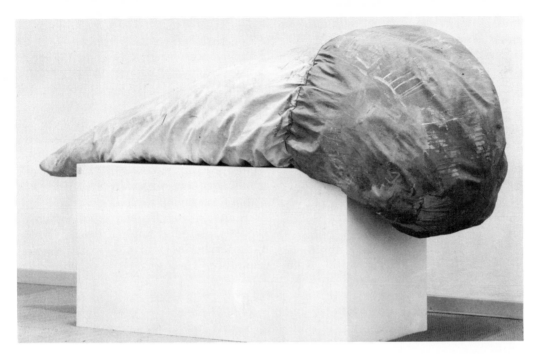

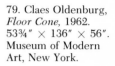

79. Claes Oldenburg, *Floor Cone*, 1962. 53¾″ × 136″ × 56″. Museum of Modern Art, New York.

80. Claes Oldenburg, *Bedroom Ensemble*, 1963. 5.2 meters × 6.4 meters. National Gallery of Canada, Ottawa.

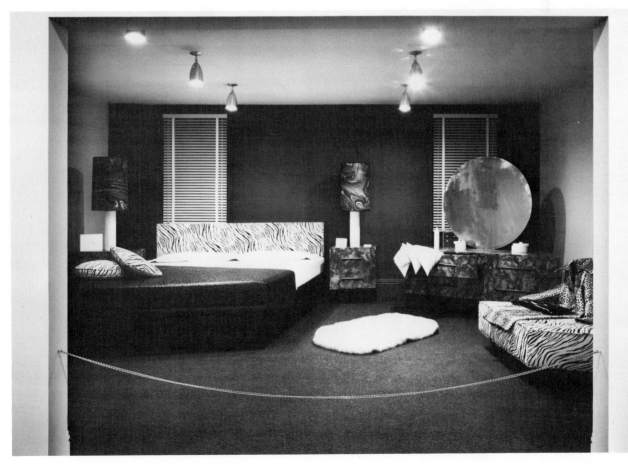

animal."[145] *Bedroom* was also an unnerving social satire on plastic America. As William Seitz wrote:

> The king-size furnishings (of which one can see the origins in windows along any shopping street) are constructed in a perverse, optically-distorted perspective which (unlike traditional linear perspective that creates the effect of space and bulk on a flat plane) makes actual bulk and space seem unreal. Every visible surface is false to its material: the dresser and the paired night tables are of formica which imitates marble; the mirror is not glass but metal; the white rug is artificial fur; the outlandish lounge is upholstered with "Zebravelour," thrown on it is a vinyl leopard-skin coat and an immense, mirror-black handbag. The towering lampshades . . . are "marbleized"; the quilted bedspread is plastic, and the sheets shine luridly . . . in white vinyl. The paintings on the walls are textiles that imitate the drip style of Jackson Pollock.[146]

After *Bedroom*, Oldenburg became increasingly interested in soft sculptures, which began with his "softening the machine [in] the Airflow car."[147] This work and subsequent ones were first made as a "ghost" version in stuffed canvas and then translated into stuffed vinyl, both of which were exhibited as finished works. Oldenburg also began to formulate monumental sculpture. He recalled: "In 1965, soon

81. Claes Oldenburg, *Giant Fag Ends*, 1967. 96″ × 96″ × 40″. Whitney Museum of American Art, New York.

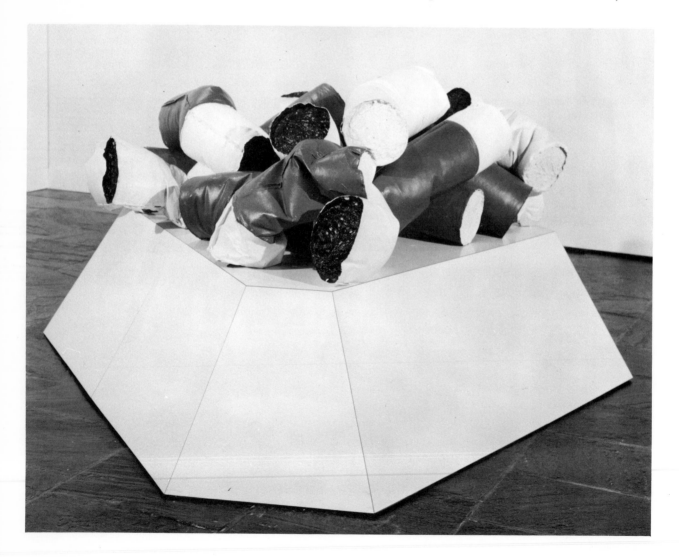

after moving into a very long and spacious loft, I found myself making objects in enormous scale—or rather proposing and imagining them."[148] In 1967, he exhibited "Proposals for Monuments": *Fagends* and *Drainpipe Variations* at the Janis Gallery, and *Giant Wiper* and other proposals at the Museum of Contemporary Art in Chicago. In 1969, he realized the first of these projects—the lofty *Lipstick,* built at Yale through a student subscription. Ellen Johnson wrote: "Male in form, it is female in subject; a two-inch object carried in every woman's purse stretches twenty-four feet into the sky."[149] The work was site-specific, situated in front of a classical war memorial whose pretentious columns it echoed and parodied. At the height of the Vietnam War, it served as an antiwar monument. As Andrew Forge wrote:

> Lipstick-rocket-tank, it mocks the military erection and puts its pink finger on a culture that measures its virility in missiles. But it is benign too. It has its own erotic claims. "I wish for the best for all things," Oldenburg has said, and the giant lipstick, no less than his teddy bear or baked potato can be seen as a monumental claim for comfort and love.[150]

Indeed, in all Oldenburg's work there is an extravagant, celebratory fantasy and sensuality at play. As he himself summed

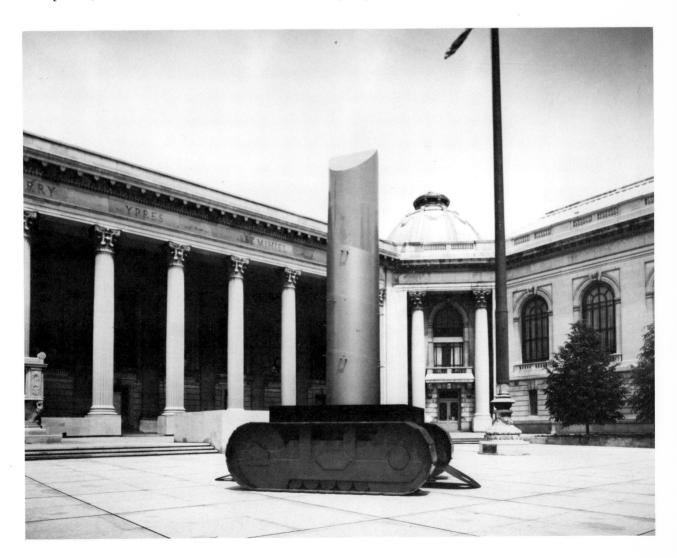

82. Claes Oldenburg, *Lipstick Ascending on Caterpillar Tracks,* 1969. 24′ × 13′ × 13′. Original location: Beinecke Plaza, in front of Woodbridge Hall, Yale University, New Haven, Conn.

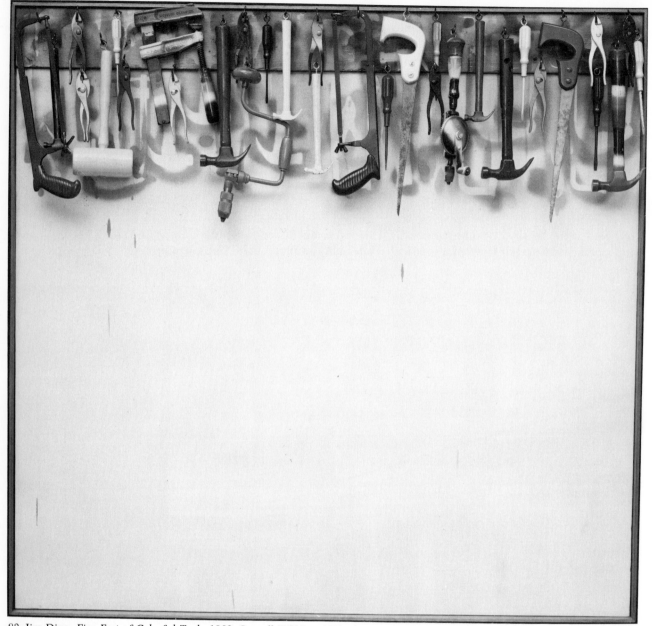

83. Jim Dine, *Five Feet of Colorful Tools,* 1962. Overall 55⅝″ × 60¼″ × 4⅜″. Museum of Modern Art, New York.

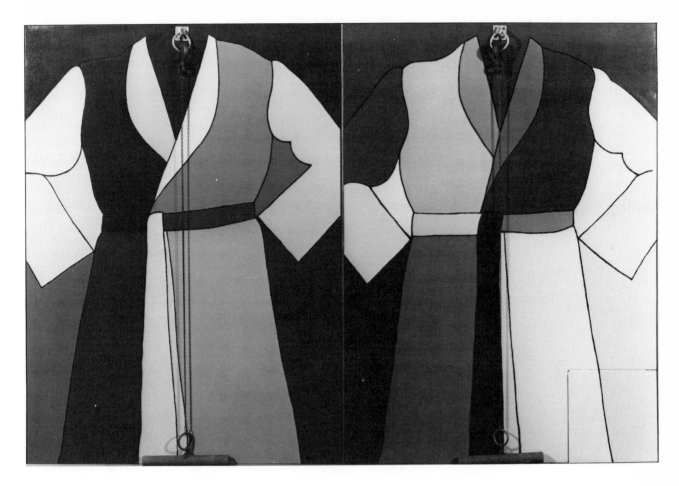

it up: "I am for an art that takes its form from the lines of life, that twists and extends impossibly and accumulates and spits and drips and is sweet and stupid as life itself."[151]

Like Oldenburg, Jim Dine made Assemblages, Environments, and Happenings in 1959–60, and in 1961 concentrated on creating works—in Dine's case, paintings—that depicted or incorporated common objects. Dine did not consider them as Pop, but they shared something of the sensibility of Pop Art, as he wrote in 1962: "My paintings are involved with 'objects.' At a time when the consumption of same is so enormous I find the most effective picture of them to be not a transformation or romantic distortion but a straight smack right there attitude. I am interested in their own presence."[152]

By 1963, however, Dine had turned away from an emphasis on objects as objects in order to focus on objects as symbols of himself as a person and as an artist—much as Oldenburg had. He said that he was "interested in personal images, in making paintings about my studio, my experience as a painter, about painting itself, about color charts, the palette, about elements of the realistic landscape—but used differently."

Like Oldenburg, Dine was occupied with "the problems of how to make a picture work . . . old artistic problems, that particular mystery that goes on in painting."[153] And Dine's painting was painterly, in the tradition of Abstract Expressionism, and even more, of Johns.

The subjects of Dine's 1961 paintings were everyday articles of clothing—neck-

84. Jim Dine, *Double Isometric Self-Portrait (Serape)*, 1964. 56⅞" × 84½". Whitney Museum of American Art, New York.

ties, belts, hats, shoes, coats—juxtaposed against their names: for example, the word "TIE" is printed near the image of a tie. The intimate subjects are often enlarged—like billboard images. In these works, Dine mixed the visual and the verbal, the literal and the expressive, the raw and the tasteful, the private and the public. In 1962, Dine began to affix real hand tools and other paraphernalia of his craft, such as palettes, to the loosely painted surfaces of his pictures. The painting became an environment for the artifacts of his personal experience. At this time, Dine said: "I came to make self-portraits when I felt I knew enough about myself to speak publicly and about that subject. I used the image of a bathrobe because I found a photo of one and after rendering it on canvas, it seemed to be my body inside."[154] The bathrobe related to the images of clothing in his 1961 pictures, but it was more intimate, more autobiographical. In time, it became Dine's consummate self-image.

Like Oldenburg and Dine, Red Grooms came to art-world attention as a Happening-maker, notably with the fantastic *The Burning Building*, 1959, assembled from "an inexhaustible amount of wood and cardboard supplied by N.Y.C. waste-baskets."[155] In 1962, Grooms collaborated with film-maker–photographer–painter Rudy Burckhardt on the film *Shoot the Moon*, a mélange of drama, painting, construction, and what have you. Grooms returned to object-making in 1963, constructing three-dimensional "stick-outs," peopled with figures influenced by Alex Katz's freestanding cutouts. The seminal work was the seven-foot-long *Le Banquet pour le Douanier Rousseau*, a witty and exuberant re-creation of the legendary 1907 homage.

In 1966, Grooms made the film *Fat Feet*, and in the following year he traveled to Chicago, where he built the first of his "sculpto-pictoramas," as he called them,[156] the twenty-five-foot-square multimedia re-creation *The City of Chicago*, 1968. This environmental work became the set for a film by Grooms, *Tappy Toes*. In 1970, he was commissioned by the Walker Art Center in Minneapolis to construct the twenty-five-foot-square walk-in *The Discount Store*. Modeled on a

85. Red Grooms, *Loft on 26th Street*, 1965–66. 28¼″ × 65¼″ × 28½″. Hirshhorn Museum and Sculpture Garden, Smithsonian Institution, Washington, D.C.

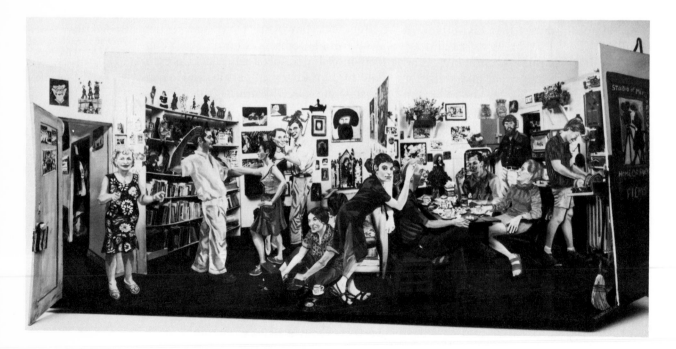

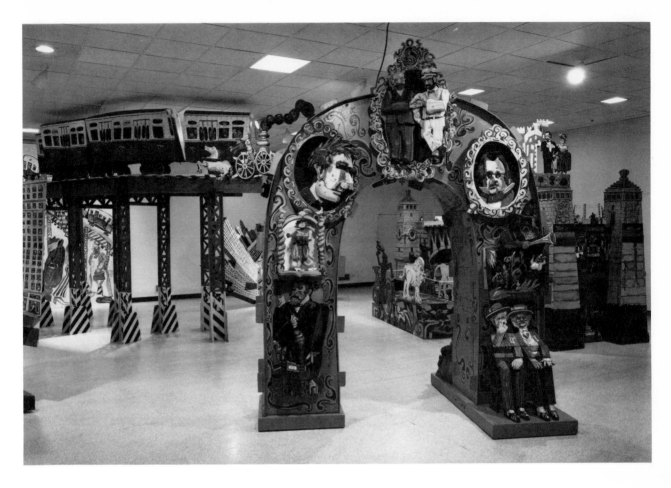

Midwestern chain, the Target Stores, Grooms's emporium is an American consumer heaven.

*The Discount Store* bears comparison with Oldenburg's *The Store* of almost a decade earlier. Both express a similar exuberant and witty vision of American urban life, which caused Grooms to be identified as a Pop artist, but not until 1967. Grooms's work differs from Oldenburg's in that his incorporates caricature images of people, retains a slapstick painterly style, and tends to be more manic and comic. Carter Ratcliff summed up Grooms as an artist, by calling attention to his

> flagrant goofiness that occasionally permits an extremely sophisticated view of the world to show through.
>
> Grooms is not a social critic. . . . He doesn't comment so much as celebrate, so his af-

fronts to good taste and high style don't read as acts of rebellion or protest.[157]

Like the works of Oldenburg and Dine, George Segal's plaster sculpture was often exhibited in shows of Pop Art, but it did not fit. His figures are realist portraits often placed in real settings, reminiscent of Environments or, as Lippard characterized them, "quick-frozen Happenings."[158] Although Segal never made a Happening, he and Allan Kaprow were close friends of long standing. Kaprow's first Happening, in 1958, took place on Segal's farm in New Jersey.

In the fifties, Segal had exhibited Expressionist paintings of massive, life-size figures. Then, as he wrote: "In 1958 I had a combined sculpture and painting show. . . . I simply made three life-size figures out of wire, plaster and burlap. . . . They

86. Red Grooms, *Chicago*, 1968. 11' high, 500' square. Art Institute of Chicago.

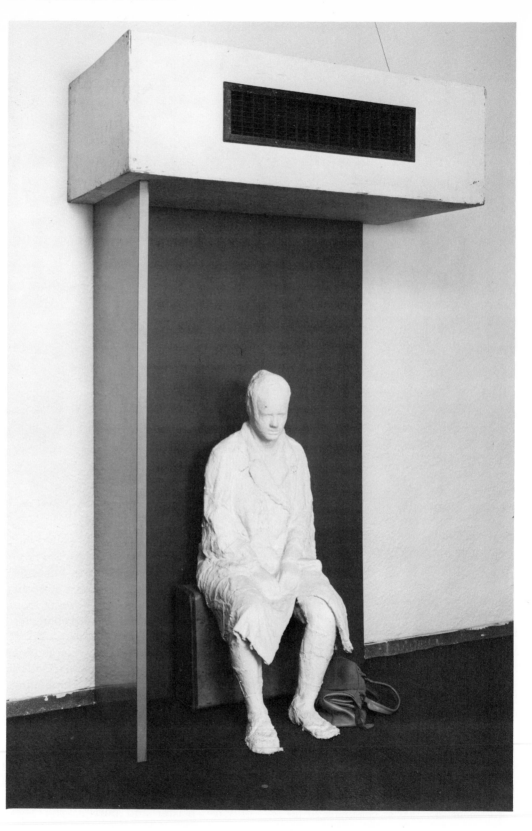

87. George Segal, *The Bus Station*, 1965. 96¼″ × 59⅛″ × 29¾″. Whitney Museum of American Art, New York.

88. George Segal, *The Billboard*, 1966. 15'9″ × 9'9″ × 1'8″. State of New York, Nelson A. Rockefeller Empire State Plaza Art Collection.

looked to me as if they had stepped out of my paintings. . . . One of the figures was sitting on a real broken chair." As with the makers of Environments and Happenings, Segal's "decision to enter literal space was determined by strong urges for total experience."[159]

Segal's next step occurred in 1961: "Someone made me a gift of some Johnson & Johnson gauze bandages. Immediately, I knew what I wanted to do. I was my own first model. I wrapped myself in the bandages and my wife put on the plaster. I had a hell of a time getting the pieces off and reassembled. But it eventually became Man at the Table. I had found my medium."[160] Segal went on to devise a technique of "mummification," "wrapping bandages dipped in wet plaster around parts of [his sitters'] bodies, cutting off the hardened sections, then later reassembling them into the whole body."[161] Segal's effigies are "real" in that they are direct molds, but their color is of white plaster and the true likeness is inside the plaster, the artist's touch manifest in every external detail, because he desired to present his "own version of naturalistic reproduction."[162] The "reality" of Segal's figures is enhanced by his introduction of furniture and other real props, but the effect is unreal—enigmatic, at times unnerving, his whitened figures recalling the plaster-filled cavities of Pompeians trapped in lava. It is the mystery with which Segal endows his commonplace figures that separates his works from hardcore Pop Art. Indeed, in their lonely isolation, his images relate to Edward Hopper's.

# NOTES

1. See "Art: The Slice-of-Cake School," *Time,* 11 May 1962; "Art: Something New Is Cooking—Jarring Blend of Billboard Pieces," *Life,* 15 June 1962; "The Growing Cult of Marilyn," *Life,* 24 January 1963; and "Pop Art—Cult of the Commonplace," *Time,* 3 May 1963.

   In a four-page spread with eight color illustrations, *Time,* in "Pop Art—Cult of the Commonplace," pp. 69–70, called "pop art . . . the biggest fad since art belonged to Dada. Symposiums discuss it; art magazines debate it; galleries compete for it. . . . Even Manhattan's Museum of Modern Art has bought a pop art sculpture called *Dual Hamburger* . . . profit-minded galleries and collectors of whatever's new are off and running with it. 'It's the most important art movement in the world today,' says Pop Art Collector Philip Johnson." This article, which lavished attention on Pop Art, made it clear that the art was not worthy of the attention it was receiving.

   "Art: Something New Is Cooking," published within six months of Pop Art's appearance, featured Lichtenstein, Rosenquist, Wayne Thiebaud, and Segal.

   The most valuable commentary on Pop Art appeared in the three years after its emergence—that is, from 1962 to 1965. By the end of this period, "the basic Pop statements [both verbally and in the art itself] had already been made," as Andy Warhol and Pat Hackett observed in *Popism: The Warhol 60's* (New York:

Harcourt Brace Jovanovich, 1980), p. 115.
2. See John Rublowsky, *Pop Art* (New York: Basic Books, 1965), pp. 152–67.
3. Warhol's first show was at the Ferus Gallery, Los Angeles, in 1962.
4. Brian O'Doherty, "Art: Avant-Garde Revolt," *New York Times,* 31 October 1962, p. 41. See also Brian O'Doherty, " 'Pop' Goes the New Art," *New York Times,* 4 November 1962, sec. 2, p. 23.

   Included in *The New Realists* show were Jim Dine, Robert Indiana, Roy Lichtenstein, Claes Oldenburg, James Rosenquist, George Segal, Andy Warhol, and Tom Wesselmann of the United States; Peter Blake of England; Arman, Christo, Yves Klein, and Jean Tinguely of France. John Ashbery, Pierre Restany, and Sidney Janis contributed essays to the catalogue.

   In the same year, the Dwan Gallery in Los Angeles mounted *My Country 'Tis of Thee,* with a text by Gerald Nordland.
5. Lucy R. Lippard, *Pop Art* (New York: Frederick A. Praeger, 1966), pp. 11–25, 69–80; and Michael Compton, *Pop Art* (London: Hamlyn, 1970), pp. 18–27.
6. It is noteworthy that Warhol initially hand-painted his pictures, before turning to silk screens. So did Lichtenstein prior to his use of stencils. Warhol, who in 1961 used silk screen to reproduce popular images, influenced Rauschenberg. However, Rauschenberg was disposed to Warhol's technique by his own earlier

rubbing of preexisting images from newspapers and magazines to transfer them onto his own work, a technique that may have influenced Warhol. See Henry Geldzahler, "Rauschenberg," *Art International,* 25 September 1963, p. 66, and Compton, *Pop Art,* p. 26.

7. Robert Rosenblum, "Pop Art and Non Pop Art," *Art and Literature* 5 (Summer 1964): 89.

Nancy Marmer, in "Pop Art in California," in Lippard, *Pop Art,* p. 148, remarked:

The central novelty and perhaps most fruitful aspect of Pop Art obviously consists not in its concentration on common objects (which, after all, have appeared sporadically throughout art history since seventeenth-century Dutch genre painting), not in its popular culture subjects (which provided material for earlier generations), nor in its "questioning" of the nature of the relationship between depiction and reality (all art since 1890 does that), but in its sanction of advertising, illustration, and commercial art conventions as well as techniques for the presentation of these . . . in the context of "high art."

Oldenburg, in Bruce Glaser, moderator, "Oldenburg, Lichtenstein, Warhol: A Discussion," *Artforum,* February 1966, p. 22, said:

Subject matter is certainly a part of it. You never had commercial art apples, tomato cans or soup cans before . . . still life that had been passed through the mass media. Here for the first time is an urban art which does not sentimentalize the urban image but uses it as it is found. This is something unusual.

8. Roy Lichtenstein, interviewed by G. R. Swenson, "What Is Pop Art?" part 1, *Art News,* November 1963, p. 25.

9. See Lawrence Alloway, "The Development of British Pop," in Lippard, *Pop Art,* pp. 44–45; and Jasia Reichardt, "Pop Art and After," *Art International,* 25 February 1963, p. 42.

10. Alloway used the term "pop art" in "The Collage Explosion," *Listener* 5 (April 1962): 604; he meant it to include Rauschenberg's combines and Happenings.

11. Lippard, *Pop Art,* p. 174–75.

12. Sidney Tillim, "In the Galleries: The New Realists," *Arts Magazine,* December 1962, p. 44.

13. Henry Geldzahler, in "A Symposium on Pop Art," *Arts Magazine,* April 1963, p. 37. (Transcript of a symposium held at the Museum of Modern Art, December 1962.) Geldzahler reported:

About a year and a half ago I saw the work of Wesselmann, Warhol, Rosenquist and Lichtenstein in their studios. They were working independently, unaware of each other, but with a common source of imagery. Within a year and a half they have had shows [and] been dubbed a movement. This is instant art history, art history made so aware of itself that it leaps to get ahead of art.

14. Ibid. As Mario Amaya wrote in *Pop as Art* (London: Studio Vista, 1965), p. 11:

Never before has the human eye been so assaulted by images printed, painted, photographed, stencilled and otherwise copied, both moving and still. Because of the immense power and spread of advertising and mass-media communications through publications and television since the Second World War, we have taken for granted a whole new set of signs, symbols, emblems and imagery . . . as a commonly shared visual experience. . . . It is not surprising that young artists who have grown up in such surroundings and who in fact know no others, should be interested in exploring the psychological, sociological, mythological (as well as purely visual) elements in such images.

15. Lawrence Alloway, "Notes on Abstract Art and the Mass Media," *Art News and Review,* 27 February 1960, p. 3. It is noteworthy that the Pop artists, as Lippard in *Pop Art,* pp. 89–90, wrote, "all have backgrounds in commercial art. Warhol was a successful fashion illustrator of shoes; Rosenquist learned billboard painting as a trade; Lichtenstein worked in design and display, Oldenburg in magazine illustration and design; and Wesselmann studied to be a cartoonist."

16. James Rosenquist, interviewed by Swenson, "What Is Pop Art?" part 2, *Art News,* February 1964, p. 63.

17. Ada Louise Huxtable, "Architecture for a Fast-Food Culture," *New York Times Magazine,* 12 February 1978, p. 25.

18. Vincent Scully, introduction, in Robert Venturi, *Complexity and Contradiction in Architecture* (New York: Museum of Modern Art, 1966), p. 10.

19. John Ashbery, "The New Realism," *The New Realists,* exhibition catalogue (New York: Sidney Janis Gallery, 1962), n.p.

20. *Art 1963—A New Vocabulary,* exhibition catalogue (Philadelphia: YM/YWHA, 1962), p. 2.

21. Robert Indiana, interviewed by Swenson, "What Is Pop Art?" part 1, p. 27. Earlier, Oldenburg and Dine tried to initiate a realist revival, indicating their predisposition. See Irving Sandler, *The New York School: Painters and Sculptors of the Fifties* (New York: Harper & Row, 1978), p. 207.

22. Warhol and Hackett, *Popism,* p. 7.

23. Tom Wesselmann, interviewed by Swenson, "What Is Pop Art?" part 2, p. 41.

24. Indiana, interviewed by Swenson, "What Is Pop Art?" part 1, p. 27.

25. G. R. Swenson, "The New American 'Sign Painters,' " *Art News,* September 1962, p. 61.

26. Roy Lichtenstein, interviewed by John Jones, New York, 5 October 1965, pp. 4–5. Transcript in Archives of American Art, New York.

27. Swenson, "The New American 'Sign Painters,' " p. 61.

28. Jasper Johns, interviewed by Swenson, "What Is Pop Art?" part 2, p. 43. Johns said: "I'm not a Pop Artist!" That was because he transformed his subjects through his painting. Johns went on to say: "I am concerned with a thing's not being what it was, with its being something other than it is, with any moment in which one identifies a thing precisely and with the slipping away of that moment."

29. Charlotte Willard, "Dealers-Eye View," *Art in America* 2 (1964): 122.

30. Lichtenstein, in Glaser, moderator, "Oldenburg, Lichtenstein, Warhol," p. 22.

31. Andy Warhol, interviewed by Swenson, "What Is Pop Art?" part 1, p. 26.

32. Sidney Janis, "On the Theme of the Exhibition," *The New Realists*, n.p. Billy Klüver, in *Art 1963–A New Vocabulary*, called Duchamp "the most exciting man of this century."

33. Rosalind Constable, "New York's Avant-Garde and How It Got There," *New York/Herald Tribune*, 17 May 1964, p. 10.

34. Lichtenstein, interviewed by Swenson, "What Is Pop Art?" part 1, p. 25.

35. Warhol, interviewed by Swenson, "What Is Pop Art?" part 1, p. 26.

36. "Art: The Slice-of-Cake School," p. 52.

37. Indiana, interviewed by Swenson, "What Is Pop Art?" part 1, pp. 27, 63–64. There is, of course, an element of irony in Indiana's remarks. This irony is clearer in a statement he made a year or so earlier about *The American Dream*, acquired by the Museum of Modern Art. "The TILT of all those millions of Pin Ball Machines and Juke Boxes in all those hundreds of thousands of grubby bars and roadside cafés, alternate spiritual Homes of the American and star-studded Take All, well-established American ethic in all realms—spiritual, economic, political, social, sexual and cultural. Full Stop." (Quoted in Sidney Tillim, "Month in Review," *Arts Magazine*, February 1962, p. 34.)

38. Swenson, "The New American 'Sign Painters,' " pp. 46, 62.

39. Geldzahler, in "A Symposium on Pop Art," p. 37.

40. Ivan Karp, "Anti-Sensibility Painting," *Artforum*, September 1963, pp. 26–27.

41. Alan R. Solomon, "The New Art," *Art International*, 25 September 1963, pp. 37–38.

42. Lichtenstein, interviewed by Swenson, "What Is Pop Art?" part 1, p. 25.

43. Rosenquist, interviewed by Swenson, "What Is Pop Art?" part 2, p. 62.

44. See Sidney Tillim, "Month in Review," *Arts Magazine*, November 1962, p. 38.

45. G. R. Swenson, "Reviews and Previews: Andy Warhol," *Art News*, November 1962, p. 15.

46. Jules Langsner, "Los Angeles Letter," *Art International*, 25 November 1962, p. 49.

47. See Lichtenstein, interviewed by Jones.

48. Lippard, *Pop Art*, p. 90.

49. Sidney Tillim, "Jim Dine, Peter Saul, James Rosenquist," *Arts Magazine*, March 1962, p. 46.

50. Lichtenstein, interviewed by Jones, p. 1.

51. John Coplans, "Pop Art, USA," *Artforum*, October 1963, p. 28.

52. Sidney Tillim, "Month in Review," *Arts Magazine*, February 1962, p. 34.

53. John Coplans, "The New Paintings of Common Objects," *Artforum*, November 1962, pp. 27–28.

Occasionally, Pop Art was treated as a social good, as Alan Solomon, in the introduction, *The Popular Image*, exhibition catalogue (London: The Institute of Contemporary Art, 1963), n.p., did when he wrote of it as "democratic." Since its subject matter "was produced in an unconscious way by the process of mass culture," it could be understood by all, even though the intention of "fine" artists was not the same as that of "commercial" artists. Duchamp, more ironic, remarked that the Pop artists (unlike the Dadaists of his generation) "seem to feel that in a democracy they should have a more reverent attitude towards a garbage can, go lower and lower in the means used to express the art of their day. . . . The lower the material used the better. Reverence in reverse. But it is reverence anyway." (Constable, "New York's Avant-Garde and How It Got There," p. 10.)

54. Arthur Secunda, interviews, "John Bernhardt, Charles Frazier, Edward Kienholz," *Artforum*, October 1962, pp. 31–32.

55. Tillim, "Month in Review," *Arts Magazine*, February 1962, p. 34.

56. Warhol, interviewed by Swenson, "What Is Pop Art?" part 1, p. 60.

57. Glaser, "Oldenburg, Lichtenstein, Warhol," p. 24.

58. David Antin, "Warhol: The Silver Tenement," *Art News*, Summer 1966, p. 48.

59. Compton, *Pop Art*, p. 25.

60. Warhol and Hackett, *Popism*, p. 221.

61. Philip Leider, "St. Andy," *Artforum*, February 1965, pp. 27–28. Larry Bell, in a statement written in September 1963, which accompanied "St. Andy," wrote that "Warhol has successfully been able to remove the artist's touch from art . . . it is dubious whether he has anything to do with the act of painting them" (p. 28). Thus his art is "anti-artistic," but not anti-art, and the distinction is an important one.

62. Sidney Tillim had a similar experience. In "Month in Review," *Arts Magazine*, November 1962, p. 37, he wrote: "a respected fellow-critic suggested that Oldenburg and the neo-Dadaists were not worthy of the attention I planned to give them here."

63. Swenson, "The New American 'Sign Painters,' " pp. 45–46.

64. Geldzahler, "A Symposium on Pop Art," p. 37. Also see Lippard, *Pop Art*, p. 77, and Irving Sandler, "The New Cool-Art," *Art in America*, February 1965.

65. D.J. [Donald Judd], "New York Exhibitions: In

the Galleries: Andy Warhol," *Arts Magazine,* January 1963, p. 49.

66. Reflecting art critical opinion that Pop Art was avant-garde, *Harper's Bazaar* in its March 1963 issue celebrated the fiftieth anniversary of the Armory Show by coupling the avant-garde then with Pop Art, which it proclaimed today's avant-garde.

67. Michael Fried, "New York Letter," *Art International,* 20 December 1962, p. 57.

68. Michael Fried, "New York Letter," *Art International,* 5 December 1963, p. 66.

69. Clement Greenberg, *Post-Painterly Abstraction,* exhibition catalogue (Los Angeles: Los Angeles County Museum of Art, 1964), n.p.

70. Clement Greenberg, "Counter-Avant-Garde," *Art International,* 20 May 1971, p. 17.

71. In "Second-Generation Abstraction," *Time,* 24 May 1963, p. 78, the art critic noted that the artists who exhibited in *Toward a New Abstraction* "refer to their work as 'high art,' as opposed to 'pop art.'"

72. Barbara Rose, "Pop in Perspective," *Encounter,* August 1965, p. 61.

73. Tillim, "Jim Dine, Peter Saul, James Rosenquist," p. 46.

74. Thomas B. Hess, "Reviews and Previews: New Realists," *Art News,* December 1962, p. 13. In "Pop and Public," *Art News,* November 1963, p. 23, Hess also blamed a "vulgar audience reaction" on the part of overeager "communicators, museum officials and collectors, all of whom [crave] modish discoveries" for the success of Pop Art.

The custodians of high culture believed, as Irving Howe, in "The Critic as Heard in Our Land," *New York Times Book Review,* 9 February 1964, pp. 1, 30, wrote:

> *Criticism, at its best, has been a defender of seriousness and distinction against the vulgarities of "mass culture"* [which has been] spreading in every industrialized society. . . . This [new cultural] blight consisted of a synthetic, commercialized pseudo-culture, deliberately manufactured to divert and distract the semi-educated millions. . . . This sleazy "mass culture"—or as the Germans call it, *kitsch* [does not create] either the disturbance or satisfaction of genuine art. . . .

In response to all this, the work of serious critics has taken on a tone of urgency, even of combative gaiety. Critics like Dwight Macdonald, Clement Greenberg and Harold Rosenberg have analyzed and attacked the falsities of "mass culture."

It is noteworthy that two of the three literary critics mentioned by Howe as upholders of high modernist culture were leading art critics. Clement Greenberg, in "Avant-Garde and Kitsch," *Partisan Review,* reprinted in *Art and Culture: Critical Essays* (Boston: Beacon Press, 1961), p. 10, had condemned the mass media for providing an "ersatz culture . . . destined for those who [are] insensible to the values of genuine culture." And Rosenberg's antipathy to mass culture was so extreme that he accused scholars who tried to analyze it of creating it, of secretly liking it; why else would they even bother with it? See Harold Rosenberg, "Pop Culture: Kitsch Criticism," in *The Tradition of the New* (New York: Horizon Press, 1959), ch. 18.

75. Hilton Kramer, in "A Symposium on Pop Art," pp. 38–39. On p. 42, Stanley Kunitz went further than Kramer and insisted that in contradistinction to Abstract Expressionist imagery, Pop Art's "signs and slogans and stratagems come straight out of the citadel of bourgeois society, the communications stronghold where the images and desires of mass man are produced, usually in plastic."

76. Peter Selz, "Variety: Pop Goes the Artist," *Partisan Review,* Summer 1963, pp. 314–16. Selz was best known for *The New Image of Man,* which he organized at the Museum of Modern Art in 1959, a show in which man was portrayed as ravaged, alienated, and disaffected.

Kunitz, in "A Symposium on Pop Art," p. 41, stated "the real artists . . . are the promoters."

77. Susan Sontag, "Notes on 'Camp,'" *Partisan Review,* Fall 1964, pp. 515, 526–27.

78. Susan Sontag, "Pop Goes the Easel," *Book Week,* 25 July 1965, p. 12.

79. Later, Pop Art subjects, such as Campbell soup cans, were mass produced and sold as novelties or house furnishings. These artifacts were camp.

80. Sontag, "Pop Goes the Easel," p. 12.

81. Thomas B. Hess, "J'accuse Marcel Duchamp," *Art News,* February 1965, p. 53.

82. Warhol and Hackett, *Popism,* p. 88.

83. Dick Schapp, in "Similes & Metaphors: Breaking Camp," *Book Week,* 13 March 1966, p. 6, wrote:

> The "Notes" have been used as a justification for Camp and as a guide to Camp. Authors toiling in such diverse publications as Time, The New York Times Magazine and Cavalier turned to the "Notes" as crutch and target, and the word "Camp," practically unknown outside a dominantly homosexual cult only two years ago, has become so widely worked and overworked that Miss Sontag deeply wishes, now, she had never pitched Camp.

Indeed, she herself remarked: "If this piece had come before pop art, it would have passed quite unnoticed. But the emergence of pop art prepared the ground. It was an historical accident." Be that as it may, her article became notorious and contributed to the notoriety of Pop Art by helping to make it a recurrent topic of discussion in intellectual circles; in return, Pop Art contributed to her celebrity.

84. Erle Loran, "Cézanne and Lichtenstein: Problems of 'Transformation,'" *Artforum,* September 1963, p. 35.

85. Ibid., p. 34.

86. Lippard, *Pop Art*, p. 82.

87. Max Kozloff, " 'Pop' Culture, Metaphysical Disgust, and the New Vulgarians," *Art International,* March 1962, pp. 33–36. Kozloff remarked: "Are we supposed to regard our popular signboard culture with greater fondness or insight now that we have Rosenquist? Or is he exhorting us to revile it, that is to do what has come naturally to every sane and sensitive person in this country for years. If the first, the intent is pathological, and if the second, dull." He predicted that the onslaught of the "New Vulgarians" was just beginning, for he concluded, "save us from . . . the Rosensteins or Oldenquists to come!"

88. Lichtenstein, interviewed by Swenson, "What Is Pop Art?" part 1, p. 25.

89. See Sandler, "The New Cool-Art."

90. See Emily Genauer, "One for the Road Signs," *New York/Herald Tribune,* 21 October 1962, p. 7. Genauer compared the New Realists to earlier painters of social subjects whose work revealed the signs of artistic skill and personality, and found the Pop artists lacking. She was also taken aback by the anonymity, banality, and sensationalism of their subject matter. Nevertheless, Pop Art was not Abstract Expressionism, which she detested above all. Pop Art did try to communicate in fresh ways, and that was to the good, a harbinger perhaps that "artists may get back to thinking, feeling, painting, communicating poetically and imaginatively again."

91. See Peter Selz, *New Images of Man* (New York: Museum of Modern Art, 1959).

92. Sidney Tillim, "Month in Review," *Arts Magazine,* February 1962, p. 34.

93. "Art: Pop: Bing-Bang Landscapes," *Time,* 28 May 1965, p. 80.

94. Swenson, "The New American 'Sign Painters,' " p. 61.

95. Leo Steinberg, in "A Symposium on Pop Art," pp. 40, 43.

96. See Cleve Gray, "Remburgers and Hambrandts," *Art in America* 6 (1963): 125.

97. Jules Langsner, "Los Angeles Letter," September 1962, *Art International,* 25 November 1962, p. 49.

98. See Lichtenstein, interviewed by Jones.

99. Loran, "Cézanne and Lichtenstein," p. 35. See also Erle Loran, "Pop Artists or Copy Cats?" *Art News,* September 1963.

100. Lichtenstein, interviewed by Swenson, "What Is Pop Art?" part 1, pp. 62–63. Jasper Johns, interviewed by Swenson in part 2, p. 67, commented: "If you have one thing and make another, there is no transformation, but there are two things. I don't think you would mistake one for the other."

101. Judd, "New York Exhibitions: Warhol," p. 49.

102. The Pop artists were extremely conscious of their individual styles. Both Lichtenstein and Warhol used comic strips as their subjects to begin with. Warhol abandoned them when they became identified with Lichtenstein. In "An Interview with Roy Lichtenstein," by John Coplans (*Artforum,* October 1963, p. 31), when asked: "What was the real crisis that precipitated your clean break with the past?" Lichtenstein answered: "Desperation. There were no spaces left between Milton Resnick and Mike Goldberg."

103. See Time Inc. Archives, New York, Rosalind Constable Reports.

Philip Johnson, in "Young Artists at the Fair and at Lincoln Center," *Art in America* 4 (1964): 113, remarked:

Roy Lichtenstein's paintings look at first like copies of panels from comic strips, but they soon appear to be expertly composed. The main quality of the work lies in the contrast between the gross and commercial appearance of the comic panel and the very developed and even traditional art with which it is represented.

104. Dorothy Seiberling, "Roy Lichtenstein: Is He the Worst Artist in the U.S.?" *Life,* 31 January 1964, pp. 79–81, 83.

105. Lichtenstein, interviewed by Swenson, "What Is Pop Art?" part 1, p. 63.

106. Ellen H. Johnson, "Lichtenstein: The Printed Image," *Art and Artists,* June 1966, p. 14.

107. John Coplans, "An Interview with Roy Lichtenstein," *Artforum,* October 1963, p. 31.

108. Lichtenstein, interviewed by Swenson, "What Is Pop Art?" part 1, p. 63.

109. D.J.[Donald Judd], "New York Exhibitions: In the Galleries: Roy Lichtenstein," *Arts Magazine,* April 1962, p. 52.

Lippard agreed, remarking in *Pop Art,* p. 18, that Léger's "robust forms, metallic surfaces, mechanical line, garish color, and clear, schematic, often heavy-handed style are reflected in Pop Art—above all, in Lichtenstein."

110. Coplans, "Talking with Roy Lichtenstein," *Artforum,* May 1967, p. 36.

111. Ibid., p. 34.

112. Pjete Lindstrom, "Letters," *Artforum,* November 1963, p. 2.

113. Coplans, "Talking with Roy Lichtenstein," p. 36.

114. Andy Warhol, "New Talent USA: Prints and Drawings," *Art in America* 1 (1962): 42.

115. Warhol and Hackett, *Popism,* pp. 16–17.

116. In "Music, Man, That's Where It's At!" *Aspen,* no. 3 (December 1966): n.p., Lou Reed, the leader of the Velvet Underground, wrote: "Repetition is so fantastic. Anti-glop. Records should have cracks after the best passages. So they will repeat over and over and over. As many times as I want to hear them."

117. Warhol moved away from the art world in the middle sixties. For example, in Warhol and Hackett, *Popism,* he does not even mention Fried, Greenberg, Hess, Rose, Rosenberg, and

most other art-world notables.

118. "Products," *Newsweek,* 12 November 1962, p. 94.

119. Andy Warhol, *The Philosophy of Andy Warhol (From A to B and Back Again)* (New York: Harcourt Brace Jovanovich, 1975), p. 54.

120. Mary Josephson, "Warhol: The Medium as Cultural Artifact," *Art in America,* May–June 1971, p. 42.

121. Warhol and Hackett, *Popism,* p. 82. Warhol said: "Everyone always reminds me about the way I'd go around moaning, 'Oh, when will I be famous, when will it happen?' . . . I worked hard and I hustled."

122. At the opening of Warhol's show at the Institute of Contemporary Art in Philadelphia in 1965, so many students packed the galleries that to protect the pictures, they were removed, "an art opening with no art." Warhol and Hackett, *Popism,* pp. 131–33. They also recalled that the students began to scream when Warhol and Edie Sedgwick arrived, as if they were rock stars.

123. Ellen Willis, "My Podhoretz Problem—and His," *Village Voice,* 3 December 1979, p. 38. Willis remarked that her generation was "impatient with prissy moralizing about the bitch goddess . . . 'a Mailer-like bid for literary distinction, fame, and money, all in one package' appealed to our sense of how mass culture worked. . . . Mailer was a genius at the art of image making."

124. Calvin Tomkins, *The Scene: Reports on Post-Modern Art* (New York: Viking Press, 1976), p. 16.

125. Judith Goldman, *James Rosenquist,* exhibition catalogue (New York: Penguin Books, 1985), p. 27.

126. "Art: The Slice-of-Cake School," p. 52.

127. Aline B. Saarinen, "Explosions of Pop Art," *Vogue,* 15 April 1963, p. 136.

128. Goldman, *Rosenquist,* pp. 27–28.

129. G. R. Swenson, "Reviews and Previews: New Names This Month: James Rosenquist," *Art News,* February 1962, p. 20.

130. G. R. Swenson, *The Other Tradition* (Philadelphia: Institute of Contemporary Art, University of Pennsylvania, 1966), p. 36.

131. James Rosenquist, in "12 Paintings from the Powers Collection," *Aspen* 3, n.p.

132. Swenson, *The Other Tradition,* p. 38.

133. John Russell, "Persistent Pop," *New York Times Magazine,* 21 July 1974, p. 33.

134. See Time Inc. Archives, New York, Rosalind Constable Reports.

135. Goldman, *Rosenquist,* p. 46.

136. John Rublowsky, *Pop Art,* p. 93.

137. James Rosenquist, interview with Jeanne Siegel, *Artforum,* June 1972, p. 32.

138. Ibid.

139. Tom Wesselmann/Stealingworth, *Tom Wesselmann* (New York: Abbeville Press, 1980), pp. 25–26.

140. Claes Oldenburg, "Extracts from the Studio Notes," *Artforum,* January 1966, p. 33.

141. "New Talent USA: Sculpture (Chosen by Robert Scull)," *Art in America* 1 (1962): 33.

142. *Art 1963—A New Vocabulary,* p. 4.

143. Glaser, "Oldenburg, Lichtenstein, Warhol," p. 22.

144. Claes Oldenburg, in *São Paulo 9,* exhibition catalogue (Washington, D.C.: Smithsonian Institution Press, 1967), p. 93.

145. Ibid.

146. William C. Seitz, "Environment U.S.A.: 1957–1967," *São Paulo 9,* p. 56.

147. Jeanne Siegel, "How to Keep Sculpture Alive In and Out of a Museum—An Interview with Claes Oldenburg," *Arts Magazine,* September–October 1969, p. 25.

148. Claes Oldenburg, in "Portfolio: 4 Sculptors, Recent Work and Statements," *Perspecta* 11 (New Haven), Summer 1967, p. 53.

149. Peter Gay, "The Burden of Prophecy," *A View of a Decade,* exhibition catalogue (Chicago: Museum of Contemporary Art, 1977), p. 33.

150. Andrew Forge, "Forces Against Object-Based Art," *Studio International,* January 1971, p. 33.

151. Claes Oldenburg, in Charlotte Willard, "Drawing Today," *Art in America* 5 (1964): 51.

152. *Art 1963–A New Vocabulary,* p. 2.

153. Jim Dine, interviewed by Swenson, "What Is Pop Art?" part 1, pp. 61–62.

154. Jim Dine, in *Art in Process,* exhibition catalogue (New York: Finch College Museum of Art/Contemporary Study Wing, 1965), n.p.

155. Red Grooms, in "Newly Nominated," *Art in America* 4 (1964): 108.

156. Carter Ratcliff, *Red Grooms* (New York: Abbeville Press, 1984), p. 97.

157. Ibid., pp. 94–95.

158. Lippard, *Pop Art,* p. 102.

159. Henry Geldzahler, "An Interview with George Segal," *Artforum,* November 1964, p. 26.

160. "Art: The Silent People," *Newsweek,* 25 October 1965, p. 107.

161. Allan Kaprow, "Segal's Vital Mummies," *Art News,* February 1964, p. 33.

162. William C. Lipke, "The Sense of 'Why Not?': George Segal on His Art," *Studio International,* October 1967, p. 149.

# 8 THE NEW PERCEPTUAL REALISM AND PHOTO-REALISM

As early as 1963, Sidney Tillim related Pop Art to a tendency that came to be known as the "New Realism" or, as I prefer to call it, the New Perceptual Realism, exemplified by the painting of Alex Katz and Philip Pearlstein. Tillim wrote:

> In a spirit analagous to pop art, the most literate realism concentrates . . . on the factual presence . . . of the object that is simply *there*—returned, regained—before it assumes those niceties of style and contingencies of feeling we generally associate with fine art. The expression is primarily in the *restitution* of the object rather than the emotional evocation *through* the object. For the moment, then, a new realism would be anti-expressionist, anti-rhetorical. Now—at last—the minimum at least of these conditions has been met by an American painter. For with Philip Pearlstein's exhibition of figure paintings . . . something new in realism has arrived on the scene . . . a breakthrough.[1]

Painterly figuration of the fifties had fluctuated between image and process—that is, between representing a subject or submitting to the painting process. Figurative artists emphasized either the appearance of reality or their subjective response to the subject, generally embodied in painterly painting, but even when the image was stressed, signs of process were cultivated. As early as 1957, Katz had turned against painting that emphasized the painterly mark or gesture in both abstract and figurative art. It struck

FACING PAGE:
89. Alex Katz, *Ada and Vincent*, 1967. 94½″ × 71½″. Collection the artist.

him as overworked and outworn; he called it "reactionary."[2]

Both Katz and Pearlstein came to believe that if figurative painting was to be renewed, it would have to venture toward realism, to look out at the world rather than into the artist's psyche. Brushy painting obscured the details of visual reality; it got in the way of recording facts as they were perceived. Moreover, painterly figuration on the whole was an essentially abstract art. Little or no consideration was given to what the figure signified. Katz and Pearlstein concluded that in order for figurative art to yield major new styles, it would have to become literal or specific or factual, and thus antigestural. The issue was not only aesthetic but ethical, because the New Perceptual Realists proposed to take greater responsibility for their subjects by being true to their appearances.[3] And, as Katz was the first to recognize, the new realism would have to adapt "the big picture" associated with Abstract Expressionism and hard-edge and stained color-field abstraction to representational painting, enabling it to hold its own visually against abstract art.

But in 1962, little of this was clear to the art world. Pearlstein wrote in an influential article titled "Figure Paintings Today Are Not Made in Heaven":

> It seems madness on the part of any painter educated in the twentieth-century modes of picture-making to take as his subject the

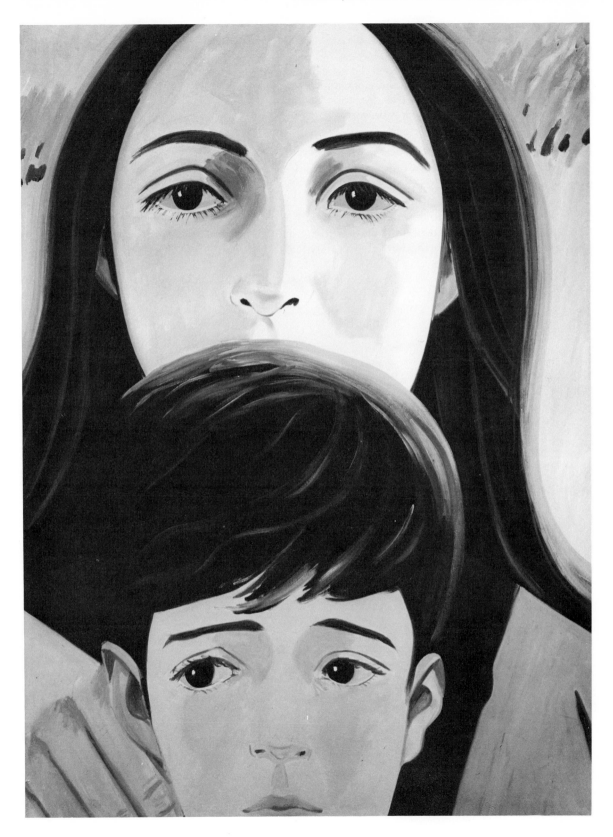

naked human figure, conceived as a self-contained entity possessed of its own dignity, existing in an inhabitable space, viewed from a single vantage point. For as artists we are too ambitious and conscious of too many levels of meaning. The description of the surface of things seems unworthy.[4]

Unworthy though it seemed, Pearlstein persisted. Indeed, he was so intent on realism, he would paint only from the model. Katz was equally intent on rendering the figure, concentrating on portraiture. The challenge was to paint *the* portrait, in the form of the portrait, as it were, relying on perceptual information. Critics have al-

leged that for Katz the abstract elements in his painting were primary; likeness was secondary, if that. He denied this, claiming: "If I wanted to make an abstract composition, I would have."[5]

With realism in mind, Katz and Pearlstein began to "harden" their painting. It came to look "finished" rather than "unfinished." Modeling was smoothed out, and contours were sharpened. Forms became "closed" rather than "open."

Katz and Pearlstein introduced their New Perceptual Realism at a time when figurative art, compared to abstraction, was generally considered *retardataire*, de-

90. Philip Pearlstein, *Female Model on Oriental Rug with Mirror*, 1968. 60″ × 72″. Whitney Museum of American Art, New York.

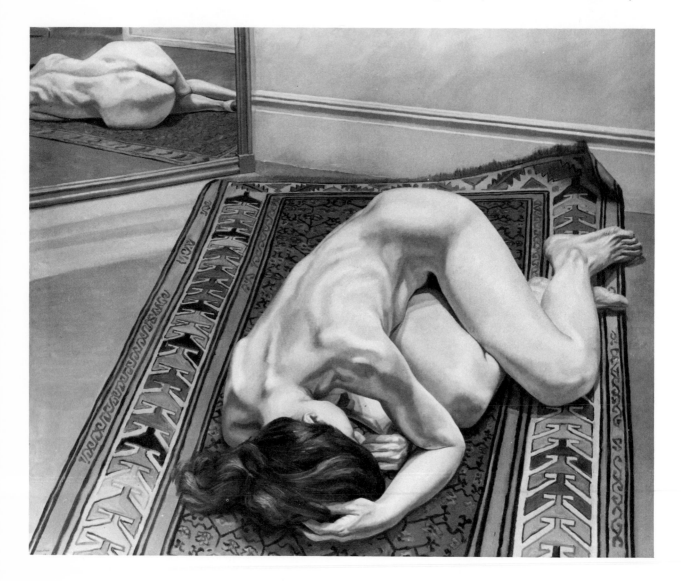

rivative, and minor. Greenberg had written in 1954—and he did not change his mind in the sixties—that figurative art tended to be second-rate. "In fact, it seems as though, today, the image and object can be put back into art only by *pastiche* or parody—as though anything the artist attempts in the way of such a restoration results inevitably in the second-hand."[6] This attitude persisted as late as the 1961–62 New York art season. In 1961, Tillim published a seminal article, "The Present Outlook on Figurative Painting," advocating a new realism. The Museum of Modern Art mounted a major survey, *Recent Painting USA: The Figure,* meant to convey the range and quality of realism in the best light, with a catalogue introduction by Alfred H. Barr, Jr.; and almost as consequential, the Kornblee Gallery organized a show, *Figures,* aimed at presenting stronger artists than the museum did, with a catalogue introduction by Jack Kroll.

All three writers implied that figuration was inferior to abstraction. Even Tillim asserted that it "has far too many flaws to be considered a serious contender for the throne it is far from certain abstract art has surrendered."[7] Barr remarked that the figurative pictures selected by him "were painted in a period (a glorious period in American art) when the painted surface often functioned in virtual and even dogmatic independence of any represented image."[8] And Kroll, much as he predicted that "the best and most interesting of [figurative artists] are moving toward the next authentic and historically secure image of man, [the abstract image] is still the seminal and resolving image of contemporary art."[9]

The New Perceptual Realists countered the formalist attacks of the advocates of the new abstraction by formulating a contemporary conceptual framework for literal representation as rigorous as formalism, a rationale that in time helped establish realism as a serious alternative to abstract art. Katz and Pearlstein confronted head-on the whole line of thinking that began with Maurice Denis, who said in 1890 that before being a battle horse or a nude woman or some anecdote, a painting is essentially a flat surface covered with colors in a certain order, and that culminated with Greenberg and Minimalist aestheticians who carried this approach to its ultimate, reductionist extreme. Indeed, the New Perceptual Realists reversed this position by insisting on the primacy of the observed subject, its unique *thingness,* and on the need to represent it accurately—rigorously.

The New Perceptual Realists challenged not only painterly figuration and the new abstraction but also Pop Art and, when it emerged around 1965, Photo-Realism. Pearlstein and Katz refused to choose their subject matter from commercial art. They considered Photo-Realism the offspring of Pop Art because it was based on the ubiquitous snapshot. To be sure, Photo-Realism resembled the New Perceptual Realism in that it was representational and sharp-focus, but Katz and Pearlstein spurned it because it viewed reality through the lens of a camera, which they believed was inferior to the eye as a tool of perception. Like the Photo-Realists (and Pop artists), Katz and Pearlstein painted only the surface of their subjects, avoiding anatomy and perspective, which are not visible; but because the eye is a scanning organ, perpetually adding information, their figures look rounded and animate, unlike the flat and frozen images recorded by a camera. Pearlstein himself remarked on the difference: "I really see more than a camera does, and it takes me more time. . . . If I look at a knee for an hour, I get conscious of every little ripple and detail."[10]

What Katz and Pearlstein offered as the justification for the New Perceptual Realism, in opposition to claims made for Pop Art and Photo-Realism, was the tradition of Western figure painting. They resumed nineteenth-century realism—Pearlstein

looking more to Courbet; Katz, to Manet—but they carried it to a *perceptual extreme.* Their concern with tradition was also manifest in the most obvious manner, because their canvases showed clearly that they were painted with brush by hand, unlike those of the Pop artists who favored mechanical means such as stencils and silk screens, and the Photo-Realists who used airbrushes. Moreover, Katz and Pearlstein emulated the technical proficiency and artistry of earlier masters.

Katz and Pearlstein rejected the new abstraction, Pop Art, and Photo-Realism when the appeal of these tendencies to the art world was at its greatest, and in turn the New Perceptual Realism was attacked as backward-looking and academic. But why did anyone bother to take notice at all? To rephrase the question: When Katz and Pearlstein chose to ignore the new abstraction, Pop Art, and Photo-Realism, why were they themselves simply not ignored? They were not, in large measure, because of the quality of their painting, but there was more to it than that. Their tough-minded realism could not be disregarded because of its emphasis on objecthood. Moreover, the New Perceptual Realism partook of the "cool" sensibility of the sixties, just as the new abstraction, Pop Art, and Photo-Realism

91. Alex Katz, *Cocktail Party,* 1965. 78″ × 96″. Paul Jacques Schupf, Hamilton, N.Y.

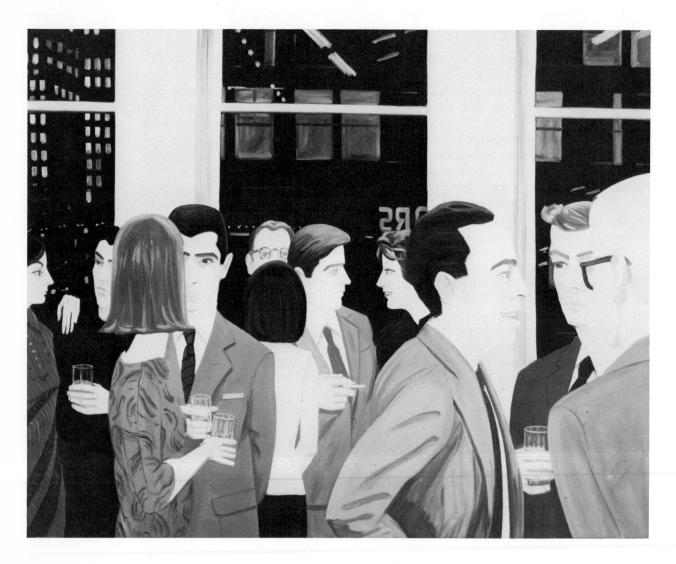

did, and therefore forced itself into the aesthetic discourse on new art.

There were significant differences between the styles of Pearlstein and Katz. Pearlstein's painting was illusionistic; Katz's, flat and thus more coloristic—and modernist. At one and the same time, Katz embraced realism, concentrating on portraiture—that is, representation at its most specific—*and* expression through color, which required a certain suppression of drawn details and light and dark modeling, flattening the imagery. However, through adjusting the contours and tones of his planar areas of color, he layered them in depth, balancing the competing pulls of his three-dimensional subject matter and modernist flatness.

In his treatment of color, Katz was influenced by Matisse, Avery, Newman, and Rothko, as were color-field and hard-edge painters who were of his generation. He was very aware of their abstractions, which were as occupied with color as his were. Katz's desire to intensify color led him to enlarge the size of his pictures. By adjusting the internal scale of his images, he could make them seem even larger than they actually were. In enlarging the size and internal scale of his pictures, Katz was also inspired by billboards and close-up movie images. References to advertis-

92. Alex Katz, *Vincent in Hood*, 1964. 54″ × 66″. Collection the artist.

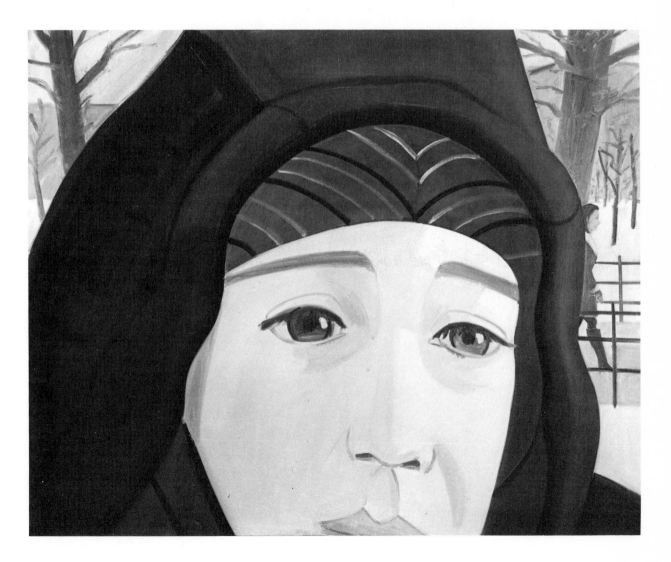

ing and popular culture struck Robert Rosenblum as peculiarly American. He observed that in Katz's paintings, "particular people from the artist's daily domestic and social life (wife, son, friends) are suddenly wrenched from the cozy intimacy of a European tradition of private portraiture and relocated disconcertingly in a territory whose scale is that of public, urban experience."[11]

Katz's portraiture partook of the sensibility of the sixties because it avoided sentimentality. John Perreault remarked that Katz's portraits are " 'likenesses' and you would expect them to have . . . humanistic content. . . . But they don't. They are peculiar, cool, and neutral . . . detached, impersonal."[12] Apart from his wife and son,

Katz's subjects were artist, poet, and dancer friends from the semiprivate world of New York's avant-garde, a world that Katz documented. He portrayed them as cool, reserved, self-distanced, and ironic, yet at ease, assured, and natural. When they are depicted in groups, as they are increasingly after 1965, it is in their leisure activities—in their communal role. Many commentators on Katz's work have been uncomfortable with the easy conviviality of his group portraits. Hilton Kramer remarked on their "emotional vacancy." Katz's image "is very explicitly 'our' world—the observable world of contemporary manners and styles, very 'young' and up-to-date in its easy sophistication . . . and its air of untroubled sociabil-

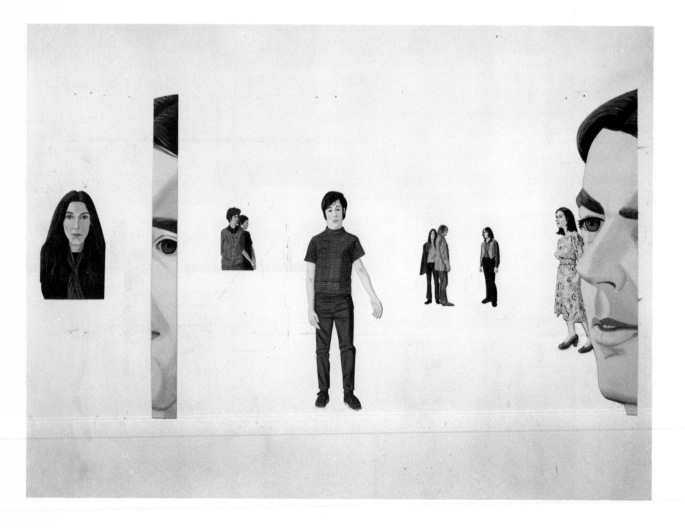

93. Alex Katz, *John's Loft*, 1969. 60" × 144". Collection the artist.

ity. It is a world in which the darker shades of feeling are, for the most part, unacknowledged. Friends and family abound, but each participant is given a mask designed to conceal his interior life. . . . We are not invited to penetrate beyond an amiable and appealing surface."[13] But it was precisely the documentary elements, the avoidance of Expressionist "depth," with its Sturm und Drang, that made Katz's work *of* the sixties—and such "coolness" in realist painting could scandalize.

Katz was known primarily for his paintings, but a significant body of his work consisted of cutouts that exist in actual space—standing, seated, or reclining portraits painted front and back on sheets of wood or metal. In these flat statues, Katz confronted the issues of illusionism and perception most provocatively and audaciously. Are they paintings (or shaped paintings), sculptures, or as representations in real space, effigies of some kind? Lucy Lippard remarked: "They aren't sculpture. You have to accept two versions, two paintings. There is no volumetric transition." Although she considered them paintings that dispense with background, she admitted: "They seem more at ease fending for themselves in their own space. They enjoy their ambiguities."[14] To be sure, the cutouts are freestanding objects, but as William Berkson saw them, "not exactly sculptures, because whatever sense of volume they possessed came from the painting and the 'drawing' at the edges."[15] Katz's juggling of reality and illusion made a charade out of the formalist notion of the autonomy of each of the arts. They obliterated any boundary line between fictive painting and actual sculpture, if only because they are flat sculptures whose surfaces are paintings (illusionistic sculptures) and paintings removed from the wall which generate the volume of sculpture.

Pearlstein resumed the tradition of painting the nude, the central subject matter in Western art, as Kenneth Clark has amply illustrated, and more spe-

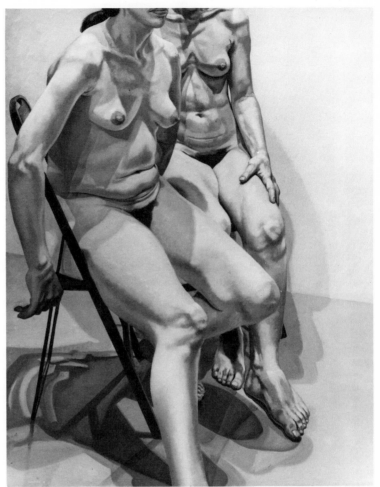

94. Philip Pearlstein, *Two Seated Models,* 1968. 60″ × 48″. Gilbert F. and Editha Carpenter.

cifically, the nude painted from life as it appears in the canvases of nineteenth-century realists, but he did not imitate them. Instead, he ventured beyond them toward greater realism, suppressing their latent romanticism, striving to be even more perceptual, even more matter-of-fact, than they had been. He strove to eliminate all interpretation, notwithstanding the fact that this was impossible, since the eye as the window of the brain cannot help but interpret as it sees.

To underline his concern with how his subjects actually looked, Pearlstein emulated his nineteenth-century predecessors in avoiding artificial "classical" poses and idealized anatomical proportions. He often painted from unexpected points of

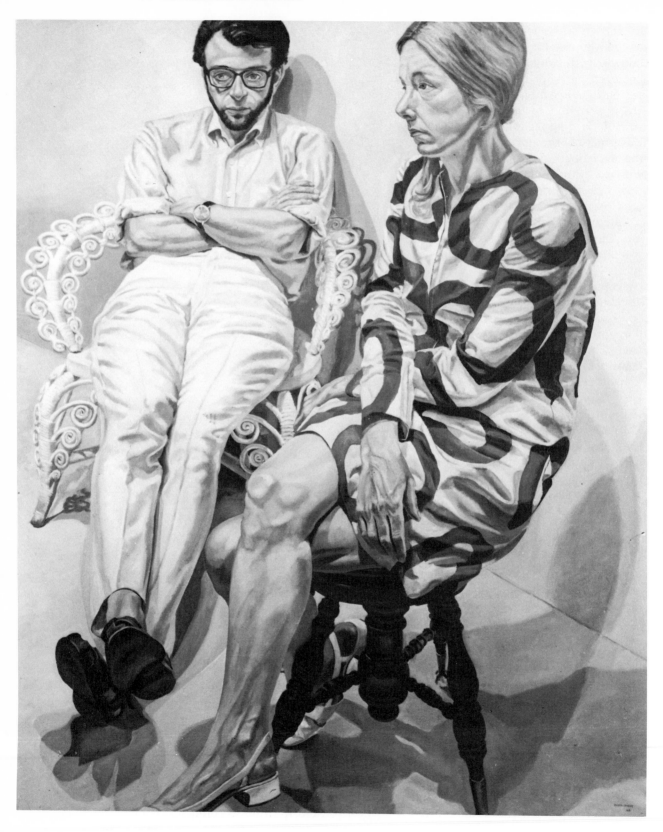

view—for example, thigh level looking up. Venturing even further, in the name of realism, he developed a radical new method of composition, or more accurately, anticomposition. He started a painting by focusing on an anatomical detail close up. In his own words: "I draw the entire hand finger by finger, wrinkle by wrinkle, and then go on to the next form. But the first form drawn provides a module for the rest of the drawing. . . . It doesn't matter where they [arms, legs, and torsos] stop. . . . Finding the scale [of the forms within the rectangle] is the essential problem."[16] Composition and scale follow perception.

Pearlstein's composing resulted in the unplanned or arbitrary cropping of his images at the edges of his pictures. This emphasizes both the picture plane whose edges slice the images and his view of reality; any slice of reality is as worthy of being described as any other. Cropping also calls to mind the unpremeditated approach of Abstract Expressionist painting, which Pearlstein liked, and the look of photographs, which he could not avoid. Cropping also pulled the close-up figures up to the surface, making them appear larger than they are, and causing them to thrust out at the viewer—with an immediacy akin to that of Franz Kline's dynamic black and white images, to which Pearlstein's configurations of torsos and limbs are related.

Pearlstein's subjects are hired models. They just express the activity of posing. Thus they reveal little of "life" that is psychological or social. The references that Pearlstein's pictures call to mind are primarily to art—how his nudes relate to and differ from those of other painters, past and present. And what made Pearlstein's realism unique and contemporary was, as Nochlin remarked, his "ruthless acceptance of things-as-they-are, visually and metaphysically, as constituting *all* that there is for the artist."[17]

Much as Pearlstein tried to avoid all interpretation, there remained his idiosyn-

cratic way of seeing. This resulted from critical pictorial decisions, such as size, scale, medium, surfacing, lighting, vantage point, which could not help being subjective or intuitive or inspired, even if inadvertent. For example, Pearlstein's figures tend to be two or three times lifesize. Such magnification facilitated the *painting* of details, but it also caused the figures to appear monumental—rather than lifelike. The sense of monumentality is intensified by the cropping, which makes the images seem too large to be contained within the picture limits. It is decisions of sensibility, which do not depend, or depend only in part, on Pearlstein's attitude toward his models, that confer on his paintings their strong sense of individual style—and their quality. Indeed, the quality of the painting situated Pearlstein in the tradition of modern realism. Charles Rosen and Henri Zerner have written, with reference to Courbet, Manet, and their associates, that realism entails "the acceptance of trivial, banal material and the refusal to ennoble it, idealize it, or even make it picturesque. What place was left then for art? Only the technique and the virtuosity of the means of representation."[18] Or, as Flaubert put it: "To write the *mediocre* beautifully."[19]

Other artists identified with New Perceptual Realism were Jack Beal, Alfred Leslie, Neil Welliver, and William Bailey. In the early sixties, Beal turned from painterly painting to realism, placing naked female figures in architectural or interior settings. Parts of bodies, furniture, and other objects are often interspersed to create an allover pattern—and the sense of abstract patterning is stronger in his works than those of Pearlstein or Katz. Beal tended to treat the figure as a thing among things, but later in the decade, he humanized his subjects, interpreting them, thus making them "hot" rather than "cool."

So did Leslie. After achieving a considerable reputation as a younger Abstract Expressionist, he began to paint enormous

FACING PAGE:
95. Philip Pearlstein, *Portrait of Linda Nochlin and Richard Pommer*, 1968. 72" × 60". Linda Nochlin and Richard Pommer, New York.

frontal portraits, using both models and photographs of the models. He stated that these images "demanded the recognition of individual and specific people . . . straightforward, unequivocal," and he added, "and with a persuasive moral, even didactic, tone."[20] At the same time, Leslie introduced a variety of deliberate references to art historical styles, such as that of Jacques-Louis David, and narrative painting—for example, Peter Paul Rubens. Leslie also aimed for dramatic effects by making his subjects gargantuan and lighting them theatrically.

In 1968, Welliver wrote: "I was educated [at Yale during Josef Albers's tenure] in the traditions of reductive abstraction and systematic figure painting. Neither of these styles engaged me." What interested him was "natural painting based on touch, fluidity."[21] To achieve such painting, Welliver reconstituted figures and landscapes from painterly abstract swatches—larger than individual brushstrokes—the flat colors so modulated as to produce the impression of reality, thus synthesizing representation and abstraction.

96. Jack Beal, *The Roof*, 1964–65. 96″ × 120″. Robert B. Mayer Family Collection.

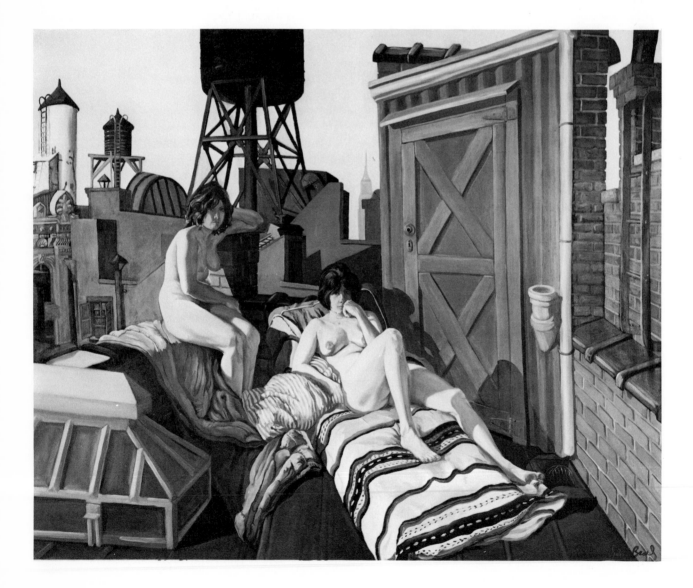

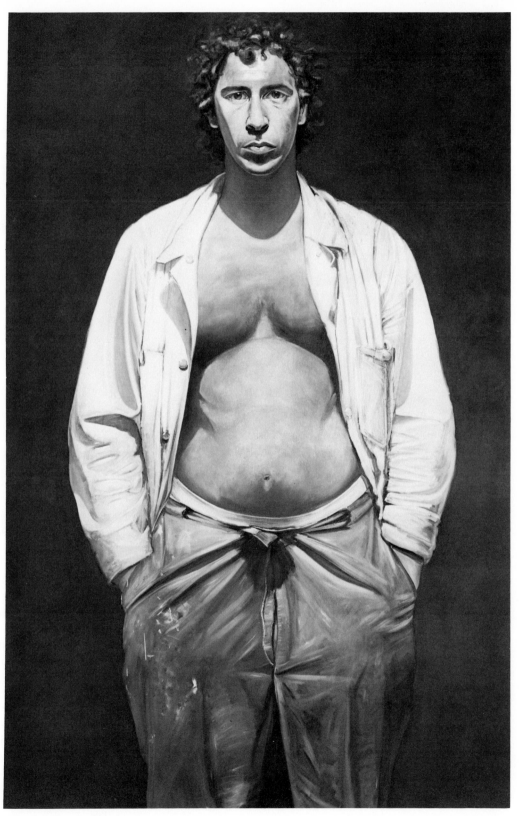

97. Alfred Leslie,
*Alfred Leslie,*
1966–67. 108″ × 72″.
Whitney Museum of
American Art, New
York.

98. Neil Welliver, study for *Pond Pass*, 1969. 48″ × 48″. Collection the artist, courtesy Marlborough Gallery, New York.

Bailey's portraits of female nudes and still lifes composed of bottles, vases, cups, and eggs (his favorite subjects) on table-tops look like perceptual realism, but they differ in their meticulous composition and, above all, their sense of otherness. The enigmatic quality of the still lifes prompted Anne McCauley to characterize them as "stiller-than-still."[22]

The Photo-Realists, beginning with Malcolm Morley in 1965, represented photographs. They aspired to be as literal and sharp-focus as the New Perceptual Realists, and they were often exhibited to-gether with the latter, although their work did not *look* related. But from the start, there was a rift between the Photo-Realists and the New Perceptual Realists. The dispute was over whether the human eye or the camera lens was a better recorder of reality. The New Perceptual Realists claimed that the eye was an *organ* of such extraordinary complexity and sophistica-tion that as a tool of perception, it was infinitely superior to the camera, which was a crude and imperfect *machine*. Moreover, the camera lens distorted real-ity, freezing and flattening its subject in an

instant of time. In contrast, the eye is perpetually scanning, accumulating information that provides the roundness and fluidity of images painted from life. Human subjects cannot hold still; they are always moving—and so is the artist.

The Photo-Realists, on the other hand, made a virtue of the fact that photographs were static. They might be insufficiently true to life, but they fixed the subject once and for all and recorded it exactly as it was. Certainly, as Tom Blackwell remarked, "the camera makes a two-dimensional approximation of the three-dimensional reality in a way that a painter never would."[23] This record of the physical world was artificial, as William Seitz pointed out, and he suggested that the term "artifactualism" would apply more aptly to Photo-Realist painting than "real-

ism."[24] In retrospect, it is clear that Photo-Realism was closer to Pop Art than to the New Perceptual Realism, if only because it represented the ubiquitous, machine-made, flat snapshot. As Seitz observed, both Pop artists and Photo-Realists made images from images.[25] Moreover, Photo-Realist subjects were often rendered by airbrush, a tool identified with commercial, not "fine," art, and even if they were not airbrushed, looked as if they might have been.

The use of photographs in painting extended back in time to Delacroix, serving "as stimuli and ancillary source materials for painters," as Seitz remarked. But not until the sixties did painters rely on photographs "wholly and unabashedly."[26] Indeed, as Dali pointed out, the photograph as represented by the Photo-Realists was a

99. William Bailey, *"N" (Female Nude)*, c. 1965. 48″ × 72″. Whitney Museum of American Art, New York.

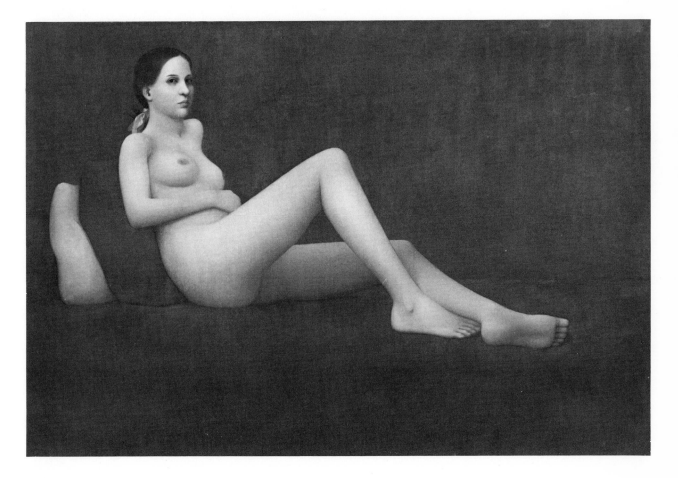

readymade, but painted by hand.[27] Then why copy it? The Photo-Realists, like the Pop artists and the New Perceptual Realists, valued extreme literalness. They aimed to emulate the factuality of photography. As Chuck Close said:

> The camera is objective. When it records a face it can't make any hierarchical decisions about a nose being more important than a cheek. The camera is not aware of what it is looking at. It just gets it all down. I want to deal with the image it has recorded which is . . . two-dimensional, and loaded with surface detail.[28]

Close's literalist intention was shared by the other Photo-Realists. In 1966, Robert Pincus-Witten wrote of Morley and Joseph Raffaele:

So exact are they in their rendering of the photographic image (their world of observable nature) that they leave out what the camera does not register or what is blurred when the photograph is mechanically transformed into color plates. At ten paces . . . Morley's paintings are dead ringers for the chromos distributed to the clients of the United States Lines.[29]

Such extreme representation involved, as Richard Estes remarked, "a cold, abstract way of looking at things, without any comment or commitment."[30]

Like the Pop artists, the Photo-Realists looked for inspiration to the mass media, in which photography is central, because they believed that the media, particularly photography, have influenced *the very way we perceive external reality*. It was

FACING PAGE:
100. Malcolm Morley, *Beach Scene*, 1968. 110″ × 89⅞″. Hirshhorn Museum and Sculpture Garden, Smithsonian Institution, Washington, D.C.

101. Richard Estes, *The Candy Store*, 1969. 47¾″ × 60¾″. Whitney Museum of American Art, New York.

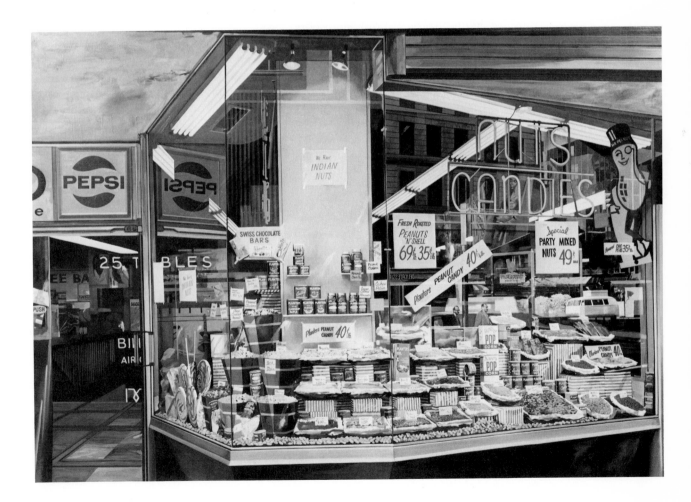

this that most of all inspired artists to examine photography in their painting.

Statements by the Photo-Realists attest to this. For example, Estes said that the media have "to affect the way you see things. Even if you don't watch TV, you are affected by it. We accept the photograph as real."[31] Blackwell agreed:

> Today photographic images, movies, TV, magazines, etc. are as important a part of our reality as actual phenomena. They strongly affect our perception of actual phenomena. I do know that personally I see "photographically." . . . The incorporation of the photograph into the means of painting is the direct way in which the media have affected the type of painting. That's what makes New Realism new.[32]

Moreover, photography in our time has been a popular pastime in America; almost everyone takes candid snapshots. Using photographs of the American scene came naturally to sixties artists. As early as 1962, painter Ed Ruscha began to produce a series of photographic albums, among which were *Twenty-six Gasoline Stations, Some Los Angeles Apartments, Thirty-four Parking Lots,* and his best-known book, *Every Building on the Sunset Strip.* These volumes anticipated and influenced the Photo-Realists.

The use of photography in painting also posed provocative questions about perception and cognition. The complexities can be suggested by considering the illustrations of Photo-Realist pictures in this book. They are reproductions of paintings of photographs or of slides used to project photographs onto the canvas. What is being experienced: the original photographic subject, the painting of the photograph, or the photographic illustration of the painting of the photograph?

Its contemporaneity notwithstanding, Photo-Realism could be situated in the tradition of Western art, as Dali situated it, with his characteristic wit. He regarded Photo-Realism as the latest stage of Classicism, counterposing it to Romanticism.

| *Sybaritic classicism* | *Pathetic romanticism* |
|---|---|
| Estes–Gérard Dou | Rothko–Rembrandt . . . |
| That which one knows | That which one imagines |
| Reality | Myth |
| That which is | That which is not . . . |
| The street | The universe |
| The chair | The cosmos |
| That to which we belong | That to which we do not belong |
| That which belongs to us | That which does not belong to us in this world[33] |

Despite their shared matter-of-factness, the Photo-Realists created a variety of styles. They differed with regard to manner of working; subject matter; and the degree to which they emphasized the image or the painting. A number—for example, Close—used airbrushes exclusively. Others, such as Estes, used brushes only, although the effect they achieved was like that of airbrushing.

Most Photo-Realists projected slides or transparencies onto their canvases and faithfully rendered the images. Another group, including Morley and Close, with an eye to Minimalist abstraction, used a grid to make the transfer. In the first of his Photo-Realist canvases, Morley started with color postcards and travel brochure illustrations of ships: the ocean liner *Cristoforo Columbo,* 1965; *S.S. Amsterdam in Front of Rotterdam,* 1966. He divided and cut the photographs into numbered squares and transferred the photographic information onto canvas, one square at a time, treating each as an independent abstract unit. His purpose was specificity; if each isolated, microscopic detail was rendered accurately, together they would add up to a macroscopic facsimile of a photograph. In order to counter the illusion of space, Morley framed his photographic images in broad borders painted white, directing the eye to the surface. By focusing on the "subjectless fragment of shape and color," Morley distanced himself from his subjects. But his choice of what to paint was telling. A number of his works satirize or protest social practices—for example,

the picture of a South African racetrack with a red *X* painted over it. But the gesture could also be viewed as a counteraction of illusionism or, perhaps, as a rejection of Photo-Realism. Morley himself denied any interest in the photographs he used and indeed, by 1970, he had abandoned his "magnifying-glass precision."[34]

Like the Pop artists, most Photo-Realists depicted phenomena associated with the American scene. Estes remarked: "It's funny, all the things I was trained to paint—people and trees, landscapes and all that—I can't paint. We're living in an urban culture that never existed even fifty years ago."[35] The favorite subjects of the Photo-Realists, with a few exceptions, were chrome and Formica surfaces, automobiles and motorcycles, diners and drive-ins, motel rooms, and the like— more often than not, without people. Estes found such subjects "hideous" and selected them because they were.[36] On the other hand, Close, an exception among Photo-Realists on the whole, preferred to render portrait heads, mainly of friends.

Photo-Realist painting verged either toward extremely factual representation or representation that incorporated a subtle painterliness. Estes, who turned to Photo-Realism in 1967, said: "I try to make it as accurate as I can, but I usually have to do otherwise, or it just doesn't look right or feel comfortable." Thus his painting was not an exact imitation of a photograph.

Even with a 4 × 5 negative, a photograph would be a bit fuzzy blown up to this [canvas] size. The paintings are crisp and sharp. . . . I can select what to do or not to do from what's in the photograph. I can add or subtract from it. [What] I'm trying to paint is not something different, but something more like the place I've photographed. Somehow the paint and the intensity of color emphasize the light and do things to build up the form that a photograph does not do. In that way the painting is superior to the photograph. And painting is trickery, because you

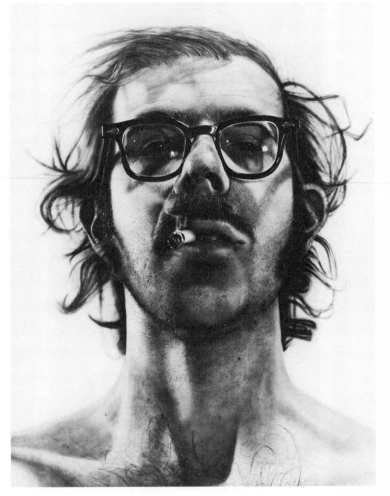

can make people respond by guiding their eyes around the picture.[37]

Particularly in his more complex pictures did Estes revise his photographic subjects and improvise—for the sake of realism and art. As Estes's paintings evolved, they grew in complexity; their images are of chrome surfaces and plate-glass walls, windows, and doors whose reflections and refractions overlap and interpenetrate to create optical involutions that make it difficult to know exactly what one is looking at. Estes's ability to maintain the exact balance between representation and painterliness, satisfying the competing demands of both, made him one of the masters of Photo-Realism.

102. Chuck Close, *Self-Portrait*, 1968. 107½″ × 83½″. Walker Art Center, Minneapolis, Minn.

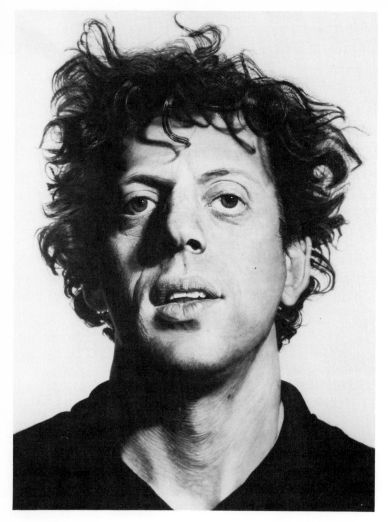

103. Chuck Close, *Phil*, 1969. 108″ × 84″. Whitney Museum of American Art, New York.

FACING PAGE: 104. Duane Hanson, *Hard Hat Construction Worker*, 1970. 47½″ × 35″ × 42″. Virginia Museum, Richmond.

Like Estes, Chuck Close turned to Photo-Realism in 1967. His motivation was the recognition that he could not help painting in other artists' styles. In order to avoid mannerisms, he formulated self-imposed restrictions that would force him to paint differently than he had. He would use set, prosaic, passport-like or mug-shot-like photographs so that he would know in advance what a picture would look like. He would select as his subjects the frontal face of himself, 1968, and of close friends—*Nancy* (Graves), 1968; *Richard* (Serra), 1969; *Phil* (Glass), 1969; and *Keith* (Hollingshead), 1970—centering each

portrait head, cut just below the neck, within and close to the framing edges of nine-by-seven-foot canvases, so that the images appeared colossal in size and scale and produced an immediate impact. In order to avoid the habits of the hand, Close would employ an airbrush; and he would limit his palette to black and white.

Representing photographs of full faces on the blown-up scale that Close did enabled him to be *specific* in rendering details—transferring information bit by bit—and, at the same time, *free* in his application of paint marks, which close up formed an abstract pattern more or less independent of the image. The big picture also enabled Close's Photo-Realist canvases to hold their own against the wall-size pictures of his contemporaries—such as Katz—whose size and scale influenced him.

In 1970, Close began to use color, at first limiting himself to the three primaries—the colors used to make color transparencies—from which he mixed all the others, emulating the process of color photography. He also began to experiment with a variety of techniques, or, as he put it, "new ways to make marks which make art."[38] Indeed, his variety in picture-making above all distinguishes him among Photo-Realists. Close's techniques (except in his finger paintings) are geared to the modular grid—the emblem of sixties design—relating his painting to Minimal Art and the Pop Art of Warhol. He also shares an anti-anthropomorphic attitude with Minimal and Pop artists. "I'm not concerned with painting people or with making humanist paintings," he said.[39] Instead, his "main objective is to translate photographic information into paint information."[40]

Like the Photo-Realists and the New Perceptual Realists, Duane Hanson and John DeAndrea aspired to an extreme mimesis. They molded their figures directly from the models and painted them in a *trompe l'oeil* fashion, achieving the effect

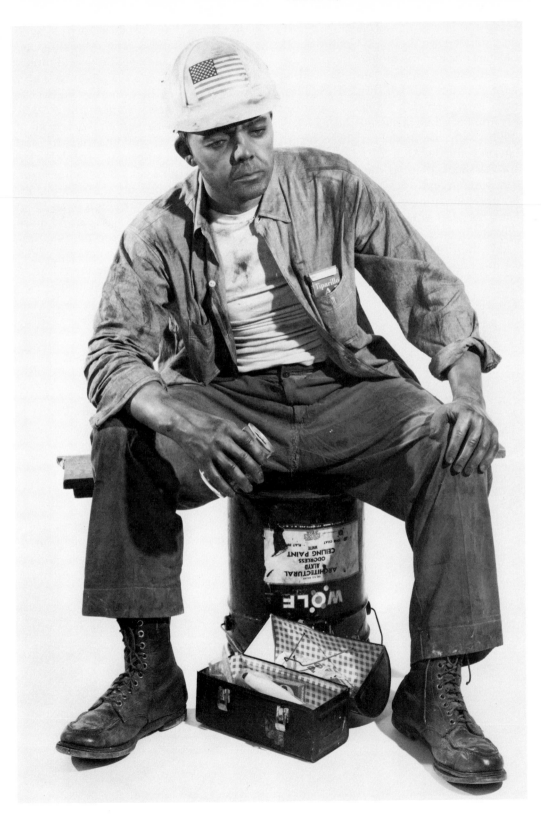

of Madame Tussaud's wax effigies. The primary influence on them was George Segal, but Segal encased the mold of the figure in his sculpture. Hanson and DeAndrea made of it the positive form. The difference was crucial. Segal sacrificed verisimilitude but achieved the effect of vitality with his modeling. In contrast, Hanson's and DeAndrea's objects, as Joseph Masheck pointed out, "unlike real men, women and works of art lack *souls*. . . . the animating principle in a thing. [Their stillness] is the mortuary stillness of bodies trapped in lifeless moments." Thus, despite their realism, they thwart humanist expectations.

Hanson's early polyester replicas of figures dressed in real clothes are engaged in violent activities—as in *Race Riot* and *Vietnam Scene*, both of 1969—and forced attention to these social events. Later figures, whose clothes identify their class position—as *Tourists*, *Supermarket Lady*, and *Hardhat Construction Worker*, all of 1970—reveal the boredom, vulgarity, and slovenliness of American types. DeAndrea's naked girls and boys differ from Hanson's figures because they are beautiful, and "they concentrate on pose, to an effect that is both more classical and more abstract," as Masheck observed. But they are in "a soap-operatic interaction," which "could be likened to the poetic content in Lichtenstein's comic-book balloons."[41]

105. John DeAndrea, *Reclining Woman*, 1970. Life-size. The David Bermant Collection.

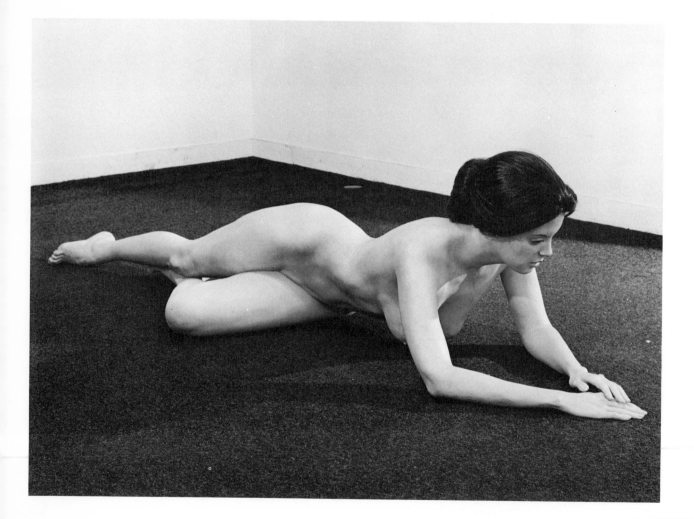

# NOTES

1. Sidney Tillim, "Month in Review," *Arts Magazine*, April 1963, p. 46.
2. Conversation with Alex Katz, New York, 18 February 1957.
3. The move of Pearlstein and Katz toward a responsible realism was viewed sympathetically by Hilton Kramer and Sidney Tillim. In their writings, they objected to the widespread practice of introducing human images into what were essentially Abstract Expressionist pictures without seeming to have given adequate consideration as to what the figures signified. As Kramer saw it, this equivocation between the role of the subject and the manner of painting—that is, between figuration and abstraction—constituted a "crisis." "Now it strikes me as somehow decadent to use the figure merely as a spatial counter." (Hilton Kramer, "Month in Review," *Arts Magazine*, January 1960, p. 45.) Sidney Tillim, too, was troubled by the crisis. There was a way out, as he saw it, revealed by Pearlstein, Katz, and a few of their contemporaries, who "have reopened the case for subject matter as more than merely a pretext for a painting" (Sidney Tillim, "The Present Outlook on Figurative Painting," *Arts Yearbook 5: Perspective on the Arts*, 1961, p. 56).
4. Philip Pearlstein, "Figure Paintings Today Are Not Made in Heaven," *Art News*, Summer 1962, p. 39.
5. Gerrit Henry, ed., "Ten Portraitist-Interviews/Statements," *Art in America*, January–February 1975, pp. 36–37.
6. Clement Greenberg, "Abstract and Representational," *Arts Digest*, 1 November 1954, p. 1.
7. Sidney Tillim, "The Present Outlook on Figurative Painting," p. 59.
8. Alfred H. Barr, Jr., *Recent Painting USA: The Figure*, exhibition catalogue (New York: Museum of Modern Art, 1962), n.p.
9. Jack Kroll, introduction, *Figures*, exhibition catalogue (New York: Kornblee Gallery, 1962), n.p.
10. Linda Nochlin, "The Art of Philip Pearlstein: Realism Is Alive and Well in Georgia, Kansas and Poughkeepsie," *Philip Pearlstein*, exhibition catalogue (Athens, Ga.: Georgia Museum of Art, University of Georgia, 1970), n.p.
11. Robert Rosenblum, "American Painting and Alex Katz," in Irving Sandler and William Berkson, eds., *Alex Katz* (New York: Frederick A. Praeger, 1971), p. 7.
12. John Perreault, "Cut-Outs," *The Village Voice*, 26 January 1967, pp. 10–11.
13. Hilton Kramer, "The World of Alex Katz: 'Big Numbers,' Fast Moves," *New York Times*, 16 December 1973, sec. D, p. 25.
14. Lucy R. Lippard, "Alex Katz Is Painting a Poet," in Sandler and Berkson, eds., *Alex Katz*, pp. 4–6.
15. William Berkson, "Alex Katz's Surprise Image," *Arts Magazine*, December 1965, p. 25.
16. "Philip Pearlstein: A Statement," *Philip Pearlstein: Zeichnungen und Aquarelle: Die Druckgraphie*, exhibition catalogue (Berlin-Dahlem: Staatliche Museum, 1972), p. 14.
17. Nochlin, "The Art of Philip Pearlstein."
18. Charles Rosen and Henri Zerner, "What Is, and Is Not, Realism?" *New York Review of Books*, 18 February 1982, p. 25.
19. Ibid., p. 24.
20. Alfred Leslie, in *Alfred Leslie*, exhibition catalogue (New York: Allan Frumkin Gallery, 1980), n.p.
21. Neil Welliver, in *Realism Now*, exhibition catalogue (Poughkeepsie, N.Y.: Vassar College Art Gallery, 1968), p. 44.
22. Anne McCauley, "William Bailey," *Seven Realists*, exhibition catalogue (New Haven: Yale University Art Gallery, 1974), p. 6.
23. Linda Chase and Ted McBurnett, "Tom Blackwell," in "The Photo-Realists: 12 Interviews," *Art in America*, November–December 1972, p. 75.
24. William C. Seitz, "The Real and the Artificial: Painting of the New Environment," *Art in America*, November–December 1972, p. 61.
25. See Ibid.
26. Ibid.
27. Salvador Dali, introduction, in Linda Chase, *Hyperrealism* (New York: Rizzoli, 1975), p. 5.
28. Cindy Nemser, "An Interview with Chuck Close," *Artforum*, January 1970, p. 51.
29. Robert Pincus-Witten, "New York," *Artforum*, March 1966, p. 47.
30. Chase and McBurnett, "Richard Estes," in "The Photo-Realists," p. 79.
31. Ibid.
32. Chase and McBurnett, "Tom Blackwell," in "The Photo-Realists," p. 76.
33. Dali, introduction, in Chase, *Hyperrealism*, p. 5.
34. William C. Seitz, "The Real and the Artificial," p. 65.
35. Chase and McBurnett, "Richard Estes," p. 80.
36. Seitz, "The Real and the Artificial," p. 65.
37. John Arthur, "A Conversation with Richard Estes," *Richard Estes: The Urban Landscape*, exhibition catalogue (Boston: Museum of Fine Arts, 1978), p. 27.
38. Louis K. Meisel, *Photorealism* (New York: Harry N. Abrams, 1980), p. 109.
39. Chase and McBurnett, "Chuck Close," p. 77.
40. Cindy Nemser, "An Interview with Chuck Close," *Artform*, January 1970, p. 51.
41. Joseph Masheck, "Verist Sculpture: Hanson and DeAndrea," *Art in America*, November–December 1972, p. 94.

# 9 OP ART AND KINETIC SCULPTURE

In 1964, it became fashionable, at the most fashion-conscious moment in the sixties, to announce that "Pop Art, only yesterday regarded as *dernier cri,* is today *vieux jeu,*" as *New York* magazine did in its special issue on the avant-garde.[1] Even serious art professionals, such as "Adelyn Breeskin, who gave us the Popular Image show at the Washington Gallery of Modern Art, states in the current issue of Museum News that 'it's already on its way out and "Optic Art" is coming in,' "[2] as Carter Brown reported. Op Art, as it was commonly called, is an art whose images create an illusion of perpetual motion. Its sculptural counterpart was kinetic sculpture, whose components actually do move. Op Art achieved its greatest notoriety in America in 1965, when it was featured in a major international survey, titled *The Responsive Eye,* at the Museum of Modern Art.

Its curator, William Seitz, did not have fashion in mind when he conceived of the show in 1962, before Pop Art was taken up by the world of fashion.[3] He chose to survey Op Art because it was the most prominent tendency in a complex of geometric abstract styles commonly labeled Constructivist, which were highly regarded in the European art world. His conception of the show was mainly shaped by developments abroad. In his catalogue, he acknowledged his great debt to George Rickey, who made available his files on a book in progress to be titled "Heirs of Constructivism," the title clearly reveal-ing the European orientation of the tendency.[4] Rickey's book was published in 1967 as *Constructivism: Origins and Evolution.*

Seitz sought to establish connections between European Constructivist painting (and its American variants, such as Richard Anuszkiewicz's) and American stained color-field and hard-edge abstraction. Just as the young Americans had reacted against gesture painting, the young Europeans had rejected its counterpart abroad, "tachist" abstraction. But the differences seemed more pronounced than any similarities. European Constructivism and the new American abstraction did not look like one another. Accountable was the fact that the Americans were inspired by the color painting of Newman and Rothko and their progenitor, Matisse. The Europeans looked for inspiration to pre–World War II Russian Constructivists and Suprematists, Dutch Neo-Plasticists, German Bauhaus associates, and geometric or "concrete" abstract artists. The Americans were intent on creating personal styles and Art with a capital *A.* The Europeans were more interested in science, technology, and social change than in aesthetic or stylistic considerations.

A number of the Europeans were so single-minded in relating their art to science and technology that, as Seitz reported, they spoke "of the elements of their work as 'information' and their compositional arrangements as 'programming.' "[5] Peter Selz spoke of the Constructivist

disdain for the mystique of the artist. Instead of trying to create a unique or subjective work of art, they hope to be able to . . . find an artistic affirmation for the modern technological world . . . a synthesis of art, science and technology. . . . Bruno Munari explains that "we now need to conduct researches with a view of re-founding a true, objective visual language, free from any personal element and aesthetic prejudice, a visual language which can naturally and intuitively communicate the dynamic factors determining our new knowledge of the world."[6]

This kind of anti-aesthetic rhetoric was rejected by the New York artists and art professionals who supported the new abstraction. As Poons put it, a painting justifies itself as a painting before it justifies itself as an idea. The painting of an artist like Vasarely never takes on the significance of painting that a painting demands.[7]

Despite the differences between European Constructivism and American new abstraction, Seitz decided to include both in *The Responsive Eye.* He subdivided the show into six sections: the "Color Image" of a Kelly, Louis, or Noland; the " 'Invisible' Painting" of a Reinhardt; the chromatic " 'Optical' Painting" of an Anuszkiewicz or a Poons; and its close ally, the "Black and White" of a Victor

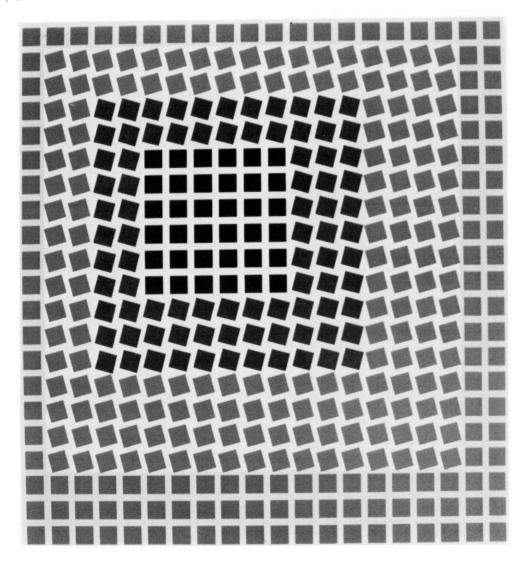

106. Victor Vasarely, *Eridan Jaune* (from the portfolio *Planetarische Folklore*), 1955–64. 24½" × 25½". Neuberger Museum, State University of New York at Purchase.

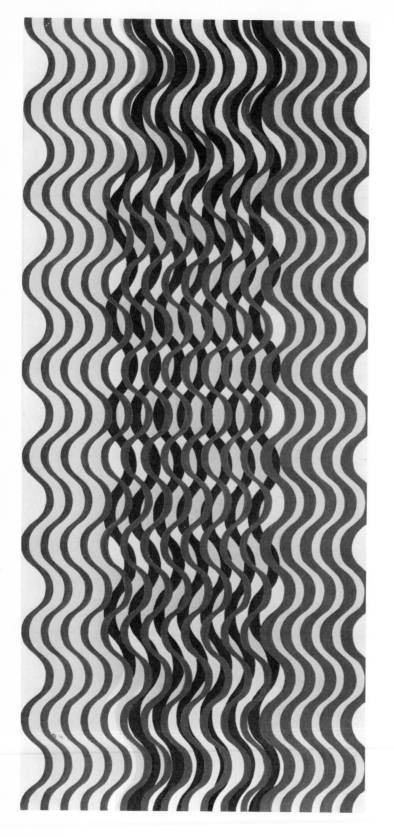

Vasarely or a Bridget Riley; the "Moiré Pattern" of a Michael Kidner; and the "Reliefs and Constructions" of a Julio le Parc.[8] But it was the Op Art of Anuszkiewicz, Poons, Riley, Kidner, and le Parc that commanded the most art critical and public attention. Op Art, despite its affinities with past Constructivist styles, was new.

Because it appeared to be ceaselessly vibrating, pulsing, and flickering, Op Art confounded the eye. Moiré effects—produced by slightly misaligned sets of parallel elements—and geometric patterns of black and white or high-keyed contrasting hues of equal value were so adjusted as to create afterimages, distortions of perspective, and a variety of other optical illusions. Seitz singled out Albers and Vasarely as the "fathers" and "masters" of "perceptual abstraction," as he called Op Art. The two painters were different. Vasarely favored black and white, and Albers, the interaction of color. Because of their influence, this difference tended to distinguish European Op Art from its American counterpart generally. But all Op artists used clearly defined, flat planes in painting and cleanly cut wood, glass, plastic, and metal in construction. This enabled them to avoid "nonessentials such as freely modulated shape and tone, brush gestures and impasto [which] muffle and distort the purely perceptual effect of lines, areas, and colors." Moreover, "All forms of representation, even ideographs, signs, and symbols, also alter or deflect whatever is innate in vision." Thus Op Art, as Seitz conceived it, had to be nonobjective. "Freed of representation, it concentrates more sharply, although in a narrower context, the obsession with movement, typical of twentieth century art," as well as solving the age-old problem in painting of simulating motion in a static medium.

Seitz went on to say that perceptual abstractionists could employ every kind of geometric figure and color but preferred uniform or slightly varied allover patterns

of dots, stripes, or lines, because "too much diversity of form impedes perceptual effect. Certain of these works therefore have a stronger family resemblance to mechanical patterns, scientific diagrams, and even to screens and textured surfaces than to relational abstract art."[9] This was not fortuitous; Op artists did draw on optical science, as did their late-nineteenth-century predecessors the Neo-Impressionists.

Art journalists who wrote for newspapers and the mass media liked Op Art and covered it extensively. John Canaday of the *New York Times* found it fascinating,[10] and Emily Genauer of the *New York Herald Tribune* welcomed it as "a healthy counteraction to the personality cult" of Abstract Expressionism and lauded its "new emphasis on technical discipline." She also viewed it as a "bridge artists may use between their world and that of science."[11] *Life* gave it a nine-page spread even before *The Responsive Eye* opened.[12] In sharp contrast, most critics who wrote for the art media, particularly those who favored Abstract Expressionism (Hess in *Art News*), the new abstraction (Krauss in *Art International*), and Minimal Art (Lippard in *Art International*),

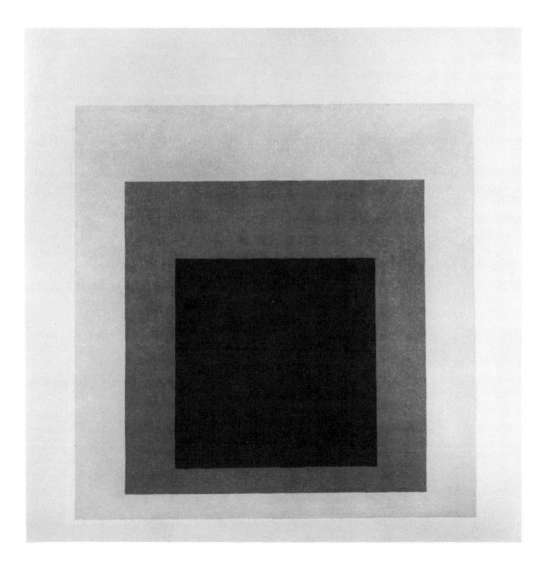

FACING PAGE:
107. Michael Kidner, *Yellow, Blue, Green, and White Wave*, 1964. 86″ × 58″. Collection the artist.

108. Josef Albers, *Homage to the Square: Gained*, 1959. 40″ × 40″. Whitney Museum of American Art, New York.

loathed Op Art. They might have been sympathetic, for as Sidney Tillim remarked, Op Art did "return to visual priorities . . . rescuing art from psychology and autobiography and asserting once more that art is primarily a visual experience."[13] But Lippard viewed Op Art's immediate activation of the eye as a mindless assault.

> So far it is an art of little substance with less to it than meets the eye. [Op Art depends] on purely technical knowledge of color and design theory which, when combined with a conventional geometric or hard-edge framework, results in jazzily respectable jumping surfaces, and nothing more.[14]

Op Art's sympathizers countered by claiming that it was a valuable investigation of the process of seeing, of "the incompletely explored region between the cornea and the brain."[15] The content of Op Art was perception itself. Much was made of the physiological effects of Op Art, exemplified by the coverage given the works of Gerald Oster, who was both an Op artist and an optical scientist at the Polytechnic Institute of Brooklyn.[16] But Op Art possessed a psychological dimension, as Bridget Riley insisted: "I have always believed that perception is the medium through which states of being are directly experienced. (Everyone knows, by now, that neuro-physiological and psychological responses are inseparable.)"[17] Riley claimed quite rightly that the other than physiological dimensions of Op Art were disregarded by the New York art world.

Art world critics were dubious about Op Art's references to technology, mass production, and mass distribution, all of which were supposed to be manifestations of social consciousness. Hess most strongly attacked the "social orientation" of Op Art. He claimed that art with a social message betrayed high art. The latter was "difficult, serious, remote, aristocratic [and] keeps its distance from the spectator," as Abstract Expressionism did. "The dialogue of Op is with . . . the audience and

through the audience to a responsive, indeed glad-handing Society. . . . Op is the art that the public flocks to see." It appeals to those "who always have felt that the function of Art is to teach, or at least divert, the People. . . . In Op they sense that art, at long last, is not only meeting the audience half-way [but] will actually come down off the walls and shake your hand." Hess concluded that the Op artist was so readily accepted by society because he was "a true conformist" who "puts his technology at the service of the People" and submitted to the pressure of society "to supply a cool, easily available entertainment."

Hess also questioned the social aspirations of Op Art by pointing to its quick acceptance by the world of fashion. He quoted

> Eugenia Sheppard, Woman's Feature Editor of the *New York Herald Tribune* [who] went to the "contributing members preview of 'The Responsive Eye' at the Museum the other night" where she saw ". . . Geoffrey Beene's skinny sheath and matching babuska made of a Luksus print—scattered black and grey circles on white silk organdie. Each of the Luksus prints is actually a piece of optical art that's good enough to frame."[18]

Profuse reportage in the fashion pages made Op Art vulnerable to attacks in the art world—just as Pop Art had been. For example, Rose could dismiss it as kitsch, "low in content and high in technique," a decorative art that fulfills the need for "titillation . . . necessary to engage the jaded sensibilities of today's museum audiences."[19] Caught between the worlds of fashion and art, Riley lamented the way in which her work was "vulgarized in the rag-trade. . . . 'The Responsive Eye' was a serious exhibition, but its qualities were obscured by an explosion of commercialism, bandwagoning and hysterical sensationalism. Understandably, this alienated a section of the art-world."[20]

But it was the coupling of color-field and hard-edge abstraction with Op Art in *The Responsive Eye* that most disconcerted

the art world. Kelly, Louis, Noland, and Stella looked out of place, as indeed they were. As Tillim wrote, with Louis, Noland, and Poons in mind, "To the extent that it is optical at all, the American style is far more color-oriented than percept-oriented—which implies structural differences as well. American-type 'opticality' is conscious of a field which expands." That pertained to Poons's pictures but not to Anuszkiewicz's.[21]

The formalist followers of Greenberg in particular were incensed at Seitz's commingling of Op Art and color-field abstraction. They viewed the one as a challenge to the other as *the* genuine "optical" art

and launched an attack against Op Art's infringement of their ideological turf, as it were. Krauss was the most furious in print. If the intent of Op Art was just "to dramatize the power of static forms and colors to stimulate dynamic psychological responses [as Seitz claimed,] this simple demonstration could have been achieved using objects taken from the workshops of the Bauhaus or the diagrams of *Gestalt* psychologists." But *The Responsive Eye*, "composed of works mainly executed since 1960 by 100 different, living artists, indicates a far more ambitious intention . . . to chronicle 'Op' Art as a new stylistic phenomenon, one which it is promoting as

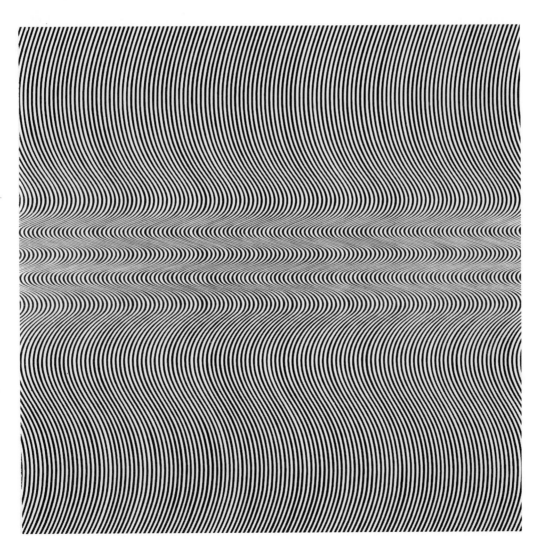

109. Bridget Riley, *Current*, 1964. 58⅜" × 58⅞". Museum of Modern Art, New York.

a significantly radical departure in contemporary art." This notion took Krauss aback, since Op artists, with their "perceptual gimmickry," "have nothing to do with opticality as it has emerged in the most important modernist painting of our time. The conceptual groundwork for Op Art and *optical* painting are in fact very far apart." Op Art was based on the contrast of black and white values, producing a tactile and illusionistic *trompe l'oeil,* which Krauss claimed was academic and outworn. In opposition, the totally optical abstraction of Poons and Louis, Stella and Noland, "has nothing to do with the Op experience, but rather explores and defines a mode of vision based first on Pollock and then on Newman."[22]

Hess, Krauss, Lippard, Rose, and most other art-world critics hostile to Op Art, much as their aesthetic attitudes differed, were all agreed that only painting that derived from American Abstract Expressionism, the preceding major style, could be major. Every other style could be nothing but provincial or minor. As Hess reported, "one critic, a devout New Yorker, said, 'Op is Out-of-Town Art'; he is right."[23] It is noteworthy that at the same time that Op Art was being denigrated in

110. Larry Poons, *Night on Cold Mountain,* 1962. 80″ × 80″. Museum of Modern Art, New York.

111. Larry Poons,
*Untitled*, 1966.
130″ × 90″.
Whitney Museum
of American Art,
New York.

New York, it was being acclaimed in Europe, reaching its acme of success in 1966, when at the Venice Biennale the first prize was awarded to le Parc (instead of Frankenthaler, Kelly, Lichtenstein, or Olitksi, who represented the United States).

Larry Poons was singled out from *The Responsive Eye* by the art world, even though he had begun to show only in 1963. The reason was that his painting related both to stained color-field abstraction and to Op Art, synthesizing the all-over chromatic intensity of the one and the retinal assault of the other.[24] Moreover, he introduced a systemic compo-

nent, influenced both by his friend Stella's modularity[25] and by Cage's chance operations; Poons had been a music student and a member of Cage's circle.

Poons's pictures each contained a stained ground color on which a rectangular grid was faintly penciled. Situated sequentially at twelve, three, six, or nine o'clock of each square or rectangle were tiny impasto circles—somewhat like notes of music—of a color different from the field. The position of each dot was determined by chance operations. The colors were so adjusted as to create an optical flicker or vibration. In 1963–64, Poons complicated his pictures, introducing el-

112. Richard J. Anuszkiewicz, *Radiant Green*, 1965. 16″ × 16″. Museum of Modern Art, New York.

lipses that suggest axial movement, a grid based on the forty-five-degree angle, and a greater variety of colors. The circles and ellipses were scattered over the grid-inscribed field as if at random, yet their positions give the impression of being rigorously preconceived. The sensuousness of the open, monochromatic ground color is offset by the optical discomfort produced by the eye-jarring activity of the circles and ellipses and the afterimages they give rise to. Despite the Op component, Poons was claimed by Greenbergian formalists, and the grounds of his pictures were indeed color-fields.[26] As if in response to that aspect of his work, in 1967 Poons suppressed the Op component and verged toward Olitski's abstraction.

The other young American to command art-world attention was Richard Anuszkiewicz, who first showed Op paintings in 1960 and was generally viewed as America's quintessential young Op artist (as Riley was Europe's), although as a student of Albers, he was schooled in the German Bauhaus tradition. Anuszkiewicz abstracted the optical component in his teacher's painting; as he put it: "My work is of an experimental nature and has centered on an investigation into the effects of complementary colors of full intensity when juxtaposed . . . and the optical changes that occur."[27] Where Albers's optical activity was subtle, Anuszkiewicz's was aggressive, the optical effects exploding stable structure.

Like Anuszkiewicz, Riley pitted conception against perception, formulating immediately recognizable, mathematically derived, black and white configurations, but of repetitive elements that made it difficult for the eye to focus on the pattern. Riley's imagery was not as disorienting as Anuszkiewicz's, however. She achieved a poetic balance between order and disorder, a balance that she hoped would "find an echo in the depths of our psychic being." She wrote in 1965:

> The basis of my painting is this: that in each of them a particular situation is stated. Cer-

tain elements within that situation remain constant. Others precipitate the destruction of themselves by themselves. Recurrently, as a result of the cyclic movement of repose, disturbance and repose, the original situation is re-stated.[28]

Seitz's *The Responsive Eye* did not include "fully kinetic sculpture," but shows mounted soon after his did. The best-known kinetic sculptor whose work related to Op Art was George Rickey. He was the first sculptor since Calder to create mobile constructions that did not call to mind Calder's. He achieved this by using geometric elements in systemic arrangements. Thus Rickey could combine a Constructivist concern with arithmetic formulas with nature's chance operations

113. Bridget Riley, *Untitled*, 1966. 25⅝" × 20⅝". Neuberger Museum, State University of New York at Purchase.

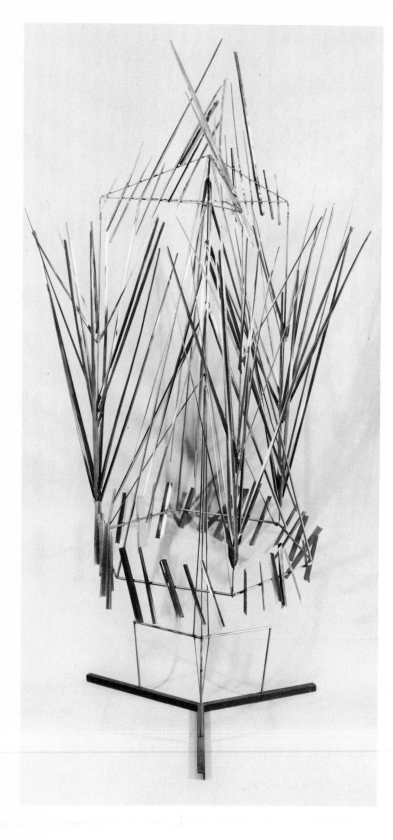

to create metaphors for chance and order.

Kinetic construction came in for the same kind of negative criticism in the art world as Op Art. As Leider wrote:

> Of some eighteen sizable exhibitions of kinetic sculpture presented during 1965, only four were held in the United States, and at least two of these four contained no work by Americans at all. . . . The figures reflect the rather naked fact that kinetic sculpture has aroused little interest in this country, either as a way of reflecting the technological revolution or of confronting the esthetic dilemmas of modernist sculpture.

Leider claimed that there was a difference between sculpture that desired to test the assumptions of the medium anew and sculpture that was a "dumb imitation of machines" or based on "bogus scientism." He concluded that

> kinetics can be seen to stand in the same sterile relationship to real sculpture as Op art stands to real painting—an irrelevant distraction. For those sculptures in which the movement is the content . . . are as empty of significance as those paintings in which the optical flicker is the content.[29]

Leider did make one exception: Len Lye, whose kinetic sculpture

> manages to compress so ferocious an energy that the viewer stands paralyzed, gripped by an emotion almost of terror. Lye's elements are supremely simple: hanging strips of stainless steel, six or seven feet long, are set to spinning around at very high speeds. The whiplash strain on the steel produces a series of frightening, unearthly sounds in perfect accord with the mood of barbaric energy that seems to have been released.[30]

Two other sculptors, Kenneth Snelson and Stephen Antonakos, were in the constructive tradition. Snelson looked to science for inspiration. As a student at Black Mountain College, he discovered a structuring principle based on the tetrahedron, which his teacher, Buckminster Fuller, would label tensegrity. Fuller applied it to architecture, Snelson, to sculpture, in the belief that an expressive art could issue

from his experimentation with tensegrity. In Snelson's constructions, rigid polished tubes—compression elements that keep components apart—and steel cables—tension elements that draw components together—are held in equilibrium. Stephen A. Kurtz wrote of Snelson: "His esthetic is so bound up with his vision of the structure of the universe that the two become inseparable. For Snelson, a scientific investigation is *an* esthetic investigation."[31] Snelson believed: "It is possible to isolate the essence of structure—the dialogue between push and pull, compression and tension—and *make it the subject of form.*"[32] He aimed to make these invisible stress forces visible in order to reveal the nature of matter, how the cosmos is ordered. These counterbalanced stresses are different from gravity, the basis of sculptures by Andre and Serra. Indeed, Snelson's *Cantilever,* 1967, which extends horizontally thirty feet in midair from a single wall it is attached to, defies gravity.

Snelson's use of tensegrity as a structuring principle—structure determining form—limited his formal options, but a wide range of possibilities remained, and his choices were largely aesthetic. This is particularly so in the more complex of Snelson's stress structures, which are organized around multiple foci. Many of their components do not serve a structural purpose, but serve only an artistic one.[33]

Antonakos fashioned abstract sculptures from light-emitting neon fixtures and integrated them into architectural settings. He recalled how he first began to use neon. "All through the 1950s I had been working with found objects, and I made constructions as well as paintings." He also made "Sewlages, which were a kind of fab-

FACING PAGE:
114. George Rickey, *Omaggio a Bernini,* 1958. 68½″ × 36″ × 36″. Whitney Museum of American Art, New York.

115. Len Lye, *Grass,* 1965. 36″ × 35⅝″. Albright-Knox Art Gallery, Buffalo, N.Y.

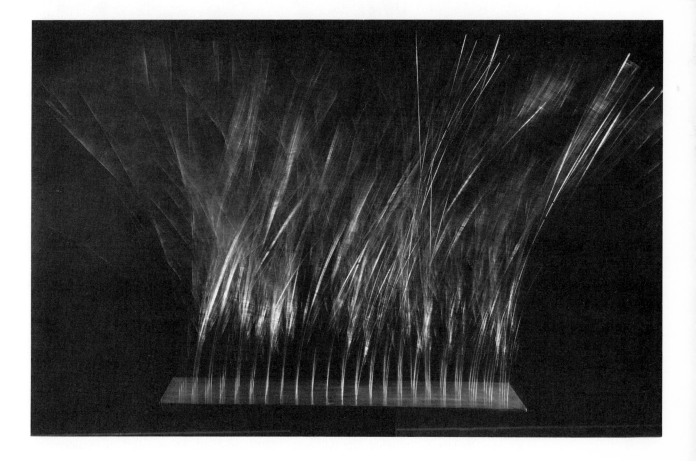

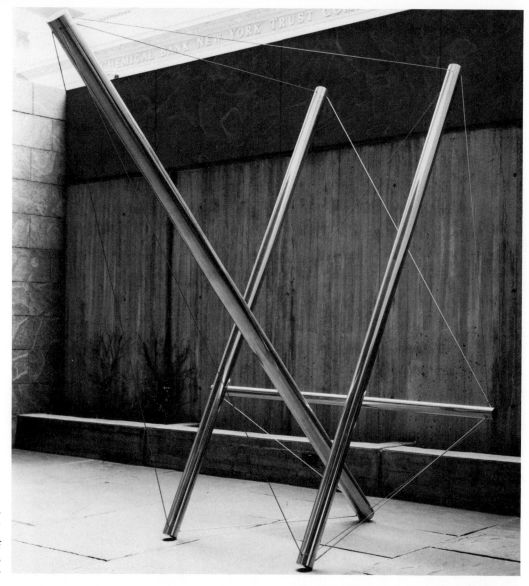

116. Kenneth Snelson, *Sun River*, 1968. 126″ × 96″ × 60″. Whitney Museum of American Art, New York.

ric collage sewn together instead of being glued. [One] day I introduced some incandescent light bulbs [but] I was not too happy with bulbs in general, because the form was so limited." One night, walking home from the studio, he noticed a neon sign and was struck by its color.

I had been looking at the old neon signs on Broadway and Times Square for years and years, but I did not really see them until that moment. I spent the next few days walking, day and night, looking up at neon signs, seeing how they were installed, the different

thicknesses of the tubes, the different colors. Then I decided to attach neon tubes to my assemblages. . . . I liked it; I worked more and more with it, less and less with other materials. It simply was that there was more and more in neon to see. . . . I used it in geometric forms from the start. . . . By 1961 or 1962 I knew that neon was what I wanted to work with.[34]

Antonakos was not interested in the technology of neon or in its Pop references to billboards and other commercial signs. Instead, he wanted to explore the

expressive potential of its colored light. He claimed that because neon was associated with advertising messages, it had not been seen "for itself, for its own qualities, and I wanted to find new forms for neon which would give it new and rich uses and meanings."

Around 1967, Antonakos began to relate his works "strongly to walls, to corners—both the inside kind and the outside kind—to angles where walls meet ceilings and floors and to other architectural elements. This led to my 'Rooms' of neon. [One] took the form of a long barrier of neon spanning a large gallery. It was huge and intimidating."[35] *Walk-On Neon*, 1968, a floor piece, was composed of parallel multicolored glass tubes programmed to go on and off to produce a changing design. Spectators could walk across the surface, from which neon clusters projected.

Toward the end of the sixties, Antonakos "minimalized" his forms and reduced their number; he favored circles and squares, arcs and right-angle fragments. In 1969, he gave up programming his works, because the on-and-off activity controlled the viewers' responses too much. From this time on, Antonakos relied exclusively on the expressiveness of colored light but in the environment of ever-changing natural light.

As if in reaction against Constructivist rationality and order, Jean Tinguely built machines that embodied an anarchic vision. His kinetic junk constructions were witty and funny—and subversive. His most notorious works were slot machines that painted "Abstract Expressionist" pictures and a self-destructing sculpture he built in the sculpture garden of the Museum of Modern Art in 1960. As described by Seitz, Tinguely's "mélange of materials ranging from bicycle wheels and dishpans to an upright piano, vibrated and gyrated,

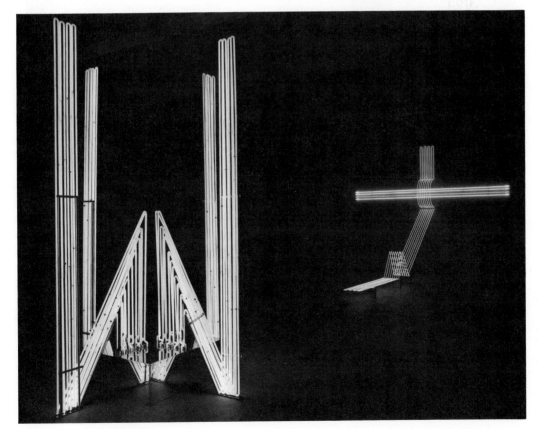

117. Stephen Antonakos. Left: *Orange Vertical Floor Neon*, 1967. 108″ × 72″ × 72″. Wadsworth Atheneum, Hartford, Conn. Right: *Red Neon, Wall to Floor*, 1967. 122″ × 144″ × 168″. Collection the artist.

painted pictures, played music, and . . . sawed, shook, and burned itself to rubble and extinction."[36]

A group of American artists employed the latest technologies in their art, but their thinking was not related to European Constructivism. Instead, they took their cues from John Cage, who asserted that art and everyday life ought to be fused. It followed that if the new technologies were central to contemporary life, then they and art ought to merge. The purpose of art was to sensitize the public to the radical changes taking place in their life. With these ideas in mind, Billy Klüver, an engineer; Robert Rauschenberg; Robert Whitman, a Happenings-maker; and a group of friends organized *9 Evenings: Theater and Engineering*, a series of events at the Twenty-fifth Street Armory (the site of the Armory Show of 1913). The life-art strategies of Cage were only implicit in the publicity. The stated motto of the theatrical events was "Technology for Art's Sake." Both the explicit aestheticist claims and the implicit Cagean anti-aestheticist claims, despite their contradictions, served to promote *9 Evenings*. The performances were not attacked by the New York art world for their technological orientation, as European Constructivism was, because they were perceived as outside the realm of painting and sculpture and dealt with as something apart, and because they enlisted respected artists, among them Cage, Rauschenberg, and Stella (as a performer), and dancers, Yvonne Rainer and Lucinda Childs.

The participating artists, most of them associated with the Judson Dance Theater, were Cage, Childs, Oyvind Fahlstrom, Alex and Deborah Hay, Steven Paxton, Rainer, Rauschenberg, David Tudor, and Whitman. They collaborated with more than thirty engineers from Bell Telephone Laboratories. Though *9 Evenings* was less than an aesthetic success, flawed as it was by engineering breakdowns and aesthetic confusion, it made artists aware of the potential of the new technology.

The *9 Evenings* series led to the formation of an organization, Experiments in Art and Technology, or EAT, as it was commonly called. According to Klüver:

> The policy of E.A.T. is to develop effective means of stimulating collaborations between artists and engineers. . . . Thus, it was decided that E.A.T. would act as a "matching agency," through which an artist with a technical problem, or a technologically complicated and advanced project, could be matched with an engineer who would be qualified to work with him and help him.

Klüver went on to ask:

> Why bring artists and engineers together? . . . The contemporary artist wants to use contemporary technology as a material. And today technology needs the artist. [His] sensual response, his autonomy and his assuming full responsibility for his work is essential to the development of technology. . . . The artist's motivation is different from the engineer's. . . . The artist brings a new content to technology and a new understanding about our relationship to the technical environment. . . .
>
> What the engineer brings is knowledge, expertise, and access to the contemporary world.

By 1968, EAT had some three thousand members in thirty groups over the world.[37]

In 1968, EAT, in conjunction with the Brooklyn Museum and the Museum of Modern Art, organized *Some More Beginnings*, an exhibition of some 120 works involving technical materials and processes. In 1970, EAT designed a pavilion for the Pepsi-Cola Company, which was built at *Expo '70* in Osaka, Japan. From 1967 to 1971, Maurice Tuchman, chief curator of the Los Angeles County Museum of Art, arranged for more than twenty artists to work in West Coast industries and other companies. In 1971, Jack Burnham extended the thinking of EAT by organizing a show, titled *Software: Information Technology: Its New Meaning for Art*, at the Jewish Museum, exploring the aesthetic potential of computer program-

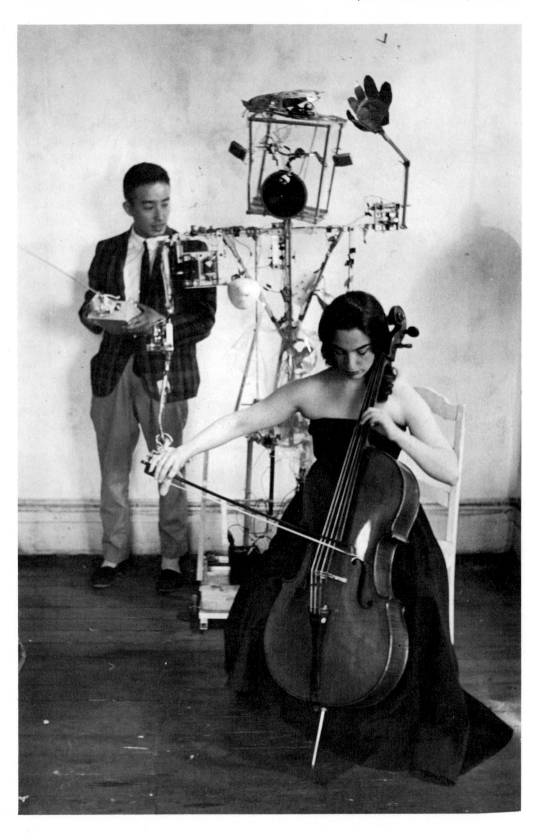

118. Nam June Paik and Charlotte Moorman, 1964. Publicity photo taken before the Second Annual Avant-Garde Festival, New York. Photo © Peter Moore.

ming. After these shows, there was a sharp decline of interest in art using new technology. However, the legacy of EAT was a greater willingness of artists to collaborate and to venture into video, film, and Performance Art.

Unaffected by the decline of experiments in art and technology was the reputation of Nam June Paik, and for good cause, because he was the most remarkable of technological artists. Although Paik was not associated with EAT, he was strongly influenced by Cage, whom he met in Germany in 1958. Like Cage, Paik embraced Zen and Dada, and in his work suppressed artistic egoism and cultivated everyday and unexpected occurrences. However, unlike Cage's performances, Paik's were often extravagant, violent, and erotic. His attitude is suggested in the titles of a number of his pieces: *Simple, Zen for Head*, 1961; *Robot Opera* and *Pop Sonata*, 1964; *Cello Sonata No. 1 for Adults Only* and *Zen for Film*, 1965; *As Boring as Possible*, 1966; *Opera Sextronique*, 1967; and *TV Bra for Living Sculpture*, 1969.

Paik's early pieces were Assemblages that produced unaccustomed sound, such as *Klavier Intégral*, 1958–63, a prepared piano that had built into it sirens, toys, kitchen utensils, telephones, and alarm clocks; and performance pieces, the best-known of which was *Étude for Pianoforte*, 1960. In *Étude*, Paik, among other of his actions, played Chopin on a piano, broke off in tears, jumped off the stage into the crowded audience, cut off Cage's necktie with a large scissors, poured a bottle of shampoo over Cage and David Tudor but not Karlheinz Stockhausen, who sat in the next seat, and pushed his way through the no longer passive spectators to the door and out. He then phoned from a bar downstairs to announce that the concert was over. Pieces such as *Étude* and *Hommage à John Cage: Music for Tape Recorder and Piano*, 1959, in which Paik arranged for the piano to tip over, prompted Allan Kaprow to call him a "cultural terrorist."[38]

In 1961, Paik became associated with Fluxus, a group of Cage-inspired, Neo-Dada, mixed-media artists, and began to participate in their anarchic performances. David Ross remarked: "Paik's own brand of Fluxus activity . . . was aimed at . . . exploring and expanding music's *visual* potential."[39] In *Violin with String*, 1961, Paik dragged a violin along the street (later exhibiting the battered instrument), and in *One for Violin*, 1962, he slowly raised a violin over his head and brought it down with a crash on a table in front of him.

In 1962, Paik purchased thirteen secondhand TV sets and altered their mechanical innards (somewhat as Cage had altered pianos). As he said: "I didn't have any preconceived idea. Nobody had put two frequencies into one place, so I just do that, horizontal and vertical, and this absolutely new thing comes out."[40] Paik's prepared televisions or video sculptures were exhibited in his first one-person show, titled *Expositions of Music-Electronic Music*, at the Galerie Parnass in Wuppertal, West Germany, 1963—the first show of electronic visual art anywhere.

In 1964, Paik visited America and stayed on, settling in New York. He met cellist Charlotte Moorman and, beginning with the Second Annual New York Avant-Garde Festival, 1964, which she was instrumental in organizing, often collaborated with her. In 1965, Paik's exhibition consisted of a six-foot-tall *Robot K-456*, which was programmed to walk, talk, gesticulate, and excrete white beans. Cage, in the catalogue introduction, wrote: "Someday artists will work with capacitors, resistors, and semi-conductors, as they work today with brushes, violins & junk."[41]

In his performance work with Moorman, Paik introduced sex into music with humor and irreverence. This led, to his distress, to Moorman's arrest for indecent exposure during her performance of *Opera Sextronique* in 1967. After a notorious trial, she was convicted and received a suspended sentence. In *TV Bra for Living Sculpture*, 1969, Moorman wore a

brassiere of two three-inch television sets and played cello compositions by Paik and other composers. As the tones changed, so did the images on the "boob-tubes," as one wit quipped.

In 1969, Paik was one of twelve artists included in a seminal show titled *TV as a Creative Medium* at the Howard Wise Gallery, and he began to achieve recognition as the Giotto of a rapidly growing video art tendency. In the following year, with Shuya Abe, he invented a videosynthesizer that enabled him to combine images from a number of television cameras. The possibilities were infinite; as Calvin Tomkins remarked,

> the synthesizer can produce a ceaseless kaleidoscope of shapes and colors on the screen—shapes and colors unlike anything anyone has ever seen before. It can superimpose as many as seven different images; cause the features of announcers and other unsuspecting subjects to vibrate, melt, change color, and spread laterally; and generally turn the familiar screen into an electronic canvas for an artist whose brush consists of light.[42]

Op and kinetic art and experiments in art and technology were related to psychedelic light and sound shows, which became popular shortly after *The Responsive Eye* exhibition. These events employed new technological media, such as high-intensity quartz-iodide lights; laser beams; magnetic distortion of electron beams; polarized light; plastics irradiated by gamma rays; polyester films coated with a mono-molecular layer of aluminum; and new phosphors having varying controlled rates of decay.[43] The best-known of these happenings, such as Dr. Timothy Leary's Celebrations for the League of Spiritual Discovery (LSD) at the Village Theater on Second Avenue, were

supposed to simulate drug-induced experiences of a quasi-religious nature, and thus were of a different order than the light pieces of Antonakos.[44] Warhol recalled that Leary's intention "was to give people a preview, through a mixed-media show, of what an ideal LSD trip was like."[45]

The label "psychedelic style" was coined in the summer of 1966 at an LSD conference in San Francisco. Its participants believed that drugs and light-sound environments offered society intense tribal experiences,[46] an idea borrowed from McLuhan, although he believed that the use of drugs yielded "a lazy man's art."[47] As a well-known group, USCO (Us Company), a commune that included artists, engineers, poets, and film-makers, who mixed film, tapes, slides, and lights in audiovisual performances, announced: "We are all, one . . . beating the tribal drum of our new electronic environment."[48] Psychedelic artists were also aware of Duchamp's kinetic and optical rotoreliefs, the Happenings and Fluxus events of the late fifties and early sixties, and Warhol's Velvet Underground at the Dom, a discotheque in the East Village.

Using Leary's prophecies as "spiritual" cachet and Warhol's Exploding Plastic Inevitable show as inspiration, commercial discotheques would model themselves after the Dom and bill themselves as "psychedelic," combining pop music and light effects. Many museums went with the flow. Martin Friedman wrote: "Epic 'light shows' converted museums into surrogate discotheques filled with flashing strobes, humming neon and 'altered' TV sets that radiated vertiginous patterns. Such phenomena were hailed by . . . [their] acolytes as evidence of art's true destiny; the medium was the mind-altering message."[49]

## NOTES

1. The Editors, "This Issue" (Special issue: "The Avant-Garde"), *New York/Herald Tribune,* 17 May 1964, p. 4.

2. "A Barbecue in the Shrine," *Washington Post-Times-Herald,* 6 December 1964.

3. See William C. Seitz, "The New Perceptual

Art," *Vogue,* 15 February 1965.

Shortly before *The Responsive Eye* opened on 25 February 1965, the following shows took place: *Color Dynamism, Then and Now,* East Hampton Gallery, 22 December–9 January; *Vibrations Eleven,* Martha Jackson Gallery, 29 December–30 January; *Impact,* Green Gallery, 22 December–9 January; *Abstract "Trompe l'Oeil": Five Painters Who Lead and Mislead the Eye,* Sidney Janis Gallery, 26 January–27 February. Two of the leading members of the art world, Janis, and Bellamy of the Green Gallery, were early supporters of Op Art.

The chicness of Op Art opened it to attack. The unfairest, to say the least, accusation was that Op Art emerged after the Museum of Modern Art had announced that it was going to feature it in a large show, this calling into question the integrity of the exhibiting artists and its curator, Seitz, one of the finest art professionals America has known. What this charge revealed was the ignorance of Op and Kinetic tendencies in Europe or a chauvinistic disregard of those tendencies. For example, Howard Junker, in "Scene and Not Herd: Finders Keepers . . . 9 to 5 in the Cellars of Art," *Harper's Bazaar,* November 1966, p. 144, reported:

> Op, as a movement, was launched by a single museum show, "The Responsive Eye," which was three years in the making and thus opened as an anticlimax. [As if Seitz had intended some kind of climax!] Since op was obviously the Modern's answer to pop, everyone jumped on. The artists produced specifically to be included—ninety-six of the one hundred twenty-three pieces were completed after the show was announced [the implication was that the work was manufactured for the exhibition]; the galleries endorsed the trend by staging their shows in tandem; the fashion industry tuned in; and the media puffed, too. . . . After surveying the ruins of op, its curator William Seitz . . . retired to the shady groves of Brandeis, worn out and embittered by the storm he whipped up.

This was indeed a twisted interpretation of Op Art and *The Responsive Eye,* and of the intentions of Seitz.

4. William C. Seitz in *The Responsive Eye,* exhibition catalogue (New York: Museum of Modern Art, 1965), p. 3, also singled out in his acknowledgments Denise René, a leading Parisian dealer in geometric and constructivist art.

George Rickey, a kinetic sculptor and a historian of Constructivism, reported in *Constructivism: Origins and Evolution* (New York: George Braziller, 1967), p. vii, that in the spring of 1961, he visited the *Movement in Art* exhibition in Amsterdam and again in Stockholm and was impressed by its "striking contrast with the prevailing Expressionist styles of that time." Then and in subsequent travels, he became aware of the scope of "this disciplined non-objective art and how little of it was known." Despite the limited contact that the artists had with each other, "there was an astonishing concurrence in their thinking. It seemed that this concurrence must have been a reaction against international 'art informel' and, furthermore, that it had developed from a conscious or unconscious identity with the principles of what has been called 'Constructivism.' "

In 1961, Constructive tendencies were featured in an international show titled *New Tendency* in Zagreb, Yugoslavia, and in *Movement in Art* at the Stedelijk Museum in Amsterdam, which traveled to the Modern Museum in Stockholm and the Louisiana near Copenhagen. In 1962, there took place the first international meeting of "Nouvelle Tendance, recherche continuelle" (NTrc) in Paris. (Seitz, "The New Perceptual Art," p. 142. Seitz, *The Responsive Eye,* (p. 3.) See Jacqueline Barnitz, "Taped Interview with Josef Albers," *Art Voices,* Winter 1965, p. 39. *The Responsive Eye* turned Albers into a progenitor and master of Op Art—against his will.

5. Seitz, *The Responsive Eye,* p. 41.
6. Peter Selz, "Arte Programmata," *Arts Magazine,* March 1965, p. 21.
7. Larry Poons, interviewed by Dorothy Seckler, New York, 18 March 1965, p. 24. Archives of American Art, New York. Barbara Rose, in "Beyond Vertigo: Optical Art at the Modern," *Artforum,* April 1965, pp. 30–31, wrote that in contrast to the "high art" of a Kelly, Louis, Noland, and Poons, "purely 'optical' art, based on textbooks and laboratory experiments, theory, equations, and proofs, is empty and spiritless." She also claimed that "science applied to art results in applied art, not fine art."
8. Seitz, *The Responsive Eye,* pp. 12–43.
9. Ibid, pp. 7–8.
10. John Canaday, "Art That Pulses, Quivers and Fascinates," *New York Times,* 21 February 1965, p. 59.
11. Emily Genauer, "Art: The Wizards of Op," *New York/Herald Tribune,* 21 February 1965, p. 58. See also Emily Genauer, "Op-otheosis in New Jersey," *New York/Herald Tribune,* 8 August 1965, p. 21.
12. Warren R. Young, "Op Art," *Life,* 11 December 1964, pp. 132–140.
13. Sidney Tillim, "Optical Art: Pending or Ending?" *Arts Magazine,* January 1965, p. 23.
14. Lucy Lippard, "New York Letter," *Art International,* March 1965, p. 50.
15. Seitz, "The New Perceptual Art," p. 80.
16. See Edward Edelson, "Chemist Mixes Op Art Formula," *New York World-Telegram,* 28 January 1966; Gerald Oster, "Moirage," *Art Voices,* Summer 1966. Oster himself stressed the psychological dimension of Op Art. In "Moirage," p. 33, he wrote: "Certainly moirage is a science—but is it art? . . . If a moiré work brings to the beholder joy and a wonderment of nature (including the fabulous eye-mind complex

of man), then it is, in my opinion, high art."

17. Bridget Riley, "Perception Is the Medium," *Art News*, October 1965, p. 32.

18. Thomas B. Hess, "You Can Hang It in the Hall," *Art News*, April 1965, pp. 42–43, 49–50.

19. Rose, "Beyond Vertigo," p. 31.

20. Riley, "Perception Is the Medium," p. 32.

21. Tillim, "Optical Art: Pending or Ending?" p. 19. Tillim distinguished between the two Americans Poons and Anuszkiewicz by calling the latter a European-type American.

22. Rosalind Krauss, "Afterthoughts on 'Op,' " *Art International,* June 1965, pp. 75–76. The denigration of Op Art was largely a result of attacks by Greenberg-inspired critics, although writers identified with Minimalism and Abstract Expressionism did their share.

23. Hess, "You Can Hang It in the Hall," p. 42.

24. See Max Kozloff, "Poons," *Artforum*, April 1965, and Rose, "Beyond Vertigo."

25. Frank Stella owned a painting titled *Double Speed*, 1962–63, by Larry Poons, reproduced by Bruno Alfieri in *Metro* 10 (1965): 12.

26. Krauss, "Afterthoughts on 'Op,' " p. 76. See also Kermit S. Champa, "New Paintings by Larry Poons," *Artforum*, Summer 1968.

27. Charlotte Willard, "Drawing Today," *Art in America* 5 (1964): 54.

28. Riley, "Perception Is the Medium," p. 33.

29. Philip Leider, "Kinetic Sculpture at Berkeley," *Artforum*, May 1966, pp. 40–41.

30. Ibid., p. 43. Len Lye made his first kinetic machine in 1918. In 1961, he exhibited his *Tangible Motion Sculptures* at the Museum of Modern Art. He conceived of his sculptures as theatrical and musical performances. Douglas Davis, in *Art and the Future* (New York: Praeger, 1973), p. 48, wrote:

> In 1965, he displayed a group of "Bounding Steel Sculptures" at the Howard Wise Gallery in New York. *The Loop*, a twenty-two-foot strip of polished steel, rested on a magnetized and motorized bed, which activated the strip at programmed intervals, causing it to clang and undulate viciously. *The Flip and Two Twisters* turned itself out with a cascade of thunderous sound. *Ritual Dance*, six slender three-foot steel rods, swayed on a platform accompanied by ringing bells.

31. Stephen A. Kurtz, "Kenneth Snelson: The Elegant Solution," *Art News*, October 1968, p. 83.

32. Kenneth Snelson, "How Primary Is Structure?!" *Art Voices*, Summer 1966, p. 82.

33. Howard N. Fox, "Kenneth Snelson: Portrait of an Atomist," *Kenneth Snelson*, exhibition catalogue (Buffalo, N.Y.: Albright-Knox Art Gallery, 1981), p. 17.

34. Stephen Antonakos, in *Stephen Antonakos: Neons and Drawings*, exhibition catalogue (Waltham, Mass.: Rose Art Museum, Brandeis University, 1986), p. 12.

35. Stephen Antonakos, in *Glass in Environment*, Conference, Crafts Council, Royal College of Art, Royal Institute of British Architects, London, reprinted in *Stephen Antonakos: Neons and Drawings*, pp. 10–11.

36. William C. Seitz, *the Art of Assemblage*, exhibition catalogue (New York: Museum of Modern Art, 1961), p. 89.

37. Billy Klüver, "E.A.T. Remarks by Billy Klüver," in "La Sfida del Sistema," *Metro* 14 (1968): 57. See Jasia Reichardt, *Cybernetic Serendipity: The Computer and the Arts*, the catalogue of a show held at the Institute of Contemporary Art in London in 1968 and the Corcoran Gallery in Washington, D.C., in the summer of 1969. It was a special issue of *Studio International*, published by Praeger in 1969. The three sections of the show were: (1) computer-generated graphics, computer-animated films, computer-composed and -played music, and computer poems and texts; (2) cybernetic devices as works of art, cybernetic environments, remote-control robots and painting machines; and (3) machines demonstrating the uses of computers and the history of computers.

See also Douglas Davis, "Art and Technology," *Art in America*, January–February 1968. Davis lists works of art using new technology with respect to four options: (1) use by artists of materials produced by new technology; (2) use by artists of tools and methods produced by new technology; (3) use by artists of imagery produced by new technology; and (4) full partnership between artist and scientist, who, as Klüver suggested, would aim to produce something that neither would have imagined or created alone.

38. Calvin Tomkins, "Profile: Video Visionary," *The New Yorker*, 5 May 1975, p. 51.

39. David A. Ross, "Nam June Paik's Videotapes," *Nam June Paik*, exhibition catalogue (New York: Whitney Museum of American Art, 1982), p. 102.

40. Tomkins, "Profile: Video Visionary," p. 46.

41. Ibid., p. 44.

42. Ibid., p. 43.

43. These and other media were listed in *Light in Orbit*, introduction, exhibition catalogue (New York: Howard Wise Gallery, 1967), n.p.

44. The use of light in art had a long history. See Douglas Davis, *Art and the Future* (New York: Praeger, 1973); Nan R. Piene, "Light Art," *Art in America*, May–June 1967; and Elizabeth Baker, "The Light Brigade," *Art News*, March 1967.

45. Warhol and Hackett, *Popism*, p. 183.

46. Jud Yalkut, "The Psychedelic Revolution," *Arts Magazine*, November 1966, p. 22.

47. Ibid., p. 22.

48. Frank Popper, "De groep Usco," *Kunst Licht Kunst*, exhibition catalogue (Eindhoven, Holland: Stedelijk–van Abbemuseum, 1968), n.p.

49. Martin Friedman, "The Sixties: Remembrance of Things (Recently) Past," *A View of a Decade*, exhibition catalogue (Chicago: Museum of Contemporary Art, 1977), p. 12.

# 10 MINIMAL SCULPTURE

Minimal sculpture came to art-world attention with the one-person shows of Donald Judd and Robert Morris in 1963, Dan Flavin in 1964, and Carl Andre in the following year;[1] and the group shows *Shape and Structure*, organized by Stella, Rose, and Geldzahler in 1965, which included Judd, Morris, and Andre,[2] and *Primary Structures*, a major survey, at the Jewish Museum in 1966. None of the artists called Minimalists liked the label,[3] primarily because it implied that their work was simplistic. They also believed, with justification, that the differences in their styles outweighed the similarities, so that any single label would be misleading.

But similarities did exist. Minimal sculptures consisted of elementary geometric volumes or symmetrical and serial sequences of modular geometric volumes placed not on pedestals but directly on the floor or wall. Their design was nonrelational; their surfaces were uninflected, lacking in signs of process; and their colors were simply those of the substances employed. Judd, Andre, and Flavin used industrial materials—prefabricated in the case of Andre and Flavin, fabricated in machine shops in the case of Judd. If the label "Minimal sculpture" has any substantive meaning, it is because the works it refers to look minimal in appearance and, more important, because they seem to focus on the essential quality that makes them sculpture—namely, their literal ob-jecthood. As Rose remarked in an early article on Minimalism, the "object sculptures" of Judd and Morris are distinguished by "no more than a literal and emphatic assertion of their existence. . . . The thing . . . is not supposed to be suggestive of anything other than itself."[4]

At the same time, Minimal sculpture was conceptual in origin in that its extreme physicality was based on preconceived ideas. However, as Judd said: "Even if you can plan the thing completely ahead of time, you still don't know what it looks like until it's right there. [I want] to be able to see what I've done. . . . Art is something you look at."[5] In contrast, Sol LeWitt considered ideas primary, not the visible objects they yielded. His modular, open cube constructions were often related by critics and curators to Minimal sculpture, but they fit better in the context of Conceptual Art, and will be dealt with in that context.[6]

The intention of making a work of art into a thing-in-itself only was anticipated by Stella's black, aluminum, and copper paintings.[7] They impressed the Minimalists, because, as Judd asserted, they made "the shallow depth of Abstract Expressionism old-fashioned."[8] He went on to say that most of Stella's pictures

suggest slabs, since they project more than usual, and since some are notched. . . . The notches in the aluminum paintings determine the patterns of the stripes within. The projection, the absence of spatial effects and

the close relation between the periphery and the stripes make the paintings seem like objects, and that does a lot to cause their amplified intensity.[9]

Visual intensity or impact—or *immediacy,* as Abstract Expressionist painters such as Newman called it—was very much on Judd's mind, because he thought that the more immediate art was the more advanced. Much as he admired the visual impact of Stella's and Newman's pictures,[10] he had come to believe that painting, any painting, could no longer hold its own visually against new work in three dimensions, work that he labeled Specific Objects. Immediacy resulted from objecthood. The illusionism of painting weak-

ened it visually. So did its "look of history," to quote Flavin.[11] Painting seemed to Judd to be closed off and circumscribed by its long tradition. But the Specific Object was too novel and unconventional for its limits to be known. "It opens to anything," wrote Judd,[12] and he implied that the new in art was more visually arresting than the old.

Working in "three-dimensions makes it possible to use all sorts of materials and colors," particularly unorthodox industrial materials, such as fluorescent lights, Formica, fiberglass, Plexiglas, chrome, and plastic. "Actual materials, actual color and actual space" had a specificity and power that painting lacked. And because of that,

119. Robert Morris, *Untitled (Ramp),* 1965. 24″ × 192″ × 12″. Panza Collection.

Judd announced, painting "has to go entirely."[13] Judd insisted that the new materials be closely related to the form of a work in order to call attention to its thingness.[14]

Judd claimed that his concern with industrial materials, modularity, and machine fabrication was exclusively aesthetic. However, Minimal sculpture was reminiscent of manufacturing processes, such as mass production, and its products, for example, Levittowns, much as Pop Art called to mind commercial art. Connections in style and content were often made between Minimal and Pop Art.[15] Both repudiated the "neo-humanist sentimentality" attributed to Abstract Expressionism. Linking Minimal sculpture to post-painterly abstraction, Rose remarked that they were

> as removed from . . . the hand-worked look of thumbed, scarred, finished and treated sculpture as the impersonal new painting is from the personality-centered romanticism of the old [Abstract Expressionism. The new work] looks machine-made, industrial, standardized, materialized or stamped out as a whole, rather than made in parts that relate one to another.[16]

Indeed, because their work was preplanned and fabricated, or arranged from prefabricated materials, Minimal artists were able to avoid the improvisational process of creation associated both with Abstract Expressionism and with construction sculpture. Rose repeatedly called attention to Minimal sculpture as "an art whose blank, neutral, mechanical impersonality contrasts so violently with [and rejects] the romantic, biographical abstract expressionist style which preceded it that spectators are chilled by its apparent lack of feeling or content."[17] In sum, it was a nihilistic, reductive art.

On the whole, Minimal artists rejected Rose's claim that their art was negative or reductive. Stella remarked: "I don't think people are motivated by reduction. . . . I'm motivated by the desire to make something, and I go about it in a way that seems best."[18] Judd agreed: "The most the term [reductive] can mean is that new work doesn't have what the old work had."[19] It had other qualities—honesty, for example, found in the physicality of Specific Objects. Agreeing with Judd, Rose revised her opinion: "Fooling the eye is not candid: it is a form of deception. To this line

120. Donald Judd. *Untitled (4 Boxes)*, 1965. 33" × 141" × 30". Philip Johnson.

of reasoning . . . even the most minimal illusionism is a distortion of the true nature of the object." This kind of truth could be achieved *"only* in the perception of objects that exist to begin with in all three dimensions. [Then] what the eye registers accord[s] with what the mind knows to be true from experience." Rose concluded that Specific Objects deny the traditional purpose of painting and sculpture—namely, "the depiction of an image or idea," a purpose that is dualistic in that something referred to something else. In contrast, Minimal artists wanted "to make objects that do not bear such a once-removed relationship to images, objects that are realized directly . . . objects that are *presented* rather than depicted or represented."[20]

The presentation of sculpture-as-object was generally considered avant-garde in the early and middle sixties, in comparison to the open, Cubist, welded construction of David Smith, and after him, Mark di Suvero and Anthony Caro, whose formal and technical premises the Minimalists appeared to challenge.[21] As Rose remarked: "In its oversized, awkward, uncompromising, sometimes brutal directness, and in its . . . (being simply too big or too graceless or too empty or too boring to appeal) this new art is surely hard to assimilate with ease."[22]

Above all, the work was often viewed as boring.[23] Minimal artists and sympathetic critics disagreed, or made a virtue of boredom. For example, Lippard asserted:

> The exciting thing about . . . the "cool" artists is their daring challenge of the concepts of boredom, monotony and repetition, their brinksmanship in ruling out hitherto considered essentials and their demonstration that intensity does not have to be melodramatic. When this kind of expression fails, it is boring like any other kind.[24]

Minimal objects did look boring and ugly to the extent of seeming nihilistic and hostile in intention, but only when they first appeared. In time, they came to look increasingly elegant and artful.

Despite its innovations, Minimal Art was recognized as having predecessors, among them the Readymades of Duchamp and the Suprematist paintings of Malevich (notwithstanding their contrasting intentions). Malevich's white square on a white ground was on view at the Museum of Modern Art (where it had impressed Stella strongly) and something of his Suprematist aesthetic was known. His ideas reached young artists through the polemics of Reinhardt, reinterpreted by him to the extent that their source in Suprematism was often overlooked. Reinhardt singled out the art-for-art's-sake component in Malevich's thinking and forgot the mysticism. Reinhardt himself became a guru figure to Minimal sculptors, who were influenced not only by his writing and conversation but by his painting, as Rose noted, because it, like their work, evolved "through a series of complicated, highly informed decisions, each involving the elimination of whatever was felt to be nonessential."[25]

Flavin and Andre were in debt to Russian Constructivist art, although they had not seen much of the work, even in reproduction. Camilla Gray's seminal *The Great Experiment: Russian Art 1863–1922* was not published until 1962. Flavin dedicated a series of works to Vladimir Tatlin and claimed to want to extend Russian avant-garde art.[26] According to Stella, it was Flavin's corner pieces inspired by Tatlin that introduced Constructivist ideas into the discourse of Minimal Art. Andre saw illustrations of Alexandr Rodchenko's modular wood constructions "where they looked big but you could tell they were not from the end-grain." They impressed him because they provided an "alternative to the semi-Surrealist work of the 1950s such as Giacometti's and to the late Cubism of David Smith." Moreover, Rodchenko's construction had a "look of nascence"; it did not have "a second-generation look."[27]

Judd and Morris denied that they owed a debt to Constructivism. Judd acknowl-

edged that he had seen a couple of Pevsners that he admired, but they had not influenced him because they looked small in scale and too composed. He went on to say that everything before Abstract Expressionism struck him as dainty.[28] And Morris recalled that he didn't think that what he was doing was Constructivism. But he liked its complete abstraction (Tatlin), literal use of all kinds of materials, and treatment of sculpture as environment (Lissitzky).[29] If the extent of the influence of Constructivism and Suprematism on Minimal Art is problematic, it is clear that the Americans became interested in the Russian avant-garde because of the development of their own work. In 1967, when Brian O'Doherty compiled his "box" of materials that aimed to exemplify the sensibility of the sixties *(Aspen 5+6)*, he focused on artists identified with Minimalism—LeWitt, Mel Bochner, and Tony Smith—and included an entire section on historic Constructivism, linking the old and the new, as it were.

Minimal Art has been viewed—by George Rickey, for example—as the American counterpart of international constructive art in the sixties, the most interesting of which was based on modular and serial systems, but the Minimalists denied this. Judd thought that there was "an enormous break" between the two "despite similarity in patterns." Immediacy made the difference. Stella remarked that the

> Groupe de Recherche d'Art Visuel actually painted all the patterns before I did—all the basic designs that are in my painting—not the way I did it. But [it] still doesn't have anything to do with my painting. I find all that European geometric painting—sort of post–Max Bill school—a kind of curiosity—very dreary.[30]

The Minimalists also rejected the scientific and social claims with which the Europeans justified their art. The Minimalists attributed no special extra-aesthetic significance to mathematically derived

modules and series but claimed to use them as pretexts for creating new art.

On the whole, Minimal sculptors owed a greater debt to Brancusi than to Constructivism and Suprematism. Andre called himself a disciple,[31] and Morris had written a master's thesis on Brancusi.[32] They and Judd and Flavin admired the monolithic nature of his works generally, and specifically the simplicity of the post-and-lintel sculptures and the modular endless column. There was a difference, however, as Stella pointed out. Brancusi emphasized the beauty of his materials; the Minimalists valued his sculpture for its mass and modularity.

In seminal articles titled "Local History," 1964, and "Specific Objects," 1965, Judd asserted that the three-dimensional work that interested him aimed "to get clear" not only of painting but of sculpture. As he defined it, "sculpture" was either modeled, carved, or constructed—that is, "made part to part, by addition, composed," revealing itself to the viewer slowly instead of immediately. Construction sculpture was suggestive of nature or bodily parts and gestures, in a word, "anthropomorphic"; was usually made of traditional wood and metal; and was seldom colored. Judd went on to say: "There is little of this in the new three-dimensional work. So far the most obvious difference . . . is between that which is something of an object, a single thing, and that which is open and extended."[33] Judd's uneasiness both with painting and with sculpture in the round led him to favor relief, or so it seemed, since he made no special claims for it. But there was in his writing the implication that Specific Objects constituted a new, "third" medium, as it were.

If the Specific Object was neither painting nor sculpture, to which was it closer? In Judd's opinion, it "obviously resembles sculpture more . . . but it is nearer to painting."[34] This sounds paradoxical because Judd believed that painted space was fictive and thus dead, killed off by the actual space of the new three-dimensional

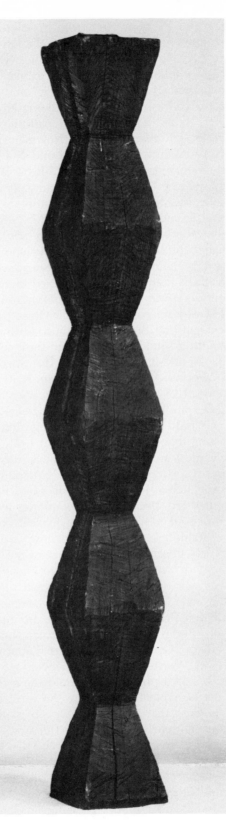

FACING PAGE:
121. Dan Flavin, *Monument for V. Tatlin, No. 61*, 1969. 119″ × 23″ × 4″. Leo Castelli.

122. Constantin Brancusi, *Endless Column*, 1918. 80″ × 9⅞″ × 9⅝″. Museum of Modern Art, New York.

art. But he exempted from his obituary painters who had "developed the last advanced versions," because in their work the "wholeness of a piece is primary, is experienced first and directly," and because the work approached being an object. As he wrote: "In the paintings of Pollock, Rothko, Still, and Newman, and more recently of Reinhardt and Noland, the rectangle is emphasized." It becomes a "definite form," a single thing. It also calls attention to its relationship to the wall, as one flat thing to another.[35] Nevertheless, ideas first formulated by painters had found their most radical development in three dimensions, partly because the painters themselves had realized them as fully as it was possible in two dimensions. The next step was the Specific Object, and the fact that the best and most advanced painting—Judd implied that they were the same—had approached the Specific Object was further proof to him of its superiority.[36]

Despite his classification of Specific Objects, Judd claimed to spurn categories, insisting that history was not that neat. He included among Specific Object makers an assortment of artists: Assemblagists, such as John Chamberlain and Rauschenberg, because their combines were composed of "real objects in real combinations";[37] Oldenburg, whose works closely resembled the objects they recreated; Minimalists Morris and Flavin; as well as Shusaku Arakawa, Richard Artschwager, Ronald Bladen, Lee Bontecou, George Brecht, Alfred Jensen, Ed Kienholz, Philip King, George Ortman, Lucas Samaras, George Segal, Robert Watts, and H. C. Westermann.[38] However, given Judd's own premises, it would seem that Specific Objects that were the most object-like—that is, indivisible in shape, color, and surface—would be the most "intense, clear and powerful,"[39] and that the works that best fulfilled this requirement were his own and those of Morris, Flavin, and Andre.

Judd's conception of the Specific Object interested the art world, because the art he dealt with was new and problematic, because he was perceived as its spokesperson,[40] and because his style of writing was unusually matter-of-fact—like his art—to the extent of being provocative.[41] However, his implication that Specific Objects constituted a third medium, between painting and sculpture, embracing the variety of artists he claimed it did, was too broad to enter the formalist discourse of the sixties, the discourse that commanded most attention. The main issue in contention was the definition of the unique nature of painting and sculpture as distinctive arts. An in-between or hybrid medium was peripheral to this argument.

Morris recognized this, and in his "Notes on Sculpture," the first part of which was published at the beginning of 1966, he treated Minimal sculptures, or Unitary Objects, as he called them, from the vantage point of what made them sculpture-as-sculpture. His formalist or purist approach was derived from that of Reinhardt and particularly that of Greenberg, who conceived of modernism as a process whereby each of the arts progressively zeroed in on what made it autonomous and unique as an art. Greenberg interpreted painting in these terms, but he did not measure sculpture by the same criteria. His taste told him, he claimed, that the best modern sculpture was the open, welded construction of David Smith and Caro, which he viewed as essentially *pictorial*. Based on "drawing" in space with linear and planar elements, construction sculpture was liberated from the monolithic and thus was almost as visual as painting.

Greenberg had maintained that the goal of advanced painting was objecthood, that its primary concern was to accept the literal qualities of the rectangular, flat canvas. But he also asserted that the essence of painting was color, which was optical, appealing to the eye only, and not to the touch. Morris saw a contradiction in this dual development: "If painting has sought

to approach the object, it has sought equally hard to dematerialize itself on the way." He called for making clearer distinctions between "sculpture's essentially tactile nature and the optical sensibilities involved in painting."[42] Morris implied that Greenberg's preference in sculpture was a denial of his own formalist premises. This left the way open for Morris to apply Greenberg's "modernist reduction" to sculpture, whose nature was its object-hood, its literal, monolithic physicality. Morris asserted that Minimal sculpture was the logical and necessary development of sculpture-as-sculpture, the *legitimate* latest stage not only of modernist sculpture but of modernist art; like Judd, Morris believed that painting's unavoidable illusionism had made it "antique"—outmoded. As he said: "The Minimalist . . . redefinition for sculpture was as radical, as American, and as modernist as were the efforts which earlier transformed and redefined painting."[43]

In characterizing what made sculpture-as-sculpture not only qualitatively different from painting-as-painting but antithetical to it, Morris took issue with Judd. He asserted that the

> relief . . . cannot be accepted today as legitimate. The autonomous and literal nature of sculpture demands that it have its own, equally literal space—not a surface shared with painting. Furthermore, an object hung on the wall does not confront gravity; it timidly resists it. One of the conditions of knowing an object is supplied by the sensing of the gravitational force acting upon it in actual space. . . . The ground plane, not the wall, is the necessary support for the maximum awareness of the object.

Moreover, in disagreement with Judd, Morris claimed that color in sculpture was unacceptable, because its "essentially optical, immaterial, non-containable, non-tactile nature . . . is inconsistent with the physical nature of sculpture," and indeed subverts it. Therefore, only neutral colors, which do not call attention to themselves, were acceptable.

According to Morris, the physical qualities of sculpture are its "scale, proportion, shape, mass. Each of these qualities is made visible by the adjustment of an obdurate literal mass." To maximize these physical properties, "simpler forms which create strong gestalt sensations" are necessary, particularly the regular polyhedrons, such as cubes and pyramids. In experiencing these, "one need not move around the object for the sense of the whole, the gestalt, to occur. One sees and immediately 'believes' that the pattern within one's mind corresponds to the existential fact of the object."

Sculptures "dominated by wholeness" were apprehended as gestalts—that is, as constant, known shapes. "Characteristic of a gestalt is that once it is established all the information about it, *qua* gestalt, is exhausted. . . . Furthermore, once it is established it does not disintegrate. [It] remains constant and indivisible." However, Morris insisted:

> Simplicity of shape does not necessarily equate with simplicity of experience. [Scale,] proportion, etc., are not thereby canceled. Rather they are bound more cohesively and indivisibly together. The magnification of this single most important sculptural value, shape, . . . makes on the one hand the multipart, inflected formats of past sculpture extraneous, and on the other, establishes both a new limit and a new freedom for sculpture.[44]

What its "new freedom" would be became a central theme in Morris's subsequent articles.

In Part 2 of his "Notes on Sculpture," Morris reasoned that to be experienced as sculpture, an object had to exist somewhere between monument and ornament, between architecture and jewelry. The measure of sculpture-as-sculpture was the viewer's body, which imposes qualities of distance or intimacy, of "publicness or privateness . . . on things." By its nature, sculpture was public and opposed to intimacy. Consequently, sculpture-as-sculpture should aspire to "publicness" by

avoiding small-scale, "intimacy-producing relations," such as segmentation into parts, color, specific "sensuous material or impressively high finishes," signs of process, and other "details" that separate themselves from the whole and set up internal relationships.[45]

But when relationships were taken out of a work, they were transferred to the context in which it was shown.[46] Thus Morris was led to take into account changeable light and the viewer's field of vision, expanding the realm of sculpture's freedom, as it were.[47] Morris was aware of a contradiction in his reasoning. On the one hand, as a gestalt, the simple Unitary Object resisted becoming environmental. On the other hand, lacking internal rela-

123. Robert Morris, *Floor Piece*, 1964. 17″ × 17″ × 288″. Installation photo, Green Gallery, New York, 1964.

tionships, it established or could not help establishing relationships with its environment, leading the viewer to become aware of the intricate variations its "constant known shape" undergoes while the work is being experienced. He tried to have it both ways. The Minimal sculptor carefully placed a unitary object into its environment. This did not entail "a lack of interest in the object itself." It was not less important. "But the concerns now are for . . . the entire situation [involving] the variables of object, light, space, body." Morris concluded: "The situation is now more complex and expanded." Thus, in the view of Morris, Minimal sculpture ended up by emphatically calling attention to a work's setting and the viewer's awareness of him-

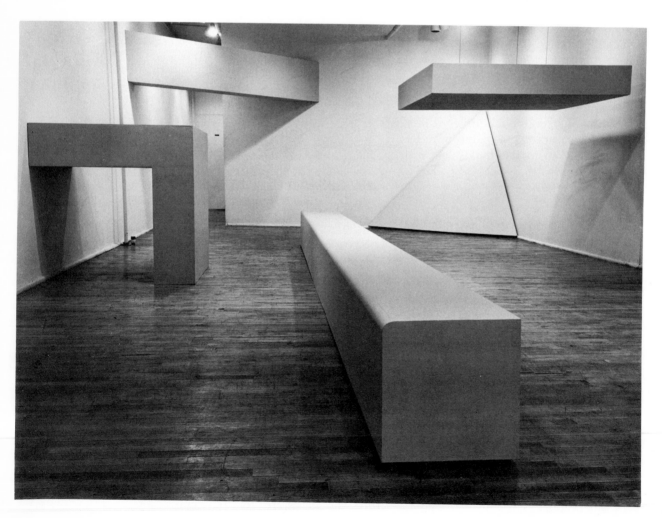

self or herself existing in the same space as the work, or of the "situation." Taking the Unitary Object's "spatial setting" into consideration as an integral component of sculpture led to the next step—and it was a short one—to make a work of the environment, not only in an indoor space but out of doors as well. Morris himself asked: "Why not put the work outside and further change the terms? A real need exists to allow this next step to become practical."[48] Thus was sculpture further liberated.

Tony Smith, one of Morris's professors, whose sculpture was often labeled as Minimalist, was also speculating about environmental art—more daringly than Morris. In an interview about his sculpture, Smith digressed to talk about a drive he took one night on the unfinished New Jersey Turnpike. The road and its surroundings had overwhelmed him as no conventional art ever had. And yet such phenomena were not identified as art. Smith remarked: "I thought to myself, it ought to be clear that's the end of art. Most painting looks pretty pictorial after that."[49] But he could conceive of no way that his experience of the landscape could be transformed into art. Smith's problem would be taken up as a challenge by other artists of the late sixties, and they would offer novel solutions.

As I remarked, Morris used Greenberg's ideas to claim that Minimal sculpture was the logical latest phase of modernist art, dismissing painting and "pictorial" sculpture as outmoded. And the Minimalists made themselves heard. In 1966, the topic "Is Easel Painting Dead?" was seriously debated by the art world.[50] In the face of Morris's challenge, Fried took up the standard of formalist art, urgently pressing its claim as the rightful heir of modernism. And on the attack, he condemned the Minimalists as heretics, the enemies not only of the authentic modernist art of our time but of art itself. He would "break the fingers of [their] grip" on the issues for modernist painting and sculpture.[51]

Fried acknowledged Morris's assertion that there was a conflict between the demands of the physical picture support and immaterial, optical color, between literalism and illusionism, and that this conflict was the central issue of modernist painting. Fried claimed, however, that the conflict had been resolved shortly before 1960 with the discovery of a new *"pictorial structure based on the shape rather than the flatness,* of the support. With the dissolution . . . of the flatness of the support by the new optical illusionism, the shape of the support—including its proportions and exact dimensions—came to assume a more active, more explicit importance than ever before."[52] Thus shape that belonged to painting was as crucial to Fried as literal shape in sculpture was to Morris.

Fried needed to reclaim shape for painting so that painting could be both object *and* illusion. He pointed out that Minimalism's preoccupation with literalness derived from advanced painting in the first place. But he rejected the assertion of Judd and Morris that their "wholly literal" objects had advanced beyond advanced painting, whose inherent illusionism had compromised its objecthood. Fried countered that Minimalism was not an advance but a reduction, an impoverishment, of modernist art. Minimalism had isolated and settled for only one component in the dialectic between literal shape and illusionistic space. Noland, Olitski, and Stella had synthesized the two and, thus, had renewed art.

As Fried saw it, Stella's role was central. He had been "crucial to the literalist view" but had gone beyond it in his latest paintings, which "depart from his stripe paintings in two general respects—first, by not acknowledging literal shape, and second, by resorting to illusion—both of which ought to make them unpalatable to the literalist sensibility."[53] To put it another way, Stella's picture had progressed from being a literal object to being a flat shape whose surface could maintain a certain amount of illusion, which was inescapable in painting, in any case.

Fried's initial assault on literalism was not sufficient to bury it, so he continued the attack in 1967 in what became his most famous article, "Art and Objecthood." He declared that Minimal Art led to the perversion not only of modernist art *but of art itself.* The reason was that objecthood had become art's irreconcilable enemy. But objecthood had long been the goal of formalist painting, that which made it unique and thus what it ought to aspire to, a view formulated by Greenberg and accepted by Fried. Fried had believed that "the entire history of painting since Manet could be understood . . . as consisting in the progressive . . . revelation of its essential objecthood."[54] Why was a drastic reversal of this position necessary? Because in creating literal objects devoid of internal relationships, Minimal sculptors had directed the viewer's attention to the external relationships between the works and their environment, an environment in which the viewer was included as a kind of "actor." Zeroing in on the potential contradiction in Morris's formulation, Fried claimed that art concerned with its "situation" was inherently theatrical, because it subverted the autonomy of the work. He concluded that "the literal espousal of objecthood amounts to nothing other than a plea for a new genre of theater; and theater is now the negation of art."

To clinch his case, Fried shifted from Morris to Tony Smith, implying that Smith's thinking was a necessary extension of Morris's. Quoting Smith's description of his nocturnal automobile ride on the unfinished New Jersey Turnpike, Fried commented: "What seems to have been revealed to Smith that night was the pictorial nature of painting—even, one might say, the conventional nature of art. And *this* Smith seems to have understood, not as laying bare of the essence of art, but as announcing its end." Fried asserted that Smith's experience was that of *"theater"* (not, as Smith believed, of self-transcending reality). "It is as though the turnpike

. . . reveal[s] the theatrical character of literalist art, only without the object, that is, *without the art itself."* Thus "the theatricality of objecthood" made it the enemy of art, and made it necessary that modernist painting defeat its objecthood as the cause of theater. "And *this* means that there is a war going on between theater and modernist painting, between the theatrical and the pictorial." The war was also raging in modernist sculpture, despite the fact that sculpture was inherently three-dimensional. Fried quoted Greenberg as saying that the new construction sculpture aspired to "render substance entirely optical . . . incorporeal, weightless, and [to exist] only optically like a mirage." In Fried's opinion, Caro's work, in particular, resisted being seen in terms of objecthood.[55]

Fried branded as theatrical not only Minimal Art but the work of Kaprow, Joseph Cornell, Rauschenberg, Oldenburg, Kienholz, Segal, Samaras, Christo—"the list could go on indefinitely"—just as Greenberg had lumped together Minimal, Assemblage, Pop, Environment, Op, and Kinetic Art as Novelty Art.[56] In actuality, it was Cage who had championed a theatrical art; he claimed that all of the arts ought to break down the barriers between art and life and aspire to the condition of theater. Cage should have been Fried's primary enemy, but Fried singled out Judd and Morris instead, even though or, more accurately, precisely because they made claims for Minimalism similar to his for formalism. It was as if in his urgent need to dissociate Minimalism and formalism, Fried attributed to Minimalism theatricality, the chief aspiration of the art most opposite to both—namely, Cage's. Fried's tactic was a kind of guilt by association. He might have rejected Minimalism by declaring that it was the wrong kind of modernism, but he wanted to banish it beyond the pale completely.

In so banishing Minimalism, Fried could call into question its aesthetic quality, because, as he wrote: *"concepts of quality*

*and value . . . are meaningful, or wholly meaningful only* within *the individual arts,"* whose areas of competence and traditions could be defined.[57] Conventional painting and sculpture each met this test, but Minimal objects did not, because Judd had defined them as neither painting nor sculpture. (Morris disagreed with Judd, but Fried disregarded that.) Supporters of Minimal Art rebutted by claiming that it possessed quality but that formalists could not apprehend it because their appetites for formalist art got in the way of taste. As Smithson, who became a formidable opponent of Fried, wrote:

> The viewer, be he an artist or a critic, is subject to a climatology of the brain and eye. The wet mind enjoys "pools and stains" of paint. . . . Such wet eyes love to look on

melting, dissolving, soaking surfaces that give the illusion at times of tending toward a gaseousness, atomization or fogginess. This watery syntax is at times related to the "canvas support."

> The artist or critic with a dank brain is bound to end up appreciating anything that suggests . . . liquid states. . . . They prize anything that looks drenched, be it canvas or steel.[58]

Critics influenced by Greenberg, notably Rose, Krauss, and Leider, who embraced Minimal sculpture, would not allow Fried to co-opt quality for formalist art. They insisted that Minimal sculpture was sculpture and that its quality resided in its rightness of proportion, scale, surface, and spatial interval. These critics had to cope with the tough rhetoric of Minimal sculpture, and in the end ignored it. As

124. Anthony Caro, *Georgiana*, 1969–70. 5′ × 15′3″ × 8′. Albright-Knox Art Gallery, Buffalo, N.Y.

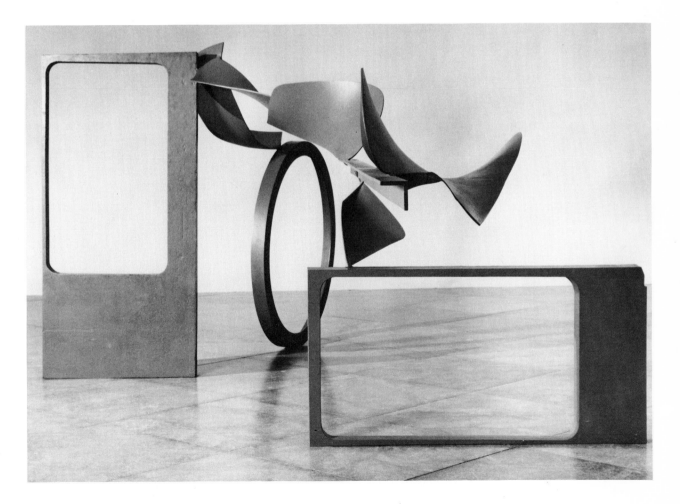

Krauss wrote: To approach Judd's work from within the frame of reference that it was "brute physical presence,"

> one is totally unprepared for the extraordinary beauty of the sculptures themselves, a beauty and authority which is nowhere described or accounted for in the polemics of object-art which leads one to feel all the more acutely the inadequacy of the theoretical line, its failure to measure up (at least in Judd's case) to the power of the sculptural statement.[59]

So avid was Fried in his war against objecthood that he disregarded distinctions between sculpture and painting altogether. Instead, he sought a common denominator, some quality found in no other art, and discovered it in "presentness." As theater, Minimal sculpture was experienced in time. It had "presence," a kind of stage presence. In contrast, formalist art had "presentness"; the work of Noland, Olitski, and Caro *"has* no duration . . . because *at every moment the work itself is wholly manifest."* In its "instantaneousness," it defeated theater. "Presentness" was a quality possessed by no art other than visual art and thus was its "true" nature. Fried's final sentence took on a mystical aura, rare in sixties aesthetics: "Presentness is grace," because it transcended the physical, the temporal, the ordinary state of the world.[60]

Fried's "Art and Objecthood" was the last formalist salvo against Minimalism that commanded art-world attention. The leading formalist artists were established and their numerous followers did not generate much enthusiasm, except in narrowing formalist circles, since Rose, Krauss, Leider, and others had joined the Minimalist enemy. Greenberg and Fried cut back their art critical writing, Greenberg directing his attention to aesthetic issues, and Fried, turning increasingly to art history, reexamining the roots of modernism

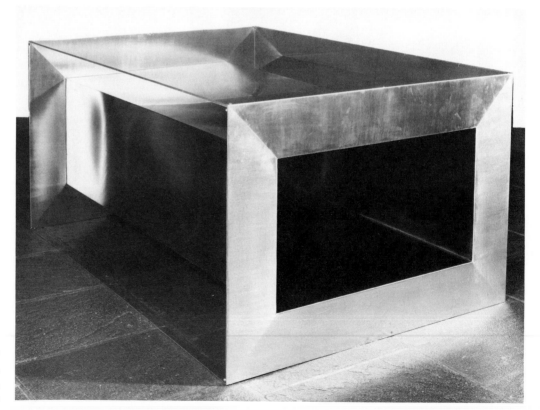

125. Donald Judd, *Untitled,* 1968. 33″ × 68″ × 48″. Whitney Museum of American Art, New York.

in what seemed in part an attempt to establish art historical precedents for his claims about art and objecthood.

Minimalist writers also lost interest in the controversy. Judd stopped writing and Morris turned to other aesthetic issues. As in the case of formalism, there seemed little that was new and relevant to current art to say about Minimalism. The latter had become increasingly familiar and established after 1966, with the *Primary Structures* show at the Jewish Museum. Art-world interest shifted elsewhere—for example, to Process Art, Earth Art, and Conceptual Art.

Although there was a common denominator in Minimal sculpture—just as there was in Pop Art—it was the most common of denominators and was not as interesting as what distinguished the artists it labeled.

Judd's antipathy toward illusionism led him to abandon painting in 1961 and to turn to three-dimensional construction.

The urge was for wholeness and for a stronger physical presence. He hoped, as Roberta Smith summed it up, "to make it clear that art is and has always been an object, and what makes objects art is . . . the way they separate from the world and [provide] access to the artist's ideas and decisions about structuring experience."[61]

Judd's show in 1963 consisted of open frames, boxes, and ramps composed of wood and pipe. They were painted a light cadmium red, because it was a strong color and defined forms sharply. These pieces include most of the features found in Judd's later Minimal works—the enclosed volume whose interior is visible, the repetition of modular elements, and symmetrical arrangements. In 1964, Judd focused on relief, constructing boxes and cantilevering them off walls. He then had them fabricated in galvanized iron. Of the change in medium, Judd remarked that metal was harder and provided a "thin-

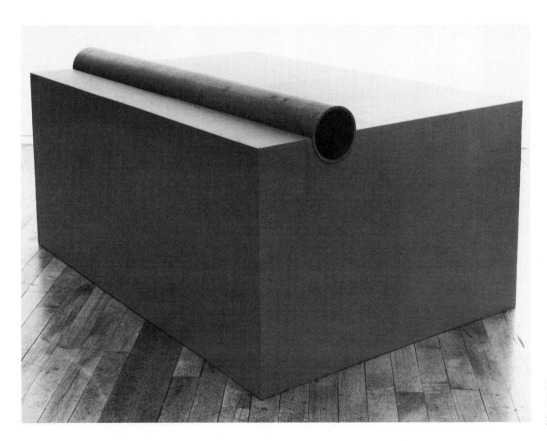

126. Donald Judd, *Untitled*, 1963. 19½″ × 45″ × 30½″. Philip Johnson.

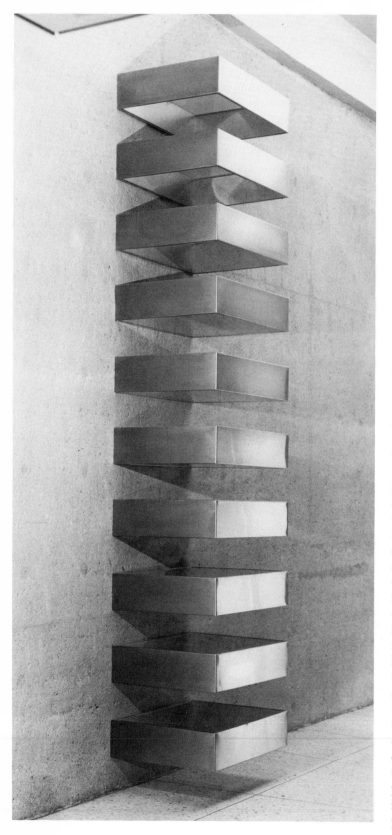

ner, more shell-like surface," which defined interior space more rigorously. "Also I wanted to get out of painting pieces."[62]

Judd stacked his boxes vertically or suspended them horizontally from pipes. He liked "the stack going from floor to ceiling [because] it's not a column and not resting on its base," and therefore did not refer to the human figure.[63] The stack's lightness and structural tension also appealed to him. Each of the elements in these works is isolated—calling attention to itself as a Specific Object—and yet it is part of a whole, arranged according to mathematical progressions, this providing an order that did not require composing. Judd adopted *arrangement* because it avoided traditional composition, "a balancing of major and minor parts, one against the other, into a hierarchical structure in which" parts were neither equal nor clear. Traditional composition reflected a "larger idea of order and an acceptance of a scheme which is exterior to the work of art." Like illusionistic space, it referred to "something else, which dilutes the immediate experience of art."[64]

In time, Judd used metals other than galvanized iron, his repertory including hot-rolled, cold-rolled, perforated, and stainless steel, brushed and anodized aluminum, copper, and brass. He sometimes sprayed the surfaces with industrial enamel and lacquer. He also introduced colored Plexiglas because its color was inherent in the material and transparent enough to be seen through, exposing the inner volumes of the boxes and thus eliminating mystery and ambiguity. Judd's hollow boxes are distinguished not only by their nonrelational composition and industrial materials and processes but by their immobility. As he said: "I am interested in static visual art and hate imitation of movement," which he believed was another kind of illusionism.[65] In the late sixties, Judd concentrated on large floor pieces, often composed of perforated surfaces, emphasizing more than before simplicity, openness, and clarity.

By 1968, Judd's literalist rhetoric no longer seemed as convincing as it had. Elizabeth Baker for one called into question his blunt denial that his works were "sculptures" and his assertion that they owed nothing to European art. On the contrary, she wrote, they grew out of an international "mainstream of geometric abstraction." Moreover, they had come to look handsome and sensuous, and Baker could remark on "slithery reflections coming off satiny surfaces."[66]

Unlike Judd, who aspired to literalism and rejected ambiguity and enigma, Morris embraced objecthood even while undercutting it, often ironically. Thus, he introduced ideas culled from Duchamp and Johns into Minimal Art. Early in his career, Morris was preoccupied with the continuity of process and product, more specifically with how to get the process to show in a work. As he saw it, this problem had been posed by Pollock, but unlike Pollock, Morris was unable to solve it in painting, and so he turned to construction. There he succeeded, as in the first of a series of objects he began to make in 1961, *Box with the Sound of Its Own Making*. A walnut box containing the three-hour-

long tape-recorded sounds of its own fabrication, it exemplifies process in a finished object. This piece also links present real time (the existing object) with past time (the process of its making), another concern of Morris. For example, *Metered Bulb*, 1963, is a readymade light bulb with its own readymade meter, which gives the present reading of light expended in the past. The process-product dialectic would engage Morris throughout the sixties.

In appearance, *Box with the Sound of Its Own Making* is a Unitary Object, as are other boxes, such as *I Box*, 1962, in which an I-shaped door opens on a photograph of the artist standing naked, presenting himself as a kind of performer, much as Duchamp had in photographs of himself. During 1962, Morris also staged a seven-minute theatrical performance at the Living Theater, whose "actor" was a plywood column, two feet square and eight feet high. The "plot" consisted of the column standing upright for half the duration of the performance and then, pulled over, lying for the remaining half. This object was included in Morris's show in 1963.

Morris's next move, perhaps in response to an emergent formalism, was to re-

FACING PAGE:
127. Donald Judd, *Untitled*, 1968. Ten units, each 9″ × 40″ × 31″; height 14′3″. State of New York, Nelson A. Rockefeller Empire State Plaza Art Collection.

128. Donald Judd, *Untitled*, 1968. Overall 48⅜″ × 120″ × 121″. Museum of Modern Art, New York.

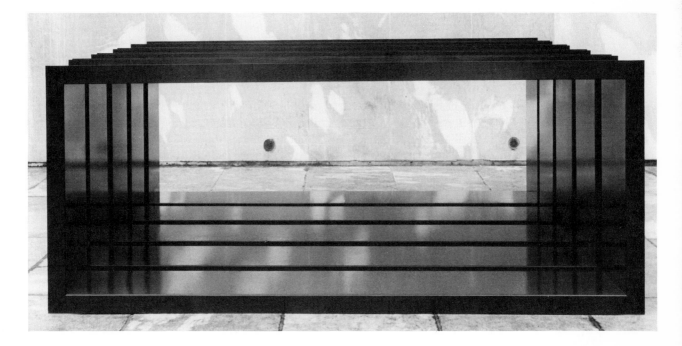

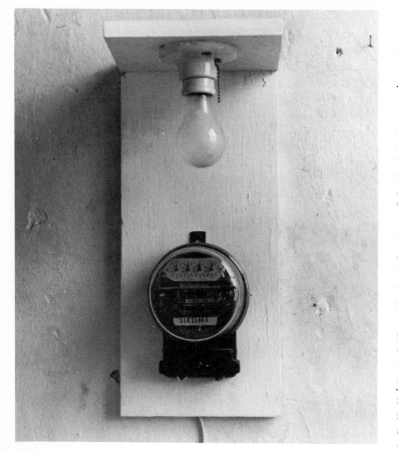

129. Robert Morris, *Metered Bulb*, 1963. c. 24″ × 12″. Jasper Johns.

rectly to the gallery space—e.g., a corner piece that fits into the corner of the room or a piece cut so as to lean obliquely between wall and floor—reducing the objecthood of the work and anticipating Morris's later environments. Moreover, the bulky shapes were painted a pale gray, an equivocal cast of "color" that shrouds materiality. The subversion of objecthood was most extreme in a 1965 piece composed of four boxes, each twenty-eight inches square and covered with mirrors. They are static, inert, and yet they reflect the flux of things in changing light and the activities surrounding them. Tangible objects, they become invisible because they dissolve into their environment through the illusion of their mirrored surfaces.

In 1965, Morris also began to compose many of his Unitary Objects from off-white fiberglass, which the viewer knew to be hollow, again undermining their objecthood. The most enigmatic of these sculptures is a ring with two slits that allow slices of light to escape from the fluorescent-lit interior space just where one would normally expect shadow. Moreover, as Lippard wrote,

instead of opening up the compact volume it adds to the closed quality of its secrecy, specifically alluding to the hollowness of the shell while continuing to deny direct experience of that inner space, referring the viewer back to the impassive exterior. Morris's work, despite its conceptual stringency, has always had this air of mystery.[68]

From 1965 through 1968, Morris put his hollow-centered Unitary Objects through variations and permutations, using a variety of simple forms—circular, oval, tapered square, triangular wedge, etc.—and diverse materials—steel mesh, aluminum, wood, granite, etc. A number of identical L-shapes were each placed in a different position, suggesting a process of change in time. Other modular pieces, whose parts could be put in varied arrangements, were made of heavy wire mesh, which at once revealed and obscured interior

duce—but not eliminate—the Duchampian component in his work. He also suppressed temporarily any sense of process. In 1964, Morris exhibited a roomful of simple, geometric volumes at the Green Gallery. They were the most object-like of his works, relating directly to the articles on sculpture he began to publish in 1966 in *Artforum.* As he saw it, these Unitary Objects purified sculpture into what it alone was. At the same time, they seemed unrelated to past sculpture, and if they called to mind anything, it was mass-produced objects, industrial-type manufacturing—standardization and repetition.[67] It was this that made them problematic as art to the public.

Although the volumes in the 1964 show were each meant to be self-contained, indivisible, and perceived immediately in their entirety, they appeared to relate di-

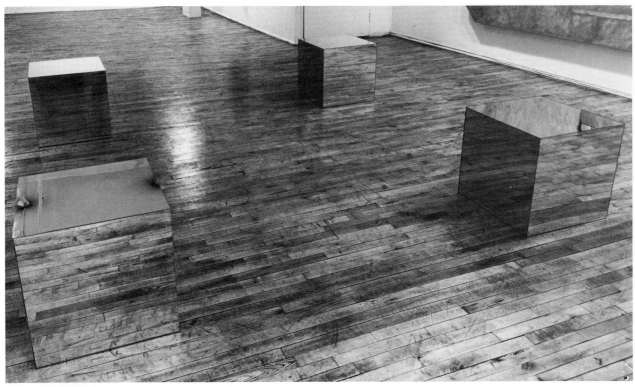

130. Robert Morris, *Untitled*, 1965. Four boxes, each 21″ × 21″ × 21″. Green Gallery, New York, 1965.

131. Robert Morris, *Untitled*, 1965–66. 24″ × 14″ × 97″ in diameter. Dallas Museum of Fine Arts.

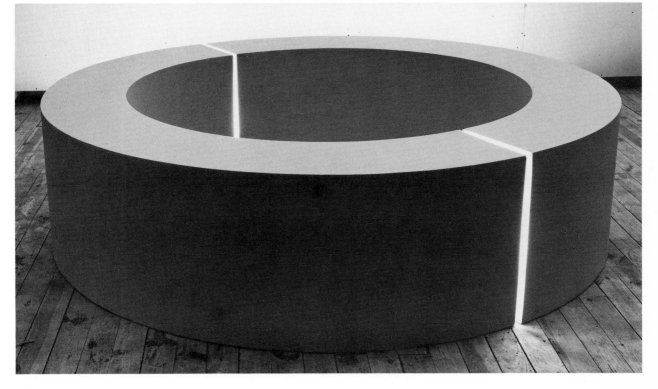

spaces. Between 1967 and 1969, Morris constructed open structures in aluminum and steel, often using I-beams, which verged close to Judd's works of the same time.

Even as he continued to explore the possibilities of *form,* Morris turned to what he considered its dialectical opposite, *matter.* Instead of fabricating "finished" objects, he manipulated materials that were "formless," whose form was changeable and open-ended. As Morris wrote in 1967, he wanted to find materials that were not determinate or indeterminate, that he could not preset; soft materials met his requirements. With an eye to Oldenburg and Joseph Beuys, he chose gray felt, because he could preconceive cutting it according to geometric progressions. But having done that, any arrangement shaped by the process of gravity was

acceptable.[69] Because the material was changeable, the resulting form had to be indeterminate. It could never be final, and because it was changeable, the work acknowledged the passage of time. Just as Morris equivocated with form, he now equivocated with "anti-form" by imposing a geometric order of cuts.

In 1970, Morris exhibited a ninety-six-foot piece composed of heavy timbers among which huge, precariously tipped concrete blocks were strewn. In this, the major work in his retrospective show at the Whitney Museum, Morris attempted a synthesis of Minimal form and "formlessness," revealing the process of its assembling by inviting the public to its installation, which he considered part of the work. (The invitation was withdrawn because the installation was deemed too dangerous.) Morris's investigations of

132. Robert Morris, *Untitled (L-beams),* 1965. Each 96″ × 96″ × 24″. Whitney Museum of American Art, New York.

FACING PAGE: 133. Robert Morris, *Untitled,* 1969. 180½″ × 72½″ × 1″. Museum of Modern Art, New York.

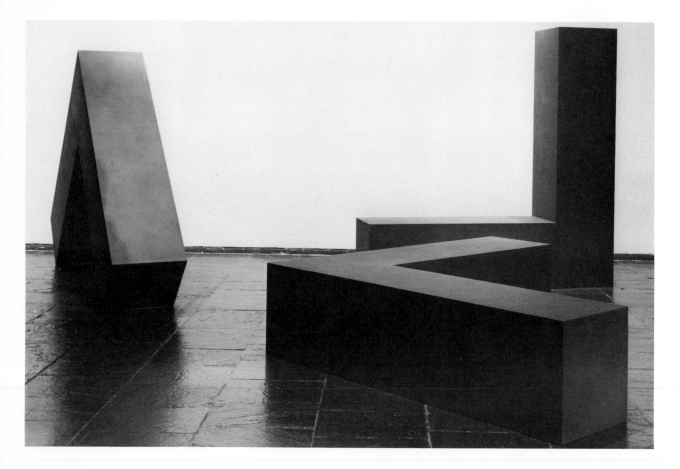

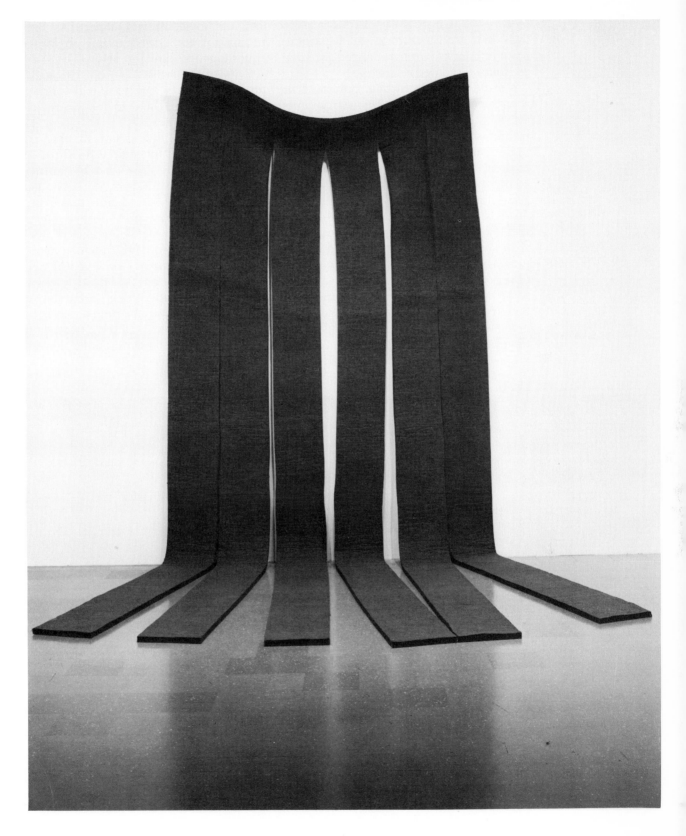

"formless" materials would eventually lead him to Earthworks and extreme manifestations of dematerialized art, such as works composed of steam.

Morris headed an article published in *Artforum* in 1970 with a quote from Ferdinand de Saussure: "Between the two extremes—a minimum of organization and a minimum of arbitrariness—we find all possible varieties."[70] More than any of his contemporaries, Morris grasped the idea that filling out paradigms at the extreme limits of art—the boundaries at which art seemed to become nonart—was central in sixties art. And he chose to fill out all the paradigms himself, even those of which he was not among the innovators. In this sense, Morris can be considered the master strategist of sixties art, a "cerebral gymnast," as Lippard called him,[71] scuttling between Duchamp and Greenberg, finished form and unfinished process, ob-

ject and idea, art and nonart. As Rose summed it up in 1965, ultimately Morris "questions the limits of art and the very activity of the artist. [Yet] Morris's sculpture manages to survive the theoretical lead it must bear and to remain, as art, elegant and expressive."[72]

Dan Flavin's fluorescent fixtures are reminiscent of Duchamp's Readymades because they are store-bought "works" not "created" by the artist. Moreover, like Duchamp, he called them "proposals," not sculptures, because he considered them to be the sketching out of fully formed ideas, frequently modular or serial, as in *Monument 7 to V. Tatlin* and *The Nominal Three*. In their systemic arrangement and literal presence as industrial objects emanating actual light, Flavin's reliefs are closely related to Judd's Specific Objects. Judd himself wrote:

134. Robert Morris, installation view of *Untitled*, 1970, during the exhibition *Robert Morris*, Whitney Museum of American Art, New York. Photo © Peter Moore.

FACING PAGE: 135. Dan Flavin, *Pink Out of a Corner—To Jasper Johns*, 1963. 96″ × 6″ × 5⅜″. Museum of Modern Art, New York.

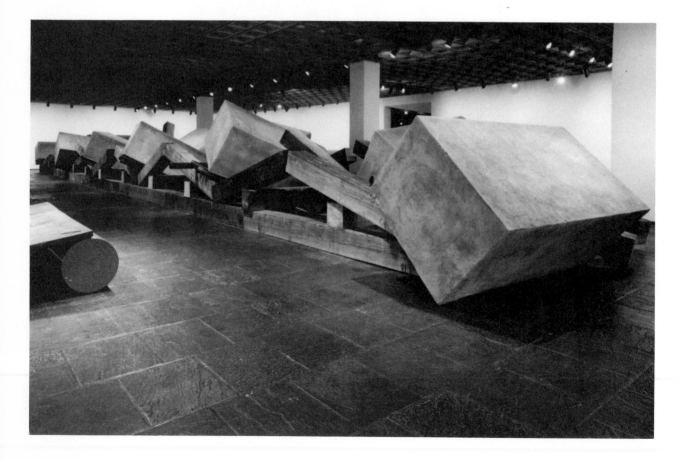

Three main aspects of Flavin's work are the fluorescent tubes as the source of light, the light diffused throughout the surrounding space or cast upon nearby surfaces, and the arrangement together or placement upon surfaces of the fixtures and tubes. The lit tubes are intense and very definite. They are very much . . . particular . . . phenomena.[73]

Flavin's earlier works, begun in 1961, were less literal than the fluorescent fixtures. They were painted square constructions against which electric lights were deployed. Flavin referred to them as "icons"—one of 1963 was subtitled "the martyr's crown." But, as he elaborated in 1962,

> my icons differ from a Byzantium Christ held in majesty; they are dumb—anonymous and inglorious. They are as mute and undistinguished as the run of our architecture. My icons do not raise up the blessed saviour in elaborate cathedrals. They are constricted concentrations celebrating barren rooms. (Space). They bring a limited light.[74]

Later, Flavin claimed to have used the word "icon" not to describe a religious object but to indicate that real electric illumination was of a higher order than painted light.[75]

Flavin attributed a spiritual signification to the first fluorescent piece he conceived, "a common eight-foot strip with fluorescent light of any commercially available color. At first I chose 'gold.' " He declared the diagram of this work *"the diagonal of personal ecstasy (the diagonal of May 25, 1963)."* Comparing it to Brancusi's *Endless Column,* he commented that the Brancusi "was like some imposing archaic mythologic totem risen directly skyward. The *diagonal . . .* had potential for becoming a modern technological fetish"[76]—the illumination, in the spiritual sense of the word, of a mass-produced artifact. He also thought of his light fixtures as suggestive of the sublime, since, quoting Kant, he pointed out, that was "to be found in a formless object so far as in it, or by occasion of it, boundlessness is represented.[77]

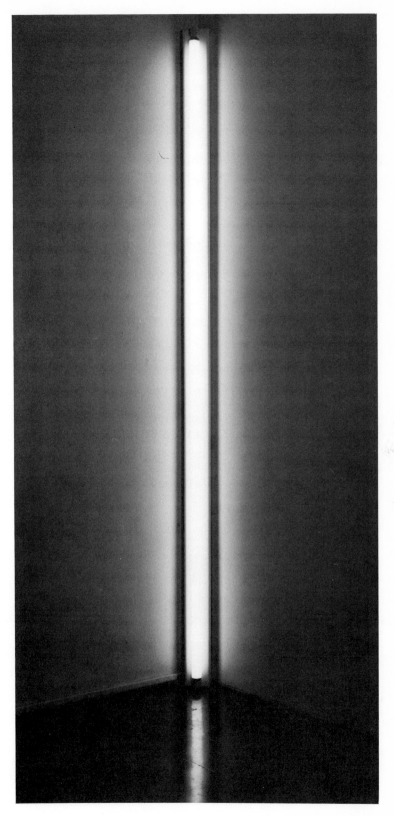

Flavin was also thinking of Russian Constructivism. Of *Monument 7 to V. Tatlin*, 1964, Flavin wrote:

> This dramatic decoration has been founded on the young tradition of a plastic revolution which gripped Russian art only forty years ago. My joy is to try to build from that "incomplete" experience as I see fit.
>   *Monument 7* in cool white fluorescent light memorializes Vladimir Tatlin, the great revolutionary, who dreamed of art as science.[78]

Flavin's statement exemplifies the personalist or, as it were, self-expressive strain in Minimal Art, using the word "joy" and the term "as I see fit" for the manner in which, the free will with which, he hoped to extend Tatlin's Constructivism. It is also noteworthy that Flavin used the word "dreamed," a highly subjective word.

Like Tatlin's reliefs and Duchamp's Readymades, Flavin's works "lack the look of history,"[79] although pieces composed of vertical fluorescent tubes on a wall do appear to be concretizations of Newman's "zips" in a color-field. Flavin's conception of his fluorescent tubes as "spiritual" changed as he came to understand the work of Tatlin and also of Johns and Stella. Their work revealed to him the value of objects as physical phenomena—in his own case, the value of untransformed fluorescent fixtures and their lights. Indeed, Flavin's pieces seem to signify only what they are. As Ira Licht observed: "The unchanged hardware . . . escapes metaphor and symbolism."[80] Flavin dedicated a work titled *The Nominal Three*, 1963–64, to William of Ockham, an English Franciscan scholastic of the fourteenth century, because he had argued that "reality exists solely in individual things and universals are merely abstract signs."[81]

To emphasize objecthood, Flavin had to articulate the literalness of both the artifact and its illumination. He wrote that

> the physical fluorescent tube has never dissolved or disappeared by entering the physical field of its own light. . . . At first sight, it appeared to do that . . . but then, with a harder look, one saw that each tube maintained steady and distinct contours. . . . The physical fact of the tube as object in place prevailed whether switched on or off.[82]

Light spreads into its actual surroundings, the illumination turning the work into an instant environment. Flavin became aware of this when he made his first diagonal fixture. As he wrote:

> Now the entire interior spatial container and its parts—wall, floor and ceiling, could support this strip of light but would not restrict its act of light except to enfold it. . . . Realiz-

136. Dan Flavin, *The Nominal Three (to William of Ockham)*, original 1964, reconstruction 1969. 96″ high. National Gallery of Canada, Ottawa.

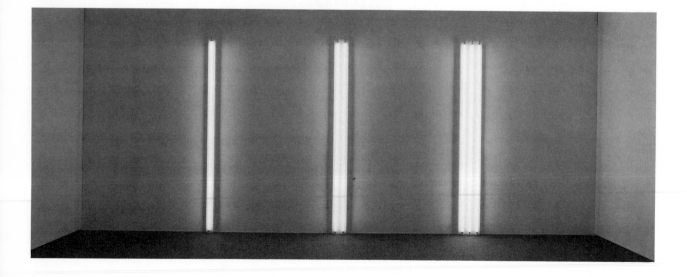

ing this, I knew that the actual space of a
room could be broken down and played with
by planting illusions of real light (electric
light) at crucial junctures in the room's com-
position.[83]

This led Flavin to propose "a sequence of
implicit decisions to combine traditions of
painting and sculpture in architecture
with acts of electric light defining
space."[84] And he articulated entire rooms,
corridors, and architectural spaces with
light.

By 1964, Flavin was using a variety of
arrangements and diverse colored lights.
This work is much less stark and ungiving,
much more sensuous and decorative.
Flavin himself accepted the decorative; of
*untitled (to the "innovator" of Wheeling
Peachblow)*, 1966–68, he wrote:

> The corner installation was intended to be
> beautiful, to produce the color mix of a
> lovely illusion. . . . I did not expect the
> change from the slightly blue daylight tint
> on the red rose pink near the paired tubes to
> the light yellow mid-way between tubes and
> the wall juncture to yellow amber over the
> corner itself.[85]

Carl Andre's ready-made, rectangular
metal plates in modular or serial arrange-
ments emphasize their objecthood, much
as Flavin's fluorescent fixtures do, except
that where the latter focused on the liter-
alness of lightweight hardware and im-
material light, Andre's works stressed the
physicality of weighty matter.[86] Indeed, of
Minimal pieces, they most resembled
things, even though their rug-like appear-
ance seemed to deny the kind of volume
generally associated with objects—and
with Minimal sculpture; Andre was the
only sculptor identified with Minimalism
who never fashioned a hollow box. Leider
wrote that Andre had carried sculpture

> to a greater literalism than anyone ever
> imagined. It was a literalism, first and fore-
> most, of materials, a matter not of truth *to*
> materials but the truth *of* materials . . . a new
> kind of truth . . . based so nakedly and explic-
> itly on the facts of the real world as to sug-
> gest a revitalized and wholly different

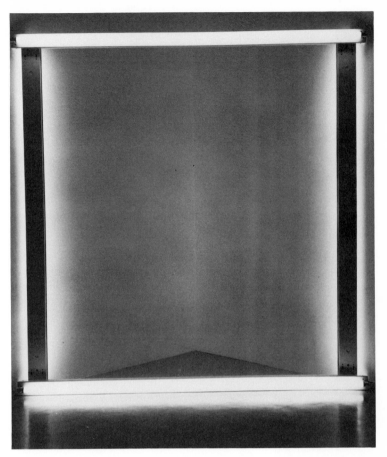

"realism." One such fact of the real world,
for example, with which sculpture had to be
made entirely congruent, was gravity, and
we find Andre conceding the victory, almost
with indifference to sculpture's age-old
struggle with gravity.[87]

Andre believed that modern sculpture
had evolved from "form" to "structure" to
"place."[88] This was the course of his own
development. In his early work, he cut
into wood to create form in the manner of
Brancusi. He went on to pile up timbers in
the way Brancusi had piled up "things
(pedestals and bases) and also structures
(benches and arches and tables like those
in Philadelphia)."[89] Brancusi's modular
*Endless Column* in particular "was the su-
preme inspiration."[90] As influential on
Andre's development as Brancusi was
Stella, whom Andre would call his last
teacher.[91] In 1959, Andre had witnessed

137. Dan Flavin,
*Untitled (to the
"innovator" of
Wheeling Peachblow)*,
1968. 96½" × 96¼"
× 5¾". Museum of
Modern Art, New
York.

the development of the black-stripe paintings while working in Stella's studio (because he lacked one of his own). Andre was particularly impressed by Stella's self-critical attitude, by the rigor with which he approached art.[92]

It was at this time that Andre arrived at the "basic principle [of] anaxial symmetry: any part can replace any other part."[93] His major early work was *Cedar Piece*, 1959,

> consisting of 19 tiers of notched, interlocking lengths of wood, each 36 1/4 inches long. . . . Each of the four elevations of *Cedar Piece* is identical, a stepped progression of modular elements that is symmetrical from side to side and from top to bottom. . . . The serrated contours and internal symmetries relate to Frank Stella's stripe paintings, while the overall structure implies a potential continuation, as in Brancusi's *Endless Column*.[94]

(Andre was probably not aware then that in 1920, Alexandr Rodchenko had stacked square timbers on vertical and horizontal axes in *Construction of Distance*.)

About his progression from woodcarving to using unworked material, Andre wrote: "Rather than cutting into the material, I use the material as the cut in space."[95] He stacked these "cuts"; his one-person show in 1965 consisted of three vertical pieces, each composed of nine-foot Styrofoam beams. Andre soon turned from stacking materials to using them "in a way that would be place-generating,"[96] dependent on the site in which they would be situated. The first of these site pieces, *Lever,* was exhibited in the *Primary Structures* show at the Jewish Museum in 1966, and created more controversy than any other piece on display. Consisting of 137 firebricks in a row, it was installed so that it could be viewed from either of two directions. Andre said of it: "All I'm doing is putting Brancusi's *Endless Column* on the ground."[97] In his one-person exhibition titled *Equivalents,* in that same year, he exhibited eight rectangular arrangements, each composed of 120 sand-lime bricks in different combinations—two layers of $3 \times 20$, $4 \times 15$, $5 \times 12$, and $6 \times 10$—and aligned them with the room in mind. Andre's most site-specific piece was his next one, *Cuts,* 1967, in which he covered the gallery floor with concrete-block capstones, leaving eight rectangular cavities, "negative sculptures," approximating the pattern and proportions of *Equivalents.*

Andre called his bricks particles, and he soon began to use standardized squares of metal—aluminum, steel, iron, magnesium, copper, zinc, and lead—one metal to a sculpture. He conceived of the periodic

138. Carl Andre, *Lead Piece (144 Lead Plates 12" × 12" × ⅜")*, 1969. Overall ⅜" × 144⅞" × 145½". Museum of Modern Art, New York.

FACING PAGE:
139. Carl Andre, *Timber Spindle Exercise*, 1964. 33" × 8" × 8". Museum of Modern Art, New York.

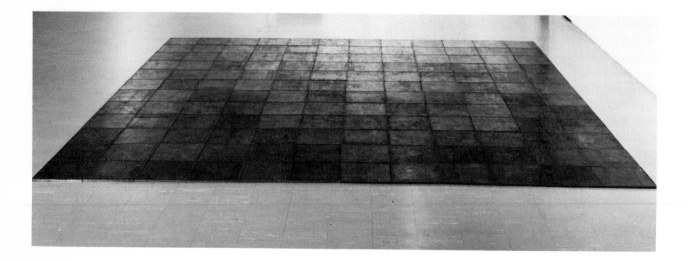

table of elements as "a kind of palette,"[98] the sculptural counterpart of "what the colour spectrum is for the painter.... Copper is more profoundly different from aluminium than red is from green."[99] In order to experience the differences among metals, each with its own weight, mass, and solidity, Andre invited viewers to walk on his pieces. As he remarked:

> There are a number of properties which materials have which are conveyed by walking on them: there are things like the sound of a piece of work and its sense of friction, you might say. I even believe that you can get a sense of mass, although this may be nothing but a superstition which I have. Standing in the middle of a square of lead would give you an entirely different sense than standing in the middle of a square of magnesium.[100]

In keeping with the flat, rectangular nature of the metal units, Andre placed them directly on the floor in unbounded checkerboard arrangements held in place by gravity. Each unit was a specific object and one of a set of identical—and therefore interchangeable—objects. "My arrangements, I've found, are essentially the simplest that I can arrive at, given a material and a place—the least conspicuous I can arrive at."[101] By insisting on "Things in their elements, not in their relations," Andre reversed Mondrian's dictum.[102]

Andre's insistence that materials dictate the form of a work is closely related to the Russian Constructivist conception of Faktura. As in Constructivism, there is a socially minded thrust in Andre's thinking. He said that he was attracted to prefabricated metal plates because they were concrete materials in and of the world, and accessible to everyone. "I believe in using the materials of society in a form the society does not use them."[103] But Andre never connected his art with revolutionary or utopian politics, as the Constructivists did. Instead, he justified his art on the grounds of personal preference. He wrote:

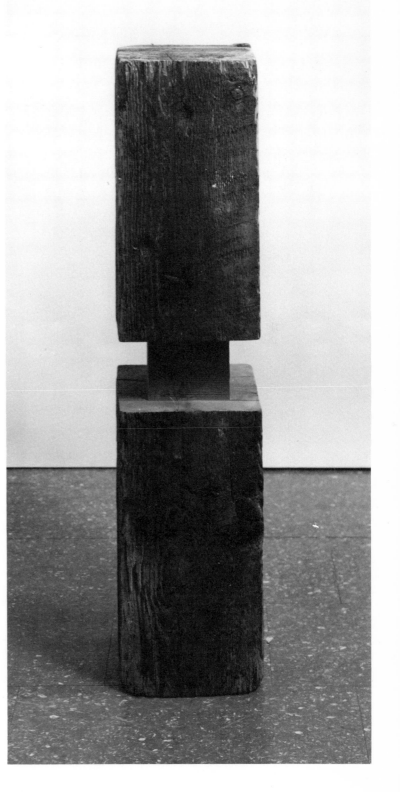

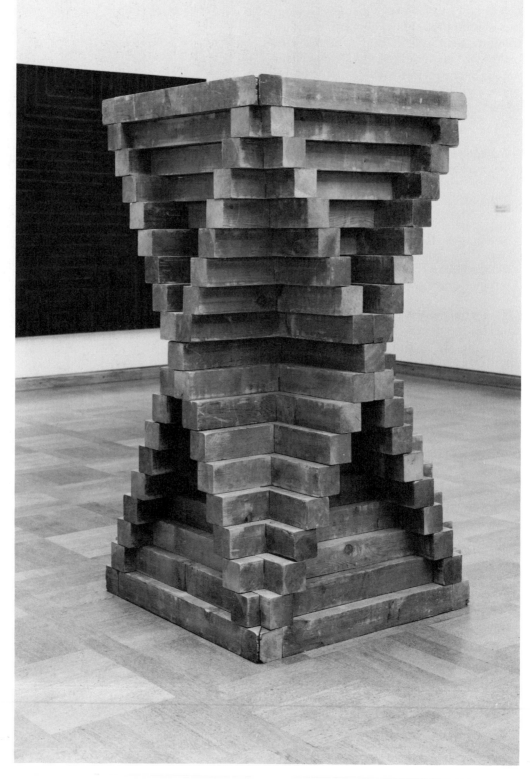

140. Carl Andre, *Cedar Piece*, 1959/1964. 68⅜″ × 36¼″. Öffentliche Kunstsammlung Basel, Museum für Gegenwartskunst.

FACING PAGE: 141. Carl Andre, *Lever*. Overall 4½″ × 8⅞″ × 348″. National Gallery of Canada, Ottawa.

142. Tony Smith, *Die*, 1962. 72″ × 72″ × 72″. Paula Cooper Gallery, New York.

"I submit to the properties of my materials out of a kind of reflection of my own temperament. . . . It's that I wish to submit to the properties of my materials." Andre went on to say: "I've always had a very primitive, infantile love of the solids and the mass, the thing that was the same all the way through."[104] Andre suggested that the source of this love was his childhood experiences of blocks of stone and steel plates in the quarries and shipyards of Quincy, Massachusetts, where he was born and grew up.

Of his function as an artist, Andre said, it is to add something that's not there yet. So the hardest thing is to find out that, what that contribution you can make that is not pre-existent in the world.[105] Andre's contribution to sculpture was to make a piece simultaneously an object, a base, and a site. Rug-like, his works deny sculpture's *traditional* verticality and references to the human figure (except that viewers are encouraged to walk on them), creating a new sculptural experience.

In their inertness and passive submission to gravity, Andre's floor sculptures are poles apart in appearance—and in feeling—from the dramatic massive volumes favored by Tony Smith and Ronald Bladen, who, like Andre and other Minimalists, used simple geometric forms—but on a huge scale. Indeed, Smith and Bladen can be characterized aptly as the monumental Minimalists.

Morris had strong reservations about "works on a monumental scale [that] can be walked through or looked up at [because they] are baroque in feeling beneath a certain superficial somberness. They share a romantic attitude of domination and burdening impressiveness. They often seem to loom with a certain humanitarian sentimentality."[106] Dan Graham was even more antipathetic to monuments.

They refer to an older, largely discarded notion of man's relationship to "Nature." The monument meant the imposing of man's supposed "transcendent nature" onto the

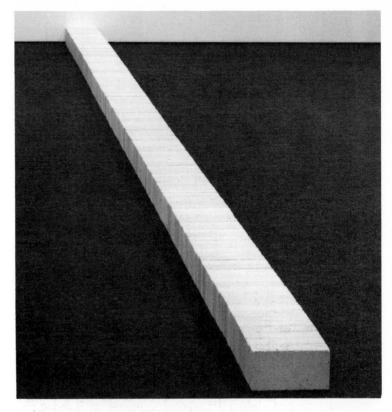

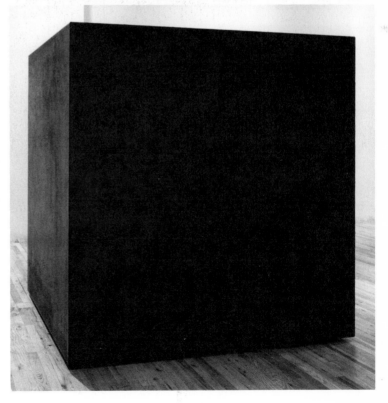

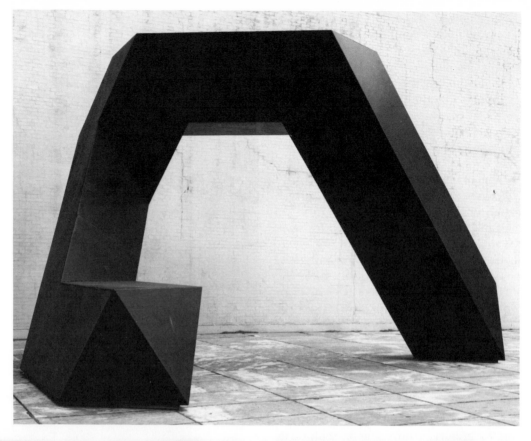

143. Tony Smith, *Cigarette*, 1961. 15'1" × 25'6" × 18'7". Museum of Modern Art, New York.

144. Ronald Bladen, *Untitled*, 1966–67. Overall length 28'4". Museum of Modern Art, New York.

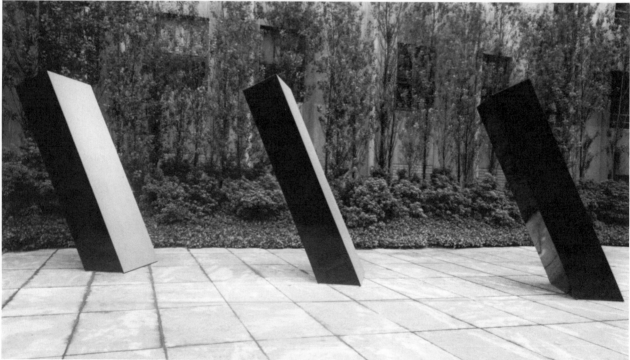

environment. Man's aspired-to "stature" was to be achieved through the projection of this projected monumentality unto "nature." His "nature" was willed against "Nature." He made his mark in the world by his "work": that is, through the exploitation of "Nature." . . . Making meant raping.[107]

Smith and Bladen enthusiastically embraced the romantic attitude the hardcore Minimalists rejected. It is precisely the heroic drama of their work that distinguishes it from that of Judd, Morris, Flavin, and Andre.

Smith's predilection for monumentality is clear in the following statement:

I like the power of African sculptures carved from single blocks. They are statements in mass and volume. There is little that is lineal in them. There is nothing impressionistic about the surfaces. Every part, as well as the piece as a whole, seems to have its own center of gravity. The parts act as masses, weights, hunks.[108]

Smith's *Die* and *The Black Box*, both of 1962 (but not shown until after 1966[109]), are five-foot cubes, the one in plywood coated with black automobile body undercoating, the other in steel, fabricated and placed in his yard. The steel was allowed to weather and darken until it took on a raw color, like the black coat in *Die*, primitivistic in feeling.

Smith based other work on tetrahedral and octahedral modules, unlike the hardcore Minimalists who favored the cube. As he said:

While the axes normal to the surfaces of a cube are three, [those] perpendicular to the planes of a space-lattice made up of tetrahedra and octahedra are seven. This allows far greater flexibility and visual continuity of surface than rectangular organizations. Something approaching the plasticity of more traditional sculpture, but within a continuous system of simple elements, becomes possible.[110]

There is in Smith's thinking a reverence for the tradition of sculpture and for geometry as a metaphor for order—in nature, in the universe—that one senses is not shared by Judd, Morris, Flavin, and Andre. Nor is his desire for complexity. Unlike their work, Smith's complex work "can not be visualized in its entirety from any single vantage point."[111] Indeed, his pieces tend not to be symmetrical; their modular forms twist, bend, and stretch space—notably in the ones that resemble portals—without sacrificing monumentality. The grandeur and physicality of Smith's sculpture call to mind awesome ancient monuments. As Samuel Wagstaff remarked: "They are related to early cultures intentionally or through sympathy—menhirs, earth mounds, cairns." And at the same time, they refer "to this culture with equal sympathy—smokestacks, gas tanks, dump trucks, poured concrete ramps."[112]

Lippard summed up Smith's achievement:

[The] strength of his best work depends on large size and on a certain awkwardness, an unfinished roughness that . . . provides a

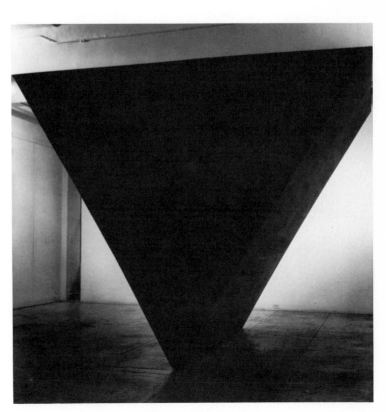

145. Ronald Bladen, *Black Triangle*, 1966. 10′ × 9′4″ × 13′. Connie Reyes.

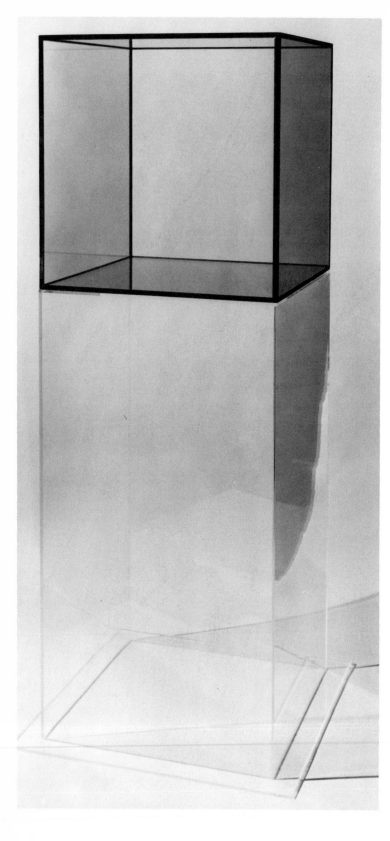

counterpoint to the rigorously geometric scaffolding. Stability is essential. Bulk and self-containment . . . are emphasized. Yet one of the most important qualities of Smith's art is the extraordinary *stretching* effect achieved.[113]

With the omission of the word "stability," much the same can be said about the sculpture for which Bladen is best known. Central to his work was instability, as in the untitled piece, exhibited in the *Primary Structures* show, whose three freestanding, tilted, nine-foot-high rhomboid-like monoliths in a row are each precariously balanced. The diagonal of the giant volumes is reminiscent of a human gesture, at once epic and grand, like the backward lean of Rodin's *Balzac,* and vulnerable, suggesting falling or bowing. They can also be viewed as a grand procession—anthropomorphic menhirs on the move.

It was Bladen's intention to achieve sensations of this kind. As he said:

My involvement in sculpture outside of man's scale is an attempt to reach that area of excitement belonging to natural phenomena such as a gigantic wave poised before it makes its fall or man-made phenomena such as the high bridge spanning two distant points.
 The scale becomes aggressive or heroic. The esthetic a depersonalized one. . . . The drama . . . is best described as awesome or breathtaking.[114]

In contrast to the huge monoliths of Tony Smith and Bladen, Larry Bell's glass boxes are antimonumental. The glass is treated with different kinds of vaporized metallic and nonmetallic substances producing tints that seem to inhere in the material. Yet, as Melinda Wortz pointed out, the colors undermine "our ability to distinguish between what is physically present and what is illusion [so] that the objects seem to de-materialize."[115] Reared on a Minimalist aesthetic, Bell thought he "was working . . . with structure," but in 1970, he realized that he "was actually working with light."[116]

FACING PAGE:
146. Larry Bell, *Untitled*, 1967. 20″ × 20″ × 20″. Whitney Museum of American Art, New York.

147. Richard Tuttle, *Gray Extended Seven*, 1967. 48½″ × 59½″. Whitney Museum of American Art, New York.

Like Bell, Richard Tuttle can be considered a late-Minimal artist. In 1965, he began to make thin, painted wood reliefs, miniature in size, and in 1967, he dyed irregular shaped pieces of cloth in a single color and attached them directly to the wall. These works are so reduced as to represent a dematerialization of Minimal Art, indeed, of painting and sculpture generally. But they are closer to traditional painting and sculpture, because Tuttle's objects, despite their unconventional "poor" appearance, are artful and expressive, imbued with poignancy.

In 1966, Lippard remarked on "abstract painting's current dilemma. We have reached the point where only the symmetrical (square), imageless, textureless, patternless, even colorless canvas can be considered radically advanced."[117] And Minimal sculptors denied that even such painting could be considered radical.

Painting was hopelessly illusionistic. However, Minimalist polemics did not prevent the development in the late sixties of what might be called Minimal painting. Still, the attack was so telling that it prompted Peter Schjeldahl to recall, some two decades later: "I can still feel, in the pit of my stomach, the terrorising authority such polemics once carried." He added: "To roll with all these punches

148. Agnes Martin,
*The Tree*, 1964.
72″ × 72″. Museum
of Modern Art,
New York.

Martin once remarked that her rectangular grid "lightens the weight of the square."[121] It does more, emanating a light that dematerializes the surface, creating an immaterial, ethereal—spiritual—aura. Pincus-Witten observed: "The effect . . . runs counter to the economy of the means."[122] It is through this effect, created by her delicate, personal touches, which call for unhurried contemplation, that Martin speaks, as it were, and it is this touch that distinguishes her work from hard-core Minimalism.

Minimalist painters who followed Martin retained her concern with touch, which, compared to Minimalist sculpture, seemed inherent in the medium of painting, although with Robert Ryman, it took time for his sensitivity to painting to be appreciated. The reason was that Ryman's primary concern was the literalist, analytic exploration of the language of painting, seemingly at the sacrifice of matters of sensibility.

In his first show, in 1967, Ryman exhibited ten square paintings of equal size, each composed of all-white brushstrokes dragged across steel sheets hung flat against the wall. He limited his palette to white because it "doesn't interfere. It is a neutral color that allows for the clarification of nuances in painting. It makes other aspects of painting visible that would not be so clear with the use of other colors."[123] Ryman said of his intention: "I wanted to make a painting getting the paint across. That's really what painting is basically about."[124] And: "I didn't want anything in the paintings that didn't need to be there."[125] Ryman denied the objecthood of his works, but he did treat the paint and its support as literal things. "You can't get away from that."[126]

Ryman's painting calls attention to the direct process of laying on paint. As he said: "There is never a question of what to paint, but only how to paint. The how of painting has always been the image—the end product."[127] Ryman varied the how of painting in as many ways as he could con-

and come up with brush in hand took a special breed of artist, and the few who did so with force and conviction—notably Agnes Martin [who developed her mature style in the early sixties, prior to Minimalist polemics], Robert Ryman, and Brice Marden . . . are a tough, heroic lot."[118]

The pictures for which Martin is best known are composed of allover grids penciled on monochrome, white, off-white, or buff oil- or acrylic-covered canvases. Martin said of them: "My formats are square but the grids never are absolutely square; they are rectangles, a little bit off the square, making a sort of contradiction, a dissonance, though I didn't set out to do it that way."[119] Annette Michelson observed: "The use of the T-square and stretched, occasionally shifted string confer upon these ruled lines a subtle unevenness, an occasional accent, a kind of visual tremolo. There will be, on a given surface, and owing to the shifting of the ruling edge, zones of greater intensity."[120]

ceive of, experimenting with differences in size, scale, texture, width, and direction of brushstrokes, luminosity, and many other aspects of medium and manipulation and surface—steel, canvas, cardboard, etc. He said that he once used a very wide brush, twelve inches.

> I got it specially—I went to a brush manufacturer and they had this very big brush. I wanted to pull the paint across this quite large surface, 9 feet square, with this big brush. I had a few failures at the beginning. Finally, I got the consistency right and I knew what I was doing and how hard to push the brush and pull it and what was going to happen when I did. That's kind of the way to begin. I didn't have anything else in mind, except to make a painting.[128]

Thus Ryman's painting can be viewed as pure painting, painting-as-painting, the paint-matter and its application on a surface constituting subject and image.

Douglas Crimp summed up Ryman's enterprise:

> There is . . . in his painting, a strict adherence to the matter at hand. . . . The systematic, single-minded, persistent attempt to once and for all empty painting of its idealistic trappings gives to Ryman's work its special place during the 1960s. . . . Ryman's paintings . . . make visible the most material of painting's conventions: its frame, its stretcher, its supporting surface, the walls on which it hangs. But more significantly, his paintings . . . make visible the very mechanical activity of laying on the brushstrokes . . . until the surface is, simply, painted.[129]

Like Ryman, Brice Marden had his first show in 1967. Marden used one allover color, generally restrained but seductive, in each work, a color that "holds the shape of the canvas beautifully."[130] His medium was a mixture of beeswax and oil, which yielded a lustrous and rich surface. Marden remarked: "I begin work with some vague color idea; a memory of a space, a color presence, a color I think I have seen. . . . A dark black green seen slightly after a foggy dusk."[131]

Roberta Smith called attention to

149. Robert Ryman, *Untitled*, 1960. 43″ × 43″. Collection and courtesy the artist.

Marden's "fine controlled handling of paint, which was loose enough to be visible and to physically define surface but tight enough that the surface did not disintegrate into a series of marks. This handling of paint involved a very precise consciousness of the picture plane, a concern with touch rather than gesture."[132] Along the bottom edges of his pictures, Marden left margins of one-half inch to one inch of bare canvas, which revealed the actual surface and the process of the painting's evolution, and provided a sense of scale and an "unfinished" foil for the "finished" matte color. As he said: "I exercise little or no control over what happens below the drawn edge."[133] But the "unfinished" painting is as romantic in feeling as the color. Among Minimal painters, Marden was a highly refined sensualist.

Robert Mangold's pictures relate more to Marden's than to Ryman's. In his first show, he exhibited hard-edge abstractions composed of curvilinear shapes influenced

by Al Held. In his subsequent pictures, which he called *Walls,* he eliminated painted images and cut asymmetrical "doors" and "windows" out of wood sheets and sprayed the surface with paint to produce a delicately nuanced monochrome. The works verged toward Minimalism in their object-like quality and impersonal paint application, but in both their atmosphere and their reference to architectural fragments, they are poetic. Mangold once spoke of his fascination for the gaps between buildings in New York, "sections of air that would glow.... Sunsets or mornings, or whatever, you'd see these incredible areas of light and they were architectural shapes and yet they were nothing, because they were the voids of architecture. . . . I used to think about a painting that would be atmospheric and architectural."[134]

*Areas,* which he painted in 1965, were even more Minimal than the *Walls.* Composed of Masonite panels, which came in a standard eight-by-four-foot size, they expressed his intention to present a work as a single flat entity. His support dictated

that "whatever other structural decisions were made I knew the work would have a seam every four feet."[135] Mangold became intrigued with the potential of this line, which brought the outer edges of the picture into the center.

> With those early pieces I got involved in sectioning and when you section a painting, certain things happen. [One] is that it makes everything stay on the surface. . . . The other thing [is] that the division of panels . . . keeps reinforcing the edge. It keeps making you think about the edge, because the edge is in the center. If the edge were just on the edge, you could drift into the painting. [The] sectioning started out as a material thing. But I realized that there were certain formal and psychological things that the line does and the way that it affects how you read something became more and more important.[136]

Mangold began to use the formal components of his works as foils for each other: actual seams and picture edges against drawn lines; the shape of the canvas against the configuration of lines; both the drawing and the shape against the painting, the illusionism of sprayed surfaces.

150. Robert Mangold, *½ Manila Curved Area,* 1967. 72″ × 144″. Whitney Museum of American Art, New York.

The work remained poetic. As Lippard remarked: "By working with colors that cannot be pinned down, that fade and intensify into and away from monochrome . . . and with surfaces that yield like skies and refuse to yield like walls, Mangold . . . is extending the possibilities of a positively reductive art."[137]

In 1966, Mangold began to vary the shapes of his canvases, using curved formats and playing them off against geometric configurations within them. In 1970, he began to dissociate the shapes and the internal linear images. As he summed it up: "I think all of my works are about things fitting or not really fitting together, with the structural shape either dictating the terms of the interior structure or setting up a framework the interior structure plays off of."[138]

## NOTES

1. The shows of Donald Judd, Robert Morris, and Dan Flavin were held at Richard Bellamy's Green Gallery; the Carl Andre show, at the Tibor de Nagy Gallery.

2. The other artists in the *Shape and Structure* show were Walter Darby Bannard, Larry Bell, Charles Hinman, Will Insley, Robert Murray, Neil Williams, and Larry Zox. The show was held at the Tibor de Nagy Gallery.

3. Richard Wollheim, in "Minimal Art," *Arts Magazine*, January 1965, popularized the label. Barbara Rose, in "ABC Art," *Art in America*, October–November 1965, applied it to young Americans. Other labels were Object Sculpture, Primary Structures, Cool Art, Unitary Objects, and Specific Objects.

   Sol LeWitt, in "Paragraphs on Conceptual Art," *Artforum*, Summer 1967, p. 80, wrote that no artist he knew would admit to making Minimal Art,

   > primary structures, reductive, rejective, cool, and mini-art. . . . Therefore I conclude that it is part of a secret language that art critics use when communicating with each other through the medium of art magazines.

   See also Dan Flavin, "some other comments," *Artforum*, December 1967. Flavin, in "several more remarks," *Studio International*, April 1969, p. 174, rejected the label "minimalism" as a "dubious, facetious, epithetical, proto-historically movemented" stereotype. Donald Judd, in Kynaston McShine, *Primary Structures*, exhibition catalogue (New York: Jewish Museum, 1966), n.p., objected to the label "minimal," because it meant reductive, and he denied that his work was reductive.

4. Rose, "ABC Art," p. 66.

5. Bruce Glaser, "Questions to Stella and Judd," *Art News*, September 1966, pp. 60–61. Judd's remark was prompted by a question posed to him and Stella by Glaser asking why they could not simply verbalize their diagrams rather than making works. Stella replied:

   > A diagram is not a painting; it's as simple as that. I can make a painting from a diagram, but can you? . . . It can just remain a verbalization. . . . You actually want to see the thing. That's what motivates you to do it in the first place.

6. See LeWitt, "Paragraphs on Conceptual Art."

7. Stella's influence on Minimal artists was also a personal one. He got to know Andre by 1958; Flavin, by 1960; Judd by 1962; and somewhat later Morris and LeWitt. Andre acknowledged Stella's influence. He also wrote the introduction on Stella in the catalogue of *Sixteen Americans* at the Museum of Modern Art, 1959. For the importance of Stella to Judd, see Donald Judd, "Local History," *Arts Yearbook 7, New York: The Art World* (1964): 32. See Lucy R. Lippard, "The Third Stream: Constructed Paintings and Painted Structures," *Art Voices*, Spring 1965, p. 46.

8. Judd, "Local History," p. 25.

9. Ibid., p. 32. Mel Bochner, in "Systemic," p. 40, corroborated Judd:

   > The idea that a painting is primarily a thing-in-itself has been around for a long time. But before Frank Stella not much was done about it. . . . The ideas implicit in Stella's work . . . and the materiality of the result, inevitably suggest three dimensional work, which is probably why most of the interesting work being done today is not being done in painting.

   Judd acknowledged the influence not only of Stella but of Barnett Newman, notably his *The Wild*, 1950, an eight-foot vertical picture an inch and a half wide. (Lippard also singled out Newman's tall, thin paintings of bands.) In 1964, Judd wrote an article (unpublished until 1975) on Newman in which he hailed him as "the best painter in this country." Newman's pictures were important because they were "large-scaled"—"This scale is one of the most important developments in . . . twentieth-century art"—and because of their singleness of image, their "wholeness": "Everything is specifically where it is. This wholeness is also new and important." Judd's article appeared in

Donald Judd, "Barnett Newman," 1964, *Donald Judd: Complete Writings, 1959–1975* (Halifax, Canada: Nova Scotia College of Art and Design, 1975), pp. 200–1.

Judd also esteemed Yves Klein's blue paintings. He wrote in "Specific Objects," p. 76, that they are "unspatial," even more than Stella's abstractions. It is noteworthy that Stella owned one of Klein's blue paintings.

10. Immediacy also preoccupied Morris, who discovered in Newman's abstractions, as he said in an interview with David Sylvester, in *Robert Morris,* exhibition catalogue (London: Tate Gallery, 1971), p. 19, "the greatest sense of immediacy in any painting that I've experienced." However, like Judd, Morris believed that no painting, including Newman's, was as powerful as the sculptures he called Unitary Objects. See also Lucy R. Lippard, "New York," *Artforum,* March 1964.

11. Dan Flavin, "some other comments," p. 27.

12. Judd, "Specific Objects," *Arts Yearbook 8, Contemporary Sculpture* (1965): 74.

13. Donald Judd, "New York Exhibitions: Kenneth Noland," *Arts Magazine,* September 1963, p. 54. Like Judd, Lucy R. Lippard, in "New York Letter: Recent Sculpture as Escape," *Art International,* 20 February 1966, p. 48, stated baldly that those who want to "advance" into the new are venturing into sculpture. "It is almost impossible to make a non-pictorial painting without the addition of objects or shape, or the ultimate reduction to total monochrome," but a non-sculptural sculpture is still a possibility.

14. Donald Judd, "Portfolio: 4 Sculptors," *Perspecta* (New Haven), March–May 1968, p. 44.

15. Barbara Rose, in "ABC Art," pp. 58, 65–66, 69, included Warhol. Kirk Varnedoe, "Captain Cosmo Meets Mr. Cool: Pop and Minimalism Reconsidered," lecture, Whitney Museum of American Art, 12 December 1984, linked Pop Art and Minimal Art and even claimed that Minimal Art embodied contemporary American life more than Pop Art did. See also Irving Sandler, "The New Cool-Art," *Art in America,* January–February 1965; and Henry Geldzahler, *New York Painting and Sculpture: 1940–1970* (New York: E. P. Dutton, 1969), p. 38. Peter Plagens, in "Present-Day Styles and Ready-Made Criticism," *Artforum,* December 1966, p. 39, called Minimal Art "Imageless Pop."

16. Barbara Rose, "New York Letter," *Art International,* 15 February 1964, p. 41. Lippard, in "New York," p. 18, contrasted the immediate physicality of Minimal Art to "the more profound emotional involvements demanded by New York School painting in the fifties."

17. Rose, "ABC Art," p. 58. See Mel Bochner, "Primary Structures," *Arts Magazine,* June 1966, p. 34.

18. Glaser, "Questions to Stella and Judd," p. 59.

19. Judd, in McShine, *Primary Structures.*

20. Barbara Rose, in "A New Aesthetic," *A New Aesthetic,* exhibition catalogue (Washington, D.C.: Washington Gallery of Modern Art, 1967), p. 18.

21. See Barbara Rose, "Donald Judd," *Artforum,* June 1965.

McShine, in *Primary Structures,* remarked that he chose artists for the show who had reacted "against the open welded sculpture of the fifties, with its emotionalism, improvisation, and emphatic marks of individual sensibility." These "sculptors of the sixties have been the most critical and radical among artists, in relation to work of the recent past. Their activity has become purposely more philosophical and conceptual in content. They are anxious to find out what sculpture is and to discover how to make it."

Edward F. Fry, in "Sculpture of the Sixties," *Art in America,* September–October 1967, p. 28, viewed Minimal Art as too radical to fit into the history of art, because it was a deliberate attempt to "escape" from earlier-twentieth-century styles, to bypass "compositional methods basic to Western art from the Renaissance through cubism."

See also Bochner, "Primary Structures," *Arts Magazine,* June 1966, and Corinne Robins, "Object, Structure or Sculpture: Where Are We?" *Arts Magazine,* September–October 1966.

22. Rose, "ABC Art," p. 69.

23. For example, in Irving Sandler, "New York Letter," *Art International,* 1 December 1960, the first major review of Stella's work, I claimed that boredom was one of its primary values. Later, in "The New Cool-Art," p. 97, I reiterated this: "Stella appears to have made it [boredom] the content of his art—a content so novel and perverse as to be interesting." The same was often said about the repetitive, standard units in the works of Judd, Morris, Flavin, and Andre.

24. Lucy R. Lippard, "New York Letter: Recent Sculpture as Escape," p. 50.

James R. Mellow, in "New York Letter," *Art International,* 20 April 1966, p. 89, wrote: "Although some critics have found Judd's work monotonous, his exhibition was for me one of the most provocative of the season." Lucy R. Lippard, in "An Impure Situation (New York and Philadelphia Letter)," *Art International,* 20 May 1966, p. 62, agreed: "Just be-

I was also struck by the seeming lack of feeling and meaning in Minimal Art. In "The New Cool-Art," p. 97, I compared Minimal Art, Pop Art, and Op Art to Abstract Expressionism and remarked on p. 101 that they employed "a different method—the execution of simple predetermined ideas—and other values—calculation, impersonality, impassiveness, and boredom."

cause an artist *utilizes* tedium, as does Samuel Beckett, or at one point perhaps Frank Stella, does not mean that the end product, if any good, is tedious. Significant art is never boring."

The artists themselves denied that their work was boring. For example, Robert Morris, in "Notes on Sculpture: Part 2," *Artforum*, October 1966, p. 23, remarked: "It is not surprising that some of the new sculpture which avoids varying parts, polychrome, etc., has been called negative, boring, nihilistic. These judgments arise from confronting the works with the expectations structured by a Cubist esthetic." Judd, in McShine, *Primary Structures*, said: "I can't see how any good work can be boring or monotonous in the usual sense of these words. . . . This negative characterization is glib [and] not concerned with what the work is."

25. Rose, "ABC Art," p. 62.
26. "The Artists Say: Dan Flavin," *Art Voices*, Summer 1965, p. 72.
27. Maurice Tuchman, "The Russian Avant-Garde and the Contemporary Artist," *The Avant-Garde in Russia, 1910–1930*, exhibition catalogue (Los Angeles: Los Angeles County Museum of Art, 1980), p. 120.
28. Donald Judd, interviewed by Barbara Rose, New York, Fall 1965, p. 20. Transcript in Archives of American Art, New York.
29. Robert Morris, interviewed by Paul Cummings, New York, 1968, p. 9. Transcript in Archives of American Art, New York.
30. Glaser, "Questions to Stella and Judd," p. 55.
31. See symposium moderated by Lucy R. Lippard, with Douglas Huebler, Dan Graham, Carl Andre, and Jan Dibbets, WBAI-FM, 8 March 1970, in Lucy R. Lippard, *Six Years: The Dematerialization of the Art Object* (New York: Praeger, 1973), p. 155.
32. The title of Robert Morris's master's thesis at Hunter College was "Form-Classes in the Work of Constantin Brancusi."
33. Judd, "Specific Objects," pp. 74, 78.
34. Ibid., p. 77. It is noteworthy that Judd, Morris, Flavin, Andre, Ronald Bladen, Tony Smith, and Robert Smithson had been painters.
35. Ibid. Judd also singled out Stella, Alfred Jensen, Kenneth Noland, Jules Olitski, and Gene Davis. Their nonobjective painting was less illusionistic than pictures with subject matter. Of the latter, the best, in his opinion, were by Roy Lichtenstein, John Wesley, and especially James Rosenquist.
36. Like Clement Greenberg, Judd claimed to be describing what had occurred or was occurring.
37. Judd, "Specific Objects," p. 78. Junk assemblages were precursors of Minimal Art. Judd, Andre, and Flavin themselves had employed found materials in their early work and were evidently taken with the materiality of nontraditional substances and the physical process of assembling them in actual space. Flavin and Andre continued to use ready-made materials in their Minimal sculptures, indicating a persisting influence of Assemblage.
38. Judd also included John Anderson, Salvatore Scarpitta, Richard Navin, Yayoi Kusama, Masunobu Yoshimura, Nathan Raisen, and John Willenbecher as makers of Specific Objects. For example, see D. J. [Donald Judd], "In the Galleries: Kenneth Noland," *Arts Magazine*, September 1962, p. 9.
39. Judd, "Specific Objects," p. 78.
40. Rosalind Krauss, in "Allusion and Illusion in Donald Judd," *Artforum*, May 1966, p. 24, wrote: "For some time Donald Judd has been a major spokesman for works of art which seek, as their highest attainment, total identity as objects." Corinne Robins, in "Object, Structure or Sculpture: Where Are We?" p. 35, wrote that Judd's essay "Specific Objects" "came close to being a stylistic manifesto—a far from cool one."
41. Donald Judd, in "Barnett Newman," p. 201, wrote that his description of a painting by Newman "may have been dry reading but that's what's there."
42. Robert Morris, "Notes on Sculpture: Part 1," *Artforum*, February 1966, p. 43.
43. Robert Morris, "American Quartet," *Art in America*, December 1981, p. 95.
44. Morris, "Notes on Sculpture: Part 1," p. 44.
45. Robert Morris, "Notes on Sculpture: Part 2," p. 21.
46. Lucy R. Lippard, in "New York," *Artforum*, March 1964, p. 18, called attention to "a growing tendency . . . to *surround* the spectator [giving rise to his or her] increased physical participation, or immediate sensorial reactions."
47. Morris had long been disposed toward environmental art, having been close to Environment and Happening makers and related dancers in the Judson Dance Theater.
48. Morris, "Notes on Sculpture: Part 2," pp. 21, 23.
49. Samuel Wagstaff, Jr., "Talking to Tony Smith," *Artforum*, December 1966, p. 19.
50. "Is Easel Painting Dead?" Panel at New York University, November 1966, Barbara Rose, moderator, with Bannard, Judd, Poons, and Rauschenberg.
51. Michael Fried, "Art and Objecthood," *Artforum*, Summer 1967, p. 20.
52. Michael Fried, "Shape as Form: Frank Stella's New Paintings," *Artforum*, November 1966, p. 18.
53. Ibid., pp. 22, 24. Fried, in "Frank Stella," *Toward a New Abstraction*, exhibition catalogue (New York: Jewish Museum, 1963), p. 28, developed this idea earlier. Fried, in "Olitski and Shape," *Artforum*, January 1967, p. 20, wrote of Olitski's abstractions: "The fact that their shapes are experienced as *pictorial*, not merely *literal* entities—is what secures their identity as *painting*."

54. Fried, "Art and Objecthood," p. 20.
55. Ibid., pp. 15, 19–20.
56. See Clement Greenberg, "The Recentness of Sculpture," in Maurice Tuchman, ed., *American Sculpture of the Sixties,* exhibition catalogue (Los Angeles: Los Angeles County Museum of Art, 1967), p. 24. Greenberg was also hostile to Minimal Art, which he condemned on pp. 24–25 as both "the furthest-out art" and as "Good Design," meaning safe taste.
57. Fried, "Art and Objecthood," p. 21.
58. Robert Smithson, quoted in Philip Leider, introduction, *The Writings of Robert Smithson* (New York: New York University Press, 1979), p. 2.
59. Rosalind Krauss, "Allusion and Illusion in Donald Judd," p. 24. David Antin, in "Robert Morris," *Art News,* April 1966, p. 23, wrote of Morris's work: "It is simple and impassive, and quite beautiful." See also Amy Goldin, "Art in a Hairshirt," *Art News,* February 1967.
60. Fried, "Art and Objecthood," pp. 22–23.
61. Roberta Smith, "Donald Judd," *Donald Judd,* exhibition catalogue (Ottawa, Canada: National Gallery of Canada, 1975), p. 30.
62. John Coplans, "An Interview with Donald Judd," *Artforum,* June 1971, p. 44.
63. Ibid., p. 45.
64. Smith, "Donald Judd," p. 11.
65. John Coplans, "An Interview with Donald Judd," p. 49.
66. Elizabeth Baker, "Judd the Obscure," *Art News,* April 1968, p. 45.
67. Robert Morris, "Notes on Sculpture, Part 3: Notes and Nonsequiturs," *Artforum,* Summer 1967, p. 26.
68. Lucy Lippard, "New York Letter," *Art International,* Summer 1966, p. 114. See also David Antin, "Robert Morris."
69. Morris, interviewed by Paul Cummings, p. 59.
70. Robert Morris, "Some Notes on the Phenomenology of Making: The Search for the Motivated," *Artforum,* April 1970, p. 62.
71. Lippard, "New York Letter: Recent Sculpture as Escape," p. 50.
72. Barbara Rose, "Looking at American Sculpture," *Artforum,* February 1965, p. 36.
73. Donald Judd, "Aspects of Flavin's Work," *etc. from Dan Flavin,* exhibition catalogue (Ottawa, Canada: The National Gallery of Canada, 1969), p. 27.
74. Barbara Rose, "ABC Art," p. 68.
75. Dan Flavin, ". . . in daylight or cool white: an autobiographical sketch," *Artforum,* December 1965, p. 24.
76. Ibid.
77. Ibid.
78. "The Artists Say: Dan Flavin," p. 72.
79. Dan Flavin, in "Portfolio: 4 Sculptors," *Perspecta 11,* p. 44.
80. Ira Licht, "Dan Flavin," *artscanada,* December 1968, p. 62.
81. Brydon Smith, "The Catalogue," *etc. from Dan Flavin,* p. 206. The quote is from the *Columbia Viking Desk Encyclopedia.* Flavin used it in a letter to Mel Bochner, 1 November 1966. Flavin's title *The Nominal Three* is not a metaphor exactly but implies one, becoming one of what Peter Schjeldahl in "Minimalism: Dan Flavin," *Art of Our Time: The Saatchi Collection* (New York: Rizzoli, 1984), p. 19, called "lurking metaphors."
82. Flavin, ". . . some other comments," p. 28.
83. Flavin, " . . . in daylight or cool white," p. 24.
84. Ibid.
85. Smith, "The Catalogue," *etc. from Dan Flavin,* p. 238.
86. Carl Andre's pieces are based on preconceived ideas. However, in Phyllis Tuchman, "An Interview with Carl Andre," *Artforum,* June 1970, p. 60, he said: "I am certainly no kind of conceptual artist because the physical existence of my work cannot be separated from the idea of it. [I have] no art ideas. I only have art desires. . . . By nature, I am a materialist."
87. Philip Leider, " 'To Introduce a New Kind of Truth,' " *New York Times,* 25 May 1969, sec. 2, p. 41. Andre, in Tuchman, "An Interview with Carl Andre," p. 55, said: "As to truth to materials, I just like matter a great deal and the different properties of matter, the different forms of matter, different elements, different materials. . . . I don't want to disguise it at all, I don't want to make something else out of it."
88. David Bourdon, "The Razed Sites of Carl Andre," *Artforum,* October 1966, p. 15.
89. Tuchman, "An Interview with Carl Andre," p. 55.
90. Carl Andre, interviewed by Paul Cummings, New York, September 1972, p. 30. Transcript in Archives of American Art, New York.
91. See Tuchman, "An Interview with Carl Andre," p. 57.
92. Andre, interviewed by Cummings, pp. 30–31.
93. Rose, "ABC Art," p. 67.
94. David Bourdon, "A Redefinition of Sculpture," *Carl Andre: Sculpture 1959–1977* (New York: Jaap Rietman, 1978), p. 21.
95. Rose, "ABC Art," p. 67.
96. Bourdon, "A Redefinition of Sculpture," p. 24.
97. Bourdon, "The Razed Sites of Carl Andre," p. 15.
98. Leider, " 'To Introduce a New Kind of Truth,' " sec. 2, p. 41.
99. "Carl Andre: A New Structure," press release, Anthony d'Offay Gallery, London, 28 January 1981.
100. Tuchman, "An Interview with Carl Andre," p. 57.
101. Ibid.
102. Dan Graham, "Carl Andre," *Arts Magazine,* December–January 1968, p. 35.
103. Enno Develing, *Carl Andre,* exhibition catalogue (The Hague: Haags Gemeentemuseum, 1969), p. 6.

During the late sixties, Andre extended his

formal vocabulary—for example, assembling a piece made of magnetized metals; a piece, *Spill*, consisting of 800 small plastic blocks scattered at random; an outdoor work, *Joint*, composed of a row of hay bales. He also complicated his sculptures, as in *37 Pieces of Work*, 1969, in which plates of aluminum, copper, lead, magnesium, steel, and zinc were patterned in systemic arrangements, rigorous yet opulent.

104. Tuchman, "An Interview with Carl Andre," pp. 59, 61.
105. Andre, interviewed by Cummings, p. 30.
106. Morris, "Notes on Sculpture: Part 3," p. 25.
107. Dan Graham, "A Minimal Future? Models & Monuments: The Plague of Architecture," *Arts Magazine*, March 1967, p. 34.
108. Samuel Wagstaff, Jr., interview with Tony Smith, p. 17.
109. Prior to 1966, only two of Smith's sculptures were exhibited: *The Elevens*, in Hartford, 1964, and *Free Ride*, in the *Primary Structures* show in New York, 1966.
110. Lucy Lippard, "Tony Smith," *Art International*, Summer 1967, p. 25.
111. Ibid., p. 24.
112. Ibid., p. 26.
113. Ibid., p. 25.
114. Rose, "ABC Art," p. 63.
115. Melinda Wortz, "In Consideration," *Larry Bell: New Work*, exhibition catalogue (Yonkers, N.Y.: Hudson River Museum, 1981), p. 10.
116. Robert Creeley, introduction, *Larry Bell: New Work*, p. 1.
117. Lucy R. Lippard, "Robert Mangold and the Implications of Monochrome," *Art and Literature*, Summer 1966, p. 116.
118. Schjeldahl, "Minimalism," *Art of Our Time: The Saatchi Collection*, pp. 25–26.
119. Lucy R. Lippard, "Homage to the Square," *Art in America*, July–August 1967, p. 54.
120. Annette Michelson, "Agnes Martin: Recent Paintings," *Artforum*, January 1967, p. 46.
121. Lippard, "Homage to the Square," p. 54.
122. Robert Pincus-Witten, " 'Systemic' Painting," *Artforum*, November 1966, p. 43.
123. Maurice Poirier and Jane Necol, "The '60s in Abstract: 13 Statements and an Essay: Robert Ryman," *Art in America*, October 1983, p. 123.
124. Phyllis Tuchman, "An Interview with Robert Ryman," *Artforum*, May 1971, p. 49.
125. Bruce Kurtz, "Documenta 5: A Critical Preview: Robert Ryman," *Arts Magazine*, Summer 1972, p. 42.
126. Tuchman, "An Interview with Ryman," p. 52.
127. Robert Ryman, *Art in Process IV*, exhibition catalogue (New York: Finch College Museum of Art/Contemporary Study Wing, 1969), n.p.
128. Tuchman, "An Interview with Ryman," p. 49.
129. Douglas Crimp, "The End of Painting," *October 16*, Spring 1981, p. 77.
130. Carl Andre, "New in New York," *Arts Magazine*, May 1967, p. 50.
131. Ibid.
132. Roberta Pancoast Smith, "Brice Marden's Painting," *Arts Magazine*, May–June 1973, p. 36.
133. Andre, "New in New York," p. 50.
134. "Robert Mangold," interview by Robin White in *View* (Oakland, Cal.: Crown Point Press, 1978), pp. 16–17.
135. Ibid., p. 6.
136. Ibid., p. 12.
137. Lippard, "Robert Mangold and the Implications of Monochrome," pp. 129–30.
138. Mangold, interview by White, p. 12.

# 11 CONSTRUCTION-SCULPTURE

Minimal artists tended to denigrate open welded construction in space as Cubist-inspired and thus *retardataire*, an outworn and closed-off tendency. They did acknowledge that David Smith's *Cubi* had influenced them, and they greatly admired di Suvero's monumental junk Assemblages when they were first shown, in 1960. Andre recalled:

> [It] was a fantastic show because for me it broke open the scale problem. [The] di Suvero pieces were sprawling. . . . Even the sort of phantom pedestal was gone; the floor itself was the support. [There was] also the size of the timbers he was using and . . . a kind of roughness and unfinishedness of materials. . . . The only [other] good strong sculpture around at that time was David Smith.[1]

Sidney Geist remarked about di Suvero's show: "From now on *nothing will be the same*. . . . Here was a body of work at once so ambitious and intelligent, so raw and clean, so noble and accessible, that it must permanently alter our standards of artistic effort."[2]

A number of critics esteemed Minimal sculpture, because they considered it the most *innovative* in the sixties though not necessarily the *best*. They reserved that honor for the construction-sculpture of David Smith, which they proclaimed as the greatest sculpture to have emerged since World War II. And they were almost as enthusiastic about the work of Anthony Caro and, with a few exceptions, di

Suvero. For example, Barbara Rose in 1965 asserted that Caro's work exemplifies "the very best kind of sculpture being done now," while considering Minimal sculpture "our most radical sculpture, though not perhaps our fullest."[3]

Other critics, notably Greenberg and his followers, claimed that welded construction continued to be avant-garde. Even though it was some three decades old, having been innovated by Picasso and Gonzales around 1930 and embraced by Smith in 1932, they argued that it was too broad to have been anywhere near exhausted.[4] After all, construction-sculpture constituted a *major* artistic revolution, liberating sculpture from the traditional stone, wood, and bronze figurative monolith. And it was yielding new artists of the stature of di Suvero and Caro.

In construction-sculpture, mass is fragmented and turned into "drawing in space." The linear and planar elements are solid enough to be sculptural, but they also define space—that is, they reach out in space and incorporate it into the work, literally turning voids into forms and often making these "negative volumes" the primary components of the sculpture. To put it another way, space is sectioned but not filled in the sense that a material such as marble occupies it. Sculpture based on drawing in space approaches painting. The line between the two mediums is further blurred by the incorporation of color into sculpture. Color had been avoided by

FACING PAGE:
151. Mark di Suvero, *New York Dawn (for Lorca)*, 1965. 78″ × 74″ × 50″. Whitney Museum of American Art, New York.

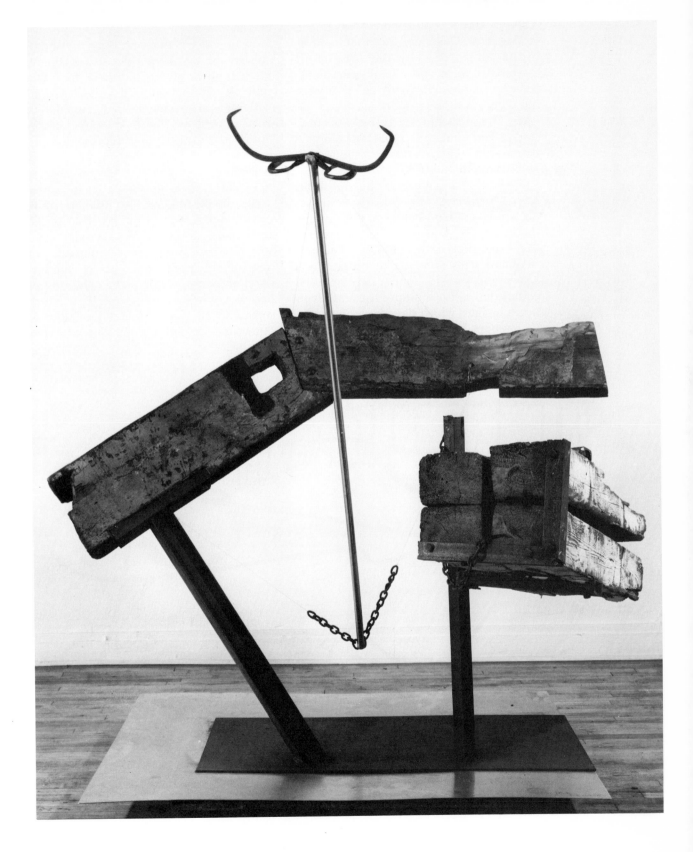

carvers and modelers since the Renaissance, most likely because the skin of pigment tended to deny the mass of the material. Linear and planar construction is more compatible with color, inviting painting and spraying. Iron, copper, lacquered and enameled automobile fenders, and other materials that are colored to begin with could also be incorporated into construction-sculpture.

Construction-sculptors cultivated a variety of materials not previously employed in sculpture—old, such as found machine parts, boilers, pipes, and scrap iron and steel; and new, such as I- and T-beams in standard sizes or made to order. These used and newly fabricated materials stimulated artists to improvise and invent fresh images, which have been viewed as metaphors for our industrial and urban civilization. The machine-shop process used in construction-sculpture is also peculiarly of our time. The oxyacetylene torch is, after all, an industrial tool. Despite its abstraction, and its associations with machines, open welded construction does generally refer to human gestures but does not illustrate or represent them, because that would detract from other sensations construction-sculptors aspired to evoke, such as gravity-defying soaring or a dramatic leap or a playful hop or the clenchedness of muscles and other physical actions. Moreover, like the body, construction-sculpture is composed of definable elements, the abstract counterparts of arms, legs, or head. The role of design, the urge to relate and to structure separable cut, bent, folded, rolled, and otherwise shaped components, is cen-

152. David Smith, *Hudson River Landscape,* 1951. 49½″ × 75″ × 16¾″. Whitney Museum of American Art, New York.

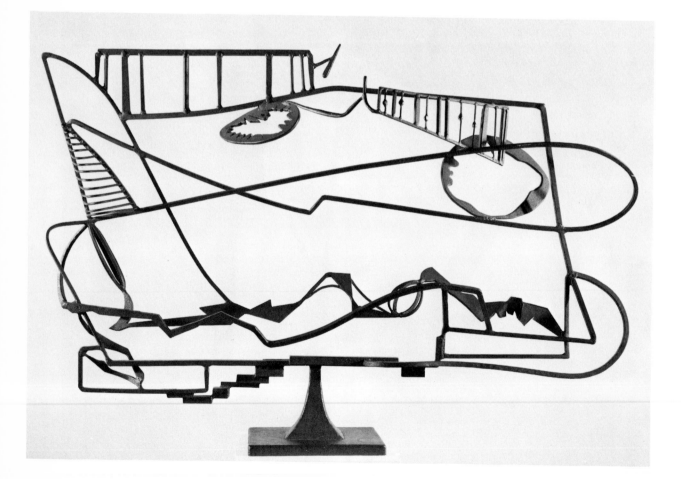

tral—for the artists and for the viewers, who tend to experience the artistic process of assembly, the part-to-part-to-whole composing. Because of the nature of its relational design and of its medium, both of which lend themselves to the free addition of often disparate elements, construction is more often than not complex. In varying degrees, metalworkers welcomed complexity and variety; delighted in the physical manipulation of materials and the craft of shaping and welding them; and cultivated invention and poetic allusions to visual reality.

Welding iron and steel enabled sculptors to enlarge their pieces, such is the toughness and flexibility of the medium. It also facilitated the elimination of pedestals, often larger than the pieces they support, which were perceived as sculpturally meaningless forms. To make pieces placed directly on the floor or ground visible, sculptors had to enlarge them, often to proportions that caused them to seem cramped in the rooms of galleries, houses, or even museums, and more suitable in out-of-door or public sites. Thus many construction-sculptors, among them di Suvero, began to think about the relation of their work to the environment, about its public role.

The differences between construction in space and Minimal objects—for example, the emphasis on space, activating space, complexity, and improvisation in the one, and on mass, occupying space, simplicity, and preconception in the other—are far more pronounced than any similarities, but there are significant affinities, notably the clarity of the forms used, which made the Smith-inspired construction of di Suvero and Caro acceptable in the sixties in a way that the welded sculpture of the fifties, such as that by Ibram Lassaw, Theodore Roszak, Seymour Lipton, Herbert Ferber, David Hare, and the somewhat younger Richard Stankiewicz, was not. Indeed, the reputations of these artists, who had enjoyed considerable acclaim in avant-garde circles in the fifties,

suddenly collapsed in the following decade.

The reason was that their sculpture was "painterly," at a time when painterly painting went into decline. Largely responsible for the decline was the formalist polemic of Greenberg and his followers. Even though they believed that welded construction in space which approached painting and was thus "pictorial" was the legitimate modernist sculpture, they refused to accept metal construction if its surfaces exhibited bubbled, pitted, or fretted signs of the welding process.

Thus formalist critics transferred their antipathy toward the *painterly* in painting from painting to sculpture, while opting for the *pictorial* in sculpture. Indeed, Greenberg was so hostile to the painterly in sculpture that he even granted that Minimal Art "has brought a certain negative gain. It makes clear as never before how fussy a lot of earlier abstract sculpture is, especially that influenced by Abstract Expressionism." But he quickly added that "the price may still not be worth it."[5] Formalists also objected to the allusions to natural subjects and processes in the abstractions of Lassaw, Roszak, Lipton, Ferber, Hare, and Stankiewicz, although they accepted them in Smith's. To sum up, in their clarity of structure and surface, the works of di Suvero and Caro were viewed as a reaction against "painterly" welded construction of the fifties and thus as possessing affinities to Minimal sculpture.

The construction-sculptures for which Mark di Suvero is best known are monumental, larger than life, although their details are nuanced, providing intimate human touches. Elements are kinetic, inviting spectators to push and even mount them, transposing them "from spectators to passengers."[6] Di Suvero's works from 1959 to 1966 are composed of bulky, roughly splintered and hacked wood beams and planks and other rugged found materials that jut and tilt powerfully into space. The components are volumetric, yet they constitute a muscular drawing in

the round on a gigantic scale. The composition is novel, since it tends to be organized not centripetally around a single axis, as are the works of Picasso, Gonzales, and Smith, but around several foci from which the components branch out—they appear flung out—at various angles and interlock, often supporting one another. Although the sculpture seems to sprawl, it is firmly designed. Because of the horizontal thrust of di Suvero's constructions, they are akin to Caro's, but di Suvero did not see any of the latter until 1964.

In 1966, di Suvero began to work more with steel beams, less with found wood timbers, as in *Elohim Adonai* of that year. The works also grew larger; the *Elohim* is twenty-two feet high. The movable elements in di Suvero's works assumed increasing importance, and they became more immense and heavy. In order to support them and maintain them in suspension, he began to structure his work around a central core rather than multiple foci. Required to provide support for each other, the girders could not sprawl as they had in earlier works.

Di Suvero's structures are stable and weighty, rooted to the ground, and at the same time they extend upward to support the free-floating mobile parts. Thus the heavy girders are structural. But they are also gestural, a kind of quasi-geometric but free handwriting, akin to Franz Kline's black swaths, which influenced di Suvero. The intimacy of gesture is also found in the heavy girders—and particularly in their clenched joints—each of which has been shaped by hand. And the intimacy is further enhanced because di Suvero's constructions invite spectator participation: being pushed, climbed, and ridden. But they are also elating, striving to be released from gravity, and they are majestic, soaring over the viewers.

Anthony Caro differed from di Suvero

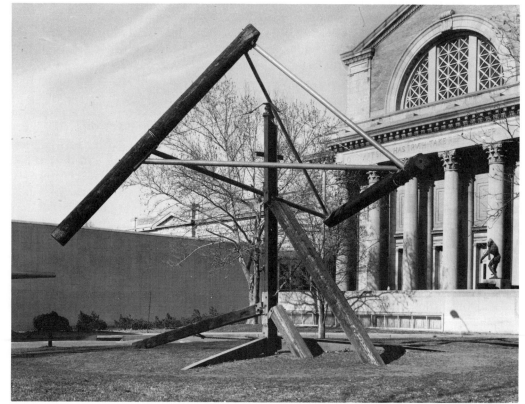

153. Mark di Suvero, *Praise for Elohim Adonai*, 1966. 22' high × 30' in diameter. Saint Louis Art Museum.

in that the welded constructions he began to make in 1959 did not aspire to monumentality, but rather hugged the floor. Indeed, they were far more intimate in size and feeling. Prior to 1959, Caro had modeled figures in plaster. Gene Baro recalled:

> In the summer of that year, Clement Greenberg visited Caro's studio and the result was, according to Caro's wife, Sheila, "confidence gained from his constructive criticism and encouragement." In the autumn, Caro did the visiting . . . under a Ford English Speaking Union Fellowship. His experience of recent art gained on this trip, and particularly of current American painting, and his contacts and friendships with American artists, perhaps especially with Kenneth Noland, were decisive in coalescing Caro's plastic impulses and ideas into a new idiom.[7]

Caro embraced Smith's method of welding metal, but his work was more horizontal and nonobjective than Smith's. Greenberg wrote of Caro's work in 1965:

Almost all surfaces and edges are rectilinear, and almost all their changes of direction are strictly rectangular. [But by] the tilting, tipping and odd-angle cantilevering of his rectangular shapes Caro achieves a kind of sprawling cursiveness that is all his own, and which makes everything that would otherwise look separate and frontal move and fuse.

Greenberg went on to say:

> Michael Fried speaks aptly of Caro's "achieved weightlessness." It is a kind of weightlessness . . . which has sprung from the Cubist collage. Part of Caro's originality of style consists in denying weight. . . . Applied color is another means to weightlessness in Caro's art, as Michael Fried, again, points out. It acts . . . to deprive metal surfaces of their tactile connotations and render them more "optical."[8]

Caro's work is gestural, and calls attention to his creative process. Fried wrote of "intimations of those cataclysmic gestures made, in the throes of love or grief or self-

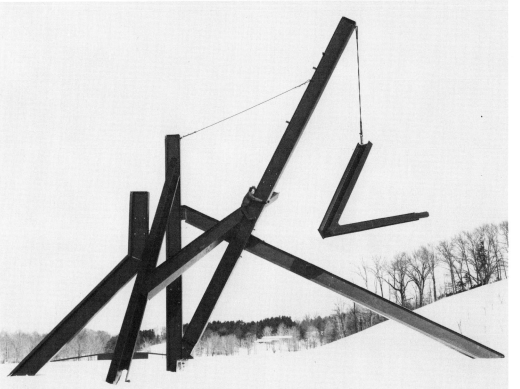

154. Mark di Suvero, *Are Years What? (For Marianne Moore)*, 1967. 40′ × 40′ × 30′. Oil and Steel Gallery, New York.

hate, by the naked spirit."[9] There is also in Caro's welded construction a sense of buoyancy and openness that in feeling relates it to the stained color-field abstractions of Noland and Olitski.

George Sugarman assumed a third position in sixties sculpture, his work partaking of the massiveness of Minimal objects and the complexity, openness, and energized space of welded construction-sculpture. Like the Minimalists and formalist construction-sculptors, Sugarman was essentially a formalist, but the formal questions he posed in his work were different from theirs. He asked:

155. Anthony Caro, *Midday*, 1960. 91¾" × 37⅜" × 145¾". Museum of Modern Art, New York.

What would happen if: I put sculpture on the floor; I put it on the ceiling; I got rid of the pedestal or integrated it; I covered whole walls with sculpture; I separated the parts of a sculpture and made them diverse; I used color; I extended its relationships into space in all directions; I combined elements of painting and sculpture.[10]

During the late fifties, Sugarman began to laminate pieces of found wood and by carving, sawing, power sanding, and further lamination, built a prodigious variety of geometric and organic, open and closed shapes. He then joined these improvised, invented volumes to improvise constructions in space. By 1960, like his friend Al Held, he started to place contrasting shapes side by side in what he called "extended space." To further separate and in-

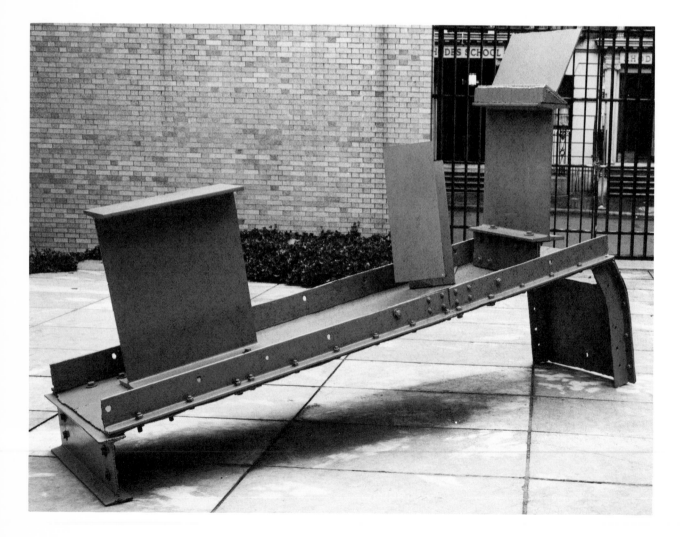

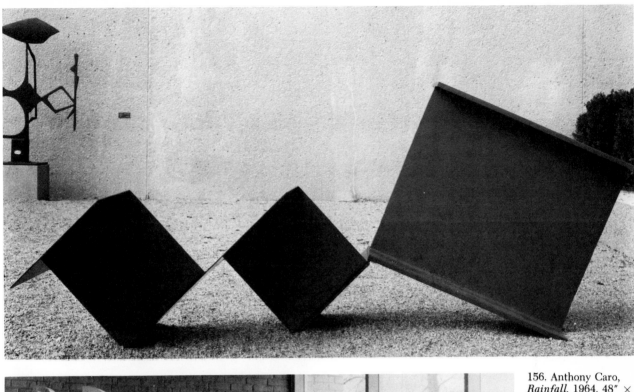

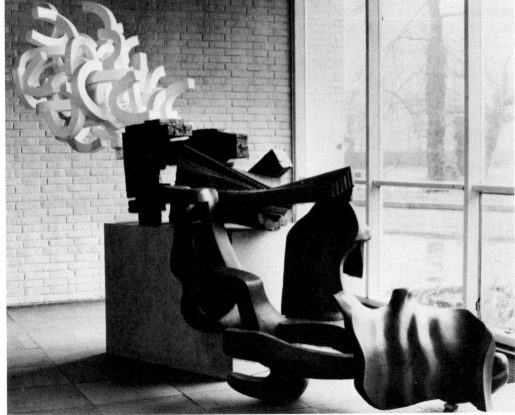

156. Anthony Caro, *Rainfall*, 1964. 48″ × 99″ × 52″. Hirshhorn Museum and Sculpture Garden, Smithsonian Institution, Washington, D.C.

157. George Sugarman, *Bardana*, 1962–63. 96″ × 144″ × 62″. Galerie Renée Ziegler, Zurich.

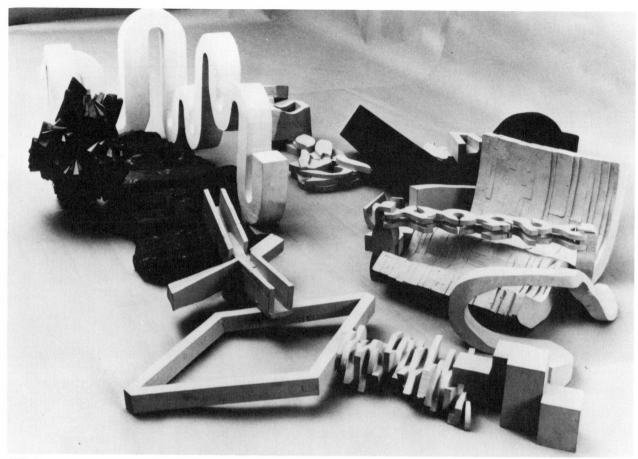

158. George Sugarman, *Inscape*, 1964. Dimensions variable. Whitney Museum of American Art, New York.

159. George Sugarman, *Two in One*, 1966. Nineteen parts, overall 85″ × 286″ × 134″. Collection the artist.

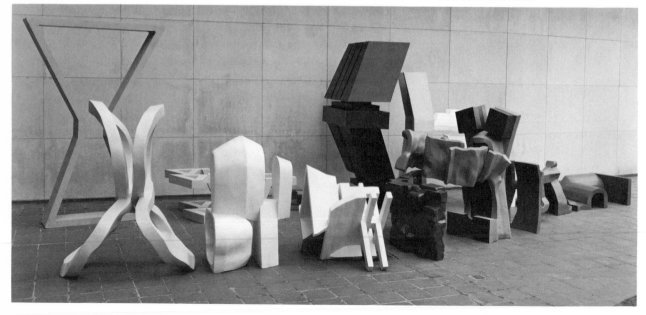

dividuate the components of his sculpture, he painted each a different intense, solid acrylic color, the color serving to articulate and augment the volumes in space. The emphasis in Sugarman's construction is on the individual component more than on the work as a whole—that is, the parts tend to be experienced in sequence, one by one. Each of his sculptures seems to be made up of many sculptures. This has required him to invent a great variety of forms.

Sugarman's bulky forms activate the space within and around themselves, like construction-sculpture. However, unlike the latter, whose forms tend to be related around an actual or implied central core in a Cubist manner, Sugarman's unrelated volumes are strung out. He also avoided Caro's use of preexisting, manufactured, right-angled, standard structural forms— hardly any of which, as Greenberg remarked, "gives satisfaction in itself"—and the sense of dematerialization and weightlessness that his pieces convey.[11]

Sugarman rejected the bareness of Minimal objects, their neutrality and austerity in shape, color, and surface, which call attention to the irreducible limits of sculpture, to qualities that have been renounced. In contrast, Sugarman's seemingly unbalanced, motile forms, varied in shape and color, call attention to the abundance, surprise, and open-endedness of his formal invention and to his rich use of the language of sculpture. Whereas Minimal objects can be instantly visualized, since parts are eliminated to emphasize the whole, Sugarman's constructions take time to be seen, not only because all the parts are different but because the whole is not immediately visible. Toward the end of the sixties, Sugarman turned from discontinuity to continuity; to experimenting with "field sculpture," in which the parts are placed at a distance from each other; and with large-scale sculpture meant to be sited in public places. But like the earlier work, the newer sculptures are dynamic, energizing rather than occupying space, complex, muscular, sensuous, and exuberant—most unlike Minimal objects, which are self-contained and inert, passive and impassive.

## NOTES

1. Carl Andre, interviewed by Paul Cummings, New York, September 1922, p. 56. Transcript in Archives of American Art, New York.
2. Sidney Geist, "A New Sculptor: Mark di Suvero," *Arts Magazine*, December 1960, p. 40.
3. Barbara Rose, "Looking at American Sculpture," *Artforum*, February 1965, pp. 33–34.
4. Clement Greenberg, in "Sculpture in Our Time," *Arts Magazine*, June 1958, p. 23, wrote: The new construction-sculpture points back, almost insistently, to its origins in Cubist painting: by its linearism and linear intricacies, by its openness and transparency and weightlessness, and by its preoccupation with surface as skin alone, which it expresses in blade- or sheet-like forms. Space is there to be shaped, divided, enclosed, but not to be filled or sealed in.
5. Clement Greenberg, "Recentness of Sculpture," *American Sculpture of the Sixties*, exhibition catalogue (Los Angeles: Los Angeles County Museum of Art, 1967), p. 26.
6. Max Kozloff, "Mark di Suvero," *Artforum*, Summer 1967, p. 43.
7. Gene Baro, "Britain's New Sculpture," *Art International*, June 1965, p. 27.
8. Clement Greenberg, introduction, *Anthony Caro*, exhibition catalogue (Otterlo, the Netherlands: Rijksmuseum–Kroller-Müller, 1967), n.p. (This essay was written in 1965.)
9. Michael Fried, "Anthony Caro," *Art International*, 25 September 1963, p. 72.
10. George Sugarman, in press release, Robert Miller Gallery, New York, 1980, n.p.
11. Greenberg, introduction, *Anthony Caro*, n.p.

# 12 THE ARTIST AS POLITICAL ACTIVIST

Before 1966, politics was not an urgent concern in the art world.[1] There did not seem to be any reason why it should have been. The sixties were ushered in with elating rhetoric by Kennedy's "New Frontier" and then Johnson's "Great Society." After the inertia of the Eisenhower administration, America seemed to be changing for the better. Struggle, such as that over civil rights, when it did occur, seemed to be leading to victory for the right cause.[2] Even after President Kennedy's assassination, in 1963, the mood was one of optimism and hope, until the war in Vietnam began to exert an irresistible and overwhelming pressure on artists in all the arts. Most of those who began each day by reading a newspaper were filled with loathing and despair. The news made their own work seem trivial and bred a debilitating demoralization and anomie.[3]

The heightened political consciousness of artists was symbolized in 1966 by the Tower for Peace in Los Angeles. A sixty-foot pylon, it was a collective effort, built by Mark di Suvero with money contributed by local artists organized by a committee headed by Irving Petlin on a plot of land rented with money advanced by Robert Rauschenberg and William Copley. The Tower was flanked by walls of pictures, each two feet square, donated by more than four hundred artists, including Sam Francis, Roy Lichtenstein, Louise Nevelson, Larry Rivers, Mark Rothko, and Frank Stella—to dramatize their opposition to the war.[4] As a symbol of the artist's new social role, the Tower for Peace supplanted Warhol's Factory.

In 1967, artists organized a variety of antiwar activities, among them the Angry Arts in New York—a week-long protest festival involving six hundred artists, which included some forty performances of film, dance, music, poetry, and drama and drew nearly fifty thousand spectators—and related activities in Chicago, Philadelphia, Washington, and London. Moreover, five hundred artists asked Picasso to withdraw *Guernica* from the Museum of Modern Art as an antiwar gesture.[5] In 1968, the political situation seemed worse than ever, exacerbated by the assassinations of Robert Kennedy and Martin Luther King, the riots at Columbia University and at the Democratic Party convention in Chicago, and the election of Richard M. Nixon to the presidency. The attempt on Warhol's life terminated most of whatever chic decadence remained in the sixties.

But the political awareness of vanguard painters and sculptors did not lead them to put their art in the service of their politics. They did not change their styles (or their life-styles).[6] Political radicalism and artistic radicalism were kept separate. What artists did in the streets, so to speak, had no influence on what they made in their studios. They could demand relevance—that favorite sixties expectation—

both in social and in aesthetic matters, but they did not connect the two spheres. Just as artists kept their art and politics separate, so they kept their art and life experiences separate. An artist might burn his draft card or smoke pot and listen to rock music (and many sixties artists did), become a disciple of some Eastern guru, participate in polymorphous sex, or even use heavy drugs—and not reveal any of these practices in his or her work.

Sol LeWitt, a nonobjective sculptor and a leading antiwar activist, summed up the attitude of most sixties artists toward art and politics:

> The artist who is concerned with painting and sculpture just does his art and believes what he believes as a person. [He is] asocial and apolitical [as an artist]. I do not think that I know of any art of painting or of sculpture that has any kind of real significance in terms of political content, and when it does try to have that, the result is pretty embarrassing. . . .
>
> The artist wonders what he can do when he sees the world going to pieces around him. But as an artist he can do nothing except to be an artist. . . .
>
> The artist as far as his work goes, does have the opportunity to pursue a pure line of work . . . which disregards society. . . . If an artist thinks he is doing something that is more moral or more right or self-righteous or has any ethical meaning, that is a delusion and a sentimentality.[7]

To most sixties artists it did not seem that art could be an effective instrument, not to mention a weapon, to effect social betterment—so why bother? Political art was thought to be retrograde and aesthetically inferior, and had been spurned by vanguard artists since the Depression thirties. Arshile Gorky had ridiculed it as "a poor art for poor people." Art in the cause of social change and art on the cutting edge of art were deemed irreconcilable.[8]

But there were a number of social-protest artists whose work was also powerful aesthetically, the best of whom were Edward Kienholz, Peter Saul, Leon Golub, and Nancy Spero.[9] They asked whether it was possible to be deeply moved by society's problems and avoid introducing social concerns into art. They insisted that art could be an effective weapon, witness *Guernica* and Grosz's caricatures. Nevertheless, after 1967, exhibitions protesting the Vietnam War contained an inordinate amount of banal art, much of it fabricated for such shows, art that tried to shock by incorporating smashed dolls or ripped and mangled American flags smeared with red paint, like ketchup in a Hollywood Western; caricatures of profiteers and generals; and cut-up gory photographs. Kienholz, Saul, Golub, and Spero avoided such feeble clichés, but their work tended to be lost in the shuffle of political art generally.

Antiwar abstract artists claimed that because their work had aesthetic significance, it might be put more effectively to work in a cause than art that had a social message. In a brochure for a show of nonobjective art, Robert Huot, Lucy Lippard, and Ron Wolin wrote that the fourteen participating artists

> are against the war in Vietnam. They are supporting this commitment in the strongest manner open to them, by contributing major examples of their current work. The artists and the individual pieces were selected to represent a particular esthetic attitude, in the conviction that a cohesive group of important works makes the most forceful statement for peace.[10]

However, a number of these artists and their colleagues made art that was so extreme as to seem unsalable and thus threaten the art market. To be sure, many did not do so with anticommercial intent; they partook of the make-it-new mentality that gripped sixties artists.[11] But some did seem motivated by disgust for a social class that they believed both considered art as a commodity and waged the Vietnam War. Barbara Rose asked how else could one account for such avant-garde works as Walter de Maria's room of dirt or trenches dug into the desert and other Earthworks; Robert Morris's Process Art, which was composed of piles of felt or of dirt, grease,

and metal odds and ends, or his "sculpture" made of steam; Joseph Kosuth's and John Baldessari's Conceptual Art, which consisted only of verbal statements regarding the nature of art; Robert Barry's and Douglas Huebler's documentation-as-art of nonexistent "work"? Or Les Levine's disposable plastic pieces, which were inexpensive enough to be thrown away and were made in unlimited editions? Her answer: "A dissatisfaction with the current social and political system results in an unwillingness to produce commodities which gratify and perpetuate that system. Here the spheres of ethics and esthetics merge." She went on to say that artists "who aspire to radicality [try to] take positions so extreme that they will finally be found unacceptable," and thus, by "denying that art is a trading commodity [erode] the very foundation of the art market."[12]

Of sixties art, it was Conceptual Art, Earth Art, and Performance Art that seemed most difficult to market, and the intention of its creators may have been anticommercial, and thus political, if only in part. A number of artists even refused at that time to provide the documentation that was the only salable part of their works. But these pieces in themselves were only infrequently political. Kynaston McShine had written in the catalogue for *Information*—an international show of Conceptual Art—which he organized at the Museum of Modern Art in 1970: "It may seem too inappropriate, if not absurd, to get up in the morning, walk into a room, and apply dabs of paint from a little tube to a square of canvas. What can you as a young artist do that seems relevant and meaningful?"[13] Only four works in the show—those by John Giorno (better known as a poet), Hans Haacke, Lucy Lippard (better known as a critic), and the New York Graphic Workshop—made direct political references. Perhaps the most political component of the *Information* show was McShine's statement.

In any case, Conceptual Art, Earth Art,

and Performance Art were made salable. Documentation—catalogues, books, statements, photographs, etc.—soon became collectors' items. Lippard wrote:

> Hopes that "conceptual art" would be able to avoid the general commercialization . . . were for the most part unfounded. It seemed in 1969 that no one, not even a public greedy for novelty, would actually pay money, or much of it, for a xerox sheet referring to an event past or never directly perceived, a group of photographs documenting an ephemeral situation or condition, a project for work never to be completed, words spoken but not recorded; it seemed that these artists would therefore be forcibly freed from the tyranny of a commodity status and market-orientation. [By 1972] the major conceptualists are selling work for substantial sums here and in Europe; they are represented by (and still more unexpected—showing in) the world's most prestigious galleries. Clearly . . . art and artist in a capitalist society remain luxuries.[14]

Not only art but even the posters and graffiti produced by rebellious students in Paris in 1968 were issued in editions and eagerly bought and sold by resourceful dealers and collectors. They were also exhibited in 1968 at the Museum of Modern Art, New York, in *Paris, May 1968, Posters of Student Revolt,* and at the Jewish Museum in *Up Against the Wall: Protest Posters.*

The works that Rose described did seem to be evidence of a crisis that was both aesthetic and social. This was the theme of an article titled "How I Spent My Summer Vacation," by Philip Leider, published in *Artforum,* in September 1970. He recounted that during a trip he took with Richard Serra and Joan Jonas to see Michael Heizer's huge Earthwork *Double Negative,*

> Serra was wondering whether the times [the period of most intense concern about the Vietnam War] were not forcing us to a completely new set of ideas about what an artist was and what an artist did. I argued for Michael Fried's idea that the conventional nature of art was its very essence, that the great

danger was the delusion that one was making art when in fact you were doing something else, something of a certain value but not the value of art.

But the experience of *Double Negative* was a revelation; although it was not the art that Fried would allow, it was profoundly moving art—and revolutionary as well.

This experience prompted Leider to question the relation of revolutionary art to social revolution. He asked why art with revolutionary subject matter tended to be reactionary as art. News came of Newman's death. "We talked about why these revolutionary artists [the Abstract Expressionists] didn't seem so revolutionary to the revolution, which seemed to prefer the art against which they revolted."

This led Leider to speculate about art made by artists who had left the art world and joined the counterculture, who were making art that did not look like art, certainly not like conventional art. Leider had encountered an artist friend who was building a house for himself in a commune, a house that exemplified the counterculture spirit of the commune and incorporated every sculptural idea he had ever had. "The revolution in Lynn's art, if there was one, was dictated by the terrain. . . . Whether this meant that Lynn wasn't an artist any more or whether he had undergone that complete redefinition of what an artist is and does that Serra worried about was my problem, not his."[15]

Ironically, some of the most politically effective protest vehicles, effective because of their appeal to television, were not in themselves works of art accepted by the art world, although they had their roots in the Happenings of the late fifties and early sixties presented by Allan Kaprow, Claes Oldenburg, Jim Dine, Robert Whitman, and Red Grooms. New Left and hippie events, such as the countercultural Be-in or the March on the Pentagon in 1967, were "revolution by theater and without a script," in Norman Mailer's phrase.[16] At times, they were bitter confrontations that ended in violence. At other times, they were joyful public celebrations; indeed, as Morris Dickstein remarked, the festive events were "aimed at preserving a utopian communal ideal in a period of strife and polarization."[17] Although such spectacles may be considered the "art" of sixties counterculture, they were unconnected with concurrent tendencies in avant-garde art.[18]

One would suppose that aggressive political dissent would have made vanguard artists less fashionable by alienating their rich and presumably conservative patrons. But by 1968, many establishment figures themselves supported the antiwar movement—and the antiracist agitation that grew in intensity at the time. Both causes had become fashionable; activities on their behalf could advance status and fame in the art world.[19] Leading antiwar and antiracist activities became chic.[20] A number became expert in attracting the media—Mailer, for example, who was just as media-savvy as Warhol. In fact, Mailer was a superstar of the world of political dissent, just as Warhol was a superstar of the world of apolitical fashion. Their self-made images became masterworks, as it were, of the "aesthetics of celebrity."[21] "The culture's skill at amiably absorbing all manner of rebels and turning them into celebrities" was undeniable, as Jack Newfield remarked: "Every thrust at the jugular draws not blood, but sweet success . . . fame and affluence. . . . Yesterday's underground becomes today's vaudeville and tomorrow's cliché."[22] But even the most careerist of antiwar activists were serious; their loathing was deep-felt, often desperate.

The Art Workers Coalition (AWC), founded to channel artists' dissent only in 1969, was a late arrival to the social protest movement. It originated on 3 January, when Takis (Vassilakis) asked the curator of an exhibition titled *The Machine as Seen at the End of the Mechanical Age,* at the Museum of Modern Art, to remove from the show a 1960 work by the sculptor. The

museum had promised to transport a recent work from Paris but for budgetary reasons had substituted, from its own collection, the earlier one, which Takis claimed did not represent his current work. When the museum denied his request, he and five friends engaged in a sit-in. After an hour, the Modern's director, Bates Lowry, conferred with the protesting artists for two more hours and agreed to remove Takis's sculpture, then hold further talks and public discussion the following month. Takis also distributed a handbill, which asserted that he hoped this act "will be just the first in a series of acts against the stagnant policies of art museums all over the world."[23] His act became a catalyst, activating dozens of younger artists who felt alienated from what they believed to be an "art establishment" in whose decision-making the role of artists had grown progressively less significant.

The coalition they formed was kept deliberately loose; no list of members was drawn up and no officers were elected or appointed. Decisions were made on the basis of "participatory democracy": any individual or group could initiate programs in the name of the general organization, subject to veto by consensus. The size of the AWC's membership at any moment could be determined only by the number that appeared at an activity; attendance at meetings varied from eighty to one hundred—more for special events. For example, within three months of the sit-in by Takis and his friends, some three hundred Art Workers demonstrated at the Museum of Modern Art. But they constituted only a small minority of the artists in New York, even though an overwhelming majority were antiwar.

Since each individual or group could do his or her own "thing," the activities of the AWC were fluid and varied. One group within the coalition was interested in creating an artists' community; a second, in the living conditions of artists (and workers) and how to improve them; a third, in the "liberation" of women artists (and women generally); a fourth, in the problems of black and Puerto Rican artists; a fifth, in the cultural life of the ghetto and in neighborhood art centers and museums; a sixth, in broader social issues, notably the antiwar movement but also a new society; and a seventh, in protesting the policies of the Museum of Modern Art and restructuring it and museums in general. Few Art Workers were engaged in more than one or two activities, but most participated in the agitation against the Modern, particularly because black artists had made it the central point of their program, demanding the establishment of a separate black wing in the museum.

At the initial sit-in, Takis and his friends stated in their handbill that they were opposed to four general museum practices and wanted them reformed. These were "the exhibition of works by living artists ... [without] their express consent," "the exclusive ownership privileges exercised by museums over the work of living artists," "the lack of consultation between museum authorities and artists, particularly with regard to the installation and maintenance of their work," and "the unauthorized use of photographs and other materials pertaining to the artist's work for publicity purposes."[24]

Within three weeks, the four points, relatively modest and achievable, had been escalated to thirteen and included demands that would have altered radically the structure and function of the Museum of Modern Art. The most controversial were that a "section of the Museum, under the direction of black artists, should be devoted to showing the accomplishments of black artists"; that the "Museum's activities should be extended into the Black, Spanish and other communities. It should also encourage exhibits with which these groups can identify";[25] that a "committee of artists with curatorial responsibilities should be set up annually

to arrange exhibits"; that the "Museum should be open on two evenings until midnight and admission should be free at all times"; that artists "should be paid a rental fee for the exhibition of their works"; that the "Museum should exhibit experimental works requiring unique environmental conditions at locations outside the Museum"; that the "Museum should include among its staff persons qualified to handle the installation and maintenance of technological works"; and that a "section of the Museum should be permanently devoted to showing the works of artists without galleries."[26]

On the whole, the New York art world was sympathetic to the AWC, but there was a widespread suspicion of self-serving on the part of technological artists, such as Takis, and of black artists. Could it be that technological artists wanted the Modern to support their kind of art and provide more resources for it? Were black artists intent only on overcoming discrimination or were they also trying to get in through the back door, as it were, bypassing the qualifications applied by the museum to white artists? The AWC professed to be neutral in aesthetic matters, but that, in fact, was impossible. Sides were taken on such issues as whether there was a black art that could be judged by whites or whether all art of significant merit was universal in quality and appeal. There was also dissension over whether art should reflect social concerns or not.

On 28 January, representatives of the AWC met with Lowry and other MoMA officials and presented the thirteen demands. The Art Workers requested a public hearing, and Lowry responded by recommending that a Special Committee on Artists Relations be appointed. The committee would hold meetings, keep a record of its proceedings, and propose suggestions for improvements—all of which would be made public. The Modern and the AWC could not resolve this issue, and each put its own proposal into effect.

In its dealings with the AWC, MoMA's position was delicate. Its administrators were afraid that if they treated the AWC cavalierly, they might increase sympathy for it. Of greater concern to the Modern's officials was the possibility that if the AWC became too frustrated, some of its members might take violent action against the museum, possibly leading to the damage or destruction of works of art. Indeed, threats of this nature were made, and one Art Worker did spray paint on *Guernica.*[27]

On 10 April, a public hearing was held at the School of Visual Arts. Approximately two hundred fifty Art Workers attended and fifty spoke; their statements were published in a book called *Open Hearing.* Among the issues raised were: the structure of the Art Workers Coalition; alternatives to museums and art institutions; the reform of art institutions; the legal and economic relationships of artists to galleries and museums; the artists' relationships to society; and black and Puerto Rican artists' rights.[28] But the Museum of Modern Art was the major subject of discussion. Taking an extremely hostile position, Gregory Battcock demanded that Lowry be tried before a "people's tribunal" for "his role in the worldwide imperialist conspiracy."[29] Few of the other speeches were as abusive as Battcock's, but on the whole, they condemned the Modern for its lack of responsiveness to artists' desires and its lack of relevance. To remedy these deficiencies, it was suggested that artists be given decision-making powers and that MoMA support recent tendencies in art by selling its earlier modern masterpieces and using the proceeds to subsidize the exhibition and purchase of current works of art.[30]

A number of Art Workers questioned whether reforming the Modern was really an issue sufficiently important to monopolize the AWC's attention. Would it not be more important, as Carl Andre suggested, to establish an artists' community that might replace the existing art market sys-

tem, which "has been the curse and corruption of the life of art in America and in the world?"[31] Should not the reformation of capitalist society and/or action against the Vietnam War, which the leaders of that society waged, take precedence? Artists intent on reforming museums countered by insisting that the Establishment or the System was monolithic: those who were responsible for the war controlled the museums for their own class interests. MoMA was the cultural arm of "American Imperialism." Strike at one, you strike at the other. Since the museum discriminated against blacks and women, it could be a rallying point for antiracist and antisexist as well as antiwar forces. And most important, it was a good target because it was highly visible and vulnerable—and within the artists' community—and action for social change ought to begin in one's backyard, as it were.

On 30 September, about thirty-five Art Workers met with representatives of MoMA at the museum to discuss the thirteen demands. The meeting was unfruitful. Two thirds of the Art Workers walked out when the museum officials refused to grant their demand for a black wing.[32] Negotiations were at an impasse. The attention of the AWC then turned to the Metropolitan Museum of Art. Antiwar activists had planned a Moratorium for 15 October. That turned out to be the same day that the Metropolitan had scheduled the opening of *New York Painting and Sculpture: 1940–1970,* the largest and most important survey of recent American art ever to be held. The Art Workers demanded that the Metropolitan postpone the opening. When they were refused, six of them mailed about four hundred leaflets asserting that the art world was observing the Moratorium, and persuaded many of the artists chosen to participate in the Metropolitan's show to inform Thomas Hoving, the museum's director, and Henry Geldzahler, the show's organizer, that they supported the AWC's demand. Hoving yielded and postponed

the opening until the following evening, sending every invited guest a telegram about the change of date. Nevertheless, the AWC picketed the opening.

At this juncture, the AWC resolved a basic issue formulated as early as 2 April: to "decide once and for all whether [its] aim is to negotiate with the Museum [of Modern Art] over reforms . . . or to try setting up a completely alternate system to museums and galleries."[33] The AWC's decision, based on its estimate of its power, was to negotiate for what it could achieve (although two Art Workers, who called themselves the Guerrilla Art Action Group, began disruptive but peaceful confrontations—in the name of the AWC—at the Modern).[34] At the same time, the museum's officials on the staff level—that is, below the board of trustees—decided to deal with the AWC on every matter within their power. The issue became the participation of artists in MoMA's decision-making process.

On 25 November, about fifty Art Workers and twenty MoMA staff members met at the museum. The meeting was chaired by Carl Andre of the AWC. Arthur Drexler, MoMA's spokesman, began by announcing that the Modern was initiating a free-admission period, but that the specifics had not yet been worked out. He then stated that every museum policy determined by the staff was open to negotiation. He insisted, however, that the staff would strongly oppose any change in the Modern's basic aims: MoMA is the only institution in the world that combines at full strength the purposes and outlook of a *Kunstmuseum* and a *Kunsthalle.* "We want to continue to be both, and this is our intention and our identity. That is why the museum was founded and has flourished. Our purpose is to make the Modern better at what it does. If you want a new framework, start your own institution."

An Art Worker demanded AWC participation in policy-making on the trustee level. Drexler responded that he could not speak for the trustees but invited the

AWC to work with the staff in shaping specific operational policies. After a long debate, the Art Workers accepted Drexler's invitation, but under protest and only as an initial wedge to real power. A committee of six, composed of two museum staff members, two Art Workers, and two artists not identified with the AWC, was selected to continue the negotiations.[35] Those at the meeting also agreed to take direct antiwar action by publishing, under the joint auspices of the Modern and the AWC, a poster condemning the massacre of Vietnamese civilians at My Lai. The museum's trustees, however, later overruled the staff and refused any MoMA support of the poster project. The Art Workers by themselves produced the poster, which turned out to be one of the most effective of antiwar gestures.

On 18 May 1970, after the invasion of Cambodia and the killing of four students at Kent State University, a large public meeting was held at New York University. The two thousand participants decided to organize an Artists' Strike Against Racism, Sexism, Repression, and War, whose purpose it was to close down all New York galleries and museums for one day. Robert Morris (who in 1968 had denied any interest in politics) and Poppy Johnson were elected to lead the strike. The next night, they and about thirty other people met in Yvonne Rainer's loft to discuss their course of action. They proposed to close down five museums: the Metropolitan Museum of Art, the Museum of Modern Art, the Whitney Museum of American Art, the Solomon R. Guggenheim Museum, and the New York Cultural Center. The artist-strikers hand-delivered to each institution letters stating their intentions. On 21 May, at another meeting, it was voted to demonstrate at one museum at a time in order to avoid dissipating the group's strength. The artist-strikers decided to meet the following morning at ten on the steps of the Metropolitan Museum. Morris adjourned the meeting by asking for a vote of good faith that they would not

allow the destruction of works of art or of anything else, which was passed and released to the press and to the museums. The strike involved about three hundred demonstrators and took place peacefully.[36] This was the last major antiwar action of the AWC, although there were other confrontations—for example, at the American Association of Museums convention in June.

In retrospect, it appears that the most valuable contribution of the Art Workers Coalition and other socially minded organizations was, as Hilton Kramer wrote in the *New York Times*, to force the art world to consider

an issue that bears serious attention. This was the issue of the artist's moral and economic status vis-a-vis the institutions that now determine his place on the cultural scene, and indeed, his ability to function as a cultural force. Though the Museum of Modern Art was the immediate target of complaint, the issue obviously went beyond the museum and its policies. What was denounced was the entire social system—not only museums, but galleries, critics, art journals, collectors, the mass media, etc.—that now decisively intervenes between the production of a work of art and its meaningful consumption. What was proposed—albeit incoherently, and with that mixture of naivete, violent rhetoric, and irrationality we have more or less come to expect from such protests—was a way of thinking about the production and consumption of works of art that would radically modify, if not actually displace, currently established practices, with their heavy reliance on big money and false prestige.

In part, then, this was a plea to liberate art from the entanglements of bureaucracy, commerce, and vested critical interests—a plea to rescue the artistic vocation from the squalid politics of careerism, commercialism, and cultural mandarinism. [This is] a moral issue which wiser and more experienced minds had long been content to leave totally unexamined.[37]

Both the *Information* show and the rapid decline of the Art Workers Coalition after Cambodia and Kent State in 1970

may be considered the end of the sixties. It may seem too pat historically to terminate a decade in art at its chronological cutoff, but the Cambodian invasion, which provoked the last great protests against the war, and the establishment of Conceptual Art were the symbols of the end of one era and the beginning of another.

## NOTES

1. Artists had acted politically on their own behalf in the early sixties. In 1961, New York painters and sculptors organized the Artists-Tenants Association (ATA) to protest to City Hall recent rezoning laws under which many artists were threatened with eviction from their lofts. They secured an agreement from the city to permit artists to live in their low-rent studios. See "Artists and New York Settle Housing Dispute," *Art News,* September 1961.

   Two years later, the agreement began to fall apart, and artists picketed Leonardo da Vinci's *Mona Lisa,* which was on display at the Metropolitan Museum of Art. See "Artists and Lofts, Part II," *Art News,* March 1963. "New York Artists Fight for Space," *Art News,* May 1964, p. 8, reported that

   various municipal agencies have seen fit either to ignore or systematically defy the agreement. The artists . . . protested the evictions in a series of negotiations, meetings and public manifestations, culminating on April 3 in a one-day strike of local exhibitions and a march on City Hall. Representatives of the Artists-Tenants Association were met by City officials who expressed the hope that mutually satisfactory solutions would be found in the near future, and the officials reaffirmed their understanding of the important role artists play in the life of New York.

2. There was some art-world concern with civil rights. See T.B.H. [Thomas B. Hess], "Editorial: Them Damn Pictures," *Art News,* May 1963, p. 23, condemning the removal of G. Ray Kerciu's pictures dealing with desegregation from a show at the University of Mississippi and the indictment of the artist for desecrating the Confederate flag. Beginning in 1962, the Congress of Racial Equality (CORE) held annual exhibitions and sales of paintings and sculptures donated by artists; Robert Rauschenberg, Larry Rivers, and other artists contributed limited editions of prints. See "Artists for CORE," *Art News,* May 1963; "Art News International," *Art News,* May 1964; and "Art News International," *Art News,* May 1965.

   However, in *Artforum,* February 1966, p. 13, there appeared a full-page advertisement soliciting membership for the Artists Civil Rights Assistance Fund, Inc., established in 1964. No artist was on the executive committee or the board of directors. Of the 130 participants listed, including such luminaries as James Baldwin, Saul Bellow, Norman Mailer, and Joseph Heller, I recognized the names of only four artists: Robert Andrew Parker, Paris-based Man Ray, photographer Robert Frank, and Wall Street broker Walter K. Gutman. Such was the extent of artists' involvement in social causes.

3. The appeal for artists to participate in the "Artists Tower Against the War in Vietnam," Los Angeles, Spring 1966, was reprinted in Dore Ashton, "Protest: Politics and Painters," *Art Voices,* Summer 1966, p. 27; it read in part: "We artists today, each day, attempt to summon creative energy in an atmosphere polluted with crime: the moral decay that is the reality of the war in Viet Nam. It is no longer possible to work in peace."

   "The Arts: Protest on All Sides," *Time,* 10 July 1967, pp. 83–84, reported: "Today, most artists are tortured by the Vietnam war." Toward the end of the sixties, a significant number of art critics stopped writing about art. Participating in a Conference on Art Criticism and Art Education, sponsored by New York University and the New York State Council on the Arts in cooperation with the American Section of the International Association of Art Critics and the Institute for the Study of Art in Education, at the Solomon R. Guggenheim Museum in May 1970, Max Kozloff and Barbara Rose questioned the relevance of art criticism in the face of the war.

4. See "Los Angeles: Tower for Peace," *Art News,* April 1966, pp. 25, 70; and "The Arts: Protest on All Sides," p. 83.

5. "The Arts: Protest on All Sides," pp. 83–84. One hundred fifty painters and sculptors collaborated on a 10-by-120 foot "Collage of Indignation" at Loeb Student Center, New York University. Moreover, in 1967, the flower children emerged. In February, there was a seminal Be-in in San Francisco. In April, there took place a giant rally at the United Nations, at which Martin Luther King came out publicly against the Vietnam War, and a huge Be-in in Central Park, New York. On 21 October, there occurred the March on the Pentagon.

6. Ashton, in "Protest: Politics and Painters," could point to very little that was interesting in socially conscious art in 1966. She was reduced to featuring Warhol; on p. 23, she wrote:

   He is the darling of the privileged classes and

decidedly chic. Yet the news data issuing from the South, of dogs used to break up demonstrations, arrested his attention. His dramatization of the facts in his painting attracts the attention of others who will remember the barbaric gladiatorial ways of Rome perhaps, or the dogs conquering men in Nazi Germany.

Illustrated were a *Race Riot* by Warhol, Rosenquist's *F-111,* a picture by Peter Saul, Rauschenberg's combine-painting with a portrait of Kennedy, Marcia Marcus's portrait of Kennedy, Philip Guston's abstract *Protest,* and Hans Hofmann's abstract *To JFK.*

7. Sol LeWitt, in "La Sfida del Sistema," *Metro* 14 (1968): 44–45. LeWitt's attitude was similar to that of Albert Camus, who wrote that "some of us should . . . take on the job of keeping alive through the apocalyptic historical vista that stretches before us, a modest thoughtfulness which, without pretending to solve everything, will constantly be prepared to give some human meaning to everyday life." (Quoted in Staughton Lynd, "The New Radicals and 'Participatory Democracy,'" *Dissent* 12 (Summer 1965): 331.

8. Lucy R. Lippard, in "The Dilemma," *Arts Magazine,* November 1970, pp. 28–29, wrote:

   Few of us today have any illusions left about the existence of a truly political art. . . . It is curious that most art associated with and used by the revolution is stylistically so reactionary. . . . No matter how strongly felt . . . the *illustration* of any situation, no matter how ghastly, provides nothing but clichés. [The My Lai Massacre protest poster] was more effective than anything done so far by a single artist.

9. There were special cases, such as George Segal. Most of Segal's work was not political, but his realist style lent itself to such statements, which he made occasionally. His *Execution,* 1967, for example, is composed of life-size white plaster figures and a blue wall against which they have just been gunned down. Spectators could move in and around the work.

10. Robert Huot, Lucy Lippard, and Ron Wolin, in a brochure for a Benefit for the Student Mobilization Committee to End the War in Vietnam, Paula Cooper Gallery, 23–31 October 1968. The participating artists were Carl Andre, Jo Baer, Robert Barry, Bill Bollinger, Dan Flavin, Robert Huot, Will Insley, Donald Judd, David Lee, Sol LeWitt, Robert Mangold, Robert Murray, Doug Ohlson, and Robert Ryman.

    Lippard in "The Dilemma," p. 28, wrote:

    An artist's public power is as an artist, not "just" as a human being, but as a human being who makes art. Suggestions that he forget about making art because the world is in such rotten shape, that he go out and bomb buildings or build roads in Latin America, are inane except in terms of the most personal life decisions.

    Claims were also made that abstract art could not help being political. For example, Donald Judd, in "La Sfida del Sistema," p. 43, insisted that because his work was unconventional and antihierarchical, it resisted existing American attitudes and social structures.

11. Robert Morris, in *Conceptual Art and Conceptual Aspects,* exhibition catalogue (New York: New York Cultural Center, 1970), p. 52, characterized avant-garde art as

    an energy driving to change perception. (From such a point of view the concern with "quality" in art can only be another form of consumer research—a conservative concern involved with comparisons between static, similar objects within closed sets.) [Art] itself is an activity of change, of disorientation and shift, of violent discontinuity and mutability, of the willingness for confusion even in the service of discovering new perceptual modes.

    The destabilization of perception could imply a destabilization of society, as I think Morris's remark does.

12. Barbara Rose, "Problems of Criticism, VI: The Politics of Art, Part III," *Artforum,* May 1969, pp. 46–48.

13. Kynaston McShine, *Information,* exhibition catalogue (New York: Museum of Modern Art, 1970), n.p.

14. Lucy R. Lippard, ed., *Six Years: The Dematerialization of the Art Object* (New York: Praeger Publishers, 1973), p. 263.

15. Philip Leider, "How I Spent My Summer Vacation," *Artforum,* September 1970, pp. 40–41, 43, 45.

16. Norman Mailer, *Armies of the Night* (New York: New American Library, 1968), p. 223. The commercial counterparts of countercultural "Be-ins" were rock concerts with their psychedelic color and light, ear-splitting decibels, and sex and drug rituals.

17. Morris Dickstein, *Gates of Eden: American Culture in the Sixties* (New York: Basic Books, 1977), p. 261.

18. Allan Kaprow, "La Sfida del Sistema," *Metro* 14 (1968), pp. 38–40. See also Allan Kaprow, "The Happenings Are Dead: Long Live the Happenings," *Artforum,* March 1966. The innovator of Happenings, Kaprow, in "La Sfida del Sistema," pp. 38–40, acknowledged that "a Happening can be conceived politically, for example, by utilizing current forms of sit-ins, lie-ins and other protest-structures . . . like Vostell, Lebel, the Provos of Holland." But as Kaprow saw it, political events were not different from any other events in everyday life. Like most other artists, he opposed making art that might be used on behalf of specific political causes. Kaprow spoke of his "anguish and helplessness knowing that we cannot directly affect the course of politics."

19. I wish to stress that most artists who became political dissenters did so out of deep conviction. However, a number of careerists joined them when social protest became fashionable, and they created a good deal of resentment among genuine radicals. I remember that when one artist made an antiwar gesture of notoriety, a poster appeared in SoHo proclaiming him the Prince of Peace.

20. See Tom Wolfe, *Radical Chic & Mau-Mauing the Flak Catchers* (New York: Harper & Row, 1970), pp. 29–40.

21. See Ellen Willis, "My Podhoretz Problem—and His," *Village Voice*, 3 December 1979, p. 38.

22. Jack Newfield, "A Prophetic Minority: The Future," in Edward Quinn and Paul J. Dolan, eds., *The Sense of the Sixties* (New York: The Free Press, 1968), p. 55.

23. Art Workers Coalition (AWC), *Documents 1*, New York, 1969, p. 1.

24. John Perreault, "Art: Whose Art?" *Village Voice*, 9 January 1969, p. 17.

25. Black artists began to organize only in 1963. A number within the New York art world who met on the March to Washington organized the Spiral Group. See Jeanne Siegel, "Why Spiral?" *Art News*, September 1966.

26. John Perreault, "Art: Les Levine Month," *Village Voice*, 6 February 1969, p. 16.

27. The possibility of vandalism against the Museum of Modern Art was broached as early as January 24 by Alex Gross in the article "Artists Attack MOMA," in *East Village Other* (reprinted in AWC, *Documents 1*, p. 11), in which he wrote that "last year's demonstrations in the universities may take place this year in the museums as well. . . . No one should be surprised if the museums do become such targets, though it is to be hoped for that works of art will not be damaged." Because of the fear of vandalism during a demonstration on 24 March, Lowry opened the garden of the museum to allow three hundred Art Workers to enter and meet there.

The museum's fears were justified. Toward the end of the sixties, antiwar activists grew increasingly frustrated, and a number turned to violence. A significant number of artists embraced destruction in art. This was the theme of "Manipulation Issue," *Aspen* 6A (Winter 1968–69). It featured Jon Hendricks, Ralph Ortiz, Bici Hendricks, Jean Toche, Allan Kaprow, Al Hansen, Geoffrey Hendricks, Steve Ross, Carolee Schneemann, Lil Picard, Kate Millet, Nam June Paik, Charlotte Moorman, Jud Yalkut, Ken Jacobs, and Takahiko Kimura.

See also Jill Johnston, "Dance Journal: Over His Dead Body," *Village Voice*, 28 March 1968, p. 19. (*Aspen* 6A was anticipated in September 1966 by a Destruction in Art Symposium in London and an issue of *Art & Artists* magazine that was supposed to reduce itself to dust in a few months.)

28. See "Subject Index," AWC, *Open Hearing*, p. iv.

29. Gregory Battcock, in AWC, *Open Hearing*, p. 8.

30. See Hans Haacke, in AWC, *Open Hearing*, pp. 46–47.

31. Carl Andre, in AWC, *Open Hearing*, pp. 30, 34.

32. Lucy Lippard, interviewed by Irving Sandler, New York, 10 November 1969.

33. Alex Gross, "Black Art-Tech Art-P—Art," *East Village Other*, 2 April 1969, reprinted in AWC, *Documents 1*, p. 56.

34. Guerrilla Art Action Group, press release, New York, 31 October 1969. The Guerrilla Group, consisting of Jon Hendricks and Jean Toche, removed Malevich's *White on White* (without harming it) from a wall of the Museum of Modern Art and replaced it with a manifesto demanding that the museum sell one million dollars' worth of its art works and give the money to the poor, "decentralize its power structure to a point of communalization" and close the museum until the end of the Vietnam War. On 10 November, Hendricks and Toche spilled animal blood on the floor of one of the museum's galleries and rolled in it while making groaning noises.

35. Irving Sandler, notes taken at a meeting between the Art Workers Coalition and Museum of Modern Art staff members, Museum of Modern Art, New York, 25 November 1969.

36. See Elizabeth C. Baker, "Pickets on Parnassus," *Art News*, September 1970. See also Sean Elwood, "The New York Art Strike of 1970" (master's thesis, Hunter College, 1981), and Corinne Robins, "The New York Art Strike," *Arts Magazine*, September–October 1970.

37. Hilton Kramer, "Artists and the Problem of 'Relevance,' " *New York Times*, 4 May 1969, sec. D, p. 23.

# 13 ECCENTRIC ABSTRACTION AND PROCESS ART

Given the art-world recognition of Minimal Art in 1966, it was in keeping with the make-it-new attitude of the sixties that a reaction set in. Lippard proclaimed:

> The conventions for this mode are already established. . . . It must have looked easy when Don Judd, then Robert Morris, and later Sol LeWitt and Carl Andre began to attract attention, but the mold has hardened fast for their imitators. Monochrome, symmetry, single forms, stepped or graded color or shape, repetition of a standard unit, the box, the bar, the rod, the chain, the triangle or pyramid, are the new clichés.[1]

Lippard said that the rigors of Minimalism made her aware of what it precluded, namely "any aberrations toward the exotic." Moreover, a considerable number of artists in New York and California had

> evolved a . . . style that has a good deal in common with the primary structure as well as, surprisingly, with aspects of Surrealism. [These artists] refuse to eschew . . . sensuous experience while they also refuse to sacrifice the solid formal basis demanded of the best in current non-objective art.[2]

Lippard had in mind such artists as Louise Bourgeois, Eva Hesse, Kenneth Price, Keith Sonnier, and H. C. Westermann, whom she included in a show, titled *Eccentric Abstraction,* that she organized at the Fischbach Gallery in the fall of 1966.[3] The central artists, such as Hesse, retained Minimalism's clear modular or serial grid-like structure and literalist treatment of new, unexpected, often floppy materials while giving rein to autobiographical, psychological, erotic—above all erotic, because of the soft materials used—and other Expressionist impulses. Their work was aptly characterized as Minimalism with an eccentric edge or a Dada or Surrealist edge, as purist funk, as sexy Minimalism. It is fitting that *Eccentric Abstraction* should have opened on the same day in the same building as *Ten,* an excellent survey of Minimal Art at the Dwan Gallery.

Anticipating Lippard, Gene Swenson had already introduced Surrealism into the discourse of avant-garde art. In a show titled *The Other Tradition,* 1966, he contrasted the Dada-Surrealist vein with the then dominant formalist abstraction and complained that artists such as Picabia, Duchamp, Ernst, and Magritte were neglected and misunderstood by contemporary formalists, who branded them as lesser artists. Swenson repudiated formalism's "self-satisfied estheticism" and proposed to rehabilitate the other, antiformalist tradition.[4] So did Lippard, who listed among the direct precursors of Eccentric Abstraction Meret Oppenheim's fur-lined teacup, saucer, and spoon and Salvador Dali's fur-lined bathtub made for a Bonwit Teller display window in 1941. Lippard also included as influences "Claes Oldenburg's gleaming, flexible blue and white vinyl bathtub [and] Yayoi Kusama['s] phallus-studded furniture." Above all,

160. Eva Hesse, *Sans II*, 1968. Two units, each 38″ × 86″ × 6″. Whitney Museum of American Art, New York.

FACING PAGE: 161. Louise Bourgeois, *The Quartered One*, 1964–65. 58¾″ × 28⅝″ × 21⅜″. Museum of Modern Art, New York.

Oldenburg has been the major prototype for soft sculpture. Though his work is always figurative, he divests his familiar objects of their solidity, permanence and familiarity. His fondness [is] for flowing, blowing, pokeable, pushable, lumpy surfaces and forms.

Lippard went on to say that the Eccentric Abstractionists "usually prefer synthetics and avoid materials with long-standing literary associations." These substances were sensuous, but their colors tended to be "dull, neutral, unbeautiful, or else acrid, garish . . . investing their three-dimensional forms with an aggressive quality not found in most polychrome sculpture." In truth, Eccentric Abstractions looked "ugly" and "empty," as if they were "anti-art." In justification, Lippard claimed that the words "are obsolete. . . . [Nothing] stays ugly for long in today's art scene."

Lippard concluded by stressing the literalness of Eccentric Abstraction in contrast to Surrealist psychology. The new artists aspired to "a more complete acceptance by the senses—visual, tactile, and 'visceral,' " and therefore avoided "literary pictorial associations. [They] prefer their forms to be felt, or sensed, instead of read or interpreted. . . . Ideally, a bag remains a bag and does not become a uterus,

. . . a semi-sphere is just that and not a breast. Too much free association on the viewer's part is combatted." After all, it was the Minimalist sensibility that gave rise to Eccentric Abstraction. No wonder that its erotic level was "near inertia." In 1966, Lippard was still thinking in Minimalist terms. Thus she played down (but could not ignore) the personalist metaphors in Eccentric Abstraction. However, she would soon articulate them strongly, particularly in interpreting the work of Louise Bourgeois and Eva Hesse, the artists who seemed to interest her most.

Lippard presented Bourgeois as the elder statesperson, pointing out that she had been working in an eccentric vein since the early forties, while a member of the Surrealist émigré circle in New York. As early as 1964, Bourgeois had exhibited

several small, earth or flesh-colored latex molds which, in their single flexible form, indirectly erotic or scatological allusions, and emphasis on the unbeautiful side of art, prefigured the work of the younger artists today. Often labially slit, or turned so that the smooth, yellow-pink-brown lining of the mold as well as the highly tactile outer shell is visible, her mounds, eruptions, concave-convex reliefs and knot-like accretions are internally directed. [They] have an uneasy aura of reality.[5]

Daniel Robbins was also struck by their "powerful but rather repellent" presence. He spoke of their having the "quality of a lair," but also remarked that the "poured fluid rubber [is] visceral. Like living flesh, the rubber quivers and flaps." It possesses "a viscous sheen like the inside of a mouth."[6]

Bourgeois's imagery evolved slowly. In 1961, she recalled that

> hollow forms appeared first in my work as details, and then grew in importance until my consciousness of them was crystallized by a visit to the Lascaux caves with their visible manifestation of an enveloping negative form, produced by the torrent of water that has left its waves upon the ceiling: my underlying preoccupation had been constant, but it has taken me some seven years to develop and give it shape.
>
> There has been a similar change from rigidity to pliability.[7]

Bourgeois's sculptures in plaster, cement, and rubber, with their cave- and vagina-like interior spaces and ambiguous-looking exterior surfaces, embody diverse psychological states, such as withdrawal and hiding, sheltering and nurturing.[8] Lippard could sum up with justification: "Rarely has an abstract art been so directly and honestly informed by its maker's psyche."[9]

Unlike Bourgeois, Hesse was directly influenced by Minimal and Conceptual Art, notably LeWitt's. Of her latest work in the *Eccentric Abstraction* show, "a labyrinth of white threads connecting three equally spaced grey panels," Lippard wrote that "Hesse has adopted a modular principle [and] limits her palette to black, white and gray, but [creates] an intensely personal mood."[10] That mood was enhanced through her use of fiberglass, latex, rubberized cheesecloth, twine, and generally flabby, cheap, and unappealing synthetics. Like Bourgeois's images, Hesse's seem to issue from her private experiences—for example, many seem sexual, loosely hanging soft substances calling to mind vaginas, breasts, and nipples (some with dangling

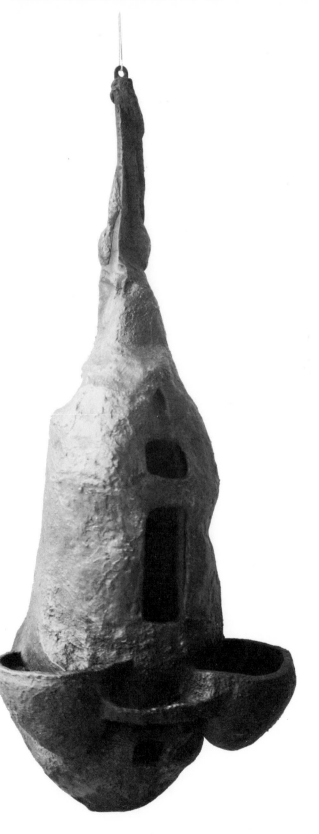

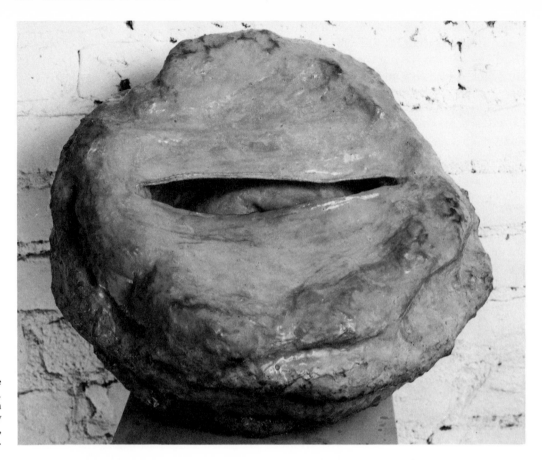

162. Louise Bourgeois, *Le Regard,* c.1968. 15″ in diameter. Courtesy Robert Miller Gallery, New York.

strings, like the flow of milk or umbilical cords).

Hesse herself remarked:

> First, when I work it's only the abstract qualities that I'm working with, which is the material, the form it's going to take, the size, the scale, the positioning, where it comes from, the ceiling, the floor. . . . However, I don't value the totality of the image on these abstract or esthetic points. For me . . . art and life are inseparable. If I can name the content . . . it's the total absurdity of life.

Hesse went on to say that absurdity

> has to do with contradictions and oppositions. In the forms I use in my work the contradictions are certainly there . . . order versus chaos, stringy versus mass, huge versus small, and I try to find the most absurd opposites or extreme opposites. . . . I was always aware of their absurdity and also

their formal contradictions and it was always more interesting than making something average, normal, right size, right proportion.

*Hang-up,* 1966, a wallpiece resembling a picture frame from which emerges a cordlike loop, "is ludicrous," Hesse wrote: "It is the most ridiculous structure that I ever made, that is why it is really good."[11] Even the systemic, seemingly rational aspect of her work struck her as absurd. With reference to *Addendum,* 1967, she remarked: "Series, serial, serial art, is another way of repeating absurdity."[12] She later added: "If something is absurd, it's much more exaggerated, more absurd if it's repeated."[13]

However, Lippard remarked that even Hesse "came to realize that the self she was finding through her work was really worth something. In her emphasis on ab-

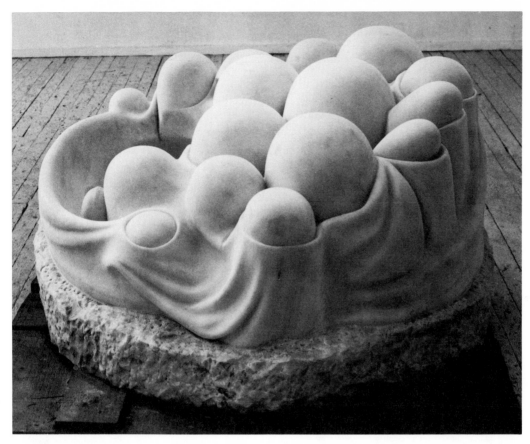

163. Louise Bourgeois, *Cumul III*, 1969. 24″ × 42″ × 40″. Robert Miller Gallery, New York.

164. Eva Hesse, *Repetition 19, III*, 1968. 19″ to 20¼″ high × 11″ × 12¾″ in diameter. Museum of Modern Art, New York.

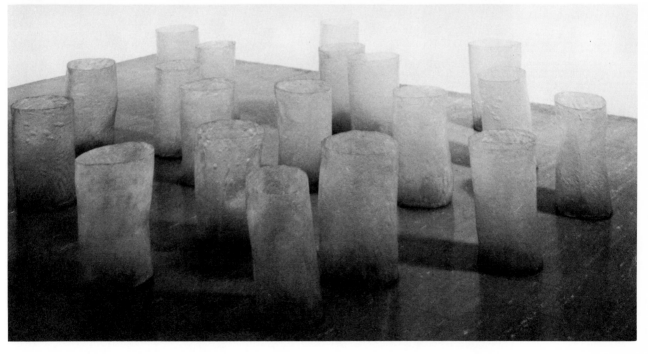

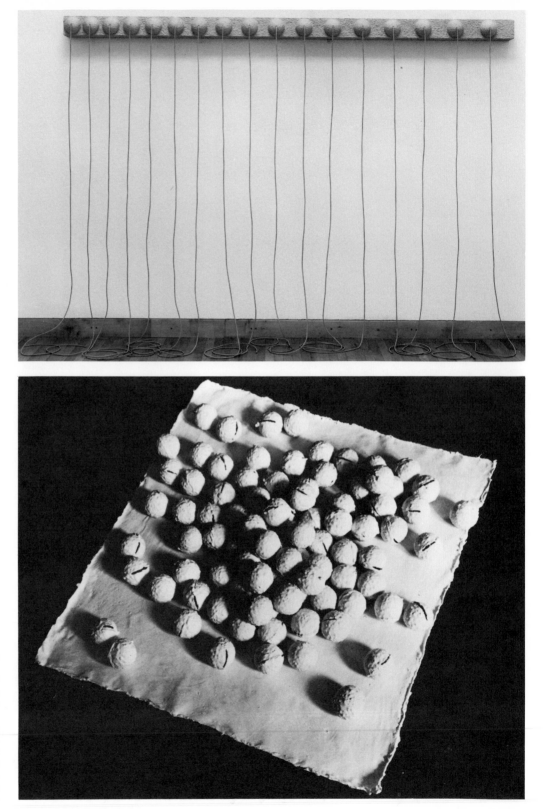

165. Eva Hesse, *Addendum,* 1967. 5″ × 119″ × 6″; cords 84½″. Tate Gallery, London.

166. Eva Hesse, *Sequel,* 1966/68. Ninety-one balls, each 2½″ in diameter; sheet, 30″ × 32″. Saatchi Collection, London.

surdity, however, she remained an existentialist artist: 'I could take risks. . . . My attitude toward art is most open. It is totally unconservative—just freedom and willingness to work. I really walk on the edge.' "[14] The attitude that Lippard attributed to Hesse resembled that of Jackson Pollock, and Hesse herself acknowledged her sense of kinship to him, both in the statement "Chaos can be structured as non-chaos"[15] and in her works, such as *Right After,* 1969, and untitled tangles of rope, wire, and wire mesh coated with plaster, fiberglass, cloth, and latex, executed in 1969–70.

It was fitting that Lippard should have included H. C. Westermann in her *Eccentric Abstraction,* since he had been an odd man out since 1961, the year his work first came to art-world attention. Like Bourgeois and Hesse, he worked in a wide range of unexpected media and with bizarre imagery. And like them, he partook of a Dada-Surrealist ethos and looked for inspiration to personal experiences—in his case, memories of combat tours with the Marines in World War II and the Korean War. They provided him with his subjects: *Death Ships,* a *Suicide Tower;* and content: the terror of battle and the helplessness of individuals, though tinged with irony and humor—metaphors of contemporary life, whose contemporaneity was accented by disturbing references to popular culture.

As in Hesse's work, a sense of the absurd permeates Westermann's. A construction of his can tell a narrative, at once funny and macabre (*Death Ship Run Over by a '66 Lincoln Continental,* 1966); can pun (*Walnut Box,* 1964, whose title is inlaid in black walnut on a lid, which, opened, reveals an interior full of real walnuts); can present a paradox (*The Big Change,* 1963, a knotted rope in turned wood) or an enigma (*Little Egypt,* 1969). The horror of Westermann's pieces is softened by their intimate scale and painstaking craft, reminiscent of the skillful woodworking of folk whittlers, which he admired. Indeed, the

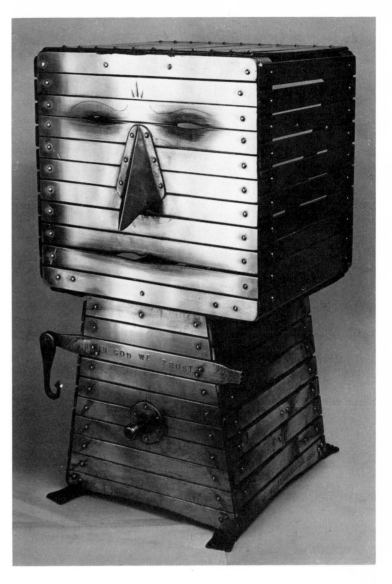

167. H.C. Westermann, *The Evil New War God,* 1959. 16¾" × 9¼" × 10¼". Whitney Museum of American Art, New York.

signs of optimism, minimal though they are, are to be found primarily in the integrity and durability of impeccable carpentry, which prompted John Ashbery to call him the "Fabergé of funk."[16]

Like Westermann, Lucas Samaras was a maverick, whose boxes, objects, and reliefs, studded with pins, razors, and other threatening components, did not fit easily into any "ism," yet commanded attention nonetheless. And like Westermann's constructions, his were autobiographical and pervaded by pain. Diane Waldman remarked:

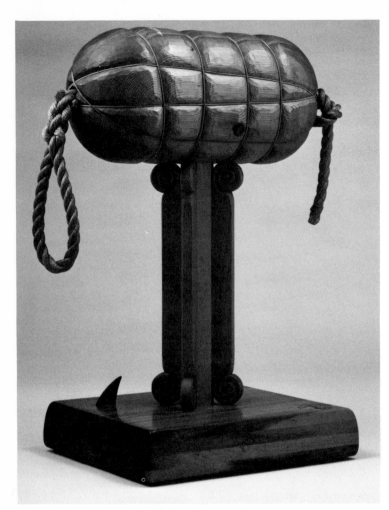

168. H.C. Westermann, *From the Museum of Shattered Dreams*, 1965. 29″ × 25″ × 15″. Walker Art Center, Minneapolis, Minn.

Samaras grew up [during] the German occupation and subsequent guerilla warfare. Memories of violence . . . are inexorably mingled with parades, religious ceremonies rooted in Byzantium, family festivities, lavishly ornamental costumes and with a history of childhood illness and a fascination for medicines and delicate instruments . . . tweezers, knives, scissors, razors . . . and incisions. In this connection he said: "I cannot separate beauty from pain."[17]

Samaras also said that his "art is an attempt to recapture lost beauties, lost excitement, things that you lose in a lifetime: parents, childhood, homes, traditions, perspiration, environments, events, attachments. You have them in mind but you know they're just in your mind."[18]

So strong was Samaras's urge to expose his life that in 1964, influenced by Allan Kaprow, who had been his professor at Rutgers University and in whose Happenings (and those of other artists) he participated, he recreated at the Green Gallery his own disheveled bedroom. He explained that he "wanted to do the most personal thing that any artist could do."[19] In 1966, Samaras constructed a mirrored room in which the self-involved artist's image and those of spectators were repeated infinitely. In 1967, Samaras turned away from pain and began to transmute ordinary phenomena into fantastic, exuberant, and witty objects that evoked what the Surrealists called "the marvelous," the most extraordinary of which were a series of *Chair Transformations,* 1969–70.

If Samaras was the narcissist of Eccentric Art, Edward Kienholz was its social conscience. As early as 1961, Jules Langsner wrote: "A couple of years ago Kienholz set out to construct 'satires in 3-D.' . . . As Kienholz puts it, he was 'bugged' by certain idiocies he observed in the contemporary world. The best way for him to expose the absurdities of mankind was by extending a repellent attitude to its extreme, and therefore absurd, conclusion."[20] Kienholz's subjects have been varied. *The Psycho-Vendetta Case*, 1960, which deals with the execution of the alleged rapist Caryl Chessman, is politically topical. *Roxy's,* 1961, a depressingly detailed recreation of a renowned brothel as it was in 1942, is historical. A number of Kienholz's tableaus depict other American scenes, such as a squalid *State Hospital,* 1964–67. The humorous but unnerving *The Beanery,* 1965, is a reconstruction of Barney's Saloon in Los Angeles, two thirds its actual size; its habitués have clocks for faces, all set at ten past ten.

Kienholz's most memorable Environments are about sex, sickness, and death—often closely linked. They are pervaded by despair, exemplified by the macabre *Illegal Operation,* which incorporates used

medical tools, bloodied pans and chair, and a lampshade tilted to provide more light.

Like Kienholz, Peter Saul aimed to make a moral statement about contemporary American society, a statement he hoped would repel the art-world "elite." Among the influences on his work were

Francis Bacon's four *Popes* . . . which gave me the idea of an "adults only" type of content; numerous canvases by Max Beckmann . . . which provided me with the idea of making large complex scenes with a complex social message arrived at by distorting the human figure; Picasso's work of the 1930s, for agonized figures; the early work of Diebenkorn, for the idea of combining messiness with figuration; Jackson Pollock, for singleness of purpose; *Mad Comics* of 1958 and '59, for the idea of using American subject matter in a humorous way; living for 10

years (1964–74) in the San Francisco area, where the dreamy love-soaked quality of the residents helped focus my attention on hate and violence.[21]

In 1964, "psychology," Day-Glo, and a concern with the Vietnam War entered into Saul's work. It became increasingly exaggerated, violent, gory, and raunchy, particularly as the war expanded and intensified. However, Saul's painting, despite the lurid colors, remained virtuoso, the refinement paradoxically augmenting his crude view of America.

H. C. Westermann's show in San Francisco in 1962 strongly influenced William Wiley, Robert Hudson, and William Allen, who with such younger artists as Bruce Nauman and Robert Arneson came to be called Funk artists.[22] There was a source other than Westermann for Funk Art in the Bay Area, a tradition that extended

169. Lucas Samaras, *Book 4*, 1962. 5½" × 8⅞" × 11½". Museum of Modern Art, New York.

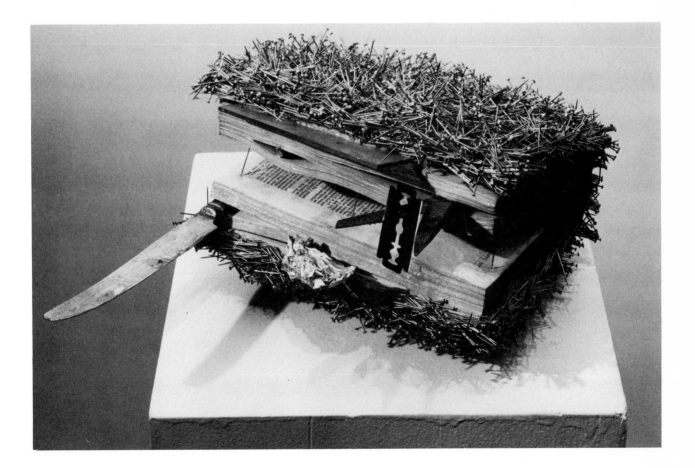

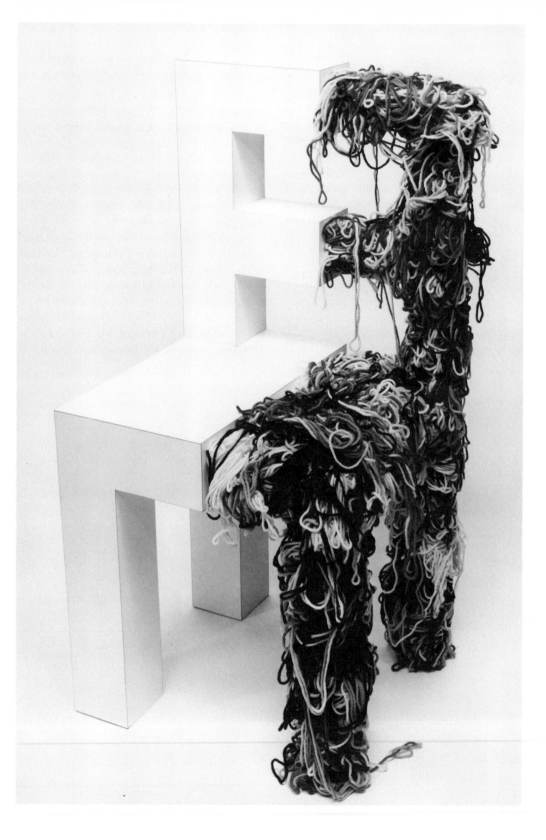

170. Lucas Samaras,
*Chair Transformation
Number 10A*,
1969–70. 38″ × 20″
× 20″. Whitney
Museum of American
Art, New York.

back into the late fifties—that of Bruce Connor, Wally Hedrick, and Joan Brown. Brown recalled:

> Uppermost in [our minds] was the idea of shocking ourselves with the objects we made . . . because of the baseness, cheapness, and crudity of the materials and techniques each of us employed in making the paintings, drawings or sculptures. It should be emphasized that being drawn to the ephemeral materials, as we all were, was important also because the final art object defied accepted tastes in an outrageous manner. The best funky things were those containing humorous elements that poked fun at sex, religion, pets, patriotism, art and politics.[23]

Funk Art was characterized by Joe Raffaele and Elizabeth Baker as

informal, idiosyncratic, often deliberately weird. Use of materials is generally casual, the results often perishable. The effort to turn idea into art as directly as possible makes "finish" undesirable. Emphasis is on process . . .

[Subject] matter is closely tied to everyday life. It is often randomly autobiographical, with object left untransformed, retaining multiple layers of meaning. It is as inclusive as possible . . . unpretentious, unsolemn, joky . . . deliberately not impressive.

Also characteristic . . . is a propensity to work in any medium, in any direction . . . [such as films]; these tend toward autobiography, too. . . .

[A] special kind of style has resulted. The works tend to be 3-dimensional. . . . Imagery tends to be freely organic . . . or fragmentarily figurative. . . . Surfaces may or may not

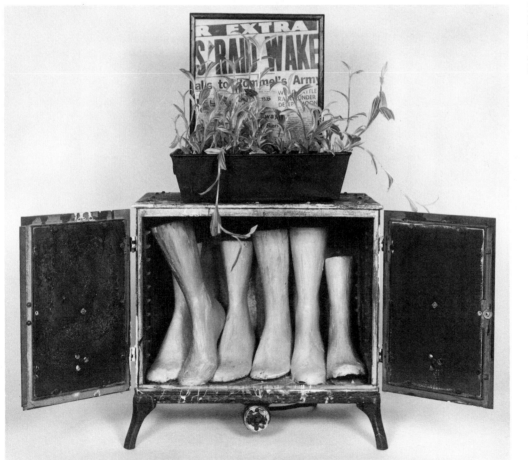

171. Edward Kienholz, *History as a Planter*, 1961. 33″ × 18⅝″ × 12⅜″. Los Angeles County Museum of Art.

be painted, are frequently irregular, messy, rough, etc.

Distant attachments to Dada and Surrealism exist. [There] is a kind of Surrealism of everyday life—a nostalgia for the most insignificant things and events, a haphazard documentation, an automatist access to ideas, referential titles.

Raffaele and Baker remarked that Funk artists were aware of Rauschenberg, Cage, Johns, Oldenburg, and Kienholz. "As with the last, there is a hint of social protest, though lower keyed, much less definite." The writers concluded that all of the Funk artists "are obsessively well-informed about New York. In fact, much of what they do is about *not* going along with

New York, and *not* being overwhelmed by it. The work itself seems to suggest a crotchety, stand-offish individualism."[24] This attitude is exemplified in a work that William Wiley made in 1966, which was illustrated in *Art News*. Titled *One Abstract-Expressionist Canvas Rolled and Taped*, it pointed to the primary difference between San Francisco Funk artists and New York Eccentric Abstractionists. The latter were concerned more with structure. In contrast, as Lippard observed, the West Coast artists dealt "with a raunchy, cynical eroticism [and were] more involved with assemblage than with structural frameworks."[25] Like the Minimalists, Lippard believed that Assemblage

172. Edward Kienholz, *The Wait*, 1964–65. 80″ × 148″ × 78″. Whitney Museum of American Art, New York.

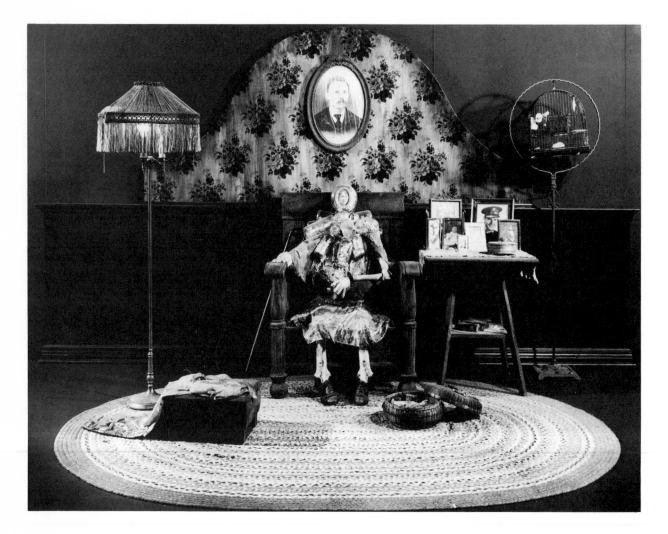

was outmoded, an opinion shared generally by the avant-garde in New York. However, two Funk artists, Wiley and Nauman, did make a strong impression.

In 1967, Wiley decided he could paint or draw or write on canvas or paper, make prints or sculptures constructed from any and every material, or work in whatever way he pleased. He selected his subjects from everyday American life, or perhaps, as John Perreault suggested, "a national fantasy derived from cowboy movies and comic books."[26] The imagery is treated with a Duchampian humor, visual and verbal punning, and explanations "that only compound the enigmas of the things they purport to clarify." *Shark's Dream,*

exhibited in the Whitney Annual, 1968, "is a smoothly illusionistic painting of a shark-like 'minimal' work of sculpture, oozing blood. A cartoon-balloon floating above the 'sculpture' contains a reversed view. It is a painting of a work of art dreaming about itself."[27]

Beneath Wiley's " 'silliness' and clowning," in an Americana manner, there is an enigma, made even more mysterious by recurring abstract motifs: the triangle or pyramid, the striped stick, the checkerboard grid, and the infinity sign, which resembles the figure 8 or the Möbius strip. These motifs take on a psychological cast, which prompted Brenda Richardson to begin an essay on Wiley with his quote: "I

173. Peter Saul, *Personal Disease,* 1966. 48″ × 64″. Private collection.

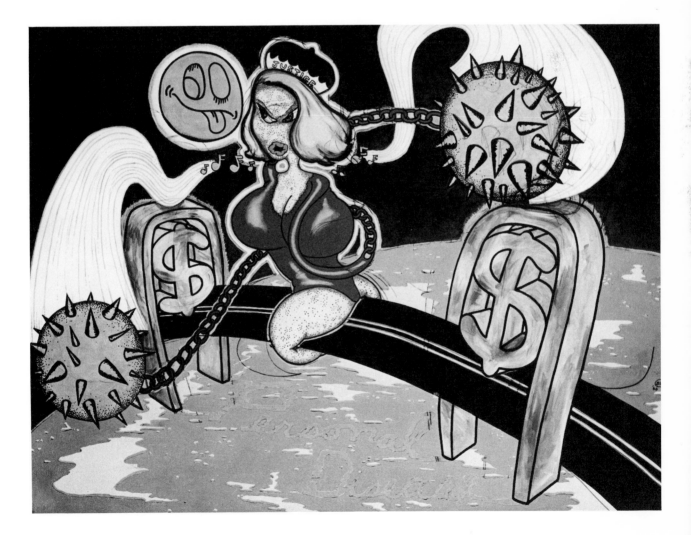

am my own enigma."[28] Wiley's intention was perhaps best stated in his Zen-like notes incorporated in *Sub-Standard Test,* 1968: "TO ALLOW NONSENSE TO ESTABLISH YOUR OWN SENSE OF IMPORTANCE AND THEN TO ALLOW THEM BOTH TO CHANGE PLACES AS THEY INEVITABLY DO AND THEN EVENTUALLY TO SEE BEYOND BOTH STATES."[29]

Nauman was both the Minimalist and the Conceptualist of Funk Art. His Minimalist side was apparent in *Shelf Sinking into the Wall with Copper Painted Casts of the Spaces Underneath,* 1966, or *Platform Made Up of Spaces Between Two Rectilinear Boxes on the Floor,* 1966, which Fidel Danieli, in an early appreciation of Nauman, called "one of the shabbi-

est pieces of construction to pass as a finished work."[30] By making Minimal Art funky, Nauman became one of the first late-Minimalists. Nauman's Conceptualism, with its clear references to works by Duchamp and Johns, particularly those that allude to human bodies, is evident in the neon[31] *My Last Name Exaggerated 14 Times Vertically,* 1967, which turns his signature into an abstraction; *Six Inches of My Knee Extended to Six Feet,* 1967; the punning *From Hand to Mouth,* 1967, in green wax, which consists of a hand, arm, and mouth; and the blue and peach neon *Window or Wall Sign,* 1967, advertising: "The true artist helps the world by revealing mystic truths," which may be a statement Nauman believes in but which calls

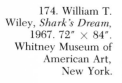

174. William T. Wiley, *Shark's Dream,* 1967. 72″ × 84″. Whitney Museum of American Art, New York.

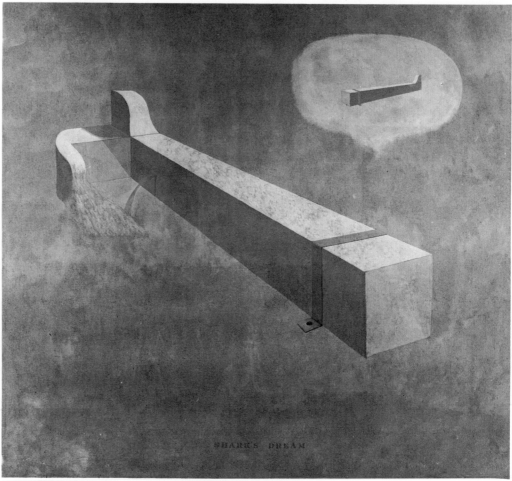

to mind Madison Avenue promotion and Pop Art.

Westermann was a major influence not only on the Funk artists in San Francisco but on a group of kindred artists in Chicago, known as the Hairy Who, among them Gladys Nilsson, James Nutt, and Karl Wirsum.[32] They took as their subjects the most primitive kind of lower-class and adolescent images—from tattoos, illustrations in comic books, such as *Mad,* "wrestling magazines, truss ads and hair-straightener come-ons, schoolboy dirty books . . . cheap novelty house mailers, the walls of the public latrine." And like their subjects, their "styles are mostly brutish," as Franz Schulze observed. "The marked stylistic kinship among the six made it pos-

sible for them to publish a show catalogue that took the form of a comic book." Hairy Who art "is not pop art . . . so much as sub-pop" or "possibly a gamier kind of commercialized surrealism."[33]

Lippard's *Eccentric Abstraction* show fascinated Castelli and prompted Robert Morris, whom he represented, to organize an exhibition of his own in the warehouse annex of the gallery. *9 in a Warehouse* included himself, Hesse, Serra, and Nauman.[34] Morris's premises were presented the year before the show, in an article titled "Anti-Form" (the title was not Morris's, and he objected to it), published in *Artforum.* Morris claimed that Minimal Art was not as physical as art could be or should be because the ordering of its mod-

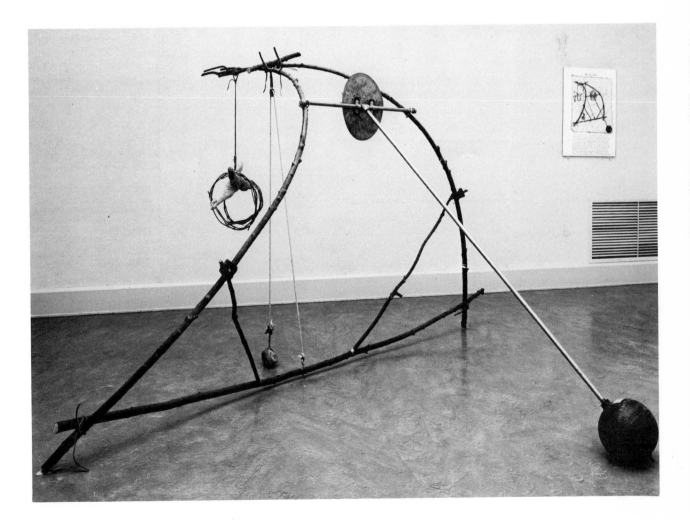

175. William T. Wiley, *The Pure Strain,* 1970. 66″ × 125″. Stedelijk Van Abbemuseum, Eindhoven, the Netherlands.

ular or serial units was not inherent in their material. To make a work more physical, the process of its "making-itself" had to be emphasized. Therefore, Morris called for a literal art whose focus was on matter and the action of gravity on it. Such an art could not be predetermined; its ordering was "casual and imprecise and unemphasized. Random piling, loose stacking, hanging, give passing form to the material. Chance is accepted and indeterminacy is implied since replacing will result in another configuration."[35] Thus Morris turned against his preoccupation in Minimal Art with preconceived, clearly defined, and durable geometric unitary volumes, but not with its emphasis on literalness. In a sense, Morris looked back to his pre-Minimal pieces, such as *Box with the Sound of Its Own Making*, 1961. There were also antecedents in Harold Rosenberg's conception of action painting, Rauschenberg's combine composed of sprouting earth, and Happenings.[36]

Morris tried to establish a tradition for "anti-form" or Process Art, as it came to be commonly known, by claiming Pollock and Louis as its progenitors:

Of the Abstract Expressionists only Pollock was able to recover process and hold on to it as part of the end form of the work. Pollock's recovery of process involved a profound rethinking of the role of both materials and tools in making. The stick which drips paint is a tool which acknowledges the nature of the fluidity of paint. . . . In some ways Louis was even closer to matter in his use of the container itself to pour the fluid.

176. Bruce Nauman, *Shelf Sinking into the Wall with Copper Painted Plaster Casts of the Spaces Underneath*, 1966. 70″ × 84″ × 6″. Katherine Bishop Crum.

FACING PAGE:
177. Bruce Nauman, *Neon Template of the Left Half of My Body*, 1966. 70″ × 9″ × 6″. Philip Johnson.

Morris stressed that Pollock and Louis "used directly the physical, fluid properties of paint. [The] forms and the order of their work were not *a priori* to the means." They went "beyond the personalism of the hand to the more direct revelation of matter itself . . . tools, methods of making, nature of material." In asserting that it was the physicality of paint and its direct manipulation that was central to the work of Pollock and Louis, and not the formalist conceptions of opticality and flatness, which Morris termed "ridiculous" and "silly," he claimed Pollock and Louis for literalism, appropriating them from formalism.[37]

There was another interpretation of Process Art, romanticist rather than literalist. Perishable materials were thought to be suggestive of the human condition, calling to mind the insignificance, powerlessness, frailty, and impermanence of man.

The new artist who emerged from the Castelli Warehouse show was Richard Serra. He exhibited three pieces, each exemplifying a kind of Process Art. Philip Leider wrote of one work:

> Along the base of one of the gallery's walls, Mr. Serra has splattered a quantity of heavy silver paint, the paint splashing on the bottom of the wall as well as along the floor. The meeting of wall and floor, a quiet and passive encounter in everyday life, here is made violent, "underlined for emphasis." But the main point is that the material has assumed no form other than one entirely natural to its own fluid, formless properties.

Leider concluded: "The emphasis here is on the natural formlessness of the material, and the refusal to force it to correspond to a vocabulary of given, *a priori* forms acceptable to 'art.' "[38] The forming agency was the force of gravity, as it were.

Serra's gesture of splashing molten lead, which became a kind of signature material, along the intersection of wall and floor can be viewed as Expressionist, reminiscent of Pollock's and Louis's pour and

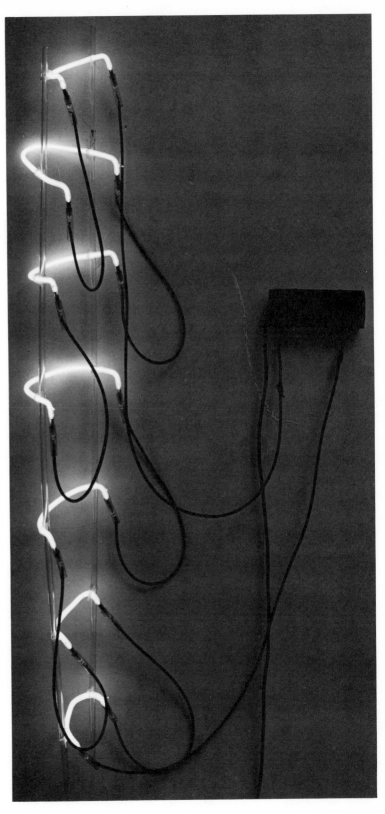

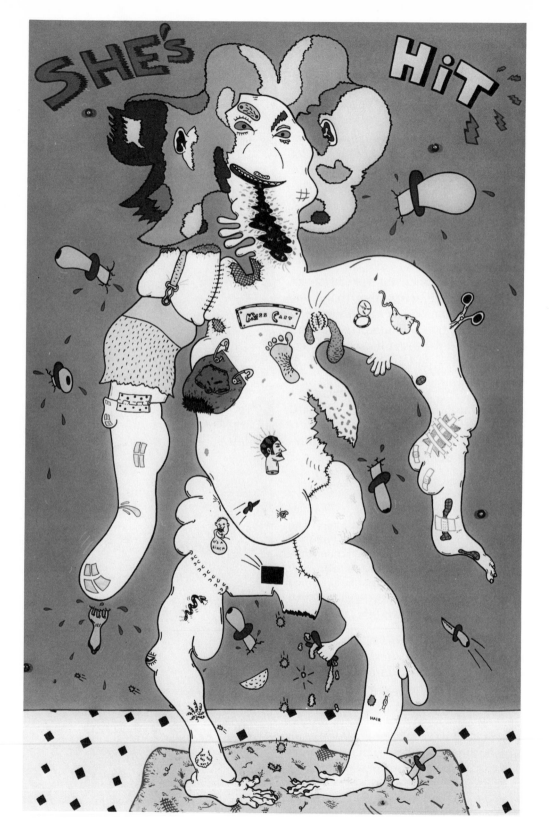

178. Jim Nutt, *She's Hit*, 1967. 36½″ × 24½″. Whitney Museum of American Art, New York.

FACING PAGE:
179. Robert Morris, *Felt*, 1967–68. Dimensions variable. Whitney Museum of American Art, New York.

stain. But it was clearly rooted in Minimal Art. Gregoire Müller pointed out that

> by eliminating or reducing to a minimum the internal compositional relations of a work (forms, colors, materials), the "properties" of a given element come across with much more clarity and strength; similarly, by choosing to relate the work directly to the "objective" environment, focusing attention on the relation between the work and the space around it, the artist endows it with a more "real" presence and establishes a closer contact with the viewer.[39]

Serra's second piece in the Castelli Warehouse consisted of a large square of thinly rolled lead pinned in place on the gallery wall by a heavy steel pipe propped against it. The pipe related the lead square to the floor; the square related the pipe to the wall; gravity, and gravity alone, provided both the "passing form" which the piece possessed as well as the suggestion that at any given moment its action could completely alter it.[40] It could fall down. What kept it standing was the energy of gravity, the stresses of which could be sensed, and which were as literal as the metal masses.

In their spareness and literalness, Serra's prop pieces were Minimalist, but unlike Minimal sculpture—indeed, antithetical to it—his work was precarious, and because of its mass, "bordering on threat," as Elizabeth C. Baker remarked of another prop sculpture, *One Ton Prop*. A kind of card house of four huge lead slabs, this piece was perpetually on the verge of disorder and danger; it might fall on the viewer. Given the size, weight, and softness of the lead, the parts were destined to overcome the process of gravity that held them in equilibrium, and collapse—and violently, at that. What looked stable was anything but. Baker was taken with the poetry of the "high-strung potential for motion" of the "ponderous elements." "Theirs is a kind of temporary and tantalizing pseudo-monumentality." Indeed, Serra seemed to *monumentalize* Minimal sculpture at the same time that

180. Richard Serra, *Splashing*, 1968. (Destroyed.)

FACING PAGE: 181. Richard Serra, *Prop*, 1968. 96″ high; sheet, 60″ × 60″. Whitney Museum of American Art, New York.

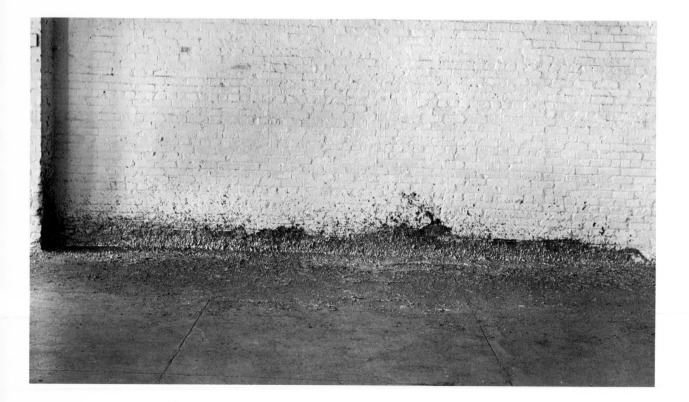

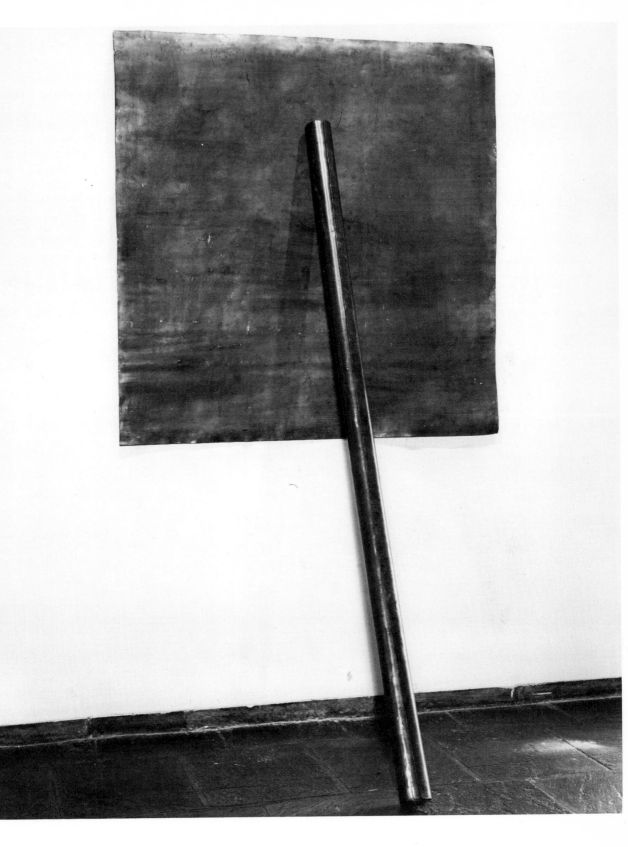

he *subverted* it, in "a kind of Dada spirit of recklessness."[41]

Serra's third piece in the Castelli Warehouse, his tour de force, in the opinion of Leider, was

a distribution of strips of latex and rubber on the floor, in an area about twelve feet square. The area is emphatically marked off by a taut diagonal of wire suspended about six or eight inches off the gallery floor by being tied to two stakes driven into the floor at either end of the area. One has the impression that virtually any arrangement of the formless strips of latex would take on a compositional unity in relation to the diagonal created by the wire.[42]

182. Richard Serra, *Casting*, 1969. 4″ × 300″ × 18″. (Destroyed.)

Serra was not the only artist to create scatter pieces. Robert Morris had exhibited compositions of gray felt tacked to the wall or piled on the floor. And Barry Le Va had also made works in this vein. Le Va turned from painting to sculpture around 1965. As Fidel Danieli wrote in 1968:

His first major pieces were stuffed, cubic, cloth volumes. The canvas cloth was spray-painted with enamel. During one painting session he realized that the scraps strewn in disorder on the studio floor possessed more vitality and possibility of development than the work with which he was then engaged. In the past year and a half he has produced a dozen pieces of increased size and numbers of parts fabricated primarily from felt. . . . Originally attracted by . . . vivid hues, he decided they were too sensuous and . . . limited himself to black, and then grey.

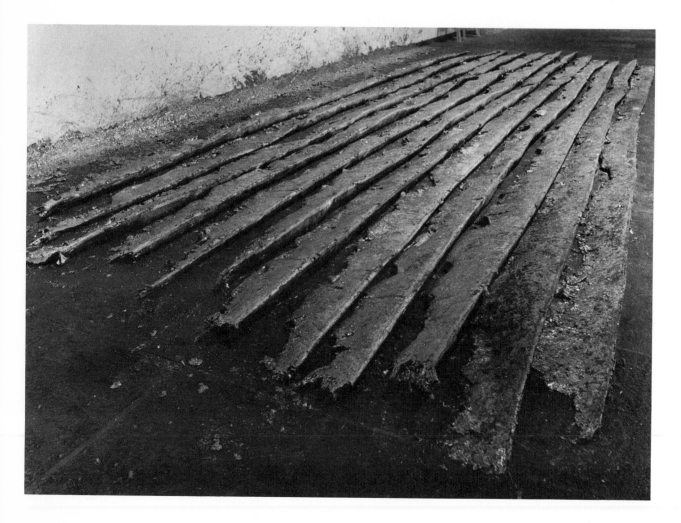

Because the components are rectangular, they give the impression of order, but the "order is mixed with chaos; twisted and irregular units cluster, and sections fold across each other."[43]

Shortly after his show of felt pieces, Morris elaborated on art "beyond objects" in an article in *Artforum.* He wrote that sculpture "was terminally diseased with figurative allusion." Some new works of art found a cure by seeming "to take the conditions of the visual field itself . . . and . . . [use] these as a structural basis for the art." This approach differed from Minimal Art, which called attention to its surroundings in a kind of figure-ground relationship. The shift to the visual field "amounts to a shift from discrete, homogeneous ob-

jects to accumulations of things or stuff, sometimes very heterogeneous. . . . In another era, one might have said that the difference was between a figurative and landscape mode."

The issue for Process Art remained the same as it was for Minimal Art—to achieve a nonrelational or unitary work, a work that denied conventional composition. As Morris put it:

What was relevant to the '60s was the necessity of reconstituting the object as art. Objects were an obvious first step away from illusionism, allusion and metaphor. They are the clearest type of artificial independent entity, obviously removed and separate from the anthropomorphic. It is not especially surprising that art driving toward

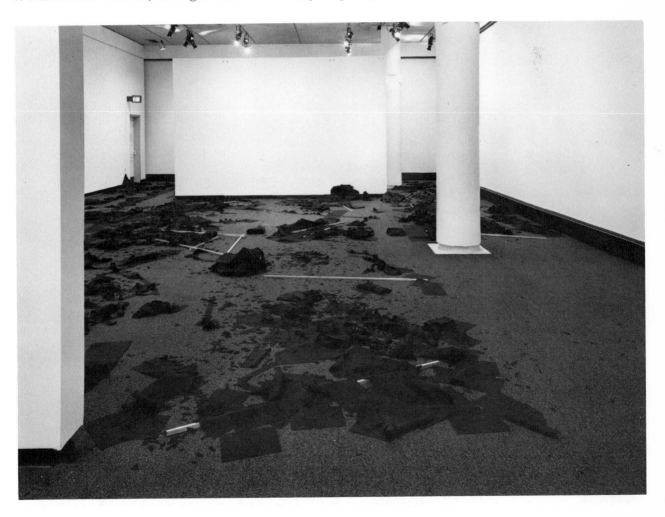

183. Barry Le Va, work of 1967; installation, New Museum, New York, 1979.

greater concreteness . . . would fasten on . . . the geometric. Of all the conceivable or experienceable things, the symmetrical and geometric are most easily held in mind as forms. . . . And to construct objects demands preconception of a whole image.

But what if reconstituting the object was no longer the first priority in art? Then it was possible for artists to use a variety of substances, including slime, and to depend on unpremeditated process to determine form. Thus: "Ends and means are brought together in a way that never existed before in art." As Morris viewed it, the course of Minimal sculpture had shifted from art as a finished object to art as "mutable stuff which need not arrive at the point of being finalized with respect to either time or space. The notion that work is an irreversible process ending in a static icon-object no longer has much relevance." What was relevant was that art had become an act of disorientation "in the service of discovering new perceptual modes."[44]

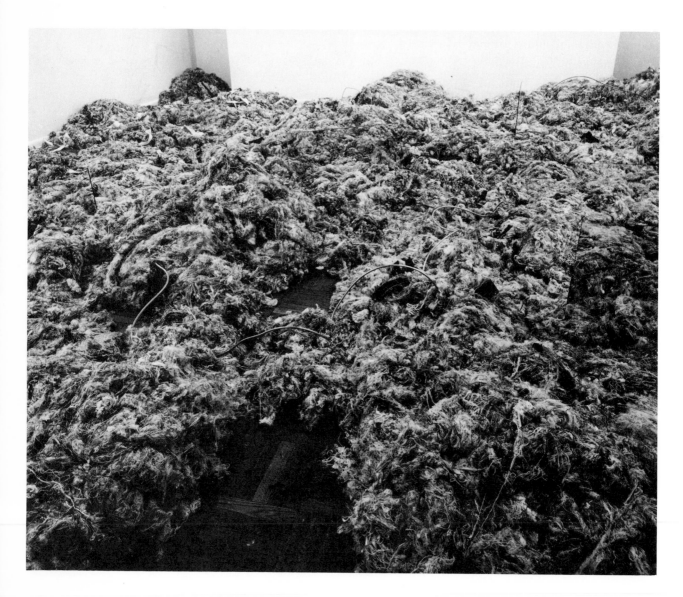

184. Robert Morris, *Untitled*, 1968. Approximately 26' × 20'.

# NOTES

1. Lucy R. Lippard, "New York Letter: Recent Sculpture as Escape," *Art International,* 20 February 1966, p. 50.

2. Lucy R. Lippard, "Eccentric Abstraction," *Art International,* November 1966, p. 28.

3. The other artists in *Eccentric Abstraction* were Alice Adams, Lindsay Decker, Gary Kuehn, Jean Linder, Don Potts, Keith Sonnier, and Frank Lincoln Viner.

4. G. R. Swenson, *The Other Tradition,* exhibition catalogue (Philadelphia: Institute of Contemporary Art, University of Pennsylvania, 1966), p. 40. Swenson's show preceded *Eccentric Abstraction* and was reviewed by Lucy Lippard in "An Impure Situation (New York and Philadelphia Letter)," *Art International,* 20 May 1966.

5. Lippard, "Eccentric Abstraction," pp. 28–39.

6. Daniel Robbins, "Sculpture by Louise Bourgeois," *Art International,* 20 October 1964, pp. 29–30.

7. Louise Bourgeois, in Philip Pearlstein, ed., "Private Myth," *Art News,* September 1961, pp. 44–45.

8. See Deborah Wye, "Louise Bourgeois; 'One and Others,' " *Louise Bourgeois,* exhibition catalogue (New York: Museum of Modern Art, 1983).

9. Lucy R. Lippard, "Louise Bourgeois: From the Inside Out," *Artforum,* March 1975, p. 27.

10. Lippard, "Eccentric Abstraction," p. 28.

11. Cindy Nemser, "An Interview with Eva Hesse," *Artforum,* May 1970, p. 60.

12. Lucy R. Lippard, "Eva Hesse," *Art in America,* May–June 1971, p. 70.

13. Nemser, "An Interview with Eva Hesse," p. 62.

14. Lippard, "Eva Hesse," p. 70.

15. "Fling, Dribble and Drip," *Life,* 27 February 1970, p. 66.

16. Kay Larson, "Art: Sculpting Figuratively," *New York,* 16 November 1981, p. 122.

17. Diane Waldman, "Samaras," *Art News,* October 1966, p. 46.

18. Kim Levin, "Samaras Bound," *Art News,* February 1969, p. 56.

19. Alan Solomon, "An Interview with Lucas Samaras," *Artforum,* October 1966, p. 43.

20. Jules Langsner, "Los Angeles Letter: January 1961," *Art International,* 1 February 1961, p. 70.

21. Peter Saul, "Saul on Saul," *Peter Saul,* exhibition catalogue (De Kalb, Ill.: Northern Illinois University, 1980), pp. 7–8.

22. Ibid., pp. 12–13. Wiley, in Barbara Haskell, *H. C. Westermann,* exhibition catalogue (New York: Whitney Museum of American Art, 1978), p. 27, wrote that H. C. Westermann was a "friend, guide and source of information and inspiration."

23. James Monte, "Making It with Funk," *Artforum,* Summer 1967, p. 56.

24. Joe Raffaele and Elizabeth Baker, "The Way-Out West," *Art News,* Summer 1967, pp. 39, 66.

25. Lippard, "Eccentric Abstraction," p. 38.

26. John Perreault, *Wiley Territory,* exhibition catalogue (Minneapolis: Walker Art Center, 1979), p. 13.

27. John Perreault, "Metaphysical Funk Monk," *Art News,* May 1968, p. 66.

28. Brenda Richardson, "I Am My Own Enigma," *William T. Wiley,* exhibition catalogue (Berkeley: University Art Museum, 1971), pp. 4, 14.

29. Ibid., p. 18.

30. Fidel A. Danieli, "The Art of Bruce Nauman," *Artforum,* December 1967, p. 19.

31. Nauman had seen reproductions of James Rosenquist's *Capillary Action II,* 1963, and *Tumbleweed,* 1964, and was impressed by their incorporation of neon, which he used in his own work in 1965. His neon works were also anticipated by those of Stephen Antonakos and Chryssa.

32. Other Hairy Who artists were James Falconer, Art Green, and Suellen Rocca.

33. Franz Schulze, "Chicago Popcycle," *Art in America,* November–December 1966, pp. 103–4.

34. The other artists in *9 in a Warehouse* were William Bollinger, William Kaltenbach, Alan Saret, and Keith Sonnier.

35. Robert Morris, "Anti-Form," *Artforum,* April 1968, p. 35. Morris did not use the label "antiform," and he repudiated it. However, Jon Gibson presented a show titled *Anti-Form* in his gallery, in the fall of 1968. The artists included were Panamarenko, Robert Ryman, Alan Saret, Richard Serra, Keith Sonnier, and Richard Tuttle.

36. Barbara Rose, "Problems of Criticism, VI: The Politics of Art, Part III," *Artforum,* May 1969, p. 47.

37. Morris, "Anti-Form," pp. 34–35.

38. Philip Leider, " 'The Properties of Materials': In the Shadow of Robert Morris," *New York Times,* 22 December 1968, sec. D, p. 31.

39. Gregoire Müller, "Robert Morris Presents Antiform," *Arts Magazine,* February 1969, p. 30.

40. Leider, " 'The Properties of Materials,' " sec. D, p. 31.

41. Elizabeth C. Baker, "Critic's Choice: Serra," *Art News,* February 1970, p. 26.

42. Leider, " 'The Properties of Materials,' " p. 31.

43. Fidel A. Danieli, "Some New Los Angeles Artists: Barry Le Va," *Artforum,* March 1968, p. 47.

44. Robert Morris, "Notes on Sculpture, Part 4: Beyond Objects," *Artforum,* April 1969, pp. 51, 54.

# 14 EARTHWORKS, MINIMAL ENVIRONMENTS, AND PERFORMANCES

At the end of 1968, Philip Leider remarked that two exhibitions "signal the closing out of what might be called 'Phase One' of the adventure that has been called 'Minimal,' 'Object,' or 'Literalist' art." One was *9 in a Warehouse*, "which may very well become one of those landmark early exhibitions which suggest that a new way of thinking about art is in the air." The second was the " 'Earthworks' exhibition at the Dwan Gallery [organized by Robert Smithson], which, via photographs, found artists making piles of rocks, digging holes in the Mojave Desert, or drawing chalk lines a mile long through some California wasteland."[1] Leider was right in viewing Earthworks as a continuation of Minimal Art. The best-known, notably Michael Heizer's *Double Negative*, 1969, and Smithson's *Spiral Jetty*, 1970, are monumental Minimal works—or, in the case of Heizer's, a negative Minimal work. Like Minimal sculptures, these Earthworks were based on preconceived ideas—ideas imposed on nature—but it was their extreme physicality, or the sense of it, that made the strongest impression. As one of their patrons, Virginia Dwan remarked, "when an artist [Heizer] has moved two hundred and forty thousand tons of dirt around, it is *not* just a concept."[2] Earthworks that imposed less on nature also tended on the whole to be Minimal in design.

There was a kind of Earthwork that was primarily conceptual. As his contribution to *Sculpture in Environment*, 1967, Claes Oldenburg hired union gravediggers to dig a "grave," a minimal six-by-six-by-three-foot cavity, in Central Park behind the Metropolitan Museum and then refill it. Oldenburg's "work" had a Duchampian edge; it could be considered an Assisted Readymade. So could other Earthworks and related phenomena, extreme examples of which were Iain Baxter's "aesthetically claimed things," which were photographs of existing phenomena in the environment. But such works did not command the attention that late-Minimal Earthworks did.

As I remarked, Minimal objects led directly to Earth Art. Because they lacked internal relationships, they seemed to establish relationships with their surroundings. To put it another way, Minimal objects articulated their outer limits so emphatically that they pointed to what was beyond these limits. This led Minimal sculptors to take into account the environment of a work and how the setting might affect the sculpture, or, as Morris remarked, "change the terms." The next step might be to put the work outside.[3] Struck by Morris's suggestion, Dennis Oppenheim predicted that the "displacement from object to place will prove to be the major contribution of minimalist art," adding that artists should find "a more deserving location" than the artist's loft or gallery.[4] That location would be America's open spaces.

Process Art preceded Earth Art in time and influenced it. Indeed, several artists ventured from the one to the other. It was natural for this shift to occur; as Morris wrote, piles or "accumulations of things or stuff" called to mind a "landscape mode."[5] The nonrigid materials favored by Process artists did not seem to fit naturally within a studio or gallery space; the four walls acted as a constraining frame, arbitrarily limiting its random form. To put it another way, the rigid confines of interior spaces were out of keeping with the spread of amorphous materials. An open, less precious space seemed more appropriate, and artists began to think that the more open it was, the more open to the processes of nature, the better, and they turned to unbounded deserts, salt flats, and the like, using the materials they encountered *in situ*, primarily earth, sand, rock, gravel, to work with. Thus it was natural for Walter de Maria to turn from forming a wall-to-wall carpet of dirt, three-feet-deep, in a Munich gallery in 1968 to creating Earthworks out of doors. Like the matter used by Process artists, substances found in nature, subject to the elements, were impermanent, indeterminate, and changeable.

Remarks by Tony Smith published in 1966 directed the attention of artists to the potential of the American scene as art or as the ground for art. Smith described his night ride on the unfinished New Jersey Turnpike:

> This drive was a revealing experience. The road and much of the landscape was artificial, and yet it couldn't be called a work of art. On the other hand, it did something for me that art had never done. [Its] effect was to liberate me from many of the views I had had about art. It seemed that there had been a reality there which had not had any expression in art. The experience on the road was something mapped out but not socially recognized. There is no way you can frame it, you just have to experience it.

185. Robert Smithson, *Spiral Jetty*, April 1970. Great Salt Lake, Utah; coil 1,500′ long, approximately 15′ wide.

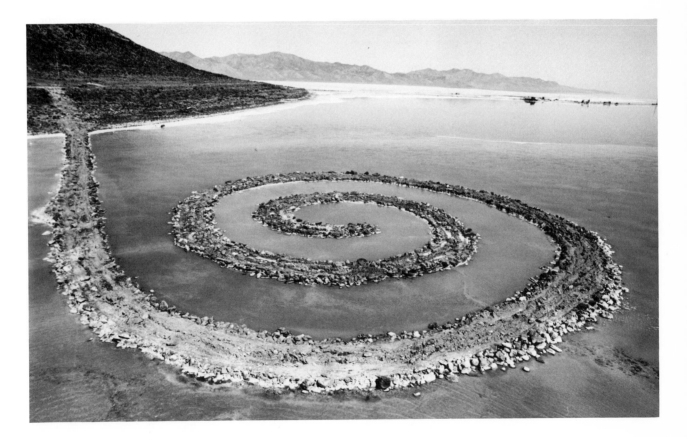

However, the aesthetic possibilities of an "artificial landscape without cultural precedent began to dawn on me."[6] Smith had anticipated Earthworks.

Robert Smithson was challenged by Smith's speculation about making art from an " 'abandoned airstrip' as an 'artificial landscape' " lacking in " 'function' and 'tradition.' " As artist consultant to a firm of engineers and architects who were developing an air terminal between Fort Worth and Dallas in Texas, Smithson had the opportunity of trying to find a frame for the kind of amorphous sensations experienced by Smith. Smithson's observations appeared in an article in *Artforum* titled "Toward the Development of an Air Terminal Site." In the process of investigating the site, auger borings and core borings were made. These soil samples intrigued Smithson, as did "Pavements, holes, trenches, mounds, heaps, paths, ditches, roads, terraces, etc., [all of which] have an aesthetic potential" and are "becoming more and more important to artists." Instead of installing works of art in the airport, Smithson proposed to take the whole site into account, its physical and metaphysical dimensions beneath the earth, on the ground, and from the sky. He also envisioned other "art forms that would use the actual land as a medium"— in remote places, such as the North and South Poles or the Pine Barrens of New Jersey. "Television could transmit such activity all over the world."[7] Smithson concluded prophetically that site-specific Earth Art was just beginning.

Smithson, who had hailed Smith as "the agent of endlessness,"[8] was particularly fascinated by disintegrating matter—sediment, sludge, and the like—as materials of art, since they verged toward a state of entropy, which, as he saw it, was the destiny of the universe.

There was a variety of attitudes toward the American landscape, as Alan Sonfist noted:

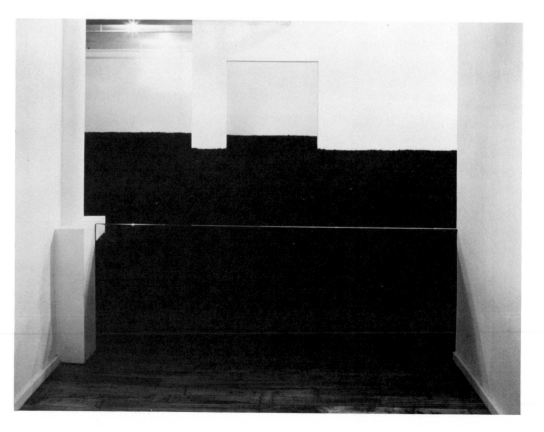

186. Walter de Maria, *The New York Earth Room*, 1977, New York. Dia Art Foundation.

At one end of the spectrum the idea of monumentality, of earth moving, is made possible by industrial tools: bulldozers, dump trucks, and so forth. The work these artists produce gives rise to thoughts of "wide open spaces." . . . These artworks were built to speak of themselves, not the land they occupy. At the other end of the spectrum there are artists pursuing the relatively new idea of cooperation with the environment, which they see as necessary because of the threat of its destruction.[9]

Earth artists who "imposed" on nature rather than "exposed" it[10] were Smithson and Heizer. Indeed, they dramatically marked the land with their presence,[11] much as de Kooning and Kline marked their Abstract Expressionist canvases with heroic gestures. Like Newman, Still, and Rothko, Smithson and Heizer aspired to the sublime. Newman had looked to the American scene for awe-inspiring phenomena and had found them in the prehistoric mounds in Ohio, notably the 1,254-foot-long Great Serpent. Smithson and Heizer were aware of the Ohio mounds and set out to create Earthworks of their own that were as awesome. The sites they favored were in what was left of the American wilderness, continuing the romance of the American frontier that harks back to the nineteenth-century painters of the West, such as Albert Bierstadt and Thomas Moran. As Morris summed it up, Smithson and Heizer carried Newman's conception of the sublime "back to nature where it originated in 19th-century American landscape painting." Thus, "Earthworks . . . were essentially a continuation of Abstract Expressionism's impulse for grandeur fused to Minimalism's emblematic forms."[12] The Minimal sculpture that most related in monumentality to the Earth Art of Smithson and Heizer was that of Tony Smith and Ronald Bladen.

After his Dallas–Fort Worth air terminal proposal, Smithson got "interested in the dialogue between the indoor and the outdoor [and developed] a dialectic that involved what I call site and non-site. The

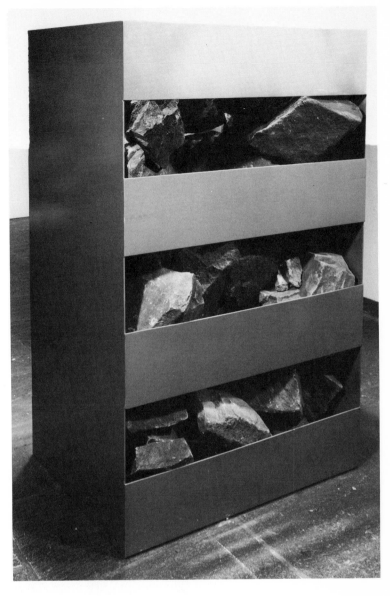

site, in a sense, is the physical, raw reality—the earth or the ground that we are really not aware of when we are in an interior room." This led Smithson "to transfer the land indoors, to the non-site, which is an abstract container."[13] "What I did was to go out to the fringes, pick a point in the fringes and collect some raw material."[14] He then placed the earth, gravel, rocks, and the like into bins, resembling his earlier Minimal sculpture, which he exhibited in gallery rooms. As part of a piece, a conceptual component, a topographical map

187. Robert Smithson, *Non-Site (Palisades, Edgewater, N.J.)*, 1968. 56″ × 26″ × 36″. Whitney Museum of American Art, New York.

A NONSITE (THE PALISADES)

The above map shows the site where trap rocks (from the Swedish word trapp meaning "stairs") for the Nonsite were collected. The map is 1 7/16" X 2". The dimensions of the map are 18 times (approx.) smaller than the width 26" and length 36" of the Nonsite. The Nonsite is 56" high with 2 closed sides 26" X 56" and two slatted sides 36" X 56" -- there are eight 8" slats and eight 8" openings. Site-selection was based on Christopher J. Schuberth's The Geology of New York City and Environs -- See Trip C, Page 232, "The Ridges". On the site are the traces of an old trolly system that connected Palisades Amusement Park with the Edgewater-125th St. Ferry. The trolly was abolished on August 5, 1938. What was once a straight track has become a path of rocky crags -- the site has lost its system. The cliffs on the map are clear out contour lines that tell us nothing about the dirt between the rocks. The amusement park rests on a rock strata known as "the chilled-zone". Instead of putting a work of art on some land, some land is put into the work of art. Between the site and the Nonsite one may lapse into places of little organization and no direction.

Robert Smithson 68

188. Robert Smithson, map and description that accompany *Non-Site (Palisades, Edgewater, N.J.)*, 1968. Map, 1½" × 2"; description, 7⅜" × 9¾". Whitney Museum of American Art, New York.

of the area in which the site was located was mounted on the wall near the bins. For example, *Non-Site, Franklin, New Jersey* is composed of five trapezoidal wood containers whose shapes correspond to an aerial photomap of the site and which are filled with raw ore from the area. Simple enough, but complexities and incongruities abound. The viewer's attention shifts back and forth from the trapezoid wood container-sculptures, the random piles of rocks, the photomap, and the room interior. As Smithson said: "The pieces and the systems are nonrepresentational, yet they relate to the sites and are in some way descriptive of it."[15] Yet the specific place from which the ore came would no longer be visible to anyone who visited it. What remains most vivid is the contrast between the finite, systemic, and precisely machined bins and the piles of rocks in them, which call to mind illimitable,

amorphous, and elemental geological processes ending in entropy. In this sense, Smithson's Non-sites embody a kind of metaphysical archaeology.

*Mirror Displacements,* 1969, abstracted the conceptual component of the Non-sites. They were put together in Mexico, but all that remained was the documentation, which appeared in an article titled "Incidents of Mirror-Travel in the Yucatán," published in *Artforum.*[16] Robert Hobbs remarked: "In the essay Smithson records the creation of temporary mirror displacements of light, atmosphere, and changing environments, and documents them with color photographs. [The] work of art is replaced by the critical-literary essay, and the gallery is supplanted by the periodical."[17]

In *Spiral Jetty,* 1970, Smithson stressed the site and sculptural components of the Non-sites. With financial support from the Dwan Gallery in New York and the Ace Gallery in Los Angeles, Smithson took a twenty-year lease on ten acres of lakefront land, hired a contractor, and using rented earth-moving equipment, moved more than six thousand tons of earth to form a gigantic spiral in the blood-red water of the Great Salt Lake. Like the Non-sites, *Spiral Jetty* calls to mind a variety of complicated metaphors. It is the shape of the salt crystals and microscopic organisms that abound in the lake and of the macroscopic spiral nebulae. A minimal form derived from Minimal sculpture, it is also reminiscent of prehistoric monuments, such as the Serpent Mound in Ohio. Even the earth-moving equipment that built it, whose tracks remain visible, took on symbolic signification, exemplifying modern industrial civilization and the primordial dinosaurs that roamed Utah. The *Jetty* is also a contradictory work. It is huge and yet will be reclaimed by nature, dissolved by the water. In fact, it is now underwater. In the end, the man-made monument will succumb to entropy. Dematerialization has occurred in another way. The *Jetty* is so inaccessible—and now largely invisi-

ble—as to be available primarily through documentation, and Smithson generated a mass of documentation, notably a thirty-five-minute film, which in its own right is a work of art.

Michael Heizer conceived of his Earthworks in 1967 but did not execute his first one until a year later. *Dissipate,* 1968, situated in the Black Rock Desert, Nevada, consisted of five rectangular trenches lined in steel, whose placement was determined by dropping matchsticks. This piece was meant to be permanent, but other of Heizer's Earthworks of that year were impermanent—for example, *Isolated Mass/Circumflex,* a 120-foot trench dug in Massacre Lake, Nevada. In *Displaced-Replaced Mass,* 1969, Heizer transported by crane three solid rocks, weighing thirty, fifty-two, and seventy tons, a distance of sixty miles. In *Double Negative,* 1969–71, he gouged out 240,000 tons of rhyolite and sandstone to create two huge excavations or cuts, thirty feet wide and fifty feet from top to bottom, which faced each other across a narrow canyon in an implied line. Like Smithson's *Spiral Jetty,* Heizer's *Double Negative* was composed of Minimal forms. But unlike Smithson, who *built* his Earthwork, Heizer *displaced* his. Heizer situated *Double Negative* in the isolated Virgin River Mesa, in Nevada. His reason, as he remarked: "In the desert I can find that kind of unraped peaceful religious space artists have always tried to put in their work."[18]

Walter de Maria's and Dennis Oppenheim's Earthworks were impermanent, quickly dematerialized and reclaimed by nature, and in this sense, did not impose on it. In 1968, de Maria made his first Earthwork, *Mile Long Drawing,* on the Mohave Desert; it consisted of two parallel lines of powdered chalk twelve feet apart. Among Oppenheim's better-known Earthworks were *Time Pocket,* 1968, in which he used a chain saw to cut an eight-foot-wide, two-mile-long swath into the ice of a frozen lake in Connecticut, and

*Directed Seeding-Canceled Crop,* 1969, in which he plowed an X with 825-foot-long arms into a Dutch grain field.

De Maria and Oppenheim were more mindful of ecology than Smithson and Heizer, but not to the extreme of Richard Long. Long gave nature precedence over his own creation, approaching it reverentially and submitting to what it suggested rather than imposing his will on it. Indeed, as Mark Rosenthal pointed out, Long " 'touch[es]' the landscape in a very delicate, unobtrusive manner. Long usually creates a small geometrical or loosely geometrical pattern of stones or branches. [He is] intent on juxtaposing the human invention of geometry with nature's cha-

189. Robert Smithson, *Gyrostatis,* 1968. 73″ × 57″ × 40″. Hirshhorn Museum and Sculpture Garden, Smithsonian Institution, Washington, D.C..

190. Robert Smithson, *1st Mirror Displacement*, 1969. 1″ thick, 12″ square. Yucatán Travels.

first Earthwork, a cliff-lined shore approximately one and a half miles long and eighty-five feet high near Sydney, Australia, which he draped with one million square feet of synthetic woven fiber and thirty-five miles of orange polypropylene rope. To realize this and other projects, Christo, with the help of his wife, Jeanne-Claude, raised considerable sums of money and engaged large working staffs, ranging from lawyers to laborers. The art-making, apart from the conception, which is intuitive, is primarily social, involving public-relations campaigns to create sympathy for projects the general public, governmental agencies, and the courts generally consider controversial. But there is poetry in Christo's packaged works. Shrouded phenomena evoke a sense of mystery. Even fabric, which is of commercial origin, is in itself expressive, as Christo views it:

> Friedrich Engels said that fabric made man different from primitive man. The process of weaving is the oldest and one of the most important processes of the evolution of man. In the same way fabric is almost like an extension of our skin, and you see that very well in the nomads, and in the tribes in the Sahara and Tibet, where they can build large structures of fabric in a very short time, pitch their tents, move them away, and nothing remains.[20]

Because of the inaccessibility and impermanence of many Earthworks, they were generally known only through photographs, films, videotapes, and articles. This raised questions concerning the relationship between a work and its documentation. Where was the art located? A number of Earth artists considered the Earthwork the art and the documentation merely documentation. Others thought of both as art forms, and still others claimed that only the documentation was the art. Intent on the physicality of earth, de Maria in 1969 announced his opposition to any photodocumentation of his work. Smithson agreed, asserting that photographs "steal away the spirit of the

otic composition. But Long's actions are of the utmost modesty."[19] Perhaps the most delicate and modest—and poetic—of Long's Earthworks consisted of trimming the flowers in a meadow to form an X.

Christo is related to both the monumental and the ecologically minded Earth artists in that his transient works are huge but he leaves natural—and man-made—phenomena just as he finds them. He is different because his work is primarily an activity outside the art world, which brings together a variety of people in a common enterprise for a period of time and then, when the work is accomplished and dismantled, the activity ends. What remains is the documentation of the activity. The work for which Christo is best known involves selecting an existing "object" and "wrapping" it. His subjects are often huge—the Chicago Art Institute, which he wrapped inside and out with heavy brown tarpaulins in 1969; and his

191. Michael Heizer, *Double Negative*, 1969–70. 240,000-ton displacement, 1,500′ × 50′ × 30′. Museum of Contemporary Art, Los Angeles.

192. Dennis Oppenheim, *Annual Rings*, 1968. 150′ × 200′. Location: U.S.A./Canada boundary at Fort Kent, Maine, and Clair, New Brunswick. Schemata of Annual Tree Rings Severed by Political Boundary. Time: U.S.A., 1:30 P.M.; Canada, 2:30 P.M.

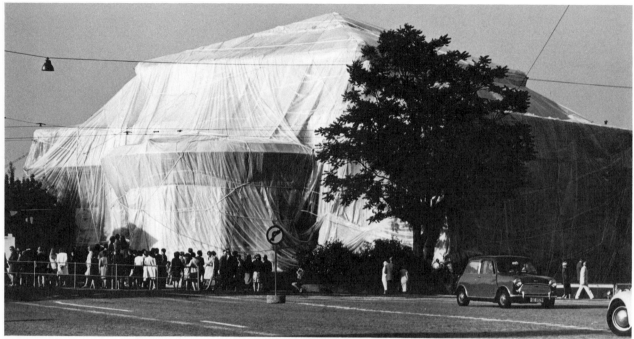

193. Christo, *Packed Kunsthalle*, Bern, Switzerland, 1968. 27,000 square feet of synthetic fabric and 10,000 feet of rope.

194. Christo, *Wrapped Coast—Little Bay, Australia*, 1969. One million square feet. Coordinator John Kaldor.

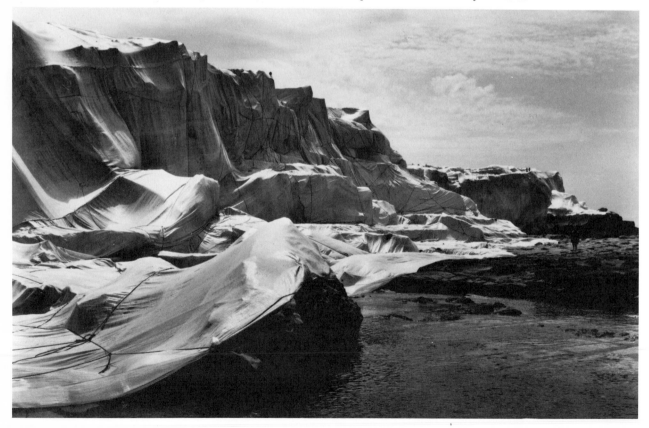

work,"[21] but he soon capitulated, making an art film of *Spiral Jetty,* which became the best-known document of an Earthwork. Oppenheim claimed that "the experience of directing the harvest was the main work, not the pictures."[22] In fact, no documentation of an Earthwork could convey the experience of walking it.[23]

For other Earth artists, such as Peter Hutchinson and Jan Dibbets, photography came to play an increasingly vital role. Speaking of *Threaded Calabash,* 1969, a work composed of five calabash fruits strung on twelve feet of rope underwater, Hutchinson said: "This piece represented to me the use of . . . large color photos as a record and proof that the work was really completed. Looking back I find that it was the photograph that was important."[24] By 1970, he was making purely photographic pieces. So was Dibbets, who, in 1968, remarked of his work made with ephemeral materials, such as sand, growing grass, etc.: "I do not make them to keep, but to photograph. The work of art is the photo."[25]

Because Earthworks were not salable, it was often assumed in the late sixties that one of the motives of their makers was anticommercial. And in the case of several, this was true; they tried to invent works that could not be dealt with as commodities. The very retreat into the desert of a Heizer, a Smithson, and a de Maria, like Old Testament prophets, seemed to symbolize an escape from art-world flesh-pots. As Dibbets said about his sand and grass pieces: "Sell my work? To sell isn't part of the art. Maybe there will be people idiotic enough to buy what they could make themselves. So much the worse for them."[26] Not all Earth artists were against shows in commercial galleries, and those who claimed to be, exhibited in them nonetheless. As Corinne Robins wrote: "While an artist such as Michael Heizer felt a moral satisfaction carving out pieces in the desert and thereby 'not adding new objects to an already surfeited world,' nei-

ther Heizer's nor Smithson's interest in making Earthworks precluded gallery exhibitions."[27] Documentation could be marketed, and was. There were also patrons—Virginia Dwan, Robert Scull, Heiner Friedrich, Horace Solomon, John de Menil, and Bruno Bischofberger—who subsidized Earthworks. For example, in 1968, Scull commissioned Heizer to execute his *Nine Nevada Depressions,* a series of holes linking dry lakes, which stretched for 520 miles in the Smoke Creek Desert. Upon completion of the project, Scull chartered an airplane to view the work he "owned."

There were other artists related to Earth artists and Christo, who created Environments. A number formed a collaborative group called Pulsa. They were, as Michael Cain, one of their members said,

> involved in research with programming environments through electronic technology. The environments we work with are varied: interior spaces, public places outdoors, country landscapes. In each case, a particular system capable of emanating . . . light and sound . . . is set up and controlled through an electronic system that we've designed. All of our work is, therefore, time extended. Generally our environments run from a period of four to ten hours, uninterruptedly, each evening for a period of a couple of weeks to several months. They're usually programmed so that they're different each night. The large membership [ten] of the group is involved in implementing these works, which are very large in scale and, technologically, extremely complex.

Cain went on to say about America:

> Our environment is totally dominated by electronic phenomena. Our total environment, at least at night, is electric. . . .
>
> In such an environment, it seems critical to the Pulsa group that a public art form be developed to deal . . . specifically with the experiences people have today, in terms of time and also of space in the world.[28]

The Pulsa group was included in a show at the Museum of Modern Art titled

*Spaces,* 1969–70. The other participants were Michael Asher, Larry Bell, Dan Flavin, Robert Morris, and Franz Erhard Walther. The purpose of the exhibition, according to its curator, Jennifer Licht, was to enable viewers to enter "the interior space of the work of art—an area formerly experienced only visually from without." Thus the viewer "is presented with a set of conditions rather than a finite object."[29]

Toward the end of the sixties, Robert Irwin also experimented with space as an encompassing experience. This was implicit in his color-field painting of 1961–63 and his dotted paintings of 1963–65, in which he tried to dematerialize the picture's literal rectangular surface. In 1966, Irwin began to articulate the interior space in which a work was placed. He sprayed aluminum disks with pigment that reflected light, extended them from the wall on concealed tubes, and illuminated them with spotlights, which served to dissolve the disks while casting a pattern of interlocking shadows on the wall behind. From a distance, the work appeared illusory—and ethereal. Because they depended on the lit space of the room and the wall for their effect, Irwin's works were site-specific, enhancing their setting as much as they required it.

Like Earth and Process artists who used nontraditional, easily moldable, temporal materials in a literalist manner, Minimal performers, or Body artists, as they were often called, used their own bodies as a

195. Robert Irwin, *No Title,* 1966–67. 48″ in diameter. Whitney Museum of American Art, New York.

physical substance. Willoughby Sharp wrote that "young artists have turned to their most readily available source, themselves, for sculptural material with almost unlimited potential, capable of doing exactly what the artist wants, without the obduracy of inanimate matter."[30] However, because Minimal performers often used photographs, film, video, notes, and other documentation, they were associated with Conceptual Art; Pincus-Witten called Vito Acconci's work Conceptual Performance.[31]

It is noteworthy that in 1968, Serra created a Minimal Performance by filming a work of Process Art. The film, titled *Hand Catching Lead,* was about the process of catching. It called to mind Hans Namuth's film of Pollock in the process of painting. On film, Pollock's creative action became a Minimal Performance; the documentary itself was a work of art.

Autobiography was unavoidable in Minimal Performance. As Jack Burnham remarked:

> Body works are probably one of the last things that can happen in avant-garde art. Because once artists totally externalize their bodily activities into a work, and then document it, that's as far as it can go. What every artist is acting out is his own autobiography; in fact all gestural or personal trademarks are autobiographical. As far as I can see, body works say, let's get the fact that art is autobiographical out into the open and deal with it for what it's worth.[32]

However, Minimal performers played down personal and subjective references by giving themselves impersonal tasks to accomplish and focusing on the physical action. In 1968, Bruce Nauman filmed himself *Walking in an Exaggerated Manner Around the Perimeter of a Square;* his intention was to experience the actual space. In a performance before an audience, titled *Correlated Rotations,* 1969, Dan Graham gave himself and another participant the task of filming each other while circling in a prescribed manner. Then the films were shown on opposite walls, causing the spectators to look back and forth from one screen to the other in the attempt to recreate the event. Cindy Nemser summed it up: "The artist sees each *I* as extended through the *eye* of the person who holds the camera."[33] The task Acconci assigned himself in *Proximity,* 1970, "was to stand near a person and intrude on his personal space. . . . If he got nervous or moved away, I would consider the piece accomplished."[34] Acconci's need to make this early performance piece was to find "reasons to be in a space, reasons to move in space," and his solution was to take "decisions of time and space . . . out of my hands," to abnegate decision-making. "I am almost not an 'I' anymore. I put myself in the service of this scheme."[35]

In his more physical works of 1970, Acconci set up closed systems by turning in on himself, by using his own body as the "primal" ground for marking. For example, *Trademarks*

> was not a public performance. The piece consisted of me, naked, trying to bite as much of my body as I could reach. . . . When a bite was achieved, I applied printer's ink to it so I was able to have a bite print. Therefore, I was turning in on myself, making a closed system and then presenting the possibility of opening that system with the print . . . and sharing it.[36]

In retrospect, Acconci remarked of his works of 1970:

> If an art-work is seen as a target for viewers experiencing art, entering an exhibition space and aiming in, then I can, beforehand, doing art, use myself as target, with the target-making activity made available to viewers. (But, then, if I focus in on myself, I close myself up in myself, presenting myself not as "person" but as "object.")[37]

In treating himself as "a kind of self-enclosed object [the pieces of 1970] [he] seemed to me almost a kind of last gasp of minimal art."[38] From this point on, Acconci's aim was to break out of self-containment. "There is a film I did in 1970 called *Openings,* which is a shot of my

196. Gilbert and George, *Underneath the Arches*, October 1971. Performed at the Sonnabend Gallery, New York.

navel and the hairs of my stomach. I pull the hairs out of my navel so that gradually the navel opening is opened further." This piece had an extraphysical dimension,

> all sorts of other connotations—sexual, for example. .,. . Navel becomes vagina.
>
> I am using art as a means of changing myself, as a means of breaking out of a category. I am categorized as a male. Now I'm trying to change that category, open up the possibility of being a female.[39]

*Openings* was only the beginning of Acconci's breakout from Minimal Performance.

There was in *Openings* and other of Acconci's pieces a pronounced element of physical pain—often cruel and menacing—which called to mind Antonin Artaud's "Theater of Cruelty." It also made one think of the Vietnam War. As a comment on the war, Ralph Ortiz guillotined a chicken in 1967.[40] It was not only Vietnam but a general social malaise, exemplified by the student riots in Europe in 1968, that seemed to give rise to a widespread concern with pain. In 1969, Rudolf Schwarzkogler at the age of twenty-nine amputated his penis inch by inch until he died, while a photographer documented it as an art event. Indeed, morbidity and masochism were frequent in sixties Body works.

At the other extreme, Gilbert and George announced that all was well in art and the world. However, their performances as "living sculptures," as they called themselves, had an unnerving

edge. In *Underneath the Arches,* 1969, to the accompaniment of the popular English song of that name, they appeared in regular suits but with their faces painted gold, one holding a cane and the other a glove, and moved around and around like motorized puppets on a small table for about six minutes.

Joseph Beuys was the most complex of sixties Performance artists. Dressed in a distinctive or signature suit but often acting like a mythic Teutonic character in a Wagnerian ritual; using unusual materials associated with his personal life, such as felt and fat, substances employed by Russian peasants to resuscitate him after his fighter plane crashed on the Russian front during World War II; and orating didactically on art and politics, Beuys layered autobiographical, social, historical, and mythical images. In *How to Explain Pictures to a Dead Hare,* 1965, Beuys's best-known early Performance, or "Action," as he called it, he

> covered his head with honey and gold-leaf, transforming himself into a sculpture. He cradled [a] dead hare in his arms and took it "to the pictures and I explained to him everything that was to be seen. I let him touch the pictures with his paws and meanwhile talked to him about them. . . . I told him that he needed only to scan the picture to understand what is really important about it . . . and actually nothing else is involved."[41]

In the seventies, Beuys would become the most influential European artist, with a large following in America as well.

## NOTES

1. Philip Leider, " 'The Properties of Materials': In the Shadow of Robert Morris," *New York Times,* 22 December 1968, sec. D, p. 31.
2. Calvin Tomkins, "Onward and Upward with the Arts: Maybe a Quantum Leap," *The New Yorker,* 5 February 1972, p. 41.
3. Robert Morris, "Notes on Sculpture, Part II," *Artforum,* October 1966, p. 21.
4. Dennis Oppenheim, in *Conceptual Art and Conceptual Aspects,* exhibition catalogue (New York: New York Cultural Center, 1970), p. 30. It is noteworthy that Happenings artists had abandoned galleries earlier.
5. Robert Morris, "Notes on Sculpture, Part IV: Beyond Objects," *Artforum,* April 1969, p. 51.
6. Samuel Wagstaff, Jr., "Talking to Tony Smith," *Artforum,* December 1966, p. 19.
7. Robert Smithson, "Toward the Development of an Air Terminal Site," *Artforum,* Summer 1967, pp. 38, 40.

8. Robert Smithson, "Letters," *Artforum*, October 1967, p. 4.
9. Alan Sonfist, ed., *Art of the Land* (New York: E. P. Dutton, 1983), p. xi.
10. Smithson, "Toward the Development of An Air Terminal Site," p. 40.
11. Mark Rosenthal, "Some Attitudes to Earth Art," in Sonfist, *Art of the Land*, pp. 62, 64.
12. Robert Morris, "American Quartet," *Art in America*, December 1981, p. 96.
13. Robert Smithson, in *Earth Art*, exhibition catalogue (Ithaca, N.Y.: Andrew Dickson White Museum of Art, Cornell University, 1970), n.p.
14. Lucy R. Lippard, *Six Years: The Dematerialization of the Art Object* (New York: Praeger Publishers, 1970), p. 88.
15. Anthony Robbin, "Smithson's Non-Site Sights," *Art News*, February 1969, p. 53.
16. See Robert Smithson, "Incidents of Mirror-Travel in the Yucatán," *Artforum*, September 1968.
17. Robert Hobbs, *Robert Smithson: Sculpture* (Ithaca, N.Y.: Cornell University Press, 1981), p. 14.
18. Michael Heizer, in brochure of a show at Galerie H, Graz, 1977, n.p.
19. Rosenthal, "Some Attitudes to Earth Art," p. 66.
20. Barbaralee Diamonstein, interview with Christo and Jeanne-Claude, *Inside New York's Art World* (New York: Rizzoli, 1979), p. 94.
21. "Discussions with Heizer, Oppenheim, Smithson," *Avalanche*, Fall 1970, p. 67.
22. Rob Bongartz, "It's Called Earth Art—and Boulderdash," *New York Times Magazine*, 1 February 1970, p. 27.
23. See Elizabeth C. Baker, "Artworks on the Land," *Art in America*, January–February 1976, p. 95.
24. Carol Hall, "Environmental Artists: Sources and Directions," in Sonfist, *Art of the Land*, p. 32.
25. Lippard, *Six Years*, p. 59.
26. Ibid.
27. Corinne Robins, *The Pluralist Era: American Art 1968–1981* (New York: Harper & Row, 1984), p. 77.
28. Lucy R. Lippard, ed., "Time: A Panel Discussion," *Art International*, November 1969, p. 20.
29. Jennifer Licht, introduction, *Spaces*, exhibition catalogue (New York: Museum of Modern Art, 1969–70), n.p.
30. Willoughby Sharp, "Body Works," *Avalanche*, Fall 1970, p. 14.
31. See Robert Pincus-Witten, "Vito Acconci and the Conceptual Performance," *Artforum*, April 1972.
32. "Willoughby Sharp Interviews Jack Burnham," *Arts Magazine*, November 1970, p. 22.
33. Cindy Nemser, "Subject-Object: Body Art," *Arts Magazine*, September–October 1971, p. 42.
34. Cindy Nemser, "An Interview with Vito Acconci," *Arts Magazine*, March 1971, p. 20.
35. Martin Kunz, "Interview with Vito Acconci about the Development of His Work since 1966," *Vito Acconci*, exhibition catalogue (Lucerne, Switzerland: Lucerne Art Museum, 1978), n.p.
36. Nemser, "An Interview with Vito Acconci," p. 20.
37. Vito Acconci, in *Vito Acconci*, exhibition catalogue (Amsterdam: Stedelijk Museum, 1978), n.p.
38. Kunz, "Interview with Vito Acconci," n.p.
39. Nemser, "An Interview with Vito Acconci," p. 21.
40. See Lil Picard, "Making the Scene with Lil Picard: Kill for Peace," *Arts Magazine*, March 1967, p. 15.
41. Ursula Meyer, "How to Explain Pictures to a Dead Hare," *Art News*, January 1970, p. 57.

# 15 CONCEPTUAL ART

Minimal artists based their works on preconceived ideas in order to produce the most objectlike of objects. Toward the end of the decade, artists began to consider such ideas autonomous and to present them in verbal form as works of art. LeWitt labeled this work Conceptual Art and defined it as art that "is made to engage the mind of the viewer rather than his eye or emotions."[1] Douglas Huebler remarked that it meant "making art that doesn't have an object as a residue."[2] If Conceptual Art was first viewed as the abstraction or bracketing out of the conceptual component of Minimal Art, it was soon perceived as well as a continuation of the central thrust in Duchamp's art and thinking. In this sense, Conceptual Art is a dematerialization (to use Lucy Lippard's and John Chandler's word)[3] of a Minimal object or a Readymade, taking either back to the original idea that generated it. Once again in sixties art, purist Minimalist and nonpurist Duchampian aesthetics were related. Conceptual works of art, as one kind of dematerialization of Minimal Art, were linked to others, namely Process works and temporary Earth pieces. Lines of powdered chalk and temporary piles led to the use of even more ephemeral "materials," such as nonvisual concepts.

Also anticipating Conceptual Art were "concept art," as Henry Flynt, a member of the Fluxus group, called it in 1963,[4] referring to pieces by his associates George Brecht and Yoko Ono, among others; Concrete Poetry, in which letters and words were treated as objects; and Ray Johnson's "mail art," delivered by post.[5] Interesting though these works were, they tended to be peripheral. There were also Conceptual developments in Europe that were peripheral to those in America, notably works by Yves Klein in France and Piero Manzoni in Italy. However, in 1963, Robert Morris made two works that did influence Conceptual artists. One was *Card File*, in which a series of plastic-encased cards documented the process of compiling the file. The second, a work titled *Document*, based on Duchamp's imagery, included a notarized "Statement of Esthetic Withdrawal," which retracted from the work it accompanied "all esthetic quality and content."[6] As in much of the Conceptual Art that followed it, Morris engaged in a dialogue with Duchamp, in the case of *Document* subtracting the value of art from the piece instead of adding it. Rauschenberg also had Duchamp in mind when, in 1961, he sent as his entry to a show of forty portraits of Iris Clert at her gallery a telegram (which soon became notorious): "This is a portrait of Iris Clert if I say so." In 1966, the Dwan Gallery began to mount language shows that suggested the potential of a Conceptual Art.

The shift in thinking from concept as the basis of Minimal Art to concept-as-art can be traced in the writing of Sol LeWitt, who formulated a rationale for a Conceptual Art in two widely discussed articles,

one of 1967, the other of 1969.[7] In the first essay, LeWitt, taking his cues from Stella, who in 1960 said that what interested him most in art was a good pictorial idea, wrote that in Conceptual Art the idea is the most important component of the work. It "means that all of the planning and decisions are made beforehand and the execution is a perfunctory affair. The idea becomes a machine that makes the art." This did not mean that Conceptual Art was rational, "theoretical or illustrative of ideas." Quite the contrary, "it is intuitive . . . and it is purposeless." Conceptual artists "leap to conclusions that logic cannot reach. . . . Irrational judgments lead to new experience." But: "Irrational thoughts should be followed absolutely and logically," blindly and mechanistically.

Thus, while LeWitt relied on intuition to formulate a plan, he avoided it in the execution of the pre-set plan. His aim was to avoid "subjectivity," which he implied was "the arbitrary, the capricious."

To "make his work mentally interesting to the spectator, [the Conceptual artist] would want it to become emotionally dry." For viewers whose expectations were conditioned by the "emotional kick" of Expressionist art, Conceptual Art might seem boring, but there was no reason to suppose that it was intended to be. Le-Witt's desire for a Conceptual Art led him to denigrate art that is meant to appeal to the eye, that is perceptual rather than conceptual. This included most optical, kinetic, and light art. It also included art that featured new materials. "The danger in making the physicality of materials so important [is] that it becomes the idea of the work (another kind of expressionism)." Le-Witt concluded that anything focusing attention on physicality distracts from the understanding of the idea.

Thinking in this vein led LeWitt to en-

197. Sol LeWitt, *Untitled Cube,* 1968. 15½″ × 15½″ × 15½″. Whitney Museum of American Art, New York.

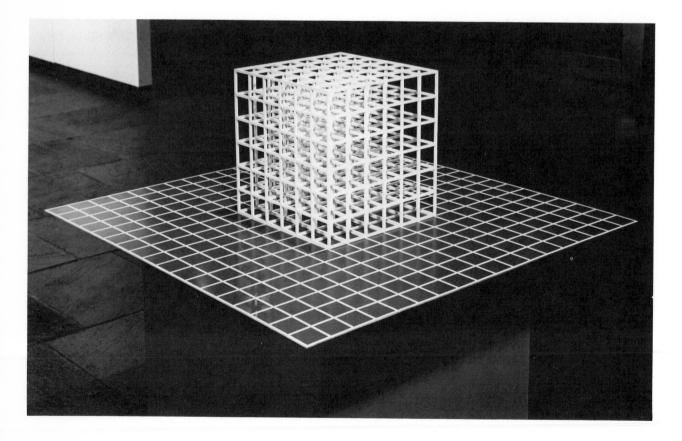

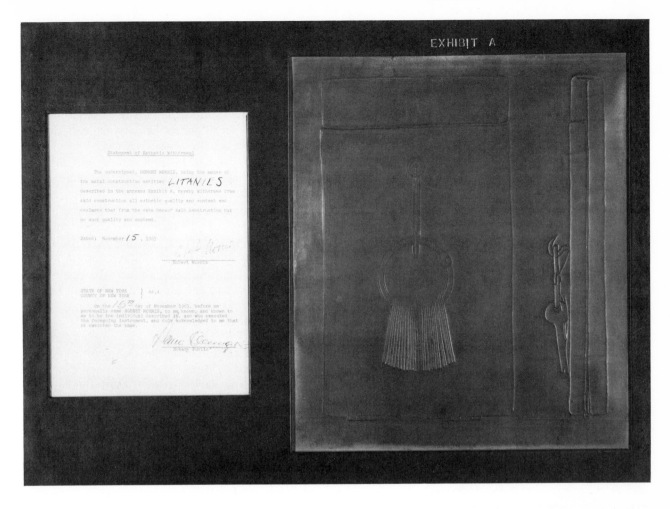

tertain the idea of a purely Conceptual Art, because every move in its creation was vital.

> The idea itself, even if not made visual, is as much a work of art as any finished product. All intervening steps—scribbles, sketches, drawings, failed works, models, studies, thoughts, conversations—are of interest. Those that show the thought process of the artist are sometimes more interesting than the final product.

Indeed, "Ideas may also be stated with numbers, photographs, or words or any way the artist chooses, the form being unimportant." It is noteworthy that LeWitt should include photodocumentation; it would become central to Conceptual Art.

Consequently, as LeWitt viewed it in 1967, Conceptual Art could range from an object generated by an idea to a written or even verbal idea, or exist in the gap between verbalization and visualization. The illustrations that accompanied his article were of works by LeWitt himself, Jo Baer, Ruth Vollmer, Dan Flavin, Carl Andre, Mel Bochner, Eva Hesse, Jane Klein Marino, Paul Mogensen, Edward Ruscha (a detail from *Every Building on the Sunset Strip*), and Dan Graham (a photograph of steps).

As for the quality of Conceptual Art, LeWitt remarked: "Conceptual art is only good when the idea is good."[8] But what made an idea good? This question was addressed by Amy Goldin and Robert Kushner. As they saw it, the entire grammar of art had changed.

198. Robert Morris, *Document*, 1963. Overall 17⅝" × 23¾". Museum of Modern Art, New York.

With conceptual art, no one is expected to contemplate the object for a meaningful artistic experience—he will soon become bored. By the same token, no one is expected to spend a day meditating on the ideas. They are too simple. Rather it is a matter of finding *that* idea butted up against *this* visual situation. This meshing or confrontation provides the basic interest of conceptual art. It is the juxtaposition, not the object or the ideas in themselves, that is the conception of conceptual art.

A balance had to be struck between the idea and the object it yielded: "If the visual material is too complex or subtle, the message will not get across," and vice versa.[9]

This kind of balance was very much on LeWitt's mind, and it accounts for the quality of his work. "Paragraphs on Conceptual Art," his essay of 1967, was not meant to apply only to his work, but the following excerpt is particularly apt:

When an artist uses a multiple modular method he usually chooses a simple and readily available form. . . . In fact it is best that the basic unit be deliberately uninteresting so that it may more easily become an intrinsic part of the entire work. Using complex basic forms only disrupts the unity of the whole.[10]

As an example of a good idea, LeWitt referred to architecture, singling out the law governing multiple, set-back office buildings—or ziggurats, as they are called (the subject of an article written by him in 1966, prior to his first article on Conceptual Art). "The zoning code pre-conceived the design of the ziggurats, just as an idea might give any work of art its outer boundaries and remove arbitrary and capricious decisions." In this case, the form is liberating rather than confining. The ziggurat buildings conform to the code, yet no two are alike; the slab-type buildings that are now being built seem more uniform. Thus, "The zoning code established a design that has much intrinsic value [despite the objections of many architects]."[11]

In the early sixties, LeWitt had made three-dimensional paintings, reliefs, and freestanding constructions consisting of a variety of rectangular volumes. In 1965, he limited himself to the open cube module as the basic unit in his grammar of

199. Sol LeWitt, *B 789*, 1966. 9⅜″ × 8½″ × 30½″. Whereabouts unknown, courtesy John Weber Gallery, New York.

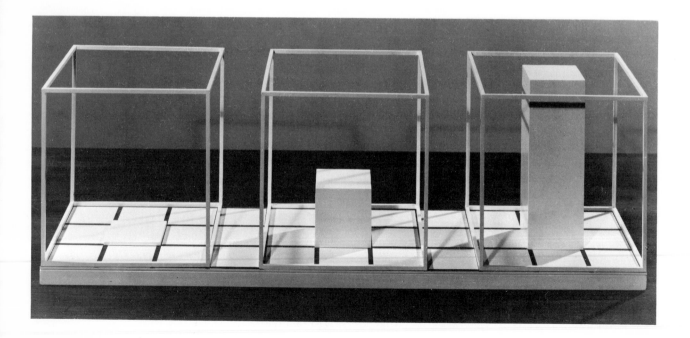

form. At first he painted the wood frame-works black, but by the end of the year he had changed to white. "This seemed more appropriate for the forms and mitigated the expressiveness of the earlier black pieces. . . . About this time also, a ratio of 8.5:1 between the material (wood or metal) and the spaces between was decided upon. As with the white color, the 8.5:1 ratio was an arbitrary decision, but once it had been decided upon, it was always used."[12]

Influencing the change in his work, as LeWitt acknowledged, were Muybridge's modular motion-study photographs; Albers's *Homage to the Square* series; Reinhardt's black-square abstractions; Johns's pictures of numbers and alphabets arranged on a grid; and Stella's black-stripe paintings. LeWitt was also stimulated by modern modular architecture—he had worked in the graphics department of I. M. Pei's architectural firm in 1955–56—and the serial music of Schoenberg and Webern and of his friends Philip Glass and Steve Reich.

LeWitt's "open modular cubic structures," as he called them,[13] insistently point to the ideas of modularity and seriality that generated them. The "mathematical systems [proceed] in linear and logical fashion from a specific generative idea to a predictable conclusion. [The] art is pure information."[14] The systems were simple because their function was to call attention to themselves as art, not as mathematics. Conceptual Art, as LeWitt remarked, had to be "smart enough to be dumb."[15]

But LeWitt's structures turn out to look very complex, and this was the artist's intention; as he implied, logic is used only to be ruined.[16] The visual effect of the sectioned interior spaces is unpredictable. What is known is not what is seen. The tension between system and sensation, between conceptual order and clarity and visual disorder and ambiguity, causes a logical, regular, passive, and sober grid to end up looking like an extravagant labyrinth. Indeed, as Lippard remarked:

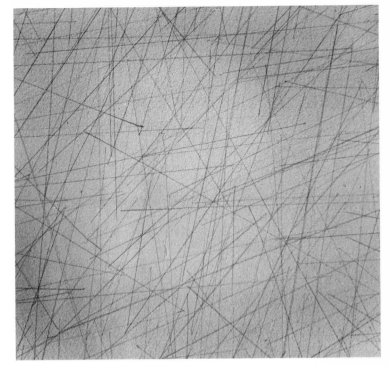

LeWitt's work is rich in contradictory material, which operates at times as a mental and at times as a visual construct. He confronts concepts of order and disorder, open and closed, inside and outside, two- and three-dimensionality, finity and infinity, static (modular) and kinetic (serial).[17]

Robert Rosenblum remarked that LeWitt's "systems of elementary shapes can proliferate with a crazy extravagance that, to our surprise, puts the rational gray matter of logic, mathematics, and science at the service of a wildly florid artistic imagination."[18]

LeWitt put the open, partly open, and closed cubes through a variety of permutations—rotation, mirroring, reversals and cross-reversals, juxtapositions and superimpositions[19]—varying the shape of the units and the whole; playing two dimensions off against three, as in *Modular Cube-base*, 1968, which consists of a base plane of 342 squares on top of which was placed a cube composed of 216 modular units. In his serial projects, the first of which was *ABCD*, 1966, LeWitt juxtaposed open and

200. Sol LeWitt, *Wall Drawing (III), Part 3*, 1971. Five parts; overall, 9'4" × 46'8". A wall divided vertically into 5 equal parts with 10,000 lines in each part; part 3: 18"-long lines. Courtesy John Weber Gallery, New York.

solid square planes and cubes. In *All Three-Part Variations on Three Different Kinds of Cubes,* 1969, consisting of forty-seven variations, he tried to exhaust the combinations.

In 1966, LeWitt started to produce inexpensive illustrated books, a logical move since books are customary containers of ideas and information, which "combine the intimacy of communication of an idea with the detachment of a manufactured item."[20] The first of these publications was a sixteen-page pamphlet recreating the *ABCD* piece for Brian O'Doherty's boxed *Aspen 5+6* magazine. In 1968, LeWitt turned from book- to mural-size drawing. His wall drawings are verbal proposals executed directly on walls by his associates. He remarked:

> If I do a wall drawing, I have to have the plan written on the wall or label because it aids the understanding of the idea. If I just had lines on the wall, no one would know that there are ten thousand lines within a certain space, so I have two kinds of form [of equal importance]—the lines and the explanation of the lines. Then there is the idea, which is always unstated.[21]

LeWitt's purpose in the wall drawings was "to do a work that was as two dimensional as possible" and to engage "the physical properties of the wall." Its "height, length, color, material, architectural conditions and intrusions, are a necessary part of the wall drawings. Different kinds of walls make for different kinds of drawings." LeWitt went on to say:

> The drawing is done rather lightly, using hard graphite so that the lines become, as much as possible, a part of the wall surface, visually. . . .
> The four kinds of straight lines used are vertical, horizontal, 45° diagonal left to right and 45° diagonal right to left.
> When color drawings are done, a flat white wall is preferable. The colors used are yellow, red, blue and black; the colors used in printing.[22]

Bernice Rose remarked on the significance for himself and other artists of Le-Witt's projection of drawing on a mural scale:

> LeWitt's transposition of his drawings from the restricted if traditional format of a sheet of paper to the architectural space of a wall with which it became absolutely identified was a radical move. It suggests transformation in the role—and the very nature—of the drawing medium, within both his own work and the history of the medium.[23]

Despite the nonvisual basis of LeWitt's sculptures, they are visually stimulating. As Lippard wrote: "Most idea-art is dull. LeWitt's is not, and the attraction of his structures is their beauty. . . . The objects are, in the end, visually impressive. If they were not, they would be mere theoretical illustrations."[24] Rosenblum agreed, writing that LeWitt's work

> elicits . . . an immediate awe that . . . has to be translated by the same feeble words—beautiful, elegant, exhilarating—that we use to register similar experiences with earlier art. The theories, the geometries, the ideas may all be called into play for a fuller elucidation of what is going on, but both initially and finally, it is the visible works of art that dominate our attention.

Rosenblum was particularly impressed by the elegance of the wall drawings: "More phantom than substance, these boundless, gossamer traceries appear like mirages on walls and ceilings." He also related them to Philip Glass's music. (LeWitt had designed the record jacket for Glass's *Music in Twelve Parts.*)

> Glass's music is constructed from what at first may seem monotonous and endlessly repetitive units of rudimentary melodic and rhythmic fragments, electronically amplified in a way that conceals personal style. But if the intellectual order of Glass's work is as rigorous and systematic as that of Le-Witt's, yet . . . the total effect is not of dry reason. The experience becomes rather a kind of slow immersion in a sonic sea.[25]

By 1968, a growing number of artists were experimenting with an art of pure idea, the only physical manifestation of which was its documentation. In an article

titled "The Dematerialization of Art," Lucy Lippard and John Chandler wrote of the increase of

> an ultra-conceptual art that emphasizes the thinking process almost exclusively. As more and more work is designed in the studio but executed elsewhere by professional craftsmen, as the object becomes merely the end product, a number of artists are losing interest in the physical evolution of the work of art. The studio is again becoming a study. Such a trend appears to be provoking a profound dematerialization of art, especially of art as object, and if it continues to prevail, it may result in the object's becoming wholly obsolete.[26]

However, by the spring of 1969, a purely Conceptual Art as an identifiable style had not yet crystalized.[27] Conceptual Art shows included the documentation of Minimal, Process, Earth, and Performance pieces. *Conceptual Art and Conceptual Aspects,* the first exclusive show, took place in the spring of 1970 at the New York Cultural Center. *Information,* presented at the Museum of Modern Art the following summer, was primarily Conceptual, but it included documentation of physical works and activities as well.

In his essay of 1969, titled "Sentences on Conceptual Art," LeWitt advanced the idea of concept-as-art more strongly and specifically than he had in his 1967 article:

> Ideas alone can be works of art; they are in a chain of development that may eventually find some form. All ideas need not be made physical. . . .
>
> Since no form is intrinsically superior to another, the artist may use any form, from an expression of words (written or spoken) to physical reality, equally.

However, LeWitt indicated his preference for an immaterial art. Above all, he rejected painting and sculpture that "connote a whole tradition, and imply a consequent acceptance of this tradition, thus placing limitations on the artist who would be reluctant to make art that goes beyond the limitation."[28]

The anti-object attitude was stated even more strongly by Douglas Huebler in 1969: "The world is full of objects, more or less interesting; I do not wish to add any more."[29] John Baldessari went even further. He published the following notarized document in a newspaper: "Notice is hereby given that all works of art done by the undersigned between May, 1953, and March, 1966, in his possession as of July 24, 1970, were cremated on July 24, 1970, in San Diego, California."[30]

In works such as these, and there are many more Conceptual pieces in this vein, a reference to things—absent things—remains. There are also frequent references to space, naturally, since Conceptual artists considered themselves visual artists, not creative writers. Lawrence Weiner remarked: "Anything that exists has a certain space around it; even an idea exists within a certain space." Robert Barry agreed that Conceptual Art had "to do with some kind of spatial experience." Huebler commented: "Whatever you do involves space. I think the essential thing is that we are not concerned . . . with the specific space wherein the so-called art image exists." Barry added: "Maybe we are just dealing with a space that is different from the space that one experiences when confronting a traditional object."[31]

Conceptual artists believed that they were venturing beyond the limitation of objects in order to create an art of pure content. But how was their work to be recognized as art? LeWitt's answer:

> If words are used, and they proceed from ideas about art, then they are art and not literature. . . .
>
> All ideas are art if they are concerned with art and fall within the conventions of art. . . .
>
> The conventions of art are altered by works of art.
>
> Successful art changes our understanding of the conventions of art by altering our perceptions.[32]

Moreover, as Lippard asserted, Conceptual Art was art because it was presented as such: "It's not the medium that counts,

I will not make any more boring art.
I will not make any more boring art.
I will not make any more boring art.
I will not make any more boring art.
I will not make any more boring art.
I will not make any more boring art.
I will not make any more boring art.
I will not make any more boring art.
I will not make any more boring art.
I will not make any more boring art.
I will not make any more boring art.
I will not make any more boring art.
I will not make any more boring art.
I will not make any more boring art.
I will not make any more boring art.
I will not make any more boring art.
I will not make any more boring art.

201. John Baldessari, *I Will Not Make Any More Boring Art*, 1971. 22⅜″ × 29⁹/₁₆″. Museum of Modern Art, New York.

FACING PAGE: 202. Joseph Kosuth, *One and Three Chairs*, 1965. Chair, 32⅜″ × 14⅞″ × 20⅞″; photo panel, 36″ × 24⅛″; text panel, 24⅛″ × 24½″. Museum of Modern Art, New York.

and it's not the message that counts, it's how either or both are presented, in what context, that counts. . . . No art, no matter how much it resembles life, or literature, can call itself anything but art as long as it has been, is, or ever will be shown in an art context."[33]

The nature or language of art was the primary content for early Conceptual artists. Goldin and Kushner observed:

Probably the major contribution of conceptual art [was] to think about what art means instead of what it formally is. With taste, connoisseurship and art history discarded as irrelevant, we may possibly get down to finding out something about artistic meaning. . . . We have hardly begun to pay attention to the way ideas get into art and how they are involved in artistic meaning.[34]

Because of their interest in the language of art, early Conceptual artists extended the epistemological concern that was cen-

tral to sixties art. This was the intent not only of LeWitt, who was identified with Minimal Art, but of Duchamp-inspired artists, such as Joseph Kosuth. When Duchamp took a urinal, placed it on a pedestal, and proclaimed it a sculpture, even giving it a proper title, *Fountain*, he said that he "took an ordinary article of life and placed it so that its useful significance disappeared under a new title and point of view—and created a new thought for that object."[35] By making his idea primary, Duchamp's Readymades led directly to Conceptual Art. More than that, they gave permission to artists to consider the formulation of ideas about art to be the total act of art-making.

In Kosuth's view, Duchamp's Readymades had deflected the course of art (although it appears to have taken a half century for Conceptual artists to grasp this). "Being an artist now means to ques-

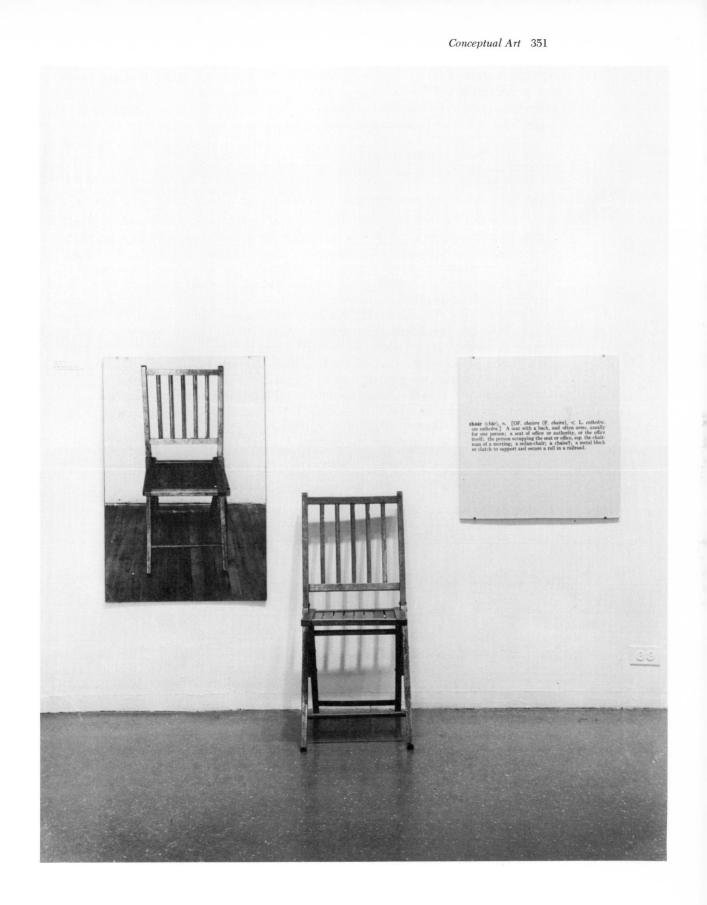

tion the nature of art." It had been possible previously to use the "language" of art objects to say new things—and as an artist of the sixties, Kosuth prized novelty—as in the case of Malevich, Mondrian, Pollock, Reinhardt, Rauschenberg, Johns, Lichtenstein, and Warhol, as well as Andre, Flavin, Judd, Morris, and LeWitt; and it is noteworthy that Kosuth should include Minimal sculptors. But it was possible no longer.[36] Reinhardt had had the last word. He succeeded, as he set out to do, in painting "the last painting anyone can make." As significant, through his extensive writing, Reinhardt conceptualized his own art and art generally. Therefore, Kosuth deduced: "Painting itself had to be erased, eclipsed, painted out in order to make art."[37] Reinhardt would have protested vociferously and never ventured toward a Conceptual Art. It was Duchamp who showed that "it was possible to 'speak an-

203. Joseph Kosuth, *Information Room*, installation at the New York Cultural Center, 1970.

other language' and still make sense in art." More than that: "With the unassisted *Readymade*, art changed its focus from the form of the language to what was being said. [This change] from 'appearance' to 'conception' . . . was the beginning of . . . 'conceptual' art." All art after Duchamp became conceptual in nature.

Kosuth went on to say that art was worthwhile only when it advanced art and it did so "by presenting new propositions as to art's nature." Indeed, the "value" of artists who followed Duchamp in time "can be weighed according to . . . 'what they *added* to the conception of art' or what wasn't there before they started." Thus they had to dispense with "the handed-down 'language' of traditional art." Kosuth was particularly hostile to the formalist art of Louis, Noland, Olitski, and others, whose "language," as he saw it, was "a rectangularly shaped canvas stretched

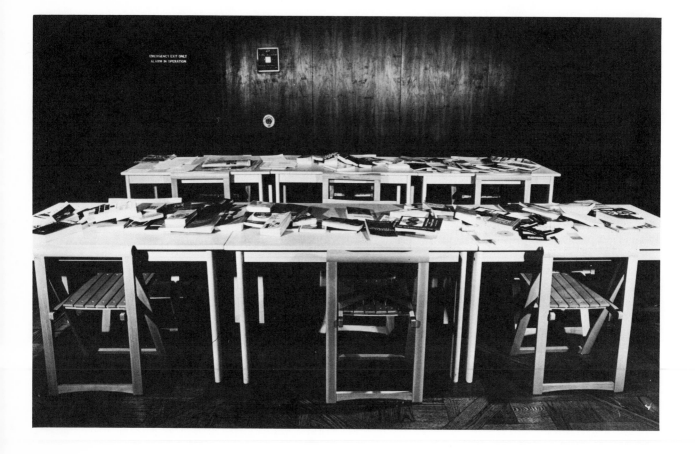

over wooden supports and stained with such and such colours, using such and such forms, giving such and such a visual experience, etc." It was obsolete because it involved a "minimal creative effort." "It's a mindless art." Formalist criticism was on the same low level as the art it promoted; it was "no more than an analysis of the physical attributes of particular objects which happen to exist in [the language of painting and sculpture]. [This] doesn't add any knowledge (or facts) to our understanding of the nature or function of art."[38]

Kosuth rejected not only formalist art but

> "earthworks," "process art," and other kinds of "reactive" art. What this art attempts is to refer to a traditional notion of art while still being "avant-garde." One support is securely placed in the material (sculpture) and/or visual (painting) arena, enough to maintain the historical continuum while the other is left to roam about for new "moves" to make and further "breakthroughs" to accomplish.

Summing up his argument, Kosuth wrote: "At its most strict and radical extreme the art I call conceptual is such because it is based on . . . *the understanding of the linguistic nature of all art propositions, be they past or present, and regardless of the elements used in their construction.*"[39] Kosuth called this enterprise "art as idea as idea" (art-as-idea as idea).

In a more speculative mood, Kosuth wrote that "Art may exist in the future as a kind of philosophy by analogy. This can only occur, however, if art remains 'self-conscious' and concerns itself *only* with art problems, changing as these problems may be."[40] This kind of thinking led contributors to the publication *Art-Language* to claim that their art criticism and theory were art. They reasoned that if critical discourse was inseparable from whatever stuff art is made of, then the critical discourse in itself was art.[41] LeWitt had published his "Sentences on Conceptual Art" in *Art-Language*, but he concluded that

his writings "comment on art, but are not art,"[42] as if to call into question the claims of its editors.

When Kosuth speculated that the future of art may be a kind of philosophic discourse about the nature or language of art, he had in mind as his model Wittgenstein's linguistic analysis. Determining the boundaries between the verbal and the visual was, as Bernice Rose remarked, *the* "problem for modern philosophy." Was visualization "prior to, anterior to, or simultaneous with verbalization"? Were "the verbal and the visual independently structured and conceived or interdependently"?

> Do our verbal structures supply us with our "picture" of the world and do they, as postulated, form the very basis of all our social structures, even to the extent of determining our kinship systems?

In the 1960s these possibilities were argued at length. Philosophers like Ludwig Wittgenstein were widely read and discussed, as were the French structural anthropologists and phenomenologists Claude Lévi-Strauss and Maurice Merleau-Ponty. The sixties saw the beginnings of a criticism based on the speculations of those philosophers whose premise was that the structure of culture is in fact determined by the grammatical structure of language. Syntax determines form in the most fundamental sense.[43]

Although most early Conceptual artists argued that to be art, the "information" they provided had to be about the language of art and its perception, a number introduced other kinds of ideas. Shusaku Arakawa provided cosmological messages stenciled on canvas, his work therefore remaining in the realm of painting. *Software: Information Technology—Its New Meaning for Art,* a show at the Jewish Museum in 1970, explored the aesthetic potential of computer systems.[44] The issue of *Aspen* that appeared in 1970, edited by Dan Graham, was devoted to *Art/Information/Science.* Among the contributors were Robert Morris, Robert Smithson, Richard Serra, Dennis Oppenheim, and Ed Ruscha; composers Philip Glass, Steve

Reich, and LaMonte Young; and dancer Yvonne Rainer. This and other issues of *Aspen,* notably O'Doherty's *5+6* in 1967, in themselves could be considered works of Conceptual Art.

Claims were made that Conceptual Art was successfully incorporating other intellectual disciplines, becoming truly interdisciplinary, as it were. Lippard had her doubts. She wrote in 1972:

> Conceptual art has not . . . as yet broken down the real barriers between the art context and those external disciplines—social, scientific, and academic—from which it draws its sustenance (or claims to). [Interactions] between mathematics and art, philosophy and art, literature and art, politics and art, are still at a very primitive level.[45]

As agitation against the Vietnam War increased, artists began to deal more with political and social issues. For example, Kienholz conveyed ideas about art as a commodity and the art market. In a piece titled *Removal Transplant: New York Stock Exchange,* 1969, Oppenheim proposed to and did transport the debris from the floor of the exchange to another location, before throwing it away. Adrian Piper's work of 1970, which is a political gloss on Morris's *Document,* read:

> THE WORK ORIGINALLY INTENDED FOR THIS SPACE HAS BEEN WITHDRAWN. THE DECISION TO WITHDRAW HAS BEEN TAKEN AS A PROTECTIVE MEASURE AGAINST THE INCREASINGLY PERVASIVE CONDITIONS OF FEAR. RATHER THAN SUBMIT THE WORK TO THE DEADLY AND POISONING INFLUENCE OF THESE CONDITIONS, I SUBMIT ITS ABSENCE AS EVIDENCE OF THE INABILITY OF ART EXPRESSION TO HAVE MEANINGFUL EXISTENCE UNDER CONDITIONS OTHER THAN THOSE OF PEACE, EQUALITY, TRUTH, TRUST AND FREEDOM.[46]

In denying objects, Conceptual artists could not help denying the art market that existed to sell art objects, and the social system it was part of, which was held accountable for the war—and the issue was vehemently debated. A number of artists—e.g., Kosuth—thought of Conceptual

Art as anticommercial. They were opposed to galleries (although most of the innovators, including Kosuth, ended up in the more prestigious of them). In their opposition to the art market, they took sustenance, as Kosuth remarked, from "Reinhardt's life-long fight against . . . the commodification of art."[47]

But even without political considerations in mind, Conceptual Art led its creators and their associates to experiment with modes of presentation alternative to commercial galleries, such as artists' books and other printed matter.[48] Seth Siegelaub, a promoter of Conceptual Art, wrote: "Until 1967, the problems of exhibition of art were quite clear, because at that time the 'art' of art and the 'presentation' of art were coincident. When a painting was hung, all the necessary intrinsic art information was there. But gradually there developed an 'art' which didn't need to be hung." The problem was how *"to make someone else aware that an artist had done anything at all.* Because the work was not visual in nature, it did not require the traditional means of exhibition, but a means that would present the intrinsic ideas of the art." Therefore, it could use printed media, since these would not alter what it had to convey. "The use of catalogues and books to communicate (and disseminate) art is the most neutral means to present the new art. The catalogue can now act as primary information for the exhibition . . . and in some cases the 'exhibition' can be the 'catalogue.' "[49] With this in mind, Siegelaub and John Wendler produced *The Xerox Book,* 1968, in which Andre, Barry, Huebler, Kosuth, LeWitt, Morris, and Weiner were each given twenty-five pages with which to make a piece more or less utilizing the Xerox medium. In 1969, Siegelaub arranged a show of works by Barry, Huebler, Kosuth, and Weiner, which was held in a rented office containing a coffee table on which catalogues were placed and a few chairs, nothing more. The organization and installation of the show prompted

204. Robert Barry,
*One Billion Dots,*
1968.

Jack Burnham to write that Siegelaub was one of the best artists in it. The others he represented "are subcontracting to his prime contract as a data organizer."[50]

Douglas Huebler was among the early Conceptual artists. He had fabricated Minimal objects in the mid-sixties, but had then turned to Conceptual Art. His "show" in 1968 consisted of a catalogue only, containing pieces documented by maps. Other works aimed to "plug into" nonart systems in the real world, such as the United States Postal Service, "in such a way as to produce a work that possesses a separate existence and that neither changes nor comments on the system so used."[51] *Duration Piece* #9, for example, involved the mails for six weeks and covered some ten thousand miles. Huebler's typewritten proposal, presented as documentation, read:

> On January 9, 1969, a clear plastic box measuring 1″ × 1″ × 3/4″ was enclosed within a slightly larger cardboard container that was sent by registered mail to an address in Berkeley, California. Upon being returned as "undeliverable" it was left altogether intact and enclosed within another slightly larger container and sent again as registered mail to Riverton, Utah—and once more returned to the sender as undeliverable.
>
> Similarly another container enclosing all previous containers was sent to Ellsworth, Nebraska; similarly to Alpha, Iowa; similarly to Tuscola, Michigan; similarly and finally to Hull, Massachusetts, which accomplished the "marking" of a line joining the two coasts of the United States during a period of six weeks of time.
>
> That final encounter, all registered mail receipts, and a map join with this statement to form the system of documentation that completes this work. January 1969.

Huebler went on to say: "An inevitable destiny is set in motion by the specific process selected to form such a work freeing it from further decisions on my part."[52]

Lawrence Weiner stopped painting in 1968 and began to jot down proposals in a notebook, publishing twenty-four of them as "statements" in that year. He soon

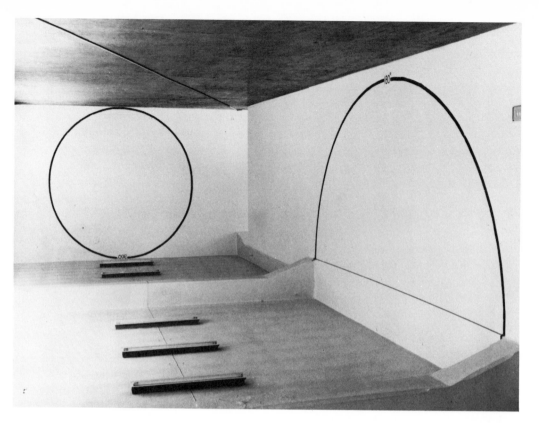

205. Mel Bochner, *Degrees*, 1969. Installation at Galleria Sperone, Turin, Italy, October 1970. Size determined by height of wall.

transferred his statements onto gallery and museum walls. In 1968, he made a proposal that relates to all his subsequent works; it reads: "1. The artist may construct the piece./2. The piece may be fabricated./3. The piece need not be built./ Each being equal and consistent with the intent of the artist, the decision as to condition rests with the received upon the occasion of receivership." In 1970, Weiner amplified this statement as follows: "As to construction, please remember that as stated above there is no correct way to construct the piece as there is no incorrect way to construct it. If the piece is built it constitutes not how the piece looks but only how it could look."[53]

The meaning of Weiner's words hovers between their being *things* on a wall and *comments* on art. But the information they provide is about the physical properties of things, the ways in which one can act upon materials. Thus Weiner's proposals are as factual as they are analytical.[54] However, as Eric Cameron remarked, the viewer might imagine Weiner's statements composed of materials other than language, but "the designation is on so general and fundamental a level that the reader is left not so much with the evocation of physical art structures as with an awareness of the subtlety of semantic distinctions."[55]

Robert Barry turned from painting to Conceptual Art around 1968. An early idea was to use invisible phenomena: electromagnetic waves, carrier waves of radio stations or citizen band transmitters, ultrasonic sound, microwaves, and radiation. Thus, in 1969 Barry released two cubic feet of inert helium gas into the atmosphere. He remarked: "There is something about void and emptiness which I am personally very concerned with. I guess I can't get it out of my system. Just emptiness. *Nothing* seems to me the most

potent thing in the world."[56] Because of the viewers' knowledge of Barry's concept—the invisible phenomena surrounding them, and their being in a seemingly empty space with nothing of interest to see—they became peculiarly aware of their roles as perceivers.

In 1968, Kosuth began to present his work in the form of purchased space in newspapers and periodicals, "with one 'work' sometimes taking up as many as five or six spaces in that many publications. . . . This way the immateriality of the work is stressed and any possible connections to painting are severed."[57] In other work, the best-known of which is a piece whose image is a chair, Kosuth juxtaposed real things, their printed dictionary definitions, and their photographs. The chair piece calls to mind Rauschenberg's *Pilgrim,* 1960, in which a stripe painted on a canvas is extended down over a chair placed against the painting, mixing or confusing painting, sculpture, and the actual thing. Kosuth appeared to want to unravel the Rauschenberg, focusing on the distinctions between diverse "languages."

In 1969, Mel Bochner showed *Measurements,* in which he measured the gallery space and marked the dimensions directly on the walls. This work was influenced by Duchamp's *Standard Stoppages* and Johns's paintings and Morris's lead reliefs employing ruling devices. But Bochner differed from Duchamp, Johns, and Morris in that he applied the idea of measurement to an art environment.

The work of European Conceptual artists in growing numbers was exhibited in New York toward the end of the sixties. The best-known of these was Hanne Darboven, whose works were based on counting. She wrote of her intention:

> A system became necessary: how else could I in a concentrated way find something of interest which lends itself to continuation? My systems are numerical concepts, which work in terms of progressions and/or reductions akin to musical themes with variations. . . .
>
> The most simple means of setting down my ideas and conceptions, numbers and words, are paper and pencil.
>
> I like the least pretentious and most humble means, for my ideas depend on themselves and not upon material; it is the very nature of ideas to be non-materialistic.
>
> Many variations exist in my work. There is consistent flexibility and changeability, evidencing the relentless flux of events.[58]

At first, Darboven's work seems utterly logical—one is followed by two, three, and so on—but it soon strikes one as irrational, the issue of a psychological need for some kind of rational activity to evade terror.

## NOTES

1. Sol LeWitt, "Paragraphs on Conceptual Art," *Artforum,* June 1967, p. 83.
2. Lucy R. Lippard, *Six Years: The Dematerialization of the Object* (New York: Praeger Publishers, 1973), p. 129.
3. Ibid., p. 5.
4. See Henry Flynt, "Essay: Concept Art (Provisional Version)," in LaMonte Young, ed., *An Anthology* (New York: La Monte Young and Jackson Maclow, 1963), n.p.
5. See David Bourdon, Jr., "An Interview with Ray Johnson," *Artforum,* September 1964, and William Wilson, "New York Correspondence School," *Art and Artists,* April 1966.
6. Lippard, *Six Years,* p. 27.
7. See Sol LeWitt, "Paragraphs on Conceptual Art," and "Sentences on Conceptual Art," *Art-Language* (England), May 1969.
8. LeWitt, "Paragraphs on Conceptual Art," p. 83.
9. Amy Goldin and Robert Kushner, "Conceptual Art as Opera," *Art News,* April 1970, p. 40.
10. LeWitt, "Paragraphs on Conceptual Art," p. 80.
11. Sol LeWitt, "Ziggurats," *Arts Magazine,* November 1966, p. 24.
12. Sol LeWitt, "Illustrations: Works by Sol LeWitt, 1962–1977, with His Commentaries," *Sol LeWitt,* exhibition catalogue (New York: Museum of Modern Art, 1978), p. 59.
13. Ibid., p. 62.
14. Ira Licht, *Sol LeWitt,* exhibition catalogue (The Hague: Gemeentemuseum, 1970), p. 30.
15. Lucy R. Lippard, "The Structures, the Struc-

tures and Wall Drawings, the Wall Drawings and the Books," *Sol LeWitt* (Museum of Modern Art), p. 23.

16. LeWitt, "Paragraphs on Conceptual Art," p. 80.
17. Lippard, "The Structures . . . ," p. 25.
18. Robert Rosenblum, "Notes on Sol LeWitt," *Sol LeWitt* (Museum of Modern Art), p. 16.
19. Lippard, "The Structures . . . ," p. 25.
20. Ibid., p. 28.
21. Ibid., p. 24.
22. Sol LeWitt, in "Documentation, Conceptual Art: Weiner, Buren, Bochner, LeWitt," *Arts Magazine,* April 1970, p. 45.
23. Bernice Rose, "Sol LeWitt and Drawing," *Sol LeWitt* (Museum of Modern Art), p. 31.
24. Lucy R. Lippard, "Sol LeWitt: Non-Visual Structures," *Artforum,* April 1967, p. 46.
25. Rosenblum, "Notes on Sol LeWitt," pp. 15–16, 20.
26. Lucy R. Lippard and John Chandler, "The Dematerialization of Art," *Art International,* February 1968, p. 31.
27. Lippard, *Six Years,* p. 111.
28. LeWitt, "Sentences on Conceptual Art," pp. 11–12.
29. Douglas Huebler, in *January 5–31, 1969,* exhibition catalogue (New York: Seth Siegelaub, 1969), n.p.
30. Lippard, *Six Years,* p. 179.
31. "Art Without Space," a symposium moderated by Seth Siegelaub, with Lawrence Weiner, Robert Barry, Douglas Huebler, and Joseph Kosuth, New York, WBAI-FM, 2 November 1969, in Lippard, *Six Years,* p. 127.
32. LeWitt, "Sentences on Conceptual Art," p. 12.
33. Lippard, *Six Years,* p. 188.
34. Goldin and Kushner, "Conceptual Art as Opera," p. 43.
35. Max Kozloff, "The Role of Criticism," *Theory and Criticism* 1 (October 1979): 35.
36. Joseph Kosuth, "Art After Philosophy," *Studio International,* October 1969, p. 135.
37. Joseph Kosuth, "Joseph Kosuth on Ad Reinhardt," *Cover,* Spring–Summer 1980, p. 10.
38. Kosuth, "Art After Philosophy," p. 135. The antipathy of conceptually minded artists to formalist criticism was exemplified by John Latham in 1966 in an event that involved taking out Clement Greenberg's *Art and Culture* from the library of St. Martin's School of Art (a formalist bastion) in London, having the pages chewed and further dematerialized—or neutralized—and then returning the book in the form of a glass container of the distilled matter. (Latham, a part-time instructor at St. Martin's, was not invited back to teach.)
39. Joseph Kosuth, "Introductory Notes by the American Editor," *Art-Language* (England) 2 (February 1970): 2–3.

40. Arthur Rose, "Four Interviews with Barry, Huebler, Kosuth and Weiner," *Arts Magazine,* February 1969, p. 23.
41. Allan Kaprow, "Doctor MD," in Anne d'Harnoncourt and Kynaston McShine, eds., *Marcel Duchamp,* exhibition catalogue (New York: Museum of Modern Art, 1973), p. 204.
42. LeWitt, "Sentences on Conceptual Art," p. 13.
43. Rose, "Sol LeWitt and Drawing," p. 35.
44. *Software* was curated by Jack Burnham. It included Vito Acconci, Eleanor Antin, John Baldessari, Robert Barry, Hans Haacke, Douglas Huebler, Joseph Kosuth, Les Levine, and Lawrence Weiner.
45. Lippard, *Six Years,* p. 263.
46. Ibid., p. 168.
47. Kosuth, "Joseph Kosuth on Ad Reinhardt," p. 10.
48. Artists' books were also anticipated by Ed Ruscha's *Twenty-six Gasoline Stations,* 1962; *Various Small Fires,* 1964; *Some Los Angeles Apartments,* 1965; and *Every Building on Sunset Strip,* 1966.
49. Seth Siegelaub, in conversation with Charles Harrison, "On Exhibitions and the World at Large," *Studio International,* December 1969, p. 202.
50. Jack Burnham, "Real Time Systems," *Artforum,* September 1969, p. 54.

    Lucy Lippard set her home up as a kind of information center and command post of Conceptual Art. In 1969, she organized a show titled *557,087* in Seattle. Peter Plagens in "557,087," *Artforum,* November 1969, p. 67, commented about her role: "Lippard is in fact the artist and . . . her medium is other artists." Lippard herself, in *Six Years,* p. 189, insisted she was a writer, not an artist.
51. Douglas Huebler, in *When Attitudes Become Form:Works-Concepts-Processes-Situations,* exhibition catalogue (Bern, Switzerland: Kunsthalle, 1969), sec. H.
52. Ibid.
53. Lawrence Weiner, in *January 5–31, 1969,* n.p.
54. See Susan Heinemann, "Lawrence Weiner: Given the Context," *Artforum,* March 1975.
55. Eric Cameron, "Lawrence Weiner: The Books," *Studio International,* January 1974, p. 5.
56. Robert Barry, in a symposium, Bradford Junior College, Bradford, Mass., 8 February 1968, with Carl Andre, Lawrence Weiner, and Seth Siegelaub, in Lippard, *Six Years,* p. 40.
57. Rose, "Four Interviews with Barry, Huebler, Kosuth and Weiner," p. 23.
58. Hanne Darboven, in *Art International,* 20 April 1968, p. 55.

# 16 EPILOGUE: 1970—THE DEATH OF THE AVANT-GARDE

The sixties ended on the evening of 2 July 1970, with the opening of *Information* at the Museum of Modern Art, an event that marked the establishment of Conceptual Art. At its most extreme, Conceptual Art seemed as extreme as art could become, because, as I wrote at the time, it "eliminated what may be irreducible conventions in art—the requirements that it be an object and visible."[1] Thus it heralded the demise of the avant-garde in that the conception of a vanguard ceased to be believable in the art world.

In retrospect, it appears that the urge to make it new—the central requirement of avant-gardism—was the slogan of sixties artists and the art world, and the tempo of stylistic change would seem to confirm this. The art world was quick to recognize radical new art, beginning with the Minimalist painting of Stella in 1960; Pop Art in 1962; stained color-field and hard-edge abstraction in 1963; Op Art in 1965; Minimal sculpture in 1966; Process Art in 1968; Earth Art and Conceptual Art in 1969–70. In 1970, it all looked acceptable, and there was nothing radically new on the horizon. That is not to say that former avant-garde artists no longer made compelling art of high quality. On the contrary, much of the best was yet to come. But avant-gardist claims for their work ceased to be convincing and thus were outdated.

The beginning of the end of the decade might be dated from 1967, because by then the premises of Minimal Art had become *familiar,* and new tendencies—Process Art, Earth Art, and Conceptual Art—had begun to emerge. I have called the latter late-Minimal rather than post-Minimal, because Minimal Art remained the aesthetic context of late-Minimalism, whereas post-Minimalism aimed to cut its throat. The situation of avant-garde art in 1967 was best summed up in *Artforum*'s "Special Issue on American Sculpture," which appeared in the summer of 1967. At that moment, its editor, Philip Leider, had his finger right on the pulse of the most provocative art in the United States and its issues, and he attracted many of the liveliest writers to deal with it: artists Morris, Smithson, and LeWitt, and critics Fried, Rose, and Kozloff, among others. Leider himself introduced the issue with a critical article on Maurice Tuchman's *American Sculpture of the Sixties,* which was *the* show of the year.

The basic premises of Minimal sculpture were recapitulated by Morris in the Special Issue. His text was accompanied by reproductions of his own work and that of Judd, Flavin, Andre, LeWitt, Larry Bell, and John McCracken. By 1967, their work had eclipsed the formalist welded metal construction of Caro and his followers. But construction-sculpture continued to be very much admired for its quality in avant-garde art circles, and Leider featured it in articles on David Smith and Mark di Suvero.

It was in the Special Issue, in "Art and

Objecthood," that Fried took up the standard of formalist art and declared war on Minimal Art.[2] Formalism did not win its war against Minimalism. Neither did it lose. By 1967, both had won; they had become established. But it was literalism in art that continued to engage the most interesting of emerging artists. At the same time, they were doubtful that Minimal sculpture could be extended in fresh ways. Indeed, it was natural, in a decade in which make-it-new was a cardinal value, for a reaction to have set in.

In 1966, Lucy Lippard, an advocate of Minimal sculpture, had organized *Eccentric Abstraction,* a show whose central artists, notably Hesse, retained Minimalism's rational structure and literalist treatment of new, often soft materials, while giving rein to Surrealist or Expressionist impulses. The *Artforum* Special Issue did not feature any of Lippard's Eccentric Abstractionists, but Leider, responding to the same aesthetic stimuli as Lippard, had published Rose's article on Oldenburg's extravagant soft sculptures of common objects, which Lippard had claimed as the primary influence on Eccentric Abstraction. *Artforum* also dealt with Eccentric Abstraction's San Francisco counterpart, Funk Art. It is noteworthy that in 1967, Morris's work took a late-Minimal eccentric or funky turn—in a series of cut-felt Process pieces—and that Serra began to write a long list of verbs of action, a number of which he would soon execute, as in his spatter pieces, prop pieces, and scatter pieces. Process art would lead to filling interior spaces with a variety of substances, often inchoate—for example, earth. From these indoor environments it was but a short step outside, into nature, into Earth Art.

Smithson, who emerged as a formidable polemicist in 1967, wrote a letter to *Artforum* rebutting Fried's "Art and Objecthood." In an article on a site-specific project in the Special Issue, titled "Toward the Development of an Air Terminal Site," Smithson concluded prophetically

that site-specific Earth Art was just beginning.[3]

Process Art and Earth Art involved a kind of dematerialization of the object, the one into undifferentiated matter, the other, into landscape. Conceptual Art was another kind of dematerialization. The seminal statement, "Paragraphs on Conceptual Art," by LeWitt, appeared in the Special Issue. It is fitting that this article should have been written by a sculptor closely identified with Minimal sculpture, which, in its late-Minimal form, is a dematerialization of the primary structure, taking it back to the original idea that generated it, and presenting the idea itself—that is, in verbal form—as an art work. Abetting this development was Duchamp's thinking, which would soon become a major inspiration to Conceptual artists.

If, during the first two thirds of the sixties, the avant-garde was preoccupied with the object, with attaining *objecthood,* then during the final third, the avant-garde seemed equally intent on the opposite of objecthood, *dematerialization.* In dialectical terms, thesis gave rise to antithesis, except that underlying both was the concern with literalness. The dematerialization of the art object in Process Art, Earth Art, and Conceptual Art seems to have been hastened by the changing political situation in 1968. The intensification of the Vietnam War politicized artists and caused them to reject commercialism and the art-world institutions that fostered it; indeed, it appeared as if growing numbers of artists aspired to create unsalable art. Inadvertently symbolic of this attitude was the attempted murder of Warhol, the exemplary Business Artist, in 1968 (and it is symbolic, again inadvertently, that the attempt failed).

In opening up to Surrealism and Expressionism, Eccentric Abstraction and Funk Art eased the way for recognition of sixties mavericks, among them Lucas Samaras and H. C. Westermann. Process Art, Earth

Art, and Conceptual Art also opened up new possibilities for art—new forms, materials, venues, and, above all, content. Indeed, art became increasingly pluralistic. The Special Issue of *Artforum* reflected this new pluralism by including articles on George Segal and the realist sculptor Richard A. Miller; had the issue been on painting, it probably would have marked the emergence of Alex Katz and Philip Pearlstein. The year 1967 also saw a general tendency toward complexity in nonobjective art, exemplified in the work of Held and Stella. In fact, in 1967, Held's painting underwent a radical change: having verged to the edge of monochromatic color-field abstraction in *The Big N*, 1965, Held soon reversed ground and in a series of black-and-white abstractions, ventured toward complexity. So did Stella's work toward the end of the sixties. Indeed, his retrospective at the Museum of Modern Art can be viewed as closing off the sixties in much the same way that his black-stripe paintings in *Sixteen Americans* opened it.

The supporters of a new pluralism logically rejected the avant-gardist claim that a succession of either formalist or literalist styles constituted *the* mainstream in modern art, a claim widely accepted in the art world. The pluralists questioned whether a mainstream had ever existed and asserted that if it had, then it had run out or turned into a delta, and the delta image was dear to pluralists.

By 1969, even before *Information*, a number of art professionals had remarked on the death of the avant-garde. For example, I wrote that the modernist enterprise of pressing to the limits could no longer be considered avant-garde because it had "become established as a tradition."

A limit in art is reached when an artist's work comes as close as possible to being non-art. This art does not go over the boundary because artists, critics, historians, museum curators and a sizable segment of the art-conscious audience treat every artist's work as art. Even dada objects . . . which were

meant not only to be non-art but anti-art, have been elevated into art.

I then indicated the extremes jumped to by contemporary artists, and concluded:

In the last two or three years, a number of artists have systematically demolished every notion of what art should be—to the extent that [they] merely think up ideas that need not result in anything visible.

The avant-garde has ceased to exist, not only because so many limits of art have been reached, but because there now exists a large and growing public that no longer responds in anger to the novel, and when not eager for it is at least permissive. Elitists may question the motives of the mass audience for art and the quality of its esthetic experiences—but not its sympathy.

Indeed, the *success* of the avant-garde called its existence into question; historically, a successful avant-garde was a contradiction in terms. I went on to say: "The demise of the avant-garde has prompted many who continue to yearn for new frontiers [to proclaim] that painting and sculpture are dead," and added: "This attitude cannot be accepted by those who *need* art objects, who live in varying degrees through them."

I then anticipated the course of art in the seventies by predicting that

the audience for paintings and sculpture may have to change some of its expectations. It may have to stop considering novelty in art a primary value. Rather it may have to attach greater importance to the quality of works of art and to the expressiveness and uniqueness with which artists mix visual ideas. The possibilities in art today are endless. There are areas of vast potential— scarcely trod by those artists who have jumped to extremes—that require fuller exploration. The audience for art objects may also have to become open as never before to multiple tendencies in art.[4]

The art world learned that painting and sculpture in all their variety were alive— and as healthy as they ever had been.

The seventies were to become the Pluralist Decade—and the opening of the

Post-Modernist era. "Pluralism" defines an art situation in which a variety of tendencies—ranging from realism to nonobjective art, from painterly painting to hard-edge—vied for art-world attention on more or less equal terms. To be sure, at different moments, different tendencies did take the limelight, but only for a short period and not under too bright a glare. The critical issue was what was good, bad, or in between *within* each tendency, and that was more a matter of personal taste than an issue to debate. This made the polemics amorphous and flat. Indeed, the very notion of pluralism involved a flattening out of art. And to many, the art itself seemed flat at the time, if it seems less so in retrospect.

But toward the end of the seventies, it appeared that a primary bias in the art of the decade had been *anti*-Minimalist—and if Minimalism was considered the latest stage of Modernism, *anti*-Modernist. Post-Modernism had emerged. The introduction of a conception of Post-Modernism sharpened polemics because it could be opposed dialectically to Modernism. The arguments became more focused and provocative. Art discourse livened and hotted up. Moreover, Post-Modernism seemed more consequential, because it connected with the most provocative controversy in architecture, namely the Post-Modernist assault on the International Style, which because of its modularity and lack of ornamentation seemed related to Minimal Art.

At first the label Post-Modernism characterized a sensibility rather than a style or a complex of styles. It was viewed as having rejected Modernism's purity and having instead welcomed impurity. Joyce Kozloff once listed 112 anti-Modernist words, in a polemic titled "Negating the Negative (An Answer to Ad Reinhardt's 'On Negation')." Among them are: anti-purist, anti-puritanical, anti-Minimalist, anti-reductivist, anti-formalist, anti-austere, anti-bare, anti-boring, anti-empty, anti-flat, anti-clean, anti-machine-made, anti-bauhausist, anti-mainstreamist, anti-systemic, anti-cool, anti-absolutist, anti-dogmatic, anti-exclusivist, anti-programmatic, anti-dehumanized, anti-detached, anti-grandiose, anti-pedantic, and anti-heroic. Kozloff affirmed

> additive, subjective, romantic, imaginative, personal, autobiographical, whimsical, narrative, decorative, lyrical . . . primitive, eccentric, local, specific, spontaneous, irrational, private, impulsive, gestural, handwritten, handmade, colorful, joyful, obsessive, fussy, funny, funky, vulgar, perverse, mannerist, tribal, rococo . . . self-referring, sumptuous, salacious, eclectic, exotic, messy, monstrous, complex, ornamental . . . delicate, warm.[5]

What Kozloff's negations add up to are the negation of anti-anthropomorphism. The sum of her affirmations is humanism. Kozloff's thinking was inspired in part by her feminism. In fact, the role of feminism—it emerged in the art world around 1969—in the development of Post-Modernism was critical. Consciousness raising played a vital role in the evolution of an introspective, personalist, antiformalist art, as did the effective proselytizing of feminist art critics, such as Lucy Lippard.

Self-scrutiny, self-revelation, and self-realization were central concerns of Post-Minimal art—and by extension of Post-Modernist art (although claims for the exact opposite have been made). Anticipating the self-concern in seventies art was Morris's *I Box*, 1962, which contained a frontal naked self-photograph (nakedness a metaphor for true self-revelation). In *Autobiography*, 1968, Rauschenberg incorporated his astrological chart, an X-ray of his skeleton, a lettered minibiography, and a costumed self-image winged as a contemporary Icarus or Superman. This combination of a variety of self-conceptions—occult, physiological, historical, fantasized, mythical, and visionary—anticipated much of seventies self-imagery. Also anticipating seventies self-imagery were Oldenburg and Dine, who made objects into surrogates of self (things re-

garded as people)—the ray gun in the case of Oldenburg, the bathrobe in the case of Dine. Also, sixties Performance artists, including Minimal Performers whose events became increasingly less minimal, showed the way to the new auto-imagery. It was a short step from the physiological to the psychological. After all, as Ira Licht put it: "Bodywork is primarily personal and private. Its content is autobiographical and the body is used as the very body of a particular person rather than as an abstract entity or in a role."[6] The issues for self-searching artists became, as Peter Frank defined them: "Who one is, how one got to be that way, what one is capable of, what one needs and desires, how one responds to experience—all become the subject matter for art."[7]

Indeed, the auto-imagism of the seventies possessed an introspection and privacy often lacking in the art of the sixties, a humanness which prompts one to look for the man or woman. Yet this diaristic tendency had a broader social role, even if many of the artists were not aware of it. It was part of a widespread concern with individual human potential and its development, furthered by the thinking of Norman O. Brown, R. D. Laing, and Erving Goffman; by feminist studies; and by a new literature on therapeutic and meditative theories and practices. There was much in the human potential movement that was faddist and self-indulgent, but much of it was genuinely self-revealing.

Post-Modernist art criticism was identified by its antiformalism, its introduction of social, psychological, autobiographical, iconographic, and other extra-aesthetic issues. It spurned Greenberg's no-nos for art critics. In an article titled "How Art Writing Earns Its Bad Name," Greenberg attacked "perversions and abortions of discourse: pseudo-description, pseudo-narrative, pseudo-exposition, pseudo-history, pseudo-psychology, and—worst of all—pseudo-poetry (which represents the abortion, not of discourse but of intuition and imagination)."[8] The ambition of Post-Modernist critics was to be more than pseudo in the disciplines Greenberg mentioned, among others, and to connect these disciplines, particularly social studies and psychology, meaningfully to art, because they could best illuminate the art.

As Kim Levin summed it up,

> all the words that had been hurled as insults for as long as we could remember—illusionistic, theatrical, decorative, literary—were resurrected as art became once again ornamental or moral, grandiose or miniaturized, anthropological, archeological, ecological, autobiographical or fictional. It was defying all the proscriptions of modernist purity. The mainstream trickled on, minimizing and conceptualizing itself into oblivion, but we were finally bored with all that arctic purity.[9]

However, I do not believe that Modernism is a passing fashion but has become rooted in our being and will continue to exert pressure on artists for some time to come. So will anti-anthropomorphism—and its counterimpulse, the exemplification of which is the auto-imagism that emerged in the succeeding decade. Indeed, it is inevitable. In our time, every vision of an ideal society or a perfectible human being has failed. In the absence of any believable system of ideal values, artists can rely only on their own experiences. Perhaps, in time, a new public vision will emerge, one leading to a society that does not stifle but advances personal growth and fulfillment. Until that happens, and perhaps as a precondition, artists will look to themselves for meaning, and if they are sufficiently honest, contemporary, and creative, they may discover and reveal the reality of their being, and in the process make us aware of our own being—that is, they may transform the subjective into the intrasubjective.

Not only did Modernism end in 1970, but so did the New York School—that is, as *the* fountainhead of major art, the towering presence in international art that need only concern itself with itself. With Process Art, Earth Art, Performance Art, and

Conceptual Art, art became national and international. This was established in 1974, when instead of mounting an "Americans" show, the Museum of Modern Art presented *Eight Contemporary Artists,* only three of whom were American. To be sure, New York City remained the major center, but it could no longer be considered believably the only center. In Europe there emerged a growing number of potentially major artists on a par with their generational counterparts in New York; internationally minded dealers who represented them and demanded and received quid pro quo from their American colleagues; and venturesome and self-confident museum directors and curators, who validated not only European artists but often American artists in anticipation of American museums. What happened was the emergence of an international art scene of which New York was only a part—the major part but still only a part.

## NOTES

1. Irving Sandler, introduction, *Critic's Choice 1969–70,* exhibition catalogue (New York: New York State Council on the Arts and the State University of New York, 1969), n.p.
2. Michael Fried, "Art and Objecthood," *Artforum,* Summer 1967, p. 20.
3. Robert Smithson, "Toward the Development of an Air Terminal Site," *Artforum,* Summer 1967, pp. 38, 40.
4. Sandler, *Critic's Choice 1969–70.*
5. Joyce Kozloff, "Negating the Negative (An Answer to Ad Reinhardt's 'On Negation')," mimeographed typescript published by the Alessandra Gallery for its show *Ten Approaches to the Decorative,* 1976, n.p.

    Robert Venturi, in *Complexity and Contradiction in Modern Architecture* (New York: Museum of Modern Art, 1966), p. 16, wrote:

    I like elements which are hybrid rather than "pure," compromising rather than "clean," distorted rather than "straightforward," ambiguous rather than "articulated," perverse as well as impersonal . . . inconsistent and equivocal rather than direct and clear. I am for messy vitality over obvious unity. . . .

    I am for richness of meaning rather than clarity of meaning. . . . I prefer "both/and" to "either/or."
6. Ira Licht, "Bodyworks," in *Bodyworks,* exhibition catalogue (Chicago: Museum of Contemporary Art, 1975), n.p.
7. Peter Frank, "Auto-art: Self-Indulgent? And How!" *Art News,* September 1976, p. 43.
8. Clement Greenberg, "Art: How Art Writing Earns Its Bad Name," *Encounter,* December 1962, pp. 70–71.
9. Kim Levin, "Farewell to Modernism," *Arts Magazine,* October 1979, p. 90.

# BIBLIOGRAPHY

After the section of General References, bibliographical entries, under their respective headings, are given in the following order: books, exhibition catalogues, articles.

## GENERAL REFERENCES

### BOOKS

ALLOWAY, LAWRENCE. *Topics in American Art Since 1945* (New York: W.W. Norton, 1975).

———. *The Venice Biennale, 1895–1968* (London: Faber and Faber, 1969).

ANDERSEN, WAYNE. *American Sculpture in Progress: 1930–1970* (Boston: New York Graphic Society, 1975).

ARNASON, H.H. *History of Modern Art: Painting, Sculpture, Architecture* (New York: Harry N. Abrams, 1968).

*Art Criticism in the Sixties* (New York: October House, 1967). Texts by Michael Fried, Max Kozloff, Barbara Rose, and Sidney Tillim; introduction by William C. Seitz.

Art Workers Coalition. *Documents 1* (New York: Art Workers Coalition, 1969).

———. *Open Hearing* (New York: Art Workers Coalition, 1969).

ASHTON, DORE. "From the 1960s to the Present Day," in John Wilmerding, ed., *The Genius of American Painting* (London: Weidenfeld and Nicolson, 1973).

———. *Modern American Sculpture* (New York: Harry N. Abrams, 1968).

———. *The New York School: A Cultural Reckoning* (New York: Viking, 1973).

———. *A Reading of Modern Art* (Cleveland: Case Western Reserve University Press, 1969).

———. *The Unknown Shore: A View of Contemporary Art* (Boston: Little, Brown, 1962).

BAIGELL, MATTHEW. *A Concise History of American Painting and Sculpture* (New York: Harper & Row, 1984).

BANN, STEPHEN, ed. *Concrete Poetry: An International Anthology* (London: London Magazine Editions, 1967).

BATTCOCK, GREGORY, ed. *The New Art* (New York: E.P. Dutton, 1973).

BELFORD, MARILYN, and JERRY HERMAN. *Time and Space Concepts in Art* (New York: Pleiades Gallery, 1980).

BURNHAM, JACK. *Beyond Modern Sculpture: The Effects of Science and Technology on the Sculpture of This Century* (New York: George Braziller, 1968).

———. *The Structure of Art* (New York: George Braziller, 1970).

BURNHAM, SOPHY. *The Art Crowd* (New York: David McKay, 1973).

BUTLER, CHRISTOPHER. *After the Wake: An Essay on the Contemporary Avant-Garde* (Oxford, England: Clarendon, 1980).

CAGE, JOHN. *Silence: Lectures and Writings* (Cambridge, Mass.: M.I.T. Press, 1967).

———. *A Year from Monday* (Middletown, Conn.: Wesleyan University Press, 1969).

CALAS, NICOLAS. *Art in the Age of Risk and Other Essays* (New York: E.P. Dutton, 1968).

CALAS, NICOLAS and ELENA. *Icons and Images of the Sixties* (New York: E.P. Dutton, 1971).

CASTLEMAN, RIVA. *Modern Art in Prints* (New York: Museum of Modern Art, 1973).

CELANT, GERMANO. *Arte Povera* (New York: Praeger, 1969).

CHASSMAN, NEIL A., ed. *Poets of the Cities New York and San Francisco, 1950–1965* (New York: E.P. Dutton, 1974).

CUMMINGS, PAUL. *Artists in Their Own Words: Interviews by Paul Cummings* (New York: St. Martin's, 1979).

D'HARNONCOURT, ANNE, and KYNASTON MCSHINE, eds. *Marcel Duchamp* (New York: Museum of Modern Art, 1973).

DIAMONSTEIN, BARBARALEE. *Inside New York's Art World* (New York: Rizzoli, 1979).

DICKSTEIN, MORRIS. *Gates of Eden: American Culture in the Sixties* (New York: Basic Books, 1977).

GABLIK, SUZI. *Progress in Art* (New York: Rizzoli, 1976).

GELDZAHLER, HENRY. *American Painting in the Twentieth Century* (New York: Metropolitan Museum of Art, 1965).

GOLDBERG, ROSALEE. *Performance: Live Art, 1909 to the Present* (New York: Harry N. Abrams, 1979).

GOTTLIEB, CARLA. *Beyond Modern Art* (New York: E.P. Dutton, 1976).

GREENBERG, CLEMENT. *Art and Culture: Critical Essays* (Boston: Beacon, 1961).

———. "Avant-Garde Attitudes: New Art in the Sixties," in Bernard Smith, ed., *Concerning Contemporary Art: The Power Lectures* (Oxford, England: Clarendon, 1975).

GRUEN, JOHN. *The New Bohemia: The Combine Generation* (New York: Grosset & Dunlap, 1967).

HENRI, ADRIAN. *Total Art: Environments, Happenings, and Performance* (New York: Praeger, 1974).

HANSEN, AL. *A Primer of Happenings and Time/Space Art* (New York: Something Else, 1965).

HERBERT, ROBERT L., ed. *Modern Artists on Art* (Englewood Cliffs, N.J.: Prentice-Hall, 1964).

HUGHES, ROBERT. *The Shock of the New* (New York: Knopf, 1981).

HUNTER, SAM. *American Art of the 20th Century* (New York: Harry N. Abrams, 1974).

JANIS, HARRIET, and RUDI BLESH. *Collage: Personalities, Concepts, Techniques* (Philadelphia: Chilton, 1962).

JOHNSON, ELLEN H. *American Artists on Art from 1940 to 1980* (New York: Harper & Row, 1982).

———. *Modern Art and the Object: A Century of Changing Attitudes* (New York: Harper & Row, 1976).

KAPROW, ALLAN. *Assemblage, Environments & Happenings* (New York: Harry N. Abrams, 1966).

KEPES, GYORGY, ed. *Arts of the Environment* (New York: George Braziller, 1972).

KIRBY, MICHAEL. *The Art of Time: Essays*

*on the Avant-Garde* (New York: E.P. Dutton, 1969).

———. *Happenings: An Illustrated Anthology* (New York: E.P. Dutton, 1966).

KLÜVER, BILLY, JULIE MARTIN, and BARBARA ROSE, eds. *Pavillion by Experiments in Art and Technology* (New York: E.P. Dutton, 1972).

KOSTELANETZ, RICHARD, ed. *The New American Arts* (New York: Collier Books, 1976).

———. *The Theatre of Mixed Means* (New York: Dial, 1968).

KOZLOFF, MAX. *Renderings: Critical Essays on a Century of Modern Art* (New York: Simon & Schuster, 1968).

KRAMER, HILTON. *The Age of the Avant-Garde: An Art Chronicle of 1956–1971* (New York: Farrar, Straus & Giroux, 1973).

KRAUSS, ROSALIND E. *The Originality of the Avant-Garde and Other Modernist Myths* (Cambridge, Mass.: M.I.T. Press, 1985).

———. *Passages in Modern Sculpture* (New York: Viking, 1977).

KUBLER, GEORGE. *The Shape of Time* (New Haven, Conn.: Yale University Press, 1962).

KULTERMANN, UDO. *Art and Life* (New York: Praeger, 1971).

———. *The New Painting* (New York: Praeger, 1969).

———. *New Realism* (Greenwich, Conn.: New York Graphic Society, 1972).

———. *The New Sculpture, Environments and Assemblages* (New York: Praeger, 1968).

LIPMAN, JEAN, et al. *The Collector in America* (New York: Viking, 1971).

LIPPARD, LUCY R. *Ad Reinhardt* (New York: Harry N. Abrams, 1981).

———. *Changing: Essays in Art Criticism* (New York: E.P. Dutton, 1971).

———. *Overlay: Contemporary Art and the Art of Prehistory* (New York: Pantheon Books, 1983).

LUCIE-SMITH, EDWARD. *Art Now: From Abstract Expressionism to Superrealism* (New York: William Morrow, 1970).

———. *Movements in Art Since 1945* (London: Thames and Hudson, 1969).

MCCOUBREY, JOHN W. *American Painting, 1900–1970* (New York: Time-Life, 1970).

MCLUHAN, MARSHALL, and QUENTIN FIORE. *The Medium Is the Message* (New York: Bantam Books, 1967).

———. *Understanding Media: The Extensions of Man* (New York: McGraw-Hill, 1964).

MASHECK, JOSEPH, ed. *Marcel Duchamp in Perspective* (Englewood Cliffs, N.J.: A Spectrum Book, 1975).

*Metro International Directory of Contemporary Art, 1964* (Milan: Editorial Metro, 1964).

MEYER, URSULA, and AL BRUNELLE. *Art–Anti-Art* (New York: E.P. Dutton, 1970).

MOORE, ETHEL, ed. *Contemporary Art, 1942–72: Collection of the Albright-Knox Art Gallery* (New York: Praeger, 1973). Texts by Lawrence Alloway, Edward F. Fry, Henry Geldzahler, R.W.D. Oxenaar, George Rickey, John Russell, Irving Sandler, and Jan van der Marck.

MÜLLER, GREGOIRE. *The New Avant-Garde: Issues of the Seventies* (New York: Praeger, 1972).

MUNRO, ELEANOR. *Originals: American Women Artists* (New York: Simon and Schuster, 1979).

NAIFEH, STEVEN W. *Culture Making: Money, Success, and the New York Art World* (Princeton, N.J.: Princeton University Press, 1966).

NEMSER, CINDY. *Art Talk: Conversations with 12 Women Artists* (New York: Scribner's, 1975).

O'DOHERTY, BRIAN. *American Masters* (New York: Random House, 1973).

———. *Object and Idea: An Art Critic's Journal, 1961–1967* (New York: Simon and Schuster).

O'HARA, FRANK. *Art Chronicles: 1954–1966* (New York: George Braziller, 1975).

O'NEILL, WILLIAM L. *Coming Apart: An Informal History of America in the 1960's* (New York: Quadrangle Books, 1977).

PELLIGRINI, ALDO. *New Tendencies in Art* (New York: Crown, 1966).

PINCUS-WITTEN, ROBERT. *Post-Minimalism* (New York: Out of London, 1977).

PLAGENS, PETER. *Sunshine Muse: Contemporary Art on the West Coast* (New York: Praeger, 1974).

POPPER, FRANK. *Art-Action and Participation* (New York: New York University Press, 1975).

QUINN, EDWARD, and PAUL J. DOLAN, eds. *The Sense of the Sixties* (New York: Free Press, 1968).

RAINER, YVONNE. *Works, 1961–73* (New York: New York University Press, 1974).

ROBINS, CORINNE. *The Pluralist Era: American Art, 1968–1981* (New York: Harper & Row, 1984).

ROSE, BARBARA. *American Art Since 1900: A Critical History* (New York: Praeger, 1967).

———. *Readings in American Art Since 1900: A Documentary Survey* (New York: Praeger, 1968).

ROSENBERG, HAROLD. *The Anxious Object: Art Today and Its Audience* (New York: Horizon, 1966).

———. *Artworks and Packages* (New York: Horizon, 1969).

———. *The De-Definition of Art: Action Art to Pop to Earthworks* (New York: Horizon, 1972).

———. *Discovering the Present: Three Decades in Art, Culture, and Politics* (Chicago: University of Chicago Press, 1973).

SANDLER, IRVING. *The New York School: The Painters and Sculptors of the Fifties* (New York: Harper & Row, 1978).

———. *The Triumph of American Painting: A History of Abstract Expressionism* (New York: Harper & Row, 1970).

SCHARF, AARON. *Art and Photography* (Baltimore, Md. Penguin Books, 1974).

SCHULZE, FRANZ. *Fantastic Images: Chicago Art Since 1945* (Chicago: Follett, 1972).

SOLOMON, ALAN R. *New York: The New Art Scene* (New York: Holt, Rinehart, Winston, 1967). Photographs by Ugo Mulas.

SONTAG, SUSAN. *Against Interpretation* (New York: Delta/Dell, 1967).

STEINBERG, LEO. *Other Criteria: Confrontations with Twentieth-Century Art* (New York: Oxford University Press, 1972).

TOMKINS, CALVIN. *The Bride and the Bachelors* (New York: Viking, 1965).

———. *The Scene: Reports on Post-Modern Art* (New York: Viking, 1976).

———. *The World of Marcel Duchamp* (New York: Time-Life, 1966).

TUCHMAN, MAURICE, ed. *Validating Modern Art: The Impact of Museums upon Modern Art History* (Los Angeles: Los Angeles County Museum, 1975).

VENTURI, ROBERT. *Complexity and Contradiction in Architecture* (New York: Museum of Modern Art, 1966).

VIVA. *Superstar* (London: Anthony Blond, 1971).

WALKER, JOHN A. *Art Since Pop* (London: Thames and Hudson, 1975).

WILLIAMS, EMMETT, ed. *An Anthology of Concrete Poetry* (New York: Something Else, 1967).

WOLFE, TOM. *The New Journalism*, with an anthology edited by Tom Wolfe and E.W. Johnson (London: Picador, 1975).

———. *The Pump House Gang* (New York: Bantam Books, 1968).

———. *Radical Chic & Mau-Mauing the Flak Catchers* (London: Michael Joseph, 1971).

## EXHIBITION CATALOGUES

BOSTON. Boston University School of Fine and Applied Arts. *American Artists of the Nineteen Sixties*, 1970. Text by H.H. Arnason.

BUFFALO. Albright-Knox Art Gallery. *Modular Paintings*, 1970. Text by Robert Murdock.

CHICAGO. Museum of Contemporary Art. *A View of a Decade: 1966–1976/Ten Years*, 1977. Texts by Martin Friedman, Peter Gay, and Robert Pincus-Witten.

IRVINE. University of California. *The Second Breakthrough: 1959–1964*, 1969. Text by Alan Solomon.

LOS ANGELES. Los Angeles County Museum of Art. *American Sculpture of the Sixties*, 1967. Texts by Maurice Tuchman, Lawrence Alloway, Wayne Andersen, Dore Ashton, John Coplans, Clement Greenberg, Max Kozloff, Lucy Lippard, James Monte, Barbara Rose, and Irving Sandler.

MINNEAPOLIS. Walker Art Center. *Eight Sculptors: The Ambiguous Image*, 1966. Texts by Martin Friedman and Jan van der Marck.

———. *Fourteen Sculptors: The Industrial Edge*, 1969. Texts by Barbara Rose, Christopher Finch, and Martin L. Friedman.

MILWAUKEE. Milwaukee Art Center. *Emergence & Progression: Six Contemporary American Artists*, 1979. Text by Michael Danoff.

———. *A Plastic Presence*, 1970. Text by Tracy Atkinson.

NEW YORK. Jewish Museum. *The Harry N. Abrams Family Collection*, 1966. Text by Sam Hunter.

———. *Toward A New Abstraction*, 1963. Texts by Ben Heller, Dore Ashton, Herman Cherry, Michael Fried, Henry Geldzahler, Robert Rosenblum, Irving Sandler, Alan R. Solomon, Leo Steinberg, and Ulfert Wilke.

NEW YORK. Metropolitan Museum of Art. *New York Painting and Sculpture: 1940–1970*, 1969. Texts by Henry Geldzahler, Michael Fried, Clement Greenberg, Harold Rosenberg, Robert Rosenblum, and William Rubin.

NEW YORK. Museum of Modern Art. *Americans 1963*, 1963. Organized by Dorothy C. Miller.

———. *The Art of Assemblage*, 1961. Text by William C. Seitz.

———. *The Art of the Real: U.S.A., 1948–1968*, 1968. Text by E.C. Goossen.

———. *The Machine as Seen at the End of the Mechanical Age*, 1968. Text by Pontus Hultén.

———. *The New American Painting*, 1958. Texts by Dorothy C. Miller and Alfred H. Barr, Jr.

———. *Sixteen Americans*, 1960. Organized by Dorothy C. Miller.

NEW YORK. New York University Art Collection. *Concrete Expressionism*, 1965. Text by Irving Sandler.

NEW YORK. Solomon R. Guggenheim Museum. *American Abstract Expressionists and Imagists*, 1961. Text by H.H. Arnason.

———. *Guggenheim International Exhibition, 1967: Sculpture from Twenty Nations*, 1967. Text by Edward F. Fry.

———. *The Shaped Canvas*, 1965. Text by Lawrence Alloway.

NEW YORK. Whitney Museum of American Art. *BLAM! The Explosion of Pop, Minimalism, and Performance, 1958–1964*, 1984. Text by Barbara Haskell.

———. *Geometric Abstraction in America*, 1962. Text by John Gordon.

———. Downtown Branch. *Nine Artists/Coenties Slip*, 1974.

———. *Two Hundred Years of American Sculpture*, 1976. Texts by Tom Armstrong, Wayne Craven, Norman Feder, Barbara Haskell, Rosalind E. Krauss, Daniel Robbins, and Marcia Tucker.

———. *The Structure of Color*, 1971. Text by Marcia Tucker.

NORTH BENNINGTON, VT. Park-McCullough House Association. *Fifteen Sculptors in Steel Around Bennington: 1963–1978*, 1978. Text by Andrew Hudson.

PASADENA. Pasadena Art Museum. *Serial Imagery*, 1968. Text by John Coplans.

PHILADELPHIA. Institute of Contemporary Art, University of Pennsylvania. *Grids*, 1972. Text by Lucy R. Lippard.

———. *The Other Tradition*, 1966. Text by G.R. Swenson.

SÃO PAULO. *São Paulo Bienal 7*, 1963. Text by Martin Friedman.

———. *São Paulo Bienal 8*, 1965. Text by Walter Hopps.

———. *São Paulo Bienal 9: USA Environment USA, 1957–1967*, 1967. Text by William C. Seitz.

PRINCETON, N.J. Art Museum, Princeton University. *Six Artists Draw*, 1974. Text by Rosalind Krauss.

STOCKHOLM. Moderna Museet. *Flyktpunkter/Vanishing Points*, 1984. Texts by Lucy R. Lippard, Ted Castle, and Olle Granath.

———. *New York Collection for Stockholm*, 1973. Text by Pontus Hultén.

TOKYO. National Museum of Modern Art.

*Two Decades of American Painting*, 1966. Texts by Lucy R. Lippard, Irving Sandler, and G.R. Swenson.

VENICE. *Biennale Internazionale d'Arte 32*, 1964. Text by Alan Solomon.

———. *Biennale Internazionale d'Arte 33*, 1966. Texts by Henry Geldzahler, Clement Greenberg, Robert Rosenblum, and William Rubin.

WASHINGTON, D.C. Corcoran Gallery of Art. *Scale as Content*, 1967. Text by Eleanor Green.

———. *A New Aesthetic*, 1967. Text by Barbara Rose.

WASHINGTON, D.C. Washington Gallery of Modern Art. *Formalists*, 1963. Text by Adelyn Breeskin.

## ARTICLES

ACKERMAN, JAMES S. "The Demise of the Avant-Garde: Notes on the Sociology of Recent American Art," *L'Arte*, March 1969, pp. 5–17.

AHLANDER, LESLIE JUDD. "The Emerging Art of Washington," *Art International*, 25 November 1962, pp. 30–33.

ALLOWAY, LAWRENCE. "Art as Likeness: With a Note on Post Pop Art," *Arts Magazine*, May 1967, pp. 34–39.

———. "Artists and Photographs," *Studio Internatinal*, April 1970, pp. 162–64.

———. "Background to Systemic," *Art News*, October 1966, pp. 30–33.

———. "The Great Curatorial Dim-Out," *Artforum*, May 1975, pp. 32–34.

———. "Hybrid," *Arts Magazine*, May 1966, pp. 38–42.

———. "Network: The Art World Described as a System," *Artforum*, September 1972, pp. 28–32.

———. "Sculpture as Cliché," *Artforum*, October 1963, pp. 26–35.

———. "The Spectrum of Monochrome," *Arts Magazine*, December 1970–January 1971, pp. 30–33.

ANDREWS, BENNY. "The B.E.C.C.: Black Emergency Cultural Coalition," *Arts Magazine*, Summer 1970, pp. 18–22.

ANTIN, DAVID. "Differences-sames: New York 1966–67," *Metro* 13 (February 1968): 78–104.

———. "It Reaches a Desert in Which Nothing Can Be Perceived but Feeling," *Art News*, March 1971, pp. 34–41, 66–71.

———. "Lead Kindly Blight," *Art News*, November 1970, pp. 36–39.

"The Artist and Politics: A Symposium," *Artforum*, September 1970, pp. 35–39.

"The Arts: Protest on All Sides," *Newsweek*, 10 July 1967, pp. 83–86.

ASHTON, DORE. "Abstract Expressionism Isn't Dead," *Studio International*, September 1962, pp. 104–5.

———. "A Planned Coincidence," *Art in America*, September–October 1969, pp. 36–47.

———. "Response to the Crisis in American Art," *Art in America*, January–February 1969, pp. 24–35.

BAIGELL, MATTHEW. "American Painting: On Space and Time in the Early 1960's," *Art Journal*, Summer 1969, pp. 368–74, 387–401.

BAKER, ELIZABETH C. "Barnett Newman in a New Light," *Art News*, February 1969, pp. 38–41, 60–64.

———. "Pickets on Parnassus," *Art News*, September 1970, pp. 30–33, 64–65.

BAKER, ELIZABETH C., and JOSEPH RAFFAELE. "The Way Out West: Interviews with 4 San Francisco Artists," *Art News*, Summer 1967, pp. 38–40.

BANNARD, WALTER DARBY. "Art Quality and the Formalist Controversy," *Quadrille*, Fall 1974, p. 8.

———. "Color, Paint and Present-Day Painting," *Artforum*, April 1966, pp. 34–36.

———. "Cubism, Abstract Expressionism, David Smith," *Artforum*, April 1968, pp. 22–32.

———. "Notes on American Painting of the Sixties," *Artforum*, January 1970, pp. 40–45.

———. "Present-Day Art and Ready-Made Styles," *Artforum*, December 1966, pp. 30–35.

———. "Willem de Kooning's Retrospective at the Museum of Modern Art," *Artforum*, April 1969, pp. 42–44.

BARO, GENE. "American Sculpture: The New Scene," *Studio International*, January 1968, pp. 9–19.

———. "Britain's New Sculpture," *Art International*, June 1965, pp. 26–31.

———. "A Gathering of Americans," *Arts Magazine*, September 1963, pp. 28–33.

———. "The Venice Biennale," *Arts Magazine*, September 1964, pp. 32–37.

BARON, STEPHANIE. "Giving Art History the Slip," *Art in America*, March–April 1974, pp. 80–84.

———. "Matisse and Contemporary Art," *Art News*, May 1975, p. 66.

BATTCOCK, GREGORY. "The Art Critic as Social Reformer—With a Question Mark," *Art in America*, September–October 1971, pp. 26–27.

———. "The Art of the Real: The Development of a Style, 1948–68," *Arts Magazine*, Summer 1968, pp. 44–47.

———. "The Politics of Space," *Arts Magazine*, February 1970, pp. 40–43.

BENSON, LEGRACE G. "The Washington Scene (Some Preliminary Notes on the Evolution of Art in Washington, D.C.)," *Art International*, Christmas 1969, pp. 21–23, 36–42, 50.

BOCHNER, MEL. "Art in Process—Structures," *Arts Magazine*, September–October 1966, pp. 38–39.

———. "Excerpts from Speculation (1967–1970)," *Artforum*, May 1970, pp. 70–73.

———. "No Thoughts Exist Without a Sustaining Support," *Arts Magazine*, April 1970, p. 44.

———. "Serial Art (Systems: Solipsism)," *Arts Magazine*, Summer 1967, pp. 39–43.

———. "The Serial Attitude," *Artforum*, December 1967, pp. 28–33.

———. "Systemic," *Arts Magazine*, November 1966, p. 40.

BOCHNER, MEL, and ROBERT SMITHSON. "The Domain of the Great Bear," *Art Voices*, Fall 1966, pp. 24–31.

BONGARD, WILLI. "When Rauschenberg Won the Biennale," *Studio International*, June 1968, pp. 288–89.

BONIN, WILKE VON. "Germany: The American Presence," *Arts Magazine*, March 1970, pp. 52–55.

BORDEN, LIZZIE. "The New Dialectic," *Artforum*, March 1974, pp. 44–51.

BOURDON, DAVID. "E=MC² à Go-Go," *Art News*, January 1966, pp. 22–25, 57–59.

BOWLING, FRANK. "It's Not Enough to Say 'Black Is Beautiful,'" *Art News*, April 1971, pp. 53–55, 82–85.

———. "Problems of Criticism I-II-III-IV-V-VI," *Arts Magazine*, May 1972, pp. 34–38.

BOWNESS, ALAN. "The American Invasion and the British Response," *Studio International*, June 1967, pp. 285–93.

BROOK, DONALD. "Art Criticism: Authority and Argument," *Studio International*, September 1970, pp. 66–69.

BURN, IAN. "The Art Market: Affluence and Degradation," *Artforum*, April 1975, pp. 34–37.

BURNHAM, JACK. "Problems of Criticism, IX," *Artforum*, January 1971, pp. 40–45.

———. "Real Time Systems," *Artforum*, September 1969, pp. 49–55.

———. "Systems Esthetics," *Artforum*, September 1968, pp. 30–35.

———. "Ten Years Before the Artforum Masthead," *The New Art Examiner*, February 1977, pp. 1, 6–7.

BURTON, SCOTT. "Time on Their Hands," *Art News*, Summer 1969, pp. 40–43.

CAGE, JOHN. "Diary: How to Improve the World (You Will Only Make Matters Worse)," *Aspen*, Spring 1967, n.p.

———. "26 Statements re Duchamp," *Art and Literature*, Autumn–Winter 1964, pp. 9–10.

CALAS, NICOLAS. "Documentizing," *Arts Magazine*, May 1970, pp. 30–32.

———. "The Sphinx: The Tradition of the New," *Arts Magazine*, November 1970, pp. 24–26.

CASTLE, FREDERICK. "Threat Art," *Art News*, October 1968, pp. 54–55, 65–66.

CHANDLER, JOHN N. "Tony Smith and Sol LeWitt: Mutations and Permutations," *Art International*, 20 September 1968, pp. 16–19.

"Chosen in Milan: The 200 Most Outstanding Artists of Today," *Metro*, December 1962, p. 122.

CLAY, JEAN. "A Cultural Heatwave in New York," *Studio International*, February 1968, pp. 72–75.

COLT, PRISCILLA. "Notes on Ad Reinhardt," *Art International*, 20 October 1964, pp. 32–34.

CONE, JANE HARRISON. "David Smith," *Artforum*, Summer 1967, pp. 72–78.

CONSTABLE, ROSALIND. "New York's Avant Garde, and How It Got There," *New York/Herald Tribune*, 17 May 1964, pp. 7–10.

COPLANS, JOHN. "Los Angeles: The Scene," *Art News*, March 1965, pp. 28–29, 56–58.

———. "Pasadena's Collapse & the Simon Takeover: Diary of a Disaster," *Artforum*, February 1975, pp. 28–45.

———. "Serial Imagery," *Artforum*, October 1968, pp. 34–43.

CULLER, GEORGE D. "Dada and Surrealism," *Art in America* 2 (1963): 68–75.

DANTO, ARTHUR. "The Art World," *Journal of Philosophy* LXI (1964): 571.

DAVIS, DOUGLAS M. "The Dimensions of the Miniarts," *Art in America*, November–December 1967, pp. 84–91.

DONAT, JOHN. "Buckminster Fuller: A Personal Assessment," *Studio International*, June 1970, pp. 242–44.

DOWNES, RACKSTRAW. "What the Sixties Meant to Me," *Art Journal*, Winter 1974–75, pp. 125–31.

ELDERFIELD, JOHN. "Grids," *Artforum*, May 1972, pp. 52–59.

FACTOR, DONALD. "Assemblage," *Artforum*, Summer 1964, pp. 38–41.

FEIGEN, RICHARD. "Art 'Boom,'" *Arts Magazine*, November 1966, pp. 23–24.

FITZGERALD, FRANCIS. "What's New, Henry Geldzahler, What's New?" *New York/Herald Tribune*, 21 November 1965, pp. 14–20.

FLEMINGER, IRWIN. "The New Art Selection Process," *Art News*, January 1967, pp. 56–57, 71–72.

FOOTE, NANCY. "The Anti-Photogra-

phers," *Artforum,* September 1976, pp. 46–54.

———. "Three Sculptors: Mark di Suvero, Richard Nonas, Charles Ginnever," *Artforum,* February 1976, pp. 46–52.

FORGE, ANDREW. "Forces Against Object-Based Art," *Studio International,* January 1971, pp. 32–37.

———. "Painting and the Struggle for the Whole Self," *Artforum,* September 1975, pp. 44–49.

———. "Some New British Sculptors," *Artforum,* May 1965, pp. 31–35.

FRANK, ELIZABETH. "At East in Zion: Clement Greenberg After Forty Years," *Bennington Review,* December 1980, pp. 29–30.

FRIED, MICHAEL. "Anthony Caro and Kenneth Noland: Some Notes on Not Composing," *Lugano Review,* Summer 1965, pp. 198–206.

———. "Art and Objecthood," *Artforum,* Summer 1967, pp. 12–23.

———. "Modernist Painting and Formal Criticism," *The American Scholar,* Autumn 1964, pp. 642–48.

FRIEDMAN, BRUCE JAY. "Dirty Pictures," *Esquire,* May 1971, pp. 112–17.

FRIEDMAN, MARTIN LEE. "14 Sculptors: The Industrial Edge," *Art International,* February 1970, pp. 35–36.

FRY, EDWARD F. "The Issue of Innovation," *Art News,* October 1967, pp. 40–43, 71–72.

———. "Sculpture of the Sixties," *Art in America,* September–October 1967, pp. 26–43.

FULLER, MARY. "An Ad Reinhardt Monologue," *Artforum,* October 1970, pp. 36–41.

———. "San Francisco Sculptors," *Art in America* 3 (1964): 52–59.

GABLIK, SUZI. "Meta-trompe-l'oeil," *Art News,* March 1965, pp. 46–49.

GELDZAHLER, HENRY. "Frankenthaler, Kelly, Lichtenstein, Olitski: A Preview of the American Selection at the 1966 Venice Biennale," *Artforum,* June 1966, pp. 32–38.

GENDEL, MILTON. "Hugger-Mugger in the Giardini," *Art News,* September 1964, pp. 32–35.

GLASER, BRUCE. "Modern Art and the Critics: A Panel Discussion" (with Max Kozloff, Barbara Rose, and Sidney Tillim.), *Art Journal,* Winter 1970–71, pp. 154–59.

———, interviewer, and LUCY R. LIPPARD, ed. "Questions to Stella and Judd," *Art News,* September 1966, pp. 55–61.

GOLDIN, AMY. "Art in a Hairshirt," *Art News,* February 1967, pp. 26, 65–68.

———. "The Dada Legacy," *Arts Magazine,* September–October 1965, pp. 26–28.

———. "McLuhan's Message: Participate, Enjoy!" *Arts Magazine,* May 1966, pp. 27–31.

———. "One Cheer for Expressionism," *Art News,* November 1968, pp. 48–49, 66–69.

———. "Patterns, Grids, and Painting," *Artforum,* September 1975, pp. 50–54.

———. "Requiem for a Gallery," *Arts Magazine,* March 1966, pp. 25–29.

———. "Situation Critical," *Art News,* March 1968, pp. 44–45, 64–67.

———. "Sweet Mystery of Life," *Art News,* May 1969, pp. 46–51, 62.

GOLDSTEIN, C. "Teaching Modernism: What Albers Learned in the Bauhaus and Taught to Rauschenberg, Noland, and Hesse," *Arts Magazine,* December 1979, pp. 108–16.

GOLUB, LEON. "The Artist as an Angry Artist," *Arts Magazine,* April 1967, pp. 48–49.

———. "16 Whitney Museum Annuals of American Painting, Percentages 1950–72," *Artforum,* March 1973, pp. 36–39.

GOOSSEN, E.C. "Distillation: A Joint Showing," *Artforum,* November 1966, pp. 31–33.

GRAHAM, DAN. "Models & Monuments: The Plague of Architecture," *Arts Magazine,* March 1967, pp. 32–35.

———. "Muybridge Moments," *Arts Magazine,* February 1967, pp. 23–24.

GREENBERG, CLEMENT. "America Takes the Lead: 1945–1965," *Art in America,* August–September 1965, pp. 108–29.

———. "Art: How Art Writing Earns Its Bad Name," *Encounter,* 19 December 1962, pp. 67–71.

———. "Avant-Garde Attitudes: New Art in the Sixties," *Studio International,* April 1970, pp. 142–45.

———. "Can Taste Be Objective?" *Art News,* February 1973, pp. 22–23.

———. "Counter-Avant-Garde," *Art International,* 20 May 1971, pp. 16–19.

———. "The 'Crisis' of Abstract Art," *Arts Yearbook 7. New York: The Art World* (1964): 89–92.

———. "Modernist Painting," *Arts Yearbook* 4 (1961): 109–16.

———. "Necessity of 'Formalism,'" *Art International,* October 1972, pp. 105–6.

———. "Poetry of Vision," *Artforum,* April 1968, pp. 18–21.

———. "Problems of Criticism, II: Complaints of an Art Critic," *Artforum,* October 1967, pp. 38–39.

———. "Recentness of Sculpture," *Art International,* 20 April 1967, pp. 19–21.

GUSTAFSON, DONNA. "Food and Death: Vanitas in Pop Art," *Arts Magazine,* February 1986, pp. 90–93.

HAHN, OTTO. "The Avant-Garde Stance," *Arts Magazine,* May–June 1965, pp. 22–29.

———. "Passport No G2553000: United States of America," *Art and Artists,* July 1966, pp. 6–11.

HANSEN, AL. "London: Destruction in Art Symposium," *Arts Magazine,* November 1966, pp. 53–54.

HESS, THOMAS B. "Editorial: Ad (Adolph Dietrich Friedrich) Reinhardt," *Art News,* October 1967, p. 23.

———. "Editorial: The Artist as a Company Man," *Art News,* October 1964, p. 19.

———. "Editorial: Artists and the Rat-Race," *Art News,* January 1965, p. 23.

———. "Editorial: Notes on American Museums," *Art News,* November 1966, p. 27.

———. "J'accuse Marcel Duchamp," *Art News,* February 1965, pp. 44–45, 52–54.

———. "The Phony Crisis in American Art," *Art News,* Summer 1963, pp. 24–28, 59–60.

HIGGENS, ANDREW. "Clement Greenberg and the Idea of the Avant-Garde," *Studio International,* October 1971, pp. 144–47.

HORVITZ, ROBERT JOSEPH. "A Talk with George Kubler," *Artforum,* October 1973, pp. 32–34.

HOWARD, MICHAEL. "The American World Presence," *Art International,* 20 June 1971, pp. 19–21.

HUDSON, ANDREW. "Scale as Content: Bladen, Newman, Smith at the Corcoran," *Artforum,* December 1967, pp. 46–47.

HUNT, RONALD. "Yves Klein," *Artforum,* January 1967, pp. 32–37.

HUTCHINSON, PETER. "Mannerism in the Abstract," *Art and Artists,* September 1966, pp. 18–20.

HUXTABLE, ADA LOUISE. "Architecture for a Fast-Food Culture," *New York Times Magazine,* 12 February 1978, pp. 23–25, 32, 36.

"John Cage in Los Angeles," *Artforum,* February 1965, pp. 17–19.

JOHNSON, ELLEN H. "Jim Dine and Jasper Johns: Art About Art," *Art and Literature,* Autumn 1963, pp. 128–40.

———. "Three New, Cool, Bright Imagists," *Art News,* Summer 1965, pp. 42–44, 62–64.

JOHNSON, PHILIP. "Young Artists at the Fair and at Lincoln Center," *Art in America* 4 (1964): 112–27.

JUDD, DONALD. "Black, White and Gray," *Arts Magazine,* March 1964, pp. 36–38.

———. "Complaints: Part 1," *Studio International,* April 1969, pp. 182–84.

———. "Local History," *Arts Yearbook* 7 (1964): 23–35.

———. "Specific Objects," *Arts Yearbook* 8 (1965): 74–82.

KAGAN, ANDREW A. "Paul Klee's Influence on American Painting," *Arts Magazine,* September 1975, pp. 87–89.

KAPROW, ALLAN. "Experimental Art," *Art News,* March 1966, pp. 60–63, 77–82.

———. "Impurity," *Art News,* January 1963, pp. 30–33, 52–55.

———. "The Shape of the Art Environment," *Artforum,* Summer 1968, pp. 32–33.

———. "Should the Artist Be a Man of the World?" *Art News,* October 1964, pp. 34–37, 58–59.

KIRBY, MICHAEL. "Sculpture as a Visual Instrument," *Art International,* 20 October 1968, pp. 35–37.

KIRBY, MICHAEL, and RICHARD SCHECHNER, "An Interview with John Cage," *Tulane Drama Review,* Winter 1965, pp. 50–72.

KOSTELANETZ, RICHARD. "Words and Images Artfully Entwined," *Art International,* 20 September 1970, pp. 44–56.

KOSUTH, JOSEPH. "Joseph Kosuth on Ad Reinhardt," *Cover,* Spring–Summer 1980, p. 10.

KOZLOFF, MAX. "Abstract Attrition," *Arts Magazine,* January 1965, pp. 46–50.

———. "American Painting During the Cold War," *Artforum,* May 1973, pp. 43–54.

———. "American Sculpture in Transition," *Arts Magazine,* May–June 1964, pp. 19–24.

———. "Andy Warhol and Ad Reinhardt: The Great Accepter and the Great Demurrer," *Studio International,* March 1971, pp. 113–17.

———. "Art and the New York Avant Garde," *Partisan Review,* Fall 1964, pp. 535–54.

———. "The Authoritarian Personality in Modern Art," *Artforum,* May 1974, pp. 40–47.

———. "The Dilemma of Expressionism," *Artforum,* November 1964, pp. 32–35.

———. "The Further Adventures of American Sculpture," *Arts Magazine,* February 1965, pp. 24–31.

———. "The Inert and the Frenetic," *Artforum,* March 1966, pp. 40–44.

———. "Johns and Duchamp," *Art International,* 20 March 1964, pp. 42–45.

———. "A Letter to the Editor," *Art International,* 25 June 1963, pp. 88–92.

———. "Men and Machines," *Artforum,* February 1969, pp. 22–29.

———. "Modern Art and the Virtues of Decadence," *Studio International,* November 1967, pp. 89–99.

———. "Painting and Anti-Painting: A Family Quarrel," *Artforum,* September 1975, pp. 37–43.

———. "Problems of Art Criticism, III: Venetian Art and Florentine Criticism," *Artforum,* December 1967, pp. 42–45.

———. "Realists and Others," *Arts Magazine,* January 1964, p. 22.

KRAMER, HILTON. "A Critic on the Side of History: Notes on Clement Greenberg," *Arts Magazine,* October 1962, pp. 60–63.

———. "The Emperor's New Bikini," *Art in America,* January–February 1969, pp. 49–53.

———. "Episodes from the Sixties," *Art in America,* January–February 1970, pp. 56–61.

———. "Notes on Painting in New York," *Arts Yearbook* 7 (1964): 9–20.

———. "Thirty Years of the New York School," *New York Times Magazine,* 12 October 1969, pp. 28–120.

KRAUSS, ROSALIND E. "The New de Kooning," *Artforum,* January 1968, pp. 44–47.

———. "On Frontality," *Artforum,* May 1968, pp. 40–46.

———. "Problems of Criticism, X," *Artforum,* November 1971, pp. 68–71.

———. "Sense and Sensibility: Reflections on Post-'60s Sculpture," *Artforum,* November 1973, pp. 43–52.

———. "A View of Modernism," *Artforum,* September 1972, pp. 48–51.

KROLL, JACK. "Some Greenberg Circles," *Art News,* March 1962, pp. 35, 48–49.

KURTZ, BRUCE. "Interview with Giuseppe Panza di Biumo," *Arts Magazine,* March 1972, pp. 40–43.

———. "Interview with Harry N. Abrams," *Arts Magazine,* September–October 1972, pp. 49–51.

———. "Last Call at Max's," *Artforum,* April 1981, pp. 26–29.

LADERMAN, GABRIEL. "Problems of Criticism, VII: Notes from the Underground," *Artforum,* September 1970, pp. 59–61.

LEE, DAVID. "Serial Rights," *Art News,* December 1967, pp. 42–45, 68–69.

LEIDER, PHILIP. "American Sculpture at the Los Angeles County Museum of Art," *Artforum,* Summer 1967, pp. 6–11.

———. "Artists and Politics: A Symposium," *Artforum,* September 1970, pp. 40–49.

———. "Books," *Artforum,* October 1965, pp. 44–45.

———. "The Cool School," *Artforum,* December 1964, pp. 47–52.

———. "Gallery '68: High Art and Low Art," *Look,* 9 January 1968, pp. 14–21.

———. "How I Spent My Summer Vacation, or, Art and Politics in Nevada, Berkeley, San Francisco and Utah," *Artforum,* September 1970, pp. 40–49.

———. "Modern American Art at the Met," *Artforum,* December 1969, pp. 62–65.

———. "The New York School in Los Angeles," *Artforum,* September 1965, pp. 4–13.

LEVIN, KIM. "Farewell to Modernism," *Arts Magazine,* October 1979, pp. 90–92.

LEVINE, LES. "A Portrait of Sidney Janis on the Occasion of His 25th Anniversay as an Art Dealer," an interview, *Arts Magazine,* November 1973, pp. 50–54.

LIPKE, WILLIAM C. "Perspectives of American Sculpture: 1 'Nancy and I at Ithaca'—Jim Dine's Cornell Project: 2 The Sense of 'Why Not?': George Segal on his Art," *Studio International,* October 1967, pp. 142–46.

LIPPARD, LUCY R. "The Art Workers' Coalition: Not a History," *Studio International,* November 1970, pp. 171–74.

———. "Change and Criticism: Consistency and Small Minds," *Art International,* November 1967, pp. 18–20.

———. "The Dilemma," *Arts Magazine,* November 1970, pp. 27–29.

———. "Escalation in Washington," *Art International,* January 1968, pp. 42–46.

———. "Flagged Down: The Judson Three and Friends," *Art in America,* May–June 1972, pp. 48–53.

———. "An Impure Situation (New York and Philadelphia Letter)," *Art International,* 20 May 1966, pp. 60–65.

———. "New York Letter," *Art International,* June 1965, pp. 51–55.

———. "New York Letter: Recent Sculpture as Escape," *Art International,* February 1966, pp. 48–58.

———. "Perverse Perspectives," *Art International,* 20 March 1967, pp. 28–33, 44.

———. "Talk About Sculpture," *Art News,* April 1971, pp. 48–49.

———. "The Third Stream: Painted Structures and Structured Paintings," *Art Voices,* Spring 1965, pp. 44–49.

———. "Time: A Panel Discussion," *Art International,* November 1969, pp. 20–23, 39.

LIPPARD, LUCY R., and JOHN CHANDLER. "The Dematerialization of Art," *Art International,* February 1968, pp. 31–36.

———. "Visible Art and the Invisible World," *Art International,* May 1967, pp. 27–30.

LOFTUS, JOHN. "The Plastic Arts in the Sixties: What Is It That Has Got Lost?" *College Art Journal*, Spring 1967, pp. 240–45.

——. "Los Angeles: Tower of Peace," *Art News*, April 1966, pp. 25, 71.

LUCIE-SMITH, EDWARD. "An Interview with Clement Greenberg," *Studio International*, January 1968, pp. 4–5.

LYNTON, NORBERT. "Venice 1966," *Art International*, 15 September 1966, pp. 83–89.

MCDONAGH, DON. "Notes on Recent Dance," *Artforum*, December 1972, pp. 48–52.

MCEVILLEY, TOM. "Freeing Dance from the Web," *Artforum*, January 1984, pp. 54–57.

MCLUHAN, MARSHALL. "Culture and Technology," *Times Literary Supplement*, 6 August 1964, pp. 700–701.

MARCHIS, GIORGIO DE. "The Significance of the 1964 Venice Biennale," *Art International*, 25 November 1964, pp. 21–23.

MARCUSE, HERBERT. "Art in the One-Dimensional Society," *Arts Magazine*, May 1967, pp. 26–31.

MARMER, NANCY. "Matisse and the Strategy of Decoration," *Artforum*, March 1966, pp. 28–33.

MESSER, THOMAS M. "Impossible Art—Why Is It?" *Art in America*, May–June 1969, pp. 30–31.

MEYER, LEONARD B. "The End of the Renaissance? Notes on the Radical Empiricism of the Avant-Garde," *Hudson Review*, Summer 1963, pp. 174–86.

MEYER, URSULA. "De-Objectification of the Object," *Arts Magazine*, Summer 1969, pp. 20–22.

MICHELSON, ANNETTE. "The 1964 Venice Biennale," *Art International*, 25 September 1964, pp. 38–40.

——. "Three Notes on an Exhibition as a Work," *Artforum*, June 1970, pp. 62–64.

MORRIS, ROBERT. "Aligned with Nazca," *Artforum*, October 1975, pp. 26–39.

——. "American Quartet," *Art in America*, December 1981, pp. 92–102.

——. "The Art of Existence: Three Extra-Visual Artists—Works in Process," *Artforum*, January 1971, pp. 28–33.

——. "Some Splashes in the Ebb Tide," *Artforum*, February 1973, pp. 42–49.

MÜLLER, GREGOIRE, "Points of View: A Taped Conversation with Robert C. Scull," *Arts Magazine*, November 1970, pp. 37–39.

——. "The Scale of Man," *Arts Magazine*, May 1970, pp. 42–43.

MYERS, JOHN BERNARD. "Junkdump Fair Surveyed," *Art and Literature* 3 (Autumn–Winter 1964): 122–41.

NAROTZKY, NORMAN. "The Venice Biennale," *Arts Magazine*, September–October 1966, pp. 42–44.

NEMSER, CINDY. "Subject-Object: Body Art," *Arts Magazine*, September–October 1971, pp. 38–42.

"New Talent USA: Sculpture (Chosen by Robert Scull)," *Art in America* 1 (1962): 32–39.

NODELMAN, SHELDON. "Sixties Art: Some Philosophical Perspectives," *Perspecta 11, Yale Architectural Journal* (1967): 72–89.

O'CONNOR, FRANCIS V. "Notes on Patronage: The 1960s," *Artforum*, September 1972, pp. 52–60.

O'DOHERTY, BRIAN. "Issues and Commentary: A New Conservatism in the Seventies," *Art in America*, March–April 1971, p. 23.

——. "Issues and Commentary: What is Post-Modernism?" *Art in America*, May–June 1971, p. 19.

——. "Vanity Fair: The New York Art Scene," *Newsweek*, 4 January 1965, pp. 54–60.

PHILLIPS, GIFFORD. "Cultural Commercialism," *Art News*, September 1969, pp. 27, 67–68.

PICARD, LIL. "Making the Scene with Lil Picard," *Arts Magazine*, February 1967, p. 17.

——. "Making the Scene with Lil Picard: Kill for Peace," *Arts Magazine*, March 1967, p. 15.

——. "Protest and Rebellion: The Function of the Art Workers Coalition," *Arts Magazine*, May 1970, pp. 18, 20.

PIENE, NAN R. "What's Next After Next," *Art in America*, March–April 1966, pp. 31–39.

PINCUS-WITTEN, ROBERT. "On Target: Symbolist Roots of American Abstraction," *Arts Magazine*, April 1976, pp. 84–90.

——. "Rosenquist and Samaras: The Obsessive Image and Post Minimalism," *Artforum*, September 1972, pp. 64–69.

——. "Theater of the Conceptual: Autobiography and Myth," *Artforum*, October 1973, pp. 40–46.

PLAGENS, PETER. "The Possibilities of Drawing," *Artforum*, October 1969, pp. 50–55.

——. "Present-Day Styles and Ready-Made Criticism," *Artforum*, December 1966, pp. 36–39.

POIRER, MAURICE, and JANE NICOL, eds. "The 60's in Abstract: 13 Statements," *Art in America*, October 1983, pp. 23–37.

RAFFAELE, JOE, and ELIZABETH BAKER. "The Way-Out West: Interviews with 4 San Francisco Artists," *Art News*, Summer 1967, pp. 38–41, 66–67, 72–76.

RAINER, YVONNE. "Don't Give the Game Away," *Arts Magazine*, April 1967, pp. 44–47.

RATCLIFF, CARTER. "Mostly Monochrome," *Art in America*, April 1981, pp. 114–16.

RAYSSE, MARTIAL. "Refusing Duality: 'The Impeccable Trajectory of Yves Klein,'" *Arts Magazine*, February 1967, pp. 34–36.

REED, ISHMAEL. "The Black Artist: 'Calling a spade a spade,'" *Arts Magazine*, May 1967, pp. 48–49.

REICHARDT, JASIA. "Pop Art and After," *Art International*, 25 February 1963, pp. 42–47.

REINHARDT, AD. "Art-as-Art," *Art International*, 20 December 1962, pp. 36–37.

——. "The Next Revolution in Art," *Art News*, February 1964, pp. 48–49.

——. "The Next Revolution in Art: Art-as-Art Dogma, Part II," *Art International*, 20 March 1964, pp. 57–58.

REISE, BARBARA. "Greenberg and the Group: A Retrospective View," part 1, *Studio International*, May 1968, pp. 254–57; part 2, June 1968, pp. 314–15.

RESTANY, PIERRE. "The World of Art: An American Year," *Art in America* 1 (1964): 96–98.

RIVERS, LARRY. "Blues for Yves Klein," *Art News*, February 1967, pp. 32–33, 75–76.

ROBBINS, EUGENIA S. "Performing Art," *Art in America*, July–August 1966, pp. 107–11.

ROBERTS, FRANCIS. "Interview with Marcel Duchamp (1887–1968): 'I propose to strain the laws of physics,'" *Art News*, December 1968, pp. 46–47, 62–64.

ROBINS, CORINNE. "Four Directions at Park Place," *Arts Magazine*, June 1966, pp. 20–24.

——. "The N.Y. Art Strike," *Arts Magazine*, September–October 1970, p. 27.

——. "Object, Structure or Sculpture: Where Are We?" *Arts Magazine*, September–October 1966, pp. 33–37.

——. "Six Artists and the New Extended Vision," *Arts Magazine*, September–October 1965, pp. 19–24.

ROSE, BARBARA. "Americans 1963," *Art International*, 25 September 1963, pp. 77–79.

——. "Dada Then and Now," *Art International* 1 (1963): 22–28.

——. "Filthy Pictures: Some Chapters in the History of Taste," *Artforum*, May 1965, pp. 21–25.

——. "How to Murder an Avant Garde," *Artforum*, November 1965, pp. 30–35.

———. "Looking at American Sculpture," *Artforum*, February 1965, pp. 29–36.

———. "Los Angeles: The Second City," *Art in America*, January–February 1966, pp. 110–15.

———. "The Problem of Scale in Sculpture," *Art in America*, July–August 1968, pp. 80–91.

———. "Problems of Criticism, IV: The Politics of Art, Part I," *Artforum*, February 1968, pp. 31–31.

———. "Problems of Criticism, V: The Politics of Art, Part II," *Artforum*, January 1969, pp. 44–49.

———. "Problems of Criticism, VI: The Politics of Art, Part III," *Artforum*, May 1969, pp. 46–51.

———. "The Second Generation: Academy and Breakthrough," *Artforum*, September 1965, pp. 53–63.

———. "Shall We Have a Renaissance?" *Art in America*, March–April 1967, pp. 30–39.

———. "The Value of Didactic Art," *Artforum*, April 1967, pp. 32–36.

ROSE, BARBARA, and IRVING SANDLER. "Sensibility of the Sixties," *Art in America*, January–February 1967, pp. 44–57.

ROSENBERG, HAROLD. "A Guide for the Unperplexed," *Art News*, September 1966, pp. 46–47, 68.

———. "Perspectives: After Next, What?" *Art in America* 2 (1963): 64–73.

ROTH, MOIRA. "The Aesthetics of Indifference," *Artforum*, November 1977, pp. 46–53.

RUBIN, WILLIAM. "Reflections on Marcel Duchamp," *Art International*, 1 December 1960, p. 49.

———. "Younger American Painters," *Art International*, January 1960, pp. 24–31.

RUDA, ED. "Park Place, 1963–1967: Some Informal Notes in Retrospect," *Arts Magazine*, November 1967, pp. 30–33.

RUSSELL, JOHN. "Concrete Poetry," *Art in America*, January–February 1966, pp. 86–89.

———. "Perspectives: Tenth Street and the Thames," *Art in America* 2 (1964): 74–76.

SANDLER, IRVING. "Ad Reinhardt: The Purist Blacklash," *Artforum*, December 1966, pp. 40–47.

———. "Expressionism with Corners," *Art News*, April 1965, pp. 38–40, 65–66.

———. "The New Cool-Art," *Art in America* 1 (1965): 96–101.

———, ed. "Is There a New Academy?" part 1, *Art News*, Summer 1959, pp. 34–37, 58–59; part 2, September 1959, pp. 36–39, 58–60.

SAUL, PETER, and JOE RAFFAELE. "Los Angeles: Subversive Art," *Arts Magazine*, May 1967, pp. 50–52.

SCHORR, JUSTIN. "Problems of Criticism, VII: To Save Painting," *Artforum*, December 1969, pp. 59–61.

SCHULZE, FRANZ. "Chicago Popcycle," *Art in America*, November–December 1966, pp. 102–4.

SCHWARTZ, PAUL. "Anti-Humanism in Art: Alain Robbe-Grillet in an Interview with Paul Schwartz," *Studio International*, April 1968, pp. 168–69.

SCHWARTZ, TERESA. "The Politicalization of the Avant-Garde," part 1, *Art in America*, November–December 1971, pp. 70–79; part 2, March–April 1972, pp. 70–79; part 3, March–April 1973, pp. 67–71.

SECKLER, DOROTHY GEES. "The Artist in America: The Audience Is His Medium," *Art in America* 2 (1963): 63–67.

———. "The Artist in America: Victim of the Cultural Boom?" *Art in America* 6 (1963): 27–39.

SEITZ, WILLIAM C. "Assemblage: Problems and Issues," *Art International*, February 1962, pp. 26–34.

———. "Mondrian and the Issue of Relationships," *Artforum*, February 1972, pp. 70–75.

———. "Problems of 'New Directions' Exhibitions," *Artforum*, September 1963, pp. 23–25.

———. "The Relevance of Impressionism," *Art News*, January 1969, pp. 28–43, 56–60.

"La sfida del sistema: Inchiesta sulla situazioni artistica attuale negli Stati Unita e in Francia: A cura di Anna Nosei Weber e Otto Hahn," answers by Dan Graham, Don Judd, Allan Kaprow, Billy Klüver, Sol LeWitt, and Robert Smithson. E.A.T., *Metro* 14 (June–August 1968): pp. 35–58.

SHARP, WILLOUGHBY. "Air Art," *Studio International*, May 1968, pp. 262–65.

———. "Willoughby Sharp Interviews Jack Burnham," *Arts Magazine*, November 1970, pp. 21–23.

———. "Willoughby Sharp Interviews John Coplans," *Arts Magazine*, Summer 1970, pp. 39–41.

SHIREY, DAVID L. "Impossible Art," *Art in America*, May–June 1969, pp. 32–47.

———. "N.Y. Painting and Sculpture, 1940–1970: The Year of the Centennial at the Met," *Arts Magazine*, September–October 1969, pp. 35–39.

SIEGEL, JEANNE. "Why Spiral?" *Art News*, September 1966, pp. 48–51, 67–68.

SMITH, ROBERTA. "Drawing Now (and Then)," *Artforum*, April 1976, pp. 52–59.

SMITHSON, ROBERT. "Aerial Art," *Studio International*, April 1969, pp. 180–81.

———. "Entropy and the New Monuments," *Artforum*, June 1966, pp. 26–31.

———. "The Museum of Language in the Vicinity of Art," *Art International*, March 1968, pp. 21–27.

———. "Quasi-Infinities and the Waning of Space," *Arts Magazine*, November 1966, pp. 28–31.

———. "Ultramoderne," *Arts Magazine*, September–October 1967, pp. 30–33.

SOLOMON, ALAN. "American Art Between Two Biennales," *Metro* 11 (June 1966): 25–35.

———. "The Green Mountain Boys," *Vogue*, 1 August 1966, pp. 104–9, 151–52.

STEINBERG, LEO. "Reflections on the State of Criticism," *Artforum*, March 1972, pp. 37–49.

TANCOCK, JOHN. "The Oscillating Influence of Marcel Duchamp," *Art News*, September 1973, pp. 23–29.

BRIE, TAYLOR. "Toward a Plastic Revolution," *Art News*, March 1964, pp. 46–49.

TILLIM, SIDNEY. "Art au Go-Go or, The Spirit of '65," *Arts Magazine*, September–October 1965, pp. 38–40.

———. "Evaluations and Re-Evaluations," *Artforum*, Summer 1968, pp. 20–23.

———. "Gothic Parallels: Watercolor and Luminism in American Art," *Artforum*, January 1967, pp. 15–19.

———. "The New Avant Garde," *Arts Magazine*, February 1964, pp. 18–21.

———. "Scale and the Future of Modernism," *Artforum*, October 1967, pp. 14–16.

———. "Toward a Literary Revival?" *Arts Magazine*, May–June 1965, pp. 30–33.

TOMKINS, CALVIN. "The Big Show in Venice," *Harper's Magazine*, April 1965, pp. 96–104.

———. "Profiles: A Good Eye and a Good Ear," *New Yorker*, 26 May 1980, pp. 40–72.

TUTEN, FREDERIC. "American Sculpture of the Sixties: A Los Angeles 'Super Show,'" *Arts Magazine*, May 1967, pp. 40–44.

VAUGHAN, ROGER. "Superpop or A Night at the Factory," *New York/Herald Tribune*, 3 August 1965, pp. 7–9.

WAGSTAFF, SAMUEL J. "Paintings to Think About," *Art News*, January 1964, pp. 33, 62.

WASSERMAN, EMILY. "Robert Irwin, Gene Davis, Richard Smith," *Artforum*, May 1968, pp. 47–49.

WATT, ALEXANDER. "The World of Art: Paris Letter—Nouveaux Réalistes," *Art in America* 2 (1961): 106–12.

WEAVER, MIKE. "And What Is Concrete Poetry?" *Art International*, 15 May

1968, pp. 30–33.

WECHSLER, JUDITH. "Why Scale?" *Art News*, Summer 1967, pp. 32–35, 67–68.

WHEELER, DENNIS F. "Ronald Bladen and Robert Murray in Vancouver," *Artforum*, June 1970, pp. 50–54.

WILLARD, CHARLOTTE. "Art Centers: New York—Dealer's-Eye View," *Art in America* 2 (1964): 120–34.

———. "Eye to I," *Art in America*, March–April 1966, pp. 49–59.

———. "Violence and Art," *Art in America*, January–February 1969, pp. 36–43.

WOLFE, TOM. "*The New Life Out There:* Marshall McLuhan. Suppose he is what he sounds like, the most important thinker since Newton, Darwin, Freud, Einstein and Pavlov—*What If He Is Right?*" *New York/Herald Tribune*, 21 November 1965, pp. 6–27.

———. "New Manners for New York," *New York/Herald Tribune*, 7 February 1965,

## CONCEPTUAL ART

BATTCOCK, GREGORY. *Idea Art: A Critical Anthology* (New York: E.P. Dutton, 1973).

BURNHAM, JACK. *Great Western Salt Works: Essays on the Meaning of Post-Formalist Art* (New York: George Braziller, 1974).

LIPPARD, LUCY R., ed. *Six Years: The Dematerialization of the Art Object* (New York: Praeger, 1973).

MEYER, URSULA, ed. *Conceptual Art* (New York: E.P. Dutton, 1972).

MIGLIORINI, ERMANNO. *Conceptual Art* (Florence: Il Fiorini, 1972).

MORGAN, ROBERT C. "The Role of Documentation in Conteptual Art: An Aesthetic Inquiry," Ph.D. Dissertation, New York University, 1978.

AMSTERDAM. Stedelijk Museum. *Op losse schroeven*, 1969. Texts by Wim A.L. Beeren, Piero Gilardi, and Harald Szeeman.

BERN. Kunsthalle. *Live in Your Head: When Attitudes Become Form—Works, Concepts, Processes, Situations, Information*, 1969. Texts by Harald Szeeman, Scott Burton, Gregoire Müller, and Tommaso Trini.

CHICAGO. Museum of Contemporary Art. *Art by Telephone*, 1969. Text by Jan van der Marck.

DETROIT. Detroit Institute of Arts. *Other Ideas*, 1969. Text by Sam Wagstaff.

NEW YORK. Dwan Gallery. *Language to Be Looked At And/Or Things to Be Read*, 1967.

NEW YORK. Finch College Museum of Art. *Art in Process IV*, 1970. Text by Elayne H. Varian.

NEW YORK. Jewish Museum. *Software: Information Technology—Its New Meaning for Art*, 1971. Text by Jack Burnham.

NEW YORK. Museum of Modern Art. *Information*, 1970. Text by Kynaston L. McShine.

NEW YORK. New York Cultural Center. *Conceptual Art and Conceptual Aspects*, 1970. Text by Donald Karshan.

NEW YORK. Seth Siegelaub Gallery. *January 5–31, 1969*, 1969.

NEW YORK. Visual Arts Gallery. *The "Air-Conditioning" Show*, 1966. Texts by Terry Atkinson and Michael Baldwin *(Art-Language)*.

SEATTLE. Seattle Art Museum. *557,087*, 1969. Text by Lucy R. Lippard.

ATKINSON, TERRY. "From an Art & Language Point of View," *Art-Language*, February 1970, pp. 25–60.

BATTCOCK, GREGORY. "Informative Exhibition at the Museum of Modern Art," *Arts Magazine*, Summer 1970, pp. 24–27.

BORDEN, LIZZIE. "Three Modes of Conceptual Art," *Artforum*, June 1972, pp. 68–71.

BURNHAM, JACK. "Alice's Head: Reflections on Conceptual Art," *Artforum*, February 1970, pp. 37–43.

CELANT, GERMANO. "Conceptual Art," *Casabella*, April 1970, pp. 42–49.

"Four Interviews with Barry, Huebler, Kosuth, Weiner," *Arts Magazine*, February 1969, pp. 22–23.

GOLDIN, AMY, and ROBERT KUSHNER. "Conceptual Art as Opera," *Art News*, April 1970, pp. 40–43.

HARRISON, CHARLES. "Against Precedents," *Studio International*, September 1969, pp. 90–93.

———. "A Very Abstract Context," *Studio International*, November 1970, pp. 194–98.

JEFFREY, IAN. "Art Theory and Practice: Art Theory and the Decline of the Art Object," *Studio International*, December 1973, pp. 267–71.

KOSUTH, JOSEPH. "Art After Philosophy," *Studio International*, part 1, October 1969, pp. 134–37; part 2, November 1969, pp. 160–61; part 3, December 1969, pp. 212–13.

———. "Introductory Note by the American Editor," *Art-Language*, February 1970, pp. 1–4.

KOZLOFF, MAX. "The Trouble with Art-as-Idea," *Artforum*, September 1972, pp. 33–37.

LEWITT, SOL. "Paragraphs on Conceptual Art," *Artforum*, Summer 1967, pp. 79–83.

———. "Ruth Vollmer: Mathematical Forms," *Studio International*, December 1970, pp. 256–57.

———. "Sentences on Conceptual Art," *0-9* 5 (January 1969): 3–5.

———. "Ziggurats," *Arts Magazine*, November 1966, pp. 24–25.

MCEVILLEY, THOMAS. "I Think Therefore I Am," *Artforum*, Summer 1985, pp. 74–84.

PERRONE, JEFF. "'Words': When Art Takes a Rest," *Artforum*, Summer 1977, pp. 34–37.

PLAGENS, PETER. "557,087," *Artforum*, November 1969, pp. 64–67.

SHAPIRO, DAVID. "Mr. Processionary at the Conceptacle," *Art News*, September 1970, pp. 58–61.

SIEGELAUB, SETH, in conversation with CHARLES HARRISON. "On Exhibitions and the World at Large," *Studio International*, December 1969, pp. 202–3.

SMITH, TERRY. "Art and Art and Language," *Artforum*, February 1974, pp. 49–52.

VINKLERS, BITITE. "Art and Information: 'Software' at the Jewish Museum," *Arts Magazine*, September–October 1970, pp. 46–49.

WHITE, ROBERT, and Gary M. Dault. "Word Art and Art Word," *artscanada*, June 1968, pp. 17–20.

WILSON, IAN. "Conceptual Art," *Artforum*, February 1984, pp. 60–61.

## EARTH ART

BEARDSLEY, JOHN. *Earthworks and Beyond* (New York: Abbeville, 1984).

HAVLICE, PATRICIA PATE. *Earth Scale Art: A Bibliography, Directory of Artists and Index of Reproductions* (Jefferson, N.C.: McFarland, 1984).

SONFIST, ALAN, ed. *Art of the Land* (New York: E.P. Dutton, 1983).

BOSTON. Museum of Fine Arts. *Earth, Air, Fire, Water*, 1969. Text by David Antin.

ITHACA, N.Y. Andrew Dickson White Museum of Art, Cornell University. *Earth*, 1969. Texts by Willoughby Sharp and William C. Lipke.

ALLOWAY, LAWRENCE. "Site Inspection," *Artforum*, October 1976, pp. 49–55.

BAKER, ELIZABETH. "Artworks on the Land," *Art in America*, January–February 1976, pp. 92–96.

BONGARTZ, ROY. "It's Called Earth Art—and Boulderdash," *New York Times Magazine*, 1 February 1970, pp. 16–17, 22–30.

BOURDON, DAVID. "What on Earth!" *Life,* 25 April 1969, pp. 80–86.

DIXON, JOHN W., JR. "Toward an Aesthetic of Early Earth Art," *Art Journal,* Fall 1982, pp. 195–99.

FRIEDMAN, BRUCE JAY. "Dirty Pictures," *Esquire,* May 1971, pp. 112–15.

HICKEY, DAVE. "Earthscapes, Landworks and Oz," *Art in America,* September–October 1971, pp. 40–49.

HOBBS, ROBERT, ed. "Earthworks: Past and Present," special issue, *Art Journal,* Fall 1982, pp. 191–233. (Includes nine essays.)

HUTCHINSON, PETER. "Earth in Upheavel, Earth Works and Landscapes," *Arts Magazine,* November 1968, pp. 19, 21.

JOHNSON, WILLIAM. "Scuba Sculpture," *Art News,* November 1969, pp. 52–53, 81–84.

KAPROW, ALLAN. "Easy: Nature Activity," *Art in America,* July 1974, pp. 73–75.

MASHECK, JOSEPH. "The Panama Canal and Some Other Works of Work," *Artforum,* May 1971, pp. 38–42.

MEADMORE, CLEMENT. "Thoughts on Earthworks, Random Distribution, Softness, Horizontality and Gravity," *Arts Magazine,* February 1969, pp. 26–28.

SHARP, WILLOUGHBY. "Discussions with Heizer, Oppenheim, Smithson," *Avalanche,* Fall 1970, pp. 48–71.

SMITHSON, ROBERT. "Frederick Law Olmstead and the Dialectical Landscape," *Artforum,* February 1973, pp. 117–28.

———. "A Sedimentation of the Mind: Earth Projects," *Artforum,* September 1968, pp. 44–50.

TILLIM, SIDNEY. "Earthworks and the New Picturesque," *Artforum,* December 1968, pp. 42–45.

TOMKINS, CALVIN. "Onward and Upward with the Arts: Maybe a Quantum Leap," *New Yorker,* 5 February 1972, pp. 44–67.

## MINIMAL ART

BATTCOCK, GREGORY, ed. *Minimal Art: A Critical Anthology* (New York: E.P. Dutton, 1968).

DÜSSELDORF. Städtische Kunsthalle. *Minimal Art,* 1969. Text by Jurgen Harten.

THE HAGUE. Gemeentemuseum. *Minimal Art,* 1968. Texts by Enno Develing, Lucy R. Lippard, and others.

HANOVER. Kestner Gesellschaft. *Minimal Art: Druckgraphic,* 1977. Texts by Norbert Lynton, Kathan Brown, and Nancy Tousley.

NEW YORK. Jewish Museum. *Primary Structures: Younger American and British Sculptors,* 1966. Text by Kynaston McShine.

NEW YORK. Whitney Museum of American Art. *Minimalism to Expressionism,* 1983. Text by Patterson Sims.

PASADENA. Pasadena Art Museum. *Serial Imagery,* 1968. Text by John Coplans.

SAN FRANCISCO. San Francisco Museum of Modern Art. *Unitary Forms: Minimal Sculpture by Carl Andre, Don Judd, John McCracken, Tony Smith,* 1970. Text by Suzanne Foley.

YONKERS, N.Y. Hudson River Museum. *8 Young Artists,* 1964. Text by E.C. Goossen.

BLOK, C. "Minimal Art at The Hague," *Art International,* May 1968, pp. 18–24.

BOCHNER, MEL. "Primary Structures," *Arts Magazine,* June 1966, pp. 32–35.

GRAHAM, DAN. "A Minimal Future? Models and Monuments," *Arts Magazine,* March 1967, p. 32.

HUTCHINSON, PETER. "The Critics' Art of Labeling: A Minimal Future," *Arts Magazine,* May 1967, pp. 19–20.

———. "Is There Life on Earth?" *Art in America,* November–December 1966, pp. 68–69.

———. "Science-Fiction: An Aesthetic for Science," *Art International,* 20 October 1968, pp. 32–34, 41.

LIPPARD, LUCY R. "Homage to the Square," *Art in America,* July 1967, pp. 50–57.

———. "Rejective Art," *Art International,* October 1966, pp. 33–37.

———. "The Silent Art," *Art in America,* January–February 1967, pp. 58–63.

MICHELSON, ANNETTE. "10 × 10: 'concrete reasonableness,'" *Artforum,* January 1966, pp. 30–31.

MORRIS, ROBERT. "Notes on Sculpture," *Artforum,* February 1966, pp. 42–43.

———. "Notes on Sculpture, Part 2," *Artforum,* October 1966, pp. 20–23.

———. "Notes on Sculpture, Part 3: Notes and Nonsequiturs," *Artforum,* Summer 1967, pp. 24–29.

O'DOHERTY, BRIAN. "Minus Plato," *Art and Artists,* September 1966, pp. 10–11.

PERREAULT, JOHN. "A Minimal Future? Union-Made Report on a Phenomenon," *Arts Magazine,* March 1967, pp. 26–31.

PIERCE, JAMES SMITH. "Design and Expression in Minimal Art," *Art International,* May 1968, pp. 25–27.

PINCUS-WITTEN, ROBERT. "'Systemic' Painting," *Artforum,* November 1966, pp. 42–45.

PLEYNET, MARCELIN. "Peinture et 'Structuralisme,'" *Art International,* November 1968, pp. 29–34.

REISE, BARBARA. "'Untitled 1969': A Foot-

note on Art and Minimal-Stylehood," *Studio International,* April 1969, pp. 166–72.

ROSE, BARBARA. "ABC Art," *Art in America,* October–November 1965, pp. 57–69.

TUCHMAN, PHYLLIS. "Minimalism and Critical Response," *Artforum,* May 1977, pp. 26–31.

WOLLHEIM, RICHARD. "Minimal Art," *Arts Magazine,* January 1965, pp. 26–32.

## THE NEW PERCEPTUAL REALISM AND PHOTO-REALISM

ARTHUR, JOHN. *Realist Drawings & Watercolors* (Boston: New York Graphic Society, 1980).

BATTCOCK, GREGORY. ed. *Super Realism* (New York: E.P. Dutton, 1975).

CHASE, LINDA. *Hyperrealism* (New York: Rizzoli, 1975).

COKE, VAN DEREN. *The Painter and the Photograph* (Albuquerque: University of New Mexico Press, 1964).

DOWNES, RACKSTRAW, ed. *Fairfield Porter: Art in Its Own Terms: Selected Criticism, 1935–1975* (New York: Taplinger, 1979).

GERDTS, WILLIAM H. *The Great American Nude* (New York: Praeger, 1974).

GOODYEAR, FRANK H., JR. *Contemporary American Realism Since 1960* (Boston: New York Graphic Society, 1981).

HODIN, J.P., et al. *Figurative Art Since 1945* (London: Thames and Hudson, 1971).

LINDEY, CHRISTINE. *Superrealist Painting and Sculpture* (New York: William Morrow, 1980).

LUCIE-SMITH, EDWARD. *Super Realism* (Oxford: Phaidon, 1979).

MATHEY, FRANÇOIS. *American Realism* (New York: Skira/Rizzoli, 1978).

MEISEL, LOUIS K. *Photorealism* (New York: Harry N. Abrams, 1980).

MEYER, SUSAN E., ed. *20 Figure Painters and How They Work* (New York: Watson-Guptill, 1979).

STRAND, MARK. *Art of the Real: Nine American Figurative Painters* (New York: Clarkson Potter, 1983).

VARNEDOE, J. KIRK, ed. *Modern Portraits/ The Self and Others* (New York: Wildenstein Gallery, 1975).

AKRON, OHIO. Akron Art Museum. *The Image in American Painting & Sculpture, 1950–1980,* 1981. Texts by I. Michael Danoff and Carolyn Kinder Carr.

———. *Selections in Contemporary Real-*

*ism,* 1974. Text by Robert Doty.

BALTIMORE. Baltimore Museum of Art. *Super Realism,* 1976. Text by Brenda Richardson.

CHICAGO. Museum of Contemporary Art. *Radical Realism,* 1971. Text by Ivan C. Karp.

HARTFORD. Wadsworth Atheneum. *New Photo-Realism,* 1974. Text by Jack Cowart.

NEW YORK. Sidney Janis Gallery. *Sharp-Focus Realism,* 1972. Text by Sidney Janis.

KATONAH, N.Y. Katonah Art Gallery. *Realism Now,* 1973. Text by Patterson Sims.

LINCOLN, MASS. De Cordova and Dana Museum and Park. *The Super-Realist Vision,* 1973. Text by Carlo Lamagna.

LONDON. Serpentine Gallery. *Photo-Realism,* 1973. Text by Lawrence Alloway.

MILWAUKEE. Milwaukee Art Center. *Aspects of a New Realism,* 1969. Texts by Sidney Tillim and William S. Wilson.

NEW HAVEN. Yale University Art Gallery. *Seven Realists,* 1974. Text by Alan Shestack.

NEW YORK. Kornblee Gallery. *Figures,* 1962. Text by Jack Kroll.

NEW YORK. Museum of Modern Art. *Recent Painting USA: The Figure,* 1962. Text by Alfred H. Barr, Jr.

NEW YORK. New York Cultural Center. *Realism Now,* 1973. Text by Mario Amayo.

———. *The Realist Revival,* 1973. Text by Scott Burton.

NEW YORK. Riverside Museum. *Painting from the Photograph,* 1970. Text by Oriole Farb.

NEW YORK. Whitney Museum of American Art. *22 Realists,* 1970. Text by James Monte.

POUGHKEEPSIE. Vassar College Art Gallery. *Realism Now,* 1968. Text by Linda Nochlin.

TULSA. Philbrook Art Center. *Realism/Photo-Realism,* 1980. Text by John Arthur.

WORCESTER, MASS. Worcester Art Museum. *Three Realists: Close, Estes, Raffael,* 1974. Text by Leon Shulman.

ALLOWAY, LAWRENCE. "Notes on Realism," *Arts Magazine,* April 1970, pp. 26–29.

CHASE, LINDA. "Photo-Realism: Post Modernist Illusionism," *Art International,* March–April 1976, pp. 14–27.

CHASE, LINDA, NANCY FOOTE, AND TED MCBURNETT. "The Photo-Realists: 12 Interviews," *Art in America.* November–December 1972, pp. 73–89.

GOODYEAR, FRANK H., JR. "Contemporary Realism: The Challenge of Definition," *American Art Review,* November 1979, pp. 52–59.

GREENWOOD, MICHAEL. "Realism, Naturalism and Symbolism," *artscanada,* December 1976, pp. xxix–5.

———. "Toward a Definition of Realism," *artscanada,* December 1976–January 1977, pp. 6–22.

HENRY, GERRIT. "The Artist and the Face: A Modern American Sampling," *Art in America,* January–February 1975, pp. 34–41.

———. "The Real Thing," *Art International,* Summer 1972, pp. 87–91.

HICKEY, DAVID. "Sharp Focus Realism," *Art in America,* March–April 1972, pp. 116–18.

LADERMAN, GABRIEL. "Unconventional Realists," *Artforum,* November 1967, pp. 42–46.

LEVIN, KIM. "The New Realism: A Synthetic Slice of Life," *Opus International,* June 1973, pp. 28–37.

MACKIE, ALWYNNE. "New Realism and the Photographic Look," *American Art Review,* November 1978, pp. 72–79, 132–34.

MASHECK, JOSEPH. "Verist Sculpture: Hanson and De Andrea, *Art in America,* November–December 1972, pp. 90–97.

NEMSER, CINDY. "Close-Up Vision: Representational Arts," *Arts Magazine,* May 1972, pp. 44–48.

———. "Representational Painting in 1971," *Arts Magazine,* December 1971–January 1972, pp. 41–46.

———. "Sculpture and the New Realism," *Arts Magazine,* April 1970, pp. 39–41.

NOCHLIN, LINDA. "The Realist Criminal and the Abstract Law," part 1, *Art in America,* September–October 1973, pp. 54–61; part 2, November–December 1973, pp. 97–103.

PEARLSTEIN, PHILIP. "Figure Paintings Today Are Not Made in Heaven," *Art News,* Summer 1962, pp. 39, 51–52.

———. "Whose Painting Is It Anyway?" *Arts Yearbook. New York: The Art World* 7 (1964): 129–32.

PERREAULT, JOHN. "Photo Realist Principles," *American Art Review,* November 1978, pp. 108–11, 141.

RATCLIFF, CARTER. "Realisms (Before and After)," *Art International,* February 1971, pp. 70–71.

SCHORR, JUSTIN. "Destination: Realism," *Art in America,* June 1964, pp. 115–18.

SEITZ, WILLIAM C. "The Real and the Artificial: Painting of the New Environment," *Art in America,* November–December 1972, pp. 58–72.

TILLIM, SIDNEY. "The Figure and the Figurative in Abstract Expressionism," *Artforum,* September 1965, pp. 45–48.

———. "The Present Outlook on Figurative Painting," *Arts Yearbook. Perspectives on the Arts* 5 (1961): 37–59.

———. "Realism and 'The Problem,'" *Arts Magazine,* September 1963, pp. 48–52.

———. "The Reception of Figurative Art: Notes on a General Misunderstanding," *Artforum,* February 1969, pp. 30–33.

———. "A Variety of Realisms," *Artforum,* Summer 1969, pp. 42–48.

## OP ART, KINETIC ART, CONSTRUCTIVE TENDENCIES, AND TECHNOLOGICAL AND VIDEO ART

ALBERS, JOSEF. *Interaction of Color* (New Haven: Yale University Press, 1963).

ARNHEIM, RUDOLPH. *Art and Visual Perception* (London: Faber, 1969).

BANN, STEPHEN, ed. *The Tradition of Constructivism* (London: Thames and Hudson, 1974).

BANN, STEPHEN, REG GADNEY, and FRANK POPPER. *Four Essays on Kinetic Art* (London: Motion Books, 1966).

BARRETT, CYRIL. *Op Art* (London: Studio Vista, 1970).

BATTCOCK, GREGORY, ed. *New Artists Video: A Critical Anthology* (New York: E.P. Dutton, 1978).

BRETT, GUY. *Kinetic Art: The Language of Movement* (London: Studio Vista, 1968).

CARRAHER, RONALD, and JACQUELINE THURSTON. *Optical Illusions and the Visual Arts* (New York: Reinhold, 1966).

COMPTON, MICHAEL. *Optical and Kinetic Art* (London: Tate Gallery, 1967).

DAVIS, DOUGLAS. *Art and the Future* (New York: Praeger, 1973).

DAVIS, DOUGLAS, and ALLISON SIMMONS. *The New Television* (Cambridge, Mass.: MIT Press, 1978).

GREGORY, ALBERT. *Construction, Colour and Moiré* (New York: Wittenborn, 1965).

HALAS, JOHN, and ROGER MANVELL. *Art in Movement: New Directions in Animation* (New York: Hastings House, 1970).

HANHARDT, JOHN G., ed. *Video Culture: A Critical Investigation* (Layton, Utah: Peregrine Smith Books, 1986).

HILL, ANTHONY. *D.A.T.A.: Directions in Art, Theory and Aesthetics* (London: Faber and Faber, 1968).

HOLT, MICHAEL. *Mathematics in Art* (New York: Van Nostrand Reinhold, 1971).

KALLARD, THOMAS. *Laser Art & Optical Transforms* (New York: Optosonic, 1979).

KEPES, GYORGY, ed. *The Nature and Art of Motion* (New York: George Braziller, 1965).

KLÜVER, BILLY. *Bibliography of Documents on E.A.T. Activities* (New York: Experiments in Art and Technology, 1977).

KLÜVER, BILLY, JULIE MARTIN, and BARBARA ROSE, eds. *Pavillion by Experiments in Art and Technology* (New York: E.P. Dutton, 1972).

KRANZ, STEWART. *Science & Technology in the Arts: A Tour Through the Realm of Science/Art* (New York: Van Nostrand Reinhold, 1974).

LANCASTER, JOHN. *Introducing Op Art* (New York: Watson-Guptill, 1973).

MALINA, FRANK J., ed. *Kinetic Art, Theory and Practice: Selections from the Journal Leonardo* (New York: Dover, 1974).

MASTERS, ROBERT E.L., and JEAN HOUSTON. *Psychedelic Art* (New York: Grove, 1968). With texts by Stanley Krippner and Barry N. Schwartz.

PAROLA, RENE. *Optical Art* (New York: Van Nostrand Reinhold, 1969).

POPPER, FRANK. *Origins and Development of Kinetic Art* (Greenwich, Conn.: New York Graphic Society, 1968).

PRICE, JONATHAN. *Video Visions—A Medium Discovers Itself* (New York: New American Library, 1977).

REICHARDT, JASIA, ed. *Cybernetic Serendipity: The Computer and the Arts* (London: Studio International, 1968).

RICKEY, GEORGE. *Constructivism: Origins and Evolution* (New York: George Braziller, 1967).

SCHNEIDER, IRA, and BERYL KOROT, eds. *Video Art: An Anthology* (New York: Harcourt Brace Jovanovich, 1976).

SELZ, PETER. *Directions in Kinetic Art* (Berkeley: University of California Press, 1966).

SPIES, WERNER. *Albers* (New York: Harry N. Abrams, 1970).

STERN, RUDI. *Let There Be Neon* (New York: Harry N. Abrams, 1979).

TOVEY, JOHN. *The Technique of Kinetic Art* (New York: Van Nostrand Reinhold, 1971).

TUCHMAN, MAURICE. *Art & Technology: A Report of the Art & Technology Program at the Los Angeles County Museum of Art, 1967–71* (New York: Viking, 1976).

YOUNGBLOOD, GENE. *Expanded Cinema* (New York: E.P. Dutton, 1970).

BERKELEY. University Art Museum. *Directions in Kinetic Sculpture*, 1966. Texts by Peter Selz and George Rickey.

BUFFALO. Albright-Knox Art Gallery. *Constructivism and the Geometric Tradition*, 1979. Text by Willy Rotzler.

———. *Kinetic and Optic Art Today*, 1965. Text by Gordon Smith.

———. *Plus by Minus: Today's Half Century*, 1968. Text by Douglas MacAgy.

KANSAS CITY. Nelson-Atkins Museum of Art. *Sound Light Silence: Art That Performs*, 1966. Text by Ralph T. Coe.

MINNEAPOLIS. Walker Art Center. *Projected Images*, 1974. Texts by Regina Cornwall, Nina Felshin, Martin Friedman, Annette Michelson, Robert Pincus-Witten, Barbara Rose, and Roberta P. Smith.

NEW YORK. Brooklyn Museum. *Some More Beginnings: An Exhibition of Submitted Works Involving Technical Materials and Processes*, 1968. Text by Billy Klüver.

NEW YORK. Foundation for Contemporary Performance Arts in cooperation with Experiments in Art and Technology. *9 Evenings: Theatre & Engineering*, 1966. Text by Billy Klüver.

NEW YORK. Independent Curators, Inc. *Concepts in Construction*, 1982. Text by Irving Sandler.

NEW YORK. Jewish Museum. *Software*, 1970. Texts by Jack Burnham and Theodor H. Nelson.

NEW YORK. Museum of Modern Art. *Contrasts in Form: Geometric Abstract Art, 1910–1980*, 1985. Text by John Elderfield.

———. *The Machine as Seen at the End of the Mechanical Age*, 1968. Text by Pontus Hultén.

———. *The Responsive Eye*, 1965. Text by William C. Seitz.

NEW YORK. Whitney Museum of American Art. *Light: Object and Image*, 1968. Text by Robert Doty.

NEW YORK. Howard Wise Gallery. *On the Move*, 1964. Text by Douglas MacAgy.

PHILADELPHIA. Institute of Contemporary Art, University of Pennsylvania. *Video Art*, 1975. Texts by David Antin, Lizzie Borden, Jack Burnham, and John McHale.

TRENTON. New Jersey State Museum. *Focus on Light*, 1967. Texts by Lucy R. Lippard and Edward Ring.

WALTHAM, MASS. Rose Art Museum, Brandeis University. *Vision and Television*, 1970. Text by Russell Connor.

AARON, CHLOE. "The Video Underground," *Art in America*, May 1971, pp. 74–79.

ARGAN, GUILIO CARLO. "Un 'futuro tecnologico' per l'arte?" *Metro* 9 (March–April 1965): 14–19.

BAKER, ELIZABETH C. "The Light Brigade," *Art News*, March 1967, pp. 52–55, 63–66.

BATTCOCK, GREGORY. "Explorations in Video," *Art and Artists*, February 1973, pp. 22–27.

———. "Monuments to Technology," *Art and Artists*, May 1970, pp. 52–55.

BIEDERMAN, CHARLES. "The Visual Revolution of Structurist Art," *Artforum*, April 1965, pp. 34–38.

BURNHAM, JACK. "Corporate Art," *Artforum*, October 1971, pp. 66–71.

CANADAY, JOHN. "Art That Pulses, Quivers and Fascinates," *New York Times Magazine*, 21 February 1965, pp. 12–13, 55–57, 59.

CHANDLER, JOHN. "Art and Automata: Cybernetic Serendipity, Technology and Creativity," *Arts Magazine*, January 1969, pp. 42–45.

———. "Art in the Electric Age," *Art International*, 20 February 1969, pp. 19–25.

CLAY, JEAN. "Vasarely: A Study of His Work," *Studio International*, May 1967, pp. 229–41.

DAVIS, DOUGLAS. "Art & Technology—The New Combine," *Art in America*, January–February 1968, pp. 28–37.

———. "Video Obscura," *Artforum*, April 1972, pp. 64–72.

FONG, MONIQUE. "On Art and Technology," *Studio International*, January 1969, pp. 5–6.

HALAS, JOHN. "Kinetics and Automated Movements," *Ark* 35 (Spring 1964): 18–21.

GOLDIN, AMY. "Art and Technology in a Social Vacuum," *Art in America*, March–April 1972, pp. 46–71.

———. "A Note on Opticality," *Arts Magazine*, May 1966, pp. 53–54.

HESS, THOMAS B. "You Can Hang It in the Hall," *Art News*, April 1965, pp. 41–43, 49.

KAPROW, ALLAN. "Video Art: Old Wine, New Bottles," *Artforum*, June 1974, pp. 46–49.

KIRBY, MICHAEL. "The Experience of Kinesis," *Art News*, February 1968, pp. 42–45, 52–53, 71.

KLÜVER, BILLY, and SIMONE WHITMAN. "Theatre and Engineering: An Experiment," *Artforum*, February 1967, pp. 26–33.

KOZLOFF, MAX. "A Confession in Buffalo: 'Plus by Minus' Rather Amounts to Less . . .," *Artforum*, May 1968, pp. 50–53.

———. "The Multimillion Dollar Art Boondoggle," *Artforum*, October 1971, pp. 72–76.

KURTZ, BRUCE. "Video Is Being Invented," *Arts Magazine*, December 1973, pp. 37–44.

KRAUSS, ROSALIND. "Afterthoughts on

'Op,' " *Art International,* June 1965, pp. 75–76.

LANGSNER, JULES. "Kinetics in L.A.," *Art in America,* May–June 1967, pp. 107–9.

LEIDER, PHILIP. "Kinetic Sculpture at Berkeley," *Artforum,* May 1966, pp. 40–45.

LIPPARD, LUCY R. "Total Theatre?" *Art International,* 20 January 1967, pp. 39–44.

LIVINGSTONE, JANE. "Some Thoughts on 'Art and Technology,' " *Studio International,* June 1971, pp. 258–63.

LONDON, BARBARA. "Independent Video: The First Fifteen Years," *Artforum,* September 1980, pp. 38–41.

LONDON, BARBARA, with LORRAINE ZIPPAY. "A Chronology of Video Activity in the United States: 1965–1980," *Artforum,* September 1980, pp. 42–45.

MARADEL, J. PATRICE. "Art & Technology," *Art International,* 20 June 1971, pp. 100–103.

MARGOLIES, JOHN S. "TV—The Next Medium," *Art in America,* September–October 1969, pp. 48–55.

METZGER, GUSTAV. "Kinetics," *Art and Artists,* September 1970, pp. 22–25.

O'BRIEN, GLENN. "Psychedelic Art: Flashing Back," *Artforum,* March 1984, pp. 73–79.

OSTER, GERALD. "Phosphenes," *Art International,* 20 May 1966, pp. 36, 43–44.

OSTER, GERALD, and NISHIJIMA YASHUMORI. "Moiré Patterns," *Scientific American,* May 1963, pp. 54–63.

PIENE, NAN R. "Light Art," *Art in America,* May–June 1967, pp. 24–47.

PIENE, OTTO. "The Proliferation of the Sun: On Art, Fine Arts, Present Art, Kinetic Art, Light, Light Art, Scale, Now and Then," *Arts Magazine,* Summer 1967, pp. 24–31.

PINCUS-WITTEN, ROBERT. "Sound, Light and Silence in Kansas City," *Artforum,* January 1967, pp. 51–52.

REICHARDT, JASIA. "Cybernetic Serendipity," *Studio International,* November 1968, p. 220.

———. "E.A.T. and After," *Studio International,* May 1968, pp. 236–37.

RICKEY, GEORGE. "Kinesis Continued," *Art in America,* December 1965–January 1966, pp. 45–55.

———. "Origins of Kinetic Art," *Studio International,* January 1967, p. 67.

———. "Scandale de Succès," *Art International,* 4 May 1965, pp. 16–23.

ROSE, BARBARA. "Beyond Vertigo: Optical Art at the Modern," *Artforum,* April 1965, pp. 30–33.

SCHWARTZ, BARRY N. "Psychedelic Art: The Artist Beyond Dreams," *Arts Magazine,* April 1968, pp. 39–41.

SEITZ, WILLIAM C. "The New Perceptual Art," *Vogue,* 15 February 1965, pp. 79–80, 142–43.

SELZ, PETER. "Arte Programmata," *Arts Magazine,* March 1965, pp. 16–21.

———. "The Berkeley Symposium on Kinetic Sculpture," part 1, *Art and Artists,* February 1967, pp. 26–31; part 2, March 1967, pp. 46–49.

SPEAR, ATHENA TACHA. "Sculptured Light," *Art International,* December 1967, pp. 29–50.

SPRUCH, GRACE MARMOR. "Two Contributions to the Art and Science Muddle," *Artforum,* January 1969, pp. 28–32.

TILLIM, SIDNEY. "Optical Art: Pending or Ending?" *Arts Magazine,* January 1965, pp. 16–23.

TUCHMAN, MAURICE. "Art and Technology," *Art in America,* March–April 1970, pp. 78–79.

———. "An Introduction to 'Art and Technology,' " *Studio International,* April 1971, pp. 173–80.

YALKUT, JUD. "Propheteer?" *Arts Magazine,* February 1967, pp. 22–23.

———. "The Psychedelic Revolution," *Arts Magazine,* November 1966, pp. 22–23.

———. "Understanding Inter-media," *Arts Magazine,* May 1967, pp. 18–19.

# POP ART

ALLOWAY, LAWRENCE. *American Pop Art* (New York: Macmillan/Collier, 1974).

AMAYA, MARIO. *Pop Art . . . and After* (New York: Viking, 1966).

COMPTON, MICHAEL. *Pop Art* (London: Hamlyn, 1970).

GELDZAHLER, HENRY. *Pop Art, 1955–70* (Sydney: Cultural Corporation of Australia, 1985).

FINCH, CHRISTOPHER. *Pop Art: Object and Image* (New York: E. P. Dutton, 1968).

LIPPARD, LUCY R. *Pop Art* (New York: Praeger, 1966). Additional texts by Lawrence Alloway, Nicolas Calas, and Nancy Marmer.

RUBLOWSKY, JOHN. *Pop Art* (New York: Basic Books, 1965).

RUSSELL, JOHN, and SUZI GABLIK. *Pop Art Redefined* (New York: Praeger, 1969).

WILSON, SIMON. *Pop* (London: Thames and Hudson, 1974).

AMSTERDAM. Stedelijk Museum. *American Pop Art,* 1964. Text by Alan R. Solomon.

BERLIN. Akademie der Kunst. *Neue Realisten und Pop Art,* 1964. Text by Werner Hofmann.

BUFFALO. Albright-Knox Art Gallery. *Mixed Media and Pop Art,* 1963. Text by Gordon Smith.

HOUSTON. Contemporary Art Museum. *Pop Goes the Easel,* 1963. Text by Douglas MacAgy.

KANSAS CITY. Nelson-Atkins Museum of Art. *Popular Art,* 1963. Text by Ralph T. Coe.

LOS ANGELES. Dwan Gallery. *My Country 'Tis of Thee,* 1962. Text by Gerald Nordland.

LOS ANGELES. Los Angeles County Museum of Art. *Six More,* 1963. Text by Lawrence Alloway.

MILWAUKEE. Milwaukee Art Center. *Pop Art and the American Tradition,* 1965. Text by Tracy Atkinson.

NEW YORK. Sidney Janis Gallery. *New Realists,* 1962. Texts by John Ashbery, Sidney Janis, and Pierre Restany.

NEW YORK. Solomon R. Guggenheim Museum. *Six Painters and the Object,* 1963. Text by Lawrence Alloway.

OAKLAND, CALIF. Oakland Art Museum. *Pop Art USA,* 1963. Text by John Coplans.

PASADENA. Pasadena Art Museum. *New Paintings of Common Objects,* 1962. Text by John Coplans.

PHILADELPHIA. YM/YWHA. *A New Vocabulary,* 1962. Text by Billy Klüver.

STOCKHOLM. Moderna Museet. *Amerikanste Pop-Kunst,* 1964. Texts by Alan R. Solomon and Billy Klüver.

TORONTO. Art Gallery of Ontario. *Painting/Sculpture—Dine, Oldenburg, Segal,* 1967. Text by Ellen J. Johnson.

WASHINGTON, D.C. Washington Gallery of Modern Art. *The Popular Image,* 1963. Text by Alan R. Solomon.

WORCESTER, MASS. Worcester Art Museum. *The New American Realism,* 1965. Texts by Daniel Catton Rich and Martin Carey.

ALFIERI, BRUNO. "Art's Condition: 'Pop' Means 'Not Popular,' " *Metro* 9 (1965): 4–13.

ALLOWAY, LAWRENCE. "Highway Culture," *Arts Magazine,* February 1967, pp. 28–33.

———. "Popular Culture and Pop Art," *Studio International,* July–August 1969, pp. 17–21.

BALDWIN, CARL R. "On the Nature of Pop," *Artforum,* June 1974, pp. 34–38.

CALAS, NICOLAS. "Why Not Pop Art?" *Art and Literature* 4 (Spring 1965): 178–84.

CANADAY, JOHN. "Pop Art Sells On and On—Why?" *New York Times Magazine,* 31 May 1974, pp. 7, 48, 52–53.

COPLANS, JOHN. "The New Paintings of Common Objects," *Artforum* 6 (1962): 26–29.

———. "Pop Art, U.S.A.," *Artforum*, October 1963, pp. 27–30.

GABLIK, SUZI. "Protagonists of Pop: Five Interviews" (Leo Castelli, Richard Bellamy, Robert C. Scull, Dr. Hubert Peeters, and Robert Fraser), *Studio International*, July–August 1969, pp. 9–12.

GLASER, BRUCE. "Lichtenstein, Oldenburg, Warhol: A Discussion," *Artforum*, February 1966, pp. 20–24.

GRAY, CLEVE. "Rembergers and Hambrandts," *Art in America*, November 1963, pp. 118–29.

THOMAS B. HESS. "Editorial: Pop and Public," *Art News*, December 1963, pp. 23, 59–60.

———. "Reviews and Previews: 'New Realists,'" *Art News*, December 1962, pp. 12–13.

IRWIN, DAVID. "Pop Art and Surrealism," *Studio International*, May 1966, pp. 187–91.

JOHNSON, ELLEN H. "The Image Duplicators—Lichtenstein, Rauschenberg, Warhol," *Canadian Art*, January–February 1966, pp. 12–19.

KARP, IVAN C. "Anti-Sensibility Painting," *Artforum*, September 1963, pp. 26–27.

KELLY, EDWARD T. "Neo-Dada: A Critique of Pop Art," *College Art Journal*, Spring 1964, pp. 192–201.

KOZLOFF, MAX. "'Pop' Culture, Metaphysical Disgust, and the New Vulgarians," *Art International*, March 1962, pp. 34–36.

KUSPIT, DONALD B. "Pop Art: A Reactionary Realism," *Art Journal*, Fall 1976, pp. 31–38.

LORING, JOHN. "Comic Strip Pop," *Arts Magazine*, September 1974, pp. 48–50.

NORDLAND, GERALD. "Marcel Duchamp and Common Object Art," *Art International* 1 (1964): 30–32.

———. "Pop Goes the West," *Arts Magazine*, February 1963, pp. 60–62.

O'DOHERTY, BRIAN. "'Pop' Goes the New Art," *New York Times*, 4 November 1962, p. 23.

REICHARDT, JASIA. "Pop Art and After," *Art International*, February 1963, pp. 42–47.

RESTANY, PIERRE. "Le Nouveau Réalisme à la conquête de New York," *Art International*, 25 January 1963, pp. 29–38.

———. "The World of Art: Paris Letter—The New Realism," *Art in America* 1 (1963): 102–4.

ROSE, BARBARA. "Pop Art at the Guggenheim," *Art International*, 25 May 1963, pp. 20–22.

———. "Pop in Perspective," *Encounter*, August 1965, pp. 59–63.

ROSENBLUM, ROBERT. "Pop Art and Non-Pop Art," *Art and Literature* 5 (Summer 1965): 80–93.

RUDIKOFF, SONYA. "New Realists in New York," *Art International*, 1 January 1963, pp. 38–41.

RUSSELL, JOHN. "Persistent Pop," *New York Times Magazine*, 21 July 1974, pp. 6–7, 25–34.

———. "Pop Reappraised," *Art in America*, July 1969, pp. 78–89.

SAARINEN, ALINE B. "Explosion of Pop Art," *Vogue*, 15 April 1963, pp. 85–87, 134, 136, 142.

SANDBERG, J. "Some Traditional Aspects of Pop Art," *Art Journal*, Spring 1967, pp. 228–33, 245.

SECKLER, DOROTHY GEES. "Folklore of the Banal," *Art in America*, Winter 1962, pp. 52–61.

SELZ, PETER. "Pop Goes the Artist," *Partisan Review*, Summer 1963, pp. 313–16.

SOLOMON, ALAN R. "The New American Art," *Art International*, 20 March 1964, pp. 54–55.

———. "The New Art," *Art International*, 25 September 1963, pp. 37–41.

SWENSON, G. R. "The New American 'Sign Painters,'" *Art News*, September 1962, pp. 44–47, 60–62.

———. "What Is Pop Art?" *Art News*, November 1977, p. 170.

———, ed. "What Is Pop Art?" part 1, *Art News*, November 1963, pp. 24–27, 60–64 (interviews with Jim Dine, Robert Indiana, Roy Lichtenstein, Andy Warhol); part 2, February 1964, pp. 40–43, 62–66 (interviews with Stephen Durkee, James Rosenquist, Jasper Johns, Tom Wesselmann).

"A Symposium on Pop Art," *Arts Magazine*, April 1963, pp. 36–35. (The symposium took place at the Museum of Modern Art, 13 December 1962. The participants were Dore Ashton, Henry Geldzahler, Hilton Kramer, Stanley Kunitz, Leo Steinberg, and Peter Selz [moderator].)

TILLIM, SIDNEY. "Further Observations on the Pop Phenomena: 'All Revolutions Have Their Ugly Aspects,'" *Artforum*, November 1965, pp. 17–19.

———. "In the Galleries: The New Realists," *Arts Magazine*, December 1962, pp. 43–44.

TUCHMAN, PHYLLIS. "Pop! Interviews with George Segal, Andy Warhol, Roy Lichtenstein, James Rosenquist, and Robert Indiana," *Art News*, May 1974, pp. 24–29.

WOLFRAM, EDDIE. "Pop Art Undefined," *Art and Artists*, September 1969, pp. 18–19.

## POST-PAINTERLY PAINTING

BUFFALO. Albright-Knox Art Gallery. *Color and Field, 1890–1970*, 1970. Text by Priscilla Colt.

CAMBRIDGE, MASS. Fogg Art Museum, Harvard University. *Three American Painters: Kenneth Noland, Jules Olitski, Frank Stella*, 1965. Text by Michael Fried.

LOS ANGELES. Los Angeles County Museum of Art. *Post-Painterly Abstraction*, 1964. Text by Clement Greenberg.

NEW YORK. Jewish Museum. *Toward a New Abstraction*, 1963. Text by Ben Heller.

NEW YORK. Whitney Museum of American Art. *The Structure of Color*, 1971. Text by Marcia Tucker.

REGINA, SASKATCHEWAN, CANADA. Norman Mackenzie Art Gallery. *Three American Painters: Louis, Noland, Olitski*, 1965. Text by Clement Greenberg.

WASHINGTON, D.C. Washington Gallery of Modern Art. *The Washington Color Painters*, 1963. Text by Gerald Nordland.

BAIGELL, MATTHEW. "American Abstract Expressionism and Hard Edge: Some Comparisons," *Studio International*, January 1966, pp. 10–15.

CARMEAN, E.A. "Modernist Art: 1960–1970," *Studio International*, July–August 1974, pp. 9–15.

COPLANS, JOHN. "Post-Painterly Abstraction: The Long-Awaited Greenberg Exhibition Fails to Make Its Point," *Artforum*, June 1964, pp. 4–9.

FINLEY, GERALD E. "Louis, Noland, Olitski," *Artforum*, March 1963, pp. 34–35.

GLASER, BRUCE. "The New Abstraction: A Discussion [with Paul Brach, Al Held, and Ray Parker]," *Art International*, February 1966, pp. 41–45.

GREENBERG, CLEMENT. "After Abstract Expressionism," *Art International*, 25 October 1962, pp. 24–32.

———. "Influences of Matisse," *Art International*, 15 November 1973, pp. 28–31, 39.

———. "Louis and Noland," *Art International*, 25 May 1960, pp. 26–29.

———. "Post-Painterly Abstraction," *Art International*, Summer 1964, pp. 63–65.

KRAUSS, ROSALIND E. "On Frontality," *Artforum*, May 1968, pp. 40–46.

ROSE, BARBARA. "Abstract Illusionism," *Artforum*, October 1967, pp. 33–37.

———. "'Formalists' at the Washington Gallery of Modern Art," *Art International*, September 1963, pp. 42–43.

———. "The Primacy of Color," *Art International*, May 1964, pp. 22–26.

STEVENS, ELISABETH. "The Washington Color Painters," *Arts Magazine,* November 1965, pp. 29–33.

## PROCESS ART

NEW YORK. Finch College Museum of Art. *Art in Process: The Visual Development of a Structure,* 1966. Text by Elaine H. Varian.

NEW YORK. Fischbach Gallery. *Eccentric Abstraction,* 1966. Text by Lucy R. Lippard.

NEW YORK. Whitney Museum of American Art. *Anti-Illusion: Procedures/Materials,* 1969. Texts by James Monte and Marcia Tucker.

ANTIN, DAVID. "Another Category: 'Eccentric Abstraction,' " *Artforum,* November 1966, pp. 56–57.

ASHTON, DORE. "Exercises in Anti-Style: Six Ways of Regarding Un, In, and Anti-Form," *Arts Magazine,* April 1969, pp. 45–57.

KOZLOFF, MAX. "9 in a Warehouse," *Artforum,* February 1969, pp. 38–42.

LIPPARD, LUCY R. "Eccentric Abstraction," *Art International,* 20 November 1966, pp. 28, 34–40.

MONTE, JAMES. " 'Making It' with Funk," *Artforum,* Summer 1967, pp. 56–59.

MORRIS, ROBERT. "Anti-Form," *Artforum,* April 1968, pp. 33–35.

———. "Notes on Sculpture, Part 4: Beyond Objects," *Artforum,* April 1969, pp. 50–54.

———. "Some notes on the Phenomenology of Making: The Search for the Motivated," *Artforum,* April 1970, pp. 67–75.

MÜLLER, GREGOIRE. "Robert Morris Presents Anti-Form: The Castelli Warehouse Show," *Arts Magazine,* February 1969, pp. 29–30.

PARIS, HAROLD. "Sweet Land of Funk," *Art in America,* March–April 1967, pp. 95–98.

SELZ, PETER. "Funk Art," *Art in America,* March–April 1967, pp. 92–93.

WASSERMAN, EMILY. "New York: Process, Whitney Museum," *Artforum,* September 1969, pp. 57–61.

## ARTISTS' BIBLIOGRAPHIES

### VITO ACCONCI

CHICAGO. Museum of Contemporary Art. *Vito Acconci: A Retrospective, 1969–1980,* 1980. Text by Judith Kirshner.

LA JOLLA, CALIF. La Jolla Museum of Contemporary Art. *Vito Acconci: Domestic Trappings,* 1987. Text by Ronald J. Onorato.

ACCONCI, VITO. "Notes on Work," *Avalanche* 5 (Acconci issue) (1972): 2, 4, 6, 8, 30, 43, 53, 62.

BURNHAM, JACK. "Acconci in a Tight Spot," an interview, *New Art Examiner,* May 1980, pp. 1, 8–11.

CELANT, GERMANO. "Dirty Acconci," *Artforum,* November 1980, pp. 76–83.

———. "Vito Acconci," *Domus,* April 1972, pp. 54–56.

GILBARD, F. "An Interview with Vito Acconci," *Afterimage,* November 1984, pp. 9–15.

GREENBERG, B. "Vito Acconci: The State of the Art," *Arts Magazine,* June 1985, pp. 120–23.

LEVINE, EDWARD. "In Pursuit of Acconci," *Artforum,* April 1977, pp. 38–41.

NEMSER, CINDY. "An Interview with Vito Acconci," *Arts Magazine,* March 1971, pp. 20–23.

PINCUS-WITTEN, ROBERT. "Vito Acconci and the Conceptual Performance," *Artforum,* April 1972, pp. 47–49.

RICKEY, CARRIE. "Vito Acconci—The Body Impolitic," *Art in America,* October 1980, pp. 118–23.

SCHWARTZ, ELLEN. "Vito Acconci: 'I want to put the viewer on shaky ground,' " *Art News,* June 1981, pp. 93–99.

WHITE, ROBIN. "Vito Acconci," an interview, *View* (Oakland, Calif.: Crown Point Press, 1979).

### CARL ANDRE

ANDRE, CARL. *12 Dialogues, 1962–1963/Carl Andre, Hollis Frampton* (New York: New York University Press, 1981).

BOURDON, DAVID. *Carl Andre: Sculpture 1959–1977* (New York: Jaap Rietman, 1978). Text by Barbara Rose.

BERN. Kunsthalle. *Carl Andre Sculpture, 1958–1974,* 1975. Text by Angela Westwater.

LONDON. Whitechapel Art Gallery. *Carl Andre Sculpture, 1959–1977,* 1978. Text by Nicholas Serota.

NEW YORK. Solomon R. Guggenheim Museum. *Carl Andre,* 1970. Text by Diane Waldman.

EINDHOVEN. Van Abbemuseum. *Wood/Carl Andre,* 1978. Text by R. H. Fuchs.

THE HAGUE. Gemeentemuseum. *Carl Andre,* 1969. Text by Enno Develing and Hollis Frampton.

BAKER, KENNETH. "Andre in Retrospect," *Art in America,* April 1980, pp. 88–94.

BOURDON, DAVID. "The Razed Sites of Carl Andre," *Artforum,* October 1966, pp. 14–17.

DEVELING, ENNO. "Sculpture in Place," *Art and Artists,* November 1970, pp. 18–21.

GRAHAM, DAN. "Carl Andre," *Arts Magazine,* January 1968, pp. 34–35.

NAUMANN, FRANCIS. "From Origin to Influence and Beyond: Brancusi's Column Without End," *Arts Magazine,* May 1985, pp. 112–18.

SHARP, WILLOUGHBY. "Carl Andre," an interview, *Avalanche,* Fall 1970, pp. 18–27.

SIEGEL, JEANNE. "Carl Andre: Artworker," *Studio International,* November 1970, pp. 175–79.

TUCHMAN, PHYLLIS. "Background of a Minimalist: Carl Andre," *Artforum,* March 1978, pp. 29–33.

———. "An Interview with Carl Andre," *Artforum,* June 1970, pp. 55–61.

VAN TIEGHEM, JEAN-PIERRE. "Carl Andre," *Opus International,* March 1970, pp. 79–80.

WALDMAN, DIANE. "Holding the Floor," *Art News,* October 1970, pp. 60–62, 75–79.

### STEPHEN ANTONAKOS

HOUSTON. Contemporary Art Museum. *Antonakos "Pillows," 1962–63,* 1971. Text by Naomi Spector.

LA JOLLA, CALIF. La Jolla Museum of Contemporary Art. *Stephen Antonakos: Neons and Works on Paper,* 1984. Text by Sally Yard.

OSHKOSH, WISC. Allen Priebe Art Gallery. *Stephen Antonakos Neons,* 1971. Texts by John Ashbery, Elizabeth C. Baker, Robert Doty, Norman A. Geske, Sol LeWitt, Lucy R. Lippard, Robert Mangold, and Robert Ryman.

DAVIES, HUGH M. "Stephen Antonakos 'Neon,' " *Arts Magazine,* January 1979, pp. 142–44.

DREISS, JOSEPH. "Stephen Antonakos," *Arts Magazine,* March 1974, pp. 54–55.

THORP, CHARLOTTE. "Stephen Antonakos," *Arts Magazine,* April 1967, pp. 61–62.

### RICHARD ANUSZKIEWICZ

Lunde, Karl. *Anuszkiewicz* (New York: Harry N. Abrams, 1977).

LA JOLLA, CALIF. La Jolla Museum of Contemporary Art. *Richard Anuszkiewicz,* 1976. Text by Richard Armstrong.

LINCOLN, MASS. De Cordova and Dana

Museum and Park. *Paintings by Richard Anuszkiewicz,* 1972. Text by Carlo M. Lamagna.

DOTY, ROBERT. "Richard Anuszkiewicz," *Museum News,* January 1970, pp. 11–12.

GRUEN, JOHN. "Richard Anuszkiewicz: 'A beautiful discourse with space,'" *Art News,* September 1979, pp. 68–74.

JACOBS, JAY. "Portrait of the Artist—Richard Anuszkiewicz," *Art Gallery Magazine,* March 1971, pp. 21–35.

## RICHARD ARTSCHWAGER

BASEL. Kunsthalle. *Richard Artschwager,* 1985. Text by Jean-Christophe Ammann.

BUFFALO. Albright-Knox Art Gallery. *Richard Artschwager's Theme(s),* 1979. Texts by Suzanne Delehanty, Linda L. Cathcart, and Richard Armstrong.

CHICAGO. Museum of Contemporary Art. *Richard Artschwager,* 1973. Texts by Richard Artschwager and Catherine Kord.

ARTSCHWAGER, RICHARD. "Hydraulic Door Check," *Arts Magazine,* November 1967, pp. 41–43.

BAKER, ELIZABETH C. "Artschwager's Mental Furniture," *Art News,* January 1968, pp. 48–49, 58–61.

BRUGGEN, COOSJE VAN. "Richard Artschwager," *Artforum,* September 1983, pp. 44–51.

KERBER, BERNHARD. "Richard Artschwager," *Kunstforum International,* January 1974, pp. 124–31.

WELISH, MARJORIE. "The Elastic Vision of Richard Artschwager," *Art in America,* May–June, 1978, pp. 86–87.

## WILLIAM BAILEY

NEW YORK. Robert Schoelkopf Gallery. *William Bailey,* 1979. Text by Mark Strand.

———. *William Bailey,* 1982. Text by John Hollander.

———. *William Bailey,* 1986. Text by Andrew Forge.

PARIS. Galerie Bernard. *William Bailey,* 1978. Text by Hilton Kramer.

GRUEN, JOHN. "William Bailey: Mystery and Mastery," *Art News,* November 1979, pp. 140–45.

## JOHN BALDESSARI

NEW YORK. New Museum. *John Baldessari,* 1982. Texts by Marcia Tucker and

Robert Pincus-Witten. Interview by Nancy Drew.

COLLINS, JAMES. "Pointing, Hybrids, and Romanticism: John Baldessari," *Artforum,* October 1973, pp. 53–58.

DROHOJOWSKA, HUNTER. "No More Boring Art," *Art News,* January 1986, pp. 62–69.

FOOTE, NANCY. "John Baldessari," *Artforum,* January 1976, pp. 37–45.

FOSTER, HAL. "John Baldessari's Blasted Allegories," *Artforum,* October 1979, pp. 52–55.

OWENS, CRAIG. "Telling Stories: A Recent Collection of John Baldessari's Narrative Art," *Art in America,* May 1981, pp. 129–35.

## ROBERT BARRY

EINDHOVEN. Stedelijk van Abbemuseum. *Robert Barry,* 1977. Text by Jan Debbaut and R.H. Fuchs.

LUCERNE. Kunstmuseum. *Robert Barry,* 1974. Text by Jean-Christophe Ammann.

OMAHA. Joselyn Art Museum. *Robert Barry,* 1980. Text by Holliday T. Day.

BROOKS, ROSETTA. "Robert Barry," *Flash Art,* April 1974, p. 18.

OLIVA, A. B. "Robert Barry," an interview, *Domus,* August 1973, pp. 55–56.

STIMSON, PAUL. "Between the Signs," *Art in America,* October 1979, pp. 80–81.

WHITE, ROBIN. "Robert Barry," an interview, *View* (Oakland, Calif.: Crown Point Press, 1978).

## JACK BEAL

MADISON, WISC. Madison Art Center. *Jack Beal: Prints & Related Drawings,* 1977. Text by Joseph Wilfer.

PARIS. Galerie Claude Bernard. *Jack Beal,* 1973. Text by Mark Strand.

RICHMOND, VA. Virginia Museum. *Jack Beal,* 1973. Text by John Arthur.

COTTINGHAM, J. "For Real: Paintings by Jack Beal," *American Artist,* November 1980, pp. 58–63.

CUMMINGS, PAUL. "Interview," *Drawing,* March–April 1981, pp. 128–31.

HENRY, GERRIT. "Jack Beal: A Commitment to Realism," *Art News,* December 1984, pp. 94–100.

## LARRY BELL

PASADENA. Pasadena Art Museum, *Larry Bell,* 1972. Text by Barbara Haskell.

SANTA FE, N.M. Museum of Fine Arts. *Larry Bell: The Sixties,* 1982. Text by Larry Bell.

YONKERS, N.Y. Hudson River Museum. *Larry Bell: New Work,* 1981. Text by Melinda Wortz.

COPLANS, JOHN. "Larry Bell," *Artforum,* June 1965, pp. 27–29.

DANIELI, FIDEL. "Bell's Progress," *Artforum,* Summer 1967, pp. 68–70.

KUTNER, JANET. "Larry Bell's Iceberg," *Arts Magazine,* January 1976, pp. 62–66.

MACINTOSH, ALASTAIR. "Larry Bell," an interview, *Art and Artists,* January 1972, pp. 39–41.

PLAGENS, PETER. "Larry Bell Reassesses," *Artforum,* October 1972, pp. 71–73.

## JOSEPH BEUYS

GOTZ, A., WINFRIED KONNERTZ, and KARIN THOMAS. *Joseph Beuys: Life and Works* (Cologne: M. DuMont Schauberg, 1973).

EINDHOVEN. Stedelijk van Abbemuseum. *Beuys,* 1968. Text by Otto Mauer.

NEW YORK. Solomon R. Guggenheim Museum. *Joseph Beuys,* 1979. Text by Caroline Tisdall.

BUCHLOH, BENJAMIN H.D. "Beuys: The Twilight of the Idol," *Artforum,* January 1980, pp. 35–43.

———, ROSALIND KRAUSS, and ANNETTE MICHELSON. "Joseph Beuys at the Guggenheim," *October* 12 (Spring 1980): 3–21.

DEAK, EDIT, and WALTER ROBINSON. "Beuys: Art Encage," *Art in America,* November–December 1974, pp. 76–79.

DE MARCO, RICHARD. "Art into Time: Conversations with Artists—Richard De Marco Interviews Joseph Beuys, London, March 1982," *Studio International,* September 1982, pp. 46–47.

"Joseph Beuys Rapping at Documenta 5," *Avalanche* 5 (Summer 1972): 12–15.

KORNIER, HANS, and REINHARD STEINER. "Plastic Self-Determination: A Critical Essay on Joseph Beuys," *Kunstwerk,* June 1982, pp. 32–41.

KUSPIT, DONALD. "Beuys: Fat, Felt, and Alchemy," *Art in America,* May 1980, pp. 78–89.

LARSON, KAY. "Joseph Beuys: Shaman, Sham or Brilliant Artist?" *Art News,* April 1980, pp. 126–27.

MEYER, URSULA. "How to Explain Pictures to a Dead Hare," *Art News,* January 1970, pp. 54–57, 71.

SHARP, WILLOUGHBY. "An Interview with Joseph Beuys," *Artforum,* December 1969, pp. 40–47.

Tisdall, Caroline. "Beuys: Coyote," *Studio International,* July–August 1976, pp. 36–40.

———, Jimmy Boyle, and Joseph Beuys. "A Dialogue," *Studio International,* March–April 1976, pp. 144–45.

Thwaites, John Anthony. "The Ambiguity of Joseph Beuys," *Art and Artists,* November 1971, pp. 22–23.

## RONALD BLADEN

Hofstra, N.Y. Emily Lowe Gallery, Hofstra University. *Ronald Bladen Sculpture,* 1967. Text by Michael Phillips.

Vancouver. Vancouver Art Gallery. *Ronald Bladen/Robert Murray,* 1970. Texts by the artists.

Berkson, Bill. "Ronald Bladen: Sculpture and Where We Stand," *Art and Literature,* Spring 1967, pp. 139–50.

Kingsley, April. "Ronald Bladen," *Art International,* 20 September 1974, pp. 42–44.

Lippard, Lucy R. "Ronald Bladen's 'Black Triangle,'" *Artforum,* March 1967, pp. 26–27.

Robins, Corinne. "The Artist Speaks: Ronald Bladen," *Art in America,* September 1969, pp. 76–81.

Sandler, Irving. "Ronald Bladen: '. . . sensations of a different order . . .'" *Artforum,* October 1966, pp. 32–35.

## MEL BOCHNER

Baltimore. Baltimore Museum of Art. *Mel Bochner: Number and Shape,* 1976. Text by Brenda Richardson.

Pittsburgh. Carnegie-Mellon University Art Gallery. *Mel Bochner: 1973–1985.* Text by Elaine A. King. Interview by Charles Stuckey.

Benthall, Jonathan. "Bochner and Photography," *Studio International,* April 1971, pp. 147–48.

Collings, Betty. "Mel Bochner's Art as a Study of Mental Processes," *Arts Magazine,* May 1984, pp. 86–89.

Coplans, John. "Mel Bochner on Malevich, an Interview," *Artforum,* June 1974, pp. 59–60.

Haller, L. "Bochner, an Interview," *Flash Art,* June 1973, pp. 14–15.

"Mel Bochner," *Data 2,* February 1972, pp. 66–67.

Perrone, Jeff. "Mel Bochner: Getting from A to B," *Artforum,* January 1978, pp. 24–32.

Pincus-Witten, Robert. "Bochner at MoMA: Three Ideas and Seven Procedures," *Artforum,* December 1971, pp. 28–30.

———. "Mel Bochner: The Constants as Variable," *Artforum,* December 1972, pp. 28–34.

van der Marck, Jan. "Mel Bochner: Point to Point," *Artforum,* April 1986, pp. 101–5.

Westfall, Stephen. "Bochner Unbound," *Art in America,* July 1985, pp. 103–13.

## LOUISE BOURGEOIS

New York. Robert Miller Gallery. *Louise Bourgeois,* 1982. Text by Robert Pincus-Witten.

New York. Museum of Modern Art. *Louise Bourgeois,* 1982. Text by Deborah Wye.

Baldwin, Carl R. "Louise Bourgeois: An Iconography of Abstraction," *Art in America,* March–April 1975, pp. 82–83.

Block, Susi. "An Interview with Louise Bourgeois," *Art Journal,* Summer 1976, pp. 370–73.

Bourgeois, Louise. Statement in Philip Pearlstein, "The Private Myth," *Art News,* September 1961, pp. 42–45, 62.

Gardner, Paul. "The Discreet Charm of Louise Bourgeois," *Art News,* February 1980, pp. 80–86.

Lippard, Lucy R. "Louise Bourgeois: From the Inside Out," *Artforum,* March 1975, pp. 26–33.

Marandel, J. Patrice. "Louise Bourgeois," *Art International,* 20 December 1971, pp. 46–47.

Ratcliff, Carter. "Louise Bourgeois," *Art International,* November–December 1978, pp. 27–28.

———. "Louise Bourgeois," *Vogue,* October 1980, pp. 342–43, 375–77.

Robbins, Daniel. "Sculpture by Louise Bourgeois," *Art International,* 20 October 1964, pp. 29–31.

Robins, Corinne. "Louise Bourgeois: Primordial Environments," *Arts Magazine,* June 1976, pp. 81–83.

Rubin, William S. "Some Reflections Prompted by the Recent Work of Louise Bourgeois," *Art International,* 20 April 1969, pp. 17–18.

## ANTHONY CARO

Blume, Dieter. *Anthony Caro,* catalogue raisonné in five volumes (Cologne: Galerie Wentzel, 1981, 1986).

Fenton, Terry. *Anthony Caro* (London: Thames and Hudson, 1986).

Rubin, William. *Anthony Caro* (New York: Museum of Modern Art, 1975).

Waldman, Diane. *Anthony Caro* (Oxford: Phaidon, 1982).

Whelan, Richard. *Anthony Caro* (Harmondsworth, Middlesex, England. Penguin, 1974). Additional essays by Michael Fried, Clement Greenberg, John Russell, and Phyllis Tuchman.

London. Hayward Gallery. *Anthony Caro: 1954–1968,* 1969. Text by Michael Fried.

London. Whitechapel Gallery. *Anthony Caro,* 1963. Text by Michael Fried.

"Anthony Caro's Work: A Symposium by Four Sculptors—David Annesley, Roelof Louw, Tim Scott, William Tucker," *Studio International,* January 1969, pp. 14–20.

Baro, Gene. "Caro," *Vogue,* May 1970, pp. 208–11, 276.

Cone, Jane Harrison. "Caro in London," *Artforum,* April 1969, pp. 62–66.

Dempsey, Michael. "The Caro Experience," *Art and Artists,* February 1969, pp. 16–19.

Feaver, William. "Anthony Caro," *Art International,* 20 May 1974, pp. 24–25, 33–34.

Forge, Andrew. "An Interview with Anthony Caro," *Studio International,* January 1966, pp. 6–9.

Fried, Michael. "Caro's Abstractness," *Artforum,* September 1970, pp. 32–34.

———. "New Work by Anthony Caro," *Artforum,* February 1967, pp. 46–47.

———. "Two Sculptures by Anthony Caro," *Artforum,* February 1968, pp. 24–25.

Fuller, Peter. "Anthony Caro," a discussion, *Art Monthly,* February 1979, pp. 6–15.

Greenberg, Clement. "Anthony Caro," *Arts Yearbook. Contemporary Sculpture* 8 (1965): 106–9.

———. "Anthony Caro," *Studio International,* September 1967, pp. 116–17.

Krauss, Rosalind. "On Anthony Caro's Latest Work," *Art International,* 20 January 1967, pp. 26–29.

Russell, John. "Closing the Gaps," *Art News,* May 1970, pp. 37–39.

———. "Portrait: Anthony Caro," *Art in America,* September–October 1966, pp. 80–87.

Tuchman, Phyllis. "An Interview with Anthony Caro," *Artforum,* June 1972, pp. 56–58.

## CHRISTO

Alloway, Lawrence. *Christo* (New York: Harry N. Abrams, 1969).

BOURDON, DAVID. *Christo* (New York: Harry N. Abrams, 1971).

*Christo: Complete Editions, 1964–1982* (Munich: Schellman & Klüser, 1982). Text by Per Hovdenakk.

*Christo: Wrapped Coast, One Million Square Feet* (Minneapolis: Contemporary Art Lithographers, 1969). Photographs by Shunk-Kender.

HAHN, OTTO, and PIERRE RESTANY. *Christo* (Milan: Editioni Appollinaire, 1966).

LAPORTE, DOMINIQUE G. *Christo* (New York: Pantheon Books, 1985).

CHICAGO. Museum of Contemporary Art. *Christo: Wrap In, Wrap Out,* 1969. Text by Jan van der Marck.

EINDHOVEN. Stedelijk van Abbemuseum. *Christo,* 1966. Text by Lawrence Alloway.

NEW YORK. Museum of Modern Art. *Christo Wraps the Museum,* 1968. Text in brochure by William S. Rubin.

ALLOWAY, LAWRENCE. "Christo," *Studio International,* March 1971, pp. 97–100.

———. "Christo and the New Scale," *Art International,* 20 September 1968, pp. 56–67.

BOURDON, DAVID. "Christo," *Art and Artists,* October 1966, pp. 50–53.

FINEBERG, JONATHAN. "Theater of the Real: Thoughts on Christo," *Art in America,* December 1979, pp. 92–99.

HAHN, OTTO. "Christo's Packages," *Art International,* April 1965, pp. 25–27, 30.

PROKOPOFF, STEPHEN S. "Christo," *Art and Artists,* April 1969, pp. 12–17.

VAN DER MARCK, JAN. "Why Pack a Museum? Christo at the Museum of Contemporary Art, Chicago," *artscanada,* October 1969, pp. 34–37.

## CHUCK CLOSE

LYONS, LISA, AND ROBERT STORR. *Chuck Close* (New York: Rizzoli, 1987).

CHICAGO. Museum of Contemporary Art. *Chuck Close,* 1972. Text by Dennis Adrian.

MINNEAPOLIS. Walker Art Center. *Close Portraits,* 1980. Texts by Lisa Lyons and Martin Friedman.

MUNICH. Kunstraum München. *Chuck Close,* 1978. Text by Hermann Kern.

NEW YORK. Pace Gallery. *Chuck Close,* 1979. Text by Kim Levin.

———. *Chuck Close,* 1983. Text by John Perreault.

———. *Chuck Close,* 1986. Dialogue with Arnold Glimcher.

DIAMONSTEIN, BARBARALEE. "Chuck Close: 'I'm Some Kind of Slow-Motion Cornball,'" *Art News,* Summer 1980, pp. 113–16.

DYKES, WILLIAM. "The Photo as Subject/ The Paintings and Drawings of Chuck Close," *Arts Magazine,* February 1974, pp. 28–53.

HARSHMAN, BARBARA. "An Interview with Chuck Close," *Arts Magazine,* June 1978, pp. 142–45.

LEVIN, KIM. "Chuck Close: Decoding the Image," *Arts Magazine,* June 1978, pp. 146–49.

NEMSER, CINDY. "An Interview with Chuck Close," *Artforum,* January 1970, pp. 51–55.

———. "Presenting Charles Close," *Art in America,* January 1970, pp. 98–101.

SANDBACK, AMY BAKER, and INGRID SISCHY. "A Progression by Chuck Close," an interview, *Artforum,* May 1984, p. 50.

SIMON, JOAN. "Close Encounters," *Art in America,* February 1980, pp. 81–83.

## HANNE DARBOVEN

MÖNCHENGLADBACH. Städtisches Museum. *Hanne Darboven,* 1969. Text by Johannes Cladders.

MÜNSTER. Westfälischer Kunstverein Landesmuseum. *Hanne Darboven,* 1971. Texts by Klaus Honnef and Johannes Cladders.

LIPPARD, LUCY R. "Hanne Darboven: Deep in Numbers," *Artforum,* October 1973, pp. 35–39.

THWAITES, JOHN ANTHONY. "The Numbers Game," *Art and Artists,* January 1972, pp. 24–25.

## WALTER DE MARIA

ADRIAN, DENNIS. "Walter de Maria: Word and Thing," *Artforum,* January 1967, pp. 28–29.

BOURDON, DAVID. "Walter de Maria: The Singular Experience," *Art International,* 20 December 1968, pp. 39–43, 72.

CELANT, GERMANO. "Walter de Maria," *Casabella,* March 1969, pp. 42–43.

"Earth Room," *Domus,* February 1969, p. 48.

SMITH, ROBERTA. "De Maria: Elements," *Art in America,* May 1978, pp. 102–5.

WINTON, MALCOLM. "Sculptures That Blow Away," *Ark,* Spring 1970, pp. 18–19.

## JAN DIBBETS

FRIEDMAN, MARTIN, R.H. FUCHS, and M.M.M. VOS. *Jan Dibbets* (New York: Rizzoli, 1987).

AMSTERDAM. Stedelijk Museum. *Jan Dibbets,* 1972. Texts by E.L.L. de Wilde, Rini Dippel, and M.M.M. Vos.

EDINBURGH. Scottish Arts Council Gallery. *Jan Dibbets,* 1976. Texts by Barbara Reise and M.M.M. Vos.

EINDHOVEN. Stedelijk van Abbemuseum. *Jan Dibbets,* 1971. Texts by R.H. Fuchs and J. Leering.

KREFELD. Museum Haus Lange. *Jan Dibbets: Audiovisuelle Dokumentationen,* 1969. Text by Paul Wember.

LUCERNE. Kunstmuseum. *Jan Dibbets, Autumn Melody,* 1975. Text by Jean-Christophe Ammann.

BOICE, BRUCE. "Jan Dibbets: The Photograph and the Photographed," *Artforum,* April 1973, pp. 45–49.

DIBBETS, JAN. "Send the right page . . . ," *Studio International,* July–August 1970, pp. 41–44.

"Interview with Jan Dibbets," *Avalanche,* Fall 1970, pp. 33–39.

REISE, BARBARA. "Jan Dibbets: A Perspective Correction," *Art News,* June 1972, pp. 38–41.

———. "Notes[1] on Jan Dibbets's[2] Contemporary[3] Nature[4] of Realistic[5] Classicism[6] in the Dutch[7] Tradition[8]," *Studio International,* June 1972, pp. 248–55.

TOWNSEND, CHARLOTTE. "Jan Dibbets in Conversation with Charlotte Townsend," *artscanada,* August–September 1971, pp. 49–50.

VOS, M.M.M. "Jan Dibbets," *Flash Art,* January 1973, pp. 18–19.

## JIM DINE

GLENN, CONSTANCE W. *Jim Dine, Drawings* (New York: Harry N. Abrams, 1985).

SHAPIRO, DAVID. *Jim Dine* (New York: Harry N. Abrams, 1981).

NEW YORK. Whitney Museum of American Art. *Jim Dine,* 1970. Text by John Gordon.

PARIS. Galerie Ileana Sonnabend. *Jim Dine,* 1963. Texts by Lawrence Alloway, Nicolas Calas, Gillo Dorfles, and Alain Jouffroy.

ALLOWAY, LAWRENCE. "The Spectrum of Monochrome," *Arts Magazine,* December 1970–January 1971, pp. 30–33.

CALAS, NICOLAS. "Jim Dine: Tools & Myth," *Metro* 7 (1962): 76–79.

FRASER, ROBERT. "Dining with Jim," an

interview, *Art and Artists,* September 1966, pp. 49–53.

GLENN, C.W. "Artist's Dialogue: A Conversation with Jim Dine," *Architectural Digest,* November 1982, p. 74.

GRUEN, JOHN. "Jim Dine and the Life of Objects," *Art News,* September 1977, pp. 38–42.

HENNESSY, S. "Conversation with Jim Dine," *Art Journal* 3 (1980): 168–75.

JOUFFROY, ALAIN. "Jim Dine: Through the Telescope," *Metro* 7 (1962): 72–75.

KOZLOFF, MAX. "The Honest Elusiveness of Jim Dine," *Artforum,* December 1964, pp. 36–40.

SHAPIRO, DAVID. "Jim Dine's Life-in-Progress," *Art News,* March 1970, pp. 42–46.

SMILANSKY, N. "Interview with Jim Dine," *Print Review* 12 (1950): 54–61.

SMITH, BRYDON. "Jim Dine—Magic and Reality," *Canadian Art,* January 1966, pp. 30–34.

SOLOMON, ALAN R. "Jim Dine and the Psychology of the New Art," *Art International,* 20 October 1964, pp. 52–56.

TOWLE, TONY. "Notes on Jim Dine's Lithographs," *Studio International,* April 1970, pp. 165–68.

ZACK, DAVID. "A Black Comedy . . .," *Artforum,* May 1966, pp. 32–34.

## MARK DI SUVERO

HOUSTON. Janie C. Lee Gallery. *Mark di Suvero,* 1978. Text by Barbara Rose.

NEW YORK. Whitney Museum of American Art. *Mark di Suvero, 1975–76,* 1976. Text by James K. Monte.

BAKER, ELIZABETH C. "Mark di Suvero's Burgundian Season," *Art in America,* May–June 1974, pp. 59–63.

GEIST, SIDNEY. "A New Sculptor: Mark di Suvero," *Arts Magazine,* December 1960, pp. 40–43.

GODDARD, DONALD. "Mark di Suvero: An Epic Reach," *Art News,* January 1976, pp. 28–31.

KLEIN, J.R. "Idealism Realized: Two Public Commissions by Mark di Suvero," *Arts Magazine,* December 1981, pp. 80–90.

KOZLOFF MAX. "Mark di Suvero: Leviathan," *Artforum,* Summer 1967, pp. 41–46.

RATCLIFF, CARTER. "Artist's Dialogue: A Conversation with Mark di Suvero," *Architectural Digest,* December 1983, p. 192.

———. "Mark di Suvero," *Artforum,* November 1972, pp. 34–42.

ROSE, BARBARA. "Mark di Suvero," *Vogue,* February 1973, pp. 160–62, 202–3.

———. "On Mark di Suvero: Sculpture Outside Walls," *Art Journal,* Winter 1975–76, pp. 118–25.

ROSENSTEIN, HARRIS. "Di Suvero: The Pressures of Reality," *Art News,* February 1967, pp. 36–39, 63–65.

## RICHARD ESTES

MEISEL, LOUIS K. *Richard Estes: The Complete Paintings, 1966–1985* (New York: Harry N. Abrams, 1986). Additional text by John Perreault.

BOSTON. Museum of Fine Arts. *Richard Estes: The Urban Landscape,* 1978. Text by John Canaday. Interview by John Arthur.

CHASE, LINDA. "Richard Estes: Radical Conservative," *New Lugano Review* 8–9 (1976): 227–28.

HERBERT, RAYMOND. "The Real Estes," an interview, *Art and Artists,* August 1974, pp. 24–29.

## DAN FLAVIN

FORT WORTH. Fort Worth Art Museum. *Dan Flavin,* 1976. Texts by Jay Belloli and Emily Rauh.

OTTAWA. National Gallery of Canada. *etc. from Dan Flavin,* 1969. Texts by Dan Flavin, Don Judd, and Brydon Smith.

BAKER, KENNETH. "A Note on Dan Flavin," *Artforum,* January 1972, pp. 38–40.

BOCHNER, MEL. "Less Is Less (for Dan Flavin)," *Art and Artists,* December 1966, pp. 24–27.

FLAVIN, DAN. ". . . in daylight or cool white: an autobiographical sketch," *Artforum,* December 1965, pp. 20–24.

———. ". . . on an American artist's education," *Artforum,* March 1968, pp. 28–32.

———. "Several More Remarks . . .," *Studio International,* April 1969, pp. 173–75.

———. "some other comments . . ." *Artforum,* December 1967, pp. 20–25.

———. "Some remarks . . .; excerpts from a spleenish journal," *Artforum,* December 1966, pp. 27–29.

GRAHAM, DAN. "Art in Relation to Architecture: Architecture in Relation to Art," *Artforum,* February 1979, pp. 22–29.

———. "Flavin's Proposal," *Arts Magazine,* February 1970, pp. 44–45.

JUDD, DONALD. "Aspects of Flavin," *Art and Artists,* March 1970, pp. 48–49.

LICHT, IRA. "Dan Flavin," *artscanada,* December 1968, pp. 50–57.

SKOGGARD, ROSS. "Flavin According to His Lights," *Artforum,* April 1977, pp. 52–54.

WILSON, WILLIAM S. "Dan Flavin: Flat Lux," *Art News,* January 1970, pp. 48–51.

## HELEN FRANKENTHALER

ROSE, BARBARA. *Helen Frankenthaler* (New York: Harry N. Abrams, 1971).

WILKEN, KAREN. *Frankenthaler: Works on Paper, 1949–1984* (New York: George Braziller, 1984).

NEW YORK. Whitney Museum of American Art. *Helen Frankenthaler,* 1969. Text by E.C. Goossen.

ALLOWAY, LAWRENCE. "Frankenthaler as Pastoral," *Art News,* November 1971, pp. 66–68, 89–90.

ASHTON, DORE. "Helen Frankenthaler," *Studio International,* August 1965, pp. 52–55.

BARO, GENE. "The Achievement of Helen Frankenthaler," *Art International,* 20 September 1967, pp. 33–38.

BATTCOCK, GREGORY. "Frankenthaler," *Art and Artists,* May 1969, pp. 52–55.

BERKSON, WILLIAM. "Poet of the Surface," *Arts Magazine,* May–June 1965, pp. 44–50.

BOWLES, JERRY. "Helen Frankenthaler at the Whitney," *Arts Magazine,* March 1969, pp. 20–22.

CHAMPA, KERMIT S. "New Work of Helen Frankenthaler," *Artforum,* January 1972, pp. 55–59.

FRANKENTHALER, HELEN. "Memories of the San Remo," *Partisan Review* 3 (1982): 412–14.

FRIEDMAN, B.H. "Toward the Total Color Image," *Art News,* Summer 1966, pp. 31–33, 67–68.

GELDZAHLER, HENRY. "An Interview with Helen Frankenthaler," *Artforum,* October 1965, pp. 36–38.

GOLDMAN, JUDITH. "Painting in Another Language," *Art News,* September 1975, pp. 28–31.

NEMSER, CINDY. "Interview with Helen Frankenthaler," *Arts Magazine,* November 1971, pp. 51–55.

ROSE, BARBARA. "Painting Within the Tradition: The Career of Helen Frankenthaler," *Artforum,* April 1969, pp. 28–33.

ROSENSTEIN, HARRIS. "The Colorful Gesture," *Art News,* March 1969, pp. 29–31, 68.

SOLOMON, DEBORAH. "An Interview with Helen Frankenthaler," *Partisan Review* 1 (1984–85): 793–98.

## GILBERT AND GEORGE

RATCLIFF, CARTER. *Gilbert and George: The Complete Pictures, 1971–1985* (New York: Rizzoli, 1986).

BALTIMORE. Baltimore Museum of Art. *Gilbert & George,* 1984. Text by Brenda Richardson.

EINDHOVEN. Stedelijk van Abbemuseum. *Gilbert and George, 1968–1980,* 1980. Text by Carter Ratcliff.

BROOKS, R. "Gilbert and George: Shake Hands with the Devil," *Artforum,* June 1984, pp. 56–60.

CASTLE, TED. "Gilbert and George Arrive Beyond Alcohol and Sex," *Art Monthly,* November 1980, pp. 8–11.

CELANT, GERMANO. "Gilbert & George," *Domus,* March 1972, pp. 50–53.

LAMBERT, JEAN-CLARENCE. "Gilbert and George," *Opus International,* May 1971, pp. 24–25.

LORBER, RICHARD. "Gilbert & George," *Artforum,* May 1978, pp. 59–60.

LYNN, ELWYN. "Gilbert and George," *Art International,* 20 March 1974, pp. 30–31.

McEWEN, JOHN. "Life and Times: Gilbert & George," *Art in America,* May 1982, pp. 128–35.

MORRIS, LYNDA. "Gilbert and George," *Studio International,* July–August 1974, pp. 49–50.

MOYNIHAN, MICHAEL. "Gilbert and George," *Studio International,* May 1970, pp. 196–97.

RATCLIFF, CARTER. "The Art and Artlessness of Gilbert & George," *Arts Magazine,* January 1976, pp. 54–57.

———. "Down and Out with Gilbert & George," *Art in America,* May–June 1978, pp. 92–93.

REISE, BARBARA. "Presenting Gilbert and George, the Living Sculptures," *Art News,* November 1971, pp. 62–65.

TRINI, TOMASO. "Gilbert & George, the Human Sculptors," *Data,* Summer 1974, pp. 20–27.

## DAN GRAHAM

FUCHS, R.H., ed. *Articles* (Eindhoven: Stedelijk van Abbemuseum, 1978).

GRAHAM, DAN. *Selected Works, 1965–72* (New York and Cologne: Koenig Brothers; London: Lisson Publications, 1972).

———. *Video-Architecture-Television: Writings on Video and Video Works, 1970–1978* (New York: New York University Press, 1979). Texts by Michael Asher and Dara Birnbaum.

BASEL. Kunsthalle. *Dan Graham,* 1976. Texts by Maria Netter and Dan Graham.

EINDHOVEN. Stedelijk van Abbemuseum. *Dan Graham,* 1978. Texts by Dan Graham, R.H. Fuchs, and B.H.D. Buchlow.

CAMERON, ERIC. "Dan Graham: Appearing in Public," *Artforum,* November 1976, pp. 66–68.

FIELD, SIMON. "Dan Graham: An Interview with Simon Field," *Art & Artists,* January 1973, pp. 16–21.

GRAHAM, DAN. "Dan Graham," *Interfunktionen,* January 1972, pp. 27–33.

———. "Intention, Intentionality, Sequence," *Arts Magazine,* April 1973, pp. 64–65.

KUSPIT, DONALD. "Dan Graham: Prometheus Mediabound," *Artforum,* May 1985, pp. 75–81.

MAYER, ROSEMARY. "Dan Graham: Past/Present," *Art in America,* November 1975, pp. 83–85.

PELZER, B. "Vision in Process," *October,* Fall 1979, pp. 105–19.

## RED GROOMS

RATCLIFF, CARTER. *Red Grooms* (New York: Abbeville, 1984).

TULLY, JUDD. *Red Grooms and Ruckus Manhattan* (New York: George Braziller, 1977).

PHILADELPHIA. Institute of Contemporary Art, University of Pennsylvania. *Red Grooms' Philadelphia Cornucopia and Other Sculpto-Pictoramas,* 1982. Texts by Janet Kardon, Paula Marincola, Carter Ratcliff, and Carrie Rickey.

PHILADELPHIA. Pennsylvania Academy of Fine Arts. *Red Grooms: A Retrospective, 1956–1984,* 1985. Texts by Judith E. Stein, John Ashbery, and Janet K. Cutler.

BERRIGAN, TED. "Red Power," *Art News,* December 1966, pp. 44–46.

BUTLER, JOSEPH T. "The American Way with Art: Red Grooms' 'City of Chicago,'" *Connoisseur,* March 1970, pp. 148–49.

GLUECK, GRACE. "Odd Man Out: Red Grooms, the Ruckus Kid," *Art News,* December 1973, pp. 23–27.

RATCLIFF, CARTER. "Red Grooms' Human Comedy," *Portfolio,* March–April 1981, pp. 56–61.

WILSON, JANET. "And Now from the Folks Who Brought You Ruckus Manhattan," *Art News,* March 1979, pp. 102–3.

## DUANE HANSON

VARNEDOE, KIRK. *Duane Hanson* (New York: Harry N. Abrams, 1985).

WICHITA. Edwin A. Ulrich Museum of Art, Wichita State University. *Duane Hanson,* 1985. Text by Martin H. Bush.

BUSH, MARTIN. "Martin Bush Interviews Duane Hanson," *Art International,* September 1977, pp. 8–25.

EDWARDS, ELLEN. "Duane Hanson's Blue Collar Society," *Art News,* April 1978, pp. 56–60.

HENRY, GERRIT. "SoHo Body Snatcher," *Art News,* March 1972, pp. 50–51.

LEVIN, KIM. "Ersatz Object," *Arts Magazine,* February 1974, pp. 52–55.

MATHEWS, M. "Duane Hanson: Super Realism," *American Artist,* September 1981, pp. 58–63.

VARNEDOE, KIRK. "Duane Hanson: Retrospective and Recent Work," *Arts Magazine,* January 1975, pp. 66–70.

## MICHAEL HEIZER

DETROIT. Detroit Institute of Art. *Michael Heizer/Actual Size,* 1974.

OTTERLO. Rijksmuseum Kröller-Muller. *Michael Heizer,* 1979. Text by Michael Heizer.

LOS ANGELES. Museum of Contemporary Art. *Michael Heizer: Sculpture in Reverse,* 1984. Text by Julia Brown. Interview with Michael Heizer.

HEIZER, MICHAEL. "The Art of Michael Heizer," *Artforum,* December 1969, pp. 32–39.

MÜLLER, GREGOIRE. "Michael Heizer," *Arts Magazine,* December 1969, pp. 42–45.

WALDMAN, DIANE. "Holes Without History," *Art News,* May 1971, pp. 44–48, 66–68.

## AL HELD

SANDLER, IRVING. *Al Held* (New York: Hudson Hills, 1984).

NEW YORK. Whitney Museum of American Art. *Al Held,* 1974. Text by Marcia Tucker.

PHILADELPHIA. Institute of Contemporary Art, University of Pennsylvania. *Al Held, Recent Paintings,* 1968. Text by John W. McCoubrey.

SAN FRANCISCO. San Francisco Museum of Modern Art. *Al Held,* 1968. Text by Eleanor Green.

ASHTON, DORE. "Al Held: New Spatial Experiences," *Studio International,* November 1964, pp. 210–13.

BURTON, SCOTT. "Big H," *Art News,* March 1968, pp. 50–53, 70–72.

CALAS, NICOLAS. "The Originality of Al

Held," *Art International,* 15 May 1968, pp. 38–41.

FINKELSTEIN, LOUIS. "Al Held: Structure and the Intuition of Theme," *Art in America,* November–December 1974, pp. 83–88.

McCOUBREY, JOHN W. "Al Held: Recent Paintings," *Art Journal,* Spring 1969, pp. 322–24.

MASHECK, JOSEPH, and ROBERT PINCUS-WITTEN. "Al Held: Two Views," *Artforum,* January 1975, pp. 54–56.

ROBBIN, TONY. "A Protean Sensibility," *Arts Magazine,* May 1971, pp. 28–30.

SANDLER, IRVING. "Al Held Paints a Picture," *Art News,* May 1964, pp. 42–45, 51.

STILES, KNUT. "The Paintings of Al Held," *Artforum,* March 1968, pp. 47–53.

WALKER, JAMES FAURE. "Al Held, Interview," *Artscribe,* July 1977, pp. 5–7.

### EVA HESSE

LIPPARD, LUCY R. *Eva Hesse* (New York: New York University Press, 1976).

LONDON. Whitechapel Gallery. *Eva Hesse: Sculpture,* 1979. Texts by Rosalind Krauss and Eva Hesse.

NEW YORK. Solomon R. Guggenheim Museum. *Eva Hesse: A Memorial Exhibition,* 1972. Texts by Linda Shearer and Robert Pincus-Witten.

OBERLIN. Allen Memorial Art Museum, Oberlin College. *Eva Hesse: A Retrospective of the Drawings,* 1982. Text by Ellen H. Johnson.

JOHNSON, ELLEN H., ed. "Order and Chaos: From the Diaries of Eva Hesse," *Art in America,* Summer 1983, pp. 110–18.

LEVIN, KIM. "Eva Hesse: Notes on a New Beginning," *Art News,* February 1973, pp. 71–73.

LIPPARD, LUCY R. "Eva Hesse—The Circle," *Art in America,* May–June 1971, pp. 68–73.

NEMSER, CINDY. "An Interview with Eva Hesse," *Artforum,* May 1970, pp. 59–63.

———. "My Memories of Eva Hesse," *Feminist Art Journal,* Winter 1973, pp. 12–13.

PINCUS-WITTEN, ROBERT. "Eva Hesse: Last Words," *Artforum,* November 1962, pp. 74–76.

———. "Eva Hesse: Post Minimalism into Sublime," *Artforum,* November 1971, pp. 32–44.

SHAPIRO, DAVID. "The Random Forms in Soft Materials and String by the Late Young Innovator Eva Hesse," *Craft Horizons,* February 1973, pp. 40–45, 77.

### DOUGLAS HUEBLER

BOSTON. Museum of Fine Arts. *Douglas Huebler,* 1972. Texts by Christopher Cooks and Douglas Huebler.

AUPING, MICHAEL. "Talking with Douglas Huebler," *Journal of the Los Angeles Institute of Contemporary Art,* July–August 1977, pp. 37–44.

BURNHAM, JACK W. "Huebler's Pinwheel and the Letter Tau," *Arts Magazine,* October 1974, pp. 32–35.

HONNEF, KLAUS. "Douglas Huebler," *Art and Artists,* January 1973, pp. 22–25.

HOPKINS, BUDD. "Concept vs. Art Object: A Conversation Between Douglas Huebler and Budd Hopkins," *Arts Magazine,* April 1972, pp. 50–53.

KINGSLEY, APRIL. "Douglas Huebler," *Artforum,* May 1972, pp. 74–78.

MEYER, RUTH K. "Douglas Huebler: An Interview," *Dialogue,* March–April 1981, pp. 14–15.

LIPPARD, LUCY R. "Douglas Huebler: Everything about Everything," *Art News,* December 1972, pp. 29–31.

STIMSON, PAUL. "Fictive Escapades: Douglas Huebler," *Art in America,* February 1982, pp. 96–99.

### PETER HUTCHINSON

KREFELD. Museum Haus Lange. *Peter Hutchinson: Art from Nature,* 1972. Text by Gisela Fiedler.

CAMERON, ERIC. "Peter Hutchinson: From Earth Art to Story Art," *Artforum,* December 1977, pp. 30–32.

JOHNSON, WILLIAM. "Scuba Sculpture," *Art News,* November 1969, pp. 52–53.

ROBBIN, ANTHONY. "Images: Two Oceans Projects," *Arts Magazine,* November 1969, pp. 24–25.

———. "Peter Hutchinson's Ecological Art," *Art International,* February 1970, pp. 52–55.

SILVER, CHARLES. "50 Years After, 50 Years Before," *Arts Magazine,* March 1969, p. 18.

### ROBERT INDIANA

KATZ, WILLIAM. *Robert Indiana: The Prints and Posters, 1961–1971* (New York: Domberger 1971).

AUSTIN. University Art Museum, University of Texas. *Robert Indiana,* 1977. Texts by Donald B. Goodall, Robert L.B. Tobin, and William Katz.

MINNEAPOLIS. Dayton's Gallery 12. *Robert Indiana,* 1966. Text by Jan van der Marck.

PHILADELPHIA. Institute of Contemporary Art, University of Pennsylvania. *Robert Indiana,* 1968. Text by John McCoubrey.

ROCKLAND, MAINE. William A. Farnsworth Library and Art Museum. *Indiana's Indianas,* 1982. Texts by Marius B. Péladeau and Martin Dibner.

WASHINGTON, D.C. National Museum of American Art. *Wood Works: Constructions by Robert Indiana,* 1984. Text by Virginia M. Mecklenburg.

KATZ, WILLIAM. "A Mother Is a Mother," *Arts Magazine,* December 1966–January 1967, pp. 46–48.

RAYNOR, VIVIEN. "The Man Who Invented LOVE," *Art News,* February 1973, pp. 58–62.

SWENSON, G.R. "The Horizons of Robert Indiana," *Art News,* May 1966, pp. 48–49, 60–62.

### ROBERT IRWIN

IRWIN, ROBERT. *Being and Circumstance: Notes Toward a Conditional Art* (Larskpur Landing, Calif.: Lapis, 1985).

WESCHLER, LAWRENCE. *Seeing Is Forgetting the Name of the Thing One Sees: A Life of the Contemporary Artist Robert Irwin* (Berkeley: University of California Press, 1982).

CHICAGO. Museum of Contemporary Art. *Robert Irwin,* 1975. Text by Ira Licht.

NEW YORK. Whitney Museum of American Art. *Robert Irwin,* 1977. Text by Robert Irwin.

PASADENA. Pasadena Art Museum. *Robert Irwin,* 1968. Text by John Coplans.

ALBRIGHT, THOMAS. "Everything I've Done in the Last Five Years Doesn't Exist," *Art News,* Summer 1977, pp. 49–54.

BUTTERFIELD, JAN. "The Enigma Suffices," *Images and Issues,* Winter 1980–81, pp. 38–40.

———. "Robert Irwin: On the Periphery of Knowing," an interview, *Arts Magazine,* February 1976, pp. 72–77.

———. "Part I. The State of the Real: Robert Irwin Discusses the Art of an Extended Consciousness," *Arts Magazine,* June 1972, pp. 47–49.

———. "Part II. Reshaping the Shape of Things," *Arts Magazine,* September–October 1972, pp. 30–32.

———. "An Uncompromising Other Way," *Arts Magazine,* June 1974, pp. 52–55.

HAZLETT, GORDON J. "An Incredibly Beautiful Quandary," *Art News,* May 1976, pp. 36–38.

IRWIN, ROBERT. "Twenty Questions," *Vision,* September 1975, pp. 38–39.

LEVINE, EDWARD. "World Without Frame," *Arts Magazine,* February 1976, pp. 72–77.

MACKINTOSH, ALISTAIR. "Robert Irwin," an interview, *Art and Artists,* March 1972, pp. 24–27.

PLAGENS, PETER. "Robert Irwin's Bar Paintings," *Artforum,* March 1979, pp. 41–43.

———. "Robert Irwin; The Artist's Premises," *Artforum,* December 1970, pp. 88–89.

SMITH, ROBERTA. "Robert Irwin: The Subject Is Sight," *Art in America,* March 1976, pp. 68–73.

WESCHLER, LAWRENCE. "Lines of Inquiry," *Art in America,* March 1982, pp. 102–9.

———. "Taking Art to Point Zero," *New Yorker,* 8 March 1982, pp. 48–94.

WORTZ, MELINDA. "Surrendering to Presence: Robert Irwin's Esthetic Integration," *Artforum,* November 1981, pp. 63–65.

## ALFRED JENSEN

BUFFALO. Albright-Knox Art Gallery. *Alfred Jensen: Paintings and Diagrams from the Years 1957–1977,* 1978. Texts by Linda L. Cathcart and Marcia Tucker.

NEW YORK. Solomon R. Guggenheim Museum. *Alfred Jensen,* 1985. Texts by Maria Reidelbach and Peter Schjeldahl.

KAPROW, ALLAN. "The World View of Alfred Jensen," *Art News,* December 1963, pp. 28–31, 64–66.

KUSPIT, DONALD B. "Alfred Jensen: Systems Mystagogue," *Artforum,* April 1978, pp. 38–41.

LORING, JOHN. "Checkers with the Right Man," *Arts Magazine,* March 1973, pp. 60–62.

## JASPER JOHNS

BERNSTEIN, ROBERTA. *Jasper Johns' Paintings and Sculptures, 1954–1974* (Ann Arbor, Mich.: UMI Research Press, 1985).

CASTLEMAN, RIVA. *Jasper Johns: A Print Retrospective* (New York: Little, Brown, 1986).

CRICHTON, MICHAEL. *Jasper Johns* (New York: Harry N. Abrams, 1977).

FIELD, RICHARD S. *Jasper Johns: Prints, 1960–1970* (New York: Praeger, 1970).

FRANCIS, RICHARD. *Jasper Johns* (New York: Abbeville, 1984).

GEELHAAR, CHRISTIAN. *Jasper Johns: Working Proofs* (London: Peterborough, 1980).

KOZLOFF, MAX. *Jasper Johns* (New York: Harry N. Abrams, 1967).

SHAPIRO, DAVID. *Jasper Johns, Drawings* (New York: Harry N. Abrams, 1984).

STEINBERG, LEO. *Jasper Johns* (New York: George Wittenborn, 1963).

NEW YORK. Jewish Museum. *Jasper Johns,* 1964. Text by Alan Solomon.

NEW YORK. Museum of Modern Art. *Jasper Johns, Lithographs,* 1970. Text by Riva Castleman.

ALLOWAY, LAWRENCE. "The Man Who Liked Cats: The Evolution of Jasper Johns," *Arts Magazine,* September–October 1969, pp. 40–43.

ASHBERY, JOHN. "Brooms and Prisms," *Art News,* March 1966, pp. 58–59, 82–84.

BERNSTEIN, ROBERTA. "Jasper Johns and the Figure," *Arts Magazine,* October 1977, pp. 142–44.

CAGE, JOHN. "Jasper Johns: Stories and Ideas," *Art and Artists,* May 1968, pp. 36–41.

CALAS, NICOLAS. "Johns, ou: Ceci n'est pas un drapeau," *XXᵉ Siècle,* June 1978, pp. 33–39.

CARPENTER, JOAN. "Infra-iconography of Jasper Johns," *Art Journal* 3 (1977): 221–27.

COPLANS, JOHN. "Fragments According to Johns: An Interview with Jasper Johns," *Print Collector's Newsletter,* May–June 1972, pp. 29–32.

FEINSTEIN, RONNI. "Jasper Johns' Untitled (1972) and Marcel Duchamp's Bride," *Arts Magazine,* September 1982, pp. 86–93.

———. "New Thoughts for Jasper Johns' Sculpture," *Arts Magazine,* April 1980, pp. 139–45.

GABLIK, SUZI. "Johns's Pictures of the World," *Art in America,* January 1978, pp. 62–69.

HERRMANN, ROLF-DIETER. "Jasper Johns' Ambiguity: Exploring the Hermaneutical Implications," *Arts Magazine,* November 1977, pp. 124–29.

———. "Johns the Pessimist," *Artforum,* October 1977, pp. 26–33.

HOBHOUSE, JANET. "Jasper Johns: 'The passionless subject passionately painted,'" *Art News,* December 1977, pp. 46–49.

HOPPS, WALTER. "An Interview with Jasper Johns," *Artforum,* March 1965, pp. 32–36.

JOHNS, JASPER. "The Green Box," *Scrap,* 23 December 1960, p. 4.

———. "Marcel Duchamp (1887–1968): An Appreciation," *Artforum,* November 1968, p. 6.

———. "Sketchbook Notes," *Art and Literature,* Spring 1965, pp. 185–92.

———. "Thoughts on Duchamp," *Art in America,* July–August 1969, p. 31.

KAPLAN, P. "On Jasper Johns' According to What," *Art Journal* 3 (1976): 247–50.

KOZLOFF, MAX. "Jasper Johns: Colors, Maps, Devices," *Artforum,* November 1967, pp. 26–31.

KRAUSS, ROSALIND. "Jasper Johns," *Lugano Review* 2 (1965): 84–98.

KUSPIT, DONALD B. "Personal Signs: Jasper Johns," *Art in America,* Summer 1981, pp. 111–13.

PERRONE, JEFF. "Purloined Image," *Arts Magazine,* April 1979, pp. 135–39.

PORTER, FAIRFIELD. "The Education of Jasper Johns," *Art News,* February 1964, pp. 44, 61–62.

RAYNOR, VIVIEN. "Jasper Johns," *Art News,* March 1973, pp. 20–22.

ROSE, BARBARA. "Decoys and Doubles: Jasper Johns and the Modernist Mind," *Arts Magazine,* March 1976, pp. 68–73.

———. "The Graphic Work of Jasper Johns," part 1, *Artforum,* March 1970, pp. 39–45; part 2, September 1970, pp. 65–74.

———. "Johns: Pictures and Concepts," *Arts Magazine,* November 1977, pp. 148–53.

ROSENBERG, HAROLD. "Jasper Johns: Things the Mind Already Knows," *Vogue,* 1 February 1964, pp. 175–77, 201–3.

ROSENBLUM, ROBERT. "Jasper Johns," *Art International,* September 1960, pp. 74–77.

SHAPIRO, DAVID. "Imago Mundi," *Art News,* October 1971, pp. 40–41, 66–68.

STEINBERG, LEO. "Jasper Johns," *Metro,* May 1962, pp. 82–109.

TILLIM, SIDNEY. "Ten Years of Jasper Johns," *Arts Magazine,* April 1964, pp. 22–26.

YAU, JOHN. "Target Jasper Johns," *Artforum,* December 1985, pp. 80–84.

YOUNG, JOSEPH E. "Jasper Johns: An Appraisal," *Art International,* September 1969, pp. 50–56.

## DONALD JUDD

JUDD, DONALD. *Complete Writings, 1959–1975* (New York: New York University Press, 1975).

NEW YORK. Whitney Museum of American Art. *Don Judd,* 1968. Texts by William C. Agee, Dan Flavin, and Donald Judd.

OTTAWA. National Gallery of Canada. *Donald Judd,* 1975. Texts by Brydon

Smith, Roberta Smith, and Dan Flavin.

AGEE, WILLIAM C. "Unit, Series, Site: A Judd Lexicon," *Art in America,* May 1975, pp. 40–49.

BAKER, ELIZABETH C. "Judd the Obscure," *Art News,* April 1968, pp. 44–45, 60–63.

BAKER, KENNETH. "Donald Judd, Past and Present," *Artforum,* Summer 1977, pp. 46–47.

CARLSON, P. "Donald Judd's Equivocal Objects," *Art in America,* January 1984, pp. 114–18.

CONE, JANE HARRISON. "Judd at the Whitney," *Artforum,* May 1968, pp. 36–38.

COPLANS, JOHN. "An Interview with Don Judd," *Artforum,* June 1971, pp. 40–50.

FRIEDMAN, MARTIN. "The Nart-Art of Donald Judd," *Art and Artists,* February 1967, pp. 58–61.

GOLDIN, AMY. "The Antihierarchical American," *Art News,* September 1967, pp. 48–50, 64–65.

JUDD, DONALD. "A Long Discussion Not About Master-Pieces But Why There Are Also So Few of Them," *Art in America,* part 1, September 1984, pp. 9–11; part 2, October 1984, pp. 9–15.

KRAUSS, ROSALIND. "Allusion and Illusion in Donald Judd," *Artforum,* May 1966, pp. 24–26.

LOUW, ROELOF. "Judd and After," *Studio International,* October 1966, pp. 171–75.

MÜLLER, GREGOIRE. "Donald Judd: Ten Years," *Arts Magazine,* February 1973, pp. 35–42.

PINCUS-WITTEN, ROBERT. "Fining It Down: Donald Judd at Castelli," *Artforum,* June 1970, p. 47–49.

ROSE, BARBARA. "Donald Judd," *Artforum,* June 1965, pp. 30–32.

SMITH, ROBERTA. "Multiple Returns," *Art in America,* March 1982, pp. 112–14.

ALEX KATZ

BEATTIE, ANN. *Alex Katz* (New York: Harry N. Abrams, 1987).

MARAVELL, NICHOLAS P. *Alex Katz: The Complete Prints* (New York: Alpine Fine Arts Collection, 1983).

SANDLER, IRVING. *Alex Katz* (New York: Harry N. Abrams, 1979).

———, and William Berkson, eds. *Alex Katz* (New York: Praeger, 1971).

NEW YORK. Whitney Museum of American Art. *Alex Katz,* 1986. Texts by Richard Marshall and Robert Rosenblum.

ALLOWAY, LAWRENCE. "Alex Katz's Development," *Artforum,* January 1976, pp. 45–51.

ANTIN, DAVID. "Alex Katz and the Tactics of Representation," *Art News,* April 1972, pp. 44–47, 75–77.

BERKSON, WILLIAM. "Alex Katz's Surprise Image," *Arts Magazine,* December 1965, pp. 22–26.

DENBY, EDWIN. "Katz: Collage, Cutout, Cut-up," *Art News,* January 1965, pp. 42–45.

KATZ, ALEX. "A Dialogue," with Jane Freilicher, *Art and Literature,* March 1964, pp. 42–56.

———. "Rudolph Burckhardt: Multiple Fugitive," *Art News,* December 1963, pp. 38–41.

———. "Talk on Signs and Symbols," *ZZZZZZ,* 6 (1977), n.p.

LIPPARD, LUCY R. "Groups: Alex Katz," *Studio International,* March 1970, pp. 93–99.

O'HARA, FRANK. "Alex Katz," *Art and Literature,* Summer 1966, pp. 91–101.

RATCLIFF, CARTER. "Alex Katz: Style as a Social Contract," *Art International,* 19 February 1978, pp. 26–29, 50–51.

SCHUYLER, JAMES. "Alex Katz Paints a Picture," *Art News,* February 1962, pp. 38–41, 52.

SCHWARTZ, ELLEN. "Alex Katz," *Art News,* Summer 1979, pp. 42–47.

SCHWARTZ, SANFORD. "Alex Katz So Far," *Art International,* December 1973, pp. 28–30.

TILLIM, ALEX. "Katz Cocktail: Grand and Cozy," *Art News,* December 1965, pp. 46–49, 67–69.

ELLSWORTH KELLY

COPLANS, JOHN. *Ellsworth Kelly* (New York: Harry N. Abrams, 1972).

WALDMAN, DIANE. *Ellsworth Kelly: Drawings, Collages and Prints* (Greenwich, Conn.: New York Graphic Society, 1971).

NEW YORK. Museum of Modern Art. *Ellsworth Kelly,* 1973. Text by E.C. Goossen.

NEW YORK. Whitney Museum of American Art. *Ellsworth Kelly, Sculpture,* 1982. Texts by Patterson Sims and Emily Rauh Pulitzer.

WASHINGTON, D.C. Washington Gallery of Modern Art. *Paintings, Sculpture, and Drawings by Ellsworth Kelly,* 1964. Text by Adelyn D. Breeskin. Interview by Henry Geldzahler.

BAKER, ELIZABETH C. "The Subtleties of Ellsworth Kelly," *Art News,* November 1973, pp. 30–33.

ELDERFIELD, JOHN. "Color and Area: New Paintings by Ellsworth Kelly," *Art-*

*forum,* November 1971, pp. 45–49.

FRIED, MICHAEL. "New York Letter: Ellsworth Kelly at Betty Parsons Gallery," *Art International,* January 1964, pp. 54–56.

GELDZAHLER, HENRY. "Interview with Ellsworth Kelly," *Art International,* February 1964, pp. 47–48.

GOOSSEN, E.C. "Paris Years," *Arts Magazine,* November 1973, pp. 32–37.

MASHECK, JOSEPH. "Ellsworth Kelly at the Modern," *Artforum,* November 1973, pp. 54–57.

RATCLIFF, CARTER. "Kelly's Spectrum of Experience," *Art in America,* Summer 1981, pp. 98–101.

RAYNOR, VIVIEN. "Ellsworth Kelly Keeps His Edge," *Art News,* March 1983, pp. 52–59.

ROSE, BARBARA. "The Sculpture of Ellsworth Kelly," *Artforum,* June 1967, pp. 51–55.

RUBIN, WILLIAM. "Ellsworth Kelly: The Big Form," *Art News,* November 1963, pp. 32–35, 64–65.

TUCHMAN, PHYLLIS. "Ellsworth Kelly's Photographs," *Art in America,* January 1974, pp. 55–61.

WALDMAN, DIANE. "Kelly, Collage and Color," *Art News,* December 1961, pp. 44–47, 53–55.

———. "Kelly Color," *Art News,* October 1968, pp. 40–41, 62–64.

WASSERMAN, EMILY. "Ellsworth Kelly," *Artforum,* December 1968, p. 58.

MICHAEL KIDNER

LONDON. Serpentine Gallery. *Michael Kidner: Painting, Drawings, Sculpture, 1959–84,* 1984. Texts by Stephen Bann, Peter Brades, Francis Pratt, and Bryan Robertson.

BANN, STEPHEN. "Michael Kidner," *Art Monthly,* April 1983, p. 12.

BRADES, PETER. "Michael Kidner," *Artscribe,* April 1983, pp. 27–31.

GILMOUR, PAT. "Michael Kidner," *Arts Review,* 8 June 1979, pp. 281–82.

LYNTON, NORBERT. "Michael Kidner," *Art International,* October 1967, pp. 52–53.

EDWARD KIENHOLZ

DÜSSELDORF. Städtische Kunsthalle. *Edward Kienholz, 1960–1970,* 1970. Text by Jürgen Harten. Interview by Pontus Hultén.

LOS ANGELES. Los Angeles County Museum of Art. *Edward Kienholz,* 1966. Text by Maurice Tuchman.

NEW YORK. Alexander Iolas Gallery. *Edward Kienholz*, 1963. Text by Dore Ashton.

STOCKHOLM. Moderna Museet. *Edward Kienholz. 11 + 11 Tableaux*, 1970. Text by Edward Kienholz.

WASHINGTON, D.C. Gallery of Modern Art. *Edward Kienholz: Works from the 1960's*, 1967. Text by Walter Hopps.

BAER, JO. "Edward Kienholz: A Sentimental Journey," *Art International*, April 1968, pp. 45–49.

CATOIR, B. "Interview with Edward Kienholz," *Kunstwerk*, March 1973, pp. 49–50.

COPLANS, JOHN. "Assemblage: The Savage Eye of Edward Kienholz," *Studio International*, September 1965, pp. 112–15.

"Edward Kienholz," *Du* 5 (1980): 42–49.

FACTOR, DONALD. "Edward Kienholz," *Artforum*, August 1963, pp. 24–25.

GABLIK, SUZI. "Crossing the Bar," *Art News*, October 1965, pp. 22–25.

HULTÉN, PONTUS. "Edward Kienholz," *Art and Artists*, June 1971, pp. 14–19.

JOUFFROY, ALAIN. "Edward Kienholz," *Opus International*, December 1970, pp. 21–25.

PINCUS, R.L. "An Ode to an 'Odious' for Neo-Dada: Edward Kienholz's Assemblages and Tableaux, 1958–1965," *Images and Issues*, Fall 1981, pp. 53–55.

RONTE, D. "Edward Kienholz's 'Portable War Memorial,'" *Oeil*, December 1972, pp. 22–29.

SILBERMAN, R. "Imitation of Life," *Art in America*, March 1986, pp. 138–43.

SILK, GERALD D. "Ed Kienholz's 'Back Seat Dodge '38,'" *Arts Magazine*, January 1978, pp. 112–18.

THWAITES, J.A. "Kienholz and Realism," *Art and Artists*, September 1973, pp. 22–27.

TILLIM, SIDNEY. "Edward Kienholz's 'Barney's Beanery,'" *Artforum*, April 1966, pp. 38–40.

TUCHMAN, MAURICE. "A Decade of Edward Kienholz," *Artforum*, April 1966, pp. 41–45.

WIGHT, FREDERICK S., AND HENRY T. HOPKINS. "Edward Kienholz: Two Views," *Art in America*, October–November 1965, pp. 70–73.

YARD, S. "Shadow of the Bomb," *Arts Magazine*, April 1984, pp. 74–75.

## JOSEPH KOSUTH

KOSUTH, JOSEPH. *The Making of Meaning: Selected Writings and Documentation of Investigations on Art Since 1965* (Stuttgart: Staatsgalerie, 1981).

LUCERNE, Kunstmuseum. *Joseph Kosuth: Investigationen über Kunst & 'Problemkreise' seit 1965*, 1973. Texts by T. Atkinson, M. Baldwin, P. Pilkington, M. Ramsden, D. Rushton, and T. Smith.

BAKER, ELIZABETH C. "Joseph Kosuth: Information, Please," *Art News*, February 1973, pp. 30–31.

BOICE, BRUCE. "Joseph Kosuth: 2 Shows," *Artforum*, March 1973, pp. 84–85.

BUETTNER, STEWART. "Joseph Kosuth's 'Tenth Investigation—Proposition Five,'" *Arts Magazine*, October 1975, pp. 86–87.

MENNA, F. "Kosuth's Linguistic Investigations," *Qui arte contemporanea*, June 1973, pp. 27–30.

MILLET, CATHERINE. "Joseph Kosuth," *Flash Art*, February–March 1971, pp. 1–2.

## NICHOLAS KRUSHENICK

HANOVER, N.H. Hopkins Center, Dartmouth College. *Nicholas Krushenick*, 1969. Texts by Truman Brackett, Matthew Wysocki, and John Perreault.

PERREAULT, JOHN. "Krushenick's Blazing Blazons," *Art News*, March 1967, pp. 34–35, 72–73.

ROBINS, CORINNE. "The Artist Speaks: Nicholas Krushenick," *Art in America*, May 1969, pp. 60–65.

SWANSON, DEAN. "Krushenick," *Art International*, April 1968, pp. 31–33.

## ALFRED LESLIE

BOSTON. Boston Museum of Fine Arts. *Alfred Leslie*, 1976. Text by Robert Rosenblum.

ARTHUR, JOHN. "Alfred Leslie Talks with John Arthur," *Drawing*, November–December 1979, pp. 81–85.

HULTÉN, PONTUS, and A. JOUFFROY. "Un Entretien avec Pontus Hultén: Alfred Leslie de l'abstraction gesturelle à Hyperréalisme," *XXᵉ Siècle*, December 1975, pp. 98–102.

LESHKO, J. "Alfred Leslie's *The Thirteen Americans:* An Appreciation," *Arts Magazine*, June 1983, pp. 122–25.

NOCHLIN, LINDA. "Leslie, Torres: New Uses of History," *Art in America*, March–April 1976, pp. 74–76.

## BARRY LE VA

DAYTON. Wright State University Art Galleries. *Barry Le Va—Accumulated Vision: Extended Boundaries*, 1977. Text by William Spurlock.

NEW YORK. New Museum. *Barry Le Va: Four Consecutive Installations & Drawings, 1967–1978*, 1978. Text by Marcia Tucker.

SALINAS, CALIF. Hartnell College Gallery. *Barry Le Va: Drawings, 1967–77*, 1979. Text by D. Ligare.

BAER, LIZA, and WILLOUGHBY SHARP. "Discussions with Barry Le Va," *Avalanche*, Fall 1971, pp. 62–75.

"Barry LeVa," *Design Quarterly* 74–75 (1969): 46–57.

KERTESS, KLAUS. "Barry Le Va's Sculpture: Ellipsis and Ellipse," *Artforum*, January 1983, pp. 58–65.

LEVA, BARRY. "Notes on a Piece by Barry Le Va: Extended Vertex Meetings—Blocked, Blown Outward," *Studio International*, November 1971, pp. 178–79.

LIVINGSTON, JANE. "Barry Le Va: Distributional Sculpture," *Artforum*, November 1968, pp. 50–54.

PINCUS-WITTEN, ROBERT. "The Invisibility of Content," *Arts Magazine*, October 1975, pp. 60–67.

ROSING, LARRY. "Barry Le Va and the Non-Descript Distribution," *Art News*, September 1969, pp. 52–53.

## SOL LeWITT

AMSTERDAM. Stedelijk Museum. *Sol LeWitt Wall Drawings, 1968–1984*, 1984. Texts by Alexander van Grevenstein, Jan Debbaut, and Michael Harvey.

THE HAGUE. Gemeentemuseum. *Sol LeWitt*, 1970. Texts by Enno Develing, Mel Bochner, John N. Chandler, Dan Graham, Coosje Kapteyn-van Bruggen, Michael Kirby, Ira Licht, Rosalind Krauss, Barbara M. Reise, and others.

KREFELD. Museum Haus Lange. *Sol LeWitt: Sculptures and Wall Drawings*, 1969. Text by Paul Wember.

NEW YORK. Museum of Modern Art. *Sol LeWitt*, 1978. Texts by Lucy R. Lippard, Bernice Rose, and Robert Rosenblum.

ALLOWAY, LAWRENCE. "Sol LeWitt: Modules, Walls, Books," *Artforum*, April 1975, pp. 38–45.

BAKER, K. "Energy as Form," *Art in America*, May–June 1978, pp. 76–81.

BORDEN, LIZZIE. "Sol LeWitt," *Artforum*, April 1973, pp. 73–77.

CELANT, GERMANO. "LeWitt," *Casabella*, July 1972, pp. 38–42.

KUSPIT, DONALD B. "Sol LeWitt: The Look of Thought," *Art in America*, September–October 1975, pp. 42–49.

———. "Sol LeWitt the Wit," *Arts Maga-*

*zine,* April 1978, pp. 118–24.

LEWITT, SOL. "All Wall Drawings," *Arts Magazine,* February 1972, pp. 39–44.

———. "Ruth Vollmer: Mathematical Forms," *Studio International,* December 1970, pp. 256–57.

———. "White in Art Is White?" *Print Collector's Newsletter,* March–April 1977, pp. 1–4.

LIEBMAN, L. "Stubborn Ideas and LeWitty Walls," *Artforum,* October 1984, pp. 64–68.

LIPPARD, LUCY R. "Sol LeWitt: Non-Visual Structures," *Artforum,* April 1967, pp. 42–46.

PINCUS-WITTEN, ROBERT. "Sol LeWitt: Word ⟷ Object," *Artforum,* February 1973, pp. 69–72.

REISE, BARBARA. "Sol LeWitt Drawings, 1968–1969," *Studio International,* December 1969, pp. 222–25.

SMITH, ROBERTA. "Sol LeWitt," *Artforum,* January 1975, pp. 60–62.

WOOSTER, ANN SARGENT. "LeWitt Goes to School," *Art in America,* May–June 1978, pp. 82–84.

———. "LeWitt's Expanding Grid," *Art in America,* May 1980, pp. 143–47.

ROY LICHTENSTEIN

ALLOWAY, LAWRENCE. *Roy Lichtenstein* (New York: Abbeville, 1983).

COPLANS, JOHN, ed. *Roy Lichtenstein* (New York: Praeger, 1972).

WALDMAN, DIANE. *Roy Lichtenstein* (New York: Harry N. Abrams, 1972).

———. *Roy Lichtenstein: Drawings and Prints* (New York: Chelsea House, 1969).

HOUSTON. Contemporary Art Museum. *Roy Lichtenstein,* 1972. Text by Lawrence Alloway.

NEW YORK. Museum of Modern Art. *The Drawings of Roy Lichtenstein,* 1987. Text by Bernice Rose.

NEW YORK. Solomon R. Guggenheim Museum. *Roy Lichtenstein,* 1969. Text by Diane Waldman.

ALLOWAY, LAWRENCE. "On Style: An Examination of Roy Lichtenstein's Development Despite a New Monograph on the Artist," *Artforum,* March 1972, pp. 53–59.

———. "Roy Lichtenstein's Period Style," *Arts Magazine,* September–October 1967, pp. 24–29.

ARMSTRONG, R. "Cheez Whiz," *Artforum,* April 1984, pp. 61–65.

BARO, GENE. "Roy Lichtenstein: Technique as Style," *Art International,* November 1968, pp. 35–38.

BOIME, ALBERT. "Roy Lichtenstein and the Comic Strip," *Art Journal,* Winter 1968–69, pp. 155–59.

CALAS, NICOLAS. "Roy Lichtenstein: Insight Through Irony," *Arts Magazine,* September–October 1969, pp. 29–33.

COHEN, R. H. "The Medium Isn't the Message," *Art News,* October 1985, pp. 77–79.

COPLANS, JOHN. "An Interview with Roy Lichtenstein," *Artforum,* October 1963, p. 31.

———. "Lichtenstein's Graphic Works: Roy Lichtenstein in Conversation," *Studio International,* December 1970, pp. 263–65.

———. "Talking with Roy Lichtenstein," *Artforum,* May 1967, pp. 34–39.

DANOFF, MICHAEL I. "Paintings That Make Your Retinas Dance: Roy Lichtenstein's Art," *Art News,* November 1981, pp. 122–25.

FRY, EDWARD. "Inside the Trojan Horse: Lichtenstein at the Guggenheim," *Art News,* October 1969, pp. 36–39, 60.

———. "Roy Lichtenstein's Recent Landscapes," *Art and Literature,* Spring 1966, pp. 111–19.

HAHN, OTTO. "Roy Lichtenstein," *Art International,* Summer 1966, pp. 64, 66–69.

HAMILTON, RICHARD, AND LAWRENCE ALLOWAY. "Roy Lichtenstein," *Studio International,* January 1968, pp. 20–24.

JOHNSON, ELLEN H. "The Lichtenstein Paradox," *Art and Artists,* January 1968, pp. 12–15.

———. "Lichtenstein: The Printed Image at Venice," *Art and Artists,* June 1966, pp. 12–15.

KOZLOFF, MAX. "Lichtenstein at the Guggenheim," *Artforum,* November 1969, pp. 41–45.

LORAN, ERLE. "Cézanne and Lichtenstein: Problems of Transformation," *Artforum,* September 1963, pp. 34–35.

———. "Pop Artists or Copy Cats?" *Art News,* September 1963, pp. 48–49, 61.

ROSENBLUM, ROBERT. "Roy Lichtenstein and the Realist Revolt," *Metro,* April 1963, pp. 38–45.

"Roy Lichtenstein à Paris," an interview, *L'Oeil,* November 1982, pp. 40–45.

SCHAFF, DAVID. "A Conversation with Roy Lichtenstein," *Art International,* January–February 1980, pp. 28–39.

SEIBERLING, DOROTHY. "Roy Lichtenstein: Is He the Worst Artist in the U.S.?" *Life,* 31 January 1964, pp. 79–81, 83.

SOLOMON, ALAN. "Conversation with Lichtenstein," *Fantazaria,* July–August 1966, pp. 36–43.

"Studies in Iconography: The Master of the Crying Girl," *Art in America,* March–April 1966, pp. 96–97.

TILLIM, SIDNEY. "Lichtenstein's Sculpture," *Artforum,* January 1968, pp. 22–24.

WALDMAN, DIANE. "Remarkable Commonplace," *Art News,* October 1967, pp. 28–31, 65–67.

RICHARD LONG

COMPTON, MICHAEL. *Some Notes on the Work of Richard Long* (London: British Council, 1976).

CAMBRIDGE, MASS. Fogg Art Museum, Harvard University. *Richard Long,* 1980. Text by Gabriella Jeppson.

NEW YORK. Solomon R. Guggenheim Museum. *Richard Long,* 1986. Text by Richard Long.

FIELD, SIMON. "Touching the Earth," *Art and Artists,* April 1973, pp. 14–19.

FOOTE, NANCY. "Long Walks," *Artforum,* Summer 1980, pp. 42–47.

FUCHS, R.H. "Memories of Passing: A Note on Richard Long," *Studio International,* April 1974, pp. 172–73.

GINTZ, C. "Richard Long: Vision, Landscape, Time," an interview, *Art Press,* June 1986, pp. 4–8.

"Nineteen Stills from the Work of Richard Long," *Studio International,* March 1970, pp. 106–11.

PAOLETTI, JOHN T. "Richard Long," *Arts Magazine,* December 1982, p. 3.

POINSOT, J. "Richard Long: To Build the Landscape," *Art Press,* November 1981, pp. 9–11.

TRINI, TOMMASO. "Richard Long," *Domus,* June 1972, pp. 48–50.

MORRIS LOUIS

FRIED, MICHAEL. *Morris Louis* (New York: Harry N. Abrams, 1970).

UPRIGHT, DIANE. *Morris Louis: The Complete Paintings* (New York: Harry N. Abrams, 1987).

AMSTERDAM. Stedelijk Museum. *Morris Louis,* 1965. Text by Robert Rosenblum.

BOSTON. Museum of Fine Arts. *Morris Louis, 1912–1962,* 1963. Text by Michael Fried.

LONDON. Hayward Gallery. *Morris Louis,* 1974. Text by John Elderfield.

LONDON. Whitechapel Art Gallery. *Morris Louis,* 1965. Texts by Alan Solomon and Clement Greenberg.

MINNEAPOLIS. Walker Art Center. *Morris Louis: The Veil Cycle,* 1977. Texts by Dean Swanson and Diane Headley.

NEW YORK. Museum of Modern Art. *Mor-*

ris Louis, 1986. Text by John Elderfield.
NEW YORK. Solomon R. Guggenheim Museum. *Morris Louis, 1929–1962*, 1963. Text by Lawrence Alloway.
WASHINGTON, D.C. National Gallery of Art. *Morris Louis: Major Themes and Variations*, 1976. Text by E.A. Carmean.
BAKER, ELIZABETH C. "Morris Louis: Veiled Illusions," *Art News*, April 1970, pp. 36–39, 62–64.
BANNARD, WALTER D. "Morris Louis and the Re-structured Picture," *Studio International*, July 1974, pp. 18–20.
CARMEAN, E.A. "Morris Louis and the Modern Tradition," part 1, *Arts Magazine*, September 1976, pp. 70–75; parts 2–3, October 1976, pp. 112–17; parts 4–5, November 1976, pp. 122–26; part 6, December 1976, pp. 116–19.
ELDERFIELD, JOHN. "Morris Louis and Twentieth-Century Painting," *Art International*, May–June 1977, pp. 24–32.
FRIED, MICHAEL. "The Achievement of Morris Louis," *Artforum*, February 1967, pp. 34–40.
———. "Some Notes on Morris Louis," *Arts Magazine*, November 1963, pp. 22–27.
GOLDIN, AMY. "Morris Louis: Thinking the Unwordable," *Art News*, April 1968, pp. 48–49, 67–69.
LEIDER, PHILIP. "You May Think You Appreciate Morris Louis, But Do You Really?" *New York Times*, 26 February 1967, sec. D, p. 27.
MILLARD, CHARLES. "Morris Louis," *Hudson Review*, Summer 1977, pp. 253–58.
MOFFETT, KENWORTH. "Morris Louis: Omegas and Unfurleds," *Artforum*, May 1970, pp. 44–47.
ROBBINS, DANIEL. "Morris Louis at the Juncture of Two Traditions," *Quadrum* 18 (1965): 41–54, 181.
———. "Morris Louis: Triumph of Color," *Art News*, October 1963, pp. 28–29, 57–58.
ROSE, BARBARA. "Quality in Louis," *Artforum*, October 1971, pp. 62–65.
ROSENBLUM, ROBERT. "Morris Louis at the Guggenheim Museum," *Art International*, December 1963, pp. 24–27.

LEN LYE

AUCKLAND. City Art Gallery. *Len Lye: A Personal Mythology*, 1980. Texts by Andrew Bogle, Gerhard Brauer, and Roger Horrocks.
MANCIA, ADRIENNE, and WILLARD VAN DYKE. "Artist as Film-maker: Len Lye,"

*Art in America*, July 1966, pp. 98–106.
PIENE, OTTO. "Mother, Turn Off the Picture," *artscanada*, June 1968, pp. 13–16.
THORBURN, RAY. "Ray Thorburn Interviews Len Lye," *Art International*, April 1975, pp. 64–68.

ROBERT MANGOLD

LA JOLLA, CALIF. La Jolla Museum of Contemporary Art. *Robert Mangold*, 1974. Text by Naomi Spector.
NEW YORK. Solomon R. Guggenheim Museum. *Robert Mangold*, 1971. Text by Diane Waldman.
BOCHNER, MEL. "A Compilation for Robert Mangold," *Art International*, 20 April 1968, pp. 29–30.
KRAUSS, ROSALIND. "Robert Mangold: An Interview," *Artforum*, March 1974, pp. 36–38.
LIPPARD, LUCY R. "Robert Mangold and the Implications of Monochrome," *Art and Literature* 9 (1966): 116–30.
MASHECK, JOSEPH. "A Humanist Geometry," *Artforum*, March 1974, pp. 39–43.
PROKOPOFF, S. "Logic of Vision," *Art News*, September 1974, pp. 45–47.
ROSENSTEIN, HARRIS. "To Be Continued," *Art News*, October 1970, pp. 63–65, 82–83.

BRICE MARDEN

HOUSTON. Contemporary Art Museum. *Brice Marden's Drawings*, 1974. Text by Dore Ashton.
LONDON. Whitechapel Art Gallery. *Brice Marden: Paintings, Drawings and Prints, 1975–80*, 1981. Texts by Nicholas Serota, Stephen Bann, and Roberta Smith.
NEW YORK. Solomon R. Guggenheim Museum. *Brice Marden*, 1975. Text by Linda Shearer.
ASHBERY, JOHN. "Gray Eminence," *Art News*, March 1972, pp. 26–27, 64–66.
BANN, STEPHEN. "Adriatics à propos of Brice Marden," *20th Century Studies* 15–16 (1978): 116–29.
GILBERT-ROLFE, JEREMY. "Brice Marden's Paintings," *Artforum*, October 1974, pp. 30–38.
POIRER, MAURICE. "Color-Coded Mysteries," *Art News*, January 1985, pp. 52–61.
RATCLIFF, CARTER. "Mostly Monochrome," *Art in America*, April 1981, pp. 128–30.

———. "Once More with Feeling," *Art News*, Summer 1972, pp. 35–36, 67–69.
RICARD, RENE. "An Art of Regret," *Artforum*, Summer 1985, pp. 86–91.
ROSENSTEIN, HARRIS. "Total and Complex," *Art News*, May 1967, pp. 52–54, 67–68.
SMITH, ROBERTA PANCOAST. "Brice Marden's Paintings," *Arts Magazine*, May–June 1973, pp. 30–41.
STORR, ROBERT. "Brice Marden: Double Vision," *Art in America*, March 1985, pp. 118–25.
WHITE, ROBIN. "Brice Marden Interview," *View* (Oakland, Calif.: Crown Point, 1980), pp. 1–24.

AGNES MARTIN

LONDON. Hayward Gallery. *Agnes Martin: Paintings and Drawings, 1957–1975*, 1977. Texts by Dore Ashton and Agnes Martin.
PHILADELPHIA. Institute of Contemporary Art, University of Pennsylvania. *Agnes Martin*, 1973. Texts by Lawrence Alloway and Agnes Martin.
ALLOWAY, LAWRENCE. "Formlessness Breaking Down Form: The Paintings of Agnes Martin," *Studio International*, February 1973, pp. 61–63.
ASHTON, DORE. "Agnes Martin," *Quadrum* 20 (1966): 148–49.
BORDEN, LIZZIE. "Early Work of Agnes Martin," *Artforum*, April 1973, pp. 39–44.
CELANT, GERMANO. "Agnes Martin," *Flash Art*, June 1973, pp. 3–8.
CRIMP, D. "Agnes Martin: Number, Measure, Relationship," *Data*, Winter 1973, pp. 82–85.
GRUEN, JOHN. "Agnes Martin: 'Everything, everything is about feeling . . . feeling and recognition," *Art News*, September 1976, pp. 91–94.
LINVILLE, KASHA. "Agnes Martin: An Appreciation," *Artforum*, June 1971, pp. 72–73.
MARTIN, AGNES. "The Untroubled Mind," *Studio International*, February 1973, pp. 64–65.
MICHELSON, ANNETTE. "Agnes Martin: Recent Paintings," *Artforum*, January 1967, pp. 46–47.
RATCLIFF, CARTER. "Agnes Martin and the 'Artificial Infinite,'" *Art News*, May 1973, pp. 26–28.
WILSON, ANN. "Agnes Martin: The Essential Form—The Committed Life," *Art International*, December 1974, pp. 50–52.

———. "Linear Webs," *Art and Artists,* October 1966, pp. 46–49.

## MALCOLM MORLEY

LONDON. Whitechapel Art Gallery. *Malcolm Morley,* 1983. Text by Michael Compton.

NEW YORK. Clocktower, Institute of Art and Urban Resources. *Malcolm Morley,* 1976. Text by Lawrence Alloway.

ALLOWAY, LAWRENCE. "Malcolm Morley," *Unmuzzled Ox* 2 (1974): 46–55.

———. "Morley Paints a Picture," *Art News,* Summer 1968, pp. 42–44, 69–71.

———. "The Paintings of Malcolm Morley," *Art and Artists,* February 1967, pp. 16–19.

LEVIN, KIM. "Malcolm Morley: Post Style Illusionism," *Arts Magazine,* February 1973, pp. 60–63.

RUBINFEIN, LEO. "Malcolm Morley," *Artforum,* December 1976, pp. 63–67.

## ROBERT MORRIS

EINDHOVEN. Stedelijk van Abbemuseum. *Robert Morris,* 1968. Texts by J. Leering and Robert Morris.

LONDON. Tate Gallery. *Robert Morris,* 1971. Texts by Michael Compton and David Sylvester.

NEW YORK. Whitney Museum of American Art, *Robert Morris,* 1970. Text by Marcia Tucker.

PHILADELPHIA. Institute of Contemporary Art, University of Pennsylvania. *Robert Morris: Projects,* 1974. Text by Edward F. Fry.

WASHINGTON, D.C. Corcoran Gallery of Art. *Robert Morris,* 1969. Text by Annette Michelson.

ANTIN, DAVID. "Art & Information, 1: Grey Paint, Robert Morris," *Art News,* April 1966, pp. 22–24, 56–58.

BATTCOCK, GREGORY. "Robert Morris: New Sculptures at Castelli," *Arts Magazine,* May 1968, pp. 30–31.

BURNHAM, JACK. "Robert Morris: Retrospective in Detroit," *Artforum,* March 1970, pp. 67–75.

CALAS, NICOLAS. "Wit and Pedantry of Robert Morris," *Arts Magazine,* March 1970, pp. 44–47.

FRIEDMAN, MARTIN. "Robert Morris: Polemics and Cubes," *Art International,* 20 December 1966, pp. 23–24.

GOOSSEN, E.C. "The Artist Speaks: Robert Morris," *Art in America,* May–June 1970, pp. 104–111.

LIPPARD, LUCY. "New York Letter," *Art International,* May 1965, pp. 57–58.

SAUERWEIN, LAURENT. "Two Sculptures by Robert Morris," *Art International,* May 1968, pp. 276–77.

WILSON, WILLIAM S. "Hard Questions and Soft Answers," *Art News,* November 1969, pp. 26–28, 81–84.

## BRUCE NAUMAN

BALTIMORE. Baltimore Museum of Art. *Bruce Nauman, Neons,* 1982. Text by Brenda Richardson.

LONDON. Whitechapel Art Gallery. *Bruce Nauman,* 1986. Texts by Joan Simon and Jean-Christophe Ammann.

LOS ANGELES. Los Angeles County Museum of Art. *Bruce Nauman: Works from 1965 to 1972,* 1972. Texts by Jane Livingston and Marcia Tucker.

NEW YORK. Leo Castelli Gallery. *Bruce Nauman,* 1968. Text by David Whitney.

BUTTERFIELD, JAN. "Bruce Nauman: The Center of Yourself," an interview, *Arts Magazine,* February 1975, pp. 53–55.

CATOIR, B. "About Bruce Nauman's Subjectivism," *Kunstwerk,* November 1973, pp. 3–12.

CELANT, GERMANO, ed. "Bruce Nauman," *Casabella,* February 1970, pp. 38–41.

DANIELI, FIDEL A. "The Art of Bruce Nauman," *Artforum,* December 1967, pp. 15–19.

HARTEN, JURGEN. "T for Technics, B for Body," *Art and Artists,* November 1973, pp. 28–33.

LEVIN, KIM. "Bruce Nauman: Stretching the Truth," *Opus International,* September 1973, pp. 44–46.

NAUMAN, BRUCE. "Notes and Projects," *Artforum,* December 1970, p. 44.

PINCUS-WITTEN, ROBERT. "Bruce Nauman: Another Kind of Reasoning," *Artforum,* February 1972, pp. 30–37.

PLAGENS, PETER. "Roughly Ordered Thoughts on the Occasion of the Bruce Nauman Retrospective in Los Angeles," *Artforum,* March 1973, pp. 57–59.

POINSET, J. "Bruce Nauman: The Problem of Non-Meaning," *Art Press,* March–April 1974, pp. 12–15.

SHARP, WILLOUGHBY. "Bruce Nauman," an interview, *Avalanche* 2 (Winter 1971): 23–35.

———. "Nauman Interview," *Arts Magazine,* March 1970, pp. 22–27.

STORR, ROBERT. "Bruce Nauman: The Not-So-Holy Fool," *Art Press,* February 1985, pp. 9–13.

TUCKER, MARCIA. "PheNAUMANology," *Artforum,* December 1970, pp. 38–44.

WALLACE, IAN, and RUSSELL KEZIERE. "Bruce Nauman Interviewed," *Vanguard,* February 1979, pp. 15–18.

## KENNETH NOLAND

MOFFETT, KENWORTH. *Kenneth Noland* (New York: Harry N. Abrams, 1977).

NEW YORK. Jewish Museum. *Kenneth Noland,* 1965. Text by Michael Fried.

NEW YORK. Solomon R. Guggenheim Museum. *Kenneth Noland,* 1977. Text by Diane Waldman.

BRUNELLE, AL. "The Sky-Colored Popsicle," *Art News,* November 1967, pp. 42–43, 76–79.

CARMEAN, E.A. "Noland and the Compositional Cut," *Arts Magazine,* December 1975, pp. 80–85.

CONE, JANE HARRISON. "Kenneth Noland's New Paintings," *Artforum,* November 1967, pp. 36–41.

———. "On Color in Kenneth Noland's Paintings," *Art International,* June 1965, pp. 36–38.

FRIED, MICHAEL. "Recent Work by Kenneth Noland," *Artforum,* Summer 1969, pp. 36–38.

HARRISON, CHARLES. "Recent Work by Kenneth Noland at Kasmin," *Studio International,* June 1968, pp. 35–38.

MACKIE, ALWYNNE. "Noland and Quality in Art," *Art International,* Summer 1979, pp. 40–45.

MOFFETT, KENWORTH. "Noland," *Art International,* Summer 1973, pp. 22–23, 91–95, 100.

———. "Noland Vertical," *Art News,* October 1971, pp. 48–49, 76–78.

POLCARI, STEPHEN. "Kenneth Noland: Independence in the Face of Conformity," *Art News,* Summer 1977. pp. 153–55.

ROSE, BARBARA. "Kenneth Noland," *Art International,* Summer 1964, pp. 58–61.

WALDMAN, DIANE. "Color, Format, and Abstract Art: An Interview," *Art in America,* May 1977, pp. 99–105.

## CLAES OLDENBURG

BARO, GENE. *Claes Oldenburg: Drawings and Prints* (New York: Chelsea House, 1969).

JOHNSON, ELLEN H. *Claes Oldenburg* (Baltimore: Penguin Books, 1971).

OLDENBURG, CLAES. *Notes in Hand* (New

York: E.P. Dutton, 1971).

———. *Proposals for Monuments and Buildings, 1965–1969* (Chicago: Big Table, 1969). Interview with Paul Carroll.

———. *Store Days* (New York: Something Else, 1967).

MINNEAPOLIS. Walker Art Center. *Oldenburg: Six Themes*, 1975. Text by Martin Friedman.

NEW YORK. Museum of Modern Art. *Claes Oldenburg*, 1970. Text by Barbara Rose.

PASADENA. Pasadena Art Museum. *Claes Oldenburg: Object into Monument*, 1971. Text by Alicia Legg.

BARO, GENE. "Claes Oldenburg, or the Things of This World," *Art International*, 20 November 1966, pp. 41–43, 45–48.

———. "Oldenburg's Monuments," an interview, *Art and Artists*, December 1966, pp. 28–31.

COPLANS, JOHN. "The Artist Speaks: Claes Oldenburg," *Art in America*, March–April 1969, pp. 68–75.

FINCH, CHRISTOPHER. "Notes for a Monument to Claes Oldenburg," *Art News*, October 1969, pp. 52–56.

FOOTE, NANCY. "Oldenburg's Monuments to the 60's," *Artforum*, January 1977, pp. 54–56.

GABLIK, SUZI. "Take a Cigarette Butt and Make It Heroic," an interview, *Art News*, May 1967, pp. 30–31, 77.

GRAHAM, DAN. "Oldenburg's Monuments," *Artforum*, January 1968, pp. 30–37.

JOHNSON, ELLEN H. "The Living Object," *Art International*, 25 January 1963, pp. 42–45.

———. "Oldenburg's Poetics: Analogues, Metaphors and Sources," *Art International*, April 1970, pp. 42–45.

LEGG, ALICIA. "Claes Oldenburg," *Art and Artists*, July 1970, pp. 20–24.

OLDENBURG, CLAES. "America: War and Sex, Etc.," *Arts Magazine*, Summer 1967, pp. 32–38.

———. "The Bedroom Ensemble, Replica 1," *Studio International*, July–August 1969, pp. 2–3.

———. "Chronology of Drawings," *Studio International*, June 1970, pp. 249–53.

———. "Extracts from the Studio Notes (1962–64)," *Artforum*, January 1966, pp. 32–33.

REAVES, ANGELA W. "Claes Oldenburg: An Interview," *Artforum*, October 1972, pp. 36–39.

ROSE, BARBARA. "The Airflow Multiple of Claes Oldenburg," *Studio International*, June 1970, pp. 254–55.

———. "Claes Oldenburg's Soft Ma-

chines," *Artforum*, Summer 1967, pp. 30–35.

———. "The Origin, Life and Times of Ray Gun," *Artforum*, November 1969, pp. 50–57.

ROSENSTEIN, HARRIS. "Climbing Mt. Oldenburg," *Art News*, February 1966, pp. 21–25, 56–69.

SIEGEL, JEANNE. "How to Keep Sculpture Alive In and Out of a Museum," an interview, *Arts Magazine*, September–October 1969, pp. 24–28.

———. "Oldenburg's Places and Borrowings," *Arts Magazine*, November 1969, pp. 48–49.

TOMKINS, CALVIN. "Profile: Claes Oldenburg," *New Yorker*, 12 December 1977, pp. 55–88.

## JULES OLITSKI

MOFFETT, KENWORTH. *Jules Olitski* (New York: Harry N. Abrams, 1981).

EDMONTON. Edmonton Art Gallery. *Jules Olitski and the Tradition of Oil Painting*, 1979. Text by Terry Fenton.

NEW YORK. Whitney Museum of American Art. *Jules Olitski*, 1973. Text by Kenworth Moffett.

PHILADELPHIA. Institute of Contemporary Art, University of Pennsylvania. *Jules Olitski: Recent Paintings*, 1968. Text by Rosalind E. Krauss.

WASHINGTON, D.C. Corcoran Gallery of Art. *Jules Olitski: Paintings, 1963–1967*, 1967. Text by Michael Fried.

BANNARD, WALTER DARBY. "Quality, Style and Olitski," *Artforum*, October 1972, pp. 64–67.

CARMEAN, E.A. "Olitski, Cubism and Transparency," *Arts Magazine*, November 1975, pp. 53–57.

CARPENTER, KEN. "On Order in the Paintings of Jules Olitski," *Art International*, December 1962, pp. 26–30.

CHAMPA, KERMIT. "Olitski: Nothing but Color," *Art News*, May 1967, pp. 36–38, 74–76.

CHISHOLM, SHIRLEY. "Jules Olitski," *Current Biography*, October 1969, pp. 31–34.

ELDERFIELD, JOHN. "Painterliness, Redefined: Jules Olitski and Recent Abstract Art," part 1, *Art International*, December 1972, pp. 92–94; part 2, April 1973, pp. 36–41, 101.

FRIED, MICHAEL. "Jules Olitski's New Paintings," *Artforum*, November 1965, pp. 36–40.

———. "Olitski and Shape," *Artforum*, January 1967, pp. 20–21.

HALASZ, P. "Jules Olitski: The Golden Mean," *Arts Magazine*, May 1984, pp. 130–33.

HUDSON, ANDREW. "On Jules Olitski's Paintings and Some Changes of View," *Art International*, January 1968, pp. 31–36.

MASHECK, JOSEPH. "The Jules Olitski Retrospective," *Artforum*, September 1973, pp. 56–60.

MILLARD, CHARLES. "Jules Olitski," *Hudson Review*, October 1974, pp. 401–8.

MOFFETT, KENWORTH. "Jules Olitski and the State of Easel Painting," *Arts Magazine*, March 1973, pp. 42–48.

———. "The Sculpture of Jules Olitski," *Artforum*, April 1969, pp. 55–59.

OLITSKI, JULES. "Painting in Color," *Artforum*, January 1967, p. 20.

SIEGEL, JEANNE. "Olitski's Retrospective: Infinite Variety," *Art News*, Summer 1973, pp. 61–63.

THOMSON, B. "The Strange Case of Jules Olitski," *Art in America*, January–February 1974, pp. 62–64.

## DENNIS OPPENHEIM

AMSTERDAM. Stedelijk Museum. *Dennis Oppenheim*, 1974. Text by Dennis Oppenheim.

MONTREAL. Musée d'Art Contemporain. *Dennis Oppenheim: Retrospective Works, 1967–1977*, 1978. Texts by Alain Parent, Peter Frank, and Lisa Kahane. Interview by Alain Parent.

BAKER, KENNETH. "Dennis Oppenheim: An Art with Nothing to Lose," *Arts Magazine*, April 1975, pp. 72–74.

BOURGEOIS, JEAN-LOUIS. "Dennis Oppenheim: A Presence in the Countryside," *Artforum*, October 1969, pp. 34–38.

BURNHAM, JACK. "The Artist as Shaman," *Arts Magazine*, May–June 1973, pp. 42–44.

———. "Dennis Oppenheim: Catalyst, 1967–1970," *artscanada*, August 1970, pp. 29–36.

CRARY, JONATHAN. "Dennis Oppenheim's Delirious Operations," *Artforum*, November 1978, pp. 36–40.

GOLDBERG, LENORE. "Dennis Oppenheim: Myth and Ritual," *Art and Artists*, August 1973, pp. 22–27.

HERSHMAN, LYNN. "Interview with Dennis Oppenheim," *Studio International*, November 1973, pp. 196–97.

OPPENHEIM, DENNIS. "Interactions: Forms-Energy-Subject," *Arts Magazine*, March 1972, pp. 36–39.

———. "Recurring Aspects in Sculpture," *Cover 2*, January 1980, pp. 36–39.

SCHWARTZ, ELLEN. "Dennis Oppenheim: Art Between Mind and Matter," *Art News,* December 1982, pp. 58–61.

SHARP, WILLOUGHBY. "Dennis Oppenheim . . . Recall," *Avalanche,* May–June 1974, pp. 14–15.

————. "Dennis Oppenheim," an interview, *Studio International,* November 1971, pp. 186–93.

WALKER, DOROTHY. "Interview with Dennis Oppenheim," *Studio International,* April–May 1983, pp. 39–41.

WOOD, STEVE. "Interview with Dennis Oppenheim," *Arts Magazine,* June 1981, pp. 133–37.

## NAM JUNE PAIK

NEW YORK. Galeria Bonino. *Paik-Abe Video Synthesizer with Charlotte Moorman: Electronic Art III,* 1971. Texts by John Cage and Russell Conner.

————. *Nam June Paik: Electronic Art,* 1965. Text by John Cage.

————. *Nam June Paik: Electronic Art II,* 1968. Text by Allan Kaprow.

NEW YORK. Whitney Museum of American Art. *Nam June Paik,* 1982. Texts by John G. Hanhardt, Michael Nyman, Dieter Ronte, and David A. Ross.

SYRACUSE, N.Y. Everson Museum of Art. *Nam June Paik: Videa 'n' Videology, 1959–1973,* 1974. Text by Nam June Paik.

GARDNER, PAUL. "Tuning in to Nam June Paik," *Art News,* May 1982, pp. 64–73.

KURTZ, BRUCE. "Paikvision," *Artforum,* October 1982, pp. 52–55.

PAIK, NAM JUNE. "Random Access Information," *Artforum,* September 1980, pp. 46–49.

STURKEN, MARITA. "Video Guru," *American Film,* May–June 1982, pp. 13–16.

TOMKINS, CALVIN. "Profiles: Video Visionary," *New Yorker,* 5 May 1975, pp. 44–79.

YALKUT, JUD. "Art and Technology of Nam June Paik," *Arts Magazine,* April 1968, pp. 50–51.

## PHILIP PEARLSTEIN

BOWMAN, RUSSELL. *Philip Pearlstein: The Complete Paintings* (New York: Alpine Fine Arts Collection, 1983).

VIOLA, JEROME. *The Paintings and Teaching of Philip Pearlstein* (New York: Watson-Guptill, 1982).

ATHENS, GA. Museum of Art, University of Georgia. *Philip Pearlstein,* 1970. Text by Linda Nochlin.

MILWAUKEE. Milwaukee Art Museum. *Philip Pearlstein: A Retrospective,* 1983. Texts by Russell Bowman, Philip Pearlstein, Irving Sandler.

MAINARDI, PATRICIA. "Old Master of the New Realists," *Art News,* November 1976, pp. 72–75.

MIDGETT, WILLARD. "Philip Pearlstein: The Naked Truth," *Art News,* October 1967, pp. 54–55, 75–78.

NOCHLIN, LINDA. "The Ugly American: The Work of Philip Pearlstein," *Art News,* September 1970, pp. 55–57, 65–70.

PEARLSTEIN, PHILIP. "The Evolution of Philip Pearlstein," part 1, *Art International,* Summer 1979, pp. 62–67; part 2, September 1979, pp. 54–61.

POMEROY, RALPH. "Pearlstein Portrait," *Art and Artists,* September 1973, pp. 38–43.

SCHWARTZ, ELLEN. "A Conversation with Philip Pearlstein," *Art in America,* September 1971, pp. 50–57.

SHAMAN, SANFORD SIVITZ. "An Interview with Philip Pearlstein," *Art in America,* September 1981, pp. 120–26, 213, 215.

TILLIM, SIDNEY. "Philip Pearlstein and the New Philistinism," *Artforum,* May 1966, pp. 21–23.

## LARRY POONS

BOSTON. Museum of Fine Arts. *Larry Poons Paintings, 1971–1981,* 1981. Text by Kenworth Moffett.

CHAMPA, KERMIT S. "New Paintings by Larry Poons," *Artforum,* Summer 1968, pp. 39–42.

COPLANS, JOHN. "Larry Poons," *Artforum,* June 1965, pp. 33–35.

FRIED, MICHAEL. "Larry Poons' New Paintings," *Artforum,* March 1972, pp. 50–52.

FRY, EDWARD F. "Poons: A Clean and Balanced World?" *Art News,* February 1967, pp. 34–35, 69–71.

HENNING, EDWARD B. "Larry Poons: Untitled," *Cleveland Museum Bulletin,* April 1970, pp. 118–22.

KOZLOFF, MAX. "Larry Poons," *Artforum,* April 1965, pp. 26–29.

LIPPARD, LUCY R. "Larry Poons: The Illusion of Disorder," *Art International,* April 1967, pp. 22–26.

MONTE, JAMES. "Larry Poons: A Brief Review," *Arts Magazine,* December 1979, pp. 150–51.

TILLIM, JAMES. "Larry Poons: The Dotted Line," *Arts Magazine,* February 1965, pp. 16–21.

TUCHMAN, PHYLLIS. "Interview with Larry Poons," *Artforum,* December 1970, pp. 45–50.

## ROBERT RAUSCHENBERG

ASHTON, DORE. *Rauschenberg's XXXIV Drawings for Dante's Inferno* (New York: Harry N. Abrams, 1964).

FORGE, ANDREW. *Robert Rauschenberg* (New York: Harry N. Abrams, 1969).

TOMKINS, CALVIN. *Off the Wall: Robert Rauschenberg and the Art World of Our Time* (Garden City, N.Y.: Doubleday, 1980).

AMSTERDAM. Stedelijk Museum. *Robert Rauschenberg,* 1968. Text by Andrew Forge.

LONDON. Whitechapel Art Gallery. *Robert Rauschenberg: Paintings, Drawings, and Combines, 1949–1964,* 1964. Text by Bryan Robertson.

MINNEAPOLIS. Walker Art Center. *Robert Rauschenberg: Paintings, 1953–1964,* 1965. Text by Dean Swanson.

NEW YORK. Jewish Museum. *Robert Rauschenberg,* 1963. Text by Alan Solomon.

PHILADELPHIA. Institute of Contemporary Art, University of Pennsylvania. *Rauschenberg: Graphic Art,* 1970. Text by Lawrence Alloway.

WASHINGTON, D.C. National Collection of Fine Arts. *Robert Rauschenberg,* 1976. Text by Lawrence Alloway.

BERNSTEIN, ROBERTA. "Robert Rauschenberg's 'Rebus,'" *Arts Magazine,* January 1978, pp. 138–41.

CAGE, JOHN. "On Robert Rauschenberg, the Artist and His Work," *Metro,* May 1961, pp. 36–51.

DAVIS, DOUGLAS M. "Rauschenberg's Recent Graphics," *Art in America,* July–August 1969, pp. 90–95.

GABLIK, SUZI. "Light Conversation," *Art News,* November 1968, pp. 58–60.

GELDZAHLER, HENRY. "Robert Rauschenberg," *Art International,* 25 September 1963, pp. 62–67.

GRUEN, JOHN. "Robert Rauschenberg: An Audience of One," *Art News,* February 1977, pp. 44–51.

KOTZ, MARY LYNN. "Robert Rauschenberg's State of the Universe Message," *Art News,* February 1983, pp. 54–61.

O'DOHERTY, BRIAN. "Rauschenberg and the Vernacular Glance," *Art in America,* September–October 1973, pp. 82–87.

PERRONE, JEFF. "Robert Rauschenberg," *Artforum,* February 1977, pp. 24–31.

RAUSCHENBERG, ROBERT. "The Boy from Port Arthur: Robert Rauschenberg Reflects on his Texas Roots," *Art & Antiques,* February 1986, pp. 58–61.

SECKLER, DOROTHY GEES. "The Artist Speaks: Robert Rauschenberg," *Art in America*, May–June 1966, pp. 72–84.

STUCKEY, CHARLES F. "Reading Rauschenberg," *Art in America*, March 1977, pp. 74–84.

SWENSON, G.R. "Rauschenberg Paints a Picture," *Art News*, April 1963, pp. 44–47, 65–67.

## GEORGE RICKEY

ROSENTHAL, NAN. *George Rickey*, (New York: Harry N. Abrams, 1977).

BERLIN. Galerie Springer. *George Rickey*, 1962. Text by Henry Hope.

LOS ANGELES. UCLA Galleries. *George Rickey: Retrospective Exhibition, 1951–71*, 1971. Interview by Frederick S. Wight.

NEW YORK. Solomon R. Guggenheim Museum. *George Rickey*, 1979. Texts by George Rickey, Wieland Schmied, and Hayden Herrera.

NEW YORK. Staempfli Gallery. *George Rickey*, 1964. Text by George W. Staempfli.

WASHINGTON, D.C. Corcoran Gallery of Art. *George Rickey*, 1966. Texts by Peter Selz and George Rickey.

GRUEN, JOHN. "Sculpture of George Rickey: Silent Movement, Performing in a World of Its Own," *Art News*, April 1980, pp. 94–98.

PIENE, NAN R. "Going with the Wind: Rickey's 'Lines' and 'Planes,'" *Art in America*, November 1975, pp. 89–93.

RICKEY, GEORGE. "A Note," *Art International*, 20 June 1974, p. 39.

SCHMIDT, DORIS. "George Rickey—Zeit and Raum," *Art International*, April 1975, pp. 13–19.

## BRIDGET RILEY

SAUSMAREZ, MAURICE DE. *Bridget Riley* (London: Studio Vista, 1970).

BUFFALO. Albright-Knox Art Gallery. *Bridget Riley: Works, 1959–78*, 1978. Text by Robert Kudielka.

HANOVER. Kunstverein. *Bridget Riley*, 1970. Texts by Wieland Schmied and Bryan Robertson.

LONDON. Arts Council of Great Britain. *Bridget Riley: Paintings and Drawings, 1960–73*, 1973. Interview by Robert Kudielka.

NEW YORK. Museum of Modern Art. *Bridget Riley: Drawings*, 1966. Text by Jennifer Licht.

BARO, GENE. "Bridget Riley, Drawing for Painting," *Studio International*, July 1966, pp. 12–13.

———. "Bridget Riley's 'Nineteen Greys,'" *Studio International*, December 1968, pp. 280–81.

EHRENZWEIG, ANTON. "The Pictorial Space of Bridget Riley," *Art International*, February 1965, pp. 20–24.

FORGE, ANDREW. "On Looking at Paintings by Bridget Riley," *Art International*, 20 March 1971, pp. 22–25.

GRUEN, JOHN. "Bridget Riley: Transcending the Labels and Fads," *Art News*, September 1978, pp. 88–91.

RILEY, BRIDGET. "Notes on Some Paintings," *Art and Artists*, June 1968, pp. 24–27.

———. "On Travelling Paintings," *Art Monthly* 39 (1980): 5–9.

———. "Perception Is the Medium," *Art News*, October 1965, pp. 32–33, 66.

———, and MAURICE DE SANSMAREZ, "A Conversation," *Art International*, 20 April 1967, pp. 37–41.

ROBERTSON, BRYAN. "Color as Image," *Art in America*, March–April 1975, pp. 69–71.

SYLVESTER, DAVID. "Bridget Riley Interviewed by David Sylvester," *Studio International*, March 1967, pp. 132–35.

THOMPSON, DAVID. "Bridget Riley," *Studio International*, July–August 1971, pp. 16–21.

## JAMES ROSENQUIST

GOLDMAN, JUDITH. *James Rosenquist* (New York: Viking Penguin, 1985).

NEW YORK. Whitney Museum of American Art. *James Rosenquist*, 1972. Text by Marcia Tucker.

OTTAWA. National Gallery of Canada. *James Rosenquist*, 1968. Text by Ivan C. Karp.

ALLOWAY, LAWRENCE. "Derealized Epics," *Artforum*, June 1972, pp. 35–41.

CALAS, NICOLAS and ELENA. "James Rosenquist: Vision in the Vernacular," *Arts Magazine*, November 1969, pp. 38–39.

GELDZAHLER, HENRY. "James Rosenquist's F-111," *Metropolitan Museum of Art Bulletin*, March 1968, pp. 277–81.

HEARTNEY, ELEANOR. "Rosenquist Revisited," *Art News*, Summer 1986, pp. 98–103.

LIPPARD, LUCY. "James Rosenquist: Aspects of a Multiple Art," *Artforum*, December 1965, pp. 41–46.

SCHJELDAHL, PETER. "The Rosenquist Synthesis," *Art in America*, March–April 1972, pp. 56–61.

SCULL, ROBERT C. "Re the F-111: A Collector's Notes," *Metropolitan Museum of Art Bulletin*, March 1968, pp. 282–83.

SIEGEL, JEANNE. "An Interview with James Rosenquist," *Artforum*, June 1972, pp. 30–34.

SWENSON, G.R. "The F-111: An Interview with James Rosenquist," *Partisan Review*, Fall 1965, pp. 589–601.

———. "Social Realism in Blue: An Interview with James Rosenquist," *Studio International*, February 1968, pp. 76–83.

TILLIM, SIDNEY. "Rosenquist at the Met: Avant-garde or Red Guard?" *Artforum*, April 1968, pp. 46–49.

"Young Talent USA: Painter, James Rosenquist," *Art in America* 3 (1963): 48–49.

## EDWARD RUSCHA

SAN FRANCISCO. San Francisco Museum of Modern Art. *The Works of Edward Ruscha*, 1982. Texts by Anne Livet, Dave Hickey, and Peter Plagens.

ANTIN, ELEANOR. "Reading Ruscha," *Art in America*, November–December 1973, pp. 64–71.

BARENDSE, H.M. "Ed Ruscha: An Interview," *Afterimage*, February 1981, pp. 8–10.

BOURDON, DAVID. "A Heap of Words about Ed Ruscha," *Art International*, 20 November 1971, pp. 25–28.

———. "Ruscha as Publisher (Or All Booked Up)," *Art News*, April 1972, pp. 32–36, 68–69.

COPLANS, JOHN. "Concerning 'Various Small Fires': Ruscha Discusses His Perplexing Publications," *Artforum*, February 1965, pp. 24–25.

FAILING, PATRICIA. "Ed Ruscha: Dead Serious About Being Nonsensical," *Art News*, April 1982, pp. 74–81.

FOX, CHRISTOPHER. "Ed Ruscha Discusses His Latest Work," *Studio International*, June 1970, pp. 281, 287.

PINDELL, HOWARDENA. "Words with Ruscha," *Print Collector's Newsletter*, January–February 1973, pp. 125–28.

SHARP, WILLOUGHBY. "'. . . a Kind of HUH?' An Interview with Edward Ruscha . . .," *Avalanche*, Winter–Spring 1973, pp. 30–39.

## ROBERT RYMAN

BASEL. Kunsthalle. *Robert Ryman*, 1975. Text by Carlo Huber.

LONDON. Whitechapel Art Gallery. *Robert*

*Ryman*, 1977. Text by Naomi Spector.

NEW YORK. Solomon R. Guggenheim Museum. *Robert Ryman*, 1972. Text by Diane Waldman.

CANE, LOUIS, and CATHERINE MILLET. "Robert Ryman," *Artpress*, March–April 1975, pp. 4–6.

DOMINGO, WILLIS. "Robert Ryman," *Arts Magazine*, March 1971, pp. 17–19.

GRIMES, NANCY. "Robert Ryman's White Magic," *Art News*, Summer 1986, pp. 86–92.

HAFIF, MARCIA. "Robert Ryman: Another View," *Art in America*, September 1979, pp. 88–89.

OLIVA, ACHILLE BONITO. "An Interview with Robert Ryman," *Domus*, February 1973, p. 49.

RATCLIFF, CARTER. "Robert Ryman's Double Positive," *Art News*, March 1971, pp. 54–56, 71–72.

STORR, ROBERT. "Robert Ryman Making Distinctions," *Art in America*, June 1986, pp. 92–97.

TUCHMAN, PHYLLIS. "An Interview with Robert Ryman," *Artforum*, May 1971, pp. 70–73.

## LUCAS SAMARAS

LEVIN, KIM. *Lucas Samaras* (New York: Harry N. Abrams, 1975).

CHICAGO. Museum of Contemporary Art. *Lucas Samaras, Boxes*, 1971. Text by Joan C. Siegfried.

DENVER. Denver Art Museum. *Lucas Samaras: Pastels*, 1981. Text by Peter Schjeldahl.

NEW YORK. Pace Gallery. *Chair Transformations, 1969–1970*, 1970. Text by Lucas Samaras.

———. *Lucas Samaras, Selected Works, 1960–1966*, 1966. Texts by Lawrence Alloway and Lucas Samaras.

NEW YORK. Whitney Museum of American Art. *Lucas Samaras*, 1972. Text by Lucas Samaras.

FRIEDMAN, MARTIN. "The Obsessive Image of Lucas Samaras," *Art and Artists*, November 1966, pp. 20–23.

GLIMCHER, ARNOLD. "Lucas Samaras," *Flash Art*, October–November 1985, pp. 40–44.

GRUEN, JOHN. "The Apocalyptic Disguises of Lucas Samaras," *Art News*, April 1976, pp. 32–35.

KURTZ, BRUCE. "Samaras' AutoPoloroids," *Arts Magazine*, December 1971–January 1972, pp. 54–55.

LEVIN, KIM. "Eros, Samaras and Recent Art," *Arts Magazine*, December–January 1973, pp. 35–37, 54–56.

———. "Samaras Bound," *Art News*, February 1969, pp. 35–37, 54.

MAUFARREGE, N.A. "Face a Face: Dust, Spit, and Thread—The Pastels of Lucas Samaras," *Arts Magazine*, May 1983, pp. 74–77.

RATCLIFF, CARTER. "Modernism Turned Inside Out: Lucas Samaras' 'Reconstructions,' " *Arts Magazine*, November 1979, pp. 92–95.

ROSE, BARBARA. "Lucas Samaras: The Self as Icon and Environment," *Arts Magazine*, February 1978, pp. 144–49.

SAMARAS, LUCAS. "Autopolaroid," *Art in America*, November–December 1970, pp. 66–83.

———. "An Exploratory Dissection of Seeing," *Artforum*, December 1967, pp. 26–27.

———. "A Reconstituted Diary: Greece, 1967," *Artforum*, October 1968, pp. 54–57.

SCHWARTZ, B. "Interview with Lucas Samaras," *Craft Horizons*, December 1972, pp. 36–43.

SOLOMON, ALAN. "An Interview with Lucas Samaras," *Artforum*, October 1966, pp. 39–44.

WALDMAN, DIANE. "Samaras: Reliquaries for St. Sade," *Art News*, October 1966, pp. 44–46, 72–75.

## PETER SAUL

DE KALB, ILL. Swen Parson Gallery, Northern Illinois University. *Peter Saul: Retrospective Exhibition*, 1980. Text by E. Michael Flanagan and Peter Saul.

NEW YORK. Allan Frumkin Gallery. *Peter Saul*, 1964. Text by Ellen H. Johnson.

———. *Peter Saul*, 1976. Text by A. James Speyer.

———. *Peter Saul*, 1987. Text by Peter Saul.

PARIS. Galerie Darthea Speyer. *Peter Saul*, 1962. Text by Georges Boudaille.

ABBE, RONALD. "Peter Saul," *Arts Magazine*, January 1978, p. 15.

STORR, ROBERT. "Peter Saul: Radical Distaste," *Art in America*, January 1985, pp. 92–107.

ZACK, DAVID. "That's Saul, Folks," *Art News*, November 1969, pp. 56–58, 78–79.

## GEORGE SEGAL

HUNTER, SAM. *George Segal* (New York: Rizzoli, 1984).

SEITZ, WILLIAM C. *George Segal* (New York: Harry N. Abrams, 1972).

TUCHMAN, PHYLLIS. *George Segal* (New York: Abbeville, 1983).

VAN DER MARCK, JAN. *George Segal* (New York: Harry N. Abrams, 1977).

MINNEAPOLIS. Walker Art Center. *George Segal Sculptures*, 1978. Texts by Martin Friedman, Graham W.J. Beal, and George Segal.

PHILADELPHIA. Institute of Contemporary Art, University of Pennsylvania. *George Segal: Environments*, 1976. Texts by Jose Barrio-Garay and Suzanne Delehanty.

ZURICH. Kunsthalle. *George Segal*, 1971. Text by Jan van der Marck.

ELSEN, ALBERT. " 'Mind Bending' with George Segal," *Art News*, February 1977, pp. 34–37.

FRIEDMAN, MARTIN. "George Segal: Proletarian Mythmaker," *Art International*, January–February 1980, pp. 14–27.

GELDZAHLER, HENRY. "An Interview with George Segal," *Artforum*, November 1964, pp. 26–29.

HEGEMAN, WILLIAM R. "George Segal's Old Friends," *Art News*, January 1979, pp. 80–82.

JOHNSON, ELLEN H. "The Sculpture of George Segal," *Art International*, March 1964, pp. 46–49.

KAPROW, ALLAN. "Segal's Vital Dummies," *Art News*, February 1964, pp. 28–31, 64–66.

KUSPIT, DONALD B. "George Segal on the Verge of Tragic Vision," *Art in America*, May–June 1977, pp. 84–85.

LIPKE, WILLIAM C. "The Sense of 'Why Not?': George Segal on His Art," *Studio International*, October 1967, pp. 146–49.

PERREAULT, JOHN. "Plaster Caste," *Art News*, November 1968, pp. 54–55, 75–76.

PINCUS-WITTEN, ROBERT. "George Segal as Realist," *Artforum*, Summer 1967, pp. 84–87.

ROSE, BARBARA. "Psychological Sculpture," an interview, *Vogue*, September 1976, pp. 348–49, 383–88.

RUBINFEIN, LEO. "On George Segal's Reliefs," *Artforum*, May 1977, pp. 44–45.

TUCHMAN, PHYLLIS. "George Segal," *Art International*, 20 September 1968, pp. 74–81.

———. "Interview with George Segal," *Art in America*, May–June 1972, pp. 74–81.

VAN DER MARCK, JAN. "Spatial Dialectics in the Sculpture of George Segal," *artscanada*, Spring 1972, pp. 35–38.

ZEIFER, ELLEN. "George Segal: Sculptural Environments," *American Artist,* January 1975, pp. 74–79.

## RICHARD SERRA

BERLIN. Galerie Reinhard Onnasch. *Richard Serra: Sculptures and Drawings,* 1983. Text by Michael Pauseback.

NEW YORK. Museum of Modern Art. *Richard Serra/Sculpture,* 1986. Texts by Rosalind E. Krauss, Laura Rosenstock, and Douglas Crimp.

PARIS. Musée National d'Art Moderne, Centre Georges Pompidou. *Richard Serra,* 1983. Texts by Yves-Alain Bois and Rosalind E. Krauss; interview by Alfred Pacquement.

TÜBINGEN. Kunsthalle. *Richard Serra: Works, '66–'77,* 1978. Texts by Clara Weyergraf, Max Imdahl, and B. H. D. Buchloh. Interview by Lizzie Borden.

YONKERS, N.Y. Hudson River Museum. *Richard Serra: Elevator 1980,* 1980. Text by Richard Serra.

AMAYO, MARIO. "Toronto: Serra's Visit and After," *Art in America,* May–June 1971, pp. 122–23.

BAER, LIZA. "Document: Spin Out '72–'73 for Bob Smithson," an interview, *Avalanche,* Summer–Fall 1973, pp. 14–15.

BAKER, ELIZABETH C. "Critic's Choice: Serra," *Art News,* February 1970, pp. 26–27.

CRIMP, DOUGLAS. "Richard Serra: Sculpture Exceeded," *October,* Fall 1981, pp. 67–78.

HAHN, OTTO. "Richard Serra," *Art Press,* February 1974, pp. 10–11.

KRAUSS, ROSALIND E. "Richard Serra: Sculpture Redrawn," *Artforum,* May 1972, pp. 38–43.

———. "Richard Serra: Shift," *Arts Magazine,* April 1973, pp. 49–55.

KUSPIT, DONALD. "Richard Serra: Utopian Constructivist," *Arts Magazine,* November 1980, pp. 124–29.

LEIDER, PHILIP. "New York: Richard Serra," *Artforum,* February 1970, pp. 68–69.

PINCUS-WITTEN, ROBERT. "Oedipus Reconsidered," *Arts Magazine,* November 1980, pp. 124–29.

———. "Richard Serra: Slow Information," *Artforum,* September 1969, pp. 34–39.

RATCLIFF, CARTER. "Adversary Spaces," *Artforum,* October 1972, pp. 40–41.

ROSE, BARBARA. "Serra," *Vogue,* 1 September 1972, pp. 252–53, 303.

SERRA, RICHARD. "Documents," *Avalanche,* Winter 1971, pp. 20–21.

———. "Play It Again, Sam," *Arts Magazine,* February 1970, pp. 24–27.

———, and JOAN JONAS. "Paul Revere," *Artforum,* September 1971, pp. 65–67.

## TONY SMITH

LIPPARD, LUCY R. *Tony Smith* (London: Thames and Hudson, 1972).

HARTFORD. Wadsworth Atheneum. *Tony Smith,* 1966. Text by Tony Smith.

NEW YORK. Knoedler & Co., Inc. *Tony Smith, Recent Sculpture,* 1971. Text by Martin Friedman. Interview by Lucy R. Lippard.

BARO, GENE. "Tony Smith: Toward Speculation in Pure Form," *Art International,* Summer 1967, pp. 27–31.

BURTON, SCOTT. "Old Master at the New Frontier," *Art News,* December 1966, pp. 52–55, 68–70.

GREEN, E. "Morphology of Tony Smith's Work," *Artforum,* April 1974, pp. 54–59.

KOLBERT, FRANK L. "Tony Smith's Gracehopper," *Detroit Institute of Arts Bulletin* 2 (1971): 19–22.

LIPPARD, LUCY R. "Tony Smith: The Ineluctable Modality of the Visible," *Art International,* Summer 1970, pp. 24–26.

———. "Tony Smith: Talk About Sculpture," *Art News,* April 1971, pp. 48–49, 68–72.

WAGSTAFF, SAMUEL, JR. "Talking with Tony Smith," *Artforum,* December 1966, pp. 14–19.

WASSERMAN, EMILY. "Tony Smith," *Artforum,* April 1968, pp. 59–61.

## ROBERT SMITHSON

HOBBS, ROBERT. *Robert Smithson: Sculpture* (Ithaca, N.Y.: Cornell University Press, 1981). Additional texts by Lawrence Alloway, John Coplans, and Lucy R. Lippard.

HOLT, NANCY, ed. *The Writings of Robert Smithson* (New York: New York University Press, 1979).

NEW YORK. New York Cultural Center. *Robert Smithson: Drawings,* 1974. Texts by Susan Ginsburg and Joseph Masheck.

ALLOWAY, LAWRENCE. "Robert Smithson's Development," *Artforum,* November 1972, pp. 52–61.

ANDRE, CARL. "Robert Smithson: He Always Reminded Us of the Questions We Ought to Have Asked Ourselves," *Arts Magazine,* May 1978, p. 102.

DWAN, VIRGINIA. "Reflections on Robert Smithson," *Art Journal,* Fall 1982, p. 233.

GILDZEN, ALEX. " 'Partially Buried Woodshed': A Robert Smithson Log," *Arts Magazine,* May 1978, pp. 118–20.

GOPNIK, A. "Basic Stuff: Robert Smithson, Science, and Primitivism," *Arts Magazine,* March 1983, pp. 74–80.

HERRMANN, ROLF-DIETER. "In Search of a Cosmological Dimension: Robert Smithson's Dallas–Fort Worth Airport Project," *Arts Magazine,* May 1978, pp. 110–13.

INSLEY, WILL. "Seriocomic Sp(i)eleology: Robert Smithson's Architecture of Existence," *Arts Magazine,* May 1978, pp. 98–101.

KUSPIT, DONALD B. "Robert Smithson's Drunken Boat," *Arts Magazine,* October 1981, pp. 82–88.

LEIDER, PHILIP. "For Robert Smithson," *Art in America,* November–December 1973, pp. 80–82.

LEVIN, KIM. "Reflections on Robert Smithson's *Spiral Jetty,*" *Arts Magazine,* May 1978, pp. 136–37.

———. "Robert Smithson No One Ever Noticed," *Art News,* September 1982, pp. 96–99.

LINKER, KATE. "Books: The Writings of Robert Smithson," *Artforum,* October 1979, pp. 60–63.

MÜLLER, GREGOIRE. ". . . The Earth, Subject to Cataclysms, Is a Cruel Master," *Arts Magazine,* November 1971, pp. 179–85.

RATCLIFF, CARTER. "The Compleat Smithson," *Art in America,* January 1980, pp. 60–65.

ROBBIN, ANTHONY. "Smithson's Non-Site Sights," *Art News,* February 1967, pp. 157–59.

ROTH, MOIRA. "Robert Smithson on Duchamp: An Interview," *Artforum,* October 1973, pp. 197–99.

SMITHSON, ROBERT. "Incidents of Mirror-Travel in the Yucatán," *Artforum,* September 1969, pp. 28–33.

———. "The Monuments of Passaic," *Artforum,* December 1967, pp. 48–51.

———. "Toward the Development of an Air Terminal Site," *Artforum,* Summer 1967, pp. 37–40.

TOMKINS, CALVIN. "Onward and Upward with the Arts," *New Yorker,* 5 February 1972, pp. 53–57.

WILSON, WILLIAM S. "Robert Smithson: Non-Reconciliations," *Arts Magazine,* May 1978, pp. 104–9.

## KENNETH SNELSON

BERLIN. Nationalgalerie. *Kenneth Snelson: Skulpturen,* 1977. Interview with Angela Schneider.

BUFFALO. Albright-Knox Art Gallery. *Kenneth Snelson,* 1981. Text by Howard N. Fox.

HANOVER. Kunstverein. *Kenneth Snelson,* 1971. Texts by James Burns, Laszlo Glozer, Burton Holmes, Stephen A. Kurtz, Gregoire Müller, Kenneth Snelson, and Kurt von Meier.

BATTCOCK, GREGORY. "Kenneth Snelson: Dialogue Between Stress and Tension at the Dwan," *Arts Magazine,* February 1968, pp. 27–29.

COPLANS, JOHN. "An Interview with Kenneth Snelson," *Artforum,* March 1967, pp. 46–49.

KURTZ, STEPHEN A. "Kenneth Snelson: The Elegant Solution," *Art News,* October 1968, pp. 48–51.

PERLBERG, DEBORAH. "Snelson and Structure," *Artforum,* May 1977, pp. 46–49.

SAWIN, MARTICA. "Kenneth Snelson: Unbounded Space," *Arts Magazine,* September 1981, pp. 171–73.

SNELSON, KENNETH. "How Primary Is Structure?" *Art Voices,* Summer 1966, p. 82.

WHELAN, RICHARD. "Kenneth Snelson: Straddling the Abyss Between Art and Science," *Art News,* February 1981, pp. 68–73.

## FRANK STELLA

ROSENBLUM, ROBERT. *Frank Stella* (Harmondsworth, England: Penguin Books, 1971).

RUBIN, WILLIAM S. *Frank Stella* (Greenwich, Conn.: New York Graphic Society, 1970).

STELLA, FRANK. *Working Space* (Cambridge, Mass.: Harvard University Press, 1986).

BALTIMORE. Baltimore Museum of Art. *Frank Stella: The Black Paintings,* 1976. Text by Brenda Richardson.

LONDON. Hayward Gallery. *Frank Stella: A Retrospective Exhibition,* 1970. Text by John McLean.

PASADENA. Pasadena Art Museum. *Frank Stella: An Exhibition of Recent Paintings,* 1966. Text by Michael Fried.

WALTHAM, MASS. Rose Art Museum, Brandeis University. *Recent Paintings by Frank Stella,* 1969. Text by William S. Seitz.

BAKER, ELIZABETH C. "Frank Stella's Perspectives," *Art News,* May 1970, pp. 46–49, 62–64.

BERMAN, A. "Artist's Dialogue: A Conversation with Frank Stella," *Architectural Digest,* September 1983, p. 70.

CASTLE, FREDERICK. "What's That, the '68 Stella? Wow!" *Art News,* January 1968, pp. 46–47, 68–71.

CONE, JANE HARRISON. "Frank Stella's New Paintings," *Artforum,* December 1967, pp. 34–41.

CREELEY, ROBERT. "Frank Stella: A Way to Go," *Lugano Review,* Summer 1965, pp. 189–97.

FINKELSTEIN, LOUIS. "Seeing Stella," *Artforum,* June 1973, pp. 67–70.

FRIED, MICHAEL. "Shape as Form: Frank Stella's New Paintings," *Artforum,* November 1966, pp. 18–27.

HALLEY, PETER. "Frank Stella and the Simulacrum," *Flash Art,* February–March 1986, pp. 32–35.

LEIDER, PHILIP. "Frank Stella," *Artforum,* (1965), pp. 24–26.

———. "Literalism and Abstraction: Frank Stella's Retrospective at the Modern," *Artforum,* April 1970, pp. 44–51.

RATCLIFF, CARTER. "Frank Stella: Portrait of the Artist as an Image Administrator," *Art in America,* February 1985, pp. 94–107.

ROSENBLUM, ROBERT. "Frank Stella: Five Years of Variation on an 'Irreducible' Theme," *Artforum,* March 1965, pp. 21–25.

## GEORGE SUGARMAN

DAY, HOLLIDAY T. *Shape of Space: The Sculpture of George Sugarman* (New York: Arts Publisher, 1981). Texts by Irving Sandler and Brad Davis.

CASTLE, WENDELL. "Wood: George Sugarman," *Craft Horizons,* March–April 1967, pp. 30–33.

FRANK, E. "Multiple Dimensions: George Sugarman," *Art in America,* September 1983, pp. 144–49.

GOLDIN, AMY. "The Sculpture of George Sugarman," *Arts Magazine,* June 1966, pp. 28–31.

HARPER, PAULA. "George Sugarman: The Fullness of Time," *Arts Magazine,* September 1980, pp. 158–60.

RABINOWITZ, M. "George Sugarman's Sculpture," *Arts Magazine,* September 1985, pp. 98–101.

SANDLER, IRVING. "Sugarman Makes a Sculpture," *Art News,* May 1966, pp. 34–37.

SIMON, SIDNEY. "George Sugarman," *Art International,* May 1967, pp. 22–26.

SZEEMANN, HARALD. "George Sugarman," *Art International,* 20 February 1970, pp. 50–51, 55.

## RICHARD TUTTLE

DALLAS. Dallas Museum of Fine Arts. *Richard Tuttle,* 1971. Text by Robert M. Murdock.

NEW YORK. Whitney Museum of American Art. *Richard Tuttle,* 1975. Text by Marcia Tucker.

KERTESS, KLAUS. "Imagining Nowhere," *Artforum,* November 1983, pp. 44–45.

LUBELL, ELLEN. "Wire/Pencil/Shadow: Elements of Richard Tuttle," *Arts Magazine,* November 1972, pp. 50–52.

NORTH, CHARLES. "Richard Tuttle Small Pleasures," *Art in America,* November–December 1975, pp. 68–69.

PINCUS-WITTEN, ROBERT. "The Art of Richard Tuttle," *Artforum,* February 1979, pp. 62–67.

YAU, JOHN. "Richard Tuttle and His 'Old Men and Their Garden,'" *Arts Magazine,* 1983, pp. 126–28.

## ANDY WARHOL

COPLANS, JOHN. *Andy Warhol* (Greenwich, Conn.: New York Graphic Society, 1971).

CRONE, RAINER. *Andy Warhol* (New York: Praeger, 1970).

GIDAL, PETER. *Andy Warhol: Films and Paintings* (London: Studio Vista, 1971).

GREEN, SAMUEL ADAMS. *Andy Warhol* (New York: Wittenborn, 1966).

KOCH, STEPHEN. *Stargazer: Andy Warhol's World and His Films* (New York: Praeger, 1973).

RATCLIFF, CARTER. *Andy Warhol* (New York: Abbeville, 1983).

STEIN, JEAN, with GEORGE PLIMPTON. *Edie: An American Biography* (New York: Alfred A. Knopf, 1982).

WARHOL, ANDY. *The Philosophy of Andy Warhol (From A to B and Back Again)* (New York: Harcourt, Brace, Jovanovich, 1975).

———, and PAT HACKETT. *POPism: The Warhol Sixties* (New York: Harcourt, Brace, Jovanovich, 1980).

WILCOCK, JOHN. *The Autobiography and Sex Life of Andy Warhol* (New York: Other Scenes, 1971).

BOSTON. Institute of Contemporary Art. *Andy Warhol,* 1966. Text by Alan Solomon.

LONDON. Tate Gallery. *Andy Warhol*, 1971. Text by Richard Morphet.

PASADENA. Pasadena Art Museum. *Andy Warhol*, 1970. Texts by Johns Coplans, Jonas Mekas, and Calvin Tomkins.

PHILADELPHIA. Institute of Contemporary Art, University of Pennsylvania. *Andy Warhol*, 1965. Text by Samuel Adams Green.

ANTIN, DAVID. "Warhol: The Silver Tenement," *Art News*, Summer 1966, pp. 47–49, 58–59.

BERGIN, PAUL. "Andy Warhol: The Artist as Machine," *Art Journal*, Summer 1967, pp. 359–63.

BETSCH, CAROLYN. "A Catalogue Raisonné of Warhol's Gestures," *Art in America*, May–June 1971, p. 47.

BLINDERMAN, B. "Modern Myths: An Interview with Andy Warhol," *Arts Magazine*, October 1981, pp. 144–47.

BOURDON, DAVID. "Andy Warhol and the Society Icon," *Art in America*, January 1975, pp. 42–45.

———. "Warhol as Film Maker," *Art in America*, May–June 1971, pp. 48–53.

———, and GREGORY BATTCOCK. "Andy Warhol's Travel Piece," *Arts Magazine*, April 1970, pp. 23–25.

CASTLE, FREDERICK. "Occurrences: Cab Ride with Andy Warhol," *Art News*, February 1968, pp. 46–47, 52.

COPLANS, JOHN. "Early Warhol: The Systematic Evolution of the Impersonal Style," *Artforum*, March 1970, pp. 52–59.

DEITCH, JEFFREY. "The Warhol Product," *Art in America*, May 1980, pp. 9–13.

FAGIOLO DELL'ARCO, MAURIZIO. "Warhol: The American Way of Dying," *Metro*, June 1968, pp. 72–79.

GELDZAHLER, HENRY. "Andy Warhol," *Art International*, April 1964, pp. 35–36.

HUGHES, ROBERT. "The Rise of Andy Warhol," *New York Review of Books*, 18 February 1982, pp. 6–10.

JOSEPHSON, MARY. "Warhol: The Medium as Cultural Artifact," *Art in America*, May–June 1971, pp. 40–46.

LEIDER, PHILIP. "Saint Andy: Some Notes on an Artist Who for a Large Section of a Younger Generation Can Do No Wrong," *Artforum*, February 1965, pp. 26–28.

LEONARD, JOHN. "The Return of Andy Warhol," *New York Times Magazine*, 10 November 1968, pp. 32–33, 142–51.

MALANGA, GERARD. "A Conversation with Andy Warhol," *Print Collector's Newsletter*, January–February 1971, pp. 125–27.

MASHECK, JOSEPH. "Warhol as Illustrator: Early Manipulations of the Mundane," *Art in America*, May–June 1971, pp. 54–59.

PERREAULT, JOHN. "Andy Warhol," *Vogue*, March 1970, pp. 164–67, 204–6.

———. "Andy Warhola: This Is Your Life," *Art News*, May 1970, pp. 52–53, 79–80.

POMEROY, RALPH. "An Interview with Andy Warhol," *Afterimage*, Autumn 1970, pp. 34–39.

———. "The Importance of Being Andy Andy Andy Andy," *Art and Artists*, February 1971, pp. 14–19.

RATCLIFF, CARTER. "Andy Warhol: Inflation Artist," March 1985, pp. 67–75.

ROSENBERG, HAROLD. "The Art World: Art's Other Self," *New Yorker*, 12 June 1971, pp. 101–5.

SCHJELDAHL, PETER. "Warhol and Class Content," *Art in America*, May 1980, pp. 112–19.

WARHOL, ANDY. "My Favorite Superstar: Notes on My Epic 'Chelsea Girls,' " *Arts Magazine*, February 1967, p. 26.

## LAWRENCE WEINER

WEINER, LAWRENCE. *Statements* (New York: Louis Kellner Foundation, Seth Siegelaub, 1968).

———. *Works* [1967–1977] (Hamburg: Anatol AV und Filmproduktion, 1977).

AACHEN. Zentrum für Aktuelle Kunst. *Lawrence Weiner: An Exhibition*, 1970. Text by Klaus Honnef.

EINDHOVEN. Stedelijk van Abbemuseum. *Lawrence Weiner: A Selection of Works*, 1976. Text by Rudi H. Fuchs.

MÜNSTER. Westfälischer Kunstverein. *Lawrence Weiner*, 1972. Text by Klaus Honnef.

BURNSIDE, MADELEINE. "Lawrence Weiner," *Arts Magazine*, June 1979, p. 22.

CAMERON, ERIC. "Lawrence Weiner: The Books," *Studio International*, January 1974, pp. 2–8.

FISHER, J. "Lawrence Weiner," *Art Monthly* 46 (1980–81): 12.

HEINEMANN, SUSAN. "Lawrence Weiner: Given the Context," *Artforum*, March 1975, pp. 36–37.

LEBEER, I. "Red as Well as Green as Well as Yellow as: . . . Conversation with Lawrence Weiner," *Chronicles de l'art vivant*, December 1973–January 1974, pp. 7–8.

LOVELL, ANTHONY. "Lawrence Weiner," *Studio International*, March 1971, p. 126.

STIMSON, PAUL. "Between the Signs," *Art in America*, October 1979, pp. 80–81.

"Works by Lawrence Weiner," *Studio International*, March 1971, p. 127.

WOOSTER, A. "A First Quarter: Lawrence Weiner's First Film," *Arts Magazine*, May–June 1973, pp. 32–35.

## NEIL WELLIVER

GOODYEAR, FRANK HENRY. *Neil Welliver* (New York: Rizzoli, 1985).

HANOVER, N. H. Currier Gallery of Art. *Neil Welliver: Paintings, 1968–1980*, 1982. Texts by Robert Doty and John Bernard Myers. Interview by Edwin Denby.

DOTY, R. M. "Imagery of Neil Welliver," *Art International*, September–October 1982, pp. 34–41.

DOWNES, RACKSTRAW. "Welliver's Travels," *Art News*, November 1968, pp. 34–36, 75–76.

KUSPIT, DONALD B. "Terrestrial Truth: Neil Welliver," *Art in America*, April 1983, pp. 138–43.

MEDOFF, EVE. "Neil Welliver—Painting, Inclusive and Intense," *American Artist*, April 1979, pp. 5, 48–53.

WELLIVER, NEIL. "Albers on Albers," *Art News*, January 1966, pp. 48–51, 68–69.

## TOM WESSELMANN

TOM WESSELMANN/STEALINGWORTH, SLIM. *Tom Wesselmann* (New York: Harry N. Abrams, 1980).

LONG BEACH, CALIF. California State University Museum. *Tom Wesselmann: The Early Years—Collages, 1959–1962*, 1974. Text by Constance Glenn.

NEWPORT BEACH, CALIF. Newport Harbor Art Museum. *Tom Wesselmann: Early Still Lifes, 1962–1964*, 1970. Text by Thomas H. Garver.

ABRAMSON, J.A. "Tom Wesselmann and the Gates of Horn," *Arts Magazine*, May 1966, pp. 43–48.

FAIRBROTHER, TREVOR K. "An Interview with Tom Wesselmann/Slim Stealingworth," *Arts Magazine*, May 1982, pp. 136–41.

FERRIER, JEAN-LOUIS. "Le Nouveau Paysage de Tom Wesselmann," *Metro*, March 1967, pp. 42–45.

GARDNER, PAUL. "Tom Wesselmann: 'I like to think that my work is about all kinds of pleasure,' " *Art News*, January 1982, pp. 67–72.

MARGOLIS, DAVID. "Wesselmann's Fancy Footwork," *Art Voices*, Summer 1966,

pp. 46–49.

SWENSON, G.R. "The Honest Nude—Wesselmann," *Art and Artists,* May 1966, pp. 54–57.

ZELENKO, L.S. "Tom Wesselmann," *American Artist,* June 1982, pp. 58–62.

## H.C. WESTERMANN

LOS ANGELES. Los Angeles County Museum. *H. C. Westermann,* 1969. Text by Max Kozloff.

NEW YORK. Whitney Museum of American Art. *H.C. Westermann,* 1978. Text by Barbara Haskell.

ADRIAN, DENNIS. "The Art of H.C. Westermann," *Artforum,* September 1967, pp. 16–22.

———. "Some Notes on H.C. Westermann," *Art International,* 25 February 1963, pp. 52–55.

FRIEDMAN, MARTIN. "Carpenter Gothic," *Art News,* March 1967, pp. 30–31, 74–76.

RATCLIFF, CARTER. "Notes on Small Sculpture," *Artforum,* April 1976, pp. 35–42.

## WILLIAM T. WILEY

RICHARDSON, BRENDA. *William T. Wiley: Graphics, 1967–1979* (Chicago: Landfall, 1980).

BERKELEY. University Art Museum. *William T. Wiley,* 1971. Text by Brenda Richardson.

MINNEAPOLIS. Walker Art Center. *Wiley Territory,* 1979. Texts by John Perreault and Graham W.J. Beal.

PERREAULT, JOHN. "Metaphysical Funk Monk," *Art News,* May 1968, pp. 52–53, 66–67.

PLAGENS, PETER. "Artist's Dialogue: A Conversation with William Wiley," *Architectural Digest,* November 1980, p. 66.

RAYMOND, HERBERT. "Prince of Wizdumb," *Art and Artists,* November 1973, pp. 24–27.

TOOKER, DAN. "How to Chart a Course: An Interview with William T. Wiley," *artscanada,* Spring 1974, pp. 82–85.

WASSERMAN, EMILY. "William T. Wiley and William Allan: Meditations at Fort Prank," *Artforum,* December 1970, pp. 62–67.

# INDEX